The Arts of Antioch

Art Historical and Scientific Approaches to Roman Mosaics and a Catalogue of the Worcester Art Museum Antioch Collection

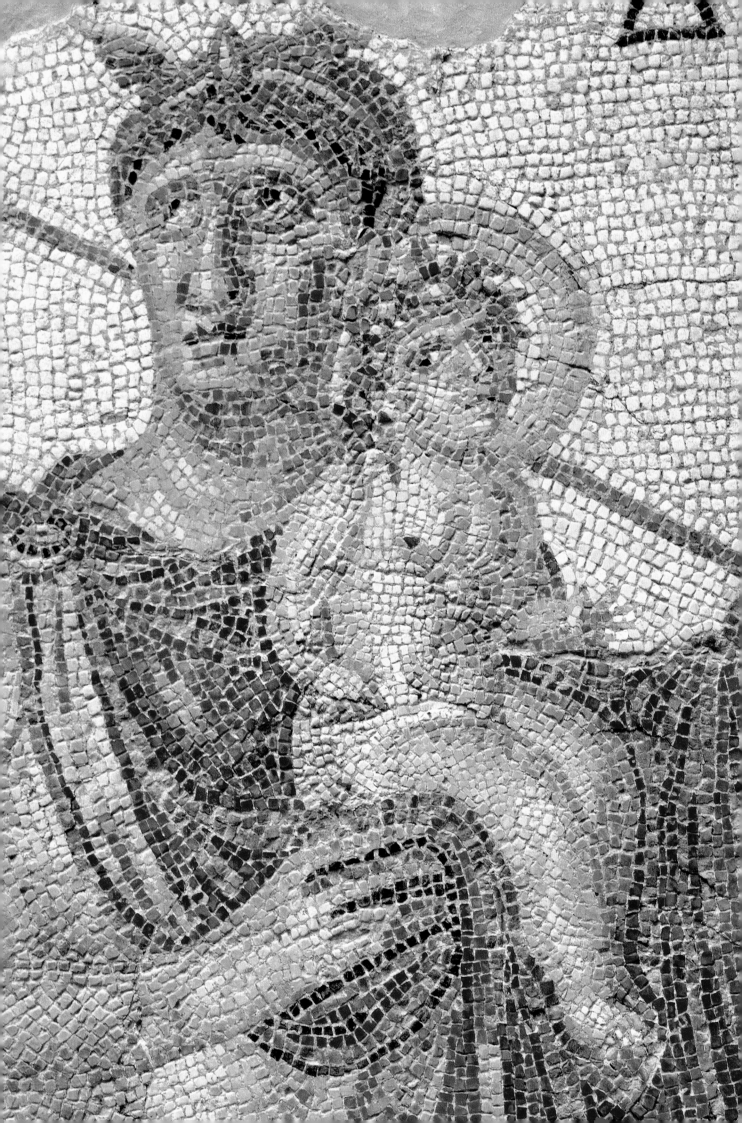

The Arts of Antioch

Art Historical and Scientific Approaches to Roman Mosaics and a Catalogue of the Worcester Art Museum Antioch Collection

Lawrence Becker
Christine Kondoleon

Worcester Art Museum

The Arts of Antioch: Art Historical and Scientific Approaches to Roman Mosaics and a Catalogue of the Worcester Art Museum Antioch Collection was published with major support from the Andrew W. Mellon Foundation and additional support from the Samuel H. Kress Foundation, the J. Paul Getty Trust Grant Program, and Cornelius and Emily Townsend Vermeule.

Published by Worcester Art Museum, 55 Salisbury Street, Worcester, MA 01609-3123
www.worcesterart.org

Distributed by Princeton University Press, 41 William Street, Princeton, NJ 08540
In the United Kingdom: Princeton University Press, 3 Market Place, Woodstock,
Oxfordshire OX20 1SY
pup.princeton.edu

Jacket illustrations: Detail of tigress and cubs from the Worcester Hunt Mosaic, 480–520 C.E., Worcester Art Museum (1936.30). Bust of Ktisis, detail from Mosaic of Ktisis, late fifth cent. C.E., Worcester Art Museum (1936.35).

Frontispiece: Detail of Mosaic of Hermes Carrying the Infant Dionysos, 350–400 C.E., Worcester Art Museum (1936.32).

Library of Congress Control Number 2004113016

ISBN 0-691-12232-6

British Library Cataloging-in-Publication Data is available

Design and composition by Jon Albertson
albertson-design.com

Set in Monotype Centaur and Linotype Syntax

Color separations and printing by Meridian Printing, East Greenwich, RI

Printed on acid-free paper. ∞
Printed and bound in the United States

10 9 8 7 6 5 4 3 2 1

Contents

Foreword

Ever since their installation in the Worcester Art Museum's Renaissance Court in 1936, the mosaics from ancient Antioch have been a highlight of the Museum's permanent collection. Located near the main entrance, they have captured the attention and imagination of Museum visitors for generations. During the past decade, the Museum generated renewed interest in its Antioch holdings through a variety of related projects. As some of the finest treasures from one of the Roman world's largest and most cosmopolitan cities, the Antioch material was a natural focus for the Museum's Art of Discovery project, begun in 1994 to expand and diversify the Museum's audience. Supported by a major grant from the Lila Wallace–Reader's Digest Fund, this project was the catalyst for hiring Christine Kondoleon for more effective interpretation of the Museum's ancient Greek and Roman collections. Soon thereafter the Museum hired its first full-time objects conservator, Lawrence Becker, a specialist in the conservation of ancient art, who had recently treated a major Antioch mosaic at the Virginia Museum of Fine Arts in Richmond.

Having the appropriate curatorial and conservation expertise, the Museum undertook a reinstallation of its ancient Greek and Roman collections while introducing a number of objects from storage. When it was also decided to work toward a major exhibition of the art and culture of Antioch, one of the first steps was to resurrect the rest of the Museum's mosaics collection, many of which had been in storage since the 1930s, including the border fragments from the Worcester Hunt. Extensive conservation work on the mosaics followed, including the treatment of two border fragments for the exhibition. At this time the Museum's Antioch collection was enhanced by a gift of over one hundred Antioch coins from Emily Townsend Vermeule and Cornelius Vermeule in memory of Francis Henry Taylor, the director responsible for Worcester's participation in the Antioch dig. The Museum also took the opportunity to purchase several other related objects, including one of the few available small bronze Tyches of Antioch.

The exhibition *Antioch: The Lost Ancient City*, which included loans from both American and European museums, opened in the fall of 2000. The interdisciplinary exhibition and catalogue, which focused on the life and art of ancient Antioch, had contributions from over 20 scholars. After attracting a record number of visitors at Worcester, the show traveled to Cleveland and Baltimore where it proved equally popular.

As part of the Lila Wallace–Reader's Digest grant, the Museum created the Discovery Gallery adjacent to its Renaissance Court to house additional Antioch material and serve as an introduction to the Antioch collection. As a related project, the Museum also engaged over a thousand local citizens to create a 13.7 meter-long community mosaic representing the diversity of Worcester. The popular work, mounted on an exterior wall on the Lancaster Street side of the Museum, was unveiled at a large public gathering as a preamble to the Antioch show.

Following the close of the Antioch exhibition, the Museum began an extensive conservation treatment of the Worcester Hunt, including the addition of the remaining border fragments, a project made possible by funding from the Florence Gould Foundation. With Centennial Campaign funds, the Museum also made several improvements to the Renaissance Court to create a better environment for viewing the mosaics, including the reintroduction of natural light, which had been eliminated two decades earlier due to leaks in the skylight, and the addition of focused lighting for evening viewing as well as air-conditioning to offset the summer heat.

During its showing of *Antioch: The Lost Ancient City*, the Worcester Art Museum was awarded a grant from the Andrew W. Mellon Foundation to continue research on the objects brought together for the show and to publish the results. This publication also serves to catalogue the Museum's entire holdings of Antioch material, which is, in effect, a microcosm of the Museum's landmark exhibition.

With the publication of this volume, the Museum concludes a decade of intensive work on its Antioch holdings. We are grateful to many individuals and organizations for the realization of this ambitious undertaking. I would like to begin by thanking the staff of the Worcester Art Museum whose talent, high standards and hard work have upheld the Museum's long tradition of excellence. I would like to particularly acknowledge Christine Kondoleon and Lawrence Becker whose expertise and teamwork were a driving force in accomplishing our various Antioch projects, including this publication. Special thanks also to Paula Artal-Isbrand for her excellent conservation work and her role as project coordinator for this volume. We are grateful to the many other scholars who have contributed to both our Antioch publications.

We appreciate the generous funding provided by the Andrew W. Mellon Foundation, which supported much of the conservation work on our Antioch collection and made this publication possible. We are also indebted to the Samuel H. Kress Foundation for its support of both conservation work and the present volume; Cornelius and Emily Townsend Vermeule for their gift toward the publication; and the J. Paul Getty Trust Grant Program for its award of a Curatorial Research Fellowship to Christine Kondoleon.

We are pleased to publish the research conducted by curators, conservators, and scientists in conjunction with the Antioch exhibition, and hope that this publication will provide a foundation of scientific and art historical collaboration upon which future studies can build.

James A. Welu
Director

Acknowledgments

The present publication grew out of the Worcester Art Museum exhibition *Antioch: The Lost Ancient City* organized by the Worcester Art Museum and the accompanying catalogue edited by Christine Kondoleon. Like its predecessor, *The Arts of Antioch* owes much to the cooperation and generosity of our colleagues and the museums they represent.

Firstly, we are greatly indebted to Catherine Metzger of the Musée du Louvre who from the beginning provided unwavering support and encouragement for our research, along with invaluable counsel, observations and insights. We also owe much to our colleagues at Princeton University, organizer of the 1930s excavation. Michael Padgett of the Art Museum, a steadfast friend of the project, gave many hours of his time to provide access to Antioch objects in the galleries and to the trove of study material brought by the excavators to Princeton. Shari Kenfield of the Department of Art and Archaeology was our dedicated guide through the labyrinth of the Antioch Expedition Archives. Without her organizational prowess and knowledge of the material, it is doubtful we would have uncovered many of the field notes, drawings, photographs, and other records that enrich this volume.

The reassembly, study, analysis and conservation of the Atrium House *triclinium* pavement was realized only because Catherine Metzger and Michael Padgett, along with Sona Johnston and Mary Sebera of the Baltimore Museum of Art, and Susan Taylor and John Rossetti of the Davis Museum and Cultural Center, Wellesley College, kindly gave consent for mosaics in their care to be reunited with the Worcester Art Museum panel. They also generously permitted the sampling and analyses of glass and stone tesserae from the *triclinium* and other mosaics, which were essential to the technical studies in this volume.

We are also indebted to John J. Herrmann of the Museum of Fine Arts, Boston; Carlos A. Picón and Christopher S. Lightfoot of The Metropolitan Museum of Art; and Margaret Ellen Mayo of the Virginia Museum of Fine Arts for the inclusion of mosaics from their collections in this publication. Further, we would like to thank: Mei-An Tsu of the Museum of Fine Arts, Boston for photography and sampling of the Marine Mosaic; Jennifer Mass of the Winterthur Museum/University of Delaware for her part in the analyses of glass tesserae from mosaics at the Worcester Art Museum and the Casa della Fontana Piccola at Pompeii; and Robert H. Tykot of the Laboratory for Archaeological Science at the University of South Florida and Marie Archambeault, formerly of the University of South Florida, for the stable isotope analyses that contributed greatly to the Triclinium essay.

Others who generously shared their time and knowledge include Susan A. Boyd and Stephen R. Zwirn at the Dumbarton Oaks Collection, Eric Morvillez of the Université d'Avignon et des Pays de Vaucluse, Guy Métraux of York University, Toronto, Pauline Donceel-Voûte of the Université Catholique de Louvain, and John J. Dobbins of the University of Virginia.

The research leading up to this publication took place while the editors were at the Worcester Art Museum, and we owe much to the Museum's Director, James A. Welu, who championed the Antioch project from the beginning and has actively participated in every phase of this publication. We would also like to thank Philippe de Montebello, Director of The Metropolitan Museum of Art, and Malcolm Rogers, Director of the Museum of Fine Arts, Boston for allowing us the time to continue our research and writing.

Many staff members at the Worcester Art Museum were loyal friends of this project. Steve Briggs photographed most of the objects included in the book. We thank Deborah Diemente, Nancy Swallow, and Selina Bartlett of the Registrar's Department, Kathleen Corcoran of the Development Department, and Janet Manahan of the Director's Office for advancing the preparation of this volume. We also thank Chester Brummel for consulting on the photography of the Drinking Contest.

The support of Chief Conservator Rita Albertson and others in the Conservation Department played a vital role. Philip Klausmeyer, Sylvia Schweri, and Corine Norman of the Department devoted innumerable hours to the painstaking digital photography of the *triclinium* pavement and the organization and integration of the images. We also thank Philip for his analyses of metal objects in the catalogue section and Louise Groll for compiling the photo credits. Many conservators, interns, and volunteers participated in the conservation of the Worcester mosaics. A full roster of names can be found in the essay The Mosaic Conservation Campaign; their contribution to the study and appreciation of these objects cannot be overstated. In addition to the leading role played by Paula Artal-Isbrand, four conservators deserve special mention: Sarah Nunberg, Diane Fullick, Alisa Vignalo, and Judith Jungels.

This book would not have been possible without funding from the Andrew W. Mellon Foundation. We are deeply grateful to Angelica Zander Rudenstine of the Foundation for making reality out of the opportunity the Antioch exhibition provided for scholars from different disciplines to investigate mosaics that may never be reunited. In many ways the direction of this project was shaped through our discussions with her. We would also like to single out for appreciation Julie Douglass of the Mellon Foundation.

Additional funding was provided by the Samuel H. Kress Foundation and the J. Paul Getty Trust Grant Program in the form of a curatorial research fellowship for Christine Kondoleon. At the Kress Foundation we are very grateful to Lisa M. Ackerman for her longstanding support, which extends back to the initial conservation work on the mosaics in 1995. The superb collection of Antioch coins published for the first time in this catalogue was generously given to the Worcester Art Museum by Cornelius and Emily Townsend Vermeule, who also provided funds for their photography and publication.

The present volume draws on the maps and plans created for *Antioch: The Lost Ancient City* by Victoria I, along with Jim Stanton-Abbott, Mary Todd and Wes Chilton. Several new ground plans and drawings developed by Victoria I and this same team were adapted for this volume. Their contribution to helping us visualize the context of these mosaics was outstanding.

Our appreciation goes to Katrina Avery for editing the volume and also to Rosemary Simpson for providing the index. We thank Karen Jones and Hanne Winarsky of the Princeton University Press and Nancy Grubb, formerly of the Princeton University Press, for their guidance in publishing and distribution. Adam Freedman and everyone at Meridian Printing did an outstanding job in the printing of the book.

Unquestionably, the greatest measure of gratitude, however, is due our designer, Jon Albertson. We are indebted to Jon not only for the beautiful design and layout of the book and for the innumerable visual details and graphic cues that enhance the text, but in many ways he is responsible for the existence of the volume itself. Without his talent for organizing every facet of the publication, his consummate professionalism, sure judgment, infinite patience and his dedication to producing the best book possible, this volume would never have come to fruition. It has been a delight to work with him.

Lastly to our families — Frederic and Lucas, Jane and Nathan — thank you so much for being there.

This book is dedicated to the late Ernst Kitzinger, a maverick in mosaic studies who inspired our research and especially admired the Worcester mosaics.

Lawrence Becker

Christine Kondoleon

Contributors to the Catalogue

Paula Artal-Isbrand, Worcester Art Museum

Lawrence Becker, The Metropolitan Museum of Art

Anna Gonosová, University of California, Irvine

Florent Heintz, Sotheby's

Christine Kondoleon, Museum of Fine Arts, Boston

Rebecca Molholt, Columbia University

Richard Newman, Museum of Fine Arts, Boston

Antero Tammisto, Institutum Historicum Universitatis Helsingiensis

Cornelius C. Vermeule III, Museum of Fine Arts, Boston

James A. Welu, Worcester Art Museum

Anne L. Windham, Assumption College

Mark T. Wypyski, The Metropolitan Museum of Art

Shorter catalogue entries are initialed by author:

ALW Anne L. Windham, Assumption College

Chronology

66/67 C.E.
Outbreak of violence against Antiochene Jews

70–80 C.E.
Theater built at Daphne with spoils of Jewish wars

c. 80–90 C.E.
Gospel of Matthew written at Antioch (?)

98 C.E.
Antioch becomes headquarters for war against Parthia

115–16 C.E.
Major earthquake; Emperor Trajan is slightly injured

117–38 C.E.
Hadrian improves water supply system

161–65 C.E.
Co-emperor Lucius Verus resides at Daphne

192 C.E.
Pescennius Niger, governor of Syria, with support of Antiochenes, challenges imperial authority of Septimius Severus; city is punished and Olympic Games suspended

212. C.E.
Caracalla returns imperial favors to city and restores Olympic Games

215–17 C.E.
Caracalla and his mother, Julia Domna, rule from Antioch; she starves herself shortly after his death in 217

256 and 260 (?) C.E.
Antioch sacked by Persian troops

266–72 C.E.
Queen Zenobia of Palmyra takes over Antioch

272 C.E.
Aurelian defeats Zenobia and recaptures Antioch

306–37 C.E.
Emperor Constantine converts to Christianity and commissions the building of the Great Church on the city's island

338 C.E.
Constantius in Antioch as emperor of the East. City continues to be used as headquarters in the war against Persia

341 C.E.
Great Church completed

361–63 C.E.
Pagan revival under Julian II based in Antioch

379–95 C.E.
Reign of Theodosius I; Libanios and John Chrysostom active

387 C.E.
Tax riots; imperial portraits and statues destroyed

438 C.E.
Empress Eudocia has city walls enlarged

458 C.E.
Major earthquake destroys nearly all buildings on the island

459 C.E.
Death of Symeon the Stylite; relics brought to Antioch

484 C.E.
Pretender emperor Leontius reigns from Antioch; ousted by Zeno

507 C.E.
Circus riots; the synagogue at Daphne is burned

525 C.E.
Great fire

526 C.E.
May 29, major earthquake destroys almost entire city, leaves 250,000 dead

528 C.E.
Nov. 29, major earthquake leaves 5,000 dead. Antioch is renamed Theopolis (City of God)

540 C.E.
Antioch captured and sacked by the Persians. City destroyed and depopulated. Bubonic plague begins two years later

540–65 C.E.
Major rebuilding effort under Justinian, focusing on defenses and infrastructure

573 and 610 C.E.
Persians sack the city

637/38 C.E.
Capture by the Arabs

Antioch and Surrounding Region

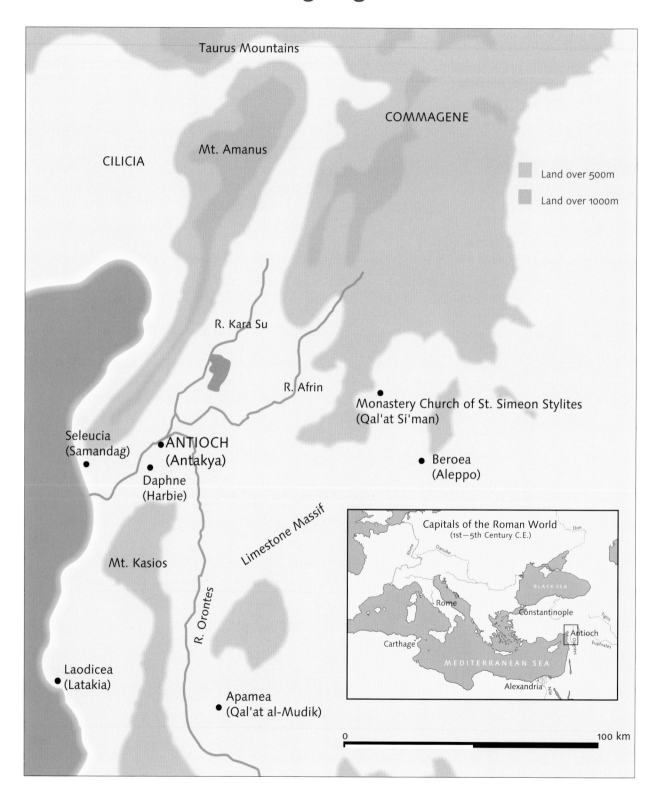

Taurus Mountains

COMMAGENE

CILICIA

Mt. Amanus

Land over 500m

Land over 1000m

R. Kara Su

R. Afrin

Monastery Church of St. Simeon Stylites
(Qal'at Si'man)

Seleucia
(Samandağ)

•ANTIOCH
(Antakya)

Beroea
(Aleppo)

Daphne
(Harbie)

Limestone Massif

Mt. Kasios

R. Orontes

Capitals of the Roman World
(1st–5th Century C.E.)

Don

Rhine

Danube

BLACK SEA

Rome

Constantinople

Tigris

Carthage

Antioch

Euphrates

Orontes

MEDITERRANEAN SEA

Alexandria

Nile

Laodicea
(Latakia)

Apamea
(Qal'at al-Mudik)

0 100 km

Ancient City of Antioch

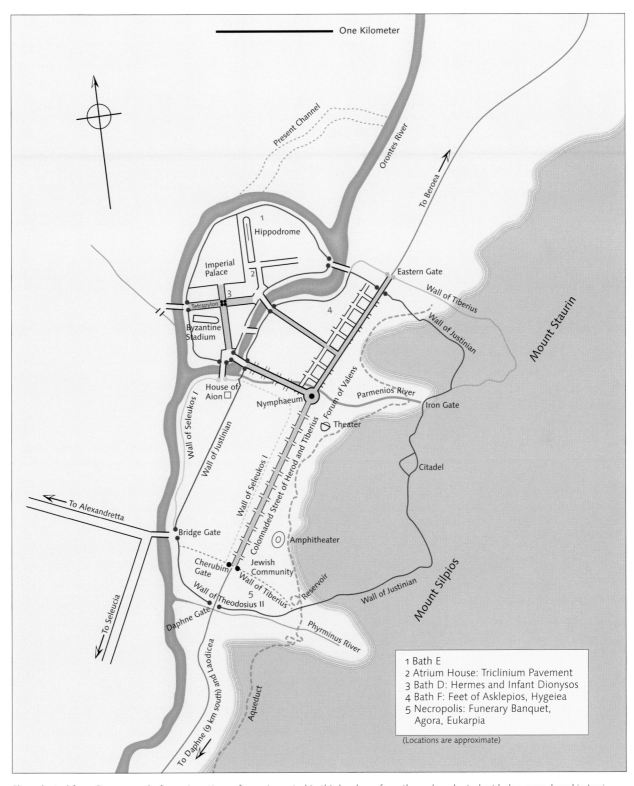

One Kilometer

To Beroea

Orontes River

Present Channel

1 Hippodrome

Imperial Palace

2

3 Tetrapylon

Byzantine Stadium

Eastern Gate

Wall of Tiberius

4

Wall of Justinian

Mount Staurin

House of Aion

Nymphaeum

Forum of Valens

Parmenios River

Iron Gate

Theater

Wall of Seleukos I

Wall of Justinian

Wall of Seleukos I

Colonnaded Street of Herod and Tiberius

Citadel

To Alexandretta

Bridge Gate

Amphitheater

Cherubim Gate

Jewish Community

Wall of Tiberius

Reservoir

Wall of Justinian

Mount Silpios

To Seleucia

5

Wall of Theodosius II

Daphne Gate

Phyrminus River

To Daphne (9 km south) and Laodicea

Aqueduct

1 Bath E
2 Atrium House: Triclinium Pavement
3 Bath D: Hermes and Infant Dionysos
4 Bath F: Feet of Asklepios, Hygeiea
5 Necropolis: Funerary Banquet, Agora, Eukarpia

(Locations are approximate)

Plan adapted from Downey 1961, fig. 11. Locations of mosaics noted in this book are from the archaeological grid plan reproduced in Levi 1947, vol. II, plans I-III.

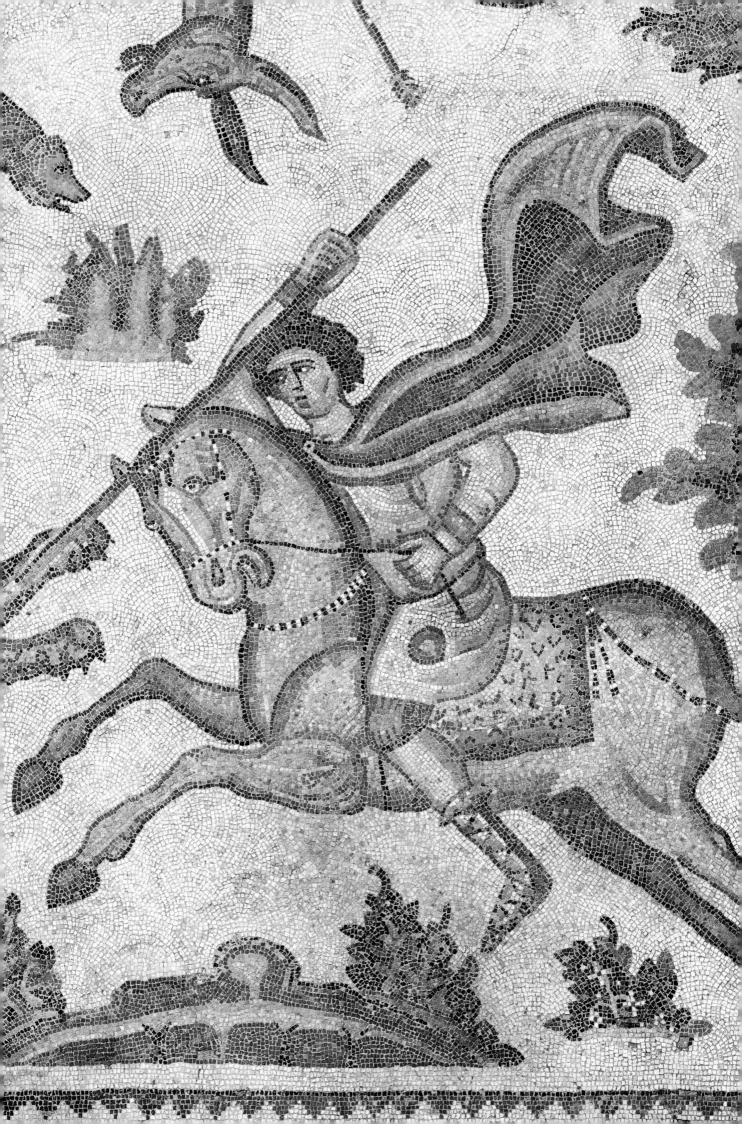

Essays

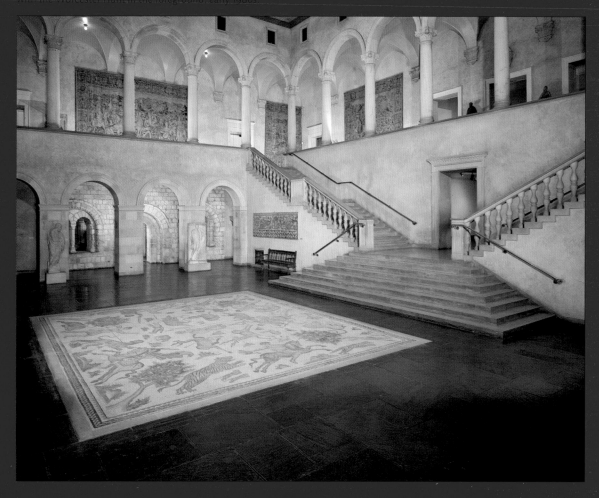

From Antioch to Worcester

The Pursuit of an Ancient City

James A. Welu

ANTIOCH, THE ANCIENT Syrian metropolis, and Worcester, Massachusetts (fig. 1), though worlds apart, will forever be linked because of two very determined men: Charles Rufus Morey (fig. 2) and Francis Henry Taylor (fig. 3). Only three years out of graduate school when named director of the Worcester Art Museum, Taylor took charge in June 1931, including overseeing the construction of a major new wing that would more than double the Museum's size. No sooner had Taylor begun at Worcester than Morey, his former teacher at Princeton University, suggested that the Worcester Art Museum become a sponsor of the first major excavation of Antioch.[1] How Worcester became a key player in uncovering this ancient city and eventually the home of some of its finest treasures is a story of the friendship, commitment and, above all, entrepreneurship of these two very talented men.

fig. 2. (left) Charles Rufus Morey (1877–1955) in the 1920s, when Francis Henry Taylor studied with him at Princeton University. Morey was chairman of the Department of Art and Archaeology when, in 1930, he was approached to organize the excavation at Antioch.

fig. 3. (right) Francis Henry Taylor (1903–1957) in 1931, the year he was first appointed director of the Worcester Art Museum. Taylor, who orchestrated the Museum's participation in the Antioch excavation, was director of the Museum from 1931 to 1940 and from 1955 to 1957.

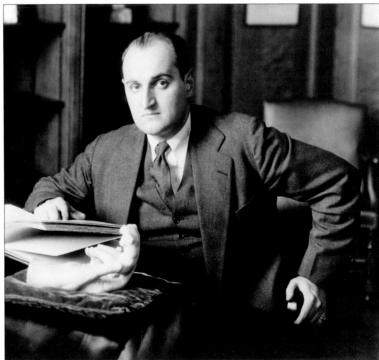

Antioch had long intrigued scholars as the chief Hellenistic center of the Roman East and the place where Christianity first flourished. One of the four great cities of the Roman world, Antioch never regained its stature following a devastating earthquake in the sixth century. Although its population had numbered about 800,000 at its peak, in the 1930s it was a relatively small town of about 20,000 inhabitants. It was, therefore, still possible to undertake systematic excavation at Antioch, unlike the other major Roman cities—Rome, Alexandria and Constantinople—which, by the early 20th century, were far too populous for any extensive archaeological exploration.

The opportunity to excavate at Antioch opened up after World War I, when Syria came under French mandate.[2] By the mid-1920s, Charles Rufus Morey and Princeton's Department of Art and Archaeology had expressed interest in such an excavation provided that political conditions were safe and that the necessary funds, estimated to be considerable, could be raised. In 1930, the National Museums of France, confident of their political connections, approached Princeton to organize the excavation. With the prospect of discovering early Christian works, the French were particularly attracted to Morey, who in 1917 had established at Princeton the Index of Christian Art. In an accord signed in November 1930 by the High Commissionary of the State of Syria and Morey as Princeton's representative, a concession was agreed upon to excavate at Antioch and its vicinity for a six-year period beginning January 1, 1931.

The excavation was dependent upon raising $220,000; the National Museums of France had pledged $30,000 and Princeton $40,000. For the remaining funds, Morey approached a variety of individuals, foundations, and institutions, ranging from Yale University's Divinity School to the Ny-Carlsberg Glyptothek in Copenhagen, where a former student was assistant director.[3] While Morey generated widespread interest in the project, he had difficulty in securing signed commitments due to the major downturn in the world economy. When he approached Taylor in the summer of 1931, the Princeton professor had only oral commitments from two institutions, the University of Philadelphia and the Philadelphia Museum of Art, where Taylor had been curator when he first learned of the proposed dig. Desperate to secure additional partners or risk abandoning the entire project, Morey was determined to engage the Worcester Art Museum. His proposal for a contribution of $30,000 over a five-year period would entitle Worcester to receive 5% of the finds.

Taylor's interest in archaeology had been fostered by Morey, who in 1925 had traveled with him to Greece to study ancient ruins. Like Morey, Taylor saw the Antioch excavation as a window of opportunity, especially with the military protection and political connections offered by the French. Also aware that his alma mater's focus would be the scientific research aspect of the excavation, Taylor saw Worcester's participation as a chance to acquire a major share of the art treasures that would come to America. He relished the fact that these ancient works of art, unlike most on the open market, would be of known origin. Even before he was able to commit to Morey, Taylor claimed that Worcester

"should be entitled to have an exhibition at some time of all the collected finds that are brought to this country." [4]

Morey continued to press Taylor for a decision on what he considered "the greatest archaeological proposition in existence." [5] He wrote Taylor, "I will do anything to get this big thing started. It simply must not fall through." [6] But Taylor was in no position to give an immediate response. Fully occupied with the Museum's largest building project ever, the 28-year-old first-time director had also the task of selling the Antioch project to his trustees, many of them more than twice his age, including several who had been on the Board since the Museum's founding in 1896.

Taylor knew that the best way to promote the project would be to emphasize its "prestige for a small institution." [7] To help Taylor convince his trustees of the importance of the dig, Morey invited him and members of his board to join the Antioch Visiting Committee for a weekend get-together at Princeton in the fall of 1931. Morey was now desperate for a commitment from Worcester, having learned that same week that one of his earliest prospects, the Museum at the University of Pennsylvania, was unable to sign on due to a cutback in city funding. Morey carefully orchestrated the Princeton meeting around a stag dinner and the Princeton-Michigan football game. Following the meeting, he also arranged for several letters of endorsement that Taylor could share with his trustees, including one from Robert Garrett, a trustee of Princeton University and of the recently established Baltimore Museum of Art. Garrett, who was familiar with the Near East, including Antioch, and had been working for over a year to engage the Baltimore Museum of Art in the dig, wrote that "Antioch is one of the most promising sites still untouched" and that "the museums participating will reap a harvest in art objects." [8] George Elderkin, the Princeton archaeologist who had examined Antioch as early as 1923 and eventually directed the dig during its first season, wrote Taylor that he "was readily convinced that it would generously repay excavation." Elderkin recommended devoting the first campaign to "a principal excavation within the circuit of the ancient city and to a series of subsidiary soundings in all parts of the site, including the road to Daphne which was the area of the ancient villas with their mosaics and sculptures." [9] Another letter from Princeton's T. Leslie Shear, excavator of the Athenian *agora*, concluded with the tantalizing line, "Experience, however, proves that when a rich city is dug valuable finds are always made." [10] Taylor also received a letter from fellow-Princetonian Bayard Dodge, president of the American University of Beirut. Dodge wrote, "Of course digging for art treasures, like digging for gold is always an uncertain affair. On the other hand, treasures dated and authentic, of known origin, are always much more important than those purchased in the open market." He further encouraged Worcester's involvement by stating, "Evidently Baltimore desires inscriptions & Princeton the credit of scientific research, so that your museum ought to come in for the lion's share of any art treasures at the disposal of the Americans." [11]

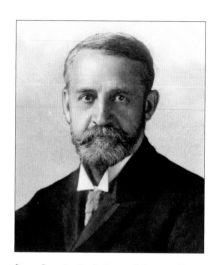

fig. 4. Rev. Austin S. Garver (1847–1918) served as President of the Worcester Art Museum from 1913 to 1918. Funds from his and his wife Sarah's estates enabled the Worcester Art Museum to participate in the Antioch excavation.

Reluctant to recommend to his fiscally conservative board the use of current funds, Taylor suggested two other possibilities: one, to seek the support of Aldus Higgins, a wealthy Museum trustee who was an officer of the French Legion of Honor and "very generously disposed to any official enterprise of France;"[12] the other, to use two recent bequests to create a memorial to the Rev. Austin S. Garver (fig. 4), and his wife, Sarah. A former president of the Worcester Art Museum, Rev. Garver had a lifelong interest in ancient art; enhancing the suitability of using Garver funding was the expectation that the excavation would shed light on the early history of Christianity, "particularly in regard to certain references in the *Epistles* and in the *Acts of the Apostles.*"[13] Finally, on November 23, 1931, only a month before the anticipated start of the project, the Worcester Art Museum board voted to use the Garver funds to become a partner in the excavation. Extremely grateful for Taylor's "persistence and success," Morey wrote, "It is enough to say that but for you and Robert Garrett, I think the project would have had to be given up, and that would have been a lasting pity."[14] Worcester was the first museum to commit in writing to the Princeton proposal; the Baltimore Museum of Art signed on as the third American partner in January of the following year. No sooner had Worcester enrolled, however, than the Philadelphia Museum of Art, which a year and a half earlier had begun raising funds toward the dig, had to withdraw.[15] As a result, Morey again turned to Taylor, asking him to consider a second share so that Worcester could be in a better position in dividing the finds, meaning "that the best pieces in the American portion would for the most part go to Worcester."[16] But Taylor was unable to secure a second subscription, leaving Morey $90,000 short of his $220,000 goal. Determined nonetheless to take on the project, Morey reconfigured the budget after learning that labor costs in Turkey were considerably below those in Greece, the basis of his original estimate.

The excavation finally began in March 1932, with George W. Elderkin, of Princeton's Department of Art and Archaeology, as general director and Clarence S. Fisher, field archaeologist of the American School of Oriental Research at Jerusalem, as field director. William Alexander Campbell of Wellesley College was appointed assistant field director with the understanding that he would succeed Fisher. The excavation required from 200 to 300 laborers and, while the coalition made a conscious effort to hire local workers, it insisted on securing Egyptians to serve as foremen because of their experience in earlier digs. In the end, the wages for the Turkish workers, though reduced, proved attractive, even to the point of upsetting the local pay scale and prompting some village protests.

The Committee for the Excavation of Antioch and Its Vicinity, consisting of representatives of the subscribers to the dig, met at Princeton at the end of each year to monitor the excavation and decide on the division of the moveable objects. The most significant find of the first season was the well-preserved mosaic floor of a *triclinium* or dining room from the Atrium House, dating from the early second century c.e. To satisfy the contributing parties, the Committee voted the following year to divide the floor among the four participating museums, with one additional fragment presented to Wellesley College in honor of

William Alexander Campbell. The Louvre acquired the largest and finest piece, the Judgment of Paris, and, thanks to Robert Garrett of Baltimore who deferred to Taylor, Worcester received the second most important piece, the Drinking Contest Between Herakles and Dionysos. Extremely pleased, Taylor stated that the Drinking Contest "more than repays the Museum for its participation in these excavations."[17] The Drinking Contest arrived in Worcester in the summer of 1933 (fig. 5).

In 1935 Baltimore requested first choice in that year's division of finds among the American museums, since it had not fared well in the previous year's division. Taylor agreed with Baltimore's request and sought his board's permission to abstain from that year's partition of the finds provided it have first choice in the following year. Taylor was aware of some superior finds from the previous fall that would be included in the 1936 division. At the same time Taylor registered a formal complaint to Morey about what he saw as "the rapacious attitude of the Louvre" and asserted that in general neither Worcester nor Baltimore had received their fair share of the finds. "I can see no advantage to handling the situation any longer with kid gloves," wrote Taylor; "the time has come for a little polite but plain speaking." He suggested that if Worcester were to renew its contract the following year it would prefer to deal directly with the Syrian authorities and not to work with the National Museums of France.[18]

fig. 5. Francis Henry Taylor (left), David Rosen (center), and Perry Cott (right) stand before the newly unpacked Drinking Contest mosaic in the Museum's Renaissance Court in the summer of 1933.

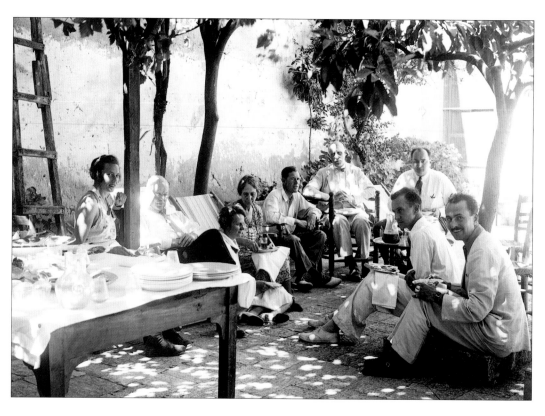

fig. 6. Representatives of the Committee for the Excavation met at Antioch in July 1936. Here they lunch under the lemon arbor outside the Princeton Expedition House. From left to right, Mlle. Maillart, Charles Rufus Morey, Gladys Baker, Myrtilla Avery, William Alexander Campbell, Robert Garrett, Francis Henry Taylor, Richard Stillwell, and W. H. Noble (Antioch Expedition Archives).

Taylor's complaint called for skillful diplomacy on Morey's part, and, hoping to satisfy all parties, the Committee for the Excavation decided to wait until the summer of 1936 when their representatives could meet in Antioch to divide the large quantity of accumulated objects, while refraining from breaking up the major compositions. Taylor thus met in Antioch with representatives from the Louvre, the Syrian government, Princeton University, and the Baltimore Museum of Art to divide the 253 mosaics and other objects unearthed during the first five excavation seasons. The international team spent several days touring the sites and discussing allocations of the finds. Having lived and taught in France, Taylor was prepared to negotiate with the French delegate, Jean Charbonneaux, especially regarding fairness to the American museums. Whether it was the many pleasant hours under the lemon arbor outside the Princeton Expedition House (fig. 6) or the abundance of rich finds to pick among that added to the amity of the group, in the end all representatives left satisfied with their allotment, as reflected in Taylor's cable back to Worcester: "finds exceed highest hopes both quality and importance."[19]

Taylor's trip to Antioch was an unqualified success; he had secured for Worcester an enviable group of objects including the largest mosaic found at Antioch, now known as the Worcester Hunt. Discovered the previous summer as part of a villa at Daphne, the Worcester Hunt dates from shortly before the earthquake destroyed the city in 526 C.E. Measuring 8.6 by 7.65 meters, the work had to be cut into a number of large pieces for removal and eventual transport (fig. 7). Taylor also claimed for Worcester a major sculpture of Hygieia discovered during the Committee's stay in Antioch. Found deep beneath an olive grove and thought to be part of an Asklepion, the Hygieia proved to be the largest sculpture uncovered at Antioch (figs. 8, 9).

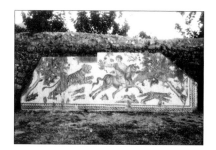

fig. 7. A fragment of the Worcester Hunt mosaic photographed at Antioch in October 1936, the year after its discovery (Antioch Expedition Archives).

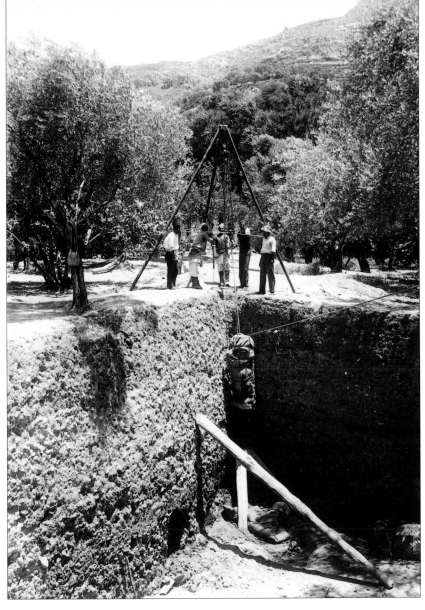

fig. 8. The Hygieia
sculpture being
raised on July 7, 1936,
three days after it
was discovered
(Antioch Expedition
Archives).

Thanks to Taylor's involvement throughout the process, Worcester fared extremely well in the first five years of the dig, acquiring eleven mosaic panels ranging in date from the second through the sixth century c.e. While Taylor had gone to Antioch rather skeptical, he returned "convinced that this is one of the most distinguished and rewarding enterprises undertaken by any Museum in the United States." As he stated, "We have acquired a group of objects valued at not less than $250,000 for an initial investment of $30,000."[20] Charbonneaux, who considered the finds of the first two years of secondary quality and derivative of the motifs of ancient painters, was also extremely enthusiastic about the subsequent discoveries, especially those dating from the third century on, when (as he later wrote Taylor) "the mosaic art had liberated itself by revising and renewing its technique and had entered into the paths of original creative art." Charbonneaux further noted that "A sense of grandeur, a spiritual intensity that classic art had never known, a love of nature and finally a sensibility closely akin to our own modern sensibilities is brought to light, particularly in the gestures, expressions, and facial character of the figures."[21] So impressed was Charbonneaux with what he saw at Antioch that he convinced his French colleagues to continue as a partner in the dig, in spite of their earlier decision not to do so.

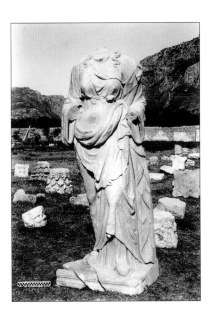

fig. 9. The Hygieia sculpture at Antioch
shortly after its discovery (Antioch
Expedition Archives).

Worcester also had to decide whether or not to renew its subscription. Eager to continue and to insure that William Campbell from nearby Wellesley College remain as head of the dig, Taylor worked toward maintaining

Campbell's position on the Wellesley faculty. Campbell, in turn, added to Taylor's enthusiasm, noting that "Antioch and its vicinity is the one remaining center of ancient civilization of importance from which objects of art can be secured for museums by excavation."[22] Taylor admitted that for a museum "to assign a portion of its purchasing funds for archaeological purposes is at best something of a gamble," but justified the Museum's involvement by stating that "Worcester would have an important part in writing one of the great chapters of the history of our civilization."[23] Still, Taylor wanted to be sure that Worcester's funds were applied to excavation rather than research, since the money had come from acquisition funds.[24] Having acquired a wealth of mosaics, the Worcester board hoped that subsequent years of the dig would produce major works in other media, like the Hygieia, which would add to the art-historical breadth of the Museum's collection. In December 1936 the board voted to participate in the Antioch excavation for five more years at $6,000 per year. Several years later, Taylor wrote of his Board's decision, "I believe the only reason they supported my recommendation was out of a sense of sportsmanship. I pointed out to them that they should not leave the game while they were still winning."[25]

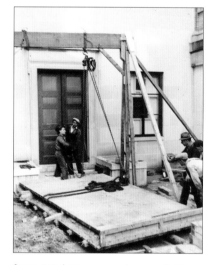

fig. 10. Workmen prepare to move Antioch mosaics into the Worcester Art Museum in the fall of 1936.

The Antioch pieces assigned to the American museums traveled a long and circuitous route to their final destination. From Antioch they were trucked through the mountains to the port town of Alexandretta; it took two days to secure the crates properly in the S.S. Exhibitor for transport to Jersey City, where the Worcester share, weighing over 21 tons, went by train to its final destination. The challenge in Worcester was getting the large mosaic fragments into the building (fig. 10) and deciding on the installation. Only two months before his trip to Antioch, Taylor had written of his trustees' reluctance to devote a large part of their galleries to the mosaics.[26] In the end, however, they gave them the most prominent position in the Museum: they voted to place four major pieces on the walls of the Renaissance Court and directed that the largest, the Worcester Hunt, "be sunk flush with the floor of the Court," which meant cutting into the flagstone floor completed only four years earlier (fig. 11).[27] It was decided not to install the fragmentary border to the Worcester Hunt, but instead to

fig. 11. Workmen install the Worcester Hunt mosaic in the floor of the Renaissance Court in the fall of 1936.

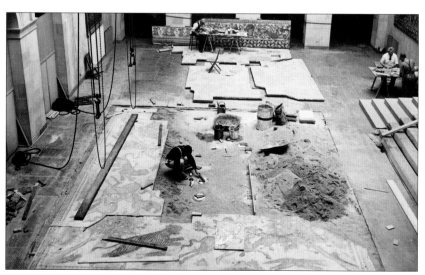

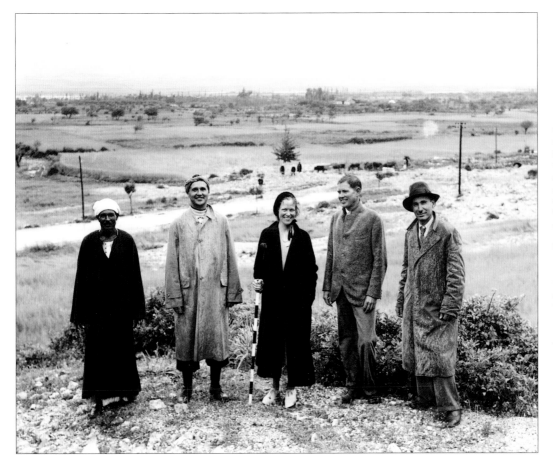

fig. 12. Louisa Dresser (center) (1908–1989), as the Worcester Art Museum's Associate Curator of Decorative Arts, visited Antioch in May 1938. Identified next to her are (left) Jean Lassus, Assistant Field Director, and (right) William Alexander Campbell, Field Director (Antioch Expedition Archives).

use tesserae from it to fill losses in the main part. The remaining border fragments were put back in the crates and eventually stored in an exterior light well of the Museum building.

To prepare the mosaics for exhibition, the Museum hired the conservator David Rosen and four mosaic workers who spent 3½ months on the project. Taylor's long-awaited exhibition, *The Dark Ages: Pagan and Christian Art in Latin West and Byzantine East,* opened in February 1937. In addition to Worcester's eleven mosaics, the show featured loans from public and private collections, including a painting from the Yale excavations at Dura and paper casts and watercolors of the mosaics recently uncovered at Hagia Sophia, Constantinople. For the first time in America one could observe the development of monumental painting from classical times to the Middle Ages, or as Morey noted, "the darkest of the Dark Ages."[28] Taylor added further excitement to the show by borrowing from a private collection the so-called Antioch Chalice, believed by many to be the Holy Grail. If Taylor had any doubts about the "goblet Christ used" he never revealed them; instead, he requested that visitors stand at least three feet from the ornate cup, which he had put under 24-hour armed guard. The arrangement was typical of Taylor, so fond of saying, "Showmanship should never show; but if you haven't got it, you have the kiss of death."[29] This exhibition was considered the most important event in the Museum's history, and the opening night was nothing short of spectacular; a local reporter observed, "Looking down from the balcony into

the courtyard at the Museum where the huge Hunting Scene pavement mosaic has been laid, the multicolored gowns of the women and the black and white of their escorts' clothes formed an almost moving modern mosaic."[30] The show, which ran for one month, attracted a record number of 4200 visitors in its first three days and was accompanied by a three-day symposium chaired by Morey.

Once the success of the Antioch dig was realized, others began to express interest in taking part. Before 1936 Taylor had been reluctant to engage additional partners,[31] but once Worcester acquired a major share of works he was open to additional subscribers. In early 1937 the Worcester Board voted to permit the participation of Mr. and Mrs. Robert Woods Bliss, who signed on for five years to benefit Dumbarton Oaks. It was also Taylor who recommended to the Antioch Committee that a mosaic fragment be donated to Antioch College, which incorporated it into its library.[32]

In May 1938, the Worcester Art Museum's Associate Curator of Decorative Arts, Louisa Dresser, traveled to Antioch to make a preliminary selection of additional objects for Worcester while Taylor went to Paris to confer with Mr. Charbonneaux. Miss Dresser spent a week at the various excavation sites (fig. 12), hoping to identify objects of high quality, including, with luck, the head of Worcester's Hygieia. While in Antioch, she watched the construction of the museum designed to house many of the finds. The week proved eventful as torrential rains caused mountain streams to run wild and sent the Orontes River over its banks. It was also marked by civil unrest, including an all-night street fight between Turks and Arabs in which two gendarmes were shot.[33] The unrest escalated and within a month of Dresser's visit the entire Princeton team had to relocate temporarily to Beirut.

Having acquired an abundance of mosaics, Taylor and his board now saw the Antioch dig as an opportunity to get objects that could eventually be sold or exchanged for other works. Though concerned about the political situation, Taylor still favored going forward with the excavation. By February 1939, when political conditions in Turkey had worsened, Morey began talking with Taylor about Worcester's potential involvement in another site, safer than Antioch. Morey chose Salamis on Cyprus, where he hoped to uncover objects from the Mycenaean culture. Although unenthusiastic about digging in Cyprus, Taylor had to assume a renewed interest in archaeology for the Worcester Art Museum since Paul B. Morgan was about to be named its president. Morgan, who had visited Antioch the previous spring, had a passion for excavation and was a trustee of the Archaeological Institute of America. His son, Charles Hill Morgan, had just returned to the States after serving for five years as Director of the American School in Athens. Taylor was willing to accept Cyprus as an alternative only if Campbell should have to leave Antioch. As he later told Morey, "My original interest was for the excavation at Antioch because of the history and significance of the site, and not for digging for the sake of digging."[34]

By early 1940, the war in Europe had discouraged Taylor from further commitments to any excavations in the Near East. Just as the opportunity

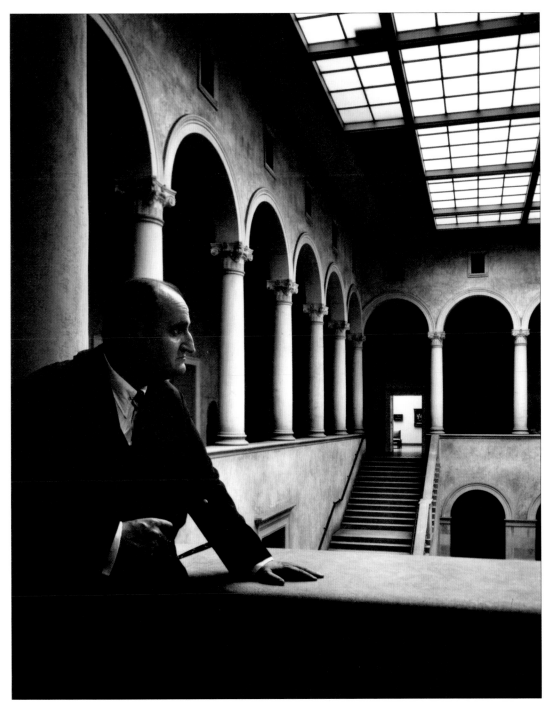

fig. 13. In June 1957 Yousuf Karsh photographed Francis Henry Taylor on the balcony of the Renaissance Court overlooking the Worcester Art Museum's collection of Antioch mosaics (Worcester Art Museum, 1971.83).

for excavation was coming to a close, so was Taylor's tenure at Worcester. In January of that year he accepted the directorship of The Metropolitan Museum of Art. Appropriately, one of his last official acts before leaving for New York was to notify Morey of Worcester's decision to withdraw from further excavation.[35] The Antioch dig had been a leitmotif of Taylor's years at Worcester, from his very first days on the job until his resignation almost nine years later.

Worcester was still arranging for its last shipment of mosaics in 1940 when, like Baltimore, it began offering mosaics to other museums. Over subsequent years the Museum sold mosaics to Amherst College, Oberlin College and the J. Paul Getty Museum, and in a few cases also exchanged them for other works of art, as it did with the Museum of Art, Rhode Island School of Design.

In 1955, after a long and distinguished career, Charles Rufus Morey passed away at age 78. That same year, after directing The Metropolitan Museum of Art for 15 years, Francis Henry Taylor returned to the Worcester Art Museum as director. Within weeks of his return he was again dealing with Antioch mosaics, this time responding to a request from the Art Gallery of Ontario about a possible exchange of a mosaic for a Chinese object. Taylor's second tenure at Worcester was to last only a year and a half, for he died unexpectedly in 1957, aged 54. Only months earlier, Taylor had posed for a photograph by Yousuf Karsh (fig. 13), appropriately on the balcony of the Renaissance Court, overlooking one of his most prized additions to the Worcester Art Museum, the Antioch mosaics.

Worcester's Antioch holdings remain one of Taylor's greatest legacies. America's richest display of objects from the great ancient city, the Worcester collection is also a shining reminder of the long friendship between this ambitious museum director and Charles Rufus Morey, his distinguished teacher. Working together, these two men played a key role in uncovering and displaying one of the most intriguing cities of the ancient world.

1. Having studied medieval art with Morey at Princeton, Taylor was well aware of the Antioch project before coming to Worcester.

2. In a letter dated December 23, 1927, to Bayard Dodge, president of the American University of Beirut, Morey wrote that the excavation of Antioch had been "a dream for some years, but felt that the political conditions were too unsettled in the French mandate to warrant a serious try at it." He also noted that "the financing of the expedition would be a difficult matter, because it seems to me to be a particularly expensive site to excavate." Princeton Archives.

3. Harald Ingholt, assistant director of the Ny-Carlsberg Glyptothek, was also being considered by Morey for field director. Morey also contacted members of the Cliff Dwellers (Alfred E. Hamill, Cyrus H. McCormick, Sr., Henry J. Patten, Charles H. Worcester and a Mr. Fentress), all connected with the Art Institute of Chicago, and John Nicholas Brown of Providence.

4. Letter from Taylor to Morey, August 24, 1931, WAM Archives.

5. Letter from Morey to Taylor, August 18, 1931, WAM Archives.

6. Letter from Morey to Taylor, August 26, 1931, WAM Archives.

7. Letter from Taylor to Morey, August 18, 1931, WAM Archives.

8. Letter from Garrett to Taylor, November 3, 1931, WAM Archives.

9. Letter from Elderkin to Taylor, November 13, 1931, WAM Archives.

10. Letter from Shear to Taylor, November 14, 1931, WAM Archives.

11. Undated letter from Dodge to Taylor, WAM Archives.

12. Letter from Taylor to Morey, August 24, 1931, WAM Archives.

13. The bequest came to the Museum upon the death of Rev. Garver's widow, Sarah Garver, who had also been active at the Worcester Art Museum. A Unitarian minister, Austin Garver served as the Museum's second president, from 1913 to 1918. An ardent classicist who had conducted volunteer classes in ancient art, Garver had also assembled a small collection of ancient Greek objects that he and his wife donated to the Museum. WAM *Annual Report*, 1934, 14–15.

14. Letter from Morey to Taylor, November 25, 1931, Princeton Archives.

15. In a letter to Morey dated May 8, 1930 (Princeton Archives), Fiske Kimball, director of the Pennsylvania Museum of Art (renamed the Philadelphia Museum of Art in 1938), reported that at the meeting of his Board on May 6 a subscription of $10,000 was secured to cover participation in the dig for the first year and part of the second. Kimball had hoped to secure additional funding in the succeeding years.

16. Letter from Morey to Taylor, December 2, 1931, WAM Archives.

17. WAM *Annual Report*, 1934, 15.

18. Letter from Taylor to Morey, May 9, 1935, WAM Archives.

19. Telegram from Taylor to WAM, July 21, 1936, WAM Archives.

20. Letter from Taylor to Alexander H. Bullock, Chairman of the Museum Committee at WAM, December 12, 1936, WAM Archives.

21. Letter from Charbonneaux to Taylor, August 25, 1936, WAM Archives. "[N]ous voyons…l'art de la mosaïque se libérer, renouveler sa technique et entrer dans la voie des créations originales. …Le sens de la grandeur, une spiritualité intense que l'art antique n'a pas conue [sic], l'amour de la nature, enfin une sensibilité toute proche de notre sensibilité moderne et qui se fait jour en particulier dans les gestes, les regards, le caractère individuel des visages."

22. Letter from Campbell to Taylor, December 11, 1936, WAM Archives.

23. Worcester Art Museum *News Bulletin and Calendar*, Oct. 1936, vol. 1, 2,3.

24. In a letter to William Alexander Campbell (November 3, 1936, WAM Archives), Taylor writes, "However, I want to make very certain, if Worcester continues to participate in the excavation for the next five years, that the actual days of excavation will be increased and that the money subscribed by Worcester will be used for that purpose. Our contribution has been paid for out of purchase funds so that it makes it impossible for us to look at the expedition in any other light however creditable it may be to carry the torch of enlightenment to future generations."

25. Letter from Taylor to Morey, March 13, 1940, WAM Archives.

26. In a letter dated April 11, 1936 to George Harold Edgell, director of Museum of Fine Arts, Boston, Taylor wrote, "One of the reasons that my Trustees are sending me over is to bring back a report as to whether or not we should continue and if so on what basis. They are naturally opposed, in this museum which seeks to specialize in nothing and to form a sort of general introduction and perspective to the Museum of Fine Arts in Boston to the public of Worcester, to devote a large part of our galleries to these mosaics," WAM Archives.

27. WAM Trustee Minutes, November 10, 1936.

28. C. R. Morey, "Art of the Dark Ages: A Unique Show," *The Art News*, February 20, 1937, 1.

29. *New York Times*, November 23, 1957.

30. *Worcester Telegram and Gazette*, February 2, 1937.

31. In a postscript to a letter to Morey dated November 8, 1933 (WAM Archives), Taylor wrote: "I must point out that my Trustees will not look with favor upon any proposal to bring in any other institution which might call for a share in the excavation. Any arrangement that does not disturb the status quo on this point is of course perfectly satisfactory."

32. Letter from Taylor to Morey, February 7, 1938, WAM Archives.

33. Dresser documented her stay in a letter to her mother dated May 16, 1938 and in handwritten calendar notes. Lincoln–Dresser Family Archives, Worcester.

34. Letter from Taylor to Morey, March 13, 1940, WAM Archives.

35. Letter from Taylor to Morey, May 8, 1940, WAM Archives.

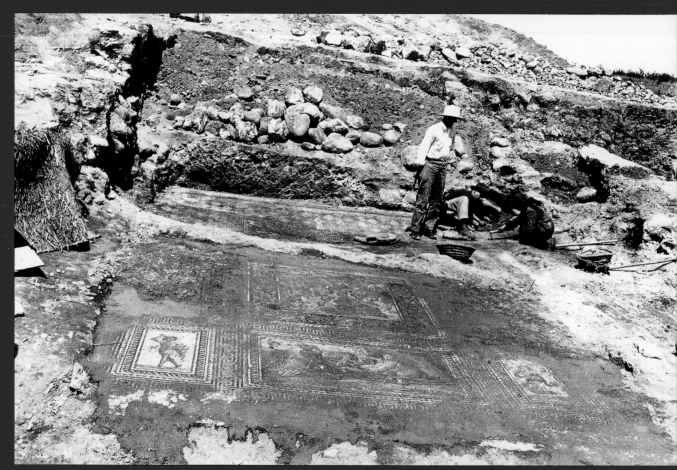

fig. 1. The Atrium House *triclinium, in situ,* 1932
(Antioch Expedition Archives).

Lawrence Becker, Christine Kondoleon,
Richard Newman, Mark T. Wypyski

The Atrium House Triclinium

Archaeology, Iconography, Technique and Style

Lawrence Becker and Christine Kondoleon

THE ATRIUM HOUSE *triclinium* pavement (figs. 1, 2) was excavated in 1932, during the initial field season of the Antioch Expedition. Hailed from the time of its discovery as one of the great finds of the excavation, the floor was lifted in sections and the figural panels divided among the excavation sponsors: Princeton University, the Worcester Art Museum, Musées Nationaux de France, and the Baltimore Museum of Art.[1] A small border section was allocated to Wellesley College in recognition of William Campbell's contributions to the excavation. Only a few sections of geometric pavement were lifted from the area reserved for the dining couches (*kline*); they are now stored in the Hatay Archaeological Museum in Antakya.

In the fall of 2000, for the first time since their excavation, the figural panels of the *triclinium* and their surrounding borders were rejoined for the exhibition *Antioch: The Lost Ancient City*, organized by the Worcester Art Museum (figs. 3–5). A mosaic pavement in a museum is separated from its archaeological context, depriving investigators of firsthand access to critical contextual information. On the other hand, a museum environment allows detailed examination and material analyses to be carried out under optimal conditions rarely, if ever, found in the field. The reassembly of the Atrium House *triclinium* pavement for the Antioch exhibition and the attendant international symposia provided an unprecedented opportunity for mosaic scholars, curators, archaeologists, conservators, and materials scientists to study the *triclinium*. This essay grows out of their collaboration.

Our objective is to examine the pavement from related perspectives with the aim of identifying stages in the laying of the floor and different hands involved in the mosaic work. There is little by way of ancient documents to guide our inquiry into mosaic workshops and the principal sources of information are the pavements themselves. For the most part, mosaic scholars have been concerned with the description and interpretation of mosaics, while evidence of mosaic fabrication is less prominent in their writings. Workshop identifications,

when made, are generally based on the classification of common motifs and compositions rather than on similarities of material or technique, so that methodologies for identifying and comparing mosaic fabrication techniques are relatively undeveloped. The reassembly of the Atrium House pavement provided a catalyst for refining questions and proposing sounder methods for future investigation. Direct observation of the physical evidence made possible by the exhibition and a close reading of the field notes, drawings, and photographs available in the Princeton University Antioch Archives suggest some new avenues for approaching mosaic workshops and practices.

The first part of this essay presents a description of the floor and its relation to other pavements produced by Eastern mosaic workshops and an interpretation of the scenes depicted. The second part focuses on the original excavation reports and photographs found in the archives of Princeton University. When the panels came together again, we were able to measure dimensions, including the proportions of the figures within each panel, to gather data on the varying densities, shapes, and orientations of tesserae, and to make careful notes about palette changes and variations in technique. These observations form the third part of the essay.

The fourth part of the essay presents the results of the optical examination and compositional analysis of the materials used in the pavement. Permission from the lending institutions enabled us to take samples from various areas of the mosaic for study of the glass and stone tesserae. To date, analysis of mosaic materials has focused primarily on identification, methods of processing, and sources. Material studies are well advanced for glass tesserae because they provide a plentiful source of samples with which to trace the development of vitreous technology. The essay on glassmaking technology below expands this field of study with our data from Antioch, which must have been a significant glass-production center. The present essay, however, seeks primarily to apply the analytical findings to questions about the fabrication of the pavement. Also examined is the relationship between mosaicists and those who provided their materials.

Ideally, there should be continuity between the field study of mosaic production and work done in the laboratory. In this case, we are handicapped by the lifting of the mosaics and the back filling of the excavation site, not to mention the almost seventy-year gap between excavation and material analyses. Nonetheless, this detailed analytical investigation of a single room is a pioneering effort that we hope will lead to new lines of inquiry in the field and encourage analysis of materials from sites where field evidence is still accessible for reference.

Initially called the Roman Villa (found under House A; see fig. 6) by the excavator Clarence S. Fisher, the structure containing the *triclinium* was designated the Atrium House by Doro Levi in his 1947 publication of the mosaics.[2]

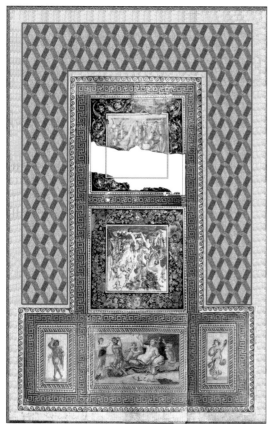

fig. 2. Mosaic floor of the *triclinium* (7.2 × 4.8 m). Computer-generated photocomposite of surviving panels with reconstruction of couch border.

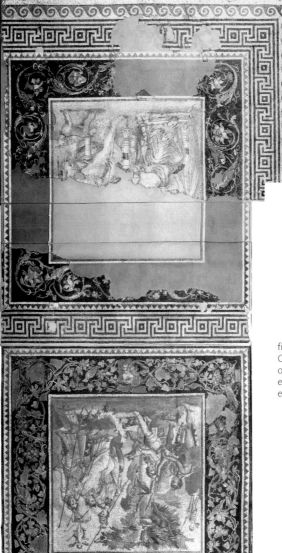

fig. 3. Mosaic floor of the *triclinium*.
Composite of 72 digital photographs
of the figural panels and border
elements reunited for the Antioch
exhibition in 2000.

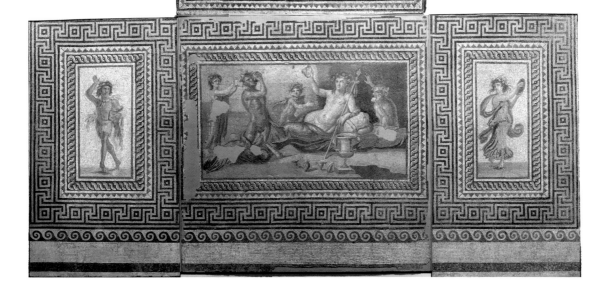

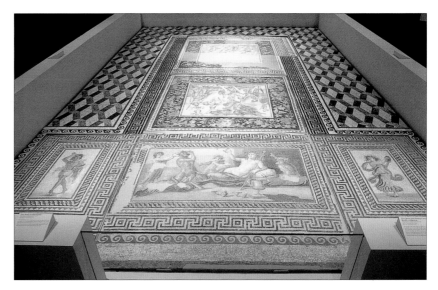

fig. 4. Atrium House *triclinium* reassembled for the Antioch exhibition, Worcester Art Museum installation, 2000. View is looking into the dining room from the perspective of the entering guests.

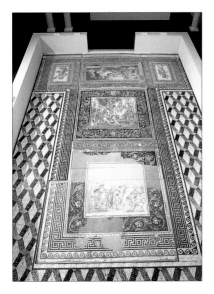

fig. 5. Same as fig. 4, seen from the dining couches.

Part of this structure was found beneath a larger building known as Bath B and part beneath a series of ruined houses.[3] Fisher identified three periods of construction in the Atrium House. Levi follows Fisher's conclusion that the earliest construction dates from the Augustan period.[4] Fisher assigns the building of the *triclinium* to the years immediately following the earthquake of 94 C.E. According to Fisher, the room was damaged in the earthquake of 115 and our pavement was laid between 115 and 150. To support his conclusion that the mosaic was not originally part of the room, Fisher reports evidence of an earlier floor indicated by a layer of surviving plaster or stucco.[5] Levi agrees with Fisher's sequence of events, but not necessarily with the dating. He argues that the restoration of the building may not be tied to earthquake damage, but if there is a relationship, construction could just as easily have followed the earthquake in Caligula's reign. If so, the Atrium House *triclinium* would date between 37 and 115.[6]

The evidence for dating the first phase of the building relies on Fisher's observation that the limestone masonry had the "characteristic dressed edges of the Augustan era."[7] The finds beneath the mosaic obviously would provide a terminus post quem, and Fisher notes that the "debris" below the mosaic contained terra sigillata sherds.[8] Unfortunately, these are not published or catalogued in the field notebooks. If we accept a general date of late first or early second century for the lamps with the busts of Serapis and Isis found in the eastern part of the peristyle (fig. 6, area 83 of plan), then their presence in the debris in the peristyle would be consistent with a collapse of the building in 115.[9]

As for the physical space of the dining room, we can turn to Vitruvius for ancient specifications; he indicates that the length of a *triclinium* should be twice its width.[10] The Atrium House pavement measures approximately 7.2 meters × 4.8 meters. While not conforming to Vitruvius's standard, these dimensions are closer to his ideal than two other Antiochene *triclinia* cited

Arts of Antioch

by Morvillez in his recent study of dining spaces:[11] the *triclinia* of the House of the Boat of the Psyches (5.5 × 5.5 m) and the House of the Drinking Contest (7 × 8 m). If we consider the size of excavated couches—those from Pompeii, for example, measure from 2.25 to 2.80 m in length—then we can suggest possible furnishings for the Atrium House dining room. The room would have been able to hold five couches, each with a pair of reclining guests. The longer sides of the room could each accommodate two couches with one couch across the rear. Three-legged tables were probably set in front of the couches at regular intervals.[12]

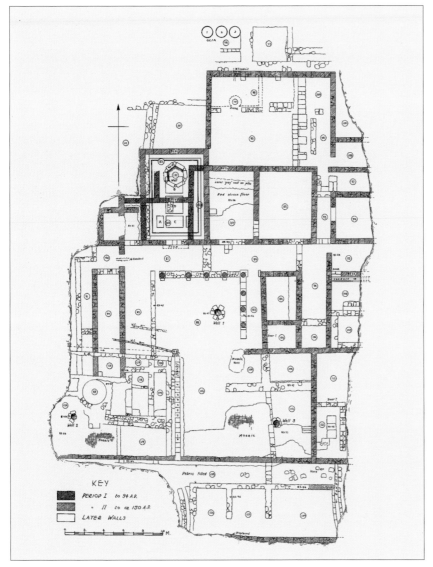

fig. 6. Plan of the Roman Villa under House A. The Atrium House *triclinium* (no. 82) is outlined in red.

fig. 7. *In situ* detail of fragment of *triclinium* couch border (Antioch Expedition Archives).

Description

When the guests arrived for festivities at the Atrium House, they were led into the *triclinium*. Once over the threshold, they proceeded toward dining couches arranged in a U around the figural panels. A polychrome diamond-shaped lattice against a white background marks the area where the couches were set (fig. 7). The figural panels were arranged in the traditional T, the crossbar containing three panels, the Drinking Contest in the center and a dancing satyr and maenad on either side, with the vertical shaft formed by the Judgment of Paris and the Aphrodite and Adonis (see figs. 3–5, 9–12, 14). The last two panels were oriented toward the rear of the room for viewing by the diners on their couches, while the Drinking Contest faced the guests as they entered. The five figural panels are united by a series of shared borders (fig. 8). Working from the perimeter inward, they are: a band of wave crests (red on white), a meander (black on yellow),[13] and a narrow band of stepped triangles (red on white). The entire pavement is surrounded by a white band with a black border. The multiplication of borders enhances the effect of framed stone paintings.

The mythological scenes represented in each panel reinforce the impression of individual paintings. Three panels form an ensemble at the entrance area: at the center is the Drinking Contest Between Herakles and Dionysos flanked by a dancing satyr on the left and a dancing maenad at the right (figs. 9–11). The satyr, of reddish brown complexion, can be identified as a Dionysiac follower by the spotted animal skin tied around his neck and his hips, as well as by his vine wreath. As a celebrant, he holds the pan pipes in one hand while lifting the other in the air. He turns in toward the central panel as he rises onto his toes in the midst of a dance. The maenad, of paler skin, plays the cymbals (*cymbalistria*) as she turns and looks back over her shoulder toward the central panel. Her blue *chiton* and brown mantle swirl with the motion of her dance.

The Drinking Contest Between Herakles and Dionysos, rarely depicted in ancient art, represents the god of wine turning over his empty cup to show he is the victor. Dionysos reclines upon a long green cushion and rests his

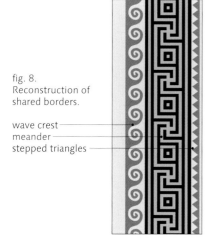

fig. 8. Reconstruction of shared borders.

wave crest ————
meander ————
stepped triangles ————

fig. 9. (left) Mosaic panel of Dancing Satyr (Baltimore Museum of Art, 33.52.2).

fig. 10. (center) Mosaic panel of the Drinking Contest Between Herakles and Dionysos (Worcester Art Museum, 1933.36).

fig. 11. (right) Mosaic panel of Dancing Maenad (Baltimore Museum of Art, 33.52.1).

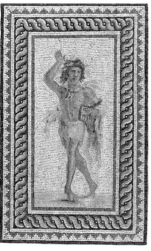
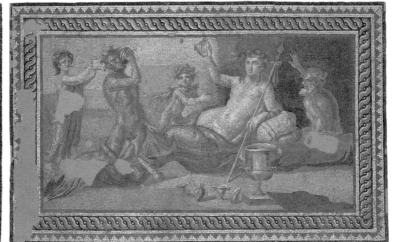
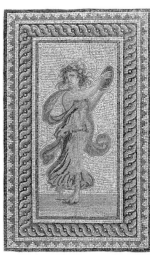

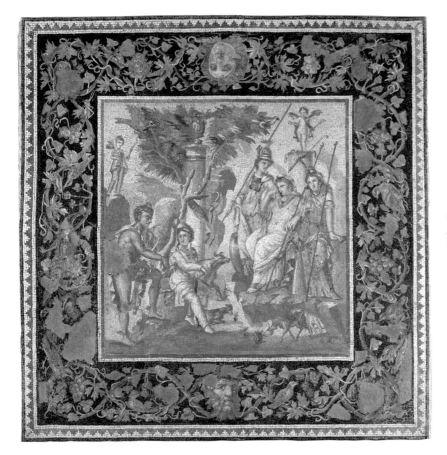

fig. 12. Mosaic panel of the Judgment of Paris (Musée du Louvre, Ma 3443).

elbow on a tall white cushion. Herakles, in contrast, seems tipsy as he leans backward on his knees, grabs at the drapery around his legs, and lifts the wine cup to his lips. At the left side of the scene, complementing the flanking satyr and maenad, a female plays the double flute into Herakles' ear. Eros rushes with outstretched hands toward Dionysos as if to applaud the winner. Silenos with white hair and beard sits behind Dionysos and raises his right arm in a triumphant gesture.

The most elaborate of the scenes, at the center of the room, depicts the Judgment of Paris (fig. 12). The scene illustrates the mythological origins of the Trojan War, when Paris is called upon by Zeus to give the Golden Apple of Discord to the most beautiful of the three goddesses who claimed that title. Although tempted by the seductions of Hera and Athena, he chooses Aphrodite, who offers him the most beautiful mortal, Helen. Within a lush sylvan landscape we see the three goddesses elevated on a hillock on the right side and Paris conferring with Hermes in the left foreground. Paris, dressed in Phrygian garb, watches over a flock of oxen, sheep and goats. The winged Psyche with her lighted torch stands high on a rock behind Hermes and looks across to Eros perched even higher on a pedestal. At the center of the panel is a column with a golden vessel in front of a large green tree.

One of the outstanding pictorial features of the *triclinium* pavement is the lush vegetal borders against a black background that frame the Judgment of Paris and the Aphrodite and Adonis figural scenes. These foliate scrolls, imaginary conflations of several varieties of plants, were extremely popular during the first and second centuries of our era.[14] Such scrollwork was carved on public buildings throughout the Empire (most notably the Ara Pacis in Rome); it covered the cinerary urns of private citizens and worked its way onto the mosaic floors and frescoed walls of private houses. Typically, the rich vines spring from acanthus plants and unfurl at regular intervals to envelop a variety of motifs drawn from

fig. 12 details.

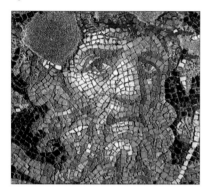

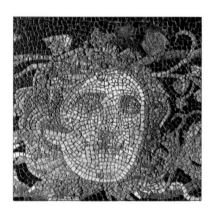

nature. Because the foliage is lush and laden with grapes and flowers in full bloom, these scrolls imply eternal abundance and spring everlasting—the message of a golden age. Although such inhabited scrolls continue to appear into the late Roman period, the type represented in the Atrium House at Antioch is closer to those of the early Imperial period. These scrolls reflect the naturalism characteristic of Hellenistic examples from Pergamon, the early houses of Pompeii, and some of the marble reliefs from early Imperial Rome (Augustan to Flavian periods). For mosaic parallels, the acanthus volutes filled with birds, insects, snails, roses and mice from a room in the Villa at Dar Buc Ammera in Zliten (Libya) seem to be an early precursor, probably of the late first century, to the Atrium House scrolls.[15] Levi took the greater number of creatures in the Judgment border as evidence of a more "realistic" hand, one he associated with the Flavian age.[16]

A green vine scroll inhabited with various birds and garden creatures surrounds the Judgment of Paris. Entwined in the leafy border are the head of a bearded male at the base of the panel and one of a female at the top. The filling elements, moving clockwise from the top of the panel at the right of the female head, are: a cluster of white grapes, a cricket or grasshopper, a cluster of red grapes, a red-legged partridge, another cluster of red grapes, a warbler with a rounded tail, a lizard and bird (damaged) nibbling at a cluster of red grapes, a thrush, a bearded male mask, a swallow, another lizard and a bird with a long, colorful tail pecking at a cluster of red grapes, a peacock striding toward a thrush about to peck at a white butterfly, at the corner a bird (damaged) turning to gaze at the grasshopper (long white antennae), and a bird nibbling at white grapes to the right of the female face. (See Appendix: Identification of the Birds in the Judgment of Paris for further identifications of birds depicted in the mosaic.)

The two faces do not derive from the theatrical masks that were common in these foliate borders. Rather, they correspond more closely to those found in the Dionysiac repertoire; the female might be the bust of a maenad, the bearded male, the bust of Silenos. Dionysiac heads appear as decorative motives in the mosaics of the Roman East. For example, in the so-called Villa of Dionysos at Knossos, Crete is a room with a pavement decorated with Dionysos and eight busts of his attendants.[17] Because the Cretan mosaic is dated by its pottery and the style of its capitals to the early decades of the second century C.E., it offers an especially appropriate comparison for the Atrium House borders. Two female busts mark the center points of two sides of a rich acanthus scroll framing a complex Dionysiac mosaic from Sepphoris in Galilee dated to the first half of the third century (fig. 13).[18] The foliage unfurls in even convolutions against a darkened background, and while the coloration and style of the animals and hunters differ, the Atrium House foliate borders seem to be direct antecedents to those in the house in Galilee. For example, the acanthus border of the Sepphoris mosaic and that around the Aphrodite and Adonis panel at Antioch share the demarcation of the acanthus leaves with a white dotted line. Indeed, the excavators have concluded that an Antiochene workshop was either directly involved or enormously influential in producing the mosaics found throughout ancient Sepphoris.[19]

The third picture panel, at the rear of the Atrium House dining room, shows two large seated figures who faced the diners—a draped Aphrodite on the left beside a nude Adonis (fig. 14). The long spear he holds and the hound in the foreground identify him as a hunter. Because the upper half of the figural scene was destroyed by the construction of a later wall, it is difficult to discern whether the gathering of drapery beside Aphrodite belongs to a standing figure now lost or to a curtain in the room. However, a photograph from the Princeton Archives of the panel *in situ* makes clear that there was an arm and hand (pale skinned, probably female) emerging from a cloak, seemingly offering something to Aphrodite (fig. 15). A female servant can be found on sarcophagus reliefs representing a similar scene in which the goddess sits beside her lover and tries to warn him of impending doom.[20] The lovers are shown at a moment of languid repose before Adonis departs for the fateful hunt.

The foliate scroll surrounding Aphrodite and Adonis differs from the Judgment border. The tendrils unfurl in circles and are punctuated by pink flowers against a black ground.[21] The tightness and crispness of line and general coloration recall the Hellenistic borders of the so-called Hephaistos mosaic from Pergamon now on display in Berlin (fig. 16).[22] Although this mosaic is dated to the early decades of the second century B.C.E., it shares such refinements as the

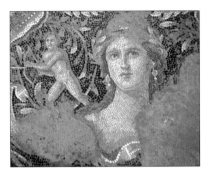

fig. 13. Detail of female bust from acanthus scroll border of Dionysiac mosaic from Sepphoris.

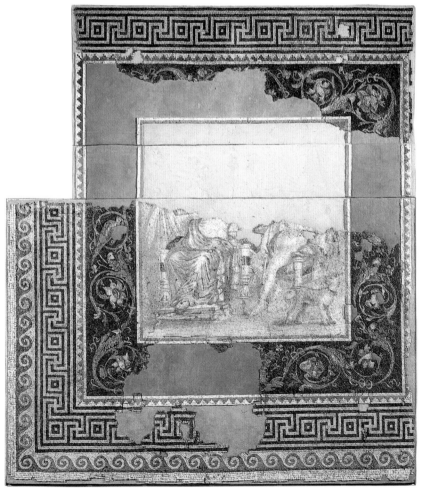

fig. 14. Mosaic panel of Aphrodite and Adonis (Princeton University Art Museum, 40-156; Wellesley College Museum, 1933.10 border fragment, upper portion of panel). Area of loss running diagonally through the upper half of the panel is from a later wall.

fig. 15. *In situ* detail of Aphrodite and Adonis panel showing servant's hand at viewer's left, part of which was lost when the mosaic was lifted (Antioch Expedition Archives).

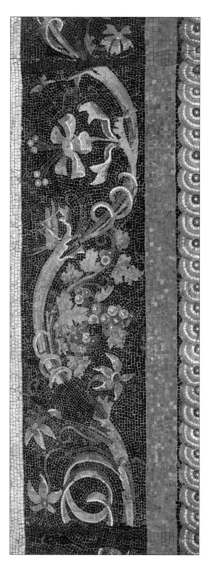

white outlining of the petals to create highlights, the subtle shading of the petals and tendrils, and the manner in which the thin tendrils wrap around the stems. Moreover, the Pergamon scroll is one of several frames including a Greek meander and wave crest, as in the Atrium House mosaic. The Aphrodite and Adonis border derives from such Hellenistic models and seems closer to them in its precise execution than to foliate scrolls created in the later second and third centuries.

In general terms, the style of the Antioch mosaics demonstrates a remarkable continuity with the Hellenistic artistic tradition, as seen in the selection of Greek themes and patterns and in the illusionistic treatment of the vine scroll border. Many of the early Antiochene mosaics employ multiple borders to frame figural panels. The panels, themselves, generally have a single viewpoint. The three-dimensional treatment of interiors and landscapes, the naturalistic representation of the human anatomy, and the variety of colors indicate a dependence on painting styles. These techniques effectively produce stone "paintings" that deny the solidity of the very floor upon which they are set; they trick the eye of the viewer. Finds from nearby sites (Apamea, Zeugma, Shahba-Philippopolis, and Palmyra) are similarly "traditional" and point to the existence of a "mosaic school" of Eastern art that extends beyond the workshops of Antioch.

The style of the dining room mosaic fits well into the early second century, as indicated by the comparisons for the borders discussed above. The figural scenes also point to this date. The landscape in the Judgment of Paris panel especially evokes the pastoral scenes discovered in 1779 in the Residence Basilica at Hadrian's Villa and now on display in the Vatican (fig. 17).[23] These panels from Tivoli and from Antioch share a similar staging of the characters and elements within a sacred landscape of trees with goats and sheep grazing by a stream and

fig. 16. Hephaistion mosaic: detail of border with grasshopper and grapes. Greek mosaic, from Pergamon, Palace V, 159-138 B.C.E. Attalos II? Inv. Mos. 70. (Staatliche Museen, Berlin).

fig. 17. Mosaic panel from the Residence Basilica of Hadrian's Villa at Tivoli. (Vatican Museums).

rocky ledges adorned with bronze statues. They exhibit a sophisticated handling of foreshortening, shading, and lighting that reproduces the effects of painting. The accounts of the discovery of the Hadrianic panels indicate they were enclosed by frames of vine leaves, again reminiscent of the Antiochene panels. Some have suggested that the *emblemata* found in the Residence Basilica might in fact date to a pre-Hadrianic age and represent the antiquarian collector's tastes of the emperor. In any case, the Antiochene panels derive from similar types of scenes that provide a general date in the early decades of the second century.

Iconography

It is important not to lose sight of the original function and context of these splendid mosaics. They must have engaged their viewers as individual scenes, as well as an ensemble. Accordingly, let us briefly consider how the myths were understood.

The three-panel group at the entrance to the room focused on the Drinking Contest, with the dancing maenad and satyr, the drinking vessels in the foreground, the female flute player, and the saluting Silenos, conveys the message, "Eat, drink, and be merry." Yet a more careful look at the central panel of the Drinking Contest (fig. 18) reveals another message. Dionysos' elegant repose and the unbalanced Herakles capture the essence of the struggle between mortal and immortal. On one level, the message is fairly obvious and direct: one should be mindful and drink in moderation. Thus the Drinking Contest is a pictorial analogue to a convivial toast but is also a plea for *sophrosyne*, a Greek virtue much discussed by Plato and Aristotle meaning "moderation in desires." In a city as

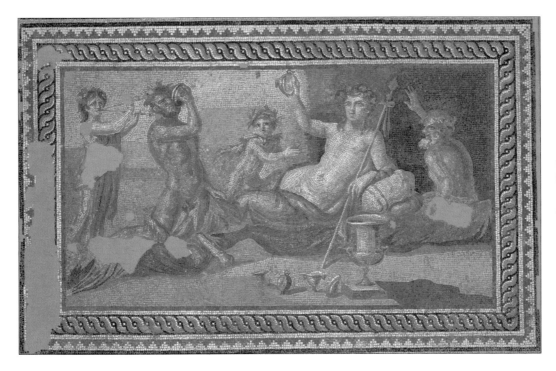

fig. 18. Mosaic panel of the Drinking Contest Between Herakles and Dionysos.

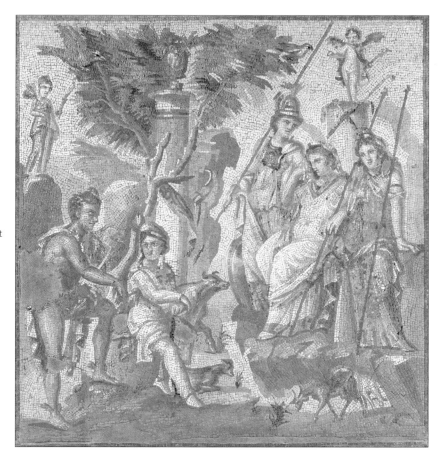

steeped in Hellenic culture as Antioch, *sophrosyne* was surely discussed, if not con-
scientiously embraced. In ancient texts on banquets, such as Plutarch's *Convivial
Questions* and Athenaios' *Sophists at Dinner*, much is written about drunkenness as a
state to be avoided. Excess was something brought on by too much revelry, which
needed to be checked at the door, as it were. In order to avoid excess, ancient
guests knew to mix their wine with water. In the Atrium House Drinking Contest,
the mixing *krater* in the foreground reminds the guests to do just that.

 The simplest explanation for the inclusion of the Judgment of
Paris (fig. 19) in this house at Antioch is the one offered by Libanios, the famous
fourth-century teacher and native son of Antioch, who wrote that the contest took
place in Antioch rather than at Mount Ida, as was commonly believed.[24] But the
other myths represented in this room suggest that the selection of the scene went
beyond local pride. Athenaios writes in book 12 of his *Sophists at Dinner*, "I for one
affirm that the Judgment of Paris, as told in the poetry by writers of an older
time, is really a trial of pleasure against virtue."[25] Aphrodite lures Paris, the son of
Priam, to choose her as the most beautiful of the three goddesses by offering
Helen, the most desired of all mortal women. Paris selects Helen over the worldly
power offered by Hera and the military glory offered by Athena. When pleasure
(*hedone*) is given preference, all is thrown into turmoil: the Trojan War begins and
the lineage of Priam is destroyed. In at least two of the Atrium House mosaics,
the mortals are no match for the gods: just as Herakles succumbs to drink, Paris
succumbs to desire. While seemingly serious in its implication, the Judgment was
easily caricatured as evidenced in a series of decorated cups and vases associated
with the sanctuary of the Cabiri from Boeotia from the late fifth and fourth cen-
turies B.C.E.[26] There is a long tradition of theatrical, even comic, interpretations
of the Judgment scene stretching from Classical Greek to late Roman periods,

Whether as a mime in the amphitheater, or as comedy in the theater, or as a rhetorical performance or school exercise, the Judgment offered rich material on the subject of beauty, desire, love, and the tension provided by the contest.[27] While not specifically addressed as a subject for dinner theater, the Judgment might well have been among the entertaining vignettes enacted in the banquet rooms of Roman Antioch, and at the very least offered a subject for debate and moralizing.[28]

Aphrodite also plays a pivotal role in the last panel at the rear of the room, where she is seated beside her beloved, the mortal Adonis, shown nude with his hunting dog beside him. Even her divine powers could not prevent her handsome hunter from meeting his fate, a mortal wound inflicted by a wild boar. This scene is commonplace in mythological compositions, the seated couple embracing before Adonis leaves for the hunt. The guests in the Antioch dining room would presumably recognize the tragic outcome implied in the couple's repose.

The panels in the Atrium House dining room all retain their own meaning as a representation of myth, but they may well have been understood by their Hellenized audience as an ensemble as well. Guests could notice the pictorial signs, such as repeated figures, parallel compositions, and thematic links. For example, in each panel a mortal—Herakles, Paris, or Adonis—faces the trials of fate and encounters with deities. Indeed, it is the very aspect of a trial, a contest between mortal and immortal, that binds these scenes together. The theme of contests is popular in ancient art and reveals a taste for the debates embedded in myths. This is underscored by the presence of a personification labeled in Greek ΠΛΑΝΗ (error or misjudgment) in a mosaic of the Musical Contest between Apollo and the mortal Marsyas from the House of Aion at Nea Paphos, Cyprus (fig. 20). This personification, unparalleled in ancient art, indicates an active engagement with the element of contest and debate. Similarly, the lessons from myth were used as exempla in rhetorical exercises (*progymnasmata*). For example, students might be given a theme, often a trial, from myth and asked to argue a different outcome or to debate the verdicts. Myths found on mosaics may well have operated for their audiences in ways familiar to them but now largely lost to us—in other words, in a realm of discourse only hinted at in texts and educational manuals. The owners and inhabitants of these houses were interested in demonstrating their *paideia* or culture.

The hosts and guests in the dining room of the Atrium House at Antioch might contemplate the different outcomes of the Drinking Contest or the Judgment of Paris and in so doing reflect on their own conduct in relation to the pleasures of the senses. Issues of fate and how the gods played in the affairs of man are explored in all three figural panels. Desire can be seen to motivate both gods and mortals: that Aphrodite figures in two of the panels surely speaks to her importance. The myths on the floor of this Roman-period banquet hall are a reminder of a Greek past in which the eternal sensual appetites for sex, drink, and food were a subject for philosophical debate and their management was a matter of personal honor. Such scenes must have stimulated dinner discussions and a rehearsal of the lessons implied.

fig. 20. Mosaic of the Musical Contest Between Apollo and Marsyas, the House of Aion at Nea Paphos, Cyprus.

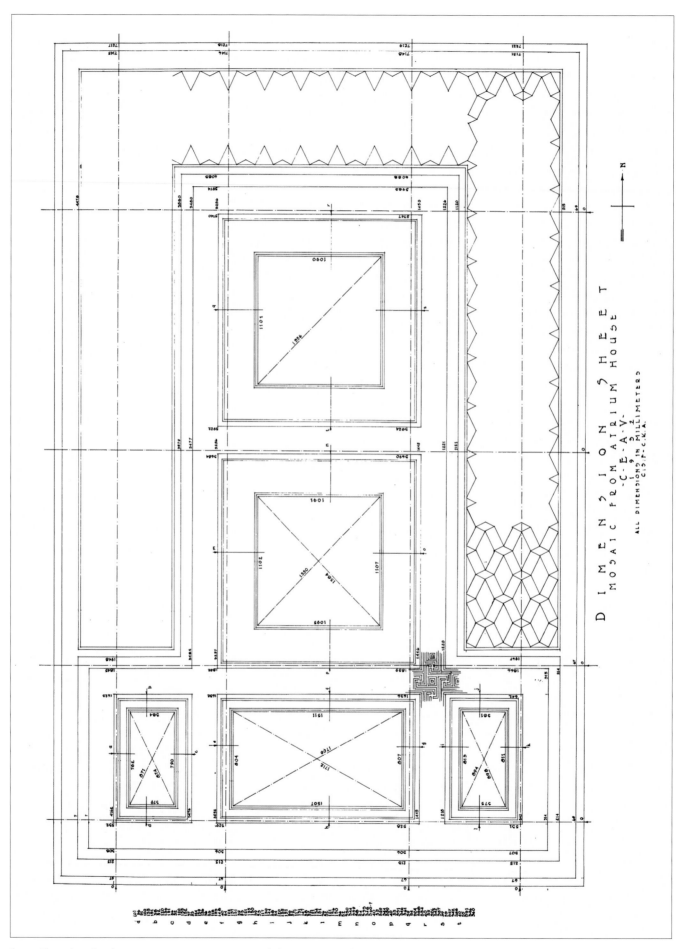

fig. 21. Floor plan of *triclinium* pavement, Atrium House, with dimensions in millimeters (1932). Drawn by Clarence Fisher, Field Director, and C. K. Agle, Architect.

The Archaeological Record

The mosaic artists whose portrayals of mortals and gods graced the Atrium House have long disappeared from oral or written record. To reconstruct their creative path we turn to archaeology to uncover the physical evidence of their workmanship and to reveal the relationship of the triclinium mosaic panels to one another and to their setting.

The archaeologists who came to Antioch in the 1930s sought the political and religious monuments of the city center—the Imperial Palace and the Golden Church of Constantine. What they found instead was a wealth of mosaic pavements that redefined conceptions of pictorial art in the Roman East. Unfortunately, the recovery of mosaic pavements was rarely accompanied by a thorough examination of their contexts. Houses were partially excavated. Sites for the production or refinement of tesserae were overlooked and only a scattering of poorly documented workshop materials (primarily tools and glass-containing crucibles) found their way into the excavation archives at Princeton. The removal of mosaics from their original setting and the loss of bedding material in the lifting process destroyed evidence of artistic process. Fortunately, the *triclinium* is better documented than other Antiochene sites and these limitations are somewhat mitigated by detailed field notes, diaries, drawings, plans, and photographic documentation in the form of black and white prints and negatives, color transparencies, and even film footage.

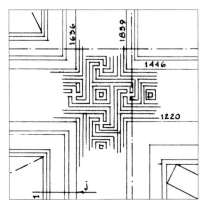

fig. 21. Detail of floorplan of *triclinium* pavement showing intersection of meander border.

Measurements of the pavement in millimeters taken by the excavators and recorded in a 1932 scale drawing (fig. 21) illustrate the accuracy attained by the ancient craftsmen in laying out the rectilinear forms that define the space. The most accurate measurements recorded on the drawing define the perimeter of the pavement, logically the first element plotted. Four measurements were taken of the length (north-south) of the pavement. The readings fall between 7217 and 7221 mm, for a variation of only 2 mm or 0.03% from the mean, indicating that the north and south edges of the mosaic floor were virtually parallel. Damage to the western edge of the room prevented measurement of the full width.

Several aspects of the interior of the pavement confirm the degree of accuracy attained there. The distance between the lines that establish the north-south axis of the three major panels (the long arm of the traditional "T" of Roman *triclinia*) was measured at four points (fig. 22). The measurements were 1807 mm, 1811 mm, 1811 mm, and 1806 mm, representing a variation of only 2.5 mm or 0.1% from a midrange of 1808.5 mm over a distance of more than 5 meters.[29] The central framed panel (the Judgment of Paris surrounded by a scroll border) measured an almost perfect rectangle, with the north and south sides 1811 mm and the east and west sides 1831 and 1832 mm, respectively. Fisher's field notes indicate that the width of the couch border was 802 mm on the east and west sides and 800 mm on the north side, a deviation of only 0.1% from the mean.[30] Both the Judgment of Paris and Aphrodite and Adonis panels are slightly longer than they are wide, the orientation of their compositions reinforcing the dominant north-south axis of the *triclinium*. While damage to the Aphrodite and Adonis prevents

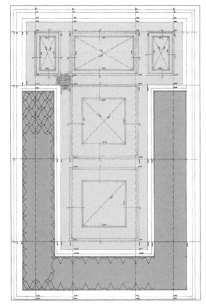

fig. 22. Floor plan of *triclinium* pavement with shading to highlight couch seating area and T-shaped orientation of figural panels.

a full comparison of the two panels, it appears from the sides that could be measured that the Judgment and Aphrodite figural interiors were virtually identical in size: the west side of the Judgment is 1102 mm and the north side is 1091 mm, while the west and north sides of Aphrodite and Adonis are 1101 and 1090 mm respectively.

Judging from the 1932 drawing, not all the geometric forms were executed with the same degree of accuracy, with the greatest variation found in the lengths of the Satyr and Maenad panels.[31] However, considering the variable dimensions of hand-cut tesserae, the correlation among measurements throughout the pavement is striking and small irregularities recorded in the drawing may not reflect original workmanship, but measurement error by the excavators or surface disruptions from ancient use, earth tremors or the flow of ground water.

For both the modern viewer and the ancient guest, the black and yellow meander border ties together the narrative panels. Whereas in many mosaics, border motifs do not always line up properly, in the Atrium House *triclinium*, the field notes, site drawings (figs. 20, 21), and photographs[32] indicate that the meander, wave, and stepped triangle borders met perfectly at each corner and intersection, as can still be seen at corners that were not disturbed during excavation. Overall, the precise dimensions of the room and the complex imagery of the figural panels suggest detailed preparation before the tesserae were laid. This was the conclusion of the excavators. As Fisher writes: "...the accuracy of the black and yellow fret [meander] border, where the spacing and divisions work out perfectly and with no fudging of spaces to make it come out right at the corner, for example, proves that the entire design was carefully laid out first."[33]

A mosaic pavement is usually executed in two stages. The first entails laying out the guidelines that demarcate the different elements, perhaps followed by more detailed delineation of specific figural or decorative motifs. The second stage is the placement of the tesserae, either directly or in some cases by insertion of prefabricated elements. The order in which the mosaic fields were set is not necessarily that in which the guidelines were laid, although the same considerations might govern the sequence in each case. While it is reasonable to infer that design elements were outlined directly on the floor to guide the *triclinium* mosaicists, any evidence of this process was destroyed in the course of lifting and backing. In general, two methods of laying guidelines have been identified on Roman mosaic pavements. Lines can either be scored into the *nucleus* or painted on its surface in *sinopia* or charcoal. Well preserved examples of incised guidelines exist on geometric pavements from the Villa Arianna at Stabiae and the House of the Cascade at Utica (both meander patterns), dated to the second half of the first century and the early second century respectively, and also in a late Republican house, the Villa San Rocco at Francolise. In some instances, such as the Villa Arianna, both incised and painted lines were used on the same floor.[34] Preliminary drawings of figural scenes made directly on the *nucleus* have occasionally been reported, most recently at Sepphoris in the House of Dionysos.[35]

Fisher was interested in questions of manufacture, and a number of observations about the construction of the pavement are noted in his diary and field notes, particularly with reference to the Judgment of Paris panel. As often with field notes, some comments represent merely preliminary impressions and thoughts in progress. Nevertheless, Fisher's observations are an invaluable primary source for evaluating evidence destroyed during excavation. In the course of this essay we will test his theories against our own visual study and technical analyses.

The *triclinium* pavement was built up in layers over the floor of an earlier building phase (fig. 23). In his field notes of June 2, 1932 Fisher describes a distinct floor line of white plaster visible about 35 cm below the level of the *triclinium* mosaic.[36] The order of layers, from a foundation of rubble or cobbles through progressively finer layers of mortar, corresponds generally to the sequence advocated by Vitruvius.[37] According to Fisher, the bottommost layer consisted of a bed of "cobbles and earth filling" approximately 270 mm deep. Over this was found a "rough layer, averaging 45 mm in thickness" that Fisher describes as gray in color with "bits of charcoal and fine pebbles in it, the usual ash and lime mortar." The next layer was "a smoothing coat 12-13 mm. [It was] yellowish in color and sandy, and could be scaled off easily."[38]

The uppermost layer, that is the "bedding layer in which, while soft, the stones were placed," measured 10 mm.[39] The makeup and color of the bedding layer were variable. Generally, Fisher characterizes it as a "firm grey cement, 10 mm thick."[40] However, the bedding layer for the Judgment of Paris figural panel is described "as a pinkish cement, which is quite different from the cement of the other parts of the floor."[41] The makeup of the bedding layer under the Aphrodite and Adonis, the companion panel to the Judgment scene, is not described anywhere in the field notes. It is possible that the later wall that damaged this panel compromised its study.

Fisher reports that the tesserae range in thickness from 3 to 6 mm,[42] a variability generally observed in Antioch mosaics by the present authors. To achieve a level surface with tesserae of inconsistent thickness implies the use of a leveling board or tool while the mortar was still workable.[43] A level surface could also be achieved using an indirect or reverse method by which tesserae were glued face down to a support material. The unit was then inserted into the floor with the tesserae face up and the support material removed. While this method offers certain advantages, as yet no definitive evidence for its use has been recovered through excavation or review of ancient texts.[44]

After each mosaic panel was lifted in excavation, it was placed face down and the mortar removed layer by layer. When the final layer was exposed, features of the bedding mortar were revealed. Unlike fresco, where the divisions between *giornate* can be seen in the plaster, boundaries between applications of mortar for mosaic work can be easily hidden by the mortar lines between tesserae. Describing the bedding layer as seen from the underside (figs. 24, 25), Fisher writes: "[t]he whole surface is not uniform but is divided by little ridges into

"[B]edding layer in which, while soft, the stones were placed," measured 10 mm.

A 12–13 mm smoothing coat, "yellowish in color and sandy" and easily scaled off.

Rough layer, averaging 45 mm thick, that Fisher describes as gray with "bits of charcoal and fine pebbles in it, the usual ash and lime mortar."

Bed of "cobbles and earth filling" approx. 270 mm.

Floor of earlier building phase.

fig. 23. Cross-section of layers of the *triclinium* pavement based on Clarence Fisher's field drawing (Field Notebook, June 2, 1932) and description (Field Diary, June 1, 1932).

fig. 24. Site photograph dated April 15, 1933, showing reverse of Judgment of Paris panel after lifting and removal of the preparatory layers down to the bedding layer. Archive print is labeled "back of panel D, showing joint in plastering..." (Antioch Expedition Archives).

patches irregular in size and shape. They do not follow the pattern of the mosaic except that the fret border, and the plainer fields are outlined by them. The markings indicate that pats of plaster were laid down, handful by handful and spread out flat against the portions already in position."[45] He wrote in the field notes: "In laying the tesserae, the final hard plaster was laid in irregular patches varying in size according to the difficulties in the pattern, and allowing time for it to remain soft. The yellow and black fret [the meander] was laid in a line."[46]

The ridges indicate boundaries between successive applications of mortar. While Fisher's notes omit specific dimensions, they suggest that the limited working life of the mortar permitted the laying of only a relatively small area of tesserae at a time—the more exacting the passage to be laid, the smaller the patch of plaster applied. His writings also suggest that the method of applying the bedding mortar in the pictorial areas differed from the meander border and the background ("the plainer fields"), with applications in pictorial passages following, to some extent, the outlines of the forms. This observation underscores what can be seen more clearly on the decorated surface: tesserae were not set row by row across the entire mosaic, but instead primary elements of the composition were laid first (see below: The Visual Evidence: Technique and Style).

fig. 25. Second site photograph of reverse of Judgment of Paris panel (Antioch Expedition Archives).

Features observed during the excavation and field treatment of the Judgment of Paris provide important evidence on the manufacture of the pavement. After lifting, when the Judgment was turned over and the underlayers of mortar removed, a join line or seam between the figural interior and the scroll border was revealed. This seam is clearly visible on a photograph taken of the reverse of the panel on April 15, 1933 (figs. 24, 25), labeled "[b]ack of panel D, showing joint in plastering." In addition, the excavators noted that the pink bedding mortar under the Judgment figural scene differed in color and texture from the surrounding border. The mortar was colored to reflect the palette of the mosaic by modifying the amount of brick or charcoal filler. The pink mortar used in the interior

would have complemented the warmer colors of the Judgment figural scene, while a gray mortar would suit the black background of the vine scroll border.[47]

Evidence of the seam is still visible today in the narrow loss that runs the length of the bottom edge of the Judgment figural panel (fig. 26). While other losses to the pavement are irregular in shape and seem unrelated to manufacture, the shape and position of this loss are most readily explained by the separation during burial or lifting of a seam or joint between the figural interior and the scroll border.

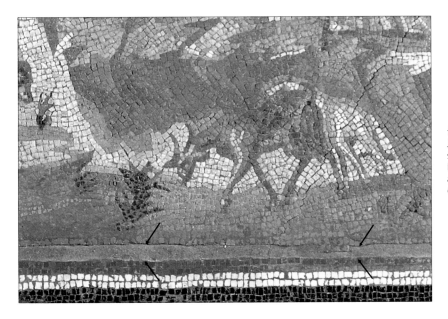

fig. 26. Detail of Judgment of Paris showing narrow loss (arrows) along lower edge of figural interior.

Perhaps the most revealing feature in the excavation record was the observation of a beveled or sloped edge between the central panel and its border. Elderkin writes in the Director's Report for 1932: "[a]n interesting fact was observed when the panel representing the Judgment of Paris was turned over and cleaned down to the mortar course on which the tesserae were laid. The central panel had a distinct edge which sloped inward and downward [fig. 27]. The panel had been let into its rinceau frame. A difference in texture was also observed indicating as Mr. Fisher pointed out that the panel and its border had been separately made in the atelier of the mosaicist and then brought to the house and laid."[48]

figural panel scroll border

fig. 27. Reconstruction of sloped edge of Judgment of Paris figural interior as described by Elderkin in the Director's Report for 1932.

The features documented in the excavation records are evidence that the Judgment figural panel and its scroll border were laid in different stages. Whether they support Fisher and Elderkin's conclusion that some elements of the floor—in particular the main figural panels—were prefabricated is another question. In this they may have taken the evidence too far. While a beveled edge might facilitate the insertion of a preformed element, the evidence is not strong enough to rule out alternatives: the edge may have been sloped merely to key in the newly applied mortar for tesserae being laid *in situ*. In either case, however, the direction of the slope establishes the important point that the central figural panel was laid *after* the scroll border. The published data from other mosaic excavations

are insufficient to indicate if this sequence is typical. Evidence of an analogous practice in painting may be seen at Pompeii, where recent excavations have revealed wall paintings completed except for their central panels.[49]

Pauline Donceel-Voûte has reported the presence of a beveled edge or seam between two parts of a mosaic pavement in a public building of early Byzantine date at Bosra excavated by her in 1981.[50] As with the Atrium House *triclinium*, the beveled edge sloped inward, indicating that work had proceeded from the perimeter toward the center of the room. Because the sloped edge on the Bosra mosaic lies between two geometric elements, it seems unlikely to indicate prefabrication. On both the Antioch *triclinium* and the Bosra pavements, sloped edges were found only between distinct compositional elements of the floor and not in the middle of mosaic fields, suggesting that these edges do not merely signify *giornate*, or breaks necessitated by the setting time of the mortar, but rather delineate separate stages in the laying of the floor.

Fisher argued that "[t]he whole [*triclinium*] floor…must have been finished in its entirety in a workshop" with each figural panel a separate element and the borders fabricated in sections.[51] In his opinion, they were brought to the site adhered to a support material, laid into the wet mortar and leveled. Fisher offers several possible theories for the method of prefabrication, including a reverse technique with a rigid facing and a technique that involved unrolling the preformed mosaic.[52] However, a survey of the field reports does not yield evidence to support these hypotheses. It is possible, of course, that Fisher based his explanations on observations that he did not document.

The issue of prefabrication is one of the most intriguing questions in the study of ancient mosaic technique. While conventional practice involved laying individual tesserae directly on the floor, this was not always done. During the Hellenistic and early Roman periods, prefabricated central figural elements known as *emblemata* were prepared in terracotta or stone trays and laid in the floor as a unit, the tray remaining in the pavement (fig. 28). *Emblemata* were assembled in workshops that may have been no more than temporary work stations on the building site. The majority of *emblemata* were probably prepared for local use in a specific location, but being portable they were in some instances traded or taken from their original placement and reused.[53]

Opinion differs on whether *emblemata* were positioned first and the floor laid around them[54] or were inset into otherwise completed floors.[55] As indicated earlier, analogies from wall painting and archaeological evidence from the Atrium House tend to support the latter sequence, although it can be argued that these examples, which probably deal with elements completed *in situ*, may not be comparable. Circumstances might vary, particularly when *emblemata* were recycled, and in any case, the archaeological record appears scanty. *Emblemata* from many sites have been removed without detailed study of evidence of the sequence in which the floor was laid, although examination of unpublished field notes might reveal new information.

fig. 28. Mosaic *emblema* showing Hylas and the Nymphs, from Roman villa in Tor Bella Monaca, 1st century B.C.E. or early 1st century C.E. The edge of the terracotta tray is visible at the perimeter of the figural scene (National Museum of Rome, Palazzo Massimo alle Terme, inv. 423108).

By the time the *triclinium* mosaic was executed—that is, the second century—traditional *emblemata* were rarely used in pavements, although the technique may have persisted for small wall panels.[56] Levi reports that at Antioch traditional *emblemata* "prepared in a terracotta frame made out of tiles" were found in only the second-century House of Polyphemus and Galatea (fig. 29).[57] Unfortunately, there is no documentation of this example in the field notes or archive photographs. It should be noted that Levi was not present during the excavations and did not actually see these panels. Certainly no evidence of stone or terracotta trays was found with the Atrium House panels. Therefore if elements were prefabricated, another method must have been used.

The discontinuance of traditional *emblemata* does not necessarily mean that prefabrication was abandoned, since a different method may have been adopted for transferring panels to the site. Traditional *emblemata* were relatively small, generally no more than 0.50–0.75 m in any direction, considerably smaller than the Atrium House panels. For example, the sides of the Judgment figural panel each measure about 1.10 m, while the Drinking Contest is more than 1.50 m in length. If larger panels such as these were prefabricated, a lighter, more flexible support material—textile or matting—would offer advantages over the heavier, brittle terracotta. This alternative has been suggested by a number of investigators.[58] However, no trace of organic support material has been documented. If mosaicists used organic supports of any kind, they either were removed as part of the setting process or deteriorated in burial to the point that their remains, or the impressions of their remains, were not discernible to excavators or were misinterpreted.[59] While organic support materials would have offered advantages, their use remains speculative pending more convincing archaeological evidence.

At the late Republican villa at Francolise, Guy Métraux characterized 15 hexagons with flowers marking the threshold of the *tablinum* as *emblemata* on the basis of differences in the mortar composition, the thickness of the *nucleus*, and the size and color of the tesserae. No stone or terracotta slab or tray was found beneath the mosaic, and the excavator found no trace of any temporary support used to transfer the *emblemata*. The differences noted by Métraux are comparable to the differences between the Judgment figural panel and its border recorded by Elderkin and Fisher.[60]

fig. 29. House of Polyphemus and Galatea. Detail of panel showing swimming fish, perhaps one of several *emblemata* according to Levi (Antioch Expedition Archives).

The Visual Evidence: Technique and Style

It is generally believed that Roman mosaics were created by workshops, which are defined here to include any group of workers or other entity engaged in the ongoing production of mosaics. The existence of workshops is indicated by inscriptions in some mosaics and by comparative evidence from other crafts and time periods.[61] Indeed, workshops are a logical mechanism for the organization of large-scale, labor-intensive projects such as the mosaic decoration of buildings and public spaces.

However, ancient texts are relatively silent about Roman mosaic workshops and many questions remain unanswered. Inscriptions rarely name the artists responsible for the mosaics. The handful of extant artists' signatures on mosaic pavements are perhaps overly mined as evidence. To underline the challenge, consider the fact that at Antioch, where some 300 mosaics were uncovered, many with Greek labels, not a single inscription naming an artist has been found. Yet an artist's signature does survive in Crete to bear witness to the influence of Antioch workshops. On a third-century floor depicting Dionysos discovering Ariadne in Chania, Crete, a mosaicist identifies himself as coming from Daphne, probably an itinerant craftsman trained in the metropolitan area of Antioch-on-the-Orontes, Daphne being its garden suburb.[62] The Cretan find suggests that mosaicists traveled some distance to practice their trade. Further evidence of the reach of the Antioch-region workshops comes from the southern coast of the Black Sea. A mosaic discovered in 1959 at Amissos and today in the Samsun Archaeological Museum shows Thetis handing the weapons to Achilles. The mosaic, probably of the early third century, is signed "Orontes made this mosaic," very possibly an artist from the Orontes River region.[63]

Recent rescue operations necessitated by dam construction at the site of Zeugma on the Euphrates have revealed an extensive group of mosaic pavements.[64] The selection of myths, geometric and vegetal ornaments, and the overall style of these mosaics indicate a strong relationship with the workshops of Antioch, some one hundred kilometers southwest of Zeugma. Rescue excavations of summer 2000 confirmed a major burning and destruction phase around the middle of the third century corresponding to the Sasanian sack of Zeugma in c.e. 253 or 256 by Shapur I. The relatively restricted date thus established for mosaic production at Zeugma makes these mosaics a compelling and important new control group by which to assess developments at other sites, especially Antioch.

Two Zeugma mosaics contained an inscription with the same name, at once complicating and possibly elucidating the identification of an artist or workshop. One panel, from the House of Poseidon, depicts Aphrodite on her shell held up by tritons; the inscription "Zosimos of Samosata made this" is written crudely across the top.[65] Samosata (modern Samsat) was the capital of Commagene, the province to which Zeugma was most closely allied. Why did Zosimos include the name of his home town while working in nearby Zeugma? Like the mosaicist from the Orontes working on the Black Sea and the one from Daphne working on Crete, Zosimos named his city of origin. Perhaps itinerant

artists, as outsiders, were more likely to sign their works and name their home towns or regions. Links in the artifacts and some of the mosaics at Zeugma with the Commagene kingdom and with Syrian cities other than Antioch suggest that there was an active market for the skills of artists from neighboring regions.

In a house a few dozen meters away from Zosimos's Marine Aphrodite is a mosaic that is signed at the bottom "Zosimos made this painting of the Synaristosas," a play by Menander. In the opinion of French mosaic specialist Jean-Pierre Darmon, the two mosaics were made by the same hand.[66] Their differences, he suggests, are due to the fact that they belong to distinct iconographic traditions. He also suggests that because the Marine Aphrodite was not well known in the Greek East, Zosimos was less familiar with the composition. However, even if we take into account that the panels are derived from different models or artistic traditions, their overall styles—the treatment of the figures, drapery, space—are quite distinct. In the Menander mosaic, the bodies are formed by a subtle use of dark and lighter shades of color, whereas the Aphrodite figures rely heavily on outline. The clumsiness of the Marine Aphrodite artist is obvious in the depiction of water spilling out of the shell that resembles long, gray strings. Typically, we assume that a signature is to be associated with an individual artist, but given the Zeugma finds, perhaps a more likely explanation is that a workshop may be named for its master or owner. Alternatively, of course, there may have been two mosaicists named Zosimos, and the one from Samosata signed with his city name to distinguish himself from the other.

While the Zeugma finds suggest some possible ways in which the mosaicists identified themselves, we are still left with many questions. The clearest inscriptional evidence for workshops is provided by surviving signatures in the form *ex officina* (from the workshop of) followed by the name of a person, for example the signature *ex officina Anniponi* found on a mosaic of the Discovery of Ariadne at Emerita (Mérida) in Spain,[67] that suggest the aegis of a single master or owner. Assuming a hierarchical structure, which may not have always been the case, there remains scant evidence regarding the division of labor within workshops. The head of a workshop might be its foremost mosaicist, or the workshop could have included craftsmen of equal or even superior artistic ability. It is also possible that the owner of a mosaic workshop was not primarily a mosaicist but rather an architect, builder or entrepreneur. Below the master or masters were presumably artists of lesser stature down to the level of apprentice. When it came to laying a pavement, tasks were allocated: the master took charge of the primary or most demanding images, secondary but still important sections fell to the next level of craftsman, and so on down to the apprentices, who might lay out repetitive borders or assist with preparatory tasks. The signatures of individual mosaic artists on central panels is consistent with a division of labor between highly skilled and less skilled craftsmen who might have been assigned to surrounding borders.

The relationship of the workshop to architects, designers, and patrons needs clarification. How were decisions on the selection of images and the composition of panels divided or shared among these groups? To what extent

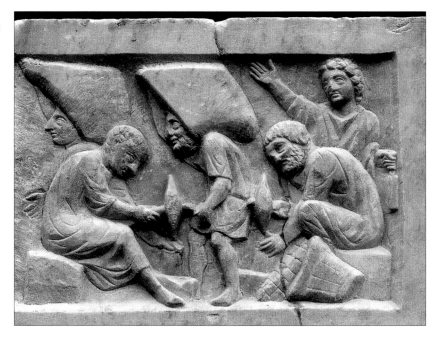

fig. 30. Detail of grave stele from Ostia showing the preparation of tesserae (Museo Ostiense, Inv. 132. Probably early 4th century).

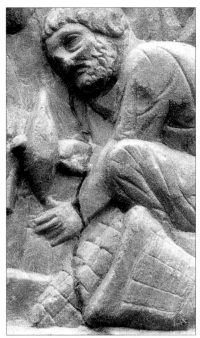

fig. 30 detail.

was the workshop involved in the laying of floor levels below the *nucleus*, the incising or painting of guidelines, or the creation of preparatory drawings? The source of materials is also an issue. Did mosaicists fabricate their own tesserae and, if so, in what form did they receive the raw materials? A rare piece of contemporary evidence is provided by a grave stele from Ostia (fig. 30) that depicts men taking bars or slabs from a basket, placing the material on an anvil and splitting the blocks along pre-scored lines with a hammer to create tesserae.[68]

Little is known about the size of mosaic workshops, which likely ranged from small family ateliers to large, hierarchical establishments. The number of mosaicists in a workshop would obviously influence the scale of possible commissions, the time required to complete pavements, and the number of commissions that might be undertaken simultaneously. Workshops occasionally may have collaborated on projects, but there is no reason as yet to think that this was customary.[69] More needs to be learned about the order or stages in which elements of a floor were laid. Little has been done by way of replicating the laying of pavements to gain a clearer idea of the time involved and the number of people who could work *in situ* as a team. Prefabrication of panels would, of course, change the parameters significantly.

The mosaicists who created the *triclinium* floor, whatever their relationship, shared a common legacy. Their representations derive from the same visual and cultural vocabulary and, as befits a workshop tradition, a basic continuity of technique extends throughout the pavement. One feature seen in all the Atrium House panels—and indeed throughout the Roman world—is the presence of several courses of tesserae outlining the figures and other pictorial forms, evidence that these elements were laid first and the background afterward. The size of the tesserae varies. The largest tesserae are found in the backgrounds of the panels and the geometric borders; tesserae are smaller in the pictorial elements

Arts of Antioch

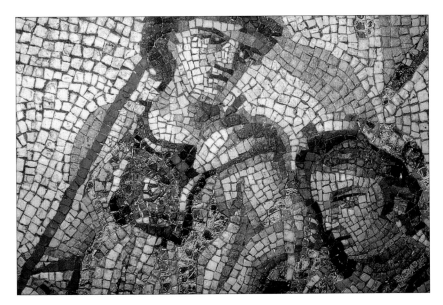

fig. 31. Detail of Judgment of Paris showing worklines around figures.

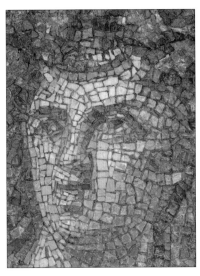

fig. 32. Detail of face of Dionysos from the Drinking Contest Between Herakles and Dionysos.

and the smallest tesserae are reserved for the faces. This can be seen by comparing tesserae counts taken from 10 × 10 cm areas on different parts of the Judgment of Paris panel. The face of Paris, who occupies center stage, contains 712 tesserae per square decimeter, the face of Hera contains 600 tesserae, the bearded head on the floral border 498 tesserae, the green tree in the background of the figural scene 327 tesserae, and the background of the floral scroll border 269 tesserae. The wave and meander borders that circumscribe the figural panels contain 207 and 179 tesserae respectively.[70] The shapes of the tesserae vary as well. Tesserae in the backgrounds and geometric borders are almost always roughly cubic. In the pictorial elements, however, especially the faces, the shape is more variable and tesserae were cut to define the forms sculpturally (figs. 31, 32).

Stone was used exclusively in the meander, wave and stepped-triangle borders, as well as the area reserved for the couches. Most of the tesserae in the framed figural panels are stone, but glass is exploited both to expand the palette and to take advantage of its superior reflective quality. In some instances, because it can be viewed as a surrogate for precious and semiprecious stones (lapis, turquoise, emeralds and the like), glass may carry other associations.[71] The fine gradations of color available in stone, complemented by the extraordinary glass palette, gave the mosaicists the tools needed to emulate painting. Subtle color transitions and changes in material were used to impart three-dimensionality to the forms. The interplay of highlight and shadow, vital to the *triclinium* space, was enhanced through the juxtaposition of stone with glass or the combination of opaque and translucent glass (fig. 33). For example, the staff held by Paris in the Judgment panel is laid in two rows of tesserae—a row of black glass on the sunlit side and a row of black stone on the side in shadow.

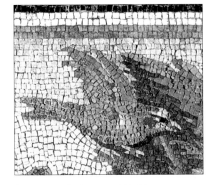

fig. 33. Detail of tree and bird from Judgment of Paris showing the subtlety of the glass palette and the juxtaposition of stone shadows and glass highlights.

We have seen that the figural panels work together thematically as myths, while common technical features, influenced by painting, further unify the pavement. Yet, when the floor was reassembled in 2000 for the first time since its excavation, those present were immediately struck by differences in execution

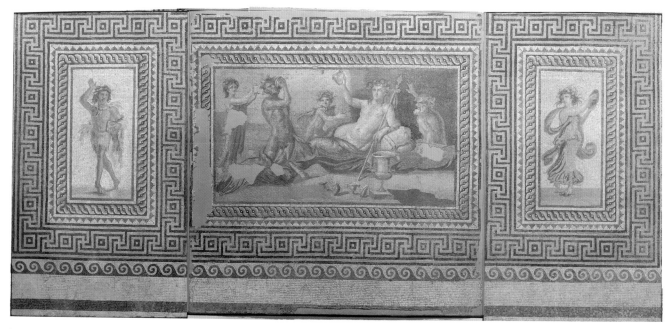

fig. 34. Mosaic panels of the Satyr, Drinking Contest, and Maenad. Composite of digital photographs taken of the figural panels and border elements reunited for the Antioch exhibition in 2000.

among the panels. These differences, bearing the imprint of individual interpretation and practice, raised the question of how many hands worked on the room and even whether perhaps separate workshops or an outside master contributed. Indeed, it is the very contrast between the separate parts and their integration into a whole that reveals the process behind the creation of this dining room. The significance of the present investigation rests heavily on the observation that the mosaic panels were individual creations joined according to the dictates of the architectural space of the dining room and the expectations of the viewers, both inhabitants and guests. Only two of the panels, the Maenad and Satyr, seem close enough in conception, execution and material to attribute them to a single hand or at least to the same stage in the laying of the pavement. The three main framed figural panels (Drinking Contest, Judgment of Paris, and Aphrodite and Adonis) differ not only from the Satyr and Maenad panels but also from one another.

The formal and narrative divisions of the pavement provide a framework for visual comparison of the mosaic panels. Since the Drinking Contest and the Satyr and Maenad panels function spatially as an entryway and thematically as a Dionysiac scene, it is logical to consider them as a unit. The Judgment of Paris and Aphrodite and Adonis panels were viewed together by the diners and they too may be compared with each other. A strong visual axis is formed by the three main figural panels—Drinking Contest, Judgment, and Aphrodite and Adonis—and this grouping also invites comparison. The following visual observations are organized with these relationships in mind.

While the three Dionysiac panels greet the entering guest as a narrative ensemble (figs. 9–11, 34), examination reveals strong differences between the Drinking Contest and the others. The simplest figural panels, the Maenad

and the Satyr (figs. 9, 11), share many features. They both show a single figure standing contrapposto against a uniform white background, with only a ground line and a few abbreviated shadows thrown by the figures' feet to convey a sense of depth. The two-dimensional quality of these subsidiary panels differs from the complex space in the Drinking Contest and the other figural scenes. The Drinking Contest (figs. 10, 18, 34), in particular, uses contrasts of light and shadow to create depth and articulate the figures. The fair skin of Dionysos stands out against a field of dark reddish-brown tesserae, while the ruddy complexion of the drunken Herakles is accentuated by placing his swaying figure against a light background. In addition, although the three panels form an ensemble they are lit inconsistently: the light within the Satyr and Maenad panels comes from the viewer's right, while in the Drinking Contest the light comes from the left.

Comparison of the satyr figure with those of Herakles and Dionysos highlights the differences between the Drinking Contest and its pendants (figs. 35, 36). The tesserae used to create the satyr are generally of the same size and uniformly cubic. Their orientation repeats the outline of the figure flattening the representation. In contrast, the Drinking Contest tesserae vary in shape, size and orientation depending on the anatomy of the figures, giving the contestants a more animated, realistic bearing.[72] While the shadows on the satyr's chest are inconsistent, fragmenting the musculature rather than defining it, the shadows on the chests of Herakles and Dionysos solidify the forms by fidelity to the direction of light. The proportions of the figures are also telling. The head of the satyr is oversized for his torso—both being about the same length—while Herakles' torso is twice as long as his head and neck, producing a more sinuous figure. Taken together, these observations suggest different hands at

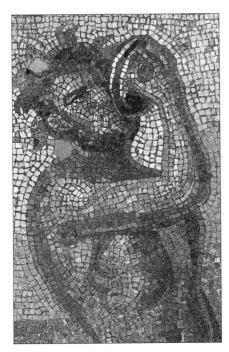

fig. 35. Detail of Herakles from the Drinking Contest Between Herakles and Dionysos.

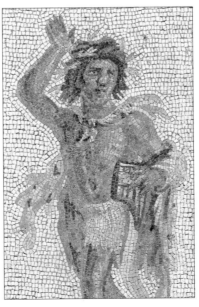

fig. 36. Detail of Dancing Satyr. Note the differences in the direction of light between figs. 35 and 36.

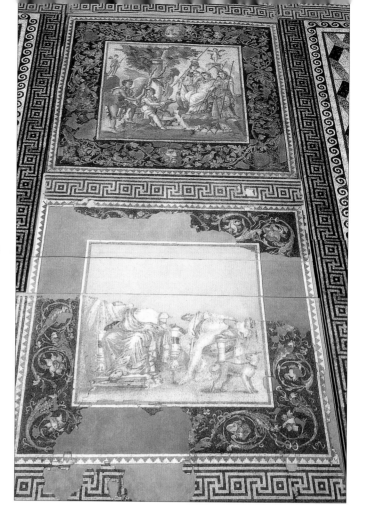

fig. 37. Mosaic
panels of
Judgment of Paris
and Aphrodite
and Adonis.

work, with the creator of the Drinking Contest the more sophisticated artist. As noted earlier, the assignment of subsidiary panels to a less accomplished mosaicist is a typical workshop division of labor. The technical relationship between the three panels is explored further in the discussion of materials below.

Having passed through the entryway and reached their couches, the reclining diners would contemplate the Judgment of Paris and the Aphrodite and Adonis panels (figs. 5, 12, 14, 37), both facing north toward the place of honor. The dimensions of the two figural panels are virtually identical and they present a common thematic message. Each is surrounded by a lush floral border on a dark background. Everywhere the hand of a master captures our attention. But the closer one enters their visual world, the more the panels diverge.

This is quickly seen in the choice of palette. Stone earth tones (dark, rich browns complemented by red and yellow ochres) and blue and green glass predominate in the Judgment panel. Glass is concentrated in two areas: the sumptuous green foliage of the large tree and the garments of the three goddesses where blue glass is prevalent, particularly the profusion of blue that marks Aphrodite as the winner. Flecks of cool blue glass also highlight the brown hair of Hermes, while small groupings of light green and yellow glass tesserae scattered throughout the large tree evoke sunlight dappling the leaves. The palette of the Aphrodite and Adonis panel, on the other hand, is paler, almost pastel in tonality. The dominant impression is of muted colors of amethyst, pink, yellow, red, and tan, with some areas of green. Even the whites tend more toward pink, as opposed to the browner accent of the Judgment whites. Bands of yellow glass and stone define Aphrodite's drapery. Red glass, absent from the Judgment panel, plays a leading role, as do orange and red-orange. While much of the upper part of the figural panel is missing, it is unlikely that the palette would have changed

significantly, though more green might be expected and the surviving upper right corner indicates that a dark stone similar in color to the stone tesserae in the upper right of the Drinking Contest was used to establish an interior setting.[73]

In both panels the figures are created with great skill, but comparison of the seated goddesses—Hera in the Judgment scene and Aphrodite in the Aphrodite and Adonis panel—shows that the emphasis differs. The representation of Hera has a linear quality. Her drapery is defined graphically by darker lines of tesserae that zigzag back and forth into the lighter-colored areas. The focus is on the animated surface and the form of the goddess beneath the garment is unrealized (fig. 38). In contrast, the figure of Aphrodite is full and rounded, her body palpable beneath folds of drapery that fall in broad, deliberate swaths of color without abrupt transitions (fig. 39).

Aphrodite and Adonis occupy a clearly defined, realistic space. In contrast, the goddesses in the Judgment scene appear perched in mid-air, pressed against the foreground of the picture plane; the outcropping on which they stand, detached from the landscape, floats suspended above a pond (fig. 40). The breakdown of realistic space in the Judgment is emphasized by inconsistencies in lighting and scale. The grazing animals around Paris are diminutive compared with the figures, whereas the hunting dog at the feet of Adonis is in proportion to his master. In a second, less obvious, discrepancy the figure of Paris in the foreground is smaller than that of Hera seated in the same posture further back in the picture plane. (Measuring from toe to knee, Hera's leg is about 20% longer, fig. 41.) It might be argued that these spatial inconsistencies derive from the elaborate composition of the Judgment scene compared with the other panels, which raises inevitable questions of decision making: to what extent was the mosaic artist free to interpret the scene depicted? The Drinking Contest, also a competition involving gods and mortals, unfolds in a simpler, more balanced setting. Are these differences reflections of individual artistic expression or choices on the part of the patron or designer of the pavement?

The figures of Adonis and Dionysos present another revealing comparison. The rounded quality of the forms in each panel is achieved by different techniques. With Dionysos, laying the tesserae in circular or spiral patterns creates the contours of the musculature, and the shapes of the tesserae are gradually tapered to articulate the rounded forms (fig. 42). The same technique can also be seen in the figure of Herakles from the same panel (figs. 18, 35). With Adonis, however, the orientation of the tesserae merely repeats the outline of the form. The tesserae are laid generally in parallel courses with their size and shape uniform. In the hand of the artist of the Satyr panel, this technique yields a two-dimensional effect. But here, the roundness of the forms—the illusion of depth and weight—is achieved by varying the color, shade and material of the tesserae. This can be observed, for example, in the left thigh of Adonis, where volume is created by a gradual progression from darker to lighter and back to darker colored stone (fig. 43). The same technique is evident on the chair leg in the center of the composition. A transition from red glass to red stone to red-orange glass

fig. 38. Detail of Hera from the Judgment of Paris.

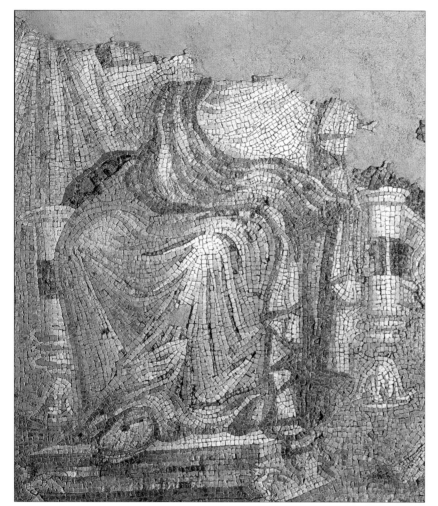

fig. 39. (left) Detail of Aphrodite from the Aphrodite and Adonis.

fig. 40. (right) Detail of the three goddesses from the Judgment of Paris.

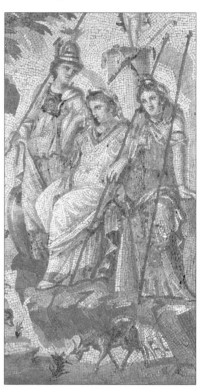

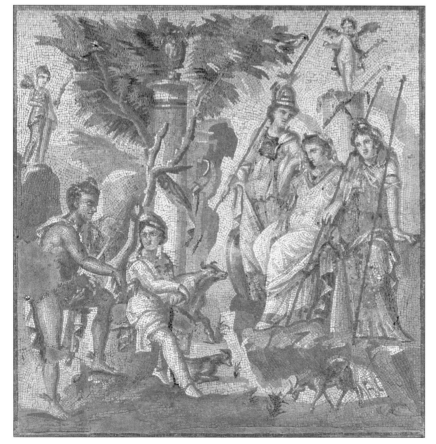

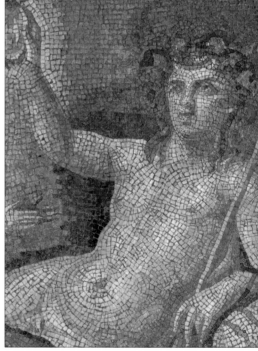

fig. 41. (left) Detail of the figural panel from the Judgment of Paris.

fig. 42. (above) Detail of Dionysos from the Drinking Contest Between Herakles and Dionysos.

Arts of Antioch

to orange glass to light brown stone creates the illusion of a cylindrical form even where the tesserae are laid in horizontal rows (fig. 43).

At first glance, the framing of the Judgment and Aphrodite panels seems similar: each is bordered by an inhabited vegetal scroll with masks or faces set against a black stone background. On closer inspection, however, these borders are quite distinct in character. The thick vines of the Judgment border intertwine and form ellipses (c. 30 × 20 cm) except in the corners, where the shape created is more circular. The vines are filled with creatures and laden with grapes, and a head is placed at the midpoint of the north and south sides. Compared with the Aphrodite and Adonis border, the composition is denser and more teeming with animal life, but also more static. The broader vines and compressed oval forms of the Judgment border leave little open space. In harmony with the figural interior, the palette of the Judgment border displays shades of green glass and deep brown, green, and ochre stones. Each convolution of the vine is marked either by a cluster of yellowish or red grapes or by a bird competing with the occasional lizard or butterfly for the tasty leaves and insects (figs. 44, 12 details).

The thick green vines of the Judgment scroll contrast with the floral swirls of the Aphrodite border with its strong red highlights and palette of pink, mauve, green, and amethyst. The Aphrodite border has a lighter, airier feel to the handling of the forms (figs. 45, 46). Tendrils entwine to form circular orbits (c. 20 cm in diameter), each enclosing a rose-like flower. Some of the flowers are

fig. 43. Detail of Adonis seated in a chair from the Aphrodite and Adonis.

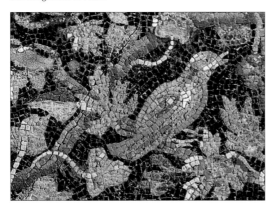

fig. 44. Detail of the scroll border of the Judgment of Paris.

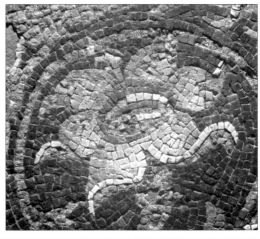

fig. 45. Detail of the scroll border of the Aphrodite and Adonis.

fig. 46. Detail of the scroll border of the Aphrodite and Adonis. Compare to fig. 16, border of the Hephaistion mosaic.

open while others are closed, curled, or turned away from the picture plane. The stems and veins of the leaves are distinguished by alternating green and white (or brown and white) tesserae, creating a pattern of longitudinal stripes that may be characteristic of the plant depicted. The plants of the Judgment border lack this feature. As with the Judgment, a head is placed at the midpoint of the north and south sides; a bearded male face on the north border is visible in the site photographs but did not survive the lifting process. Birds occupied the midpoint of the east and west sides with only a parrot on the east side surviving. (See earlier discussion of the different historical antecedents and parallels for the two borders and also see Appendix: Identification of the Birds in the Judgment of Paris.)

In conclusion, investigation of the *triclinium* underscores how close study of mosaics is rewarded with an increased understanding and appreciation of the possibilities of the medium. It reveals the marks of individual practice that, like characteristic brush or chisel work, betray the hand of particular artists.[74] Differences in execution among the main figural scenes suggest that three masters may have been involved in the creation of the pavement—each artist working within the overall design and thematic program of the dining room yet each distinguished by his own technique and sensibility.

Material Study: The Glass

Lawrence Becker and Mark T. Wypyski

THE STUDY OF THE PAVEMENT included optical examination and compositional analysis of glass tesserae in order to study vitreous technology and apply technical research to questions about fabrication of the pavement and workshop practice. We were interested in whether the visual or formal distinctions observed among panels were reflected in the materials used and whether material comparisons might suggest other relationships.

Samples of glass tesserae were examined using light and scanning electron microscopy (SEM) and analyzed with energy dispersive and wavelength dispersive X-ray spectrometry (EDS and WDS). The essay Glassmaking Technology at Antioch discusses the sampling and analytical techniques. At least one sample was taken from every color present in each mosaic element. This allowed comparison of materials from each element to understand better the relationship of different parts of the floor and the stages in the laying of the pavement. Figural panels and their associated borders were considered separately for a total of ten elements, i.e. the five figural panels, the two scroll borders surrounding the dining-area mosaics, and the three guilloche borders around the entryway mosaics. Overall, 109 tesserae were sampled.

Little is known about the relationship between Roman mosaicists and those who fabricated the glass tesserae. Relevant ancient documentation is lacking and published excavations of pertinent glass-making sites, although increasing, remain limited.[75] For example, none of the sites mentioned in Gorin-Rosen's summary of glass factories and workshops in Roman and Byzantine Palestine showed evidence of activities specific to tesserae production.[76] Glassmaking may have been divided into two stages, with primary production of raw glass carried out near sources of sand, alkalis, and fuel while refinements such as the introduction of colorants and opacifiers, reduction firing, and glass shaping took place in workshops located in population centers.[77] It is uncertain whether glass vessels and tesserae were fabricated by the same workshops. The production of tesserae and sheet glass for windows might conjoin since tesserae can be cut from sheets. However, the compositions of tesserae and window glass usually differ with the former typically opaque and the latter translucent. Similar colors found in tesserae and enamels suggest that the same workshops may have made glass for both uses, but the properties desired for enamelwork and mosaics are somewhat different and compositional variations have been noted in glass samples from the two art forms.[78]

Mosaic workshops might have included glassworkers,[79] or glass-makers may have worked independently, commissioned by mosaicists to provide materials on order. If independent, glass workshops may have maintained a stock of tesserae in commonly used colors or sold glass in chunk, cullet (broken glass for remelting) or another intermediate form to mosaic workshops, which then made the glass into tesserae.[80] The grave stela from Ostia discussed earlier (see

fig. 30) may shed some light on this question. If the material shown is glass, the relief illustrates one form in which glass for tesserae reached the mosaic workshop.[81]

In some instances material studies might help clarify the relationship between mosaic artists and glassmakers. If a specific glassmaker were attached to a mosaic workshop, either directly or by contract, material consistencies might be evident in the tesserae used. On the other hand, if a mosaic workshop commonly purchased from a range of glassmakers or suppliers, then more variation in composition and processing features might be expected. Glass workshops may have specialized in certain colors or types of glass; this has been suggested for the production of red and orange glasses in particular. Therefore, strict comparisons need to be made within the same color. Possible reuse of glass tesserae, either intact or by remelting, is another complicating factor. Of course, there is no guarantee of consistent practice. Various mosaic workshops may have functioned differently and an individual workshop might have changed its practice for any number of reasons, such as the prices or availability of materials, the death of a particular craftsman, or travel to complete a commission in another city.

Technical study of the *triclinium* pavement reveals an extraordinary glass palette. The full spectrum appears — reds, blues, yellows, greens, oranges, violets, purples, as well as black, white, and clear, including the natural glass obsidian. Particularly impressive is the range of variation within each color classification. For example, 18 different greens were found in the pavement. The Judgment of Paris alone contains 10 distinct greens, each applied as a separate color. Both opaque and translucent glasses are found, with a continuum of effects observed from fully opaque (the most common type) through various degrees of opacity to translucent. The quality of the floor speaks not only to the superb artistry of the mosaicists but also to the presence at Antioch of a well-developed glass-making tradition capable of manipulating materials to create a palette of great refinement. The glass palette varies throughout the pavement. A different mix of colors was used on each panel, with the Satyr and Maenad showing the closest affinity. The greatest contrast is seen between the Judgment of Paris and the Aphrodite and Adonis mosaics.

The color, opacity, and stability of a glass depend on its composition and firing conditions. Therefore samples were characterized on the basis of both optical examination and analysis. The Appendix: Glass Compositional Analyses gives the analyses and visual notes for all the samples taken. To facilitate use of the data, results are listed both by mosaic (separating interior from border) and by color. Since the present essay focuses primarily on mosaic workshop practice rather than glass technology, discussion of the makeup and processing of specific glasses is mainly reserved for the essay Glassmaking Technology at Antioch. That essay also gives a broader discussion of glassmaking at Antioch from the second to the fifth century.

In comparing glasses found on different parts of the pavement, three parameters will be used — color, batch and type. *Color* is a visual phenomenon based on the absorption and reflection of certain wavelengths of light by the

material being observed. Our assessments of color were generally made with the unaided eye and a binocular microscope with the goal of designating the commonly understood divisions of the spectrum. Only general classifications of color are employed—for example, green or yellow-green. Because of the heterogeneity of ancient glass and the weathering of tesserae during burial, no attempt was made to use a more detailed method of notation such as the Munsell system. For some very deteriorated samples, color determination was based primarily on the presence of colorants identified by analysis rather than a purely visual assessment.

The term *batch* denotes a specific mixture of raw or previously fired materials heated at a particular time to form a glass. In assessing the relationship of the different mosaic panels comprising the *triclinium*, the composition and optical features of glass samples were compared to identify instances in which glass from the same batch may have been used on more than one element of the floor, the assumption being that batch similarities among panels are indicative of other links, such as a common workshop, mosaicist, or stage in the laying of the pavement. The validity of this assumption can be tested only in conjunction with other criteria such as style, content, palette, and formal composition.

Samples were analyzed for the presence and concentration (weight percent) of nineteen elements generally found in Roman glass. Most elements are reported as oxides, since they are usually present in this form in the glass melt. Samples were deemed to be from the same batch if the concentrations of all nineteen elements were identical within the analytical margin of error and the samples displayed consistent optical features. In some instances, inclusions and crystal forms were critical in identifying batches. In comparing samples, allowance was made for the heterogeneity of ancient glass—even samples from the same tessera may not give identical results, particularly for the opaque glasses. The closer the compositional and optical correlation between two samples, the greater the probability that they came from the same batch.

Samples originally from the same batch of glass might vary in color or opacity if part of the batch was held at the firing temperature longer, fired at a higher temperature, allowed to cool at a different rate, or otherwise fired under different conditions. This appears to be the case with orange and red-orange glasses from the Judgment and Aphrodite and Adonis borders (see Appendix: Glass Compositional Analyses, samples 79, 80 and 107, 108). Both colors have virtually identical compositions, indicating they originally came from the same batch, but differences in furnace conditions, such as longer a firing time for the red-orange fraction, resulted in larger cuprite crystallites, accounting for the redder color.[82] An analogous situation is presented by some of the light blue and light green glasses that have virtually identical compositions (28, 38 and 29, 69). In this case, typical oxidizing conditions would produce the blue while a shift to more reducing conditions for part of the batch would yield a green color.[83]

The term *type* is used to denote a broader set of qualities that help group glasses from different batches. Features that might distinguish types are basic processing parameters such as: firing conditions (e.g. oxidizing vs reducing),

material sources (e.g. natron vs plant ash), choice of constituents (e.g. cobalt colored blue vs copper colored blue), or proportion of constituents (e.g. high lead/low antimony vs low lead/high antimony). Glasses of the same type, while they may vary in the concentration of different components, share fundamental processing features. Unlike with batch, definitions of type can vary depending on the aspect of production or feature of the glass being compared. Of particular interest in comparing parts of the floor are instances in which glasses of the same color are of a different type, since this may indicate the production of separate workshops.

The condition of the glass tesserae varies. In some cases this can be attributed to composition or glass type; in others the cause is less apparent. Green, yellow, and certain blue tesserae in the Drinking Contest are more deteriorated than glass in other parts of the floor. This disparity does not seem related to composition, since the makeup of these colors is consistent with better preserved examples of the same colors found elsewhere. Nor does the difference in condition appear related to burial environment; site photographs reveal no distinction between the burial environment of the Drinking Contest and the other panels. Moreover, the blue, green and yellow glasses on the Satyr, Maenad and Judgment panels immediately adjacent to the Drinking Contest are generally in very good condition. Optical examination of the two blue glasses in the Drinking Contest border reveals frequent voids and bubbles in these glasses, suggesting that, at least in this case, defects in glass formation during manufacture provided sites for deterioration.

Figure 47 illustrates the differential weathering of glass and stone on the Drinking Contest panel. Deterioration of the glass has undermined the artist's intent. Originally the cushions beneath the reclining Dionysos were cool blues and greens, emphasizing the relaxed demeanor of the victorious god and contrasting with the warm palette under the drunken Herakles. This effect is lost today in the brown tones of the deteriorated glass.

While certain colors such as orange or yellow-green were uniformly of the same type and similar composition, other colors were more diverse. Particularly striking is the variation among the red glasses. Red glasses have always commanded interest in technical studies because they require carefully controlled reducing conditions during firing. The process is more difficult to achieve than the oxidation firing used to produce most colors, which has led to speculation that specialized workshops produced red glasses and that these glasses were more highly valued.[84] Six different reds were found on the *triclinium* pavement — relatively few compared with the abundance of greens or blues. However, among these six colors three types of red may be designated, probably corresponding to different glass workshops. Type 1 can be characterized as a relatively highly leaded glass with a plant-ash alkali source, as evidenced by comparatively high potassium, phosphorus and magnesium levels (12, 13, 89, 90; see Appendix: Glass Compositional Analyses). Type 1 also has somewhat higher levels of aluminum and calcium than the other reds.[85] Mixed alkali glasses using a plant-ash flux and containing

fig. 47. Detail from the Drinking Contest showing deterioration of glass tesserae as compared with better preserved stone areas.

magnesium levels above 2% are often associated with Eastern production.[86] It has been suggested that the plant ash may have been added to promote a reducing environment in the furnace.[87] The red glasses in the Drinking Contest and Aphrodite and Adonis figural panels are both Type 1, but differences in composition indicate that the tesserae on the two panels do not come from the same batch (samples 12, 13, 89, 90).

Types 2 and 3 may both be characterized as soda-lime glasses with a natron alkali source and low magnesium and potassium levels. Despite this similarity, several salient features distinguish these reds. First of all, significant differences in the levels of calcium and aluminum indicate that the primary glass used to produce these reds comes from different sand deposits, and therefore probably from different production sites. Secondly, Type 2 reds (37, 46) contain approximately 2.5% lead compared with Type 3 samples (34, 102–106) in which either no lead or only a trace amount was detected. While it may be argued whether lead in the 2–3% range represents an intentional addition,[88] there is no obvious path by which this amount of lead could have entered the melt as an impurity. Its presence may result from the combination of different glasses, one of which contained lead. Whether the lead levels in Type 2 point to the introduction of lead intentionally or as an impurity, a different material source for reds 2 and 3 is indicated.

Compared with the other red glasses, Type 2 has the highest level of sodium, which tends to increase glass solubility, and the lowest levels of the glass stabilizers aluminum and calcium, characteristics that might lead to deterioration. However, it is the best-preserved red on the pavement. Type 2 appears on the guilloche borders of the Satyr and Maenad (37, 46). Analysis and examination of samples of tesserae from both borders indicate that the tesserae are not only of the same glass type but also come from the same batch (see below). It is interesting to note that, aside from the iron levels, the compositions of the Type 2 reds are very close to that of the three greens (35, 44, 85) that comprise batch number 6 (Appendix: Glass Compositional Analyses). Factoring out the increased iron level in the reds, all five samples are virtually identical in composition. (Although these reds contain significant amounts of antimony, they do not contain crystalline lead antimonate as in the greens.) It is possible that the same workshop produced both the reduction-fired reds and the oxidation-fired greens. If so, then the elevated iron level in these reds may be evidence for the intentional addition of iron as a reducing agent.

Red Type 3 can be divided into two subgroups, termed for convenience 3A (102–104) and 3B (34, 105, 106). Type 3A was found only on the border of the Aphrodite and Adonis mosaic. Samples from three tesserae were analyzed with consistent results. Type 3B was found on the border of the Aphrodite and Adonis and the interior of the Maenad panel and it is likely that these glasses are from the same batch. Types 3A and 3B are almost identical in composition except for their manganese levels: Type 3A samples contain an average of 0.6% manganese while only a trace of manganese (avg. 0.05%) was detected in Type 3B reds. 3B samples also had somewhat lower copper levels.

Manganese levels for Type 3B are so far below those for other Antioch reds analyzed (see Appendix: Glass Compositional Analyses) that the lack of manganese is probably the result of a deliberate selection process. Manganese acts as a decolorant, insuring a brighter red by counteracting the greenish hue that iron otherwise imparts to glass. In the absence of manganese, the effect of iron is more pronounced and the red produced is darker and browner in color. By including or withholding manganese, a workshop could produce two different color reds from the same basic recipe. The manganese may have been introduced by adding recycled clear glass that had been decolorized with manganese.

There are no established criteria for identifying the number of workshops responsible for the red glasses in the pavement. The same workshop might have produced several types of red either to expand the range of colors offered or because of changes in the availability of materials. However, fundamental differences in type, composition, and material sources displayed by the red tesserae make it likely that at least three workshops produced these glasses. This hypothesis would be strengthened if all the tesserae were produced over a short period of time preceding the creation of the mosaic (the most probable scenario), since this would eliminate the effect of changes over time in the sources and availability of materials. The question remains whether the three workshops were located in Antioch or whether some red glass was imported.

Oranges, like reds, require a carefully maintained reducing atmosphere. In both cases the colorant is primarily cuprite and the glass becomes redder as the crystal size increases.[89] The rationale that assigns the production of red glass to specialized workshops also applies to orange and red-orange glass. However, unlike the red glasses, orange and red-orange glasses in the pavement are uniformly of the same type and similar composition. It is likely that they were all produced using the same recipe and common material sources. This may indicate the production of a single workshop or may result from the particular requirements needed to insure an orange color. If the same workshop produced both the red and orange glass used on the pavement, the most likely candidate is the workshop that produced red Type 1. This red is the closest in composition and type to the orange glasses, but there are still significant differences and it is more likely that separate workshops produced the orange and red glasses.

Both metallic copper and cuprite have been detected in orange glasses[90] and their production may require even stronger reducing conditions than red glasses. This cannot be accomplished by increasing the temperature or duration of firing, since both conditions would favor the development of red dendritic cuprite.[91] In fact, to limit crystal growth, the firing period was probably relatively short. Orange glasses in the pavement show levels of phosphorus, potassium, and magnesium indicative of the use of plant ash, which, as noted above, would have helped maintain a reducing environment. Formation of cuprite was further enhanced by the presence of internal agents, particularly lead but also tin and iron, that promote reduction and increase the number of cuprite particles.[92] Analyses of orange glasses typically show lead levels above 20% and the

low-lead compositions found in red glasses in the pavement may not have been feasible for the production of orange.[93]

The relatively high ratio of tin to copper (on average approximately 1:5) in the *triclinium* orange glasses exceeds the normal range for Roman bronzes and thus probably cannot be attributed solely to the use of bronze scrap, corrosion products, or scale as a copper source. Tinned bronze vessels were prevalent in the Roman world[94] and the direct recycling of tinned vessel scrap is a possible source of the relatively high tin levels found consistently in the orange glasses but also in some greens, blues, and reds. Indeed, in several samples, copper alloy inclusions with a distinct tin layer were observed (fig. 48). Another possibility, advanced by Freestone, Stapleton and Rigby, is that scrap metal containing tinned vessels and perhaps pewter was reprocessed to obtain silver, and the litharge or slag byproducts of this operation were used as a glass-making material.[95] (While recycled pewter would provide a source of tin, widespread use of this alloy in vessels during the Roman period seems confined to the British Isles.)[96] As Freestone and his co-authors point out, the addition of previously reduced material in the form of litharge or slag would have facilitated the attainment of a reducing environment in the furnace.[97] An alternative explanation for the high tin levels observed is the direct introduction of cassiterite, another tin-bearing mineral, or in some cases even tin metal itself. The presence of tin oxide inclusions in samples 107 and 108 may indicate the deliberate addition of tin as a reducing agent.

fig. 48. Scanning electron microscope photomicrograph (650×) of a copper alloy inclusion with a thin outer layer of tin (glass sample 6 from the Drinking Contest).

The concentration of tin in the orange and red-orange glasses shows little variation. Seven of the eight tesserae have levels of 1.2 or 1.3 weight percent and the eighth has a level of 1.5 per cent. The lead:copper:tin ratio is relatively uniform in all eight glasses and the concentration of each metal varies comparatively little from sample to sample. Silica levels are also tightly grouped (41.2% ± 1.3). This correlation might be explained by a common material source, with either a single workshop involved or different workshops sharing access to the same, compositionally consistent supply of a lead-copper-tin-bearing byproduct of a metallurgical process such as the recovery of silver. Another possibility is the precise measurement of individual components according to a common recipe, analogous to the mixing of various metals to create an alloy. Some materials might have entered the melt together. For example, lead could have been added separately, with copper and tin entering the mix as a recycled material of consistent Cu-Sn ratio. Alternately, copper and lead may have entered together as copper-containing litharge and the tin was added separately. It is interesting to note that orange tesserae analyzed from third- and late fourth-century Antioch mosaics show compositions similar to the Atrium House samples, suggesting a continuity of production methods and material resources for at least 250 years (see Appendix: Glass Compositional Analyses). Given the narrow range of compositions, it is possible that orange glass produced in the first half of the second century or earlier was still being used in the late fourth century.

Unlike the specialized manufacture of red or orange glass, green glass was a typical product of ancient workshops. It is the most common color in

the *triclinium* pavement and is of two types—a low-lead/high-antimony glass (opacified with Ca-Sb) found only on the Judgment of Paris and Maenad panels, and a high-lead/low-antimony glass (opacified with Pb-Sb or Pb-(Sb+Sn)) encountered throughout the floor.[98] The two types may signify the activity of different workshops or may reflect efforts by the same glassmaker to produce a variety of greens. Within the basic division noted, there are several outliers: two glasses from the Judgment interior with a high level of manganese (56, 58; average of 1.3% MnO compared with a general average of 0.4%), and a translucent glass from the Drinking Contest (4, 5, 6) that appears to be the only green glass fluxed with plant ash.[99]

Applying the criteria detailed earlier, we found fifteen instances in which glass from the same batch was used on more than one element of the floor (see Appendix: Glass Compositional Analyses for a list of proposed batches). Excluding duplicate samples of a color taken from the same mosaic, 41 of the 91 tesserae sampled (45%) came from one of these shared batches. In some instances glass from the same batch was used in four or even five elements. The presence of shared batches throughout the pavement confirms that all the panels are of contemporary manufacture and none were reused from an earlier building phase or a later addition. This is an important point given the archaeological evidence of multiple building campaigns in the Atrium House, some of which included the *triclinium*. It also suggests reliance on a single glass supplier, at least for most of the colors.

fig. 49. Detail of guilloche border of the Dancing Maenad.

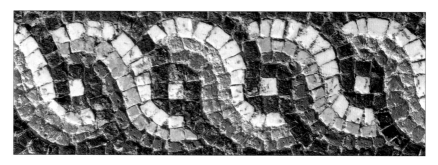

While shared batches were found on all ten elements of the pavement (five interiors and five borders), their distribution is not uniform. The incidence of shared batches is higher in the border elements, where 21 of the 36 colors (58%) analyzed come from shared batches. In contrast, only 20 of the 55 colors (36%) in the figural interiors come from shared batches.

In certain cases the correspondence between elements is quite striking. For example, the guilloche borders surrounding the Satyr and Maenad panels contain strands of red, green, and yellow-green glass (fig. 49). For each of these three colors, the glass used in both panels probably came from the same batch. Both the red (37, 46) and green (35, 44) glasses are a close match. The green found in the Aphrodite and Adonis interior (85) is also from the same batch. Batch identification of the red glasses was confirmed by the presence of distinctive antimony-, silver- and arsenic-bearing copper inclusions that were not present in

other reds in the pavement.[100] There is more variability in the composition of the yellow-green, but the four samples taken from the interior and border of the Satyr and Maenad (31, 36, 41, 45) are close enough to be from the same batch. Certainly all four yellow-greens, as well as the yellow-green from the Aphrodite and Adonis border (100), were made from the same recipe. The material similarities between the Satyr and Maenad panels are consistent with the formal, stylistic, narrative, and other technical similarities noted elsewhere.

By the same token, the visual differences noted previously between the Judgment and the Aphrodite and Adonis figural panels are also reflected in the materials used. In no instance were tesserae from the same batch of glass found in both the Judgment of Paris and the Aphrodite and Adonis figural interiors. There are other important differences in the color and type of glass used. Red glass, which plays a key role in the Aphrodite and Adonis and is also present on the other framed panels, is conspicuously absent from the Judgment interior and border. On the other hand, white, clear, and the natural black glass obsidian are confined to the Judgment figural scene, and this panel and its border are the only elements to contain blue translucent glass. While the Judgment figural interior contains 20 colors of glass, more than any element of the floor, only in three instances (15%) do the tesserae come from the same batch as glass used elsewhere in the *triclinium*. This is the lowest percentage for the pavement. Overall, the glass palette on the Judgment interior stands apart in certain respects from the rest of the pavement. How this relates to the creation of the mosaic is unclear. As previously noted, certain formal, narrative, and spatial features are also specific to the Judgment scene.

Considered together with the archaeological evidence, the results of the material analyses clarify stages in the laying of the pavement. As discussed earlier, excavation reports and site photographs document a clear distinction between the makeup of the bedding layer of the Judgment figural interior and its scroll border. The same might hold for the Aphrodite and Adonis, but the field notes are silent on this point and later wall construction bisecting the Aphrodite panel may have affected investigation of the bedding layers. Our analyses of glass tesserae underscore the excavators' observations regarding the Judgment and suggest that the Aphrodite and Adonis interior and border were also laid independently.

In no instance does glass from the same batch appear in both the Aphrodite and Adonis figural panel and its vine-scroll border, even though eight of the 14 colors in the Aphrodite border come from shared batches. Particularly telling is the fact that while red glass plays an important role in both elements, the red glass found in the interior is of a very different type from the two reds in the border. The interior red is relatively high in lead, with comparatively high levels of potassium, magnesium and phosphorus, which indicate a plant-ash alkali source (Type 1 above). The reds from the border (Types 3A and 3B) contain no lead and no evidence of plant ash; natron appears to be the only alkali source. There are also considerable differences in the levels of calcium and aluminum between the border and interior reds.

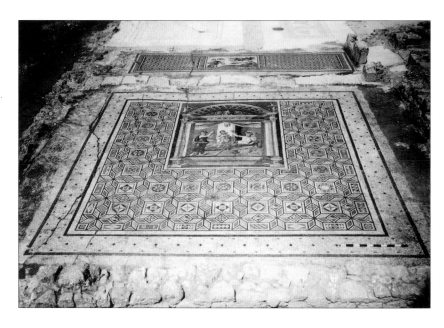

fig. 51. Detail of the Drinking Contest Between Herakles and Dionysos from the House of the Drinking Contest *triclinium*.

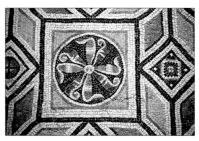

fig. 52. Detail of the geometric border from the House of the Drinking Contest *triclinium*.

In the Judgment, in only one instance were tesserae from the same batch used in both the interior and border (53 and 70). Examination of the green glass emphasizes the distinction between the two elements. While ten greens were found in the Judgment panel—six in the interior and four in the border—nowhere does glass from the same batch appear in both. Yellow glass is also present in both elements but the compositions are very different. Although black is found in both the interior and border, the natural black obsidian is found only in the interior. White, amethyst, and clear glass tesserae are also found only in the interior, while red-orange appears only in the border.

The pronounced material differences in bedding mortar and glass tesserae between the scroll borders and figural interiors suggest more than *giornate* or brief stopping points between stages laid in succession. Differences may reflect divisions of labor in the workshop, with borders and interiors delegated to different mosaicists.[101] Aesthetic choice probably underlies variations in mortar colors, with the inert components, such as brick dust or charcoal, chosen to reinforce the palette of the mosaic. Aesthetics may also have influenced the glass selected, although it is unlikely that pervasive material differences between elements can be explained on this basis alone. A significant delay between the laying of the borders and figural elements could have affected the materials available and led to certain distinctions. Prefabrication could also affect the distribution of materials. Fisher's hypothesis that elements were prefabricated cannot be ruled out, although it requires more corroborating archaeological evidence. Even if the tesserae were set *in situ*, borders and interiors may first have been arranged separately on temporary supports, preparatory drawings, or sand beds to work out features of the complicated compositions.

It is difficult to evaluate the technical evidence in isolation. Some comparative information is offered by two other mosaic groupings from Antioch examined by the authors (for the analyses, see Appendix: Glass Compositional Analyses). These are the House of the Drinking Contest (figs. 50–57), dated to the beginning of the third century, and the Tomb of a Women's Funerary Banquet (see figs. 58–61), dated to the mid- to late fourth century.[102] The two groupings present very different models for the use and sources of materials.

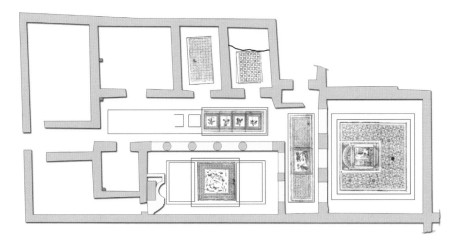

fig. 53. Plan of House of the Drinking Contest. Examined mosaics outlined in red (adapted from plan by Victoria I and Mary Todd based on Antioch 3, 259, Plan VIII).

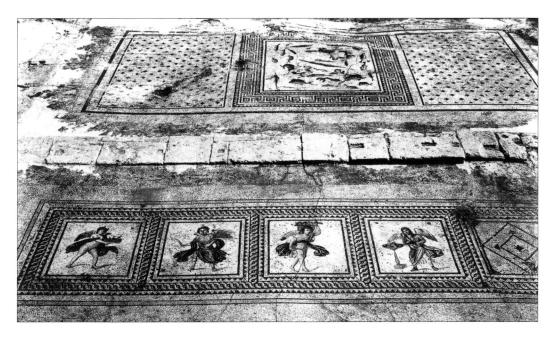

fig. 54. *In situ* photograph of mosaic of the Four Seasons (Virginia Museum of Fine Arts 51.13.1/4) and the Marine Mosaic (Museum of Fine Arts, Boston 2002.128.1–3, formerly Dumbarton Oaks).

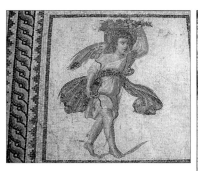

fig. 55. Detail of Autumn from the Four Seasons.

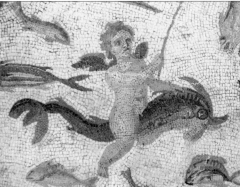

fig. 56. Detail of fishing Eros from the Boston Marine Mosaic.

fig. 57. Detail from the Boston Marine Mosaic.

Three pavements were examined from the House of the Drinking Contest, located in the port of Seleucia Pieria. These are the *triclinium* mosaic of the Drinking Contest Between Herakles and Dionysos (the same scene encountered in the entryway of the Atrium House *triclinium*), surrounded by a detailed geometric couch border (figs. 49–51); the mosaic of the Four Seasons (figs. 54, 55), part of an east-west corridor in the center of the house; and the Marine Mosaic (figs. 56, 57), located in a courtyard in the southern part of the building.[103] The tesserae analyzed reveal a consistency of glass palette, type, and composition extending throughout the house. Blue, orange, and blue translucent glass from the same batch appear on more than one mosaic (Appendix: Glass Compositional Analyses), while green, turquoise, and light blue glass from different parts of the house show minimal variation in composition and probably came from the same recipe and workshop, if not the same batch. Somewhat greater compositional differences are evident in other colors, such as yellow and red, but the glass type for each color is consistent throughout the house. The material consistency in the tesserae analyzed suggests that a single mosaic workshop working with one glass supplier and a small circle of glassmakers was responsible for decoration of the entire residence.

The mosaic of a Women's Funerary Banquet (cat. 4) presents a very different picture. The pavement, located in a necropolis, consists of a central panel, the Funerary Banquet (fig. 58), surrounded by a group of personifications. The two main personifications survive and are included in this study—Agora (fig. 59) and Eukarpia (fig. 60).[104] Ten glass colors appear in the Funerary Banquet, seven in the Agora, and 12 in the Eukarpia. In no case was glass from the same batch used in more than one panel. Moreover, glass palette, type, and composition vary considerably among the three panels; in many cases there is not even consistency among samples from the same panel. The differences among the panels are particularly striking given their physical proximity (fig. 61) and thematic integration. It is unlikely from the analytical evidence that the glass was

fig. 58. Funerary Banquet mosaic, Tomb of a Women's Funerary Banquet (Worcester Art Museum 1936.26).

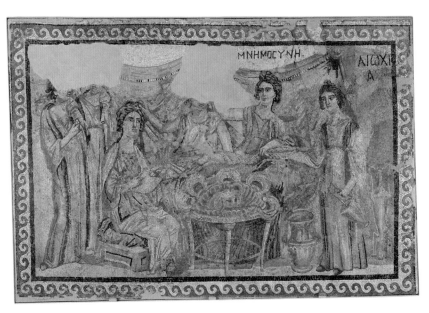

fig. 59. Personification of Agora, Tomb of a Women's
Funerary Banquet (Worcester Art Museum 1936.29).

fig. 60. Personification of Eukarpia, Tomb of a Women's
Funerary Banquet (Worcester Art Museum 1936.28).

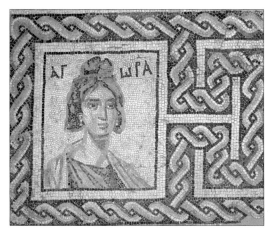

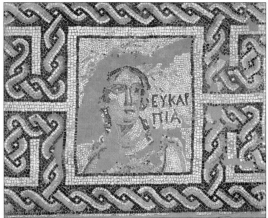

commissioned specifically for the tomb. More probably, the mosaicists used a
mixed lot of materials originating from a number of sources, which may have in-
cluded tesserae recycled from earlier mosaics.

The picture presented by the Atrium House pavement is closer to
that of the House of the Drinking Contest. In both houses batch similarities are
evident among mosaic elements—in the Atrium House among the panels of the
triclinium, and in the House of the Drinking Contest within the *triclinium* and
throughout the building. However, there are differences. Three of the four colors
analyzed in the border of the House of the Drinking Contest *triclinium*—tur-
quoise, blue, and green—are from the same batch as the figural interior. This
contrasts with the Atrium House *triclinium,* where compositional variations be-
tween tesserae on the scroll borders and figural scenes suggest a greater division
of labor in the laying of the pavement. Further comparison of the houses awaits
a full study of the House of the Drinking Contest, including investigations of
style, content, and the archaeological record.

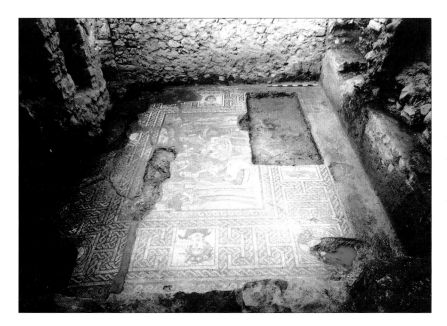

fig. 61. *In situ*
photograph of the
Tomb of a Women's
Funerary Banquet
(Antioch Expedition
Archives).

Material Study: The Stone

Richard Newman

STONE WAS USED for the majority of the tesserae in the *triclinium* mosaics. The colors include white, brown, yellow, pink, red, dark green and black, with variations in precise color within each of these groups. With the exception of the dark greens, all of the types of stone are fine-grained and even-colored to the naked eye, showing no mineral inclusions, structural features or color variations within single tesserae. The dark green tesserae in virtually all cases consist of a dark fine-grained matrix containing occasional larger elongated, angular white grains. Here we present some observations on the types of stones utilized and their compositions. In comparing analyses of samples from different parts of the *triclinium* as well as from other Antiochene mosaics, our objectives are to learn more about the fabrication of the Atrium House pavement and explore the broader picture of stone sources and usage from the second to the sixth century.

According to Libanios (*Antiochikos 25*), limestone and basalt were quarried near Antioch. There are only a few references to quarry sites in the Antioch excavation publications. Wilber mentions a number of ancient quarries in the hills of Daphne, including instances in which building foundations for villas were built over quarry faces as the population of the suburb grew.[105] He omits details about the quarries but from the context of his discussion it seems clear that they are limestone quarries.

Wilber reports two kinds of limestone used in the construction of the theater at Daphne, which he dates to the last quarter of the first century. In the public sections of the theater without marble cladding and in areas "exposed to wear," a hard, "very fine grained white limestone was used." Elsewhere a "soft tawny limestone" was employed that was "known to have been quarried on the slopes of the theatre hill-side." According to Wilber, this stone, which is prevalent in the area, was strong enough for direct weight bearing but eroded rapidly from foot traffic.[106]

A contour map of Antioch and Daphne published in the excavation reports (Plan VIII, Antioch II, 222) identifies one quarry in the foothills of the Daphne plateau and a group of quarries approximately 1500 meters from the city walls. The plan does not specify the stones quarried or indicate evidence that the quarries were active in antiquity. Whether the same quarries were used to quarry stone for tesserae and for architectural elements is an open question. It is possible that tesserae, at least in some cases, were made not from freshly quarried stone but from the byproducts of architectural elements.

Table 1. Description of Stone Samples Analyzed

Mosaic	#	Description
Mosaic of the Judgment of Paris (Atrium House): Louvre Ma 3443	1	border: dark green in vine
	2	border: black
	3	interior: black
	4	interior: dark green foliage
	5	interior: dark maroon on head
	6	border: maroon, edge of head
Mosaic of Dancing Maenad (Atrium House): Baltimore Museum of Art 33.52.1	7	drapery of figure: dark green
	8	inner border: black
	9	outer border: black
	10	edge around figure: maroon
	11	pyramid decoration: maroon
	12	figure: dark green
	47	red
	48	red
Mosaic of Dancing Satyr (Atrium House): Baltimore Museum of Art 33.52.2	13	edge of musical instrument: dark green
	14	edge of lyre: maroon
	15	edge: black
	16	edge: violet
	17	geometric pattern on edge: black
	18	ground below figure: grayish brown
	49	red
	50	red
Mosaic of Aphrodite and Adonis (Atrium House): Princeton University Art Museum 40-156 Border fragment, Aphrodite and Adonis Mosaic: Wellesley College Museum 1933.10	19	dog collar: orange
	20	red
	21	spear: white
	22	border foliage: dark green
	23	bird in border: white
	24	border: dull violet
	25	border: shiny black
	26	border: black
	27	border: black
	28	border: white
	29	yellow ochre
	30	border: red ochre
Mosaic of the Drinking Contest Between Herakles and Dionysos (Atrium House): Worcester Art Museum 1933.36; cat. 1	38	foliage below reclining figure: dark green
	39	foliage: purplish red
	40	black
	41	border: black
	42	dark green
	43	border: yellow ochre
	44	upper leg of drinking man: flesh shadow
	45	near 7, pale greenish gray
	46	inside urn: smooth pale beige
	51	red
	52	red
	53	white
Mosaic of a Funerary Banquet (Tomb of a Women's Funerary Banquet, Necropolis, sector 24-L): Worcester Art Museum 1936.26; cat. 4	31	dark green
	32	dark green
	33	border of dress: black
	34	border: black
	35	deep red
	36	violet
	37	violet
Hunt Mosaic (House of the Worcester Hunt): Worcester Art Museum 1936.30; cat. 8	54	white
Dionysos and Ariadne (House of the Sundial): Worcester Art Museum 1936.25; cat. 2	55	white

fig. 62. Sample 53, white tessera.
Photomicrograph of thin section
(plane-polarized light) at 50×
magnification. Width of field 2.3 mm.

fig. 63. Sample 54, white tessera.
Photomicrograph of thin section
(plane-polarized light) at 50×
magnification. Width of field 2.3 mm.

fig. 64. Sample 55, white tessera.
Photomicrograph of thin section
(plane-polarized light) at 100×
magnification. Width of field 1.2 mm.

Samples and analytical procedures Fifty-five tesserae were analyzed (see Table 1), 46 of them from mosaics of the Atrium House *triclinium*. In addition, 51 tesserae from various mosaics were analyzed by stable isotope mass spectrometry (Table 2), of which 23 were from the *triclinium*. Unless otherwise noted, samples discussed below come from the *triclinium* pavement.

Small chip samples, usually about two millimeters or less in size, were taken from 55 tesserae. In each mosaic, samples of the various major colors were taken. Polished cross sections were prepared for qualitative X-ray microanalysis in an electron microprobe or scanning electron microscope (SEM).[107] This technique identifies elements in the samples, from which the minerals present can be inferred, and often allows grain sizes and shapes to be studied and other textural features to be noted. A few samples were also prepared as thin sections for examination by polarizing light microscopy.[108] Small portions of two samples were also analyzed by Fourier transform infrared (FTIR) microspectroscopy.[109] Scrapings from tesserae were analyzed by stable isotope mass spectrometry. In comparison with the number of tesserae used in the mosaics, the number of samples examined is clearly very small, and our conclusions cannot be assumed to hold for the full range of stone materials used. Photomicrographs of some of the samples appear as figs. 62–70. Some of the thin sections were photographed by transmitted light on a polarizing light microscope. Some of the photomicrographs were taken in a scanning electron microscope, using back-scattered electron imaging. In this type of image, compounds containing heavier elements show in lighter shades of gray than ones containing lighter elements. For example, calcium carbonate is lighter gray than quartz.

Limestones (white, brown, black) The samples of white, brown, and black tesserae were all limestone, and some red or pink tesserae also are of this type of rock. Limestone is a widely available sedimentary rock that can have many different colors. Soft and easy to work, many limestones are fine-grained and homogeneous in appearance to the naked eye. These properties of course make them ideal for mosaic tesserae.

Most of the limestone tesserae consist predominantly of calcite (calcium carbonate), the major mineral in most limestones. Some samples also contain some dolomite (calcium magnesium carbonate), another mineral common in limestones, usually in smaller amounts than calcite. Small amounts of quartz are present in some. The limestones used in the tesserae also contain very small amounts of other minerals such as apatite and rutile, but the compositions of these minor minerals have not been specifically determined for most of the samples. The colors of these tesserae come from small amounts of noncarbonate minerals. The specific compounds responsible for the colors in the tesserae samples were not determined, but iron oxides probably produce the yellow or tan colors and carbonaceous compounds (derived from organic materials) the black.

Geologists have identified many subvarieties of limestones, but these distinctions can be made accurately only with the aid of thin sections. Only

Table 2. Results of Stable Isotope Analyses of Tessera Samples

	Sample no.	WAM no.	Title and sample description	XRD result	$\delta^{13}C$	$\delta^{18}O$
Triclinium Mosaics	01	1933.36	Drinking Contest, white 1 (outer white band)	calcite	−2.7	−6.4
	02	1933.36	Drinking Contest, white 2 (interior white band)	calcite	−2.9	−7.2
	03	1933.36	Drinking Contest, white 3 (stepped triangle border)	calcite	−2.9	−6.5
	04	1933.36	Drinking Contest, white 4 (figural interior)	calcite	−2.6	−6.6
	05	1933.36	Drinking Contest, white 5 (figural interior)	calcite	−2.7	−6.9
	06	1933.36	Drinking Contest, red 1 (figural interior)	dolomite	−4.5	−1.8
	07	1933.36	Drinking Contest, red 2 (figural interior)	dolomite	0.6	0.4
	08	1933.36	Drinking Contest, red 3 (stepped triangle border)	dolomite	−0.5	2.7
	09	1933.36	Drinking Contest, red 4 (stepped triangle border)	dolomite	−1.8	1.6
	10	1933.36	Drinking Contest, red 5 (stepped triangle border)	dolomite	−0.4	2.7
	11	1933.36	Drinking Contest, red 6 (wave border)	dolomite	−4.1	−0.6
	12	1933.36	Drinking Contest, brown (figural interior)	calcite	1.3	-3.0
	13	1933.36	Drinking Contest, black (figural interior)	calcite	-1.0	-4.3
	14	*	Aphrodite and Adonis, red 1 (stepped triangle border)	calcite	-1.4	-5.2
	15	*	Aphrodite and Adonis, red 2 (scroll border)	(not analyzed)	-3.3	-6.2
	16	*	Aphrodite and Adonis, red 3 (scroll border)	calcite	-3.6	-6.1
	17	*	Aphrodite and Adonis, red 4 (interior red band)	(not analyzed)	-2.4	1.1
	18	*	Aphrodite and Adonis, white 1 (stepped triangle border)	calcite	-3.2	-5.6
	19	*	Aphrodite and Adonis, white 2 (scroll border)	calcite	-3.5	-4.4
	20	*	Aphrodite and Adonis, white 3 (white interior band)	(not analyzed)	-3.4	-6.4
	21	*	Aphrodite and Adonis, black 1 (scroll border)	calcite	0.1	-3.2
	22	*	Aphrodite and Adonis, black 2 (meander)	calcite	-1.1	-3.3
	23	*	Aphrodite and Adonis, brown 1 (figural interior)	(not analyzed)	0.6	-2.5
	24	1936.25	Dionysos and Ariadne, white 1	calcite	-4.9	-5.7
	25	1936.25	Dionysos and Ariadne, white 2	calcite	-6.1	-6.2
	26	1936.25	Dionysos and Ariadne, white 3	calcite	-6.2	-6.2
	27	1936.25	Dionysos and Ariadne, red 1	dolomite	-0.5	2.5
	28	1936.25	Dionysos and Ariadne, red 2	dolomite	0.0	2.7
	29	1936.25	Dionysos and Ariadne, red 3	dolomite	0.2	2.8
	30	1936.25	Dionysos and Ariadne, black	calcite	-0.5	-4.6
	31	1936.26	Funerary Banquet, white 1	calcite	−3.2	−5.5
	32	1936.26	Funerary Banquet, white 2	calcite	−5.6	−6.3
	33	1936.26	Funerary Banquet, red	calcite	−5.0	−5.8
	34	1936.29	Agora, white 1	calcite	−3.1	−5.2
	35	1936.29	Agora, white 2	calcite	−4.0	−5.4
	36	1936.29	Agora, red 1	calcite	−5.0	−5.2
	37	1936.29	Agora, red 2	calcite	−5.2	−6.1
	38	1936.28	Eukarpia, white 1	calcite	−2.7	−5.3
	39	1936.28	Eukarpia, white 2	calcite	−4.5	−5.6
	40	1936.28	Eukarpia, red 1	calcite	−5.7	−5.9
	41	1936.28	Eukarpia, red 2	calcite	−3.8	−5.5
	42	1936.32	Hermes and the Infant Dionysos, white 1	calcite	-3.8	-5.2
	43	1936.32	Hermes and the Infant Dionysos, white 2	calcite	-4.0	-5.2
	44	1936.30	Worcester Hunt Mosaic, white	calcite	−5.4	−5.5
	45	1936.30	Worcester Hunt Mosaic, red	calcite	−7.1	−6.9
	46	1936.31	Worcester Hunt Mosaic East Border, white	calcite	−3.8	−5.2
	47	1936.31	Worcester Hunt Mosaic East Border, red	calcite	−3.0	−4.6
	48	1939.90	House of Aion, white 1	calcite	-2.0	-6.3
	49	1939.90	House of Aion, white 2	calcite	-2.4	-6.5
	50	1939.90	House of Aion, red	dolomite	-5.8	-1.7
	51	1936.23	Peacock Mosaic, white	calcite	-4.8	-4.6

Analyses were performed by Robert H. Tykot and Marie Archambeault at the Laboratory for Archaeological Science, University of South Florida.

* Object is in the collection of the Wellesley College Museum (accession no. 1933.10)

fig. 65. Sample 40, black tessera. Photomicrograph of thin section (plane-polarized light) at 200× magnification. Width of field 0.62 mm.

fig. 66. Sample 11, maroon tessera. Photomicrograph of thin section (plane-polarized light) at 200× magnification. Width of field 0.62 mm. Angular grains: dolomite; dark borders around and between adjoining grains contain fine-grained red iron oxide.

fig. 67. Sample 11, maroon tessera. Photomicrograph taken in scanning electron microscope (back-scattered electron image), width of field 0.20 mm. Gray grains: dolomite; black areas: pore spaces.

a few samples taken for this project could be prepared as thin sections, so detailed classifications of most of the limestone tesserae have not been possible.

White tesserae. Three fairly large chips of white tesserae were prepared as thin sections. One, from the Drinking Contest of the Atrium House *triclinium*, is a fossiliferous limestone with some pelloids and a micritic matrix (fig. 62). The second sample, from the Worcester Hunt, is a fossiliferous limestone with some pelloids, but with mostly sparry matrix (fig. 63). Some of the fossils are up to 0.8–1.2 millimeters across (and would be visible to the naked eye). The third sample, from the Dionysos and Ariadne mosaic (House of the Sundial), is a micritic limestone containing abundant pelloids (fig. 64). The matrix is sparry in places, with calcite grains up to 20–40 micrometers.

Black tesserae. Cross sections show that the black tesserae are fine-grained rocks containing small amounts of dolomite (usually in rhombohedral grains) or quartz. Thin sections of three black samples were prepared. Two of these, from the Dancing Satyr and Drinking Contest of the *triclinium*, appear quite similar. They contain a very fine-grained calcite matrix filled with dusty dark brown or black material that gives them their black color. Both contain abundant fossils, which are usually 50 micrometers or smaller and thus not visible to the naked eye (fig. 65). The third sample, from the Funerary Banquet is fine-grained but lacks fossils.

Dolomites (red, maroon, violet)

Many of the red, maroon and violet tesserae are another type of sedimentary rock, dolomite. Dolomite is the general rock name and is also the name of the mineral of which they are mainly made up. All the tesserae samples contained only dolomite, present as small rhombohedral or irregular polygonal grains with sizes mostly in the range 20–60 micrometers (figs. 66 and 67). Very small amounts of other minerals (such as quartz) are sometimes present. The color of these tesserae results from very fine-grained red iron oxide that coats the edges of many dolomite crystals and appears in grain boundaries between individual dolomite crystals. The rocks are slightly porous. The dolomite-containing tesserae would have been somewhat harder than the limestone ones. A sample of an orange tessera also was found to be a dolomite.

Calcareous siltstone (dark green)

In the one thin section that was prepared, the matrix has a pale greenish-gray color and is extremely fine-grained. Patches of colorless coarser-grained calcite are also present. Cross sections of all of the dark green tesserae show a similar fine-grained matrix in which are scattered larger calcite grains (usually less than 100 micrometers in size and thus invisible to the naked eye). The samples examined did not include any of the much larger white angular inclusions visible without magnification in the dark green tesserae, so their identity is not known.

SEM examination of the fine-grained matrix shows three distinct minerals (others may also be present, but in smaller quantities than these). Rounded subangular grains of quartz (usually 1–10 micrometer in size) are sur-

rounded by calcite. Trapped in the boundaries between quartz and calcite grains, or sometimes between calcite grains, are elongated patches of chlorite, a micaceous mineral that often has a green color due to its fairly high iron content. The chlorite is estimated to have a magnesium to magnesium plus iron atom ratio of 0.2–0.3, based on standardless quantitative SEM/EDS analysis. The calcite in the matrix seems to have grown between the quartz grains, acting as a cement. Typical examples are shown in figs. 68–70.

On the basis of the mineralogy and texture, the rock can provisionally be classified as a calcareous siltstone that seems to have been recrystallized or slightly metamorphosed. Siltstone is a variety of detrital sedimentary rock that contains grains in what sedimentary rock specialists call the 'silt' size range, 4–62 micrometers. Most of the quartz grains in these tesserae fall in the lower end of the silt range, actually extending into the 'clay' size range (individual grains less than 4 micrometers). This rock would have been harder than the limestones but, given the substantial amount of carbonate that acts as the cement of the rock, probably not much harder. It seems to have been quite homogeneous and was thus quite suitable for cutting into small tesserae.

Obsidian The volcanic glass obsidian is found only in the Judgment of Paris figural panel (see Appendix: Glass Compositional Analyses for analysis). While the source of the obsidian has not yet been identified, no local sources are known and the material was almost certainly imported.[110]

Quarry Sources and Relationships

On the basis of the few tesserae examined, some observations can be made regarding possible common sources of some of the colors. The dark green limestone tesserae are all quite similar in composition and could have come from one quarry source. If so, the source was used over at least the two centuries that separate the Atrium House *triclinium* from the Funerary Banquet mosaic. The red, maroon and violet dolomite tesserae also could have originated from a single quarry area utilized over the same time period.

The two black limestone tesserae from the *triclinium* Drinking Contest and Satyr panels examined in thin section could have come from a single quarry area, but a third tessera, from the later Funerary Banquet, probably came from a separate source. The three white tesserae examined in thin section all probably originated from separate quarry sources, but these were from three mosaics from separate houses and time periods.

The analytical information on glass compositions, coupled with other technical and stylistic information, suggests that the Satyr and Dancing Maenad mosaics from the Atrium House are closely related. In contrast, the major panels—the Judgment of Paris, Aphrodite and Adonis and Drinking Contest—show variations in material and technique that distinguish them from one another as well as from the Satyr and Maenad. While the makeup of the glass

fig. 68. Sample 4, dark green tessera. Photomicrograph taken in scanning electron microscope (back-scattered electron image) at 300× magnification. Width of field 0.40 mm. Lighter gray: calcite; darker gray: quartz.

fig. 69. Sample 4, dark green tessera. Photomicrograph taken in scanning electron microscope (back-scattered electron image) at 1500× magnification. Width of field 0.08 mm. Lighter gray: calcite; darker gray: quartz; white flakes: chlorite.

fig. 70. Sample 7, dark green tessera. Photomicrograph taken in scanning electron microscope (back-scattered electron image) at 650× magnification. Width of field 0.19 mm. Lighter gray: calcite; darker gray: quartz.

tesserae varies in different parts of the pavement, often reflecting stylistic or formal transitions, the stone tesserae analyses do not show analogous distinctions. There would appear to have been common sources for stones used in at least some of the mosaics that might be attributed to different artists or stages in the setting of pavement. For example, the samples of black tesserae from the Dancing Satyr and Drinking Contest could well have come from the same quarry. As just noted, the dark green tesserae in all of the five mosaics also could well have originated from a single quarry.

It is of course possible that some of the colored stones in all the mosaics had one source (or closely related geological sources). Perhaps these stones were locally available and there was no shortage of material. It is also possible that, although the general petrographic features of some of the rocks used in the different mosaics are quite similar, the quarry sources were different; other analytical data will be necessary to determine this.

Stable isotope analysis of tesserae A number of tesserae were sampled for stable isotope analysis.[111] Small samples of a few milligrams each were taken, and every effort was made to sample only fresh rock, not surface material (since it can often display a quite different isotope signature from the fresh rock due to weathering). Results are given in Table 2 and fig. 70. Portions of nearly all of the small samples were initially analyzed by powder X-ray diffraction to determine their mineral compositions. The majority of the samples were whites; these all contained calcite, and, given the results of cross-section and thin-section analyses, are likely to be limestones. Of the red tesserae analyzed, some contained dolomite and some calcite. The former are likely to be dolomite rocks, as were all of the red tesserae examined by cross-section or thin-section analyses. Some red tesserae contained calcite. No examples of these kinds of red tesserae were included among the samples from which cross-sections or thin-sections were prepared, but they are probably limestones. A few black and brown tesserae were examined; all contained calcite and are probably limestones.

Stable isotope analysis provides valuable information for characterizing rocks that contain carbonate minerals such as calcite and dolomite. Like most elements in nature, carbon and oxygen (two of the major elements in carbonate minerals) consist of different isotopes, and the relative abundances of these isotopes vary from one sample to another. As extensive research on white marble used in the ancient Mediterranean has shown, rock taken from one specific quarry can often be distinguished from rock taken from another quarry on the basis of its isotopic composition. Even though specific limestone or dolomite quarry sources are not known to us at the moment, some conclusions on whether tesserae are likely to have come from a single source or not can be made on the basis of isotopic analysis.

Isotope analysis determines the ratios of the two stable isotopes of carbon (^{12}C and ^{13}C) and the two stable isotopes of oxygen (^{16}O and ^{18}O), with reference to ratios of these isotopes in an international carbonate standard. Results

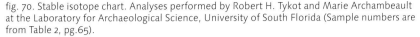

fig. 70. Stable isotope chart. Analyses performed by Robert H. Tykot and Marie Archambeault at the Laboratory for Archaeological Science, University of South Florida (Sample numbers are from Table 2, pg.65).

are typically plotted as in fig. 70, with the oxygen results on the x-axis and carbon results on the y-axis.

Eight white samples were taken from the *triclinium* pavement: two from the Drinking Contest figural panel, two from the geometric borders associated with the Drinking Contest, one from the Aphrodite and Adonis scroll border, two from the geometric borders associated with the Aphrodite and Adonis, and one from the wide white band around the perimeter of the entire pavement. The samples from the Drinking Contest display very similar isotope signatures, so close that the rock could well have originated from one small area of a single quarry. One possibility is that a large block or blocks of limestone extracted from a quarry may have been made into tesserae on site or shipped to another location for that operation. Many tesserae could be prepared from a fairly small block. Analyses of samples of limestone or marble from single blocks such as would have been used to create a near life-size sculpture show some variation in isotope composition, but these usually cluster as closely together on an isotope map as the Drinking Contest samples. The three samples from Aphrodite and Adonis are not likely to have originated from one block of stone, since their isotopic signatures do not plot very close to one another.

The two samples from the House of Aion plot close to the Drinking Contest whites, possibly indicating that they originated from the same part

of the same quarry. Both samples from Hermes and the Infant Dionysos could have come from one block of stone, and two of the three samples from Dionysos and Ariadne could also have come from one block of stone.

Interestingly, virtually all of the white tessera samples, which came from ten different mosaics dating from approximately 125 to 540 C.E., cluster together closely enough that they could have originated from a single quarry. However, this is only speculation at the moment. Although considerable data on the isotopic compositions of white marble sources in Turkey are available, there is no similar database on limestones, so that no possible sources for the limestone can yet be suggested.

Ten red samples from the *triclinium* were also analyzed: two from the Drinking Contest figural interior, three from the stepped triangle border around the Drinking Contest, one from the Aphrodite and Adonis figural interior, two from the Aphrodite and Adonis scroll border, one from the stepped triangle border around the Aphrodite and Adonis, and one from the wave border that runs around all five figural panels. The tesserae sampled appear to be all dolomite except for three of the samples from the Aphrodite and Adonis (two from the scroll border and one from the stepped triangle border). The variations in dolomitic isotope ratios are substantial, but not more than one might expect from a single quarry source, although most are much greater than would be expected from a single block.

Two samples (08 and 10 from the Drinking Contest stepped triangle border) had virtually identical compositions and could well have come from one block. All three red dolomite samples from Dionysos and Ariadne plot quite close to one another and also to the two Drinking Contest red dolomites just mentioned. All of these samples could have come from the same area of one quarry, possibly even from one block of stone. The two mosaics are dated about 150 years apart based on archaeological and stylistic evidence.

The calcitic reds, which came from five different mosaics, plot in the same general region as the whites. Possibly all of these originated from one quarry. Two of the three calcitic samples from the Aphrodite and Adonis (15 and 16 from the scroll border) plot virtually on top of one another, suggesting they may have come from one block. The third did not come from this same block.

Very few black and brown tesserae were analyzed, but as fig. 70 shows, it is possible that the blacks, which came from three different mosaics, originated from one quarry. Only two browns, from two different mosaics, were analyzed. Again, they plot fairly close to one another, pointing possibly to one quarry source for both.

Conclusion

CERTAIN OBSERVATIONS stand out from our examination of the Atrium House triclinium. Common features throughout the pavement include a reliance on Hellenistic painting and the selection of Greek themes, sometimes with Antiochene associations. Contests involving deities provide the plot for several panels. Desire and the dangers of excess are explored and all three figural scenes concern the consequences for mortals when their lives become entwined with the gods. The selection and placement of the scenes provided drama for the diners and food for thought and conversation. The themes chosen also reflect the public image the householder wished to cultivate.

The basic makeup and sequence of the pavement's preparatory layers and the method of embedding the tesserae are consistent throughout the room. A high degree of professionalism is apparent in all aspects of the work. Archaeological evidence, such as variations in the composition and color of mortars, and divisions and beveled edges between elements, clarifies the order of work and distinguishes stages in the laying of the floor. Geometric border elements, including the couch border, are laid exclusively in stone. While the majority of tesserae in figural scenes and scroll borders are also stone, glass gave the pavement a sumptuous luminescent quality, somewhat diminished from burial but still very evident, and glass highlights helped mosaicists create an illusionistic space.

The consistent iconography of the various scenes does not carry over to uniform style and technique. Artistic variations among the panels are illuminating. Differences in quality, palette, choice of material, and the definition of space and form are evident. Tesserae are cut and oriented differently from panel to panel. The presence of different artists of varying skill and the mark of more than one master mosaicist are clear. What this tells us is less evident. Does it signify a fairly large, stratified workshop (the most traditional scenario) or some alternative arrangement, perhaps a temporary combination of talents specific to the *triclinium* commission. However the mosaic program was organized, the essential unity of the work is undeniable and may reflect the overriding vision of a single individual, although the evidence is insufficient to identify this central figure as mosaicist, architect, designer or patron.

Analysis of the glass and stone tesserae in the pavement provides information on such issues as dating, material sources, glass-making technology, the relationship of glass workshops and mosaic workshops, stone quarrying, stages in laying the pavement, artistic practices, and the identification of individual workshops and mosaicists. Stone tesserae examined suggest that stones from the same quarry or even the same block were probably used throughout the pavement irrespective of stylistic or formal distinctions among panels. Limestones, dolomites, and calcareous siltstones predominate. The only stone identified as clearly imported is obsidian. Results of isotopic analyses of tesserae from the Atrium House and later Antioch mosaics indicate that the same quarry may have furnished stones for mosaics from about 125 to 540 C.E.

The possibilities of the glass medium were fully exploited in the *triclinium* pavement, and the depth and subtlety of the palette speak to the high level of glassmaking at Antioch. Unlike stone, which is found in nature, the character of glass depends on human selection from a variety of possible components, material sources and processing options. The resulting variation in the makeup of glass tesserae makes glass a useful indicator of distinctions among panels and tracking stages in the construction of the floor. The degree of variation depended on color: some colors, such as orange, are relatively consistent in type and composition throughout the room, while others, such as red, showed considerable variability. Changes in the composition and type of glass tesserae are often seen at stylistic or formal boundaries in the pavement, for example between figural scenes and their scroll borders.

The comparative architectural groupings studied reveal a range of possible relationships between glass suppliers and mosaic workshops. In the House of the Drinking Contest, analyses throughout the building are consistent with the fabrication of glass specifically for the mosaic commission, or at least with contemporary production by a few glassmakers, while in the Tomb of a Women's Funerary Banquet, mosaicists used a mixed lot of materials originating from a number of glass workshops and very possibly including reused or remelted tesserae. As painterly mosaics became less popular and the size and shape of tesserae more uniform, reuse of both glass and stone tesserae may have become more common.

The interdisciplinary approach used here aims to present a broad picture of how the various threads of art, culture, technology and commerce combined to produce Roman mosaics. This essay is part of ongoing scholarly work in mosaic studies and its conclusions are subject to revision as more research is undertaken. For example, our interpretations of analytical data will need to be re-evaluated as additional mosaics are analyzed. Nonetheless, scrutiny of even a single work such as the Atrium House pavement casts light on life in the Roman East and on mosaic artists who, for all their accomplishments, remain primarily in shadow. The more we understand each detail of their craft—the procedures, processes and cultural dictates that governed their tasks, the materials they fashioned and used, the images and colors that filled their vision and gave it content—the more we can appreciate the works that have survived.

1. After lifting, most of the original preparatory and bedding layers were removed and the mosaics were backed with a layer of concrete and iron reinforcing rods. For a detailed description of the excavation and treatment of mosaics at Antioch, including the *triclinium*, see The Mosaic Conservation Campaign: Three Case Studies in the present volume.

2. Fisher, Antioch I 1934, 8–19; Levi, 1947, 15–25.

3. Fisher, Antioch I 1934, 10; Elderkin, Antioch I, 42.

4. Levi, 1947, 15.

5. Fisher, Field Diary, June 1, 1932; March 19, 1933.

6. Levi, 1947, 16.

7. Fisher, Field Diary, June 8, 1932; see also Fisher, Antioch I, 1934, 18.

8. Fisher, Antioch I 1934, 18.

9. Waagé, Antioch I 1934, 62.

10. Vitruvius Bk. VI, Ch. III (8), Morgan trans. 1960, 179; see also Dunbabin 1996.

11. Morvillez 2005, forthcoming.

12. Morvillez 2005, forthcoming.

13. Décor 1985, 80–81, pl. 38c, "swastika-meander of spaced singled-returned swastikas with a square in each space."

14. Levi 1947, 489–517, traces the stylistic development of this type of "vegetable decoration," as he calls it (also referred to as a rinceau), from the Hellenistic through the late Roman periods. For the most relevant parallels for the Atrium House foliate scrolls, see pp. 489–495.

15. Dunbabin 1978, 278, cat. Zliten 1.f, pl. 2.

16. Levi 1947, 492.

17. Sweetman 2003, 521–522, pl. 73a, who suggests that the mosaic of the *oecus* was laid in the mid-second century.

18. Talgam and Weiss 2004, 92, fig. 87.

19. Talgam and Weiss 2004, esp. 88–94 on the frame of acanthus medallions; for the general stylistic similarities with Antioch, see 107–113.

20. The servant girl approaches Adonis from the right on the oldest of these reliefs, the mid-second-century sarcophagus from Casino Rospigliosi in Rome, Koortbojian 1995, 27–28, fig. 4.

21. See below under The Visual Evidence: Technique and Style for further description of this border.

22. Kriseleit 2000, cat. 5, 17–23, figs. 13–15. The mosaic is named for the signature of the artist "Hephaistos" inscribed within it.

23. MacDonald and Pinto 1995, 163–165, 298, and figs. 210 and 387, both in the Vatican Museum.

24. Or. 11.241.

25. See Athenaios 12.510 (trans. Gulick). Athenaios (*Deip.* 15.687) is describing a scene from a now lost satyr play by Sophocles on the subject of the Judgment. Aphrodite appears as *hedone* or Pleasure and Athena offers a contrast as *sophrosyne*, Wisdom and Virtue.

26. Two examples of these vases are found in Boston, MFA 99.533 and 01.8069.

27. A Roman mosaic from Kos includes the Judgment of Paris as part of larger composition, including wild beast hunts, seemingly depicting amphitheater spectacles, see Kondoleon 1991, 109–110, figs. 5–8 and 5–9. The inclusion of the Judgment in the reliefs on the *pulpitum* of the theater at Sabratha confirm its place in the theatrical repertoire of the Roman world. For discussion of the reliefs and related texts (Pollux, Tertullian, Lucian), see Caputo 1959, 21–22, figs. 79–82.

28. Huskinson 2002–2003, 131–165, offers an excellent survey of what the extant Antioch mosaics reveal about the range of theatrical experiences available in this metropolis. She aptly quotes Julian (*Misopogon* 342A and B) who commented that Antioch had "more mimes than ordinary citizens" to support the likelihood that many of the theatrically depicted myths on Antiochene mosaics found their counterparts in live performances—some possibly in the very dining rooms they decorated.

29. Measurements are taken from the inside edge of the meander border.

30. Fisher, Field Notes, May 8, 1932; the Field Notes are Fisher's handwritten notations, drawings, and diagrams made during the course of excavation. The Field Diary is his typed record of events and observations.

31. The meander border that runs across the vestibule (east to west) ranges from 220 to 223 mm in width, for a variation from the mean of only 1.5 mm or 0.7%. The width of the meander border that runs north to south along the east side of the room varies only 0.7 % or 2 mm from a mean of 225.5. The west meander border ranges from 221 to 227 mm, for a variation of only 3 mm or 1.3% from the mean of 224 mm. The meander running east to west on both sides of the Aphrodite and Adonis panel ranges from 234 to 238 mm for a mean variation of only 2 mm or 0.8%. The greatest variation in measurement between comparable elements of the room is between the figural panels of the Satyr and Maenad. While the widths of both panels are very close, the lengths or north/south dimensions vary by 21 mm along their east edges and 29 mm on their west edges, by far the most substantial variation noted in the field drawing, but still only an average discrepancy of approximately 2.5 cm. or 1 in.

32. The photographs included in Levi's 1947 publication and the catalogue, *Antioch: The Lost Ancient City* are inaccurate where the panels join, since they are composite images created from photographs taken after the panels had been cut and lifted.

33. Fisher, Field Diary, June 2, 1932.

34. See Dunbabin 1999, 281–286, where several examples are cited and Métraux 1985, 141–42.

35. Talgam and Weiss 2004, 116; Dunbabin 1999, 284–85.

36. Fisher, Field Notes, June 2, 1932; Field Diary, June 1, 1932 and March 19, 1933.

37. Vitruvius, Morgan trans. 1960, 202–203.

38. Fisher, Field Diary, June 1, 1932 and March 19, 1933; see also Field Notes June 2, 1932.

39. Fisher, Field Notes, June 2, 1932 and Field Diary, June 1, 1932. Nowhere in the field notes does Fisher discuss a division in the bedding layer between a nucleus and supra-nucleus.

40. Fisher, Field Diary, June 1, 1932.

41. Fisher, Field Diary, June 8, 1933.

42. Fisher, Field Diary, June 2, 1932.

43. Vitruvius, Morgan trans. 1960, 203, refers to the use of a rule and level. The Ostia stele (fig. 30) discussed below shows a man, perhaps the deceased, holding what may be a leveling tool, See also Lavagne 2001, 104–105.

44. An indirect method involves adhering the tesserae face down to a support material. The unit is then reversed and set into a mortar bed so that the support material is on top. The support material is then removed, leaving a generally level mosaic surface if the technique is executed properly. A variation on this method involves setting the tesserae face up in a sand bed, leveling them, and then attaching a support material with an adhesive. When the adhesive hardens the ensemble is removed from the sand bed for transfer to the pavement. See Ling 1994 for a full description and discussion of indirect or reverse methods.

45. Fisher, Field Diary, June 1, 1932.

46. Fisher, Field Notes, June 2, 1932.

47. Fisher, Field Diary, June 8, 1932.

48. Elderkin 1932, 21–22. The sloped edge is not described in the field notes, but there is no reason to doubt the accuracy of Elderkin's report.

49. Ling 2000, 55.

50. Pauline Donceel-Voûte private communication and AIEMA 2005, forthcoming.

51. Fisher, Field Diary, June 8, 1932.

52. Fisher, Field Diary, June 8, 1932.

53. Dunbabin 1999, 288; Ling 1998, 14.

54. Henderson in Ling 2000, 85.

55. Clarke 1991, 40–41.

56. Kondoleon 2000, 184–186 for a discussion of cat. 68 (Detroit Institute of Arts 54.492; 58.4 cm × 58.1 cm).

57. Levi 1947, 2, 25, 630.

58. See e.g., Neal in Strong and Brown 1976, 244–45.

59. Indirect methods would involve removal of the support material after the tesserae were bedded. However, as noted earlier, there is no conclusive archaeological or textual evidence for the use of this method.

60. Métraux 1985, 139–143, and personal communication.

61. For a list of mosaicists who sign their works and what their inscriptions reveal about their social standing and organization of their workshops, see Donderer 1989. Documentation is more plentiful for the Middle Ages. See Harding's 1989 account of mosaic workshop practice in 13th-century Orvieto, Harding 1989, 73–102. On workshop practices for the Greek and Roman periods see Ling 2000, 78–107, and Clarke 1994, 89–101. Allison 1995 is more critical of the term workshop and suggests replacing it with the expression "decorators' team."

62. Although the mosaic inscription is fragmentary, scholars agree that Daphne refers to a place name and reconstruct it as "Antiochus of Daphne made it," based on related inscriptions in other media; see Donderer 1989, 81, no. A42, and Markoulaki 1990, esp. 461–462, nn. 55–57.

63. AIEMA 2001, 74, a presentation by Turkish archaeologist Derya Sahin.

64. Kennedy 1998, esp. 11–17; Basgelen and Ergeç 2000; Önal 2002.

65. Abadie-Reynal and Darmon 2003, esp. 99, fig. 27.

66. Ibid. fig. 23, esp. 87–99.

67. Dunbabin, 272, and fig. 163.

68. The relief is in Ostia at the Museo Ostiense, Inv. 132; see Dunbabin 1999, 281, fig. 287.

69. Regarding the analogous practice of wall painting, Allison has argued that surviving evidence is insufficient to judge whether ongoing workshops were more common than temporary collaborations of craftsmen to complete a specific commission. Allison 1995, 98–109.

70. Tessera counts from backgrounds or geometric borders are average counts from several areas.

71. The designation of glass with reference to precious stones dates back to formative periods of glassmaking in Mesopotamia, where, for example, texts dated to the second half of the second millennium B.C.E. refer to certain blue glass as *uqnu kuri*, "lapis from the kiln." Oppenheim et al. 1988, 10. For a recent discussion of glass as a substitute for jade in China see An Jiayao 2004, 56–65.

72. Tessera counts over a 10 × 10 cm area average 656 for the face of Dionysos, 580 for the face of Herakles, 592 for the face of the satyr, and 547 for the face of the maenad. The last is the lowest count for any of the faces on the figural panels. See Talgam and Weiss 2004, 115.

73. The mosaicist reinforced the outdoor setting of the Judgment scene by laying the background tesserae in undulating lines that echo the mountainous landscape.

74. See Clarke 1994, 89–102.

75. Weinberg 1988; Freestone 2003, 111–115.

76. Gorin-Rosen in Nenna 2000, 49–63.

77. Freestone, Gorin-Rosen and Hughes in Nenna 2000, 66–83.

78. See e.g. Henderson 1991, 601–07; also compare the composition of white enamel cat. 37 with white tesserae samples in Appendix: Glass Compositional Analyses.

79. See Harding 1989, 73–102.

80. Freestone 2003, 111.

81. See Lavagne 2001, 104.

82. See Freestone, Bimson and Buckton 1990, 274; Brill and Cahill 1988, 30.

83. In instances such as these, the question arises whether the colors produced are the result of intentional manipulation of firing parameters or whether glassmakers took advantage of accidental fluctuations in furnace conditions. The high level of glassmaking seen in the Atrium House argues for the former explanation. In any event, for purposes of examining fabrication of the pavement, the paramount issue is whether the colors originate from the same batch, not whether the color achieved was premeditated.

84. Brill and Cahill 1988; Freestone 1987, 182.

85. The aluminum level may be related to the silica source; the lead level, while high for the triclinium, might still be considered a low-lead composition by certain criteria. Freestone, Stapleton and Rigby in Entwistle 2003, 145; Freestone 1987, 186–87.

86. Freestone, Bimson and Buckton 1990, 272, Smith 1963.

87. Freestone, Stapleton and Rigby in Entwistle 2003.

88. Freestone, Stapleton, and Rigby in Entwistle 2003, 145; see also Freestone 1987, 187. The explanation of the red Type 2 lead levels might be found in their connection to the batch 6 greens, as discussed in the paragraph below.

89. See e.g. Cable and Smedley 1987, 161.

90. Metallic copper was detected by X-ray diffraction. Brill and Cahill 1988, 24.

91. Brill and Cahill 1988, 23–24.

92. See Cable and Smedley 1987, 154, 162; Freestone, Stapleton and Rigby 2003, 144–46; Freestone 1987, 183–84. Antimony would also promote reduction but this effect would be insignificant at the antimony levels detected in the *triclinium* orange glasses.

93. Analyses of orange glasses are less frequently published than their red counterparts.

94. Strong and Brown 1976, 39.

95. Freestone, Stapleton, and Rigby in Entwistle 2003, 142–154; see also Mass, Wypyski, and Stone 2002, 67–82.

96. Strong and Brown 1976, 26.

97. Freestone, Stapleton, and Rigby in Entwistle 2003, 149.

98. The only glass falling outside this grouping is a translucent green from the Judgment interior (54) with low levels of both lead and antimony.

99. This glass may be an oxidation-fired glass (intentional or accidental) from a workshop generally manufacturing reds and oranges, colors often produced with plant ash, or may come from a remelted batch combining different types.

100. These inclusions may point to a particular copper ore source or batch of recycled metallurgical byproduct.

101. Clarke 1994, 90.

102. See the section Glassmaking Technology at Antioch and Appendix: Glass Compositional Analyses for complete analyses and further discussion of the glass technology.

103. See Levi 1947, 141–42, 626; Kondoleon 2000, 53–57; Herrmann and Kondoleon 2003, 16–19.

104. See cat. 4, Mosaic of a Women's Funerary Banquet; Levi 1947, 291–304, 626; Kondoleon 2000, 121–22;

105. Antioch II 1938, 49–51.

106. Antioch II 1938, 59–60.

107. Chips were mounted in Buehler Epothin epoxy resin and sanded and polished to expose as much sample area as possible. The polished cross sections were coated with carbon and analyzed in a Cameca MBX electron beam microprobe equipped with a Tracor Northern 5500 energy-dispersive X-ray fluorescence system, or in a JEOL 646oLV scanning electron microscope equipped with an Oxford Instruments INCA energy-dispersive X-ray spectrometer.

108. Thin sections without cover slips were prepared with Buehler Epothin epoxy resin, following initial vacuum impregnation in the same resin. The samples were initially examined with a Leica DM/LM microscope under polarized transmitted light. Photomicrographs were taken with an attached Diagnostics Instruments SPOT RT digital camera.

109. Small portions of the solid samples were pressed between the diamond windows of a SpectraTech Micro Sample Plan, then analyzed in a Nicolet 510P FTIR spectrometer with an attached Nicolet NicPlan infrared microscope. One hundred scans at four wavenumbers resolutions were acquired. Identifications of mineral phases were made with reference to a variety of commercial and in-house spectral libraries and published mineral spectra.

110. Reported ancient Near Eastern sources for obsidian include Central Anatolia, the region of Lake Van, and Armenia. Moorey 1994. 63–71.

111. Small samples, each a few milligrams in size, were analyzed by Robert H. Tykot at the Laboratory for Archaeological Science, University of South Florida. Stable isotope ratio analysis was carried out using a Finnigan MAT Delta Plus XL stable isotope ratio mass spectrometer equipped with a Kiel III individual acid bath carbonate system. Isotopic studies of tesserae are rare. For a published example see Herz and Garrison 1998, 210.

Identification of the Birds in the Judgment of Paris

Of the two birds in the central panel and 10 in the surrounding scroll, only the Quail and the Peacock in the scroll can be identified by species. Identifiable by probable species are a Saker Falcon in the central panel and a Roller and a Mustached Warbler in the scroll.

1. Unidentifiable species, probably Gray-headed Woodpecker (Picus canus) or Green Woodpecker (Picus viridis), possibly Greenfinch (Chloris chloris) or Tristram's Serin (Serinus syriacus).

This bird's large size relative to the falcon in the central panel and to the human figures, together with its overall yellow-green colors and forked tail, make it most closely resemble the Gray-headed Woodpecker (Picus canus) or the Green Woodpecker (Picus viridis), the latter occurring in Asia Minor.[1] However, woodpeckers have a longer, more distinctive bill, usually dark, not the creamy white bill of the bird here. Moreover, the Green Woodpecker has a markedly red head and the male Gray-headed Woodpecker has a red patch on its forehead. The woodpeckers also have a slightly forked tail, although this is not easily seen in flight.

If the representation does not correspond to the bird's actual size, the colors and the forked tail could also indicate the Greenfinch (Chloris chloris) or possibly Tristram's Serin (Serinus syriacus), though the bird's beak is not very close to a seedeater's. Both species have some blue-gray on the head, like the bird in the mosaic. The female Crossbill (Loxia curvirostra) is also greenish and has a forked tail, but its dark bill is more distinctive than that of the bird here. Although the Blue-cheeked Bee-eater (Merops superciliosus), the Little Green Bee-eater (Merops orientalis) and the Rose-ringed Parakeet (Psittacula krameri) are green birds with forked tails, their tails are longer and slimmer and their bills are different.

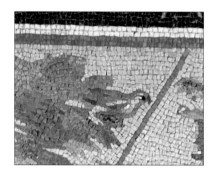

2. Falcon sp. (Falconidae spp.), most likely Saker Falcon (Falco cherrug), possibly Lanner Falcon (Falco biarmicus).

The shape, colors and the raptor beak identify the bird as a falcon species closest to the Saker Falcon (Falco cherrug) or to the Lanner Falcon (Falco biarmicus), species typical of the regions around Antioch. Raptors can be difficult to distinguish and a generic representation like this cannot be identified with certainty. It is unclear to what extent the white and light brown tesserae around the ear, neck, breast, scapulars, flanks, tail and leg are diagnostic or are merely used to make the shape more visible. At least the tail and legs seem to have been colored white to distinguish them from the leaves of the tree. The pale colors may also indicate reflections of light in the bird's plumage, as in the bird's right leg.

The falcon may be the emblem of Hera but more probably refers to Paris, perhaps to his ability as an archer, as suggested by the falcon above Paris in a Judgment of Paris mosaic from the House of Dionysos at Kos.[2]

3. Unidentified species, most likely Roller (Coracias garrulus), possibly passerine species (Passeriformes spp.).

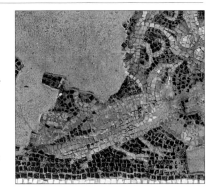

The general features—medium-sized bird with brown upper parts and bluish underparts—fit only the Roller (Coracias garrulus), though they do not correspond in all details. The bird's bill is relatively strong, as it should be, though it is light instead of black. The Roller has a black lore but not such a distinctive eye-stripe. An adult Roller's head should be blue instead of brown, and the Roller has also a blue wing patch and black primaries not present in the mosaic. However, the possibility of a conventional use of colors cannot be entirely ruled out because another bird in this scroll, a small passerine (no. 5), also has blue-green underparts and brown upper parts, though it differs in other respects.

The identification as the Roller is supported by some very rare representations of the species, most significantly in a scroll with several kinds of birds from a probably late Republican building in Rome.[3]

4. Small passerine (Passeriformes spp.), probably Garden Warbler (Sylvia borin) or some other warbler species (Sylviidae spp.).

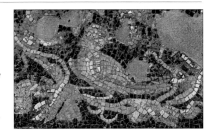

The small passerine (Passeriformes spp.), with gray-brown upper parts, lighter underparts and a little green on the flanks, seems a rather generic "small bird," such features being closest to the Garden Warbler (Sylvia borin). If the white bill is diagnostic, it could point to some reed warblers (Acrocephalus spp.) or Hippolais warblers (Hippolais spp.).

5. Small passerine (Passeriformes spp.), possibly Icterine Warbler (Hippolais icterina) or leaf warbler species (Phylloscopus spp.).

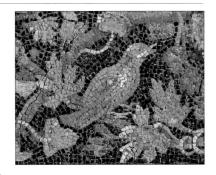

This small passerine differs in size and shape from the probable Roller (no. 3), though both show the unusual combination of blue-green underparts and brown upper parts. The application of a common color pattern cannot be entirely ruled out, making the diagnostic significance of the colors doubtful. This bird has a more distinctive white eye-stripe than the probable Roller; this might point to the Icterine Warbler, supposing that the green underparts represent the yellow underparts of the Icterine Warbler or the very similar but more western Melodious Warbler [Hippolais polyglotta], less probably to some leaf warblers (Phylloscopus spp.).

6. Reed-warbler species (Acrocephalus spp.), Mustached Warbler (Acrocephalus melanopogon) or Sedge Warbler (Acrocephalus schoenobaenus).

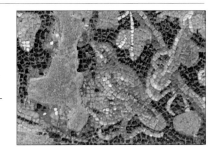

The shape, size and colors, especially the black eye-stripe, are compatible only with the Mustached Warbler or the Sedge Warbler, though their dark head-stripes are not shown. The Aquatic Warbler (Acrocephalus paludicola) has more distinctively striped breast and flanks and is therefore excluded here.

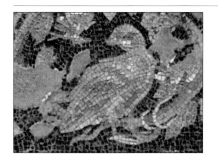

7. Quail (Coturnix coturnix).

The shape, size and colors are clearly characteristic of the Quail, the absence of more distinctive black colors in the head and neck suggesting a female.

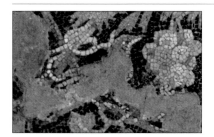

8. Passerine species (Passeriformes spp.), possibly Fieldfare (Turdus pilaris) (incertus due to damage).

The shape, size and colors—gray head and yellow bill—are closest to the Fieldfare (Turdus pilaris); this identification is not certain, however, since nearly the entire body is missing.

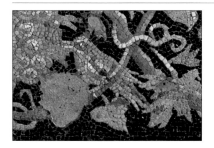

9. Passerine, possibly Fieldfare (Turdus pilaris), or Menetier's Warbler (Sylvia mystacea) or Red-breasted Flycatcher (Ficedula parva).

This may be a slightly varied instance of the same color patterns as in the probable Fieldfare (no. 8), though the body is more warbler-like than thrush-like; in addition, the Red-breasted Flycatcher cannot be ruled out, though its tail has different distinctive black and white colors.

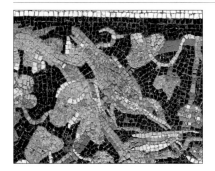

10. Passerine (Passeriformes spp.), probably Subalpine Warbler (Sylvia cantillans), possibly White-throated Robin (Irania gutturalis), or Rock Thrush (Monticola saxatilis), or Redstart (Phoenicurus phoenicurus).

The bird's shape and size (in comparison to the grasshopper it is pecking) suggest a small or medium-sized passerine, though both are too large in relation to the Peacock nearby; evidently such size relations were portrayed only approximately at best, and the Peacock has obviously been made smaller to fit the space available. The passerine's blue-gray upper parts, with some red in the underparts, white mustache stripe and white stripe in the lesser and middle coverts are (if diagnostic) features closest to the male Subalpine Warbler (Sylvia cantillans) or White-throated Robin (Irania gutturalis). However, the white mustache stripe seems instead to be a mannerism followed by the mosaicists for most of the birds here. The green tesserae in the underparts probably represent the glitter of the plumage, like the green stripe in the Peacock's neck. Hence possible alternatives would be the male Rock Thrush (Monticola saxatilis), with somewhat similar colors, though it lacks a mustache stripe and its rump is white, or the Redstart (Phoenicurus phoenicurus), especially the subspecies P.p. samamisicus with white secondaries, though its upper parts are more gray than blue.

11. Peacock (Pavo cristatus).

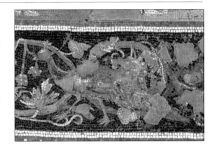

The Peacock (Pavo cristatus) can be identified without any doubt by its characteristic shape and colors, though the face is damaged. The bill is rightly white, while the crown on the head seems mauve and light brown and the green tips of the crown feathers are not shown. The neck is blue with a green stripe, the latter representing the glitter of the plumage. The white color renders the reflections of light in the shiny plumage, especially in the lesser and middle coverts; this same technique appears not only in wall paintings but also in earlier mosaics.[4] White was probably used in this way in many other birds here, whereas the white in the somewhat damaged area of the scapulars and the lesser and middle coverts of this Peacock is more likely diagnostic.[5] Together with the pinkish brown colors in the secondaries and a black stripe in the primaries, these colors are characteristic of Peacock wing feathers. Peacock wings are dominated by black-striped white scapulars, black coverts and secondaries, and chestnut brown primaries. The tail here is rendered mainly in various brown colors instead of the dominantly green tail feathers of the Peacock. This probably indicates the use of painted models, as many Peacocks in wall paintings are rendered in brownish violet colors. On the other hand, the "eyes" of the Peacock's tail are rendered here with blue tesserae; these eyes are often omitted in wall paintings, especially when the peafowl are minor decorative elements.[6]

12. Passerine (Passeriformes spp.), perhaps Subalpine Warbler (Sylvia cantillans), perhaps White-throated Robin (Irania gutturalis), or Rock Thrush (Monticola saxatilis), or Redstart (Phoenicurus phoenicurus) (incertus because of damage).

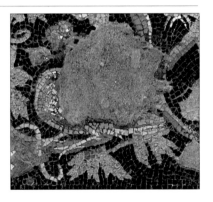

Bill, throat and back lack tesserae, because of which the similarity with the passerine resembling most a Subalpine Warbler (Sylvia cantillans) cannot be ascertained. The preserved part of the tail of this individual is white instead of the bluish gray of the former individual, but this bird also has somewhat similar underparts and possibly had bluish gray upper parts.

Antero Tammisto

1. For a probable Green Woodpecker in the border of the fish mosaic from the Casa del Fauno in Pompeii, see Tammisto 1997, 120.

2. Kondoleon 1995, 309–10, figs. 198–199.

3. See Tammisto 1997, 42–43, 417–419, cat. SC2, pls. 60–62, figs. SC2, 1–8.

4. Tammisto 1997, pls. 11–14, 22–23, 40.

5. So also in the Peacocks in Tammisto 1997, pl. 48, fig. SP5, 11b and fig. SP5, 43b.

6. For the only five Peafowl in mosaics B.C.E., see Tammisto 1997, 448, no. XIX.

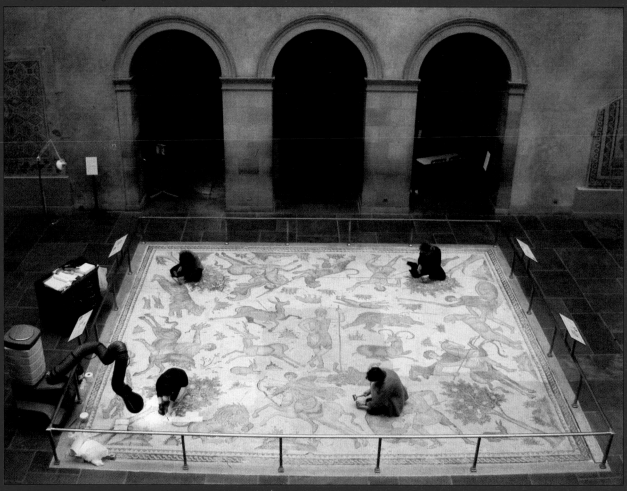

The Mosaic Conservation Campaign

Three Case Studies

Paula Artal-Isbrand

THE 2000–2001 EXHIBITION *Antioch: The Lost Ancient City* was the catalyst for a conservation campaign of Antioch mosaics at the Worcester Art Museum that ran from 1995 to 2004. During this project most of the mosaics in the Worcester collection as well as mosaics on loan for the exhibition from other museums were studied and treated (figs. 1, 2).

Three mosaics represent the different challenges faced by conservators during this conservation campaign: the *triclinium* floor of the Atrium House, the pavement of the Tomb of a Women's Funerary Banquet, and the Worcester Hunt (fig. 1). Each case study is prefaced by a description of the treatment in the field during and following excavation, which greatly affected the condition of the mosaics.

The conservators (assisted by numerous interns and volunteers) and the curator discussed treatment approaches throughout the conservation campaign.[1] Presentation issues such as the filling of losses and the extent of restoration of original parts were discussed as well as the materials chosen for these purposes. Decisions were based on both conservation and art historical considerations. New materials and techniques developed during this conservation campaign were presented at professional conferences.[2] An invaluable reference throughout was the archaeologists' unusually extensive diaries, field notes and drawings, black-and-white photographs, and film footage kept at the Antioch Archives at Princeton University.

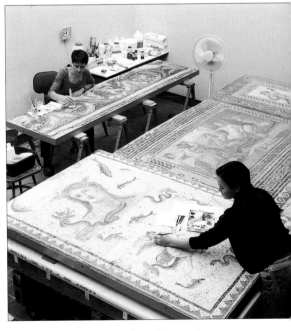

fig. 2. Conservators treating mosaics placed on sawhorses in a gallery converted into a workshop during the mosaic conservation campaign.

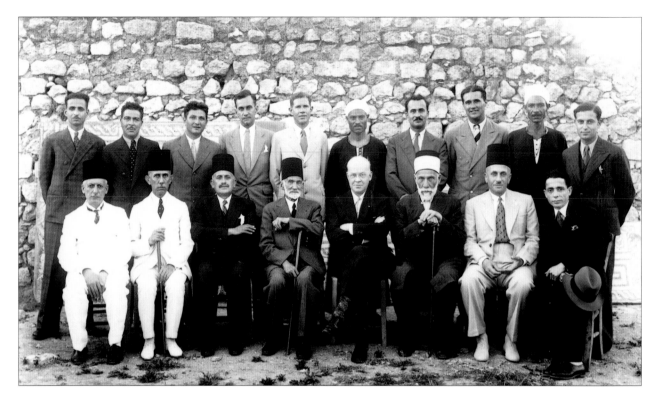

fig. 3. 1936 members of the excavation team with local dignitaries at Antioch. Photo includes William Gad Gabriel, Technical Expert on the mosaic excavation team; Richard Stillwell, Director of Publications at Princeton; William A. Campbell, Field Director; Jean Lassus, Assistant Field Director; Berberi Mahmud Isa, Head Foreman; and Charles R. Morey, Chair of the Antioch Committee, see key below (Antioch Expedition Archives).

W. G. Gabriel
R. Stillwell
W. A. Campbell

C. R. Morey
J. Lassus
B. M. Isa

Excavation and Treatment of the Antioch Mosaics in the Field

The Antioch archaeologists realized early on that the numerous mosaic finds required a special team to prepare them for travel to France and the United States.[3] Clarence S. Fisher, Field Director during the second excavation season (1933), hired William Gad Gabriel, a professional mosaicist, to head the mosaic lifting crew (fig. 3).[4] Gabriel was on staff for at least four seasons.[5] In 1932, the first year of the dig, Berberi Mahmud Isa, an Egyptian, was *Reis* or Foreman in charge of lifting mosaics (fig. 3).[6] After Mr. Gabriel was hired, Mr. Isa became Head Foreman of the team of Syrian workers.

Mr. Gabriel and the Antioch archaeologists developed a system of lifting and backing the mosaics that was used throughout the excavation.[7] After the surface of a newly excavated mosaic was cleared of burial dirt, its outside edges and the edges of large losses were reinforced with cement to secure loose tesserae and prevent further damage during lifting (fig. 4). Small areas of loss within the tesselatum were also filled with cement. William A. Campbell, Field Director 1934–39 (fig. 3), describes this process as "cementing the holes in the surface of the mosaic."[8]

The next step was to cut the larger mosaics into sections by first lifting a row of tesserae on either side of the proposed cut.[9] These tesserae were saved for reattachment when the sections were rejoined during museum installa-

fig. 4. Detail of the
Worcester Hunt
showing cement
reinforcements
(Antioch Expedition
Archives).

tion. To keep the tesserae in position during lifting, each mosaic section was
faced by gluing cloth and paper to its surface.[10] The next step was to cover each
section with boards for support during lifting.[11] The excavators then dug away
the bedding layer beneath the mosaic while supporting the mosaic with wooden
blocks. Wooden poles were then slid underneath the mosaic and tied with ropes
to the boards on top.[12] The sections were then turned over so that the mosaic was
lying face down, still supported by the wooden boards. The remains of the an-
cient mortar substrate were chipped away until the back sides of the tesserae were
completely exposed (fig. 5).[13] The mosaics were then backed with 7 cm. of con-
crete reinforced with iron rods and wire mesh, which also filled the large losses
within the tesselatum (fig. 6). According to Charles Rufus Morey, chair of the
Antioch Committee (fig. 3), the end result of this process was an "indestructible
monolith."[14] The weight of these concrete-backed mosaics was about 170 kg/m²;
for example, the Drinking Contest panel from the Atrium House *triclinium* weighed
approximately 676 kg. and the Funerary Banquet panel weighed 790 kg. Fully aware
of the problem posed by the weight of the mosaic panels, Clarence S. Fisher
writes, "they will be heavy to transport, but with care in handling, will not suffer
any breakage."[15] This lifting and backing technique for newly excavated mosaics
remained common practice in Syria for many years.[16]

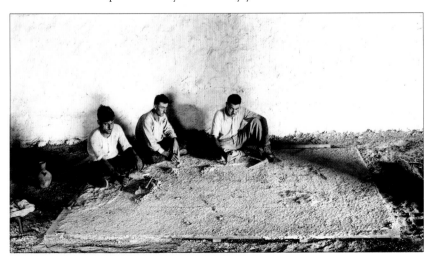

fig. 5. Workmen
chipping away
ancient bedding
mortar from the
underside of a
mosaic section
(Antioch Expedition
Archives).

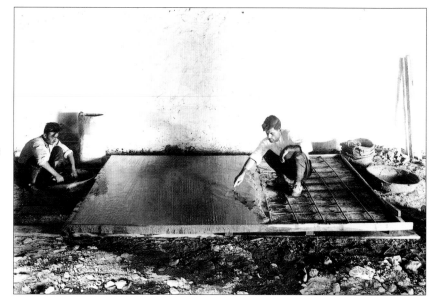

fig. 6. A mosaic section laid face down is backed with concrete reinforced with a grid of iron rods and iron mesh (Antioch Expedition Archives).

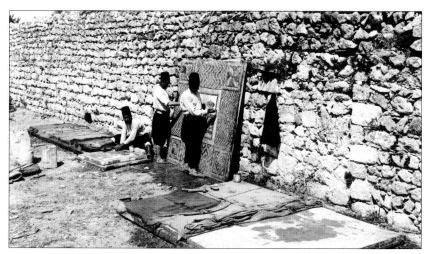

fig. 7. Workmen cleaning and scraping mosaics. Wet burlap sacks were placed over the mosaics to soften the facing glue for removal of the cloth and paper facing (Antioch Expedition Archives).

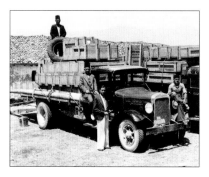

fig. 8. Wooden crates containing mosaics on their way to the port of Alexandretta for transfer to ships headed to France or the United States (Antioch Expedition Archives).

Once the concrete had set, the cloth and paper facing was removed.[17] Workmen then scrubbed the surface of the mosaic with wire brushes and scraped it with stones to remove burial accretions and smooth the surface (fig. 7). After field treatment, the mosaics were prepared for travel to the sponsoring institutions (fig. 8). For protection during travel, cloth was again glued to the surface and the mosaic sections were packed in wooden crates padded with mattresses and sawdust.[18] Zinc banding was placed around the crates for security.[19]

Three Case Studies

While the primary goal of the 1995–2004 Antioch mosaic conservation campaign was to stabilize and preserve the ancient floors, the aesthetic and accurate presentation of these mosaics in a museum setting was also considered. The following case studies discuss numerous treatment decisions made by the conservators and curator. A recurrent and problematic issue was how to deal with losses. Should they be restored to look like the original tessellated surface? Or should they be filled with a recessed neutral-colored mortar to resemble ancient bedding mortar? Losses varied greatly, from large sections down to a few tesserae. The design in areas of loss is often but not always predictable: for example, a large loss in a repetitive geometric border is predictable, while a relatively small loss in the face of a figure may not be. The general rule was to fill small predictable losses with restoration tesserae, and other losses with a neutral-colored recessed mortar resembling bedding mortar. But the situation was more complicated than this simple scenario; for example, post-excavation museum treatment varied greatly and decisions to remove, modify, or accept older restorations had to be made on a case-by-case basis, with the lender involved in decisions affecting borrowed works. The three case studies illustrate how treatment of losses depended on a variety of factors including the mosaic's spatial composition and use of perspective, the size and location of losses, and the shape of the tesserae in the area to be filled. Generally the more illusionistic the space, the more visually disruptive the losses. Previous restorations influenced decisions and the materials chosen had to withstand vibration and other stresses during transport and installation.

Conservation materials are described in the endnotes as they appear in the text. All materials used in association with the mosaics have been studied for conservation purposes. They are believed to be reversible over time, nonreactive with the ancient material, and for the most part visually stable. Each case study discusses the treatments in the field, the treatments over the subsequent seven decades in museums, and the implications of these treatments for the latest conservation campaign. Finally, the most recent conservation treatment is described. After-treatment photographs are shown in the catalogue entries.

Case Study 1:

The *Triclinium* Floor from the Atrium House

The first case study focuses on the treatment and reassembly for the Antioch exhibition of the Atrium House *triclinium* floor made of stone and glass tesserae. Its multiple sections, now belonging to six different museums, had been separated since their excavation in 1932. With the exception of the original U-shaped seating area (fragments of which are in storage at the Hatay Archaeological Museum in Antakya, Turkey), all the mosaic panels were brought to Worcester to be reunited on the gallery floor with the Museum's own panel, the Drinking Contest Between Herakles and Dionysos (WAM 1933.36). Two sections came from the Baltimore Museum of Art (BMA), one depicting a maenad, the other a satyr. The Musée du Louvre lent the Judgment of Paris, and Princeton University and Wellesley College both lent fragments of the Aphrodite and Adonis. Treatment of these panels also included preparing them for travel to two other exhibition venues.

Having been treated in various ways since excavation and having been exposed to different environments (one was exhibited on an outside wall in a northern climate), the mosaic sections varied greatly in condition. In order to join the panels for exhibition and achieve smooth transitions between them and a consistent appearance throughout, the Worcester Art Museum requested permission from the lending museums to treat their works. Permission was granted with a few restrictions: the Louvre asked that treatment be confined to cleaning, while the Baltimore Museum of Art requested that their painted fills not be removed (to keep their mosaics consistent with others in their collection).

Excavation and Dispersal

The Atrium House *triclinium* pavement, the first and only major mosaic find during the initial field season at Antioch, was discovered on April 11, 1932 (fig. 9).[20] It was cut in ten sections that were dispersed among the sponsoring institutions.[21] All pieces were lifted and backed in the manner described above; however, since it was the end of the season, there was not enough time to remove the bedding mortar and apply the concrete backing, which required ten days of curing. Fearing that the faced mosaic segments would be harmed over the winter, the excavators backed each panel with plaster of Paris.[22] It appears that during this first field season small losses were also filled with plaster instead of cement. At the beginning of the following season the plaster of Paris was chipped away and the ancient bedding mortar was removed, which Fisher describes as a "very hard and a slow task."[23] Only then were the mosaic sections backed with reinforced concrete as described. In some places plaster from this early intervention still survives.

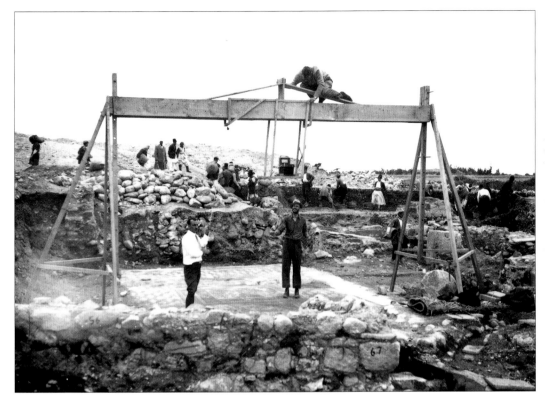

fig. 9. Photography frame set up over the newly exposed *triclinium* floor. Photographer Schirmer stands under suspended camera (Antioch Expedition Archives).

Condition

When the five borrowed mosaic sections arrived at the Worcester Art Museum for the 2000–2001 Antioch exhibition, their general appearance varied greatly. All but the Wellesley fragment had been exhibited at their respective museums. The areas of loss that were filled after excavation with concrete, cement or plaster had been treated in different ways: some museums had left them untreated, others had painted over them replicating the missing designs, and still others had removed some of the concrete and filled the losses with neutral-colored mortar. The main structural problems derived from field treatment, the most serious being the cracking of the concrete-backed mosaics. A number of mosaics had metal frames. Generally, glass tesserae were deteriorated more than stone tesserae. Modern surface coatings had been applied to some panels, and dirt and grime covered all surfaces to some degree.

From the evidence of the excavation photographs, some losses already existed when the pavement was uncovered; others occurred during lifting. A major loss in the *triclinium* pavement predating the excavations was caused by the construction of a wall on top of the mosaic; the excavators discovered the foundations of this wall still *in situ* (see fig. 1 in The Atrium House *Triclinium*). The area affected most by the wall was the upper part of the panel representing Aphrodite and Adonis. The heads of the three figures in this section were destroyed as well as part of the upper foliate scroll, which had probably incorporated a central mask corresponding to the one on the opposite edge of this scroll. Part of the geometric pattern for the seating area was also missing.

Close examination of photographs taken while the mosaic was still *in situ*, indicate that at least two areas were damaged during lifting: the left side of the Drinking Contest panel, including its border and parts of the fallen

fig. 10. The Dancing Satyr from the Baltimore Museum of Art: painted concrete fills imitate the original designs on the bottom center and left corner.

fig. 11. Aphrodite and Adonis on an exterior wall of the Princeton University Art Museum. Some parts of the concrete fills had been painted, such as the meander pattern in the geometric border.

fig. 12. Detail of the Judgment of Paris showing blanched fills and halo around the edges.

drapery below Herakles, and a large area in the foliate and geometric border of the Aphrodite and Adonis panel below the seated group including a central mask (see The Atrium House *Triclinium*, pg. 25).

The excavators' fills were treated differently at each museum after the mosaics arrived from Antioch in the 1930s. While fills were left untreated in the Wellesley panel, the BMA panels were painted over to complete the missing designs replicating a tessellated surface (fig. 10). At Princeton some areas of the fills on the Aphrodite and Adonis mosaic were left untreated, while others were painted (fig. 11). On the Louvre panel, the concrete was replaced with recessed neutral-colored mortar fills in two different colors—gray for losses in the garland border and tan for losses in the figural panel. These fills have since blanched and a halo was visible around the edges when the mosaic arrived in Worcester (fig. 12). On the WAM panel the plaster fills were retouched freely and often inaccurately to complete the missing design (fig. 13).

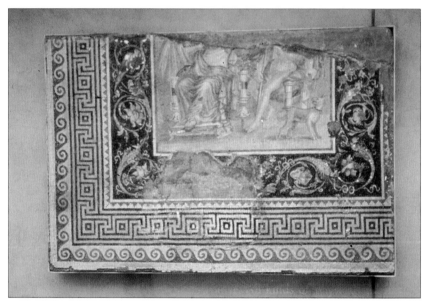

The iron reinforcement bars and iron mesh in the concrete backing of the mosaic panels have corroded from exposure to moisture, producing iron oxide (rust). Since iron oxide occupies a greater volume than elemental iron and concrete is a rigid material, this chemical change has caused radial cracking, which typically extends through the thickness of the concrete backing and runs between tesserae. Cracking of the mosaics was also caused by impact or vibration during travel and handling, as Field Director Clarence Fisher describes in his field diary. He writes, "the trip over the rough road jolted them about so that several are cracked into several pieces." [24] This is probably the explanation for cracking that goes right through the tesserae instead of between them. Cracks were also present on the front of the panels, not penetrating into the concrete backing. Since they are visible in site photographs and therefore predate excavation, they were probably caused by earth tremors. As for example in the Maenad panel from Baltimore, they pose an aesthetic problem, though not a structural one.

The worst cracking, extending through the thickness of the concrete backing, was found in the Princeton section because its outdoor exhibition site had exposed it to northeastern winters since 1989. The iron corrosion problem was exacerbated during freeze-thaw cycles by the expansion of the water in the cracks upon freezing. All but the two Baltimore mosaics exhibited cracking through the thickness of the panels. Princeton University and Wellesley College had constructed iron or steel frames around their mosaics. WAM's Drinking Contest panel is the only mosaic that is bowed: the center is on a higher plane than the left and right sides. This probably occurred because of failure to support the mosaic properly during backing.

Overall, the tesserae were well anchored in the modern concrete backing, although in a few panels small areas of tesserae had become loose or detached completely during deinstallation at the lending museums or during transport to Worcester. Glass tesserae were generally in worse condition than stone tesserae, although the degree of deterioration varied with the composition of the glass tesserae. Glass damage typically occurs during burial with the leaching of certain water-soluble glass components, particularly alkali fluxes (fig. 14). Glass tesserae in the Judgment of Paris panel have fared relatively well, and the subtle gradations of green glass can easily be distinguished (fig. 15). In the Princeton panel, the glass and stone tesserae are equally etched, probably due to exposure to the elements (in addition to deterioration predating excavation).

As described above, the bedding mortar was chipped away in the field before the concrete backing was poured. Overall this process left most of the ancient mortar between the tesserae intact. Examination during the recent treatment campaign showed that this mortar was stable and in good condition, with one exception: in the Princeton panel much of the original mortar between the tesserae had been replaced with modern concrete during the backing process. Possibly the faced mosaic section flexed during lifting and the loose mortar fell out from between the tesserae.

A thick coating was applied to the weather-damaged surface of the Princeton mosaic in the 1990s to protect it and saturate the colors, giving the etched surface a shiny and artificial appearance. The Drinking Contest and the Wellesley panels had been coated with varnishes that had yellowed. Overall, the mosaics were dirty and dusty, especially the Wellesley fragment, which had always been in storage. Both Baltimore panels had burial accretions and small roots still attached to the surface. Close examination of the Drinking Contest panel revealed that only the borders had burial accretions: the central narrative part of the panel had at some point been selectively cleaned. Conservators also observed on all panels that the concrete from the fills often extended over original tesserae along the edges of the losses, obscuring them entirely.

fig. 13. Detail of painted plaster in the Drinking Contest filling losses predating excavation and losses that occurred during lifting.

fig. 14. Detail of the Drinking Contest. Stone tesserae are surrounded by deteriorated glass tesserae.

fig. 15. Detail of the Judgment of Paris. Glass tesserae of many shades of green are in excellent condition.

Treatment of the *Triclinium* Mosaic Panels (1998–2000)

Because of the size of the mosaics and the limited space available in the conservation laboratory, Museum galleries were temporarily converted into a mosaic treatment workshop that was partially accessible to the public. Most of the treatment work was done while the mosaics lay horizontally across steel sawhorses (see fig. 2).

One goal of the treatment of the mosaic panels was to reintegrate them visually while preserving their identity as discrete works for reinstallation at WAM and the lending museums. Conservators sought to clean the mosaics and expose original surface beneath the grime and discolored coatings, and to remove cement or concrete that extended over original tesserae along fill edges. A further treatment goal was to address structural problems to insure safe travel to the other exhibition venues. Because museums had treated their panels so differently, the following paragraphs describe the recent treatment at WAM of each panel separately.

fig. 16. Detail of the Drinking Contest photographed in raking light to highlight the new recessed mortar fills.

While the Drinking Contest mosaic was still on the gallery wall, a yellowed varnish was removed and the plaster fills taken out. For protection during removal from the wall, tesserae along the edges of the losses were secured with an acrylic consolidant.[25] Surface grime and facing glue remaining from the excavation were cleared, and remaining burial accretions and traces of roots were removed mechanically from the geometric borders to bring these areas into better balance with the figural panel.

Losses were compensated with a tan, textured and recessed acrylic fill simulating the original bedding mortar (fig. 16).[26] Brittle areas of 1930s concrete at the corners and edges of the mosaic were consolidated and the concrete backing was reinforced along the edges with a commercial patching cement.[27] To insure safe transport of the heavy, brittle mosaic to other exhibition venues, a steel frame was fabricated and fastened with screws anchored in the sides of the concrete backing. Padded crossbars screwed to the back of the frame and positioned perpendicular to major cracks, provided additional support (fig. 17).

fig. 17. The Drinking Contest receives a steel frame with crossbars that will be padded with polyethylene foam for additional support of cracks during transit to other exhibition venues. Crossbars were placed perpendicular to major cracks.

The surface grime and facing glue residue were removed from Baltimore's Dancing Satyr and Dancing Maenad panels with an aqueous solution in areas of stone, while the water-sensitive glass tesserae were cleaned with ethanol.[28] Excess concrete backing along the edges of both panels was removed so that the panels would fit properly next to the Drinking Contest when assembled on the gallery floor during exhibition. In some areas it was necessary to extend the edges with commercial patching cement in order to make them straight and square. Consistent with the other restorations, these surfaces were inpainted with acrylic paints to resemble the original tesserae. As requested by the BMA, the larger painted tesserae fills extending into the interior of the mosaic were not removed. After the cleaning of the adjacent original tesserae, these areas were much darker than the rest of the mosaic and therefore had to be lightened with acrylic paints to maintain visual balance. A number of detached tesserae from the bottom right

corner of the Maenad mosaic were reattached with acrylic adhesive and a surface crack on the Maenad mosaic extending across the figure's proper right arm was filled.

Grime was removed from the surface of the Judgment of Paris panel (Musée du Louvre) in the same manner as for the BMA panels. Cleaning the tinted mortar fills with deionized water and ethanol reduced the halo described above. Detached tesserae from the bottom proper right corner were reattached and gaps between adjacent tesserae were filled with bulked acrylic resin (the same material used to fill losses in the Drinking Contest panel).

The Aphrodite and Adonis panel required the most complicated treatment. Due to the very different physical appearance and state of preservation of the Princeton and Wellesley fragments, creating a smooth transition between them was challenging. In addition, conservators had to fabricate a connecting element to fill the large loss between the two sections. The cracks on the Aphrodite and Adonis fragment were reinforced and strengthened while the mosaic was vertical in its open crate. Once the mosaic was in a horizontal position, the concrete fills were reduced mechanically to the level of the original bedding mortar. Small plaster fills were taken out as well.

Removal of the coating revealed the etched surface caused by outdoor exposure (fig. 18). Areas of poorly adhered tesserae were reattached or consolidated as necessary. Lost mortar around detached tesserae was replaced with bulked adhesive colored to resemble the bedding mortar. Cracks on the front were strengthened with consolidant, and a new, very dilute acrylic coating was applied to the surface.[29] This coating achieved the desired degree of color saturation without excessive surface gloss, bringing this element into closer visual balance with the adjacent mosaic panels.

fig. 18. Detail of the Aphrodite and Adonis mosaic during the removal of a thick, glossy coating, exposing the weather-damaged surface.

The areas of loss were filled with a variety of materials. In order to join the Princeton and Wellesley fragments visually, it was decided to extend repetitive design elements to connect the floral and geometric borders with the central figural composition (fig. 19). Molded plaster replicas imitating the tessellated surface were fabricated and painted with acrylic paints in a value lighter than

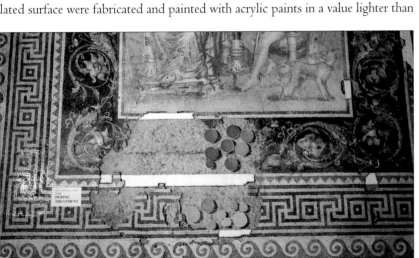

fig. 19. Detail of the Aphrodite and Adonis mosaic after the concrete fills were recessed and the newly fabricated plaster tesserae sections connecting the stepped triangle and line borders were in place but not yet painted. Samples of different shades of tan and gray are being assessed for mortar fills.

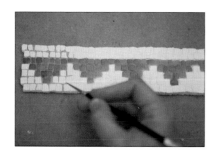

fig. 20. Plaster restoration during painting with acrylic paint. After the repetitive pyramidal pattern was painted by airbrush, the color of the individual tesserae was adjusted using a conventional brush. The mortar between the tesserae was also painted in this manner.

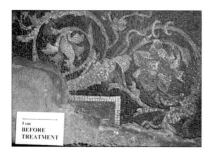

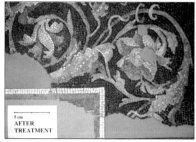

figs. 21, 22. Detail of the Aphrodite and Adonis border fragment before and after treatment.

fig. 23. The Aphrodite and Adonis section is joined with its top border section by a newly fabricated fill panel.

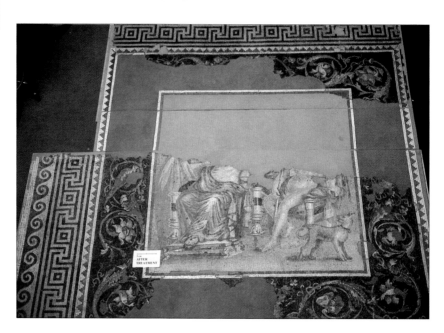

the original, so as to distinguish the restorations, and attached to the areas of loss (fig. 20).[30] After the edges of original tesserae were consolidated, the remaining losses were filled with mortar, slightly recessed to resemble bedding mortar.[31] The two colors of mortar used were similar to the colors of the mortar fills in the Louvre mosaic: a bluish-gray was used in the darker floral border, and a tan in the lighter central figural section and the geometric border below.[32]

In areas where glass tesserae adjoined small losses, the fill material had to be non-aqueous due to the sensitivity of glass to water. Conservators used bulked acrylic resin tinted with inorganic pigments, producing a fill that approximates both the color and texture of the new mortar fills.

The treatment of the upper border of Aphrodite and Adonis panel (Wellesley College) began with the removal of the large concrete-filled loss running diagonally across the fragment. Poorly attached areas of tesserae were secured with adhesive. The concrete overflow from fills covering original tesserae was removed mechanically, as were some of the remaining burial accretions. Cracks in the concrete were consolidated and filled. Losses were filled in the manner described above using three approaches: painted plaster restorations for connecting border design elements, mortar in two different colors, and, for losses abutting glass tesserae, a bulked resin with inorganic pigments. Figures 21 and 22 show a detail of this mosaic panel before and after treatment. To compensate for the large gap of missing pavement caused by a later wall, a separate fill panel was fabricated with sealed exterior plywood as the substrate for plaster and mortar restorations (fig. 23). The use of two different mortar colors in the large areas of loss and the spanning of these losses with plaster replica tesserae help to integrate visually the two parts of the Aphrodite and Adonis panel and enhance the visitor's appreciation for the undamaged parts of the mosaic.

The six mosaic panels and the newly fabricated fill panel for the Aphrodite and Adonis section were placed horizontally on wooden pallets and assembled on the gallery floor so that a forklift or gantry could be used for adjustments (fig. 24). Thin strips of wood painted the color of the tan fills were placed between the mosaic sections to hide the metal frames. The entire U-shaped sitting area with its diamond pattern was replicated to scale with a black-and-white photographic reproduction, and a low wall was built around the mosaic to create an architectural context, with an opening in the front next to the Drinking Contest to indicate the original entryway (fig. 25).

fig. 24. The mosaic panels placed on wooden pallets are assembled on the gallery floor.

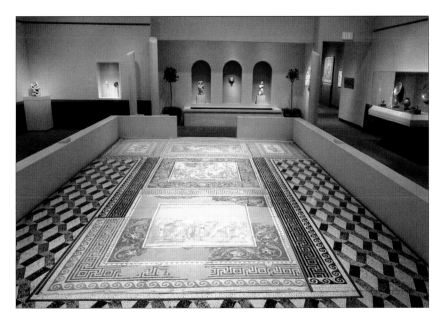

fig. 25. The *triclinium* floor (during exhibition) is surrounded by a low wall; an opening in the front indicates the original entryway. The diners' U-shaped sitting area is suggested by a photographic reproduction.

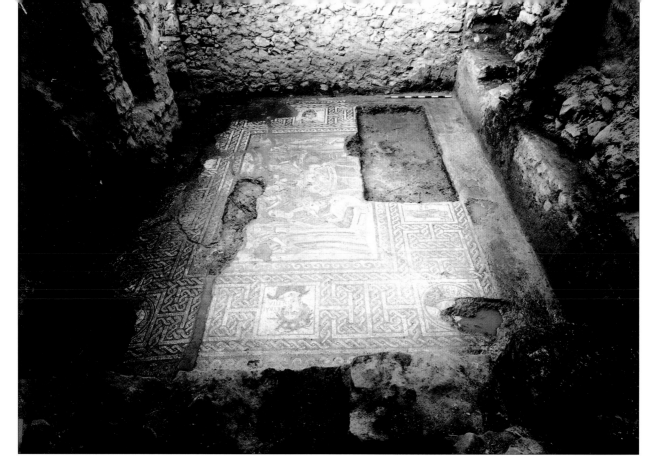

fig. 26. Tomb of a Women's Funerary Banquet after excavation. The large rectangular loss was caused by the insertion of a sarcophagus during a later burial (Antioch Expedition Archives).

fig. 27. Reconstruction of the mosaic floor of the Tomb of a Women's Funerary Banquet.

Case Study 2:

The Pavement of the Tomb of a Women's Funerary Banquet

The second case study describes the treatment of the pavement of the Tomb of a Women's Funerary Banquet, made of stone and glass tesserae (fig. 26). This mosaic, which had been cut in four sections and allocated to the Worcester Art Museum, includes a central panel representing a funerary banquet attended by six women and three border fragments incorporating female personifications. The group was never exhibited as a whole and one of the border fragments was eventually sold (see Mosaic of a Women's Funerary Banquet, cat. 4, fig. 5).[33] The goal of the current treatment was to prepare the central panel for the Antioch exhibition as well as for permanent display with the two extant border fragments on a gallery wall. The main conservation issue concerned the large stone tesserae fills made by mosaic artists hired by the Museum in 1936/37. It was decided to conceal areas of the 1930s restoration which included part of three faces. This was accomplished by covering the modern reconstruction with Japanese paper toned a neutral color similar to the original bedding mortar, so that the covered areas appear to the viewer as a loss.

Excavation and Early Restorations

A local resident discovered this important mosaic pavement, a rare representation of a women's funerary association (see herein Mosaic of a Women's Funerary Banquet, cat. 4), and reported the find to the Antioch excavation team on April 15, 1935. Jean Lassus, Assistant Field Director that season, representing the Musées Nationaux de France (see fig. 3), immediately began to excavate the site, which

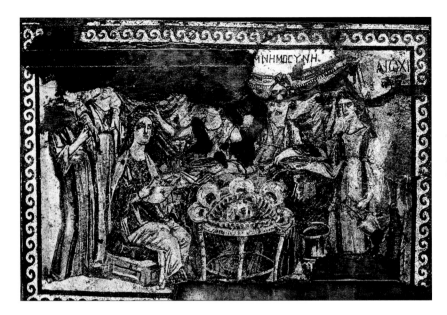

fig. 28. The Funerary
Banquet after backing
with reinforced
concrete (Antioch
Expedition Archives).

was found to be a tomb consisting of a large room, half of which was concealed under a house.[34] Two weeks later, on April 29, Field Director W. A. Campbell reported that the removal of the wall covering the mosaic revealed a pavement representing a funerary banquet attended by six women and surrounded by an intricate geometric border incorporating ten personifications (fig. 26, 27).[35] The pavement had sustained numerous losses (figs. 26, 27, 28): three faces in the central panel and seven personifications in the border were damaged. The greatest damage to the mosaic was the excision of a rectangular area of the pavement for a later sarcophagus, that destroyed part of the central panel's bottom right edge as well as a section of the geometric border with two personifications. The mosaic was lifted in four sections, treated in the field as described above, and shipped to Worcester in the fall of 1936, where it was restored by four Italian mosaic artists from New York City hired by WAM.[36] The section depicting Winter and the Winter Solstice was sold to the Mead Art Museum at Amherst College a few years later. During their four months at the Worcester Art Museum the mosaic artists also restored other Antioch mosaics.[37]

The Funerary Banquet Mosaic

After removal of cement and concrete, larger losses were filled with tesserae while smaller cement fills were left intact. Figure 29 shows a mosaic artist gluing restoration tesserae onto paper for transfer to a loss. On the edge of the workbench in the foreground are restoration sections ready to be incorporated into the border of the Funerary Banquet.

Most of these tesserae fills match the color of the original. However, except for the repetitive border, the restorations are generally inaccurate. Possibly referring to the restored faces, Perry B. Cott, Associate Curator at WAM, wrote, "our mosaic workers needed some supervision as they were inclined to be too realistic," with the unfortunate result that the original faces, because of their weathered condition, seemed inferior to the fresh-looking restored

fig. 29. Mosaic artist during the 1936/37
restoration campaign reconstructing the
wave pattern for the bottom of the
Funerary Banquet.

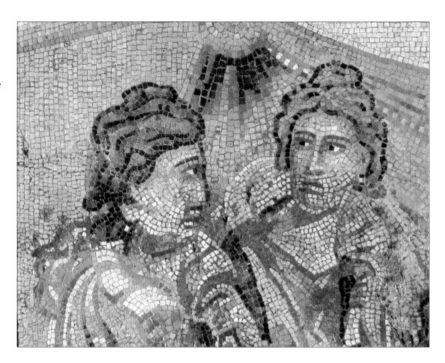

fig. 30. Detail of the Funerary Banquet showing the restored faces of two women on the left side of the mosaic. Note the restored "collar" of the woman on the left.

ones (figs. 30 and 31).[38] The mosaic artists misinterpreted several passages in the Funerary Banquet. For example, the sack slung over the right shoulder of the woman on the left in fig. 30 was interpreted as a collar, so a loss on her other shoulder was filled to resemble a collar (Roman garments did not have collars). Also inaccurately rendered were the three vases, the footwear in the foreground, and the curtain (compare figs. 28 and 31).

Condition. The mosaic has many cracks; some go through the concrete backing, while others predate the backing process and are now locked in place by the concrete. For example, a very wide crack going through the faces of two women

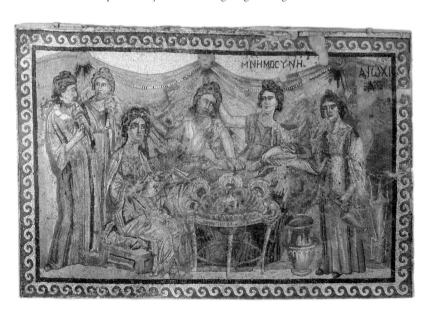

fig. 31. Funerary Banquet after the 1936/37 restoration with stone tesserae.

on the right most likely occurred during an earthquake. Many parts of the mosaic are out of plane, due to either earth tremors before excavation or damage during lifting.

The surface of the mosaic was in relatively poor condition. The glass tesserae are much more deteriorated than the stone ones, although the extent of deterioration varies with the composition of the glass. In areas of loss, cement and concrete overflow covered the tesserae along the margins. The scratch marks clearly visible on the mosaic's surface were caused by the abrasive tools and stones used in the field to remove burial accretions (see fig. 32). Closer examination reveals an uneven surface in which the more prominent tesserae are polished while the recessed areas, including the deteriorated glass tesserae, still retain an irregular archaeological surface. These variations interfere with perspective and spatial relationships, making it difficult to view the narrative. Conservators identified two modern discolored coatings; one coating was probably shellac, and the other a wax.[39]

fig. 32. Detail of the Funerary Banquet showing surface scratches caused by the use in the field of abrasive tools and stone to remove burial accretions.

1998–2000 Treatment. Cement fills remaining from treatment in the field were removed mechanically, in some places exposing original bedding mortar sandwiched between these fills and the backing concrete. Coatings and surface grime were removed with aqueous and organic solvent mixtures.

Several filling approaches were used in treating the Funerary Banquet. Larger areas of loss were generally filled with light brown mortar.[40] Where glass tesserae adjoined losses, dry mortar was mixed with an acrylic resin to protect the glass from water. Cellulose powder was added to this mixture to achieve the desired consistency and texture. To compensate for the irregularity of the mosaic surface, fills were sometimes made flush with the surface and other times recessed. Areas with original bedding mortar remaining were left unfilled as sites for future study.

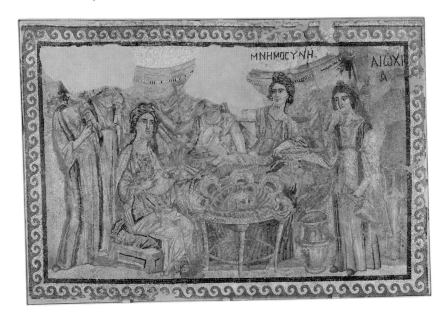

fig. 33. Funerary Banquet after treatment.

fig. 34. Detail of the Funerary Banquet after treatment. The incorrectly restored faces were covered with tinted tissue paper, and the invented "collar" was removed and the area filled with mortar.

The next step in treating the Funerary Banquet was to address the 1930s tesserae restorations. The restorations could not be removed without probable damage to the ancient tesselatum; it was also thought that they should be retained as part of the mosaic's history. Instead, a large area, including three inaccurately restored faces, was covered with archival light-weight Japanese paper, toned to resemble bedding mortar (figs. 33, 34). The 1930s restoration of the curtain was left mostly uncovered, since the work is roughly accurate and the curtain was deemed an essential element of the pictorial space. The 1930s tesserae in the shape of a collar on the garment of the woman at the far left were carefully removed and replaced with a neutral-colored fill (fig. 34). Small losses were filled with paper pulp tesserae.[41] To maintain the illusionistic space (figs. 35, 36, 37) the restoration tesserae were painted to match the original palette. Filling these losses with recessed mortar would have created numerous, visually disruptive shadows. The restorations can easily be discerned with an ultraviolet light source.

Prior to travel for the Antioch exhibition, cracks in the concrete backing were filled with epoxy resin and further stabilized with fiberglass strips. As with the Drinking Contest, a steel frame was fabricated and fastened to the mosaic backing.

fig. 35. (left) Detail of the Funerary Banquet showing the face of the woman on the far right after removal of modern cement fills.

fig. 36. (center) Detail of the Funerary Banquet showing the face in fig. 37 after insertion of restoration tesserae.

fig. 37. (right) Detail of face in fig. 38 after retouching.

fig. 38. Eukarpia section after lifting and backing with reinforced concrete. Much of the garland of fruit and leaves was damaged during lifting.

fig. 39. Computer-enhanced detail from photo taken by archaeologists *in situ* (see fig. 26). It shows the intact floral and fruit wreath now largely lost (Antioch Expedition Archives).

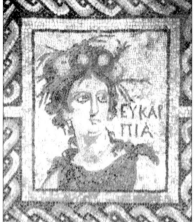

The Eukarpia and Agora Panels

Condition. The leaf and fruit garland in Eukarpia's hair as well as part of her garment were damaged during lifting, perhaps because the facing cloth did not adhere properly to the deteriorated glass tesserae (compare figs. 38 and 39). There are losses to the right of the head, in the right border, along the edges of the fragment, and a number of the black stone tesserae in the word ΕΥΚΑΡΠΙΑ shifted position during lifting.

Photographs of the Eukarpia fragment taken immediately after excavation show a larger portion of the right border (compare figs. 38 and 40). This border section may have been cut for use during restoration work in 1936/37 either on this panel or elsewhere. As with the Funerary Banquet, cleaning in the field abraded high points of tesserae, but left recesses undisturbed. A large area

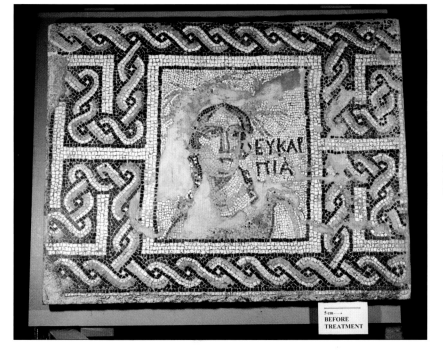

fig. 40. Eukarpia section after the right side was cut and restored in 1936/37.

fig. 41. Agora section after lifting and backing with reinforced concrete.

of loss on the left side of the Agora panel (figs. 26, 41) was filled in the 1930s with stone tesserae, possibly reusing the tesserae from the right border of the Eukarpia mosaic (fig. 42). Several cracks in the upper right quadrant do not penetrate the concrete backing, and were most likely caused by an earth tremor predating excavation.

Treatment. Loose glass tesserae were readhered by flowing consolidant into the cracks around them. Concrete and cement were removed in areas of loss to the level of the original bedding mortar, and concrete and cement overflow on tesserae surfaces was removed in the same manner. The surface was cleaned and the edges of the tesserae adjacent to losses were sealed. Areas of loss were then filled with a recessed mortar as in the Funerary Banquet, since the three panels were to be exhibited together.[42] Smaller losses in the central part of the design were filled with painted plaster tesserae. Cracks were filled using bulked adhesive and inorganic dry pigments.[43] In the Eukarpia panel the letters in the word ΕΥΚΑΡΠΙΑ that had shifted were returned to their original location.

fig. 42. Agora section after restoration by mosaic artists in 1936/37. Note that the lines in the top and bottom borders are not parallel to the edges of the section.

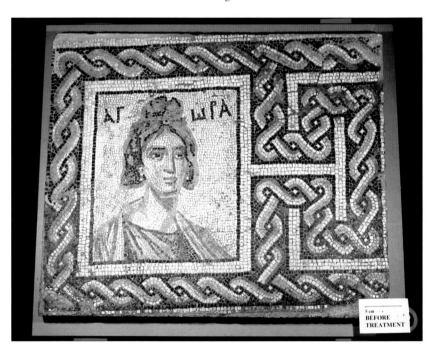

Assembly

In addition to preparing the Funerary Banquet panel for the Antioch exhibition, the ultimate goal of the treatment was to permanently install the Eukarpia and Agora border fragments next to the central panel on a gallery wall. Because of the fragmentary state of this pavement and because the Worcester Art Museum no longer owns all surviving sections, it was decided not to join the two personifications to the central panel in their original position (see fig. 27). Instead, they were placed beside it as a pair, accompanied by a text panel showing the original floor plan of the burial chamber (fig. 43).

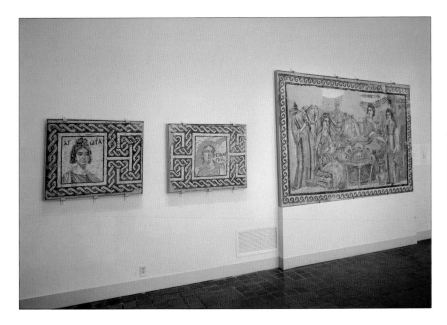

fig. 43. Mosaics from the Tomb of a Women's Funerary Banquet on the gallery wall at the Worcester Art Museum.

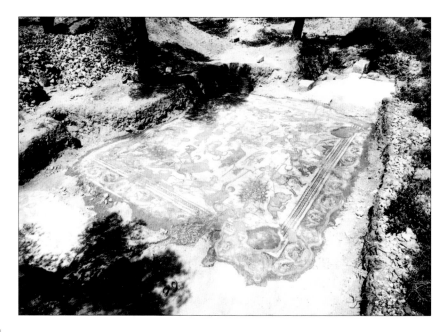

fig. 44. The Worcester Hunt *in situ* after excavation in Antioch, 1935 (Antioch Expedition Archives).

fig. 45. A crate containing a Worcester Hunt section arriving at the Museum on October 1, 1936.

fig. 46. Opening a crate containing a Worcester Hunt section. Mosaics in the crates were padded with sawdust and straw mattresses on either side.

Case Study 3:

The Worcester Hunt

The third case study concerns the conservation of the Worcester Hunt, made of stone tesserae only, which since 1936 has enjoyed a central location on the floor of the Worcester Art Museum's main hall, the Renaissance Court.[44] Soon after this mosaic's multiple sections arrived from Antioch, they were permanently installed in the floor without their fragmentary border, and losses within the central panel were restored with tesserae by the mosaic artists mentioned in Case Study 2. The pavement became an extension of the Museum floor, and the partial barriers put in place after it was installed did not always keep visitors from walking on the ancient pavement. Sometimes performances took place on the mosaic and occasionally it was covered to serve as a dance floor. Not surprisingly, the mosaic required extensive treatment over the years. The most recent conservation project entailed removing a yellowed coating and filling losses. In addition, the fragmentary border was installed. Its placement around the central panel in a museum hall with space limitations, and the challenge of achieving a smooth transition between two components are discussed below. Unlike the approach taken on the Funerary Banquet, modern restorations were not covered or removed. For greater protection, a permanent railing was installed around the entire mosaic.

Excavation and Installation

The Worcester Hunt was discovered on May 14, 1935 less than a meter below the surface in the district of ancient Daphne on the outskirts of Antioch (fig. 44).[45] The mosaic's inhabited vine border survived only partially. Field diaries indicate that the soil layer directly in contact with the mosaic's surface contained fragments of charcoal, suggesting that a fire occurred when the villa was destroyed, probably during the earthquake of 526 C.E. The resulting fire damage is still visible on parts of the mosaic's surface where the otherwise cream-colored limestone tesserae have turned colors ranging from pinkish orange to gray (see fig. 55).[46]

Once the mosaic was cleared of dirt, the edges strengthened, and small losses filled with cement (see fig. 4), the pavement was divided into nine sections (five interior and four border) that were faced, lifted, and backed with reinforced concrete as described above. A year later the nine mosaic panels were packed in crates and shipped to Jersey City, New Jersey.[47] Worcester Art Museum Director Francis Henry Taylor wrote to the shipping company, "it will not be necessary to cover the crates, as they are not affected by weather conditions. The mosaic pavements should always be handled on edge and never flat. And the mosaics should be eased down on the dock by the winch and not dumped."[48] Records indicate that the "antique stone pavements" were valued at $100 per case.[49] After transfer to a train and then to a truck, the crates arrived at the Worcester Art Museum on October 1, 1936 (fig. 45).[50] Within four days the four Italian mosaic artists from New York arrived at the Museum to help install and restore the newly acquired mosaic.

After the Worcester Hunt sections were unpacked, the cloth facing was removed and within ten days the mosaic sections had been placed in the floor on a bed of sand (figs. 46–49).[51] The mosaic was installed without its damaged and incomplete border. The mosaic artists filled the joins between sections by reattaching the two rows of tesserae removed by the archaeologists before lifting (see pg. 82), and removed the cement and concrete that filled the major losses. They filled these areas with a combination of new and ancient tesserae to complete the Roman designs (figs. 50–53). Where the correct color was not available, the artists painted over the restored areas with oil paints to match the original (see fig. 60).[52]

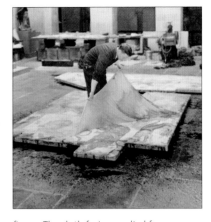

fig. 47. The cloth facing applied for protection during travel has been soaked with water and is being removed from the surface of the mosaic sections.

fig. 48. The mosaic sections are placed on a bed of sand on the floor of the Renaissance Court.

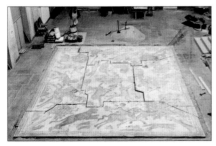

fig. 49. The five Worcester Hunt sections are assembled on the floor without the border.

fig. 50. A mosaic artist restoring the hunter's head in figure 51. Near the front edge of the workbench lies a restoration section for the Worcester Hunt's central panel (see fig. 60). In the background are the Peacock (1936.23) and the Rams' Heads (1936.33) mosaic sections.

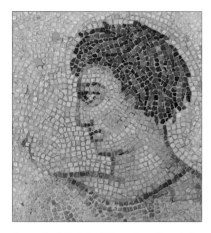

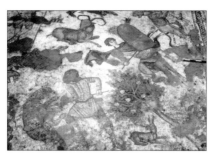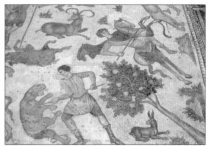

fig. 51. (left) Detail of the restored head of the hunter in figs. 52, 53. While all original heads of hunters are shown in three-quarters view, this one appears, probably inaccurately, in true profile.

fig. 52, 53. A detail of the Worcester Hunt after excavation (center) and after restoration (right) by the mosaic artists. Areas of loss were filled with ancient and modern tesserae.

The tesserae restorations made during this early restoration campaign were not always accurate. For example, while all hunters' heads are shown in three-quarters view with both eyes visible, the restored head in fig. 51 appears in true profile, probably incorrectly (in fig. 50 a mosaic artist is assembling this new head). In some instances the mosaicists traced undamaged parts of the mosaic to transfer the images to areas of loss. For example, the restored horse's head in fig. 54 (shown as a mirror image of the actual restoration for easier comparison) is a copy of the horse's head in fig. 55. As mentioned, the restorers used modern as well as ancient tesserae during their reconstruction work. Modern replacement tesserae were purchased from suppliers in New York City, and the Worcester Hunt border served as a source for ancient tesserae, which led to the further destruction of the already fragmentary borders (see fig. 66).[53, 54] Loose tesserae from Antioch and from the Yale excavations at Jerash were also used.[55] While the new tesserae are easily recognized upon close inspection, restorations made with ancient tesserae are often hard to differentiate from original workmanship.

fig. 54. (left) The ancient head of the horse in fig. 55 was used as a prototype for the restoration of this head. This image is reversed here for easier comparison.

fig. 55. (right) The head of this horse was the prototype for the restoration shown in fig 54. The fire damage to the mosaic in antiquity is visible in the bottom half of this image: tesserae have turned a darker tone, mostly a pinkish orange.

The restoration seems to have been well underway by December, 1936, when Benjamin H. Stone, Secretary at WAM, wrote to Professor W. A. Campbell at Wellesley that "many of the tesserae are already in the mosaics." The mosaic artists did not use all the tesserae they had collected; many were left over and were offered to other museums that owned Antioch mosaics.[56]

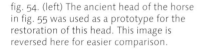

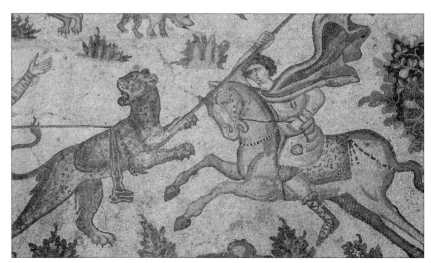

fig. 56. Dance
performance
featuring Twyla
Tharp on the
Worcester Hunt
protected with
plastic sheeting
in 1970.

Treatment of the Worcester Hunt
(1937–2000)

Partial barriers (see fig. 58) set up around the mosaic did not always keep visitors
from walking on it, and occasional performances took place on the ancient pave-
ment (fig. 56).[57] In order to protect it from abrasion it was coated repeatedly: re-
cords show multiple campaigns of coating application and removal between 1937
and 2000. In the 1980s planters were placed around the perimeter to prevent visitors
from walking on it, but it was still used as a dance platform during openings and
parties, although it was covered with rubber mats and a wooden floor (fig. 57). In
the late 1990s a permanent railing was installed around the entire mosaic.

 The first recorded coating, applied in 1941, was Vinylite, a polyvi-
nyl acetate dissolved in methanol.[58] An additional coating of hard paste wax was
applied over the resin. By 1950 these coatings had been removed and the mosaic
recoated with the same materials at least once.[59]

fig. 57. A dance on the Worcester Hunt
mosaic. The mosaic was covered with
rubber mats and a wooden floor.

 In July of 1950 conservator Carroll Wales from the Fogg Art Mu-
seum at Harvard University used organic solvents and ammonia to remove the
wax and Vinylite coatings, a treatment that also removed the oil-paint toning ap-
plied by the mosaic artists in 1936/7.[60] The mosaic was then cleaned with water
and Tide (a relatively new commercial product that contained phosphate chelat-
ing agents), applied on muslin pads that were weighted down on the mosaic for
one to two days.[61] Afterwards the surface was "scrubbed with stiff brushes, a lib-
eral amount of detergent, a coarse pumice stone, and in places with wire brushes."
Residual archaeological deposits from burial were removed with "a steel tool made
from a scratch awl." Wales then applied two coats of methyl methacrylate (known
by the trade name Lucite). In October of the same year a coating of Valspar var-
nish followed by a coating of hard waxes was applied.[62] In May, 1953, the surface
was cleaned and coated again with methyl methacrylate, and in November, 1954,
another coating of Valspar varnish was applied.[63]

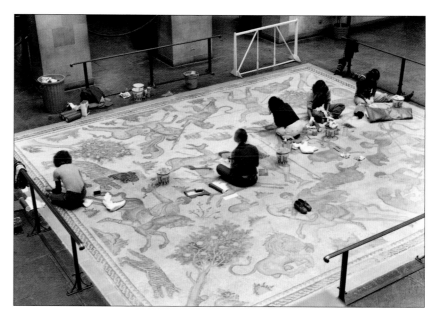

fig. 58. In 1978 six Oberlin College conservation students removed multiple coatings from the surface of the mosaic.

In February, 1963 the Museum's conservator, Edmond de Beaumont noted the excellent condition of the methyl methacrylate coating.[64] He went on to state that the Valspar varnish, on the other hand, was severely abraded, and that the high points of the tesserae showed some marks of abrasion.[65] That same year de Beaumont removed the wax with xylene and cleaned the surface using Clorox bleach and Comet abrasive cleanser.[66] The worn high points were coated with methyl methacrylate followed by Valspar varnish and a wax coating of Butcher hard floor wax or Boston polish. This treatment was repeated in 1970.[67]

In 1978, a team of six painting conservation students from the Oberlin College conservation program came to treat the Worcester Hunt (fig. 58). They started by removing the multiple coatings on the mosaic using All-Pro Semi-Paste paint remover. Additional losses in the mosaic along the border that were still filled with cement were carved out and filled with the commercial product Rapid Stone, which they painted with acrylics applied with a small sponge pad to simulate the tessellated surface (see fig. 61).[68] Finally, the students coated the mosaic with polyurethane.

At some point, modern mortar was used to fill missing bedding mortar between tesserae. There are no records to indicate who did this treatment or when. The material used was a true lime mortar, very light in color and with small dark inclusions that on close examination give it a speckled appearance.

In the early 1980s James A. Welu, then Associate Curator at the Museum, decided to place planters around the mosaic to discourage visitors from walking on the ancient floor. In December of 1985 Paul Haner, Chief Conservator, wrote that he was "very concerned about the disfigured appearance and condition of the mosaic resulting from the irreverent treatment it is receiving [during Museum events]." He recommended that "an alternative location be found for functions requiring a large floor space, and (instead of covering the mosaic during special events to gain more floor space) the mosaic remain uncovered and surrounded by the planter barricade."[69]

Arts of Antioch

Conservation of the Worcester Hunt (2000–2004)

Two quite different treatment approaches were employed in the conservation of this mosaic. The first part of the discussion below treats the conservation of the central portion and the second the conservation of the incomplete border.

Conservation of the Central Portion. Conservators were especially concerned about the mosaic's structural condition after having been walked on for many years. Initial inspection of the central panel in 2001 revealed no visible cracks. Conservators also determined that the uneven surface, especially evident in raking light, was due to the backing process after excavation and was not caused by subsequent use of the floor (fig. 59). Each of the five mosaic sections exhibits a pattern of parallel lines caused by the boards supporting the mosaic sections during application of the reinforced concrete backing. The conservators also observed that both ancient and new tesserae were well anchored into the modern concrete backing.

fig. 59. Worcester Hunt under raking light.

To treat the Worcester Hunt properly, it was necessary to examine the approaches to filling losses taken by previous restorers. Figure 60 shows a restoration by the mosaicists in the 1930s with stone tesserae. Tesserae and mortar used by them remained in good condition. However, the oil paint retouching was removed during the 1950s cleaning campaign. Figure 61 shows a detail of a restoration by the Oberlin students using Rapid Stone that was painted. These latter fills, although in good condition, were sloppily executed. Figure 62 shows an undamaged ancient section of the mosaic.

The bedding mortar visible between the tesserae in the Worcester Hunt varies in color. The original mortar ranges from medium to dark gray, and the mortar used in the 1930s restorations matches the original. However, in many areas of the mosaic modern mortar applied after the mosaic artists' restoration campaign is lighter in color and does not match the original bedding mortar. When observed from a distance, the similarity in tone of this light restoration mortar to the cream-colored background tesserae blurs the distinction between tesserae and mortar (fig. 63). While restorers in the past filled the larger areas of

Three details of the central section of the Worcester Hunt.

fig. 60. (left) The 1936/37 restoration with tesserae by the mosaic artists.

fig. 61. (center) The 1978 restoration by Oberlin students using painted commercial Rapid Stone.

fig. 62. (right) An undamaged ancient section.

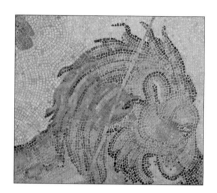

fig. 63. Detail from the Worcester Hunt. Note how the light-colored restoration mortar used in the upper right has blurred the definition of the individual background tesserae and increased the contrast in the colored tesserae in the head design.

fig. 64. The softened polyurethane coating was removed with cotton swabs and acetone.

loss, hundreds of small gray cement and concrete fills from the field remained on the surface of the mosaic, often covering original adjacent tesserae.

The polyurethane coating applied by the Oberlin students eventually yellowed and gave the mosaic a flat and lifeless appearance. Underneath it the surface of the tesserae was abraded, probably from a combination of field treatment and the many cleaning campaigns. No salt efflorescence was visible on the surface of the tesserae or in the mortar between them from either their burial environment or modern cleaning materials.[70]

The conservators and curator had to decide how to deal with the Italian mosaicists' skillful but sometimes inaccurate tesserae restorations in the figural parts of the mosaic. Because of the proximity of original tesserae to restored areas, removal of the latter might damage original parts. Also, in many areas it was difficult to distinguish the boundary between tesserae in their original position and ancient tesserae reused in the 1930s. Should the 1930s tesserae fills be removed? Should restorations made with modern tesserae be treated differently from restorations with ancient tesserae? In addition, compensation techniques used on other mosaics were not feasible for the Hunt. Due to its placement in the floor and its proximity to the museum entrance, the mosaic collects dust and debris, making recessed mortar fills or paper overlays problematic as they would quickly trap dust and dirt. For these reasons, it was decided not to remove the 1930s tesserae restorations. Instead, text panels point out these restorations and explain the issues to the museum visitor.

Treatment started with the removal of the multiple small cement and concrete fills. Cement overflow covering original tesserae was removed, as were the painted fills from the 1978 treatment. The next step was removal of the yellowed polyurethane coating.[71] Initial tests showed that the coating softened after two hours of contact with a 5:1 solution of acetone and ethanol.[72] A double layer of cotton pads soaked in the solvent mixture was applied to the surface of the mosaic and covered with a polyethylene film to avoid evaporation. Once softened, the coating was removed with cotton swabs soaked in acetone (fig. 64).

Small areas of loss were filled with plaster tesserae, which were painted to match the original for the same reasons discussed in the treatment of the Funerary Banquet (Case Study 2). Larger losses were filled with recessed mortar. The restoration tesserae toned in the 1930s with oil paints to match the original and subsequently cleaned were retouched again, this time using acrylic paints to match surrounding original tesserae. The light-colored modern mortar was darkened with acrylic paints to match the original bedding mortar.

Conservation and Installation of the Border. Approximately one-third
of the excavated border was removed in discrete sections by the 1936/37 mosaic
artists and used to fill losses in the central panel. Figures 65 and 66 show a border
section in the condition before and after the removal of the tesserae.

figs. 65, 66. Mosaic border fragment before
and after removal of tesserae by mosaic
artists in 1936/37.

After they arrived in Worcester, the border fragments were stored
uncrated in an exterior light well, and much of their poor condition is the result
of this exposure to the elements.[73] They were structurally weak, and radial crack-
ing from the corrosion and expansion of the iron reinforcing bars had occurred
in the concrete backing. Tesserae were often detached or loose, especially along
the outside edges and the perimeters of areas of loss. Some of the tesserae were
cracked and the bedding mortar was partially or entirely missing between them.
The surface was matte, due to etching and some spalling and shattering of stone.
The surface was also grimy and some areas were discolored and stained by the
glue used to face the mosaics during transport to Worcester.

Areas where tesserae had been removed and only the concrete
backing remained were cut off. Cracks were then reinforced on the verso of the
fragments using fiberglass strips and fractured and loose tesserae were adhered.
Cement and concrete were removed along with grime and adhesive residues. A
thin acrylic resin coating was applied to the surface to consolidate the tesserae
and mortar and to saturate the etched tesserae to restore color balance with the
mosaic's central panel.

At the urging of the curator, a mosaic scholar, it was decided that
the border was an essential part of the mosaic's composition and should be in-
stalled with the rest of the mosaic. Because of space limitations in the gallery and
the fragmentary state of the border, it was not possible to install all the fragments
in their original positions. There was only enough space to expand the mosaic on
two sides and still allow public access. The fragments were placed on opposite
sides of the central section, corresponding to the original west and east sides. Pri-
ority was given to arranging the border fragments in the order most accurately re-
producing the repeating scroll, even though this meant the installation of only
one fragment (west side) close to its original location (section 1 in figs. 67 and
68). Both fragments originally spanning the entire north border of the mosaic (sec-
tions 3 and 4) were kept together and placed on the entire former east side. The
border section surviving from the east side (section 2) was moved to the west. Af-
ter sections of the Renaissance Court's flagstone floor were removed, the border
fragments were laid on a bed of sand with the additional support of numerous ce-
ment shims to place them at the correct height.

Large gaps between border fragments and large losses within them
were filled with a recessed mortar in a gray-brownish color in keeping with the
dark background of this border.[74] While recessed mortar areas will trap dust and
dirt and must be cleaned regularly, filling them with restoration tesserae would
have meant inventing designs. Small areas of loss were filled with painted plaster
tesserae, and missing bedding mortar between tesserae was replaced with a tan

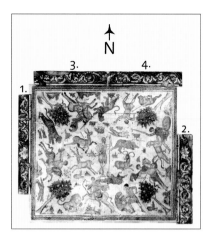

fig. 67. (above) Photocomposite of Worcester Hunt showing original location of the border fragments.

fig. 68. (right) The Worcester Hunt with border fragments in their current position. See fig. 67 for their original location.

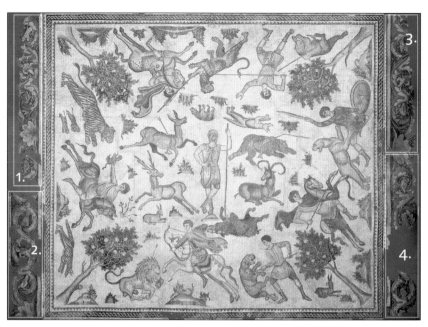

acrylic mortar. The narrow join between the border sections and the central part of the mosaic was also filled with painted plaster tesserae.

Conservation treatment of the Worcester Hunt has dramatically changed the viewer's perception of this work. Removal of the yellowed coating and the filling with restoration tesserae of the hundreds of small losses previously filled with concrete has brought the hunting scene to life again. The inpainting of the modern restoration tesserae from the 1930s and the white mortar has also pulled together original and restored parts. The mosaic has been transformed by the rejoining of the ancient border. Once again the darker palette of the border dramatically sets off the center. The playful *erotes* of the border balance the graphic hunting scenes of the interior. The various filling techniques applied in the fragmentary border were chosen to further aid in unifying the sections visually. In order to mitigate dust accumulation on the mosaics, a shallow barrier made of stone tiles will be installed around the perimeter.

Conclusion

The mosaic conservation campaign at the Worcester Art Museum took hundreds of hours of research, careful examination and treatment. Considerable time was spent in preparatory research in the Antioch Archives at Princeton University, and in discussions regarding presentation issues with the curator, director and colleagues in the field. In order to design and implement a successful conservation treatment plan for over fifteen mosaics, it was essential that the conservators understand the excavation techniques, materials used in the field, and treatments undertaken at the Worcester Art Museum and other museums after the mosaics became part of these museums' collections. This entire process has given the conservators and the curator a unique opportunity to learn about this favorite Roman art medium. The comprehensive conservation campaign has not only improved the appearance and presentation of the Antioch mosaics but also resulted in a new appreciation for them by colleagues in conservation, archaeology, and art history as well as the general public.

1. Conservators participating in this mosaic treatment campaign were Lawrence Becker, Diane Fullick, Connie Green, Judith Jungels, Sarah McGregor, Sarah Nunberg, Sari Uricheck, Alisa Vignalo, and the author. Interns and volunteers were Anna Boeschenstein, Greg Coffey, Deborah Diemente, Emily Egan, Suzanne Fonck, Louise Groll, Elizabeth Holter-Mehren, Casey Light, Christina Marcus, Anya McDavis-Conway, Courtney Mikoryak, Rebecca Molholt, Corine Norman, Robin Osten, Marjorie Peairs, Abita Raj, Jessica Smith, Meg Stivison, and Marc Walton. The curator was Christine Kondoleon.

2. Artal-Isbrand 2002; Artal-Isbrand and Nunberg 2003; Artal-Isbrand and Vignalo 2005 (in press).

3. Antioch ll 1938, 2, 4; Fisher 1932, Field Diary, April 10, 1933, 120.

4. Antioch ll 1938, 4. Campbell 1934, Field Diary, April 14, 1934

5. Gabriel was on staff through 1936, when he is last mentioned in the expedition record.

6. Fisher 1932a, Field Diary, May 11, 1932, 85; Stillwell 1936, 4.

7. This system can be observed in numerous photographs and a 1932 excavation film, and is also documented in the field notebooks.

8. Campbell 1934, Field Diary, April 19, 1934, 160.

9. Fisher 1932a, Field Diary, May 30, 1932, 96.

10. Fisher 1933, Field Diary, April 22, 1933, 125.

11. Cott 1940.

12. Campbell 1934, Field Diary, April 20, 1934, 160; 1932 movie clip.

13. Fisher 1932, Field Diary, June 2, 1932, 99; Fisher 1933, April 11, 1933, 121; Campbell 1934, Field Report, 15.

14. Morey 1938, 27.

15. Fisher 1933, Field Diary, April 22, 1933, 125, 126.

16. Hafez 1977.

17. Campbell 1934, Field Report, 15; Fisher 1932, Field Diary, June 2, 1932, 99, April 22, 1933, 125.

18. Cott 1940; materials are listed in invoices 7, 8, 9, 16, 24 August, 1936 (WAM Archives).

19. As described in invoice of expenses for 'Worcester Museum Shipment' (voucher 8) (WAM Archives).

20. Fisher 1932, Field Diary, April 11–20, 59–67, and April 21, 85, 1932; this mosaic's discovery and excavation were meticulously documented in field notes, drawings, photographs and movie footage.

21. Fisher 1932b, Director's Report, 20.

22. Fisher 1932a, Field Diary, June 1, 1932, 98, 99.

23. Fisher 1933, Field Diary, April 10, 1933, 121.

24. Fisher 1933, Field Diary, April 22, 1933, 125.

25. Acryloid B-72 consolidant is a 8–20% solution in acetone: ethanol, 3:1 unless otherwise indicated.

26. The composition of the fill was: Acryloid B-72 adhesive (50% solution in acetone: ethanol, 4:1), 3M glass microballoons and inorganic pigments (which are stable over time and do not fade on exposure to light). This mosaic was the first one treated during the Worcester campaign. The B-72 and 3M glass microballoon fill was discontinued after completion of the treatment of this mosaic because it is very time-consuming to make and because upon complete drying it is quite brittle.

27. Conpro-set is a patching cement containing Portland cement, calcium carbonate, crystalline silica, acrylic polymer and a proprietary ingredient.

28. The aqueous solution was composed of deionized water in a saturated solution of calcium carbonate. The calcium carbonate was added to maintain a pH level above 9.5 to avoid dissolution of calcite in the limestone tesserae. This solution was not used on the glass tesserae because of their sensitivity to water.

29. The coating consisted of two layers of Acryloid B-72, 4% in acetone: ethanol, 4:1.

30. The plaster replicas were made as follows. A mold of the mosaic surface was made with President two-part dental silicon-based impression compound. The surface of the mosaic was first coated with an isolating layer of B-72, 8% in acetone: ethanol, 9:1, to avoid stains from the oily residue of the impression compound. A wood frame was built around the mold and plaster was poured into it. After curing, the segments were individually cut to fit the areas of restoration and the sides carved to resemble the edge of a tessellated structure. The isolating layer on the mosaic surface was later removed with acetone.

31. The filling compound is a restoration mortar, Edison Coatings salt-free System 45, a two-part system: part A is a water-based acrylic compound that is mixed with part B, the dry cement-based mortar. Edison Coatings has a full range of colors in their line of mortars. Stable inorganic pigments and ground colored stones are added to the mortar to achieve specific colors and textures. The components are mixed in a proportion of about 7:1 by weight and applied to the substrate, which is first primed with Part A.

32. The gray-bluish color was achieved by mixing the following components of Edison Coatings System 45 (part B): 50% #102, 25% #502, 25% #505. The tan color was achieved by mixing: 50% #170, 25% #102, 25% #32.

33. The Worcester Art Museum sold this mosaic section to the Mead Art Museum at Amherst College in 1942.

34. Campbell 1935, Field Diary, April 15, 1935, 242; Levi 1947, 291.

35. Campbell 1935, Field Diary, April 29, 1935, 246.

36. The four men who arrived on October 5, 1936 were Honore Pasquali (in charge of the team), Hector Moro-Lin, Antonio Cimarosti and Albino Tizian. They were paid $11.50 per day (eight hours), $14 per week for board, and railroad fare to and from New York (letter from Perry B. Cott, Associate Curator, to Elizabeth H. Payne at Smith College Museum of Art, December 10, 1938). Mr. Moro-Lin went to Wellesley afterward and restored their Antioch mosaics and Mr. Tizian restored the mosaics in Providence (one originally from WAM).

37. The Worcester Hunt (1936.36) (see Case Study 3), the Peacock (1936.23), the Ktisis (1936.35), the Dionysos and Ariadne (1936.25), and the Rams' Heads (1936.33) mosaic sections. They finished work in January of 1937, according to a letter dated March 15, 1941 from Worcester Art Museum Secretary Benjamin H. Stone to Baltimore Museum of Art Director Leslie Cheek (in WAM Archives).

38. Letter from Perry B. Cott to Elizabeth H. Payne at Smith College Museum of Art, December 10, 1938.

39. One coating's distinctive bright orange-yellow fluorescence under ultraviolet light identified it as shellac. Fourier transform infrared spectroscopy analysis performed by George Wheeler at the Metropolitan Museum of Art indicates that the second coating is a mixture of carnauba wax and beeswax, possibly with some oil added.

40. The light brown color was achieved by mixing Edison Coatings System 45 (part B): 50% #170, 25% #102, 25% #32.

41. These tesserae were cast from plasticine molds prepared by taking an impression from an intact area of the mosaic surface, which was first isolated with Acryloid B-72 consolidant to avoid staining of the original surface. The isolating layer was later removed with acetone.

42. The Edison mortar color is the same mix as in the Funerary Banquet mosaic, endnote 40.

43. While 3M glass microballoons were used as a bulking agent in the Eukarpia section, for the Agora section Whatman's cellulose powder was used because it achieved the desired texture and consistency.

44. Due to its large size this mosaic was not part of the traveling exhibition.

45. Campbell 1935, Field Diary, May 14, 1935, 251.

46. Calcite, the major mineral in limestones, would be altered to calcium oxide by extensive heating, but this is also a white compound. However, limestones usually contain small amounts of other minerals that might produce colors as they are broken down by heating. A pinkish orange color suggests iron oxide (s) produced by chemically breaking down iron-containing minerals (which could include clays). Gray could be produced by organic material in the limestone.

47. Campbell 1936 (letter to B. Stone), August 13, 1936 (WAM Archives).

48. Taylor 1936 (letter to J. Stevens at American Express Company), September 15, 1936 (WAM Archives).

49. Cable from Francis Henry Taylor, July 21, 1936 (WAM Archives).

50. The crates were trucked by E.J. Cross Co. of Worcester from the Worcester train station to the Lancaster Street entrance of the Worcester Art Museum.

51. Letter from Benjamin H. Stone to William Campbell at Wellesley in 1937. The E.J. Cross Company completed the work for $1,100. Letter from Robert Cross, Vice President, to Benjamin H. Stone, November 10, 1936 (WAM Archives).

52. 1950s Conservation Summary on the Treatment of the Worcester Hunt Mosaic (WAM Archives).

53. Report on Antioch Mosaics (no date). Modern cubes were purchased from E.J. Cornelis, 225 West 34th St., New York, and De Paoli Mosaic Co., 739 2nd Ave., New York (WAM Archives). This information is also in a letter from George L. Stout, WAM Director, to Leslie Cheek, Director of the Virginia Museum of Fine Arts, July 5, 1951 (WAM Archives).

54. On a list of Antioch mosaics in storage at WAM compiled by H. E. Werner in June 1950, Group 3 are the four border fragments stored in the basement corridor to the storeroom. This document states that "tesserae were removed from these mosaics after their arrival at Worcester to repair the large Hunting scene and there are no photographs of them in their present condition" (WAM Archives).

55. In a letter dated October 10, 1936 to Benjamin H. Stone, Adib Ishak, Antioch Expedition Secretary, mentions bags of loose tesserae. In a letter dated October 15, 1936, Yale University Gallery of Fine Art's Director Everett V. Meeks offers Francis H. Taylor tesserae from Jerash (WAM Archives).

56. In June, 1937, tesserae were sold to Wellesley, and in July of the same year Dumbarton Oaks accepted Worcester's offer of unused tesserae and noted that loose tesserae from the excavation might also be available at Princeton. In December, 1937, Perry Cott offered several "bags of cubes" to Smith College (letter from Elizabeth Payne). In 1951, Worcester director George Stout wrote the Virginia Museum of Fine Arts that "we have a large number of miscellaneous tesserae in bags, some from the wreckage of Antioch mosaics... (WAM Archives)."

57. In a letter to Baltimore Museum of Art Leslie Cheek in Baltimore, May 15, 1941, Benjamin H. Stone writes, "we only place mats on our mosaics when we use the hall as an auditorium for we then place chairs and seated people scuffling their feet would soon wear through the Vinylite" (in WAM Archives).

58. This is a precursor to the conservation material AYAF. Vinylite was recommended by the mosaic artists, as mentioned in a letter from Stone to Cheek in Baltimore, May 15, 1941 (WAM Archives).

59. In conservation summary of the 1950s (in WAM Archives).

60. Carroll Wales' treatment is described in a conservation summary of this mosaic covering the period 1936–1953 (WAM Archives); it is also described in the *Worcester Art Museum News Bulletin and Calendar*, November, 1950, Volume XVI, No. 2.

61. At this time phosphates were added to bond preferentially with minerals that tend to harden water, such as calcium. The Tide used on the surface of the mosaic for one or two days probably affected the surface of the limestone tesserae to some extent by reacting with the calcium.

62. Valspar is a line of commercial products still current. The hard wax coating was a mixture of carnauba, ceresin and bleached beeswaxes (WAM Archives).

63. In conservation summary of the 1950s (WAM Archives).

64. From a report on the examination of the Worcester Hunt mosaic, February 5, 1963 by Edmond de Beaumont. He also recommends that the wax coating be "renewed at least twice a year (possibly more often during the winter season when great deal of grime is brought into the Museum)" and he also suggests that "the application of spar varnish should be undertaken three to four weeks later to allow thorough evaporation of the solvents. In turn, this should be allowed a month to oxidize fully before the wax coating is applied" (WAM Archives).

65. Report on the Examination of the Worcester Hunt Mosaic by Edmond de Beaumont, February 5, 1963 (WAM Archives).

66. Conservation record of the Worcester Hunt Mosaic, 2, 1963 (WAM Archives).

67. March 20, 1970 conservation summary (WAM Archives).

68. Conservation record of the Worcester Hunt Mosaic, last page (WAM Archives).

69. Memorandum, 12 December 1985 (WAM Archives).

70. For example, Clorox contains chlorine, which forms chloride salts, and Tide detergent forms phosphate salts. Concrete and cement can also contain compounds such as nitrites and chlorides that lead to salt formation.

71. The polyurethane coating was identified as an oil alkyd resin modified blend. Analysis was performed by Michele Derrick at the Museum of Fine Arts, Boston, and also by Jennifer Mass from the Winterthur Museum Analytical Laboratory, Winterthur, DE.

72. The addition of oil to urethane renders the film very tough and durable, since the oil cross-links. Initial tests for polyurethane removal allowed a gel made of acetone and hydroxy propyl cellulose to remain on the surface for two hours. Conservators were concerned about using this material because it dries on the surface and is hard and time-consuming to remove. Mixing the solvent into the gel was yet another time-consuming step.

73. In June 1950 the border sections were stored in the basement corridor to the storeroom. They were unpacked and placed leaning against the west wall of the Museum. They were noted to be in "poor condition" and "not exchange material" (letter of G. Stout to Adelyn D. Breeskin, Director of BMA, 17 March, 1952, in WAM Archives). In 1970 the borders were put into dead storage in the light well.

74. Composition of the gray-brownish mortar is Edison Coating System 45 (part B): 50% #102, 50% #502.

fig. 1. Detail of guilloche border of the Dancing Maenad.

Glassmaking Technology at Antioch

Evidence from the Atrium House Triclinium and Later Mosaics

Mark T. Wypyski and Lawrence Becker

Introduction

A WIDE VARIETY OF COLORS of glass tesserae were found in the mosaics from the Atrium House *triclinium* as well as in those analyzed from other houses and tombs dated from the second to late fourth century excavated at Antioch[1] (fig. 1). X-ray microanalyses were done of samples of the different colors from a number of glass-containing mosaics. Quantitative analyses of the glass compositions of these tesserae can provide comparative information for these mosaics, and can clarify the relationship between the glass in use at Antioch and the late Roman world in general. For a related discussion of these issues see Material Study: The Glass in the Atrium House *Triclinium* essay.

Analytical Methods

Small samples of the tesserae were removed using a diamond-edged scribe and steel scalpel, with care taken to sample intact glass from below the outer weathered surfaces. The samples, on the order of one cubic millimeter in volume, were prepared for analysis by embedding them in epoxy and grinding with silicon carbide paper to expose the interiors. The cross sections were then polished with cerium oxide and given a high-vacuum carbon coating for conductivity. The samples were analyzed over as much of the exposed areas as possible, while avoiding areas of obvious weathering or alteration. High-magnification analyses were also done of the crystals and inclusions present in many of the glasses.

The samples were analyzed in the X-ray microanalysis laboratory at The Metropolitan Museum of Art using an Oxford Instruments INCA analyzer equipped with an energy dispersive X-ray spectrometer (EDS) using a Link Pentafet

SATW X-ray detector, and a Microspec WDX-400 wavelength dispersive X-ray spectrometer (WDS) equipped with LiF, PET, TAP and LSM 80 crystals, one flow proportional counter and one sealed proportional counter X-ray detectors. The X-ray analyzers were attached to a LEO Electron Microscopy model 1455 variable pressure scanning electron microscope (VP-SEM). Analyses were performed under high vacuum conditions at an accelerating voltage of 20 KV, using a beam current of approximately 1 nA for EDS analysis and 50 nA for WDS analysis.

Weight-percentage concentrations of the elements detected were calculated in comparison to well characterized reference glasses and glass standards, including Corning A, B, C and D and Society of Glass Technology standards 5 through 11. The relative variation in the calculated percentages for the major element oxides with this EDS under these conditions is estimated to be less than 2 percent for silicon and sodium, less than 5 percent for potassium, calcium, and lead, and about 10 percent for magnesium, aluminum, tin, antimony, copper, and iron. The minimum detection limits (MDL) for most elements with EDS were found to be about 0.1 percent by weight, although the MDL for elements such as phosphorus was somewhat higher, estimated at approximately 0.2 percent under these operating conditions: the detection limits for elements such as lead, antimony and tin were even higher, about 0.5 percent, mainly due to peak overlap problems. Some of the limitations of EDS analysis were obviated by using the WDS detector to analyze for elements present or possibly present in very small amounts (at or below the EDS detection limits).[2] The MDL with the WDS under these operating conditions was estimated at about 0.01 percent for most of the oxides investigated here, with lead oxide estimated at about 0.05 percent.

X-ray microanalysis using both the EDS and WDS detectors has several advantages over other bulk analytical or surface analytical techniques such as neutron activation analysis (NAA) or X-ray fluorescence (XRF). Ancient glass may be partly or mostly weathered, altering the chemical composition of the surface. Both bulk analysis and surface analysis of this type of glass give an unrealistic reading of the overall composition. X-ray microanalysis of properly prepared samples can focus on the remaining intact glass in a partially weathered sample, and can also characterize inclusions and crystalline phases within the glass matrix (fig. 2).

The Appendix gives the quantitative results for the combined EDS and WDS analyses of 19 elements commonly found in ancient glasses. Analyses were done of samples of 109 tesserae from the *triclinium*, dated to the early second century C.E. on archaeological and art-historical evidence, as well as 117 tesserae from other Antiochene mosaics from the late second century to the end of the fourth century, for a total of 226 different tesserae from 15 different mosaics. The samples are individually numbered and organized by mosaic, with tesserae from the mosaic interiors and borders listed separately. The tesserae are described by color, and chemically distinct glasses with the same approximate color are listed by number; i.e., Green, Green 2 and Green 3 are all green tesserae of approximately

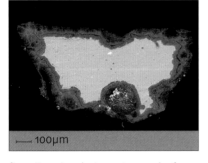

fig. 2. Scanning electron micrograph of a cross-sectioned sample of yellow glass (no. 33) showing the weathered exterior of the glass and the lead-antimonate crystals in the glass matrix (original magnification 200×).

the same visual appearance but somewhat different compositions. All the tesserae are opaque except as noted in the color description.

The results, given in oxide weight percentages, are from EDS analysis for the major and minor components 1 percent or more; amounts less than 1 percent are from WDS analysis. Results are rounded to the nearest tenth of a percent, with results under 0.1 percent reported to two decimal places. Elements listed as 'n.d.' were not detected by EDS or WDS analysis. The Appendix also gives observations and comments on some of the samples based on light microscopy (LM) and scanning electron microscopy (SEM) examination, and high magnification spot analyses with EDS. Analyses of some of these samples appeared in a previous article.[3] These samples were re-analyzed for the present publication using the methods and equipment described above.

Overall Compositions

The vast majority of the glass tesserae analyzed here, with the exception of some of the reds and the orange tesserae, have soda-lime-silica (i.e. based on sodium, calcium and silicon) compositions, with relatively low levels of magnesia and potash (magnesium and potassium oxides), about one half to one percent each. This type of glass is often called *natron-based* or simply *natron* glass, as it is thought to have been produced using natural mineral deposits of soda such as from the Wadi Natrun in Egypt; ancient documentary sources such as the Roman author Pliny as well as modern analytical studies support this theory.[4] (While the term natron is commonly used to refer to the inorganic sodium salts found at the Wadi Natrun and elsewhere, the main mineral species of sodium carbonate usually found is called *trona*.) With natron as a fluxing agent, silica (silicon dioxide, the main component of most forms of glass) can be melted at a much lower temperature than pure silica alone. The source of the silica used in natron glass is usually thought to be sand containing a significant amount of lime, such as coastal sand with a relatively large amount of shell (calcium carbonate). While this simple two-component system can account for the overall composition of natron glass, there is also some evidence that shell may have been intentionally added to the glass mix.[5] The percentage of alumina (aluminum oxide) in natron glasses is generally rather high, typically about 2 to 3 percent (although many examples have been found containing less than 2 or considerably more than 3 percent). The presence of the alumina is mainly due to aluminum silicate minerals in the sand used as the silica source, and varies depending on where the sand was obtained. Natron glass, sometimes referred to as low-magnesia low-potash glass (LMLK), was the most common type of glass produced throughout the Mediterranean world and Europe from about the middle of the first millennium B.C.E. through the ninth century C.E.[6]

Soda (sodium oxide) levels in these tesserae vary mainly between about 14 to about 20 percent, with smaller amounts found in the oranges, many of the reds, and some of the greens and yellows that contain significant amounts of lead oxide. Lime (calcium oxide) for the most part is present between about 5 to 8 percent, although more than 9 percent lime was found in several of the reds,

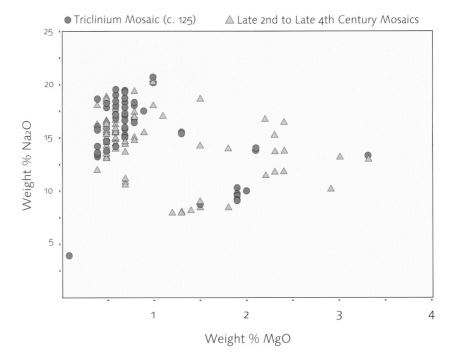

fig. 3. Soda and magnesia concentrations of glasses from the *triclinium* and the later mosaics.

and several high-lead yellow tesserae contain less than 4 percent. Alumina levels were generally between about 2 to 2.5 percent. Again, some of the reds and oranges differ: many of the reds contain close to 3 percent alumina and most, though not all, of the orange tesserae contain about 3 percent or more. Comparisons of the relative amounts of some of the major glass components show that the same approximate ranges are found in the tesserae from the triclinium as well as the later mosaics, although the range for the later mosaics is slightly broader (figs. 3, 4).

Recent work by Freestone and others recognizes at least five groups of natron-based primary glass production sites in use from between about the fourth and ninth centuries c.e.[7] Other researchers have also tentatively recognized earlier groups from the Roman period.[8] Primary glass, or raw glass, is that produced directly from the basic raw materials, which is then either worked into various forms or transported as unworked chunks of glass to local glassworking sites to be shaped into the final product. While all five groups are thought to have been made with the same basic alkali source, the sand used as the silica source probably varied from site to site, accounting for most of the differences seen among groups. These glass groups were identified by comparing the relative amounts of the major elements present, as well as the ratios of certain trace elements, particularly the rare earth elements such as lanthanum and cerium. While it is not possible to quantify the range of these trace elements with the analytical techniques used in this study, comparison of the major elements in the Antioch tesserae reveals that many of them show affinities to the HIMT glass group. HIMT glass has been identified in fourth-century groups mainly from England and Italy and contains relatively high levels of iron, manganese and titanium. This type of glass is relatively high in soda, but contains somewhat less alumina and lime than some of the other groups identified.

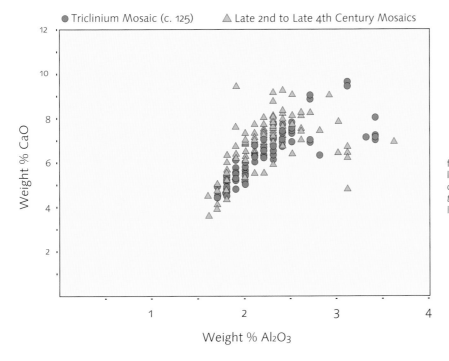

The figure shows a scatter plot.

● Triclinium Mosaic (c. 125) △ Late 2nd to Late 4th Century Mosaics

Weight % CaO

Weight % Al₂O₃

fig. 4. Alumina and lime concentrations of glasses from the *triclinium* and the later mosaics.

Other glasses from Antioch may belong to the group designated Egypt II. Egypt II type glass, while also relatively high in soda and relatively low in alumina, generally contains more lime than HIMT glass. This glass, though, is mainly known from Egyptian production during the eight to ninth centuries, and may not even have been made during the second to fourth centuries. A few of the glasses may belong to one of the other groups associated with higher alumina, such as that designated Levantine I, known from early Byzantine period sites but also associated with a fourth-century Palestinian site. The majority of the high-alumina glasses from Antioch, however, are reds and oranges, which, as discussed later, contain higher levels of magnesium and certain other elements; since they may not be natron based, they do not fit into the scheme of primary production sites identified so far (see fig. 5).

Identification of primary glass sources of colored glasses such as these mosaic tesserae is somewhat problematic, as the colorants used were almost certainly unpurified, and other materials may have been added along with the colorant that could affect the amounts of the trace elements used to characterize the groups. Colorants present in large amounts can also significantly affect the apparent amounts of the main glass elements that characterize the different groups. For example, the yellow glass sample no. 155 from the Marine Mosaic contains nearly 30 percent lead oxide as well as significant amounts of antimony and iron, but less than 11 percent soda, under 2 percent alumina and much less than 4 percent lime. Normalizing the amounts of the other elements present to reflect the basic glass composition and omitting the elements present due to the yellow colorant (lead, antimony and some of the iron), one can calculate an original glass composition of about 16 percent soda, more than 5 percent lime and about 2.5 percent alumina. The possibility of recycling or mixing of glass from different primary

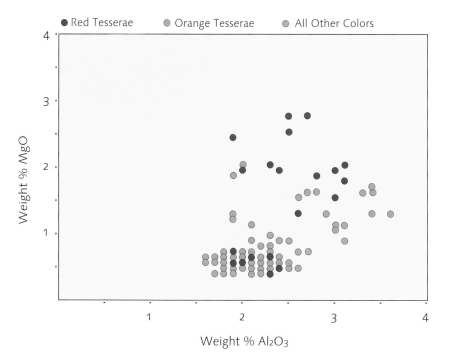

fig. 5. Comparison of magnesia and alumina concentrations for red, orange and all other color glasses.

production sites also greatly complicates identifying the possible origins of the glasses.

Small amounts or traces of certain elements were also noted in nearly all the glasses, regardless of color, and presumably were added unintentionally with the main ingredients of the primary glasses. Chlorine (Cl) was consistently found at close to 1 percent in all glasses, with some containing as much as 1.5 percent. Sulfate (SO_3) is also present in the glasses, generally in the range 0.2 to 0.3 percent. Phosphate (P_2O_5) is also present, generally below 0.2 percent and in many cases below 0.1 percent. However, some of the reds and orange tesserae contain significantly more phosphorus oxide, sometimes more than 1 percent, which is consistent with the use of a plant ash as the alkali source, rather than a mineral such as natron. Some studies, particularly earlier analyses of glasses, do not report the amounts of these trace elements, although they can add up to two or more percent of the total composition and can provide important classification clues.

Opacifiers and Colorants

The majority of the tesserae are of opaque glass, that is, they contain particles or inclusions within the glassy matrix that impede the transmission of light. Most tesserae were found to contain significant amounts of antimony, and high-magnification examination of the opaque tesserae revealed crystals consisting mainly of calcium and antimony, or of lead and antimony. This is consistent with the presence of the opacifier calcium antimonate ($Ca_2Sb_2O_7$ or $CaSb_2O_6$) in the opaque whites, turquoises and blues, or lead antimonate ($Pb_2Sb_2O_7$) in the opaque yellows and greens. Studies have shown that these antimony compounds were the predominant opacifying agents used in glassmaking from the middle of

the second millennium B.C.E. to about the fourth century C.E., after which tin-based opacifiers became prevalent.[9] Although some of the tesserae in the present study date to the mid to late fourth century, no clear evidence was found for the intentional use of tin-based opacifiers instead of antimony compounds. One light green translucent tessera, no. 169 from the Funerary Banquet, was observed to contain a few yellow lead-tin crystals (apparently in the form of lead stannate, $Pb_2Sn_2O_7$) and no lead antimony, but this does not appear to have been used to opacify the glass, although it may have affected its color. It is uncertain whether this was an intentional addition to the glass.

The antimony in the calcium antimonate probably came from stibnite, an antimony sulfide ore that was roasted to convert it to antimony oxide.[10] When added to the glass melt, the antimony oxide reacted with the calcium already present to form calcium antimonate crystals as the melt cooled. The relative uniformity and morphology of the calcium antimonate crystals in the opaque glasses suggest that they were precipitated in the melt in this way, rather than being already formed before being added to the glass. It has been noted that glasses containing large amounts of antimony are often associated with slightly higher sulfur contents (for example, white tesserae 64, 65 and 66), possibly due to the addition of incompletely oxidized stibnite.

Opaque white glass tesserae appear in only one of the mosaics from the *triclinium*, the Judgment of Paris, although white glasses were found in four of the later mosaics dating from the late second to the fourth century. White glass tesserae were certainly used before the triclinium's creation, as examples have been reported from the first century C.E.[11] The absence of white glass tesserae in the other mosaics from the *triclinium* appears to have been an artistic decision, similar to the lack of red glass tesserae in the Judgment mosaic. The amount of antimony in the tesserae opacified by calcium antimonate varies considerably. Most of these tesserae contain somewhere in the range of about 1 to 3 percent antimony oxide, with an unknown percentage of the antimony actually present in the form of calcium antimonate crystals. Several, though, were found to contain about four percent antimony oxide, such as two of the three white tesserae from the Judgment mosaic, and the light blue from the Dancing Satyr (no. 38). Studies of other opaque Roman-period glass have shown that antimony oxide values vary widely, from less than one percent to as much as about ten percent, although most are in the range of about two to five percent. A sample of white enamel from an enameled copper alloy oval brooch from Antioch dated to the second or third century C.E. (cat. no. 37) was found to have a similar overall composition to the white tesserae from the mosaics, but contains more than twice as much antimony oxide as any of the Antioch tesserae opacified with calcium antimonate.

Rather small amounts of antimony oxide, less than one percent, are present in some of the opaque tesserae, in some cases measured at 0.5 percent or less, as in the two turquoise tesserae from the Princeton Drinking Contest mosaic (110 and 124). It seems somewhat surprising that such small amounts of antimony can produce an opaque glass. This might indicate a better control with time

over the production of the glass, with the ability to precipitate all or nearly all of the antimony in the glass melt as calcium antimonate crystals. Alternately, it might be due to economic factors, such as an increase in the cost of antimony ore at the time that the Princeton mosaic was made, although the white tesserae (121 and 122) from this mosaic contain nearly 4 percent antimony oxide. Possibly the use of the lightly opacified tesserae was simply due to an aesthetic choice on the part of the artist creating this mosaic, who had a preference for tesserae with a more opalescent than opaque look.

In an earlier study of Roman glass, Henderson found that British white enamels opacified with calcium antimonate were characterized by relatively high levels of magnesium, while other opaque enamels had only small amounts of magnesium.[12] Studies of Roman glass from other areas, however, have generally found that white glass has the same overall composition as other opaque glasses, with generally low levels of magnesium. All the white tesserae analyzed from the Antioch mosaics were also found to contain only small amounts of magnesia, less than 1 percent. High-magnesia Roman white glass may have been produced in a Roman British context, but does not appear to have been commonly used elsewhere. Possibly these whites were produced with a different source of antimony that contained some magnesium, or else the magnesia was introduced separately, perhaps by adding dolomite.

While the main source of antimony of the calcium antimonate opacifier may have been stibnite, evidence suggests that the source of the yellow lead-antimonate form may have been quite different, possibly antimonial litharge.[13] Litharge is a yellow form of lead oxide produced in antiquity as a by-product of the cupellation process used to extract silver or gold from lead or lead-containing ores. The extraction of silver from ores containing significant fractions of antimony produced large quantities of litharge contaminated with antimony. It has been argued that this antimonial litharge could have been the source of both the lead and the antimony in the lead-antimonate-opacified glasses.[14] Whether the antimony and lead were added as antimonial litharge or not, lead antimonate-containing glasses and crystals are also associated with high levels of iron, indicating that different sources of antimony were used to produce the lead antimonate and the calcium antimonate, which is not associated with iron. Also unlike the calcium antimonate-containing glasses, the uneven distribution of the lead antimonate crystals and the morphology of most of these crystals indicate that the lead antimonate was added to a glass batch mainly as already formed particles, rather than precipitating in the glass melt as it cooled (fig. 6).

The amounts of lead oxide in the different yellow opaque glasses in this study varied tremendously, from less than 5 percent to nearly 30 percent. In other studies some yellow opaque glasses, mainly from glass vessels, have been found with even more than 30 percent lead oxide, but most yellows, like the tesserae from Antioch, contain somewhere in the range of 5 to 15 percent. While the amounts of lead and antimony in the glasses opacified with lead antimonate show a general correlation, the individual ratios of lead oxide to antimony oxide

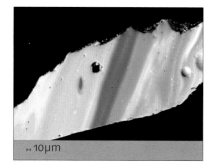

fig. 6. SEM micrograph of yellow glass sample (no. 209) showing heterogeneous mix of translucent and opaque phases. Brighter areas correspond to areas of higher lead oxide and lead antimonate concentrations, while the darker streaks are translucent, low-lead areas (original magnification 500×).

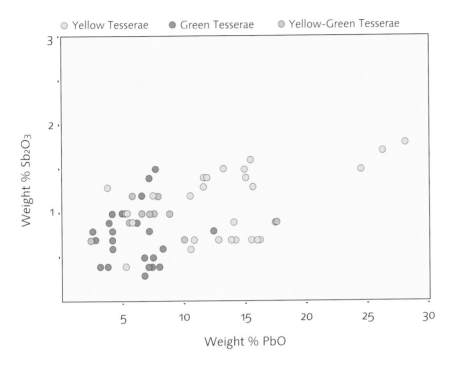

fig. 7. Lead oxide and antimony oxide concentrations in yellow, yellow-green and green opaque glasses.

in these glasses vary widely, from a low of about 3 to 1 to more than 20 to 1, with an average ratio of about 10 to 1 (fig. 7). The amount of antimony in a litharge byproduct may have varied quite a bit, being dependent on the composition of the ore being smelted and the processing conditions, and this variation might account for the variation in the lead to antimony ratio observed in these glasses. The lead content of all the glasses, though, appears to exceed what is needed to have all of the antimony present in the form of the lead antimonate.

The green opaque glasses also contain lead antimonate crystals; the green color arises from the combination of the yellow lead antimonate and the copper oxide in the glass matrix, which by itself would produce a light blue or turquoise glass. Copper oxide is present in these glasses at about 1 to 3 percent. Glasses described as yellow-green generally contain less copper oxide than the greens, mostly around 1 percent, although several of the yellow-greens contained more copper than some of those described as green. The overall appearance of the color depends on several factors, including the size and density of the yellow crystals in the matrix and the amount of copper oxide. The description of these colors is also somewhat subjective: some of those placed in one of these two categories might easily fit into the other.

The greens and yellow-greens generally contain less lead oxide than the opaque yellows, usually no more than about 10 percent, with many under 5 percent, although one green opaque contained more than 12 percent and two yellow-greens contain more than 17 percent. Other than the yellow, green, orange, and some of the red tesserae, little lead was found in most of the tesserae, although traces of lead (less than 1 percent) were found in many of the colors, possibly due to the recycling of lead-containing glass cullet in manufacture. Most, though not all, of the opaque turquoise and light blue copper-colored glasses contained

traces of lead. Small amounts of lead oxide greater than 1 percent, however, were found in a few tesserae where there was no apparent need to add lead, as in the pale gray-blue tessera no. 19 from the *triclinium* Drinking Contest. This is almost identical in composition to the other three pale gray-blue tesserae from this mosaic except for the presence of about 4 percent lead oxide. About 3 percent lead oxide was also noted in one of the black tesserae (81), while little or no lead was detected in the other five black tesserae analyzed. Lead oxide has been noted in some other Roman glasses in which it seems to have no relation to the color, as in the white glass of the British Museum's Portland Vase.[15] The white in this well-known cameo glass vase was found to contain 12 percent lead oxide, while the dark blue glass did not contain any significant amount of lead. Lead was probably intentionally added to make the white overlay glass softer and therefore easier to cut and grind to form the image on the vase.

Analyses of some of the individual yellow crystals in the green and yellow glasses, as indicated in the observations in the Appendix, show that many of them contain small amounts of tin as well as the lead and antimony, and seem actually to be a mix of lead antimonate and lead stannate, rather than pure lead antimonate. The ratio of antimony to tin in these crystals was generally about 3:1, although some had ratios as low as 2:1 or even 1:1. It is unclear where the tin in these crystals originates. The lead antimonate/tin crystals were more noticeable in the opaque greens than the yellows, suggesting that the tin may be due to the source of the copper oxide added to the glass. While most of the crystals may have been formed before addition to the glass, the presence of tin in some crystals suggests that these crystallized after addition to a glass to which the copper source had already been added. However, some tin was noted also in a few yellow tesserae, where copper levels are very low; the tin in these glasses may have been added with the lead and antimony source. Although small amounts of tin were found in many of the yellow and green tesserae, there appears to have been no deliberate use of lead stannate (lead-tin yellow) in place of the lead antimonate, as in natron-based tesserae dating from the fifth century and later. Relatively large, rounded clear inclusions were noted in some of the yellows as well, which EDS analysis revealed to be silica (SiO_2) particles (fig. 8).

An unusual type of opaque green glass, designated pale green in the Appendix, was found in two of the mosaic panels from the *triclinium* as well as in one of the later mosaics. The green color is not due to a mixture of yellow antimonate crystals and blue copper oxide, as in the other opaque greens. Analyses of the opacifier crystals in these tesserae revealed that they consisted mainly of calcium antimonate. Only traces of lead were found in the pale greens from the *triclinium* mosaic, although slightly more was found in the tessera (181) from the Agora. This tessera was also found to contain a few lead antimonate crystals along with the calcium antimonate. The pale green tesserae have the visual appearance of white glass that has been lightly tinted with green, although in overall composition they closely resemble many of the light blue tesserae. One of the pale greens from the Maenad mosaic (28) has a nearly identical composition to the light blue from the Satyr (38), while another pale green (29) is almost an exact

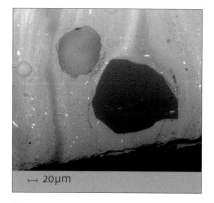

fig. 8. SEM micrograph of yellow glass (no. 101) with large silica particle in glass matrix (original magnification 500x).

⊢ 20μm

match, except for color, to the light blue from the Judgment of Paris border (69). How these green tesserae may have been produced is uncertain. Although they appear visually like a mixture of opaque white and green translucent glasses, their similarity to the light blue tesserae suggests that they were made in the same way, possibly from the same batch of glass, except for a difference in oxidizing conditions in the furnace.

Calcium antimonate crystals were also noted as the principal opacifier in the opaque turquoise, light blue, blue and pale gray-blue tesserae. Many translucent glasses were also found to contain significant amounts of antimony as well, several with more than two percent, as in the blues from the Princeton Drinking Contest (111 and 112). Although some of these have a few calcium antimonate crystals in the glass matrix, the macroscopic impression of these glasses is translucent, and most of the antimony present is dissolved in the glass. These tesserae may have been produced from glass decolorized with antimony oxide, or may have been made using glass containing some recycled opaque glass; during remelting, the calcium antimonate crystals would for the most part have dissolved in the glass melt.

The blue tesserae contain cobalt oxide as the colorant. A significant amount of iron was also found in the blue glasses. Iron above the level normally found in primary glasses is common in Roman blue glass, and appears to be an unintentional addition from the use of a cobalt ore source associated with iron. Studies of cobalt sources used in glass and ceramics have identified several groups of cobalt sources by their association with other elements such as iron, nickel and arsenic. The association of cobalt with iron is consistent with the group identified as Roman-type, which is known from objects dating from the first millennium B.C.E. to about the end of the first millennium C.E.[16] Traces of copper were also found in most of the blues, but the small amounts present do not appear to be enough to affect the color significantly, and were probably unintentional additions. However, one of the blue translucent glasses, no. 48 from the Judgment of Paris, has a copper inclusion in the glass, possibly from deliberately added copper. Eighteen tesserae in the present study were identified as pale gray-blue in color. With a single exception, these were also found to contain traces of cobalt oxide, generally less than 0.05 percent, while the blue opaque and translucent glasses were generally found to contain more than 0.05 percent. Cobalt is a strong colorant in glass: unlike copper, only very small amounts are required to produce a noticeable color. Aside from the traces of cobalt, the pale gray-blue glasses are essentially identical in composition to some of the white glasses containing low levels of antimony. Many of the pale gray-blue tesserae were lightly opacified, and some of the optical quality of these tesserae may also be due to an opalescent effect in contrast to the more opaque white tesserae.

The light blue and turquoise tesserae, in contrast to the blues, were found to contain significant amounts of copper but no cobalt. Copper oxide by itself in a glass can produce a light blue color. The presence of iron in a copper containing glass tends to shift the color more towards turquoise or even to green,

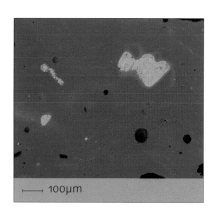

fig. 9. SEM micrograph of metallic inclusions in green opaque glass no. 7 (original magnification 220×).

depending on the overall composition and the oxidizing conditions of the melt. Small amounts of tin and lead were noted in most of the light blue, turquoise and green tesserae, probably from the use of bronze or leaded bronze as the copper source. Metallic inclusions observed in some of these copper colored glasses consist mainly of copper with some tin and appear to be bronze remnants (fig. 9). One of the dark greens was found to contain what may be a remnant of tinned bronze as well (see the Atrium House *Triclinium* essay, fig. 48). Some of the light blues and greens were observed to contain some tin oxide crystals as well. These do not appear to be deliberate additions, but probably formed in the melt after addition of a tin-containing copper source. Zinc was also noted in some of the copper colored glasses, particularly in the tesserae from the mosaics in the House of the Drinking Contest, indicating that brass or a quaternary alloy was used instead of or in addition to bronze.

Three types of glass were found in the six black tesserae analyzed. Examined by transmitted light, the samples of black glass were found to be actually dark brownish green, dark purple or gray in color, although they all appear more or less black in reflected light, as they would appear in the mosaics. Three of these tesserae, from the Judgment of Paris border, the Aphrodite and Adonis border and the Funerary Banquet (81, 109, 175), appear to owe their dark greenish color to relatively large amounts of iron oxide in the form of iron oxide alone or possibly mixed with some iron sulfide. Two others, very dark purple tesserae, from the Dionysos and Ariadne mosaic (212, 213), contain large amounts of manganese oxide. Manganese dioxide can act as a decolorant in glass by counteracting the colorant effects of iron oxide, while manganese trioxide, apparently the form present in these tesserae, acts as a purple colorant. Two glasses described as brown and amber in color, nos. 123 and 204, apparently owe their color to iron, although in these tesserae the color appears to be mainly due to iron sulfide.

The black glass from the Judgment of Paris figural interior (67) was very different in composition from all the other tesserae analyzed in this study: it contains a small amount of soda, very little lime and only a trace of magnesia, but a relatively large amount of potassium and a very large amount of alumina. The color appears to be due to the relatively large amount of iron present. Iron oxide inclusions were also noted in the sample. This glass appears to be obsidian, a naturally occurring form of volcanic glass, rather than a man-made material. Obsidian is known to have been used in Egyptian and Roman art, and to have seen some use in Byzantine enamels as well.[17] Other instances of obsidian as mosaic tesserae are not known, however, perhaps due to the relatively high cost of obsidian versus glass.

Reds and Oranges

Red glass is a fascinating topic in itself and has been the subject of entire articles.[18] Two basic categories may be distinguished in the 26 reds analyzed in the present study. Unlike the tesserae of other colors, most of the red glasses, as well as all of the orange tesserae, were found to contain relatively high levels of magnesium and potassium, as well as more phosphorus than usual in natron-type glass. These tesserae may have been produced using a plant source of alkali, rather than natron. High-magnesia, high-potash (HMHK) glass is thought to have been produced with ash made from halophytic plants. These types of ash are rich in sodium but, unlike natron, also contain significant amounts of magnesium and potassium as well as calcium and phosphorus. Plant-ash or HMHK glasses are perhaps best known from studies of ancient Egyptian and Islamic-period glass.[19]

In addition to the HMHK type reds, another type may be distinguished with simple natron-type compositions, similar to that of most of the other tesserae in this study. These reds, about two-fifths of the total number analyzed, are distinguished from the first group by the amount of lead oxide present. The low-magnesium reds were found to contain only small amounts of lead oxide, if any, up to about two percent. Most of the high-magnesium reds, in contrast, generally contain more substantial amounts of lead oxide, from about 5 percent to a maximum of 16 percent, although two of these reds, nos. 199 and 200 from the Eukarpia mosiac, contained less than 2 percent each (fig. 10).

Other studies of Roman glass have also noted HMHK compositions in red glasses. In a study of Roman-age British glass,[20] Henderson distinguished four red glass compositional types. While two of these types correspond to the

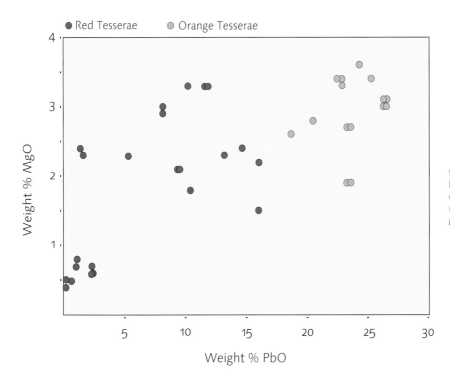

fig. 10. Magnesia and lead oxide concentrations of red and orange glasses.

two types of red found here, neither of the other types of red, sometimes called 'sealing-wax' reds, were found in any of the Antioch mosaic tesserae. Both sealing-wax reds are distinguished from the other kinds of red glass by containing very large amounts of lead oxide, generally in the range of thirty to almost forty percent by weight, as well as by much higher levels of copper oxide, around 4 to 8 percent rather than the 1 to 2 percent seen in the low-lead red glasses. The cuprite crystals in most high-lead red glasses are in the form of relatively large dendritic crystals, while the low-lead reds, like the red tesserae analyzed here, contain small round crystallites well under one micron in diameter (fig. 11). Analyses of red tesserae from other Roman sites, such as Pompeii, as well as some early Byzantine mosaics[21] also did not show any high-lead red tesserae, although high-lead red glasses were used in some Roman enamels. The advantage of high-lead glass for enameling lies in its lower softening temperature, but there seems to be no obvious advantage for mosaic work.

The colorant and opacifier in opaque red glass has been found to be mainly cuprous oxide or cuprite, a reduced red form of copper oxide. Copper is commonly present in glass in the oxidized cupric form (CuO), producing a blue or blue-green color. Under strong reducing conditions (i.e. very low oxygen), CuO can be converted to the reduced form, cuprite (Cu_2O), or even to metallic copper. These crystals can precipitate out in a glass to opacify it and give it a red color. The final appearance of the glass is determined by the amount and size of the cuprite and any copper crystals formed, as well as by the color and clarity of the surrounding glass matrix. The production of red glass is technically demanding, and depends on establishing strong reducing conditions in the atmosphere surrounding the glass melt, on the addition of chemical reducing agents to the glass mixture, or both. Maintaining reducing conditions until the glass has cooled is also crucial, as the cuprite crystals formed can readily redissolve in the molten glass if exposed to air. Partial reoxidation or incomplete reduction of the copper can render a bright red glass a darker muddy red, as the translucent glass matrix surrounding the red crystals becomes green or blue in color from the dissolved copper oxide.

Various oxides may have been deliberately added to glass melts in ancient times to aid in producing the required reducing conditions. Recent work has suggested that the high HMHK reds and oranges produced during the Roman period may have started as natron glass, with wood or plant ash added to the glass melt to act as a chemical reducing agent for the copper oxide, resulting in the higher amounts of magnesium, potassium and phosphorus observed in many of these reds.[22] However, many of the red tesserae in this study appear to be simple natron glasses, so addition of ash was not necessary to reduce the copper in the melt. The HMHK reds here may merely reflect local glassmaking practice from certain areas that used glass made from plant ash rather than natron and specialized in producing red glass. The HMHK green or blue-green translucent copper-colored glasses occasionally seen in a Roman context may actually represent failed attempts at producing red glass.

fig. 11. SEM micrograph of red glass (no. 103) showing the sub-micron cuprite crystallites in the glass matrix that color and opacify the glass (original magnification 2000×).

As noted above, many of the reds contain significant amounts of lead oxide. The presence of lead oxide in a glass favors the formation of cuprite and also improves the optical properties of the glass. Large amounts of lead oxide in a glass are almost certainly intentional additions, but it is unclear what amount of lead actually indicates an intentional addition. It has been argued that percentages as low as about one percent are probably intentional additions to red glass, while others have contended that levels below about ten percent may be unintentional. The copper and lead in some red glasses may have been added together in the form of copper-bearing litharge or slag byproducts from a metal-refining process like what has been proposed for the production of lead antimonate-containing glasses. Analyses of litharge and slag from a silver-refining process found that both contained large amounts of lead oxide as well as copper oxide, along with some silica. The ratio of lead to copper oxide in these materials is similar to that in many Roman red glasses.[23]

Other elements often appear in Roman reds as well. Small amounts or traces of tin oxide and zinc oxide are nearly always present in the reds. Like lead oxide, tin can promote the precipitation of the crystalline copper phase and would have been a useful deliberate addition, although the role of zinc is less clear. The small amounts of these elements found in most red glasses, however, appear to argue against deliberate addition. Although some Byzantine red glasses have been reported with significant levels of both tin and zinc oxide,[24] most Roman reds, like the glasses analyzed in this study, have variable but generally very small amounts of these elements. If they are unintentional additions, as seems likely in these reds, they probably were added to the glass mixture along with the source of the copper. While as noted above copper (and tin or zinc, as well) may have been introduced as a component of litharge or slag, it has been theorized that the primary source of copper was the recycling of copper alloys. Thus, small amounts of tin in a red glass may indicate that the source of the copper was a bronze alloy, while zinc would indicate the use of a brass. The presence of tin, zinc and lead might indicate the use of a quaternary alloy.

If metals were added in alloy form, the ratio of elements present in the glass should be the same as in the alloy itself. For example, use of a bronze alloy containing about 10 percent tin as a source of copper should produce a tin-copper ratio of about 1:9, regardless of the absolute amount of copper present in the glass. However, the ratio of elements such as tin to copper, while variable, is often relatively high in red glasses, much higher than usually found in most Roman bronzes or in other copper-colored glasses such as turquoise (fig. 12). This result has been used as an argument against the use of metal alloys in red glasses. However, it is likely that an oxidized form of the metal was used as a copper source in glass, rather than the metal itself, as the oxide would dissolve much more readily in the glass melt. Such oxides might have been in the form of scale produced when metal was heated in air, or possibly even natural corrosion products. Metal oxidation and corrosion products can be quite variable in composition, depending on the original alloy and the environment in which the mineralization takes place, and the ratio of elements in the various oxidized layers

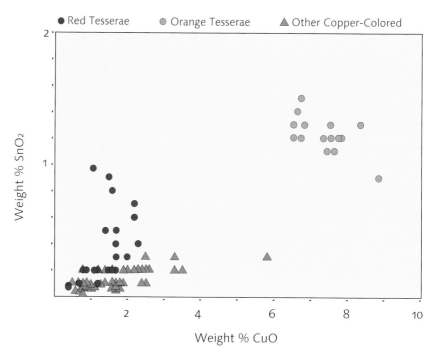

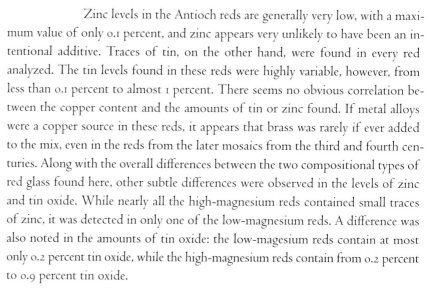

fig. 12. Copper oxide and tin oxide concentrations of red, orange and all other copper-colored glasses.

formed on a metal can also vary quite a bit from the ratios in the original alloy. The use of these naturally variable composition materials, rather than intentional differences or differences between different production sites, might be the source of the varying ratios of certain metallic elements in the glasses themselves. It should be noted, however, that inclusions in some of the red glasses included copper (fig. 13), as well as one with iron; none of the inclusions were found to be bronze, as in some of the green glasses.

Zinc levels in the Antioch reds are generally very low, with a maximum value of only 0.1 percent, and zinc appears very unlikely to have been an intentional additive. Traces of tin, on the other hand, were found in every red analyzed. The tin levels found in these reds were highly variable, however, from less than 0.1 percent to almost 1 percent. There seems no obvious correlation between the copper content and the amounts of tin or zinc found. If metal alloys were a copper source in these reds, it appears that brass was rarely if ever added to the mix, even in the reds from the later mosaics from the third and fourth centuries. Along with the overall differences between the two compositional types of red glass found here, other subtle differences were observed in the levels of zinc and tin oxide. While nearly all the high-magnesium reds contained small traces of zinc, it was detected in only one of the low-magnesium reds. A difference was also noted in the amounts of tin oxide: the low-magesium reds contain at most only 0.2 percent tin oxide, while the high-magnesium reds contain from 0.2 percent to 0.9 percent tin oxide.

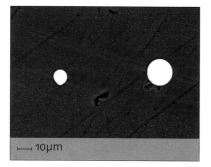

fig. 13. SEM micrograph of red glass no. 46, showing round black copper inclusions and the smaller cuprite crystallites in the glass matrix (original magnification 2000×).

In addition to the elements discussed, iron oxide levels are generally rather high in these reds, and it may have been an intentional additive. Most ancient colorless or weakly colored glass contains about 0.5 to 1 percent. The reds in this study contain an average of more than 2 percent iron oxide. The iron levels varied from a little more than 1 percent in some cases to more than 3 percent in others with the high-magnesium reds averaging less than the low-magnesium reds.

Arts of Antioch

Iron oxide can be a reducing agent as well for the copper oxide, and would seem to be a useful additive in the production of red glass. The somewhat higher levels of iron in the low-magnesium reds may be evidence that iron oxide was added more consistently to these than to the high-magnesium reds. A relatively large black inclusion observed in one of these reds, no. 103 from the Aphrodite and Adonis mosaic, consists mainly of iron surrounded by copper (see fig. 14). If the high-magnesium reds were produced by the addition of plant ash to the glass melt as a reducing agent, then, compared with the low-magnesium reds, there would be less need for an additional chemical reducing agent such as iron oxide (see also the Triclinium essay, pg. 53 above).

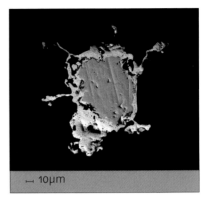

fig. 14. SEM micrograph of black inclusion, iron (slightly darker center) surrounded or coated with copper, in red glass no. 103 (original magnification 800×).

Antimony oxide was also found in many of the reds, from small traces barely above the minimum detection limit to nearly 1 percent. Like tin and iron, antimony is likely to aid in the reduction of copper oxide in the glass. The relatively small amounts seen, however, as well as the wide variation in the amounts, appear to argue against deliberate addition in these reds. It seems more likely that antimony was an unintentional addition to these glasses, probably from the use of cullet containing glass decolorized by antimony oxide, opacified with calcium antimonate, or both.

Two variants of red glass observed in the border of the Aphrodite and Adonis are designated dark red and bright red. Both reds are of the low-magnesium, low-lead category, with very similar overall compositions. The only significant difference between them is the presence or lack of manganese. Manganese oxide was commonly used as a decolorant in Roman-period and later glass and acts to counteract the green color contributed by iron to a glass. The bright reds in the Aphrodite and Adonis border contain small amounts of manganese while the darker reds were found to have only traces of manganese, an order of magnitude less than the bright reds. The bright reds are brighter in color mainly because the cuprite crystals present in the glass are suspended in a clear colorless matrix, while in the darker reds they are surrounded by a greenish color, darkening the overall shade of red. Antimony may also have been intentionally or unintentionally used in some of the other reds to decolorize the glass matrix and produce a brighter red, as in reds nos. 37 and 46 from the Maenad and Satyr borders, which contain nearly 1 percent antimony oxide.

Like most red tesserae, all seventeen orange and red-orange tesserae analyzed have HMHK compositions, indicative of the possible use of plant ash as the alkali source. Large amounts of lead were also found in all of these as well, with an average value of 23.5 percent. Although higher than in any of the red tesserae analyzed here, these lead values are less than usually found in high-lead sealing wax red glasses. Like the sealing-wax reds, though, the amounts of copper oxide present are much higher than in the reds here, ranging from more than 6 to nearly 9 percent. Traces of zinc and antimony were detected in all of the oranges and red-oranges, as well as relatively high levels of iron oxide, from about 2 percent to more than 4 percent. All of these glasses contain significant amounts of tin oxide as well, from about 1 to 1.5 percent.

fig. 15. SEM micrograph of red-orange glass no. 107 showing tin oxide inclusion and the surrounding smaller cuprite crystallites in the glass matrix (original magnification 5000×).

fig. 16. SEM micrograph of red-orange glass no. 201. Cuprite crystals are visible in the red streaks in the glass but not in the central orange streak (original magnification 3000×).

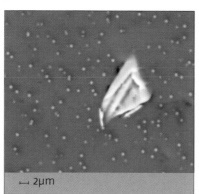

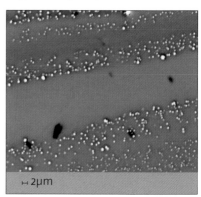

A relatively constant ratio of copper to tin was found in the orange and red-orange tesserae, unlike that found in the various red tesserae, which varied from a high of 80:1 to less than 2:1 (see fig. 12). The relatively constant ratio in the orange and red-orange glasses, averaging about 6:1, makes one suspect that the copper source in these glasses may have been a bronze alloy. However, typical bronze alloys in the Roman period generally have a higher copper-tin ratio, usually about 9 or 10 to 1. As speculated for the red glasses, a metallurgical byproduct containing lead, copper and tin may have been the source of all three elements, although if this is true, one might expect more variation in the composition of the oranges, as in the reds. Alternately, if the copper and lead were added together in the form of a copper-containing litharge, tin may have been intentionally added separately as well. The inclusions noted in one of the orange and one of the red-orange tesserae (107, 108) were found to consist mainly of tin, apparently in the form of tin oxide (see fig. 15). These tin inclusions may be evidence that cassiterite or some other source of tin was deliberately added to the glass melt as a reducing agent for the copper, rather than being an incidental addition with the copper or the lead source. The significant amounts of tin in these tesserae early on led to the speculation that the orange color might be due in part to the presence of lead-tin yellow. SEM examination, however, did not reveal the presence of any lead-tin phase in any of the orange glasses.

Like the red glasses, production of the oranges and red-oranges depended on achieving reducing conditions in the glass melt for the formation of cuprite crystallites. The orange color, however, appears to be a result of smaller particle size than in the red glasses. SEM examination readily reveals the cuprite particles in red glasses, even when they are well below one micron in diameter as here (fig. 11). Even in the SEM, though, the crystallites in the orange and red-orange glasses are not easily discernible. In the light microscope, some of the red-orange glasses can be seen to be a mix of red and orange phases. In the SEM, the cuprite crystals are readily seen in the red-orange areas but not in the orange, although spot analyses of these different areas of the glass show the same composition (see

fig. 16). Minor differences in the glass melt apparently allowed the growth of cuprite to sufficient size in the red phase, while growth stopped at a smaller size in other areas. X-ray diffraction analyses of some red and orange glasses have revealed cuprite in all the reds and oranges analyzed, while the oranges contained metallic copper as well.[25]

The orange and red-orange tesserae analyzed showed relatively little variation in composition; all appear to have been produced with the same basic recipe. The one outlier in the group, no. 201 from the Eukarpia mosaic, has the same overall composition, but contains somewhat less lead and tin than the others. Not all orange glass in the Roman period, however, was made in this way: analysis of a Roman orange glass inlay of unknown origin as well as an orange glass from a small *opus sectile* panel revealed glass compositions indicative of the use of natron rather than plant ash.[26]

Aside from the orange and some of the red tesserae, only two tesserae definitely appear to have been made using a plant-ash alkali source, the blue-green translucent tesserae from the Eukarpia mosaic from the Tomb of a Women's Funerary Banquet (188 and 189). These two tesserae, which appear to be from the same batch, probably came from a different source from most of the other tesserae in the mosaics. These two stand out as well in another way: the main colorant in the glass appears to be iron oxide rather than the copper oxide in the other translucent greens.

Conclusion

Mosaic tesserae from a fountain mosaic from Pompeii dated to the first century C.E. show similarities to and a few differences from the Antioch tesserae. The overall compositions of the Pompeii tesserae were similar to the comparable Antioch colors. The main components of the Pompeii tesserae, except for two of the four red glasses analyzed, showed relatively little variation, indicating that the Pompeii glass tesserae may have originally come from a single primary glass source. Some quantitative differences were found in the amounts of some of the colorants and opacifiers used at Pompeii. Three of the white tesserae from Pompeii were found to contain more than 5 percent antimony oxide and one had more than 10 percent, much higher than in any of the Antioch tesserae.[27]

Changes in glass composition began in the Roman world during the fourth century. Interesting comparisons with the Antioch tesserae are the colored glass inlays from the fourth-century *opus sectile* panels excavated at Kenchreai, near ancient Corinth, and from the so-called Thomas Panel, originally from Egypt, also dated to the fourth century.[28] Like the Antioch tesserae, most of these glasses have compositions consistent with natron glass. Many of the Kenchreai glasses also contained significant amounts of antimony. Unlike the Antioch tesserae, however, the yellow opaque glasses from Kenchreai and the Thomas Panel contain relatively large amounts of tin, apparently in the form of lead-tin yellow crystals rather than lead antimonate (several of these yellows have some antimony as well, though less than the amounts of tin present, and may contain a mixture of lead-tin and lead antimonate crystals). Flesh-colored glasses from these panels also contain significant amounts of tin oxide, which may be present as tin oxide crystals, replacing calcium antimonate as the white opacifier in these glasses. Byzantine glass mosaic tesserae dating from about the fifth and sixth centuries differ from the Antioch mosaics and others of the Roman period mainly in their use of lead-tin yellow rather than lead antimonate in the yellow and green opaque tesserae, although there is little evidence for the widespread use of tin oxide as an opacifier in mosaic glass until about the tenth century.

Unlike the variety of reds seen in the Antioch tesserae, all the reds from the Kenchreai panels have similar overall compositions. These reds have high-magnesium plant-ash-type compositions with only small amounts of lead, similar to the two reds from the Eukarpia mosaic. The reds from the Thomas Panel had relatively low-magnesium compositions with relatively large amounts of lead, somewhat similar to one of the reds from the Agora mosaic. The Thomas Panel reds, however, contain much more zinc oxide than any of the different reds from the Antioch mosaics, similar to what is noted in several Byzantine red opaque glasses.[29]

Only minor differences were noted between the glasses from the Antioch *triclinium* mosaics and the later ones from the third and fourth centuries. Amethyst tesserae were noted only in the *triclinium* mosaics, while blue-green translucent tesserae were found only in two of the later mosaics. Small differences like these may be due to aesthetic choices by the mosaic artists rather than to a difference in the availability of certain colors. The blue-green tesserae from the Eukarpia mosaic, however, have a different basic glass formulation from all the other tesserae, with the exception of some of the reds and the oranges. This may be evidence of a wider availability of plant-ash glass at Antioch after the third century, although it is risky to base conclusions simply on two tesserae.

This group of analyses shows the wide range of glass compositions available to the Antioch mosaicists and the variability and range of compositions within the various colors used, and testifies to the range and skill of Roman glassmakers. With the exception of the oranges, which showed a continuing tradition over the period surveyed here, the different compositions within the different colors of Antioch tesserae indicate multiple sources for the glass used, even within individual mosaics or mosaics from the same house. The compositions also are evidence for the use of more than one primary glass in the production of the various colors. With only a few exceptions, however, all the compositions fit into the ranges characteristic of different colors in Roman glass production prior to the fourth century. There seem to be no really substantive changes in the glasses used at Antioch in the second-century mosaics versus those from the third or fourth century, and the changes that occurred in glass making around the fourth century are not reflected in the later tesserae from Antioch.

1. Glass rarely appears in Antioch pavements from the fifth century and later. The reasons underlying this change are unclear. They may relate to the shift from illusionistic, painterly mosaics to what are sometimes termed "carpet" mosaics with a more two-dimensional space and multiple viewpoints. Glass tesserae may well have continued in use for wall mosaics but these have not survived from Antioch.

2. Verità, Basso, Wypyski, and Koestler 1994, 241–51.

3. Mass, Stone, and Wypyski in McCray 1998, 121–144.

4. Brill in Weinberg 1988, 257–294; Henderson 1985, 267–291. For an excellent introduction to the scientific study of glass, see Freestone in Bowman 1991, 37–56.

5. Wedepohl and Baumann 2000, 129–32.

6. Sayre and Smith 1961, 824–26; Brill 1999, 70–150.

7. Freestone, Gorin-Rosen, and Hughes in Nenna 2000, 65–84; Freestone, Ponting, and Hughes 2002, 257–72; Freestone, 2003, 111–15.

8. Nenna, Picon, and Vichy in Nenna 2000, 97–112; Foy, Vichy, and Picon 2000, 51–7.

9. Turner and Rooksby 1959, 17–29; Rooksby 1962, 20–26.

10. Turner and Rooksby 1959, 17–29; Henderson 1985, 267–291.

11. Mass, Stone and Wypyski in McCray 1998, 127–8.

12. Henderson 1991, 601–607.

13. Mass, Stone and Wypyski in McCray 1998.

14. Mass, Stone and Wypyski in McCray 1998.

15. Freestone 1990, 103–107.

16. Gratuze et al. 1996, 77–94.

17. Becker, Schorsch, Williams, and Wypyski in Gonosová and Kondoleon 1994, 410–415.

18. Freestone in Bimson and Freestone 1987, 173–191; Brill and Cahill 1988, 16–27; Freestone, Stapleton and Rigby in Entwistle 2003, 142–154.

19. Lilyquist, Brill, Wypyski and Koestler in Lilyquist and Brill 1993, 23–58; Brill 2001, 25–45.

20. Henderson 1991, 603–605.

21. Wypyski and Mass, unpublished analyses of red tesserae from the fountain mosaic in the Casa della Fontana Piccola, Pompeii; Wypyski 2005 (forthcoming); Freestone, Bimson and Buckton 1990, 271–279; Roncuzzi and Fiori 1989, 9–57.

22. Freestone, Stapleton and Rigby in Entwistle 2003, 142.

23. Freestone, Stapleton and Rigby in Entwistle 2003, 147.

24. Wypyski 2005 (forthcoming); Shugar 2000, 375–384.

25. Brill and Cahill, 1988, 24.

26. Wypyski, unpublished analyses of a group of ancient Roman glass fragments from The Metropolitan Museum of Art, part of the bequest of Edward C. Moore, 1891.

27. Mass, Stone, and Wypyski in McCray 1998, 121–144.

28. Brill in Ibrahim, Scranton, and Brill 1976, 225–255; Brill and Whitehouse 1988, 34–50.

29. Brill and Whitehouse 1988, 34–50.

Appendix

Glass Compositional Analyses

Atrium House Triclinium (ca. 125 C.E.)

The Drinking Contest Between Herakles and Dionysos (DC)
Worcester Art Museum (WAM) 1933.36

No.	Color	Na_2O	MgO	Al_2O_3	SiO_2	P_2O_5	SO_3	Cl	K_2O	CaO	TiO_2	MnO	Fe_2
Interior													
1	Turquoise	20.4	1.0	2.5	61.0	0.05	0.3	1.5	0.4	7.3	0.2	0.06	1.2
2	Turquoise	20.2	1.0	2.5	61.2	0.06	0.2	1.4	0.4	7.4	0.2	0.06	1.1
3	Light Blue	14.9	0.5	2.4	67.8	0.1	0.3	0.7	0.6	7.0	0.06	0.6	0.4
4	Dark Green*	15.5	1.3	2.1	61.4	0.3	0.2	0.8	1.0	6.7	0.1	0.8	1.1
5	Dark Green*	15.4	1.3	2.1	61.6	0.4	0.2	0.9	1.0	6.7	0.1	0.8	1.0
6	Dark Green*	15.5	1.3	2.1	61.6	0.4	0.2	0.8	1.0	6.7	0.1	0.7	1.0
7	Green	17.7	0.7	1.9	63.8	0.09	0.3	0.9	0.7	5.4	0.1	0.4	0.8
8	Green	16.7	0.7	1.9	64.0	0.1	0.3	0.9	0.7	5.5	0.1	0.4	0.8
9	Yellow-Green	17.0	0.7	1.9	62.2	0.09	0.2	0.8	0.6	5.3	0.1	0.4	0.8
10	Yellow-Green	16.6	0.7	2.0	62.4	0.1	0.2	0.9	0.6	5.2	0.1	0.4	0.8
11	Yellow	16.3	0.7	1.8	59.6	0.09	0.2	1.0	0.6	4.7	0.1	0.6	1.2
12	Red	13.3	3.3	2.7	51.0	1.1	0.1	1.2	1.4	8.8	0.2	0.7	2.1
13	Red	13.3	3.3	2.7	51.0	1.1	0.2	1.3	1.4	9.0	0.2	0.7	2.1
14	Orange	9.5	1.9	2.7	41.4	0.5	0.3	0.8	1.1	6.9	0.2	0.4	1.9
15	Orange	9.5	1.9	2.7	41.2	0.5	0.3	0.9	1.1	7.0	0.2	0.4	1.9
Border													
16	Pale Gray-Blue	18.8	0.6	2.0	67.4	0.09	0.4	1.0	0.7	5.5	0.1	0.4	0.9
17	Pale Gray-Blue	19.0	0.6	1.9	67.6	0.09	0.3	1.0	0.6	5.4	0.1	0.4	0.9
18	Pale Gray-Blue	18.0	0.6	2.0	68.0	0.09	0.3	1.1	0.6	5.4	n.d.	0.4	0.8
19	Pale Gray-Blue 2	18.5	0.6	2.0	65.0	0.1	0.3	1.0	0.6	5.0	0.1	0.4	0.9
20	Yellow	15.8	0.7	1.8	58.6	0.1	0.3	0.9	0.6	4.7	0.1	0.6	1.2
21	Yellow	15.9	0.7	1.8	58.8	0.1	0.3	1.0	0.6	4.5	0.1	0.5	1.2

* Translucent

The results, given in oxide weight percentages, are from EDS (energy dispersive X-ray spectrometry) analysis for the major and minor components 1 percent or higher, while small amounts and traces less than 1 percent are from WDS (wavelength dispersive X-ray spectrometry) analysis. Results have been rounded to the nearest tenth of a percent, with results under 0.1 percent reported to two decimal places.

n.d. = not detected by WDS analysis. Minimum detection limit for most oxides is approximately 0.01%, with lead oxide at 0.05%.

CoO	CuO	ZnO	SnO$_2$	Sb$_2$O$_3$	BaO	PbO	Observations
n.d.	2.0	0.05	0.2	2.1	0.02	0.1	
n.d.	2.0	0.07	0.2	2.2	0.02	0.1	
n.d.	1.6	n.d.	0.2	2.7	0.03	0.08	
n.d.	3.5	n.d.	0.2	0.5	0.03	4.6	*Inclusions: bronze. A few crystals: SnO$_2$ and Pb-(Sb+Sn).*
n.d.	3.3	0.01	0.2	0.5	0.02	4.4	*A few crystals: SnO$_2$ and Pb-(Sb+Sn).*
n.d.	3.3	0.01	0.3	0.5	0.02	4.5	*Inclusion: bronze with Sn surface layer.*
n.d.	2.3	n.d.	0.2	0.9	0.01	3.9	*Black inclusions: bronze (Sn ~ 13%). Crystals: Pb-(Sb+Sn), Sb>Sn.*
n.d.	2.3	0.02	0.2	0.9	0.01	3.9	*Sample somewhat weathered.*
n.d.	1.6	n.d.	0.2	1.0	0.01	7.2	*Crystals: Pb-Sb and Pb-(Sb+Sn).*
n.d.	1.6	n.d.	0.2	1.0	0.02	7.2	
n.d.	n.d.	n.d.	0.06	1.4	n.d.	11.8	*Crystals: Pb-Sb.*
n.d.	1.7	0.08	0.3	0.1	0.02	11.8	
n.d.	1.7	0.07	0.4	0.1	0.03	11.6	
n.d.	7.7	0.1	1.2	0.3	0.01	23.2	
n.d.	7.5	0.1	1.2	0.3	0.01	23.5	
0.02	0.07	n.d.	0.02	1.4	0.01	0.5	
0.02	0.05	n.d.	0.02	1.6	0.02	0.4	*Lightly opacified with Ca-Sb. Many voids/bubbles.*
0.03	0.06	n.d.	0.03	1.4	0.01	0.5	*Sample appears somewhat weathered.*
0.02	0.01	n.d.	0.02	1.4	0.01	4.2	
n.d.	n.d.	n.d.	0.05	1.5	0.02	13.2	*Pb-Sb crystals.*
n.d.	n.d.	n.d.	0.07	1.5	0.01	13.2	

Dancing Maenad
Baltimore Museum of Art (BMA) 33.52.1

No.	Color	Na$_2$O	MgO	Al$_2$O$_3$	SiO$_2$	P$_2$O$_5$	SO$_3$	Cl	K$_2$O	CaO	TiO$_2$	MnO	Fe$_2$
Interior													
22	Amethyst*	18.8	0.6	1.9	68.0	0.07	0.3	1.2	0.7	5.4	0.1	1.2	0.8
23	Light Blue	15.5	0.5	2.3	68.8	0.1	0.3	0.9	0.5	7.0	0.05	0.3	0.4
24	Pale Gray-Blue	15.3	0.5	2.5	69.2	0.1	0.2	1.0	0.6	7.5	0.06	0.5	0.6
25	Pale Gray-Blue	15.3	0.5	2.5	69.1	0.1	0.3	0.8	0.6	7.6	0.06	0.4	0.6
26	Pale Gray-Blue 2	18.4	0.6	1.9	68.1	0.06	0.3	1.0	0.6	5.3	0.1	0.3	0.7
27	Green*	17.7	0.7	1.9	63.9	0.1	0.3	1.0	0.7	5.3	0.1	0.4	0.7
28	Pale Green	17.7	0.7	1.9	65.5	0.1	0.4	0.7	0.6	5.5	0.08	0.4	0.7
29	Pale Green 2	16.5	0.6	2.2	66.7	0.1	0.3	0.9	0.6	6.7	0.07	0.4	0.5
30	Pale Green 3	17.7	0.6	1.9	65.6	0.1	0.4	0.8	0.6	5.3	0.1	0.4	0.7
31	Yellow-Green	17.7	0.7	1.9	63.8	0.09	0.2	0.8	0.8	5.4	0.1	0.4	0.8
32	Pale Yellow*	16.2	0.5	2.5	70.4	0.06	0.1	1.3	0.5	7.8	0.05	0.06	0.3
33	Yellow	15.0	0.7	1.8	57.4	0.09	0.2	0.8	0.6	4.6	0.1	0.5	1.3
34	Dark Red	15.7	0.4	2.3	68.4	0.1	0.1	1.2	0.4	6.8	0.05	0.05	3.4
Border													
35	Green	18.7	0.7	1.9	65.0	0.1	0.2	0.8	0.7	5.4	0.08	0.4	0.7
36	Yellow-Green	18.5	0.7	1.9	64.4	0.1	0.3	0.7	0.7	5.4	0.1	0.4	0.8
37	Red	18.0	0.6	2.0	64.2	0.1	0.3	1.0	0.6	5.4	0.08	0.3	2.8

Dancing Satyr
BMA 33.52.2

No.	Color	Na$_2$O	MgO	Al$_2$O$_3$	SiO$_2$	P$_2$O$_5$	SO$_3$	Cl	K$_2$O	CaO	TiO$_2$	MnO	Fe$_2$
Interior													
38	Light Blue	17.4	0.7	2.0	65.5	0.09	0.4	0.9	0.7	5.4	0.1	0.4	0.8
39	Green*	17.8	0.7	2.0	64.0	0.08	0.2	0.8	0.7	5.3	0.1	0.4	0.8
40	Green	17.3	0.7	2.0	62.5	0.1	0.3	0.9	0.7	5.7	0.1	0.4	0.7
41	Yellow-Green	18.0	0.6	2.0	64.4	0.08	0.3	0.9	0.7	5.1	0.1	0.3	0.9
42	Yellow	18.5	0.7	2.0	65.3	0.06	0.3	0.9	0.7	5.1	0.1	0.4	0.8
43	Yellow 2	16.4	0.8	1.8	59.8	0.09	0.3	0.9	0.7	4.6	0.1	0.5	1.2
Border													
44	Green	18.4	0.7	1.9	65.0	0.08	0.2	0.9	0.7	5.6	0.1	0.4	0.8
45	Yellow-Green	17.7	0.7	1.9	63.8	0.1	0.3	0.8	0.6	5.5	0.1	0.4	0.8
46	Red	17.8	0.6	1.9	64.1	0.1	0.3	0.9	0.6	5.4	0.1	0.3	2.8

* Translucent

CoO	CuO	ZnO	SnO$_2$	Sb$_2$O$_3$	BaO	PbO	Observations
n.d.	0.01	n.d.	n.d.	0.9	0.04	0.2	A few Ca-Sb crystals. Mn oxide inclusion.
n.d.	2.0	n.d.	0.2	1.1	0.02	n.d.	
0.05	0.1	n.d.	n.d.	1.0	0.03	0.5	Lightly opacified with Ca-Sb.
0.05	0.1	n.d.	n.d.	1.3	0.02	0.5	
0.02	0.08	n.d.	0.02	2.2	0.02	0.4	Sample weathered.
n.d.	2.6	n.d.	0.2	1.0	0.02	3.3	A few crystals: Pb-(Sb+Sn), Sb>Sn.
n.d.	1.0	n.d.	0.06	4.2	0.02	0.4	Ca-Sb crystals but no Pb-Sb.
n.d.	1.7	n.d.	0.1	2.3	0.01	0.1	Ca-Sb crystals but no Pb-Sb.
n.d.	2.4	n.d.	0.2	2.6	0.02	0.3	Crystals: Ca-Sb. Circular metallic inclusion: Cu with trace of Ag.
n.d.	0.8	0.01	0.1	0.9	0.01	5.5	
n.d.	0.01	n.d.	n.d.	0.02	0.02	n.d.	Yellow color from trace of Fe.
n.d.	n.d.	n.d.	0.04	1.6	0.01	15.4	
n.d.	0.7	n.d.	0.1	0.02	0.02	n.d.	Dark purplish-red opaque.
n.d.	1.7	n.d.	0.1	0.7	0.02	2.8	Crystals: Pb-Sb and some Pb-(Sb+Sn) with Sb>Sn.
n.d.	0.9	n.d.	0.1	0.8	0.03	4.3	Crystals: Pb-Sb and some Pb-(Sb+Sn) with Sb>Sn.
0.01	1.5	n.d.	0.2	0.8	0.03	2.3	Black inclusions: Cu with some Sb and traces of Ag and As.

CoO	CuO	ZnO	SnO$_2$	Sb$_2$O$_3$	BaO	PbO	Observations
n.d.	0.8	0.02	0.06	4.2	0.02	0.4	
n.d.	2.5	n.d.	0.2	0.8	n.d.	3.4	A few crystals: Pb-Sb and some Pb-(Sb+Sn) with Sb>Sn.
n.d.	2.4	0.02	0.2	1.0	0.01	5.0	
n.d.	1.2	n.d.	0.1	1.0	0.01	4.3	
n.d.	n.d.	n.d.	0.01	1.3	0.01	3.8	
n.d.	n.d.	n.d.	0.05	1.3	0.01	11.6	
n.d.	1.8	0.01	0.2	0.8	0.01	2.6	Crystals: Pb-Sb and some Pb-(Sb+Sn) with Sb>Sn.
n.d.	0.9	n.d.	0.09	1.0	0.02	5.3	Crystals: Pb-Sb.
n.d.	1.6	n.d.	0.2	0.9	0.02	2.4	Black inclusions: Cu with some Sb and traces of Ag and As. Like Maenad.

Atrium House Triclinium (ca. 125 C.E.)

Judgment of Paris (JP)
Musée du Louvre MA 3443

No.	Color	Na$_2$O	MgO	Al$_2$O$_3$	SiO$_2$	P$_2$O$_5$	SO$_3$	Cl	K$_2$O	CaO	TiO$_2$	MnO	Fe
Interior													
47	Turquoise	20.6	1.0	2.4	61.0	0.06	0.3	1.5	0.4	7.3	0.2	0.05	1.2
48	Blue*	16.8	0.6	2.2	69.0	0.2	0.3	0.9	0.7	6.3	0.08	0.7	0.8
49	Blue*	17.1	0.6	2.3	68.8	0.1	0.2	0.8	0.7	6.3	0.08	0.6	0.8
50	Amethyst*	17.5	0.9	2.2	66.0	0.2	0.2	1.0	0.8	7.0	0.1	2.1	1.0
51	Pale Gray-Blue	14.6	0.5	2.3	70.2	0.1	0.3	0.8	0.4	7.7	0.05	0.04	0.5
52	Pale Gray-Blue 2	17.8	0.5	2.1	67.8	0.08	0.4	0.9	0.5	6.6	0.04	0.2	0.5
53	Blue	15.5	0.5	2.5	68.8	0.1	0.3	0.9	0.6	7.5	0.05	0.5	0.5
54	Green*	16.3	0.6	2.3	68.8	0.1	0.2	0.9	0.6	7.1	0.05	0.6	0.4
55	Pale Green	19.2	0.7	1.9	66.6	0.1	0.4	0.9	0.6	5.3	0.1	0.3	0.6
56	Green	13.8	0.5	2.3	61.8	0.08	0.2	1.0	0.5	6.1	0.05	1.2	0.8
57	Green 2	14.6	0.5	2.2	63.5	0.09	0.2	1.1	0.6	6.3	0.06	0.2	0.9
58	Green 3	15.2	0.5	2.4	65.5	0.1	0.2	1.0	0.6	6.7	0.05	1.4	0.6
59	Dark Green	14.2	0.4	2.2	64.0	0.05	0.3	0.9	0.3	6.2	0.05	0.04	0.4
60	Yellow	13.5	0.4	2.1	63.4	0.1	0.1	1.0	0.6	6.3	0.04	0.4	0.7
61	Yellow 2	13.2	0.4	2.1	59.2	0.09	0.2	1.0	0.5	6.0	0.05	0.4	0.8
62	Orange	10.3	1.9	2.8	42.5	0.6	0.3	1.1	1.1	6.3	0.2	0.5	2.0
63	Clear*	19.5	0.6	2.0	67.8	0.08	0.4	1.1	0.6	5.1	0.1	0.4	0.6
64	White	18.4	0.7	2.0	65.4	0.09	0.5	0.7	0.6	6.0	0.1	0.4	0.8
65	White 2	18.6	0.4	1.9	67.8	0.06	0.4	1.1	0.4	6.1	0.06	0.09	0.4
66	White 3	15.2	0.5	2.4	67.8	0.1	0.4	0.6	0.6	7.4	0.05	0.07	0.4
67	Black*	4.0	0.09	13.0	74.8	0.02	0.02	0.3	5.2	0.7	0.06	0.05	1.6
Border													
68	Blue*	19.4	0.7	2.0	67.7	0.1	0.3	1.1	0.7	5.2	0.1	0.4	1.0
69	Light Blue	16.4	0.6	2.2	67.0	0.1	0.3	0.8	0.6	6.7	0.08	0.3	0.5
70	Blue	15.1	0.5	2.4	68.9	0.1	0.3	0.9	0.6	7.7	0.08	0.5	0.6
71	Green*	18.0	0.7	1.9	64.0	0.1	0.3	1.0	0.6	5.3	0.1	0.4	0.8
72	Pale Green	18.0	0.6	1.9	65.4	0.1	0.4	0.8	0.7	5.2	0.09	0.3	0.7
73	Pale Green	18.0	0.6	1.8	65.5	0.1	0.4	0.8	0.6	5.2	0.1	0.3	0.7
74	Pale Green 2	16.8	0.6	2.1	66.0	0.1	0.4	0.7	0.6	6.2	0.06	0.4	0.6
75	Green	17.2	0.7	1.8	61.3	0.1	0.3	1.0	0.6	5.1	0.1	0.4	0.8
76	Yellow-Green	17.7	0.6	1.7	62.5	0.09	0.3	1.1	0.6	4.9	0.1	0.3	0.9
77	Yellow-Green 2	17.8	0.6	1.8	62.5	0.08	0.3	1.1	0.6	4.8	0.1	0.3	0.9
78	Yellow	15.2	0.7	1.7	57.8	0.1	0.3	1.1	0.6	4.4	0.1	0.5	1.2
79	Red-Orange	9.6	1.9	3.4	40.5	0.6	0.2	1.2	1.1	7.2	0.3	0.5	2.7
80	Orange	9.8	1.9	3.4	40.4	0.6	0.2	1.1	1.1	7.1	0.3	0.6	2.7
81	Black*	15.3	0.5	2.3	67.8	0.07	0.1	1.2	0.5	6.5	0.05	0.1	2.0

* Translucent

CoO	CuO	ZnO	SnO₂	Sb₂O₃	BaO	PbO	Observations
n.d.	1.9	0.02	0.2	2.1	0.01	0.1	
0.09	0.2	n.d.	0.01	1.0	0.02	0.2	*A few Ca-Sb crystals. Cu inclusion.*
0.08	0.1	n.d.	0.02	1.1	0.02	0.2	*A few Ca-Sb crystals.*
n.d.	0.06	n.d.	n.d.	0.6	0.03	0.4	*A few Ca-Sb crystals.*
0.03	0.06	n.d.	n.d.	1.4	0.03	0.9	
0.02	0.03	n.d.	0.02	2.4	0.03	0.3	
0.09	0.2	n.d.	n.d.	1.4	0.02	0.5	
n.d.	1.3	n.d.	0.09	0.6	0.03	0.1	*A few crystals, Ca-Sb and Pb-Sb.*
n.d.	0.9	0.01	0.07	2.1	0.01	0.3	*Ca-Sb crystals.*
n.d.	2.9	n.d.	0.3	0.6	0.03	8.3	*Crystals: Pb-(Sb+Sn), Sb>Sn.*
n.d.	1.2	n.d.	0.1	0.4	0.01	8.0	*Crystals: Pb-Sb, possibly some Sn.*
n.d.	1.6	n.d.	0.2	0.4	0.04	3.8	*Crystals: Pb-(Sb+Sn) Sb>Sn.*
n.d.	5.8	n.d.	0.3	0.6	0.02	4.2	*Ca-Sb and Pb-(Sb+Sn) crystals.*
n.d.	0.01	n.d.	n.d.	0.7	0.01	10.8	*Many fine Pb-Sb crystals.*
n.d.	0.03	n.d.	0.07	0.7	n.d.	15.4	*Pb-Sb crystals.*
n.d.	8.3	0.3	1.3	0.2	0.01	20.4	*Cuprite crystallites in reddish areas.*
n.d.	n.d.	n.d.	0.01	1.4	n.d.	0.3	*Mostly clear with few Ca-Sb crystals.*
n.d.	0.01	n.d.	0.01	4.3	0.01	0.1	*Similar to White no. 65 but more Ca-Sb crystals.*
n.d.	0.2	n.d.	0.02	2.2	0.01	0.4	
n.d.	n.d.	n.d.	n.d.	4.4	0.03	n.d.	
n.d.	n.d.	n.d.	n.d.	0.02	0.01	n.d.	*Appears to be obsidian (natural glass). Some Fe oxide inclusions.*
0.06	0.05	n.d.	0.01	1.0	0.01	0.4	
n.d.	1.8	n.d.	0.1	2.2	n.d.	0.1	
0.08	0.2	n.d.	n.d.	1.4	0.02	0.6	
n.d.	2.6	n.d.	0.2	0.9	0.02	3.1	*A few crystals: Pb-(Sb+Sn), Sb>Sn*
n.d.	2.5	n.d.	0.1	2.7	0.01	0.3	*Crystals: Ca-Sb and some SnO₂.*
n.d.	2.4	n.d.	0.1	2.7	0.01	0.3	
n.d.	1.7	0.01	0.07	3.3	0.02	0.2	*Very pale green. Ca-Sb and some SnO₂ crystals.*
n.d.	2.7	n.d.	0.2	1.2	0.01	6.6	*Crystals: Pb-(Sb+Sn) and some SnO₂.*
n.d.	1.6	n.d.	0.2	1.0	0.01	6.6	*Crystals: Pb-Sb and Pb-(Sb+Sn).*
n.d.	0.5	n.d.	0.1	1.0	n.d.	7.6	*Crystals: Pb-Sb, no Pb-Sn.*
n.d.	n.d.	n.d.	0.08	1.5	0.01	14.8	*Crystals: Pb-Sb, no Pb-Sn.*
n.d.	6.6	0.06	1.4	0.1	0.03	22.8	
n.d.	6.7	0.07	1.5	0.1	0.02	22.5	
n.d.	0.1	n.d.	0.05	0.1	0.02	3.3	

Aphrodite and Adonis (AA)
Princeton University Art Museum (PUAM) 40-156

No.	Color	Na_2O	MgO	Al_2O_3	SiO_2	P_2O_5	SO_3	Cl	K_2O	CaO	TiO_2	MnO	Fe_2
Interior													
82	Light Blue	14.6	0.5	2.3	69.0	0.1	0.2	0.9	0.6	7.2	0.06	0.3	0.4
83	Light Blue 2	18.2	0.5	1.8	67.2	0.03	0.2	1.2	0.6	4.9	0.06	0.1	0.6
84	Light Blue 3	16.2	0.7	2.2	66.8	0.08	0.2	1.1	0.6	6.5	0.07	0.3	0.5
85	Green	18.3	0.8	2.0	65.0	0.06	0.2	0.9	0.7	5.5	0.1	0.4	0.7
86	Yellow-Green	17.0	0.7	2.0	60.5	0.07	0.2	0.8	0.7	5.7	0.1	0.4	0.7
87	Yellow	15.2	0.7	1.7	57.8	0.09	0.3	1.0	0.6	4.5	0.09	0.5	1.3
88	Yellow 2	16.8	0.8	1.8	60.8	0.08	0.2	1.0	0.6	4.7	0.1	0.5	1.1
89	Red	14.0	2.1	3.1	52.4	0.5	0.3	1.2	1.0	9.6	0.3	0.4	2.8
90	Red	13.8	2.1	3.1	53.0	0.5	0.3	1.1	1.0	9.4	0.2	0.4	2.8
91	Red-Orange	8.8	1.5	3.4	39.9	0.2	0.2	0.8	0.8	8.0	0.3	0.1	3.0
92	Orange	10.0	2.0	3.4	40.8	0.6	0.2	1.2	1.1	7.0	0.3	0.5	2.6
Border													
93	Amethyst*	18.7	0.7	1.8	67.5	0.09	0.3	1.2	0.7	5.4	0.09	1.6	0.8
94	Amethyst* 2	15.8	0.5	2.4	70.6	0.09	0.2	1.1	0.5	6.9	0.05	0.6	0.4
95	Light Blue	17.2	0.7	2.0	65.0	0.1	0.4	0.8	0.6	5.8	0.1	0.4	0.6
96	Pale Gray-Blue	19.0	0.6	1.9	67.6	0.07	0.3	1.0	0.6	5.3	0.1	0.4	0.8
97	Green*	18.2	0.7	1.9	63.6	0.1	0.3	1.0	0.6	5.3	0.1	0.4	0.7
98	Green	18.0	0.8	1.9	63.0	0.1	0.3	0.9	0.7	5.7	0.1	0.4	0.7
99	Green 2	17.4	0.6	1.9	61.8	0.08	0.3	1.0	0.6	4.8	0.1	0.3	0.8
100	Yellow-Green	17.8	0.7	1.9	63.5	0.1	0.2	0.8	0.6	5.3	0.1	0.4	0.9
101	Yellow	13.6	0.4	1.9	61.8	0.09	0.1	1.1	0.5	6.3	0.05	0.1	0.7
102	Red	15.8	0.5	2.4	67.5	0.07	0.1	1.0	0.6	7.1	0.05	0.7	2.1
103	Red	15.8	0.5	2.4	67.0	0.08	0.1	1.0	0.6	7.0	0.05	0.5	3.2
104	Red	15.9	0.5	2.4	66.5	0.1	0.2	1.0	0.6	6.9	0.05	0.6	3.0
105	Dark Red	16.0	0.4	2.3	70.1	0.06	0.1	1.2	0.4	6.7	0.05	0.06	1.6
106	Dark Red	15.9	0.4	2.3	69.5	0.07	0.1	1.2	0.4	6.7	0.05	0.04	2.2
107	Red-Orange	9.2	1.9	3.4	41.1	0.5	0.2	1.2	1.1	7.0	0.3	0.6	2.9
108	Orange	9.1	1.9	3.3	41.0	0.5	0.2	1.2	1.1	7.1	0.3	0.5	2.8
109	Black*	15.2	0.5	2.5	67.4	0.1	0.2	1.0	0.6	6.9	0.05	0.4	4.5

* Translucent

CoO	CuO	ZnO	SnO$_2$	Sb$_2$O$_3$	BaO	PbO	Observations
n.d.	2.0	n.d.	0.2	1.4	0.01	n.d.	
n.d.	2.6	0.03	0.2	1.0	0.03	0.4	
n.d.	1.7	n.d.	0.1	2.6	0.02	0.1	*Ca-Sb crystals and SnO$_2$ inclusion.*
n.d.	1.5	n.d.	0.1	0.7	0.03	2.8	
n.d.	1.2	0.02	0.2	1.0	0.02	8.8	
n.d.	0.01	n.d.	0.07	1.4	0.01	15.0	*Crystals: Pb-Sb, SiO$_2$ inclusions also seen.*
n.d.	n.d.	n.d.	0.05	1.2	0.01	10.5	
n.d.	1.5	n.d.	0.9	0.6	0.03	9.4	
n.d.	1.6	0.02	0.8	0.6	0.02	9.5	
n.d.	6.5	0.04	1.2	0.3	n.d.	25.2	
0.01	6.5	0.08	1.3	0.2	0.02	22.4	
n.d.	n.d.	n.d.	n.d.	0.9	0.03	0.2	*A few Ca-Sb crystals.*
n.d.	0.02	n.d.	0.02	0.6	0.03	n.d.	*A few Ca-Sb crystals.*
n.d.	1.9	n.d.	0.1	4.0	0.01	0.2	*Black inclusions: Cu+Sn.*
0.03	0.05	n.d.	n.d.	1.9	0.02	0.5	
n.d.	2.5	n.d.	0.3	1.0	0.01	3.2	*A few SnO$_2$ and Pb-Sb crystals.*
n.d.	2.1	0.02	0.3	1.0	0.02	4.2	*Crystals: Pb-(Sb+Sn).*
n.d.	1.6	n.d.	0.2	1.4	0.02	7.2	
n.d.	0.7	n.d.	0.1	1.2	0.01	5.8	*Pb-Sb and Pb-(Sb+Sn) crystals.*
n.d.	0.01	n.d.	0.05	0.7	0.01	12.8	*Crystals: Pb-Sb, SiO$_2$ inclusions also observed.*
n.d.	1.2	n.d.	0.1	0.06	0.03	0.6	
n.d.	1.6	n.d.	0.2	0.02	0.03	0.1	*Large black inclusion: Fe with Cu surrounding. Also Cu inclusions.*
n.d.	1.7	n.d.	0.2	0.03	0.03	0.1	*SiO$_2$ inclusions.*
n.d.	0.8	n.d.	0.09	0.04	0.03	n.d.	
n.d.	0.9	n.d.	0.09	0.04	0.03	n.d.	
n.d.	6.5	0.1	1.2	0.1	0.02	22.7	*Cuprite crystals in red areas. SnO$_2$ inclusion.*
n.d.	6.7	0.09	1.2	0.1	0.01	22.8	*Large SnO$_2$ inclusion.*
0.2	0.1	0.01	n.d.	0.04	0.03	0.2	

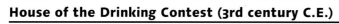

House of the Drinking Contest (3rd century C.E.)

The Drinking Contest Between Herakles and Dionysos
PUAM 65-216

Interior

No.	Color	Na$_2$O	MgO	Al$_2$O$_3$	SiO$_2$	P$_2$O$_5$	SO$_3$	Cl	K$_2$O	CaO	TiO$_2$	MnO	Fe$_2$O
Interior													
110	Turquoise	15.6	0.6	2.3	68.0	0.1	0.2	1.0	0.6	7.8	0.05	0.6	0.4
111	Blue*	18.6	0.5	2.1	68.0	0.1	0.4	1.1	0.5	5.5	0.1	0.3	0.7
112	Blue*	18.5	0.5	2.1	68.0	0.1	0.4	1.0	0.5	5.5	0.1	0.3	0.8
113	Light Blue	15.7	0.5	2.2	70.0	0.09	0.3	1.0	0.5	7.7	0.04	0.2	0.3
114	Blue	14.5	0.6	2.4	68.5	0.2	0.4	0.7	0.6	8.2	0.06	0.8	1.0
115	Blue	14.4	0.7	2.4	68.4	0.2	0.4	0.7	0.7	8.2	0.06	0.8	1.1
116	Green	14.0	0.5	2.1	63.4	0.1	0.2	1.1	0.5	7.3	0.06	0.6	0.7
117	Yellow-Green	13.6	0.5	2.0	63.0	0.06	0.2	1.0	0.4	6.8	0.04	0.04	0.8
118	Pale Yellow	14.2	0.6	2.3	66.0	0.1	0.1	1.1	0.6	7.9	0.06	0.8	0.7
119	Red	11.5	2.2	2.8	50.4	0.9	0.2	1.2	1.5	7.4	0.2	0.5	2.2
120	Orange	8.0	1.3	3.0	40.2	0.4	0.2	0.7	1.0	6.4	0.2	0.2	2.8
121	White	14.7	0.8	2.6	66.9	0.2	0.5	0.6	0.9	8.1	0.08	0.2	0.6
122	White	14.7	0.8	2.6	66.8	0.2	0.5	0.6	0.9	8.2	0.07	0.2	0.6
123	Brown*	15.8	0.6	2.2	66.2	0.1	0.3	1.0	0.6	7.3	0.07	0.7	2.7
Border													
124	Turquoise	15.5	0.5	2.3	68.4	0.2	0.3	1.0	0.6	7.6	0.06	0.5	0.4
125	Blue	14.4	0.7	2.4	68.5	0.2	0.4	0.7	0.6	8.2	0.06	0.8	1.1
126	Green	14.2	0.5	2.1	63.6	0.1	0.1	1.1	0.5	7.3	0.06	0.6	0.7
127	Yellow	13.0	0.5	1.8	58.0	0.07	0.2	0.9	0.5	6.3	0.06	0.5	0.9
128	Yellow	13.0	0.5	1.8	58.0	0.09	0.2	0.9	0.5	6.3	0.06	0.5	0.9

* Translucent

CoO	CuO	ZnO	SnO$_2$	Sb$_2$O$_3$	BaO	PbO	Observations
n.d.	1.7	0.3	0.05	0.5	0.02	0.2	
0.06	0.05	n.d.	n.d.	2.2	0.02	n.d.	
0.06	0.06	n.d.	0.01	2.2	0.03	n.d.	
n.d.	0.4	0.07	n.d.	0.8	0.02	n.d.	
0.08	0.1	n.d.	n.d.	1.7	0.03	n.d.	
0.08	0.1	n.d.	n.d.	1.6	0.03	n.d.	
n.d.	1.3	0.2	0.02	0.5	0.01	7.5	*Pb-Sb crystals.*
n.d.	0.8	0.1	0.2	0.7	0.01	10.0	
n.d.	0.01	n.d.	n.d.	0.4	0.04	5.2	*Pb-Sb crystals.*
n.d.	2.2	0.06	0.6	0.4	0.02	16.0	
n.d.	7.5	0.2	1.3	0.5	0.01	26.2	
n.d.	n.d.	n.d.	n.d.	3.8	0.02	n.d.	
n.d.	n.d.	n.d.	n.d.	3.7	0.02	n.d.	
0.01	0.2	0.02	0.03	0.7	0.04	1.5	
n.d.	1.9	0.3	n.d.	0.4	0.02	0.1	
0.07	0.1	n.d.	n.d.	1.7	0.04	n.d.	
n.d.	1.2	0.2	n.d.	0.4	0.02	7.4	*Pb-Sb crystals.*
n.d.	0.4	0.03	0.3	0.7	0.02	16.0	*Crystals: Pb-(Sb+Sn).*
n.d.	0.4	0.02	0.3	0.7	0.02	16.1	*Crystals: Pb-(Sb+Sn).*

House of the Drinking Contest (3rd century C.E.)

Four Seasons
Virginia Museum of Fine Arts (VMFA) 51.13

detail

No.	Color	Na$_2$O	MgO	Al$_2$O$_3$	SiO$_2$	P$_2$O$_5$	SO$_3$	Cl	K$_2$O	CaO	TiO$_2$	MnO	Fe$_2$
129	Light Blue	15.7	0.6	2.4	69.8	0.1	0.2	1.2	0.5	7.6	0.05	0.1	0.3
130	Blue	14.4	0.7	2.4	68.5	0.2	0.4	0.7	0.6	8.3	0.06	0.9	1.0
131	Green	13.2	0.5	2.3	67.8	0.07	0.2	1.1	0.4	7.5	0.06	0.1	0.5
132	Red	13.0	3.3	2.5	52.2	1.2	0.1	1.3	1.5	9.0	0.2	0.7	2.0

Marine Mosaic
Museum of Fine Arts, Boston (MFA) 2002.128.1

detail

No.	Color	Na$_2$O	MgO	Al$_2$O$_3$	SiO$_2$	P$_2$O$_5$	SO$_3$	Cl	K$_2$O	CaO	TiO$_2$	MnO	Fe$_2$
133	Turquoise	16.4	0.5	2.3	67.7	0.1	0.3	1.0	0.6	7.3	0.06	0.4	0.4
134	Turquoise	16.3	0.5	2.2	68.0	0.1	0.3	1.0	0.7	7.3	0.06	0.5	0.4
135	Turquoise	16.2	0.5	2.2	68.0	0.1	0.3	1.0	0.7	7.4	0.06	0.5	0.4
136	Turquoise	16.3	0.5	2.3	67.8	0.1	0.3	1.0	0.7	7.4	0.06	0.4	0.4
137	Turquoise 2	18.0	0.4	1.8	66.7	0.03	0.3	1.4	0.4	5.2	0.07	0.01	0.4
138	Blue*	18.8	0.5	2.2	67.6	0.1	0.4	1.0	0.5	5.5	0.1	0.3	0.7
139	Blue-Green*	15.8	0.5	2.3	67.2	0.1	0.2	1.0	0.6	8.0	0.05	0.5	0.4
140	Light Blue	16.4	0.5	2.3	68.6	0.1	0.3	0.9	0.7	7.4	0.07	0.6	0.4
141	Light Blue	16.2	0.5	2.2	68.6	0.1	0.3	0.9	0.7	7.5	0.06	0.4	0.4
142	Light Blue	16.3	0.5	2.3	68.7	0.1	0.3	0.9	0.7	7.5	0.06	0.4	0.4
143	Pale Gray-Blue	15.6	0.6	2.3	69.5	0.1	0.2	1.0	0.6	7.9	0.06	0.6	0.5
144	Pale Gray-Blue	15.7	0.5	2.2	69.6	0.1	0.2	0.9	0.6	8.0	0.06	0.8	0.4
145	Pale Gray-Blue	15.5	0.5	2.4	69.6	0.1	0.2	1.0	0.6	7.9	0.06	0.6	0.5
146	Pale Gray-Blue	15.6	0.6	2.4	69.4	0.1	0.2	1.0	0.6	7.9	0.06	0.6	0.5
147	Pale Gray-Blue 2	17.0	0.6	2.3	68.8	0.1	0.3	1.0	0.6	7.4	0.08	0.4	0.5
148	Green	14.8	0.5	2.1	63.2	0.1	0.3	1.0	0.6	7.0	0.06	0.7	0.6
149	Green	14.9	0.5	2.1	62.4	0.1	0.3	1.0	0.6	6.9	0.06	0.7	0.7
150	Green	14.9	0.5	2.0	62.7	0.1	0.2	1.0	0.6	7.0	0.06	0.7	0.7
151	Green	14.7	0.5	2.1	62.8	0.1	0.3	0.9	0.6	7.0	0.06	0.7	0.7
152	Yellow-Green	18.8	0.6	2.0	65.0	0.07	0.3	1.2	0.6	6.3	0.1	0.4	0.7
153	Yellow	11.2	0.7	1.7	51.6	0.1	0.2	0.8	0.5	4.1	0.1	0.6	2.2
154	Yellow	10.9	0.7	1.7	49.7	0.1	0.3	0.8	0.5	3.9	0.1	0.6	2.4
155	Yellow	10.6	0.7	1.6	48.4	0.1	0.2	0.7	0.5	3.6	0.1	0.7	2.6
156	Red	11.8	2.4	3.1	51.2	0.8	0.2	1.2	1.8	6.7	0.3	0.5	2.6
157	Orange	8.0	1.2	3.0	40.0	0.4	0.2	0.7	1.0	6.4	0.2	0.1	2.9
158	Orange	8.1	1.3	3.1	40.0	0.4	0.2	1.0	1.0	6.2	0.2	0.2	2.9
159	Orange	8.1	1.3	3.1	40.0	0.4	0.2	0.8	1.0	6.4	0.2	0.2	2.8
160	White	15.9	0.5	2.3	69.6	0.1	0.2	0.9	0.6	7.9	0.06	0.4	0.4
161	White	15.9	0.5	2.3	69.8	0.1	0.2	0.9	0.6	8.1	0.06	0.5	0.3

* Translucent

CoO	CuO	ZnO	SnO$_2$	Sb$_2$O$_3$	BaO	PbO	Observations
n.d.	1.0	0.08	n.d.	0.3	0.01	n.d.	*Lightly opacified with Ca-Sb.*
0.07	0.07	n.d.	n.d.	1.8	0.03	n.d.	
n.d.	2.4	0.08	0.2	0.4	0.02	3.2	*Pb-(Sb+Sn) crystals.*
n.d.	2.3	0.1	0.4	0.1	0.02	10.2	

CoO	CuO	ZnO	SnO$_2$	Sb$_2$O$_3$	BaO	PbO	Observations
n.d.	1.8	0.3	0.06	0.3	0.02	0.4	*Lightly opacified with Ca-Sb.*
n.d.	1.6	0.3	0.06	0.3	0.02	0.4	
n.d.	1.6	0.3	0.06	0.5	0.02	0.4	
n.d.	1.7	0.3	0.07	0.4	0.02	0.4	
n.d.	2.2	0.03	0.2	2.8	0.01	0.2	
0.05	0.05	n.d.	n.d.	2.2	0.02	n.d.	
n.d.	1.4	0.2	0.1	0.1	0.03	1.4	
n.d.	0.8	0.1	0.01	0.8	0.02	n.d.	*Lightly opacified with Ca-Sb.*
n.d.	1.0	0.2	n.d.	0.9	0.03	n.d.	
n.d.	0.9	0.2	n.d.	0.8	0.02	n.d.	
0.02	0.02	n.d.	n.d.	0.9	0.02	0.1	*Lightly opacified with Ca-Sb.*
0.02	0.02	n.d.	n.d.	0.9	0.03	0.08	
0.02	0.04	n.d.	n.d.	0.9	0.03	0.1	
0.02	0.04	n.d.	n.d.	0.9	0.02	0.1	
0.02	0.02	n.d.	n.d.	1.0	0.02	n.d.	
n.d.	1.7	0.2	0.2	0.3	0.03	6.8	*Heterogeneous mix of translucent and opaque streaks. Pb-(Sb+Sn) crystals.*
n.d.	1.6	0.2	0.2	0.4	0.02	7.3	
n.d.	1.6	0.3	0.2	0.4	0.02	7.1	
n.d.	1.7	0.3	0.2	0.4	0.02	7.1	
n.d.	0.9	n.d.	0.08	0.7	0.01	2.4	*Crystals: Pb-Sb and Pb-(Sb+Sn).*
n.d.	0.07	n.d.	0.4	1.5	0.04	24.4	*Heterogeneous mix of translucent and opaque streaks. Pb-(Sb+Sn) crystals.*
n.d.	0.07	n.d.	0.4	1.7	n.d.	26.2	
n.d.	0.1	n.d.	0.4	1.8	n.d.	28.0	
n.d.	1.6	0.1	0.8	0.4	0.02	14.6	*Inclusions: Cu+S.*
n.d.	7.5	0.2	1.2	0.5	0.02	26.4	
n.d.	7.4	0.2	1.1	0.5	0.03	26.2	
n.d.	7.3	0.2	1.2	0.4	0.02	26.5	
n.d.	0.01	n.d.	n.d.	1.1	0.02	n.d.	*Lightly opacified with Ca-Sb.*
n.d.	n.d.	n.d.	n.d.	0.7	0.03	n.d.	

Tomb of a Women's Funerary Banquet (mid- to late 4th century C.E.)

Funerary Banquet
WAM 1936.26

No.	Color	Na₂O	MgO	Al₂O₃	SiO₂	P₂O₅	SO₃	Cl	K₂O	CaO	TiO₂	MnO	Fe₂
162	Turquoise	17.0	0.6	1.6	67.3	0.02	0.3	1.3	0.4	4.5	0.08	0.02	1.0
163	Turquoise	16.6	0.5	1.8	67.8	0.05	0.3	1.2	0.5	4.3	0.1	0.02	0.9
164	Blue*	16.9	0.8	2.3	68.2	0.2	0.3	1.0	0.7	7.2	0.1	0.6	0.8
165	Blue* 2	18.4	0.7	2.2	65.8	0.09	0.4	1.2	0.7	7.3	0.1	1.0	1.3
166	Light Blue	16.6	0.6	2.5	66.4	0.06	0.4	1.1	0.5	6.4	0.08	0.2	0.7
167	Blue	14.8	0.5	2.6	67.8	0.2	0.3	0.8	0.7	7.0	0.06	0.6	0.6
168	Blue 2	14.6	0.5	2.4	68.6	0.1	0.3	0.8	0.6	7.6	0.05	0.3	0.7
169	Light Green*	17.0	1.1	2.3	64.3	0.06	0.3	1.0	0.5	8.7	0.1	0.8	2.1
170	Green	13.7	0.7	2.0	58.2	0.09	0.3	0.9	0.5	6.3	0.07	0.4	1.0
171	Red	10.2	2.9	1.9	59.0	1.0	0.1	0.9	2.8	9.4	0.1	0.2	1.6
172	Red 2	15.2	2.3	2.0	60.2	0.8	0.1	1.3	1.6	7.3	0.2	0.4	1.2
173	Orange	8.2	1.4	1.9	41.6	0.5	0.3	0.8	1.2	6.1	0.1	0.2	4.7
174	Clear*	18.6	1.5	2.9	62.4	0.06	0.3	1.3	0.4	9.0	0.2	0.5	1.2
175	Black*	18.0	1.0	2.1	64.0	0.2	0.3	0.9	0.9	7.7	0.1	0.5	3.8

Agora
WAM 1936.29

No.	Color	Na₂O	MgO	Al₂O₃	SiO₂	P₂O₅	SO₃	Cl	K₂O	CaO	TiO₂	MnO	Fe₂
176	Blue*	15.2	0.5	2.2	70.8	0.1	0.3	0.9	0.5	6.8	0.05	0.4	0.8
177	Blue* 2	17.0	0.6	2.3	68.2	0.1	0.3	0.9	0.7	6.9	0.1	0.5	0.8
178	Blue* 3	15.8	0.5	2.1	69.4	0.1	0.3	0.9	0.7	6.6	0.08	0.5	0.8
179	Pale Gray-Blue	18.8	0.5	1.8	68.4	0.03	0.3	1.0	0.6	5.5	0.09	0.1	0.7
180	Green*	16.2	0.6	2.1	63.5	0.1	0.3	1.0	0.7	6.8	0.08	0.4	0.9
181	Pale Green	17.5	0.7	2.1	66.2	0.03	0.3	1.2	0.6	7.1	0.09	0.2	0.8
182	Green	15.0	0.6	2.0	63.2	0.1	0.2	1.0	0.6	6.3	0.07	0.4	0.9
183	Yellow	13.8	0.5	2.4	62.8	0.07	0.2	1.0	0.4	6.7	0.05	0.08	0.8
184	Yellow 2	16.2	0.4	1.7	59.2	0.03	0.3	1.0	0.4	5.0	0.07	0.06	0.8
185	Red	14.2	1.5	2.6	52.0	0.4	0.3	0.9	1.0	7.5	0.2	0.3	1.4
186	Red 2	17.4	0.8	1.9	64.0	0.1	0.3	1.1	0.7	7.6	0.1	0.3	3.6

* Translucent

CoO	CuO	ZnO	SnO$_2$	Sb$_2$O$_3$	BaO	PbO	Observations
n.d.	2.2	0.02	0.2	3.0	n.d.	0.4	*Lightly opacified with Ca-Sb.*
n.d.	2.3	n.d.	0.2	2.8	0.02	0.5	
n.d.	0.1	n.d.	n.d.	0.7	0.02	0.1	*A few Ca-Sb crystals.*
0.04	0.2	0.01	n.d.	0.4	0.03	0.1	
n.d.	1.0	0.02	0.09	2.8	0.02	0.5	
0.05	0.05	n.d.	0.02	4.0	0.03	n.d.	
0.06	0.1	n.d.	0.01	2.8	0.01	0.3	
n.d.	0.04	n.d.	0.1	0.1	0.03	1.5	*A few Pb-Sn crystals.*
n.d.	2.5	0.02	0.2	0.8	0.01	12.4	
n.d.	1.1	n.d.	0.2	0.3	0.04	8.2	
n.d.	1.4	0.02	0.5	0.3	0.03	5.3	
n.d.	7.8	0.3	1.2	0.3	0.02	23.5	
n.d.	0.04	n.d.	0.02	0.07	0.03	1.6	
n.d.	n.d.	n.d.	n.d.	0.5	0.02	n.d.	*Black inclusions: Fe oxide.*

CoO	CuO	ZnO	SnO$_2$	Sb$_2$O$_3$	BaO	PbO	Observations
0.06	0.1	n.d.	n.d.	1.2	0.02	n.d.	
0.06	0.1	n.d.	n.d.	1.4	0.02	0.1	
0.05	0.07	n.d.	n.d.	1.4	0.02	0.5	
0.02	0.1	n.d.	n.d.	2.0	0.02	n.d.	*Lightly opacified with Ca-Sb.*
n.d.	1.6	n.d.	0.1	0.8	0.01	4.8	*A few crystals observed, Ca-Sb and Pb-Sb.*
n.d.	1.2	n.d.	0.1	1.0	0.01	1.1	*Mostly Ca-Sb crystals, some Pb-(Sb+Sn) crystals.*
n.d.	1.6	0.02	0.1	0.8	0.01	7.2	
n.d.	0.01	n.d.	n.d.	0.6	0.02	10.5	*Heterogeneous mix of translucent and opaque streaks.*
n.d.	0.03	n.d.	0.03	0.9	0.01	14.0	*Pb-Sb crystals.*
n.d.	1.2	0.04	0.2	0.5	0.02	16.0	
n.d.	0.4	n.d.	0.08	0.6	0.02	1.1	

Tomb of a Women's Funerary Banquet (mid- to late 4th century C.E.)

Eukarpia
WAM 1936.28

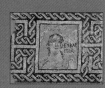

No.	Color	Na₂O	MgO	Al₂O₃	SiO₂	P₂O₅	SO₃	Cl	K₂O	CaO	TiO₂	MnO	Fe₂O
187	Blue*	18.0	0.6	2.3	68.8	0.1	0.3	1.0	0.7	5.9	0.1	0.5	0.7
188	Blue-Green*	16.7	2.2	1.9	67.6	0.5	0.2	1.0	1.4	6.7	0.2	0.2	1.1
189	Blue-Green*	16.4	2.4	2.0	67.3	0.6	0.2	1.0	1.5	6.9	0.2	0.2	1.1
190	Light Blue	17.4	0.6	1.7	67.0	0.04	0.3	1.3	0.4	4.7	0.06	0.03	0.8
191	Green*	19.5	0.7	2.0	66.0	0.09	0.4	1.3	0.6	6.5	0.1	0.1	0.7
192	Dark Green	13.5	0.5	1.9	63.3	0.2	0.2	0.8	0.6	5.7	0.07	0.3	0.8
193	Green	17.8	0.6	2.0	64.0	0.06	0.3	1.1	0.5	6.0	0.1	0.02	1.0
194	Green	17.4	0.6	2.0	64.4	0.05	0.3	1.2	0.5	6.1	0.1	0.04	1.0
195	Yellow-Green	16.2	0.5	1.9	62.0	0.04	0.3	1.1	0.5	5.3	0.08	0.1	1.2
196	Yellow	14.0	0.6	2.2	65.6	0.1	0.2	0.9	0.6	7.2	0.05	1.2	0.7
197	Yellow	13.7	0.5	2.2	65.8	0.1	0.2	0.8	0.6	7.5	0.06	1.2	0.7
198	Yellow 2	15.3	0.5	1.8	56.8	0.05	0.3	0.8	0.4	5.7	0.08	0.3	1.1
199	Red	13.7	2.4	2.3	63.0	1.1	0.3	0.8	2.6	9.1	0.2	0.4	1.4
200	Red	13.7	2.3	2.4	62.6	1.1	0.3	0.8	2.7	9.2	0.2	0.4	1.4
201	Red-Orange	8.5	1.8	2.6	45.5	0.5	0.2	0.7	1.5	7.4	0.2	0.2	2.6
202	Orange	8.5	1.5	3.6	41.4	0.4	0.2	0.7	0.9	6.9	0.3	0.2	2.8
203	Orange 2	9.0	1.5	1.9	42.5	0.4	0.2	0.7	1.2	6.4	0.1	0.2	3.5
204	Amber*	19.3	0.8	2.1	65.8	0.1	0.4	1.2	0.5	6.9	0.1	0.9	1.9

* Translucent

CoO	CuO	ZnO	SnO₂	Sb₂O₃	BaO	PbO	Observations
0.06	0.09	n.d.	n.d.	0.7	0.02	0.1	
n.d.	n.d.	n.d.	n.d.	0.2	0.02	n.d.	*Plant-ash glass, not natron based.*
n.d.	0.02	n.d.	n.d.	0.2	0.02	n.d.	
n.d.	2.2	0.02	0.2	3.0	0.01	0.4	
n.d.	1.1	n.d.	0.07	0.4	0.02	0.5	*Very weathered glass.*
n.d.	3.1	0.03	0.2	0.6	0.02	8.0	
n.d.	1.4	0.02	0.2	0.7	0.01	4.2	
n.d.	1.3	0.02	0.2	0.8	0.02	4.2	
n.d.	1.4	0.04	0.2	1.2	0.02	7.9	
n.d.	0.05	n.d.	0.04	0.9	0.03	5.9	*Pb-Sb crystals.*
n.d.	0.07	n.d.	0.04	1.0	0.04	5.4	
n.d.	0.02	n.d.	0.1	1.3	0.01	15.6	
n.d.	0.8	0.05	0.2	0.2	0.01	1.4	
n.d.	0.9	0.05	0.2	0.2	0.01	1.6	
n.d.	8.8	0.2	0.9	0.4	0.02	18.6	*Red and orange streaks. Round and a few dendritic cuprite crystals in red. SiO₂ and Si-Ca (probably wollastonite, CaSiO₃) inclusions.*
n.d.	6.8	0.2	1.3	0.2	0.02	24.2	
n.d.	7.6	0.2	1.1	0.3	0.01	23.2	
n.d.	0.07	n.d.	n.d.	0.02	0.01	n.d.	

House of the Sundial (mid- to late 3rd century C.E.)

Dionysos and Ariadne
WAM 1936.25

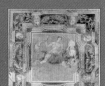

No.	Color	Na$_2$O	MgO	Al$_2$O$_3$	SiO$_2$	P$_2$O$_5$	SO$_3$	Cl	K$_2$O	CaO	TiO$_2$	MnO	Fe$_2$
205	Turquoise	20.2	1.0	3.1	62.4	0.07	0.3	1.4	0.8	4.8	0.3	0.1	1.3
206	Turquoise	20.4	1.0	3.1	62.2	0.08	0.3	1.4	0.6	4.8	0.3	0.1	1.2
207	Green	15.0	0.5	2.1	63.5	0.1	0.2	1.0	0.5	6.4	0.04	0.7	0.6
208	Green 2	17.4	0.7	2.0	63.5	0.1	0.3	0.8	0.7	5.3	0.1	0.4	0.8
209	Yellow	13.7	0.5	2.0	59.5	0.1	0.2	1.0	0.5	6.3	0.05	0.6	0.9
210	Yellow	13.5	0.5	1.9	59.5	0.1	0.2	1.0	0.5	6.3	0.05	0.6	1.0
211	Yellow 2	16.2	0.7	1.8	59.8	0.1	0.3	0.9	0.6	4.7	0.1	0.6	1.2
212	Black*	15.5	0.9	2.3	64.4	0.2	0.3	1.0	1.0	7.4	0.06	4.9	0.8
213	Black*	15.5	0.9	2.3	64.5	0.2	0.3	1.0	1.0	7.4	0.06	4.8	0.8

House of the Boat of Psyches (ca. 200–230 C.E.)

Europa
BMA 1937.129

No.	Color	Na$_2$O	MgO	Al$_2$O$_3$	SiO$_2$	P$_2$O$_5$	SO$_3$	Cl	K$_2$O	CaO	TiO$_2$	MnO	Fe$_2$
214	Pale Gray-Blue	16.3	0.7	2.4	67.4	0.2	0.3	1.2	0.7	7.2	0.07	0.4	0.5
215	Red	14.6	0.7	2.3	65.0	0.2	0.2	1.2	0.7	7.3	0.07	1.1	2.6
216	Red 2	13.2	3.0	2.5	54.4	1.2	0.1	1.3	1.5	8.1	0.2	0.6	2.5
217	White	14.8	0.6	2.4	69.2	0.09	0.3	0.9	0.5	7.4	0.05	0.05	0.4

Agros and Opora
BMA 1937.127

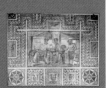

No.	Color	Na$_2$O	MgO	Al$_2$O$_3$	SiO$_2$	P$_2$O$_5$	SO$_3$	Cl	K$_2$O	CaO	TiO$_2$	MnO	Fe$_2$
218	Red	11.8	2.3	3.0	51.8	1.2	0.2	1.4	1.7	7.8	0.2	0.5	2.5
219	Red 2	14.0	1.8	3.0	53.7	0.4	0.3	1.4	0.7	7.8	0.2	0.6	3.0

House of Narcissus (ca. 150–200 C.E.)

Season (Spring or Summer)
Metropolitan Museum of Art (MMA) 38.11.12

No.	Color	Na$_2$O	MgO	Al$_2$O$_3$	SiO$_2$	P$_2$O$_5$	SO$_3$	Cl	K$_2$O	CaO	TiO$_2$	MnO	Fe$_2$
220	Pale Gray-Blue	15.4	0.6	2.5	68.5	0.2	0.4	0.9	0.6	7.7	0.06	0.7	0.5
221	Green	15.5	0.6	2.1	61.4	0.1	0.4	0.8	0.6	6.4	0.08	0.4	0.9
222	Yellow-Green	12.0	0.4	1.8	57.0	0.1	0.2	0.8	0.5	6.0	0.05	1.0	1.0
223	Yellow-Green	12.0	0.4	1.8	57.2	0.1	0.2	0.8	0.5	6.0	0.05	1.0	1.0
224	Pale Yellow	17.2	0.7	2.0	61.7	0.1	0.4	0.9	0.6	6.0	0.09	0.4	0.8
225	Dark Red	18.5	0.7	2.1	64.4	0.1	0.3	1.1	0.6	6.5	0.1	0.4	2.9
226	White	15.0	0.8	2.7	65.8	0.2	0.6	0.6	0.9	8.2	0.07	0.2	0.5

* Translucent

CoO	CuO	ZnO	SnO$_2$	Sb$_2$O$_3$	BaO	PbO	Observations
n.d.	2.0	0.04	0.2	2.0	0.02	0.08	
n.d.	2.0	0.03	0.2	2.2	0.02	0.06	
n.d.	2.4	n.d.	0.2	0.5	0.02	6.8	*Pb-(Sb+Sn) crystals.*
n.d.	0.8	n.d.	0.09	0.9	0.01	6.2	
n.d.	0.1	n.d.	0.08	0.7	0.03	13.8	*Heterogeneous mix of translucent and opaque streaks. Crystals:mostly Pb-Sb, some Pb-(Sb+Sn).*
n.d.	0.1	n.d.	0.07	0.7	0.03	14.2	
n.d.	n.d.	n.d.	0.06	1.4	0.02	11.6	
n.d.	0.06	n.d.	n.d.	0.7	0.06	0.5	*Very dark purple, Mn oxide inclusions and a few Ca-Sb crystals.*
n.d.	0.06	n.d.	n.d.	0.7	0.06	0.5	

CoO	CuO	ZnO	SnO$_2$	Sb$_2$O$_3$	BaO	PbO	Observations
0.02	0.03	n.d.	0.01	2.6	0.02	0.06	
n.d.	1.2	0.02	0.1	0.5	0.02	2.3	
n.d.	2.2	0.1	0.7	0.2	0.02	8.2	
n.d.	n.d.	n.d.	n.d.	3.2	0.02	n.d.	

CoO	CuO	ZnO	SnO$_2$	Sb$_2$O$_3$	BaO	PbO	Observations
n.d.	1.7	0.08	0.5	0.3	0.04	13.2	
n.d.	2.0	0.09	0.3	0.4	0.03	10.4	

CoO	CuO	ZnO	SnO$_2$	Sb$_2$O$_3$	BaO	PbO	Observations
n.d.	0.09	n.d.	n.d.	1.7	0.04	0.4	
n.d.	1.2	0.03	0.2	1.5	0.03	7.7	
n.d.	0.6	n.d.	0.04	0.9	0.03	17.4	
n.d.	0.7	n.d.	0.04	0.9	0.03	17.5	
n.d.	0.02	n.d.	0.2	1.2	0.02	7.5	
n.d.	0.4	0.01	0.07	0.8	0.03	1.0	
n.d.	n.d.	n.d.	0.02	4.4	0.01	n.d.	

Analyses Organized According to Color
(samples from the same mosaic are grouped together)

Identification	No.	Color	Na$_2$O	MgO	Al$_2$O$_3$	SiO$_2$	P$_2$O$_5$	SO$_3$	Cl	K$_2$O	CaO	TiO
DC interior	1	Turquoise	20.4	1.0	2.5	61.0	0.05	0.3	1.5	0.4	7.3	0.2
DC interior	2	Turquoise	20.2	1.0	2.5	61.2	0.06	0.2	1.4	0.4	7.4	0.2
JP interior	47	Turquoise	20.6	1.0	2.4	61.0	0.06	0.3	1.5	0.4	7.3	0.2
DC PUAM interior	110	Turquoise	15.6	0.6	2.3	68.0	0.1	0.2	1.0	0.6	7.8	0.0
DC PUAM border	124	Turquoise	15.5	0.5	2.3	68.4	0.2	0.3	1.0	0.6	7.6	0.0
Marine Mosaic	133	Turquoise	16.4	0.5	2.3	67.7	0.1	0.3	1.0	0.6	7.3	0.0
Marine Mosaic	134	Turquoise	16.3	0.5	2.2	68.0	0.1	0.3	1.0	0.7	7.3	0.0
Marine Mosaic	135	Turquoise	16.2	0.5	2.2	68.0	0.1	0.3	1.0	0.7	7.4	0.0
Marine Mosaic	136	Turquoise	16.3	0.5	2.3	67.8	0.1	0.3	1.0	0.7	7.4	0.0
Marine Mosaic	137	Turquoise 2	18.0	0.4	1.8	66.7	0.03	0.3	1.4	0.4	5.2	0.0
Funerary Banquet	162	Turquoise	17.0	0.6	1.6	67.3	0.02	0.3	1.3	0.4	4.5	0.0
Funerary Banquet	163	Turquoise	16.6	0.5	1.8	67.8	0.05	0.3	1.2	0.5	4.3	0.1
Dionysos & Ariadne	205	Turquoise	20.2	1.0	3.1	62.4	0.07	0.3	1.4	0.8	4.8	0.3
Dionysos & Ariadne	206	Turquoise	20.4	1.0	3.1	62.2	0.08	0.3	1.4	0.6	4.8	0.3
JP interior	48	Blue*	16.8	0.6	2.2	69.0	0.2	0.3	0.9	0.7	6.3	0.0
JP interior	49	Blue*	17.1	0.6	2.3	68.8	0.1	0.2	0.8	0.7	6.3	0.0
JP border	68	Blue*	19.4	0.7	2.0	67.7	0.1	0.3	1.1	0.7	5.2	0.1
DC PUAM interior	111	Blue*	18.6	0.5	2.1	68.0	0.1	0.4	1.1	0.5	5.5	0.1
DC PUAM interior	112	Blue*	18.5	0.5	2.1	68.0	0.1	0.4	1.0	0.5	5.5	0.1
Marine Mosaic	138	Blue*	18.8	0.5	2.2	67.6	0.1	0.4	1.0	0.5	5.5	0.1
Funerary Banquet	164	Blue*	16.9	0.8	2.3	68.2	0.2	0.3	1.0	0.7	7.2	0.1
Funerary Banquet	165	Blue* 2	18.4	0.7	2.2	65.8	0.09	0.4	1.2	0.7	7.3	0.1
Agora	176	Blue*	15.2	0.5	2.2	70.8	0.1	0.3	0.9	0.5	6.8	0.0
Agora	177	Blue* 2	17.0	0.6	2.3	68.2	0.1	0.3	0.9	0.7	6.9	0.1
Agora	178	Blue* 3	15.8	0.5	2.1	69.4	0.1	0.3	0.9	0.7	6.6	0.0
Eukarpia	187	Blue*	18.0	0.6	2.3	68.8	0.1	0.3	1.0	0.7	5.9	0.1
Marine Mosaic	139	Blue-Green*	15.8	0.5	2.3	67.2	0.1	0.2	1.0	0.6	8.0	0.0
Eukarpia	188	Blue-Green*	16.7	2.2	1.9	67.6	0.5	0.2	1.0	1.4	6.7	0.2
Eukarpia	189	Blue-Green*	16.4	2.4	2.0	67.3	0.6	0.2	1.0	1.5	6.9	0.2
Maenad interior	22	Amethyst*	18.8	0.6	1.9	68.0	0.07	0.3	1.2	0.7	5.4	0.1
JP interior	50	Amethyst*	17.5	0.9	2.2	66.0	0.2	0.2	1.0	0.8	7.0	0.1
AA border	93	Amethyst*	18.7	0.7	1.8	67.5	0.09	0.3	1.2	0.7	5.4	0.0
AA border	94	Amethyst* 2	15.8	0.5	2.4	70.6	0.09	0.2	1.1	0.5	6.9	0.0

* Translucent

MnO	Fe₂O₃	CoO	CuO	ZnO	SnO₂	Sb₂O₃	BaO	PbO	Observations
0.06	1.2	n.d.	2.0	0.05	0.2	2.1	0.02	0.1	
0.06	1.1	n.d.	2.0	0.07	0.2	2.2	0.02	0.1	
0.05	1.2	n.d.	1.9	0.02	0.2	2.1	0.01	0.1	
0.6	0.4	n.d.	1.7	0.3	0.05	0.5	0.02	0.2	
0.5	0.4	n.d.	1.9	0.3	n.d.	0.4	0.02	0.1	
0.4	0.4	n.d.	1.8	0.3	0.06	0.3	0.02	0.4	*Lightly opacified with Ca-Sb.*
0.5	0.4	n.d.	1.6	0.3	0.06	0.3	0.02	0.4	
0.5	0.4	n.d.	1.6	0.3	0.06	0.5	0.02	0.4	
0.4	0.4	n.d.	1.7	0.3	0.07	0.4	0.02	0.4	
0.01	0.4	n.d.	2.2	0.03	0.2	2.8	0.01	0.2	
0.02	1.0	n.d.	2.2	0.02	0.2	3.0	n.d.	0.4	*Lightly opacified with Ca-Sb.*
0.02	0.9	n.d.	2.3	n.d.	0.2	2.8	0.02	0.5	
0.1	1.3	n.d.	2.0	0.04	0.2	2.0	0.02	0.08	
0.1	1.2	n.d.	2.0	0.03	0.2	2.2	0.02	0.06	
0.7	0.8	0.09	0.2	n.d.	0.01	1.0	0.02	0.2	*A few Ca-Sb crystals. Inclusion: Cu.*
0.6	0.8	0.08	0.1	n.d.	0.02	1.1	0.02	0.2	*Dark blue translucent with a few Ca-Sb crystals.*
0.4	1.0	0.06	0.05	n.d.	0.01	1.0	0.01	0.4	
0.3	0.7	0.06	0.05	n.d.	n.d.	2.2	0.02	n.d.	
0.3	0.8	0.06	0.06	n.d.	0.01	2.2	0.03	n.d.	
0.3	0.7	0.05	0.05	n.d.	n.d.	2.2	0.02	n.d.	
0.6	0.8	n.d.	0.1	n.d.	n.d.	0.7	0.02	0.1	*A few Ca-Sb crystals.*
1.0	1.3	0.04	0.2	0.01	n.d.	0.4	0.03	0.1	
0.4	0.8	0.06	0.1	n.d.	n.d.	1.2	0.02	n.d.	
0.5	0.8	0.06	0.1	n.d.	n.d.	1.4	0.02	0.1	
0.5	0.8	0.05	0.07	n.d.	n.d.	1.4	0.02	0.5	
0.5	0.7	0.06	0.09	n.d.	n.d.	0.7	0.02	0.1	
0.5	0.4	n.d.	1.4	0.2	0.1	0.1	0.03	1.4	
0.2	1.1	n.d.	n.d.	n.d.	n.d.	0.2	0.02	n.d.	*Plant-ash glass, not natron based.*
0.2	1.1	n.d.	0.02	n.d.	n.d.	0.2	0.02	n.d.	
1.2	0.8	n.d.	0.01	n.d.	n.d.	0.9	0.04	0.2	*A few Ca-Sb crystals. Mn oxide inclusion.*
2.1	1.0	n.d.	0.06	n.d.	n.d.	0.6	0.03	0.4	*A few Ca-Sb crystals.*
1.6	0.8	n.d.	n.d.	n.d.	n.d.	0.9	0.03	0.2	*A few Ca-Sb crystals.*
0.6	0.4	n.d.	0.02	n.d.	0.02	0.6	0.03	n.d.	*A few Ca-Sb crystals.*

Identification	No.	Color	Na$_2$O	MgO	Al$_2$O$_3$	SiO$_2$	P$_2$O$_5$	SO$_3$	Cl	K$_2$O	CaO	TiO
DC interior	3	Light Blue	14.9	0.5	2.4	67.8	0.1	0.3	0.7	0.6	7.0	0.0
Maenad interior	23	Light Blue	15.5	0.5	2.3	68.8	0.1	0.3	0.9	0.5	7.0	0.0
Satyr interior	38	Light Blue	17.4	0.7	2.0	65.5	0.09	0.4	0.9	0.7	5.4	0.1
JP border	69	Light Blue	16.4	0.6	2.2	67.0	0.1	0.3	0.8	0.6	6.7	0.0
AA interior	82	Light Blue	14.6	0.5	2.3	69.0	0.1	0.2	0.9	0.6	7.2	0.0
AA interior	83	Light Blue 2	18.2	0.5	1.8	67.2	0.03	0.2	1.2	0.6	4.9	0.0
AA interior	84	Light Blue 3	16.2	0.7	2.2	66.8	0.08	0.2	1.1	0.6	6.5	0.0
AA border	95	Light Blue	17.2	0.7	2.0	65.0	0.1	0.4	0.8	0.6	5.8	0.1
DC PUAM interior	113	Light Blue	15.7	0.5	2.2	70.0	0.09	0.3	1.0	0.5	7.7	0.0
Four Seasons	129	Light Blue	15.7	0.6	2.4	69.8	0.1	0.2	1.2	0.5	7.6	0.0
Marine Mosaic	140	Light Blue	16.4	0.5	2.3	68.6	0.1	0.3	0.9	0.7	7.4	0.0
Marine Mosaic	141	Light Blue	16.2	0.5	2.2	68.6	0.1	0.3	0.9	0.7	7.5	0.0
Marine Mosaic	142	Light Blue	16.3	0.5	2.3	68.7	0.1	0.3	0.9	0.7	7.5	0.0
Funerary Banquet	166	Light Blue	16.6	0.6	2.5	66.4	0.06	0.4	1.1	0.5	6.4	0.0
Eukarpia	190	Light Blue	17.4	0.6	1.7	67.0	0.04	0.3	1.3	0.4	4.7	0.0
DC border	16	Pale Gray-Blue	18.8	0.6	2.0	67.4	0.09	0.4	1.0	0.7	5.5	0.1
DC border	17	Pale Gray-Blue	19.0	0.6	1.9	67.6	0.09	0.3	1.0	0.6	5.4	0.1
DC border	18	Pale Gray-Blue	18.0	0.6	2.0	68.0	0.09	0.3	1.1	0.6	5.4	n.d
DC border	19	Pale Gray-Blue 2	18.5	0.6	2.0	65.0	0.1	0.3	1.0	0.6	5.0	0.1
Maenad interior	24	Pale Gray-Blue	15.3	0.5	2.5	69.2	0.1	0.2	1.0	0.6	7.5	0.0
Maenad interior	25	Pale Gray-Blue	15.3	0.5	2.5	69.1	0.1	0.3	0.8	0.6	7.6	0.0
Maenad interior	26	Pale Gray-Blue 2	18.4	0.6	1.9	68.1	0.06	0.3	1.0	0.6	5.3	0.1
JP interior	51	Pale Gray-Blue	14.6	0.5	2.3	70.2	0.1	0.3	0.8	0.4	7.7	0.0
JP interior	52	Pale Gray-Blue 2	17.8	0.5	2.1	67.8	0.08	0.4	0.9	0.5	6.6	0.0
AA border	96	Pale Gray-Blue	19.0	0.6	1.9	67.6	0.07	0.3	1.0	0.6	5.3	0.1
Marine Mosaic	147	Pale Gray-Blue 2	17.0	0.6	2.3	68.8	0.1	0.3	1.0	0.6	7.4	0.0
Marine Mosaic	143	Pale Gray-Blue	15.6	0.6	2.3	69.5	0.1	0.2	1.0	0.6	7.9	0.0
Marine Mosaic	144	Pale Gray-Blue	15.7	0.5	2.2	69.6	0.1	0.2	0.9	0.6	8.0	0.0
Marine Mosaic	145	Pale Gray-Blue	15.5	0.5	2.4	69.6	0.1	0.2	1.0	0.6	7.9	0.0
Marine Mosaic	146	Pale Gray-Blue	15.6	0.6	2.4	69.4	0.1	0.2	1.0	0.6	7.9	0.0
Agora	179	Pale Gray-Blue	18.8	0.5	1.8	68.4	0.03	0.3	1.0	0.6	5.5	0.0
Europa	214	Pale Gray-Blue	16.3	0.7	2.4	67.4	0.2	0.3	1.2	0.7	7.2	0.0
Season	220	Pale Gray-blue	15.4	0.6	2.5	68.5	0.2	0.4	0.9	0.6	7.7	0.0

nO	Fe$_2$O$_3$	CoO	CuO	ZnO	SnO$_2$	Sb$_2$O$_3$	BaO	PbO	Observations
.6	0.4	n.d.	1.6	n.d.	0.2	2.7	0.03	0.08	
.3	0.4	n.d.	2.0	n.d.	0.2	1.1	0.02	n.d.	
.4	0.8	n.d.	0.8	0.02	0.06	4.2	0.02	0.4	
.3	0.5	n.d.	1.8	n.d.	0.1	2.2	n.d.	0.1	
.3	0.4	n.d.	2.0	n.d.	0.2	1.4	0.01	n.d.	
.1	0.6	n.d.	2.6	0.03	0.2	1.0	0.03	0.4	
.3	0.5	n.d.	1.7	n.d.	0.1	2.6	0.02	0.1	*Ca-Sb crystals and SnO$_2$ inclusion.*
.4	0.6	n.d.	1.9	n.d.	0.1	4.0	0.01	0.2	*Black inclusions: Cu+Sn.*
.2	0.3	n.d.	0.4	0.07	n.d.	0.8	0.02	n.d.	
.1	0.3	n.d.	1.0	0.08	n.d.	0.3	0.01	n.d.	*Lightly opacified with Ca-Sb.*
.6	0.4	n.d.	0.8	0.1	0.01	0.8	0.02	n.d.	*Lightly opacified with Ca-Sb.*
.4	0.4	n.d.	1.0	0.2	n.d.	0.9	0.03	n.d.	
.4	0.4	n.d.	0.9	0.2	n.d.	0.8	0.02	n.d.	
.2	0.7	n.d.	1.0	0.02	0.09	2.8	0.02	0.5	
.03	0.8	n.d.	2.2	0.02	0.2	3.0	0.01	0.4	
.4	0.9	0.02	0.07	n.d.	0.02	1.4	0.01	0.5	
.4	0.9	0.02	0.05	n.d.	0.02	1.6	0.02	0.4	*Lightly opacified with Ca-Sb. Many voids/bubbles in glass.*
.4	0.8	0.03	0.06	n.d.	0.03	1.4	0.01	0.5	*Sample appears somewhat weathered.*
.4	0.9	0.02	0.01	n.d.	0.02	1.4	0.01	4.2	
.5	0.6	0.05	0.1	n.d.	n.d.	1.0	0.03	0.5	*Lightly opacified with Ca-Sb crystals.*
.4	0.6	0.05	0.1	n.d.	n.d.	1.3	0.02	0.5	
.3	0.7	0.02	0.08	n.d.	0.02	2.2	0.02	0.4	*Sample weathered.*
.04	0.5	0.03	0.06	n.d.	n.d.	1.4	0.03	0.9	
.2	0.5	0.02	0.03	n.d.	0.02	2.4	0.03	0.3	
.4	0.8	0.03	0.05	n.d.	n.d.	1.9	0.02	0.5	
.4	0.5	0.02	0.02	n.d.	n.d.	1.0	0.02	n.d.	
.6	0.5	0.02	0.02	n.d.	n.d.	0.9	0.02	0.1	*Lightly opacified with Ca-Sb.*
.8	0.4	0.02	0.02	n.d.	n.d.	0.9	0.03	0.08	
.6	0.5	0.02	0.04	n.d.	n.d.	0.9	0.03	0.1	
.6	0.5	0.02	0.04	n.d.	n.d.	0.9	0.02	0.1	
.1	0.7	0.02	0.1	n.d.	n.d.	2.0	0.02	n.d.	*Lightly opacified with Ca-Sb.*
.4	0.5	0.02	0.03	n.d.	0.01	2.6	0.02	0.06	
.7	0.5	n.d.	0.09	n.d.	n.d.	1.7	0.04	0.4	

Identification	No.	Color	Na_2O	MgO	Al_2O_3	SiO_2	P_2O_5	SO_3	Cl	K_2O	CaO	Ti
JP interior	53	Blue	15.5	0.5	2.5	68.8	0.1	0.3	0.9	0.6	7.5	0.
JP border	70	Blue	15.1	0.5	2.4	68.9	0.1	0.3	0.9	0.6	7.7	0.
DC PUAM interior	114	Blue	14.5	0.6	2.4	68.5	0.2	0.4	0.7	0.6	8.2	0.
DC PUAM interior	115	Blue	14.4	0.7	2.4	68.4	0.2	0.4	0.7	0.7	8.2	0.
DC PUAM border	125	Blue	14.4	0.7	2.4	68.5	0.2	0.4	0.7	0.6	8.2	0.
Four Seasons	130	Blue	14.4	0.7	2.4	68.5	0.2	0.4	0.7	0.6	8.3	0.
Funerary Banquet	167	Blue	14.8	0.5	2.6	67.8	0.2	0.3	0.8	0.7	7.0	0.
Funerary Banquet	168	Blue 2	14.6	0.5	2.4	68.6	0.1	0.3	0.8	0.6	7.6	0.
Funerary Banquet	169	Light Green*	17.0	1.1	2.3	64.3	0.06	0.3	1.0	0.5	8.7	0.1
Maenad interior	27	Green*	17.7	0.7	1.9	63.9	0.1	0.3	1.0	0.7	5.3	0.1
Satyr interior	39	Green*	17.8	0.7	2.0	64.0	0.08	0.2	0.8	0.7	5.3	0.1
JP border	71	Green*	18.0	0.7	1.9	64.0	0.1	0.3	1.0	0.6	5.3	0.1
AA border	97	Green*	18.2	0.7	1.9	63.6	0.1	0.3	1.0	0.6	5.3	0.1
JP interior	54	Green*	16.3	0.6	2.3	68.8	0.1	0.2	0.9	0.6	7.1	0.
Agora	180	Green*	16.2	0.6	2.1	63.5	0.1	0.3	1.0	0.7	6.8	0.
Eukarpia	191	Green*	19.5	0.7	2.0	66.0	0.09	0.4	1.3	0.6	6.5	0.1
DC interior	4	Dark Green*	15.5	1.3	2.1	61.4	0.3	0.2	0.8	1.0	6.7	0.1
DC interior	5	Dark Green*	15.4	1.3	2.1	61.6	0.4	0.2	0.9	1.0	6.7	0.
DC interior	6	Dark Green*	15.5	1.3	2.1	61.6	0.4	0.2	0.8	1.0	6.7	0.
Maenad interior	28	Pale Green	17.7	0.7	1.9	65.5	0.1	0.4	0.7	0.6	5.5	0.
Maenad interior	29	Pale Green 2	16.5	0.6	2.2	66.7	0.1	0.3	0.9	0.6	6.7	0.
Maenad interior	30	Pale Green 3	17.7	0.6	1.9	65.6	0.1	0.4	0.8	0.6	5.3	0.1
JP interior	55	Pale Green	19.2	0.7	1.9	66.6	0.1	0.4	0.9	0.6	5.3	0.
JP border	72	Pale Green	18.0	0.6	1.9	65.4	0.1	0.4	0.8	0.7	5.2	0.
JP border	73	Pale Green	18.0	0.6	1.8	65.5	0.1	0.4	0.8	0.6	5.2	0.1
JP border	74	Pale Green 2	16.8	0.6	2.1	66.0	0.1	0.4	0.7	0.6	6.2	0.
Agora	181	Pale Green	17.5	0.7	2.1	66.2	0.03	0.3	1.2	0.6	7.1	0.

* Translucent

MnO	Fe$_2$O$_3$	CoO	CuO	ZnO	SnO$_2$	Sb$_2$O$_3$	BaO	PbO	Observations
0.5	0.5	0.09	0.2	n.d.	n.d.	1.4	0.02	0.5	
0.5	0.6	0.08	0.2	n.d.	n.d.	1.4	0.02	0.6	
0.8	1.0	0.08	0.1	n.d.	n.d.	1.7	0.03	n.d.	
0.8	1.1	0.08	0.1	n.d.	n.d.	1.6	0.03	n.d.	
0.8	1.1	0.07	0.1	n.d.	n.d.	1.7	0.04	n.d.	
0.9	1.0	0.07	0.07	n.d.	n.d.	1.8	0.03	n.d.	
0.6	0.6	0.05	0.05	n.d.	0.02	4.0	0.03	n.d.	
0.3	0.7	0.06	0.1	n.d.	0.01	2.8	0.01	0.3	
0.8	2.1	n.d.	0.04	n.d.	0.1	0.1	0.03	1.5	*A few Pb-Sn crystals.*
0.4	0.7	n.d.	2.6	n.d.	0.2	1.0	0.02	3.3	*A few crystals: Pb-(Sb+Sn), Sb>Sn.*
0.4	0.8	n.d.	2.5	n.d.	0.2	0.8	n.d.	3.4	
0.4	0.8	n.d.	2.6	n.d.	0.2	0.9	0.02	3.1	*A few crystals: Pb-(Sb+Sn), Sb>Sn.*
0.4	0.7	n.d.	2.5	n.d.	0.3	1.0	0.01	3.2	*A few SnO$_2$ and Pb-Sb crystals.*
0.6	0.4	n.d.	1.3	n.d.	0.09	0.6	0.03	0.1	*Few crystals. Ca-Sb and Pb-Sb.*
0.4	0.9	n.d.	1.6	n.d.	0.1	0.8	0.01	4.8	*A few crystals: Ca-Sb and Pb-Sb.*
0.1	0.7	n.d.	1.1	n.d.	0.07	0.4	0.02	0.5	*Very weathered glass.*
0.8	1.1	n.d.	3.5	n.d.	0.2	0.5	0.03	4.6	*Inclusions: Cu + Sn. A few crystals: SnO$_2$ and Pb-(Sb+Sn).*
0.8	1.0	n.d.	3.3	0.01	0.2	0.5	0.02	4.4	*A few crystals: SnO$_2$ and Pb-(Sb+Sn).*
0.7	1.0	n.d.	3.3	0.01	0.3	0.5	0.02	4.5	*Inclusion: bronze with Sn surface layer.*
0.4	0.7	n.d.	1.0	n.d.	0.06	4.2	0.02	0.4	*Ca-Sb crystals but no Pb-Sb.*
0.4	0.5	n.d.	1.7	n.d.	0.1	2.3	0.01	0.1	*Ca-Sb crystals but no Pb-Sb.*
0.4	0.7	n.d.	2.4	n.d.	0.2	2.6	0.02	0.3	*Crystals: Ca-Sb. Circular metallic inclusion: Cu with trace of Ag.*
0.3	0.6	n.d.	0.9	0.01	0.07	2.1	0.01	0.3	*Ca-Sb.*
0.3	0.7	n.d.	2.5	n.d.	0.1	2.7	0.01	0.3	*Crystals: Ca-Sb and some SnO$_2$.*
0.3	0.7	n.d.	2.4	n.d.	0.1	2.7	0.01	0.3	
0.4	0.6	n.d.	1.7	0.01	0.07	3.3	0.02	0.2	*Very pale green. Ca-Sb and some SnO$_2$ crystals.*
0.2	0.8	n.d.	1.2	n.d.	0.1	1.0	0.01	1.1	*Mostly Ca-Sb crystals, some Pb-(Sb+Sn) crystals.*

Identification	No.	Color	Na_2O	MgO	Al_2O_3	SiO_2	P_2O_5	SO_3	Cl	K_2O	CaO	TiO
DC interior	7	Green	17.7	0.7	1.9	63.8	0.09	0.3	0.9	0.7	5.4	0.1
DC interior	8	Green	16.7	0.7	1.9	64.0	0.1	0.3	0.9	0.7	5.5	0.1
Maenad border	35	Green	18.7	0.7	1.9	65.0	0.1	0.2	0.8	0.7	5.4	0.0
Satyr interior	40	Green	17.3	0.7	2.0	62.5	0.1	0.3	0.9	0.7	5.7	0.1
Satyr border	44	Green	18.4	0.7	1.9	65.0	0.08	0.2	0.9	0.7	5.6	0.1
JP interior	56	Green	13.8	0.5	2.3	61.8	0.08	0.2	1.0	0.5	6.1	0.0
JP interior	57	Green 2	14.6	0.5	2.2	63.5	0.09	0.2	1.1	0.6	6.3	0.0
JP interior	58	Green 3	15.2	0.5	2.4	65.5	0.1	0.2	1.0	0.6	6.7	0.0
JP border	75	Green	17.2	0.7	1.8	61.3	0.1	0.3	1.0	0.6	5.1	0.1
AA interior	85	Green	18.3	0.8	2.0	65.0	0.06	0.2	0.9	0.7	5.5	0.1
AA border	98	Green	18.0	0.8	1.9	63.0	0.1	0.3	0.9	0.7	5.7	0.1
AA border	99	Green 2	17.4	0.6	1.9	61.8	0.08	0.3	1.0	0.6	4.8	0.1
DC PUAM interior	116	Green	14.0	0.5	2.1	63.4	0.1	0.2	1.1	0.5	7.3	0.0
DC PUAM border	126	Green	14.2	0.5	2.1	63.6	0.1	0.1	1.1	0.5	7.3	0.0
Four Seasons	131	Green	13.2	0.5	2.3	67.8	0.07	0.2	1.1	0.4	7.5	0.0
Marine Mosaic	148	Green	14.8	0.5	2.1	63.2	0.1	0.3	1.0	0.6	7.0	0.0
Marine Mosaic	149	Green	14.9	0.5	2.1	62.4	0.1	0.3	1.0	0.6	6.9	0.0
Marine Mosaic	150	Green	14.9	0.5	2.0	62.7	0.1	0.2	1.0	0.6	7.0	0.0
Marine Mosaic	151	Green	14.7	0.5	2.1	62.8	0.1	0.3	0.9	0.6	7.0	0.0
Funerary Banquet	170	Green	13.7	0.7	2.0	58.2	0.09	0.3	0.9	0.5	6.3	0.0
Agora	182	Green	15.0	0.6	2.0	63.2	0.1	0.2	1.0	0.6	6.3	0.0
Eukarpia	193	Green	17.8	0.6	2.0	64.0	0.06	0.3	1.1	0.5	6.0	0.1
Eukarpia	194	Green	17.4	0.6	2.0	64.4	0.05	0.3	1.2	0.5	6.1	0.1
Dionysos & Ariadne	207	Green	15.0	0.5	2.1	63.5	0.1	0.2	1.0	0.5	6.4	0.0
Dionysos & Ariadne	208	Green 2	17.4	0.7	2.0	63.5	0.1	0.3	0.8	0.7	5.3	0.1
Season	221	Green	15.5	0.6	2.1	61.4	0.1	0.4	0.8	0.6	6.4	0.0
JP interior	59	Dark Green	14.2	0.4	2.2	64.0	0.05	0.3	0.9	0.3	6.2	0.0
Eukarpia	192	Dark Green	13.5	0.5	1.9	63.3	0.2	0.2	0.8	0.6	5.7	0.0
DC interior	9	Yellow-Green	17.0	0.7	1.9	62.2	0.09	0.2	0.8	0.6	5.3	0.1
DC interior	10	Yellow-Green	16.6	0.7	2.0	62.4	0.1	0.2	0.9	0.6	5.2	0.1
Maenad interior	31	Yellow-Green	17.7	0.7	1.9	63.8	0.09	0.2	0.79	0.8	5.4	0.1
Maenad border	36	Yellow-Green	18.5	0.7	1.9	64.4	0.1	0.3	0.7	0.7	5.4	0.1
Satyr interior	41	Yellow-Green	18.0	0.6	2.0	64.4	0.08	0.3	0.9	0.7	5.1	0.1
Satyr border	45	Yellow-Green	17.7	0.7	1.9	63.8	0.1	0.3	0.8	0.6	5.5	0.1
JP border	76	Yellow-Green	17.7	0.6	1.7	62.5	0.09	0.3	1.1	0.6	4.9	0.1
JP border	77	Yellow-Green 2	17.8	0.6	1.8	62.5	0.08	0.3	1.1	0.6	4.8	0.1
AA interior	86	Yellow-Green	17.0	0.7	2.0	60.5	0.07	0.2	0.8	0.7	5.7	0.1
AA border	100	Yellow-Green	17.8	0.7	1.9	63.5	0.1	0.2	0.8	0.6	5.3	0.1
DC PUAM interior	117	Yellow-Green	13.6	0.5	2.0	63.0	0.06	0.2	1.0	0.4	6.8	0.0
Marine Mosaic	152	Yellow-Green	18.8	0.6	2.0	65.0	0.07	0.3	1.2	0.6	6.3	0.1
Eukarpia	195	Yellow-Green	16.2	0.5	1.9	62.0	0.04	0.3	1.1	0.5	5.3	0.0
Season	222	Yellow-Green	12.0	0.4	1.8	57.0	0.1	0.2	0.8	0.5	6.0	0.0
Season	223	Yellow-Green	12.0	0.4	1.8	57.2	0.1	0.2	0.8	0.5	6.0	0.0

MnO	Fe₂O₃	CoO	CuO	ZnO	SnO₂	Sb₂O₃	BaO	PbO	Observations
0.4	0.8	n.d.	2.3	n.d.	0.2	0.9	0.01	3.9	*Black inclusions: bronze (copper and tin ~ 13%) crystals: Pb-(Sb+Sn), Sb>Sn.*
0.4	0.8	n.d.	2.3	0.02	0.2	0.9	0.01	3.9	*Sample appears somewhat weathered.*
0.4	0.7	n.d.	1.7	n.d.	0.1	0.7	0.02	2.8	*Crystals: Pb-Sb and some Pb-(Sb+Sn) with Sb>Sn.*
0.4	0.7	n.d.	2.4	0.02	0.2	1.0	0.01	5.0	
0.4	0.8	n.d.	1.8	0.01	0.2	0.8	0.01	2.6	*Crystals: Pb-Sb and some Pb-(Sb+Sn) with Sb>Sn.*
1.2	0.8	n.d.	2.9	n.d.	0.3	0.6	0.03	8.3	*Crystals: Pb-(Sb+Sn), Sb>Sn.*
0.2	0.9	n.d.	1.2	n.d.	0.1	0.4	0.01	8.0	*Crystals: Pb-Sb, possibly some Sn.*
1.4	0.6	n.d.	1.6	n.d.	0.2	0.4	0.04	3.8	*Crystals: Pb-(Sb+Sn), Sb>Sn.*
0.4	0.8	n.d.	2.7	n.d.	0.2	1.2	0.01	6.6	*Crystals: Pb-(Sb+Sn) and some SnO₂.*
0.4	0.7	n.d.	1.5	n.d.	0.1	0.7	0.03	2.8	
0.4	0.7	n.d.	2.1	0.02	0.3	1.0	0.02	4.2	*Crystals: Pb-(Sb+Sn).*
0.3	0.8	n.d.	1.6	n.d.	0.2	1.4	0.02	7.2	
0.6	0.7	n.d.	1.3	0.2	0.02	0.5	0.01	7.5	*Pb-Sb crystals.*
0.6	0.7	n.d.	1.2	0.2	n.d.	0.4	0.02	7.4	*Pb-Sb crystals.*
0.1	0.5	n.d.	2.4	0.08	0.2	0.4	0.02	3.2	*Pb-(Sb+Sn) crystals.*
0.7	0.6	n.d.	1.7	0.2	0.2	0.3	0.03	6.8	*Heterogeneous translucent & opaque streaks, Pb-(Sb+Sn) crystals.*
0.7	0.7	n.d.	1.6	0.2	0.2	0.4	0.02	7.3	
0.7	0.7	n.d.	1.6	0.3	0.2	0.4	0.02	7.1	
0.7	0.7	n.d.	1.7	0.3	0.2	0.4	0.02	7.1	
0.4	1.0	n.d.	2.5	0.02	0.2	0.8	0.01	12.4	
0.4	0.9	n.d.	1.6	0.02	0.1	0.8	0.01	7.2	
0.02	1.0	n.d.	1.4	0.02	0.2	0.7	0.01	4.2	
0.04	1.0	n.d.	1.3	0.02	0.2	0.8	0.02	4.2	
0.7	0.6	n.d.	2.4	n.d.	0.2	0.5	0.02	6.8	*Pb-(Sb+Sn) crystals.*
0.4	0.8	n.d.	0.8	n.d.	0.09	0.9	0.01	6.2	
0.4	0.9	n.d.	1.2	0.03	0.2	1.5	0.03	7.7	
0.04	0.4	n.d.	5.8	n.d.	0.3	0.6	0.02	4.2	*A few Ca-Sb and Pb-(Sb+Sn) crystals.*
0.3	0.8	n.d.	3.1	0.03	0.2	0.6	0.02	8.0	
0.4	0.8	n.d.	1.6	n.d.	0.2	1.0	0.01	7.2	*Crystals: Pb-Sb and Pb-(Sb+Sn).*
0.4	0.8	n.d.	1.6	n.d.	0.2	1.0	0.02	7.2	
0.4	0.8	n.d.	0.8	0.01	0.1	0.9	0.01	5.5	
0.4	0.8	n.d.	0.9	n.d.	0.1	0.8	0.03	4.3	*Crystals: Pb-Sb and some Pb-(Sb+Sn) with Sb>Sn.*
0.3	0.9	n.d.	1.2	n.d.	0.1	1.0	0.01	4.3	
0.4	0.8	n.d.	0.9	n.d.	0.09	1.0	0.02	5.3	*Crystals: Pb-Sb.*
0.3	0.9	n.d.	1.6	n.d.	0.2	1.0	0.01	6.6	*Crystals: Pb-Sb and Pb-(Sb+Sn).*
0.3	0.9	n.d.	0.5	n.d.	0.1	1.0	n.d.	7.6	*Crystals: Pb-Sb, no Pb-Sn.*
0.4	0.7	n.d.	1.2	0.02	0.2	1.0	0.02	8.8	
0.4	0.9	n.d.	0.7	n.d.	0.1	1.2	0.01	5.8	*Pb-Sb and Pb-(Sb+Sn) crystals.*
0.04	0.8	n.d.	0.8	0.1	0.2	0.7	0.01	10.0	
0.4	0.7	n.d.	0.9	n.d.	0.08	0.7	0.01	2.4	*Crystals: Pb-Sb and Pb-(Sb+Sn).*
0.1	1.2	n.d.	1.4	0.04	0.2	1.2	0.02	7.9	
1.0	1.0	n.d.	0.6	n.d.	0.04	0.9	0.03	17.4	
1.0	1.0	n.d.	0.7	n.d.	0.04	0.9	0.03	17.5	

Identification	No.	Color	Na_2O	MgO	Al_2O_3	SiO_2	P_2O_5	SO_3	Cl	K_2O	CaO	TiO
Maenad interior	32	Pale Yellow*	16.2	0.5	2.5	70.4	0.06	0.1	1.3	0.5	7.8	0.0
DC PUAM interior	118	Pale Yellow	14.2	0.6	2.3	66.0	0.1	0.1	1.1	0.6	7.9	0.0
Season	224	Pale Yellow	17.2	0.7	2.0	61.7	0.1	0.4	0.9	0.6	6.0	0.0
DC interior	11	Yellow	16.3	0.7	1.8	59.6	0.09	0.2	1.0	0.6	4.7	0.1
DC border	20	Yellow	15.8	0.7	1.8	58.6	0.1	0.3	0.9	0.6	4.7	0.1
DC border	21	Yellow	15.9	0.7	1.8	58.8	0.1	0.3	1.0	0.6	4.5	0.1
Maenad interior	33	Yellow	15.0	0.7	1.8	57.4	0.09	0.2	0.8	0.6	4.6	0.1
Satyr interior	42	Yellow	18.5	0.7	2.0	65.3	0.06	0.3	0.9	0.7	5.1	0.1
Satyr interior	43	Yellow 2	16.4	0.8	1.8	59.8	0.09	0.3	0.9	0.7	4.6	0.1
JP interior	60	Yellow	13.5	0.4	2.1	63.4	0.1	0.1	1.0	0.6	6.3	0.0
JP interior	61	Yellow 2	13.2	0.4	2.1	59.2	0.09	0.2	1.0	0.5	6.0	0.0
JP border	78	Yellow	15.2	0.7	1.7	57.8	0.1	0.3	1.1	0.6	4.4	0.1
AA interior	87	Yellow	15.2	0.7	1.7	57.8	0.09	0.3	1.0	0.6	4.5	0.0
AA interior	88	Yellow 2	16.8	0.8	1.8	60.8	0.08	0.2	1.0	0.6	4.7	0.1
AA border	101	Yellow	13.6	0.4	1.9	61.8	0.09	0.1	1.1	0.5	6.3	0.0
DC PUAM border	127	Yellow	13.0	0.5	1.8	58.0	0.07	0.2	0.9	0.5	6.3	0.0
DC PUAM border	128	Yellow	13.0	0.5	1.8	58.0	0.09	0.2	0.9	0.5	6.3	0.0
Marine Mosaic	153	Yellow	11.2	0.7	1.7	51.6	0.1	0.2	0.8	0.5	4.1	0.1
Marine Mosaic	154	Yellow	10.9	0.7	1.7	49.7	0.1	0.3	0.8	0.5	3.9	0.1
Marine Mosaic	155	Yellow	10.6	0.7	1.6	48.4	0.1	0.2	0.7	0.5	3.6	0.1
Agora	183	Yellow	13.8	0.5	2.4	62.8	0.07	0.2	1.0	0.4	6.7	0.0
Agora	184	Yellow 2	16.2	0.4	1.7	59.2	0.03	0.3	1.0	0.4	5.0	0.0
Eukarpia	196	Yellow	14.0	0.6	2.2	65.6	0.1	0.2	0.9	0.6	7.2	0.0
Eukarpia	197	Yellow	13.7	0.5	2.2	65.8	0.1	0.2	0.8	0.6	7.5	0.0
Eukarpia	198	Yellow 2	15.3	0.5	1.8	56.8	0.05	0.3	0.8	0.4	5.7	0.0
Dionysos & Ariadne	209	Yellow	13.7	0.5	2.0	59.5	0.1	0.2	1.0	0.5	6.3	0.0
Dionysos & Ariadne	210	Yellow	13.5	0.5	1.9	59.5	0.1	0.2	1.0	0.5	6.3	0.0
Dionysos & Ariadne	211	Yellow 2	16.2	0.7	1.8	59.8	0.1	0.3	0.9	0.6	4.7	0.1

* Translucent

MnO	Fe₂O₃	CoO	CuO	ZnO	SnO₂	Sb₂O₃	BaO	PbO	Observations
0.06	0.3	n.d.	0.01	n.d.	n.d.	0.02	0.02	n.d.	*Yellow color from trace of Fe.*
0.8	0.7	n.d.	0.01	n.d.	n.d.	0.4	0.04	5.2	*Pb-Sb crystals.*
0.4	0.8	n.d.	0.02	n.d.	0.2	1.2	0.02	7.5	
0.6	1.2	n.d.	n.d.	n.d.	0.06	1.4	n.d.	11.8	*Crystals: Pb-Sb.*
0.6	1.2	n.d.	n.d.	n.d.	0.05	1.5	0.02	13.2	*Pb-Sb crystals.*
0.5	1.2	n.d.	n.d.	n.d.	0.07	1.5	0.01	13.2	
0.5	1.3	n.d.	n.d.	n.d.	0.04	1.6	0.01	15.4	
0.4	0.8	n.d.	n.d.	n.d.	0.01	1.3	0.01	3.8	
0.5	1.2	n.d.	n.d.	n.d.	0.05	1.3	0.01	11.6	
0.4	0.7	n.d.	0.01	n.d.	n.d.	0.7	0.01	10.8	*Many fine Pb-Sb crystals.*
0.4	0.8	n.d.	0.03	n.d.	0.07	0.7	n.d.	15.4	*Pb-Sb crystals.*
0.5	1.2	n.d.	n.d.	n.d.	0.08	1.5	0.01	14.8	*Crystals: Pb-Sb, no Pb-Sn.*
0.5	1.3	n.d.	0.01	n.d.	0.07	1.4	0.01	15.0	*Crystals: Pb-Sb, SiO2 inclusions also seen.*
0.5	1.1	n.d.	n.d.	n.d.	0.05	1.2	0.01	10.5	
0.1	0.7	n.d.	0.01	n.d.	0.05	0.7	0.01	12.8	*Crystals: Pb-Sb, SiO2 inclusions also seen.*
0.5	0.9	n.d.	0.4	0.03	0.3	0.7	0.02	16.0	*Crystals: Pb(Sb+Sn).*
0.5	0.9	n.d.	0.4	0.02	0.3	0.7	0.02	16.1	*Crystals: Pb(Sb+Sn).*
0.6	2.2	n.d.	0.07	n.d.	0.4	1.5	0.04	24.4	*Heterogeneous mix of translucent and opaque streaks, crystals: Pb-(Sb+Sn).*
0.6	2.4	n.d.	0.07	n.d.	0.4	1.7	n.d.	26.2	
0.7	2.6	n.d.	0.1	n.d.	0.4	1.8	n.d.	28.0	
0.08	0.8	n.d.	0.01	n.d.	n.d.	0.6	0.02	10.5	*Dark yellow heterogeneous mix of translucent and opaque streaks.*
0.06	0.8	n.d.	0.03	n.d.	0.03	0.9	0.01	14.0	*Bright yellow Pb-Sb crystals.*
1.2	0.7	n.d.	0.05	n.d.	0.04	0.9	0.03	5.9	*Pb-Sb crystals.*
1.2	0.7	n.d.	0.07	n.d.	0.04	1.0	0.04	5.4	
0.3	1.1	n.d.	0.02	n.d.	0.1	1.3	0.01	15.6	
0.6	0.9	n.d.	0.1	n.d.	0.08	0.7	0.03	13.8	*Heterogeneous mix of translucent and opaque streaks. Crystals: mostly Pb-Sb, some Pb-(Sb+Sn).*
0.6	1.0	n.d.	0.1	n.d.	0.07	0.7	0.03	14.2	
0.6	1.2	n.d.	n.d.	n.d.	0.06	1.4	0.02	11.6	

Identification	No.	Color	Na$_2$O	MgO	Al$_2$O$_3$	SiO$_2$	P$_2$O$_5$	SO$_3$	Cl	K$_2$O	CaO	TiO
DC interior	12	Red	13.3	3.3	2.7	51.0	1.1	0.1	1.2	1.4	8.8	0.2
DC interior	13	Red	13.3	3.3	2.7	51.0	1.1	0.2	1.3	1.4	9.0	0.2
Maenad border	37	Red	18.0	0.6	2.0	64.2	0.1	0.3	1.0	0.6	5.4	0.0
Satyr border	46	Red	17.8	0.6	1.9	64.1	0.1	0.3	0.9	0.6	5.4	0.1
AA interior	89	Red	14.0	2.1	3.1	52.4	0.5	0.3	1.2	1.0	9.6	0.3
AA interior	90	Red	13.8	2.1	3.1	53.0	0.5	0.3	1.1	1.0	9.4	0.2
AA border	102	Red	15.8	0.5	2.4	67.5	0.07	0.1	1.0	0.6	7.1	0.0
AA border	103	Red	15.8	0.5	2.4	67.0	0.08	0.1	1.0	0.6	7.0	0.0
AA border	104	Red	15.9	0.5	2.4	66.5	0.1	0.2	1.0	0.6	6.9	0.0
Maenad interior	34	Dark Red	15.7	0.4	2.3	68.4	0.1	0.1	1.2	0.4	6.8	0.0
AA border	105	Dark Red	16.0	0.4	2.3	70.1	0.06	0.1	1.2	0.4	6.7	0.0
AA border	106	Dark Red	15.9	0.4	2.3	69.5	0.07	0.1	1.2	0.4	6.7	0.0
DC PUAM interior	119	Red	11.5	2.2	2.8	50.4	0.9	0.2	1.2	1.5	7.4	0.2
Four Seasons	132	Red	13.0	3.3	2.5	52.2	1.2	0.1	1.3	1.5	9.0	0.2
Marine Mosaic	156	Red	11.8	2.4	3.1	51.2	0.8	0.2	1.2	1.8	6.7	0.3
Funerary Banquet	171	Red	10.2	2.9	1.9	59.0	1.0	0.1	0.9	2.8	9.4	0.1
Funerary Banquet	172	Red 2	15.2	2.3	2.0	60.2	0.8	0.1	1.3	1.6	7.3	0.2
Agora	185	Red	14.2	1.5	2.6	52.0	0.4	0.3	0.9	1.0	7.5	0.2
Agora	186	Red 2	17.4	0.8	1.9	64.0	0.1	0.3	1.1	0.7	7.6	0.1
Eukarpia	199	Red	13.7	2.4	2.3	63.0	1.1	0.3	0.8	2.6	9.1	0.2
Eukarpia	200	Red	13.7	2.3	2.4	62.6	1.1	0.3	0.8	2.7	9.2	0.2
Europa	215	Red	14.6	0.7	2.3	65.0	0.2	0.2	1.2	0.7	7.3	0.0
Europa	216	Red 2	13.2	3.0	2.5	54.4	1.2	0.1	1.3	1.5	8.1	0.2
Agros and Opora	218	Red	11.8	2.3	3.0	51.8	1.2	0.2	1.4	1.7	7.8	0.2
Agros and Opora	219	Red 2	14.0	1.8	3.0	53.7	0.4	0.3	1.4	0.7	7.8	0.2
Season	225	Dark Red	18.5	0.7	2.1	64.4	0.1	0.3	1.1	0.6	6.5	0.1
DC interior	14	Orange	9.5	1.9	2.7	41.4	0.5	0.3	0.8	1.1	6.9	0.2
DC interior	15	Orange	9.5	1.9	2.7	41.2	0.5	0.3	0.9	1.1	7.0	0.2
JP interior	62	Orange	10.3	1.9	2.8	42.5	0.6	0.3	1.1	1.1	6.3	0.2
JP border	79	Red-Orange	9.6	1.9	3.4	40.5	0.6	0.2	1.2	1.1	7.2	0.3
JP border	80	Orange	9.8	1.9	3.4	40.4	0.6	0.2	1.1	1.1	7.1	0.3
AA interior	91	Red-Orange	8.8	1.5	3.4	39.9	0.2	0.2	0.8	0.8	8.0	0.3
AA interior	92	Orange	10.0	2.0	3.4	40.8	0.6	0.2	1.2	1.1	7.0	0.3
AA border	107	Red-Orange	9.2	1.9	3.4	41.1	0.5	0.2	1.2	1.1	7.0	0.3
AA border	108	Orange	9.1	1.9	3.3	41.0	0.5	0.2	1.2	1.1	7.1	0.3
DC PUAM interior	120	Orange	8.0	1.3	3.0	40.2	0.4	0.2	0.7	1.0	6.4	0.2
Marine Mosaic	157	Orange	8.0	1.2	3.0	40.0	0.4	0.2	0.7	1.0	6.4	0.2
Marine Mosaic	158	Orange	8.1	1.3	3.1	40.0	0.4	0.2	1.0	1.0	6.2	0.2
Marine Mosaic	159	Orange	8.1	1.3	3.1	40.0	0.4	0.2	0.8	1.0	6.4	0.2
Funerary Banquet	173	Orange	8.2	1.4	1.9	41.6	0.5	0.3	0.8	1.2	6.1	0.1
Eukarpia	201	Red-Orange	8.5	1.8	2.6	45.5	0.5	0.2	0.7	1.5	7.4	0.2
Eukarpia	202	Orange	8.5	1.5	3.6	41.4	0.4	0.2	0.7	0.9	6.9	0.3
Eukarpia	203	Orange 2	9.0	1.5	1.9	42.5	0.4	0.2	0.7	1.2	6.4	0.1

* Translucent

MnO	Fe$_2$O$_3$	CoO	CuO	ZnO	SnO$_2$	Sb$_2$O$_3$	BaO	PbO	Observations
0.7	2.1	n.d.	1.7	0.08	0.3	0.1	0.02	11.8	
0.7	2.1	n.d.	1.7	0.07	0.4	0.1	0.03	11.6	
0.3	2.8	0.01	1.5	n.d.	0.2	0.8	0.03	2.3	*Black inclusions: Cu with some Sb and traces of Ag & As.*
0.3	2.8	n.d.	1.6	n.d.	0.2	0.9	0.02	2.4	*Black inclusions: Cu with some Sb and traces of Ag & As. Same as Maenad.*
0.4	2.8	n.d.	1.5	n.d.	0.9	0.6	0.03	9.4	
0.4	2.8	n.d.	1.6	0.02	0.8	0.6	0.02	9.5	
0.7	2.1	n.d.	1.2	n.d.	0.1	0.06	0.03	0.6	
0.5	3.2	n.d.	1.6	n.d.	0.2	0.02	0.03	0.1	*Large black inclusion: Fe with Cu surrounding.*
0.6	3.0	n.d.	1.7	n.d.	0.2	0.03	0.03	0.1	*SiO$_2$ inclusions.*
0.05	3.4	n.d.	0.7	n.d.	0.1	0.02	0.02	n.d.	*Dark purplish-red opaque.*
0.06	1.6	n.d.	0.8	n.d.	0.09	0.04	0.03	n.d.	
0.04	2.2	n.d.	0.9	n.d.	0.09	0.04	0.03	n.d.	
0.5	2.2	n.d.	2.2	0.06	0.6	0.4	0.02	16.0	
0.7	2.0	n.d.	2.3	0.1	0.4	0.1	0.02	10.2	
0.5	2.6	n.d.	1.6	0.1	0.8	0.4	0.02	14.6	*Inclusions: Cu + S.*
0.2	1.6	n.d.	1.1	n.d.	0.2	0.3	0.04	8.2	
0.4	1.2	n.d.	1.4	0.02	0.5	0.3	0.03	5.3	
0.3	1.4	n.d.	1.2	0.04	0.2	0.5	0.02	16.0	
0.3	3.6	n.d.	0.4	n.d.	0.08	0.6	0.02	1.1	
0.4	1.4	n.d.	0.8	0.05	0.2	0.2	0.01	1.4	
0.4	1.4	n.d.	0.9	0.05	0.2	0.2	0.01	1.6	
1.1	2.6	n.d.	1.2	0.02	0.1	0.5	0.02	2.3	
0.6	2.5	n.d.	2.2	0.1	0.7	0.2	0.02	8.2	
0.5	2.5	n.d.	1.7	0.08	0.5	0.3	0.04	13.2	
0.6	3.0	n.d.	2.0	0.09	0.3	0.4	0.03	10.4	
0.4	2.9	n.d.	0.4	0.01	0.07	0.8	0.03	1.0	
0.4	1.9	n.d.	7.7	0.1	1.2	0.3	0.01	23.2	
0.4	1.9	n.d.	7.5	0.1	1.2	0.3	0.01	23.5	
0.5	2.0	n.d.	8.3	0.3	1.3	0.2	0.01	20.4	*Cuprite crystals in reddish areas.*
0.5	2.7	n.d.	6.6	0.06	1.4	0.1	0.03	22.8	
0.6	2.7	n.d.	6.7	0.07	1.5	0.1	0.02	22.5	
0.1	3.0	n.d.	6.5	0.04	1.2	0.3	n.d.	25.2	
0.5	2.6	0.01	6.5	0.08	1.3	0.2	0.02	22.4	
0.6	2.9	n.d.	6.5	0.1	1.2	0.1	0.02	22.7	*Cuprite crystallites in reddish areas. SnO$_2$ inclusion.*
0.5	2.8	n.d.	6.7	0.09	1.2	0.1	0.01	22.8	*Large SnO$_2$ inclusion.*
0.2	2.8	n.d.	7.5	0.2	1.3	0.5	0.01	26.2	
0.1	2.9	n.d.	7.5	0.2	1.2	0.5	0.02	26.4	
0.2	2.9	n.d.	7.4	0.2	1.1	0.5	0.03	26.2	
0.2	2.8	n.d.	7.3	0.2	1.2	0.4	0.02	26.5	
0.2	4.7	n.d.	7.8	0.3	1.2	0.3	0.02	23.5	
0.2	2.6	n.d.	8.8	0.2	0.9	0.4	0.02	18.6	*Red and orange streaks, cuprite crystals in red. SiO$_2$ & Si-Ca (likely wollastonite, CaSiO$_3$) inclusions.*
0.2	2.8	n.d.	6.8	0.2	1.3	0.2	0.02	24.2	
0.2	3.5	n.d.	7.6	0.2	1.1	0.3	0.01	23.2	

Identification	No.	Color	Na_2O	MgO	Al_2O_3	SiO_2	P_2O_5	SO_3	Cl	K_2O	CaO	TiO_2
JP interior	63	Clear*	19.5	0.6	2.0	67.8	0.08	0.4	1.1	0.6	5.1	0.1
Funerary Banquet	174	Clear*	18.6	1.5	2.9	62.4	0.06	0.3	1.3	0.4	9.0	0.2
JP interior	64	White	18.4	0.7	2.0	65.4	0.09	0.5	0.7	0.6	6.0	0.1
JP interior	65	White 2	18.6	0.4	1.9	67.8	0.06	0.4	1.1	0.4	6.1	0.06
JP interior	66	White 3	15.2	0.5	2.4	67.8	0.1	0.4	0.6	0.6	7.4	0.05
DC PUAM interior	121	White	14.7	0.8	2.6	66.9	0.2	0.5	0.6	0.9	8.1	0.08
DC PUAM interior	122	White	14.7	0.8	2.6	66.8	0.2	0.5	0.6	0.9	8.2	0.07
Marine Mosaic	160	White	15.9	0.5	2.3	69.6	0.1	0.2	0.9	0.6	7.9	0.06
Marine Mosaic	161	White	15.9	0.5	2.3	69.8	0.1	0.2	0.9	0.6	8.1	0.06
Europa	217	White	14.8	0.6	2.4	69.2	0.09	0.3	0.9	0.5	7.4	0.05
Season	226	White	15.0	0.8	2.7	65.8	0.2	0.6	0.6	0.9	8.2	0.07
JP interior	67	Black*	4.0	0.09	13.0	74.8	0.02	0.02	0.3	5.2	0.7	0.06
JP border	81	Black*	15.3	0.5	2.3	67.8	0.07	0.1	1.2	0.5	6.5	0.05
AA border	109	Black*	15.2	0.5	2.5	67.4	0.1	0.2	1.0	0.6	6.9	0.05
Funerary Banquet	175	Black*	18.0	1.0	2.1	64.0	0.2	0.3	0.9	0.9	7.7	0.1
Dionysos & Ariadne	212	Black*	15.5	0.9	2.3	64.4	0.2	0.3	1.0	1.0	7.4	0.06
Dionysos & Ariadne	213	Black*	15.5	0.9	2.3	64.5	0.2	0.3	1.0	1.0	7.4	0.06
DC PUAM interior	123	Brown*	15.8	0.6	2.2	66.2	0.1	0.3	1.0	0.6	7.3	0.07
Eukarpia	204	Amber*	19.3	0.8	2.1	65.8	0.1	0.4	1.2	0.5	6.9	0.1

* Translucent

MnO	Fe$_2$O$_3$	CoO	CuO	ZnO	SnO$_2$	Sb$_2$O$_3$	BaO	PbO	Observations
0.4	0.6	n.d.	n.d.	n.d.	0.01	1.4	n.d.	0.3	*Mostly clear with a few Ca-Sb crystals.*
0.5	1.2	n.d.	0.04	n.d.	0.02	0.07	0.03	1.6	
0.4	0.8	n.d.	0.01	n.d.	0.01	4.3	0.01	0.1	*Similar to White no. 65 but more Ca-Sb.*
0.09	0.4	n.d.	0.2	n.d.	0.02	2.2	0.01	0.4	
0.07	0.4	n.d.	n.d.	n.d.	n.d.	4.4	0.03	n.d.	
0.2	0.6	n.d.	n.d.	n.d.	n.d.	3.8	0.02	n.d.	
0.2	0.6	n.d.	n.d.	n.d.	n.d.	3.7	0.02	n.d.	
0.4	0.4	n.d.	0.01	n.d.	n.d.	1.1	0.02	n.d.	*Lightly opacified with Ca-Sb.*
0.5	0.3	n.d.	n.d.	n.d.	n.d.	0.7	0.03	n.d.	
0.05	0.4	n.d.	n.d.	n.d.	n.d.	3.2	0.02	n.d.	
0.2	0.5	n.d.	n.d.	n.d.	0.02	4.4	0.01	n.d.	
0.05	1.6	n.d.	n.d.	n.d.	n.d.	0.02	0.01	n.d.	*Appears to be obsidian (natural glass). Some Fe oxide inclusions.*
0.1	2.0	n.d.	0.1	n.d.	0.05	0.1	0.02	3.3	
0.4	4.5	0.2	0.1	0.01	n.d.	0.04	0.03	0.2	
0.5	3.8	n.d.	n.d.	n.d.	n.d.	0.5	0.02	n.d.	
4.9	0.8	n.d.	0.06	n.d.	n.d.	0.7	0.06	0.5	*Very dark purple, Mn oxide inclusions & a few Ca-Sb crystals.*
4.8	0.8	n.d.	0.06	n.d.	n.d.	0.7	0.06	0.5	
0.7	2.7	0.01	0.2	0.02	0.03	0.7	0.04	1.5	
0.9	1.9	n.d.	0.07	n.d.	n.d.	0.02	0.01	n.d.	

Atrium House Triclinium
Grouping of Samples Identified as From the Same Batch of Glass
According to Criteria Set Forth in the Glass Section of the Atrium House Triclinium essay (pg. 51)

Identification	No.	Color	Na_2O	MgO	Al_2O_3	SiO_2	P_2O_5	SO_3	Cl	K_2O	CaO	TiO
Batch No. 1												
DC interior	1	Turquoise	20.4	1.0	2.5	61.0	0.05	0.3	1.5	0.4	7.3	0.2
DC interior	2	Turquoise	20.2	1.0	2.5	61.2	0.06	0.2	1.4	0.4	7.4	0.2
JP interior	47	Turquoise	20.6	1.0	2.4	61.0	0.06	0.3	1.5	0.4	7.3	0.2
Batch No. 2												
Maenad interior	22	Amethyst*	18.8	0.6	1.9	68.0	0.07	0.3	1.2	0.7	5.4	0.1
AA border	93	Amethyst*	18.7	0.7	1.8	67.5	0.09	0.3	1.2	0.7	5.4	0.0
Batch No. 3												
DC border	17	Pale Gray-Blue	19.0	0.6	1.9	67.6	0.09	0.3	1.0	0.6	5.4	0.1
AA border	96	Pale Gray-Blue	19.0	0.6	1.9	67.6	0.07	0.3	1.0	0.6	5.3	0.1
Batch No. 4												
JP interior	53	Blue	15.5	0.5	2.5	68.8	0.1	0.3	0.9	0.6	7.5	0.0
JP border	70	Blue	15.1	0.5	2.4	68.9	0.1	0.3	0.9	0.6	7.7	0.0
Batch No. 5												
Maenad interior	30	Pale Green 3	17.7	0.6	1.9	65.6	0.1	0.4	0.8	0.6	5.3	0.1
JP border	72	Pale Green	18.0	0.6	1.9	65.4	0.1	0.4	0.8	0.7	5.2	0.0
JP border	73	Pale Green	18.0	0.6	1.8	65.5	0.1	0.4	0.8	0.6	5.2	0.1
Batch No. 6												
Maenad border	35	Green	18.7	0.7	1.9	65.0	0.1	0.2	0.8	0.7	5.4	0.0
Satyr Border	44	Green	18.4	0.7	1.9	65.0	0.08	0.2	0.9	0.7	5.6	0.1
AA interior	85	Green	18.3	0.8	2.0	65.0	0.06	0.2	0.9	0.7	5.5	0.1
Batch No. 7												
Maenad interior	27	Green*	17.7	0.7	1.9	63.9	0.1	0.3	1.0	0.7	5.3	0.1
Satyr interior	39	Green*	17.8	0.7	2.0	64.0	0.08	0.2	0.8	0.7	5.3	0.1
JP border	71	Green*	18.0	0.7	1.9	64.0	0.1	0.3	1.0	0.6	5.3	0.1
AA border	97	Green*	18.2	0.7	1.9	63.6	0.1	0.3	1.0	0.6	5.3	0.1
Batch No. 8												
Maenad interior	31	Yellow-Green	17.7	0.7	1.9	63.8	0.09	0.2	0.8	0.8	5.4	0.1
Maenad border	36	Yellow-Green	18.5	0.7	1.9	64.4	0.1	0.3	0.7	0.7	5.4	0.1
Satyr interior	41	Yellow-Green	18.0	0.6	2.0	64.4	0.08	0.3	0.9	0.7	5.1	0.1
Satyr border	45	Yellow-Green	17.7	0.7	1.9	63.8	0.1	0.3	0.8	0.6	5.5	0.1
AA border	100	Yellow-Green	17.8	0.7	1.9	63.5	0.1	0.2	0.8	0.6	5.3	0.1

MnO	Fe$_2$O$_3$	CoO	CuO	ZnO	SnO$_2$	Sb$_2$O$_3$	BaO	PbO	Observations
0.06	1.2	n.d.	2.0	0.05	0.2	2.1	0.02	0.1	
0.06	1.1	n.d.	2.0	0.07	0.2	2.2	0.02	0.1	
0.05	1.2	n.d.	1.9	0.02	0.2	2.1	0.01	0.1	
1.2	0.8	n.d.	0.01	n.d.	n.d.	0.9	0.04	0.2	*A Few Ca-Sb crystals. Mn oxide inclusion.*
1.6	0.8	n.d.	n.d.	n.d.	n.d.	0.9	0.03	0.2	*A few Ca-Sb crystals.*
0.4	0.9	0.02	0.05	n.d.	0.02	1.6	0.02	0.4	*Lightly opacified with Ca-Sb. Many voids/bubbles in glass.*
0.4	0.8	0.03	0.05	n.d.	n.d.	1.9	0.02	0.5	
0.5	0.5	0.09	0.2	n.d.	n.d.	1.4	0.02	0.5	
0.5	0.6	0.08	0.2	n.d.	n.d.	1.4	0.02	0.6	
0.4	0.7	n.d.	2.4	n.d.	0.2	2.6	0.02	0.3	*Crystals: Ca-Sb. Circular metallic inclusion: Cu with trace of Ag.*
0.3	0.7	n.d.	2.5	n.d.	0.1	2.7	0.01	0.3	*Crystals: Ca-Sb and some SnO$_2$.*
0.3	0.7	n.d.	2.4	n.d.	0.1	2.7	0.01	0.3	
0.4	0.7	n.d.	1.7	n.d.	0.1	0.7	0.02	2.8	*Crystals: Pb-Sb and some Pb-(Sb+Sn) with Sb>Sn.*
0.4	0.8	n.d.	1.8	0.01	0.2	0.8	0.01	2.6	*Crystals: Pb-Sb and some Pb-(Sb+Sn) with Sb>Sn.*
0.4	0.7	n.d.	1.5	n.d.	0.1	0.7	0.03	2.8	
0.4	0.7	n.d.	2.6	n.d.	0.2	1.0	0.02	3.3	*A few crystals: Pb-(Sb+Sn), Sb>Sn.*
0.4	0.8	n.d.	2.5	n.d.	0.2	0.8	n.d.	3.4	*A few crystals: Pb-Sb and some Pb-(Sb+Sn) with Sb>Sn.*
0.4	0.8	n.d.	2.6	n.d.	0.2	0.9	0.02	3.1	*A few crystals: Pb-(Sb+Sn), Sb>Sn.*
0.4	0.7	n.d.	2.5	n.d.	0.3	1.0	0.01	3.2	*A few SnO$_2$ and Pb-Sb crystals.*
0.4	0.8	n.d.	0.8	0.01	0.1	0.9	0.01	5.5	
0.4	0.8	n.d.	0.9	n.d.	0.1	0.8	0.03	4.3	*Crystals: Pb-Sb and some Pb-(Sb+Sn) with Sb>Sn.*
0.3	0.9	n.d.	1.2	n.d.	0.1	1.0	0.01	4.3	
0.4	0.8	n.d.	0.9	n.d.	0.09	1.0	0.02	5.3	*Crystals: Pb-Sb.*
0.4	0.9	n.d.	0.7	n.d.	0.1	1.2	0.01	5.8	*Pb-Sb and Pb-(Sb+Sn) crystals.*

Identification	No.	Color	Na$_2$O	MgO	Al$_2$O$_3$	SiO$_2$	P$_2$O$_5$	SO$_3$	Cl	K$_2$O	CaO	TiO
Batch No. 9												
DC interior	11	Yellow	16.3	0.7	1.8	59.6	0.09	0.2	1.0	0.6	4.7	0.1
DC border	21	Yellow	15.9	0.7	1.8	58.8	0.1	0.3	1.0	0.6	4.5	0.1
Satyr interior	43	Yellow 2	16.4	0.8	1.8	59.8	0.09	0.3	0.9	0.7	4.6	0.1
AA interior	88	Yellow 2	16.8	0.8	1.8	60.8	0.08	0.2	1.0	0.6	4.7	0.1
Batch No. 10												
Maenad interior	33	Yellow	15.0	0.7	1.8	57.4	0.09	0.2	0.8	0.6	4.6	0.1
JP border	78	Yellow	15.2	0.7	1.7	57.8	0.1	0.3	1.1	0.6	4.4	0.1
AA interior	87	Yellow	15.2	0.7	1.7	57.8	0.09	0.3	1.0	0.6	4.5	0.0
Batch No. 11												
Maenad border	37	Red	18.0	0.6	2.0	64.2	0.1	0.3	1.0	0.6	5.4	0.0
Satyr border	46	Red	17.8	0.6	1.9	64.1	0.1	0.3	0.9	0.6	5.4	0.1
Batch No. 12												
Maenad interior	34	Dark Red	15.7	0.4	2.3	68.4	0.1	0.1	1.2	0.4	6.8	0.0
AA border	105	Dark Red	16.0	0.4	2.3	70.1	0.06	0.1	1.2	0.4	6.7	0.0
AA border	106	Dark Red	15.9	0.4	2.3	69.5	0.07	0.1	1.2	0.4	6.7	0.0
Batch No. 13												
JP border	79	Red-Orange	9.6	1.9	3.4	40.5	0.6	0.2	1.2	1.1	7.2	0.3
JP border	80	Orange	9.8	1.9	3.4	40.4	0.6	0.2	1.1	1.1	7.1	0.3
AA border	107	Red-Orange	9.2	1.9	3.4	41.1	0.5	0.2	1.2	1.1	7.0	0.3
AA border	108	Orange	9.1	1.9	3.3	41.0	0.5	0.2	1.2	1.1	7.1	0.3
Batch No. 14												
Satyr interior	38	Light Blue	17.4	0.7	2.0	65.5	0.09	0.4	0.9	0.7	5.4	0.1
Maenad interior	28	Pale Green	17.7	0.7	1.9	65.5	0.1	0.4	0.7	0.6	5.5	0.0
Batch No. 15												
JP interior	69	Light Blue	16.4	0.6	2.2	67.0	0.1	0.3	0.8	0.6	6.7	0.0
Maenad interior	29	Pale Green 2	16.5	0.6	2.2	66.7	0.1	0.3	0.9	0.6	6.7	0.0

* Translucent

MnO	Fe$_2$O$_3$	CoO	CuO	ZnO	SnO$_2$	Sb$_2$O$_3$	BaO	PbO	Observations
0.6	1.2	n.d.	n.d.	n.d.	0.06	1.4	n.d.	11.8	*Crystals: Pb-Sb.*
0.5	1.2	n.d.	n.d.	n.d.	0.07	1.5	0.01	13.2	
0.5	1.2	n.d.	n.d.	n.d.	0.05	1.3	0.01	11.6	
0.5	1.1	n.d.	n.d.	n.d.	0.05	1.2	0.01	10.5	
0.5	1.3	n.d.	n.d.	n.d.	0.04	1.6	0.01	15.4	
0.5	1.2	n.d.	n.d.	n.d.	0.08	1.5	0.01	14.8	*Crystals: Pb-Sb, no Pb-Sn.*
0.5	1.3	n.d.	0.01	n.d.	0.07	1.4	0.01	15.0	*Crystals: Pb-Sb, SiO2 inclusions also seen.*
0.3	2.8	0.01	1.5	n.d.	0.2	0.8	0.03	2.3	*Black inclusions: Cu with some Sb and traces of Ag & As.*
0.3	2.8	n.d.	1.6	n.d.	0.2	0.9	0.02	2.4	*Black inclusions: Cu with some Sb and traces of Ag & As.*
0.05	3.4	n.d.	0.7	n.d.	0.1	0.02	0.02	n.d.	*Dark purplish-red opaque.*
0.06	1.6	n.d.	0.8	n.d.	0.09	0.04	0.03	n.d.	
0.04	2.2	n.d.	0.9	n.d.	0.09	0.04	0.03	n.d.	
0.5	2.7	n.d.	6.6	0.06	1.4	0.1	0.03	22.8	
0.6	2.7	n.d.	6.7	0.07	1.5	0.1	0.02	22.5	
0.6	2.9	n.d.	6.5	0.1	1.2	0.1	0.02	22.7	*Cuprite crystals in red areas. SnO$_2$ inclusion.*
0.5	2.8	n.d.	6.7	0.09	1.2	0.1	0.01	22.8	*Large SnO$_2$ inclusion found.*
0.4	0.8	n.d.	0.8	0.02	0.06	4.2	0.02	0.4	
0.4	0.7	n.d.	1.0	n.d.	0.06	4.2	0.02	0.4	*Ca-Sb crystals, but no Pb-Sb.*
0.3	0.5	n.d.	1.8	n.d.	0.1	2.2	n.d.	0.1	
0.4	0.5	n.d.	1.7	n.d.	0.1	2.3	0.01	0.1	*Ca-Sb crystals, but no Pb-Sb.*

House of the Drinking Contest

Grouping of Samples Identified as from the Same Batch of Glass
According to Criteria Set Forth in the Glass Section of the Atrium House Triclinium essay (pg. 51)

Identification	No.	Color	Na_2O	MgO	Al_2O_3	SiO_2	P_2O_5	SO_3	Cl	K_2O	CaO	TiO
Batch No. 1												
DC PUAM interior	110	Turquoise	15.6	0.6	2.3	68.0	0.1	0.2	1.0	0.6	7.8	0.0
DC PUAM border	124	Turquoise	15.5	0.5	2.3	68.4	0.2	0.3	1.0	0.6	7.6	0.0
Batch No. 2												
DC PUAM interior	111	Blue*	18.6	0.5	2.1	68.0	0.1	0.4	1.1	0.5	5.5	0.1
DC PUAM interior	112	Blue*	18.5	0.5	2.1	68.0	0.1	0.4	1.0	0.5	5.5	0.1
Marine Mosaic	138	Blue*	18.8	0.5	2.2	67.6	0.1	0.4	1.0	0.5	5.5	0.1
Batch No. 3												
DC PUAM interior	114	Blue	14.5	0.6	2.4	68.5	0.2	0.4	0.7	0.6	8.2	0.0
DC PUAM interior	115	Blue	14.4	0.7	2.4	68.4	0.2	0.4	0.7	0.7	8.2	0.0
DC PUAM border	125	Blue	14.4	0.7	2.4	68.5	0.2	0.4	0.7	0.6	8.2	0.0
Four Seasons	130	Blue	14.4	0.7	2.4	68.5	0.2	0.4	0.7	0.6	8.3	0.0
Batch No. 4												
DC PUAM interior	116	Green	14.0	0.5	2.1	63.4	0.1	0.2	1.1	0.5	7.3	0.0
DC PUAM border	126	Green	14.2	0.5	2.1	63.6	0.1	0.1	1.1	0.5	7.3	0.0
Batch No. 5												
DC PUAM interior	120	Orange	8.0	1.3	3.0	40.2	0.4	0.2	0.7	1.0	6.4	0.2
Marine Mosaic	157	Orange	8.0	1.2	3.0	40.0	0.4	0.2	0.7	1.0	6.4	0.2
Marine Mosaic	158	Orange	8.1	1.3	3.1	40.0	0.4	0.2	1.0	1.0	6.2	0.2
Marine Mosaic	159	Orange	8.1	1.3	3.1	40.0	0.4	0.2	0.8	1.0	6.4	0.2

House of the Drinking Contest

Grouping of Samples From the Same Basic Recipe
and Possibly from the Same Batch of Glass

Identification	No.	Color	Na_2O	MgO	Al_2O_3	SiO_2	P_2O_5	SO_3	Cl	K_2O	CaO	TiO
Batch No. 1												
DC PUAM interior	110	Turquoise	15.6	0.6	2.3	68.0	0.1	0.2	1.0	0.6	7.8	0.0
DC PUAM border	124	Turquoise	15.5	0.5	2.3	68.4	0.2	0.3	1.0	0.6	7.6	0.0
Marine Mosaic	133	Turquoise	16.4	0.5	2.3	67.7	0.1	0.3	1.0	0.6	7.3	0.0
Marine Mosaic	134	Turquoise	16.3	0.5	2.2	68.0	0.1	0.3	1.0	0.7	7.3	0.0
Marine Mosaic	135	Turquoise	16.2	0.5	2.2	68.0	0.1	0.3	1.0	0.7	7.4	0.0
Marine Mosaic	136	Turquoise	16.3	0.5	2.3	67.8	0.1	0.3	1.0	0.7	7.4	0.0
Batch No. 2												
DC PUAM interior	113	Light Blue	15.7	0.5	2.2	70.0	0.09	0.3	1.0	0.5	7.7	0.0
Four Seasons	129	Light Blue	15.7	0.6	2.4	69.8	0.1	0.2	1.2	0.5	7.6	0.0
Marine Mosaic	140	Light Blue	16.4	0.5	2.3	68.6	0.1	0.3	0.9	0.7	7.4	0.0
Marine Mosaic	141	Light Blue	16.2	0.5	2.2	68.6	0.1	0.3	0.9	0.7	7.5	0.0
Marine Mosaic	142	Light Blue	16.3	0.5	2.3	68.7	0.1	0.3	0.9	0.7	7.5	0.0
Batch No. 3												
DC PUAM interior	116	Green	14.0	0.5	2.1	63.4	0.1	0.2	1.1	0.5	7.3	0.0
DC PUAM border	126	Green	14.2	0.5	2.1	63.6	0.1	0.1	1.1	0.5	7.3	0.0
Marine Mosaic	148	Green	14.8	0.5	2.1	63.2	0.1	0.3	1.0	0.6	7.0	0.0
Marine Mosaic	149	Green	14.9	0.5	2.1	62.4	0.1	0.3	1.0	0.6	6.9	0.0
Marine Mosaic	150	Green	14.9	0.5	2.0	62.7	0.1	0.2	1.0	0.6	7.0	0.0
Marine Mosaic	151	Green	14.7	0.5	2.1	62.8	0.1	0.3	0.9	0.6	7.0	0.0

* Translucent

MnO	Fe$_2$O$_3$	CoO	CuO	ZnO	SnO$_2$	Sb$_2$O$_3$	BaO	PbO	Observations
0.6	0.4	n.d.	1.7	0.3	0.05	0.5	0.02	0.2	
0.5	0.4	n.d.	1.9	0.3	n.d.	0.4	0.02	0.1	
0.3	0.7	0.06	0.05	n.d.	n.d.	2.2	0.02	n.d.	
0.3	0.8	0.06	0.06	n.d.	0.01	2.2	0.03	n.d.	
0.3	0.7	0.05	0.05	n.d.	n.d.	2.2	0.02	n.d.	
0.8	1.0	0.08	0.1	n.d.	n.d.	1.7	0.03	n.d.	
0.8	1.1	0.08	0.1	n.d.	n.d.	1.6	0.03	n.d.	
0.8	1.1	0.07	0.1	n.d.	n.d.	1.7	0.04	n.d.	
0.9	1.0	0.07	0.07	n.d.	n.d.	1.8	0.03	n.d.	
0.6	0.7	n.d.	1.3	0.2	0.02	0.5	0.01	7.5	*Pb-Sb crystals.*
0.6	0.7	n.d.	1.2	0.2	n.d.	0.4	0.02	7.4	*Pb-Sb crystals.*
0.2	2.8	n.d.	7.5	0.2	1.3	0.5	0.01	26.2	
0.1	2.9	n.d.	7.5	0.2	1.2	0.5	0.02	26.4	
0.2	2.9	n.d.	7.4	0.2	1.1	0.5	0.03	26.2	
0.2	2.8	n.d.	7.3	0.2	1.2	0.5	0.03	26.5	

MnO	Fe$_2$O$_3$	CoO	CuO	ZnO	SnO$_2$	Sb$_2$O$_3$	BaO	PbO	Observations
0.6	0.4	n.d.	1.7	0.3	0.05	0.5	0.02	0.2	
0.5	0.4	n.d.	1.9	0.3	n.d.	0.4	0.02	0.1	
0.4	0.4	n.d.	1.8	0.3	0.06	0.3	0.02	0.4	*Lightly opacified with Ca-Sb.*
0.5	0.4	n.d.	1.6	0.3	0.06	0.3	0.02	0.4	
0.5	0.4	n.d.	1.6	0.3	0.06	0.5	0.02	0.4	
0.4	0.4	n.d.	1.7	0.3	0.07	0.4	0.02	0.4	
0.2	0.3	n.d.	0.4	0.07	n.d.	0.8	0.02	n.d.	
0.1	0.3	n.d.	1.0	0.08	n.d.	0.3	0.01	n.d.	*Lightly opacified with Ca-Sb.*
0.6	0.4	n.d.	0.8	0.1	0.01	0.8	0.02	n.d.	*Lightly opacified with Ca-Sb.*
0.4	0.4	n.d.	1.0	0.2	n.d.	0.9	0.03	n.d.	
0.4	0.4	n.d.	0.9	0.2	n.d.	0.8	0.02	n.d.	
0.6	0.7	n.d.	1.3	0.2	0.02	0.5	0.01	7.5	*Pb-Sb crystals.*
0.6	0.7	n.d.	1.2	0.2	n.d.	0.4	0.02	7.4	*Pb-Sb crystals.*
0.7	0.6	n.d.	1.7	0.2	0.2	0.3	0.03	6.8	*Heterogeneous mix of translucent and opaque streaks. Crystals: Pb-(Sb+Sn).*
0.7	0.7	n.d.	1.6	0.2	0.2	0.4	0.02	7.3	
0.7	0.7	n.d.	1.6	0.3	0.2	0.4	0.02	7.1	
0.7	0.7	n.d.	1.7	0.3	0.2	0.4	0.02	7.1	

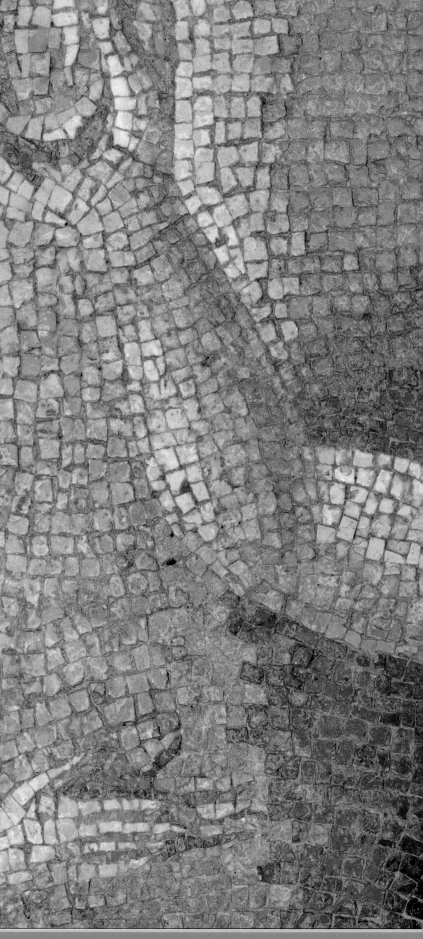

DIMENSIONS ARE GIVEN IN CENTIMETERS EXCEPT FOR THE COINS, WHICH ARE IN MILLIMETERS.
FOR MOSAICS, ONLY TWO DIMENSIONS ARE GIVEN. FOR SCULPTURE AND OTHER OBJECTS, HEIGHT,
WIDTH, AND DEPTH ARE GIVEN IN THAT ORDER BASED ON THE ORIENTATION OF THE OBJECT IN THE
CATALOGUE PHOTOGRAPH. IN SOME CASES ONLY HEIGHT AND WIDTH ARE PROVIDED OR THE
DIAMETER IS GIVEN.

FOR THE COINS, ONLY THE DIAMETER IS GIVEN. ALL CATALOGUE PHOTOGRAPHS OF THE COINS
ARE AT A SCALE OF 1:1.

Catalogue

1.

Mosaic of the Drinking Contest Between Herakles and Dionysos

Christine Kondoleon

From the Atrium House

Site: **Antioch (10-N)**

Date: **Early 2nd century C.E.**

Material: **Stone and glass tesserae embedded in lime mortar**

Dimensions: **184 × 186.4 cm**

Worcester Art Museum, Antioch excavation, 1933.36

Many aspects of this mosaic, including its iconography, technical and stylistic features, as well as its archaeological and architectural contexts, are discussed at length in The Atrium House Triclinium *in the present volume.*

The Worcester panel, Drinking Contest Between Herakles and Dionysos, was flanked by two panels, one with a dancing satyr and another with a dancing maenad, now in the collection of the Baltimore Museum of Art. The three panels functioned as a visual unit celebrating the drinking triumph of the god Dionysos over the mortal Herakles. Five figures are spread across the middle ground of the picture plane: a female double-flute player, a tipsy Herakles, a young boy with an ivy wreath (Eros or Ampelos?) running toward the reclining Dionysos, and behind him Silenos with a white beard and balding head raising his right hand (figs. 1–3). The composition captures the meaning of the contest by presenting the pale, effeminate god as relaxed in a reclined position, his left elbow resting on a decorated cushion, holding up an empty wine cup. Herakles is manly with brownish-red skin; he falls back on his knees as he empties the last drops of his cup. The raised hand of Silenos proclaims Dionysos as the victor.

Almost as if to echo its placement in a Roman dining room, the mythical contest takes place in an interior indicated

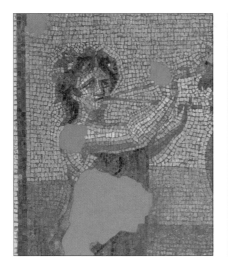
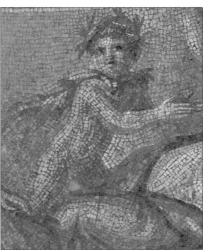

fig. 1. (left) Detail. Maenad plays the double flute (aulistria).

fig. 2. (right) Detail. Wreathed boy (Eros or Ampelos?).

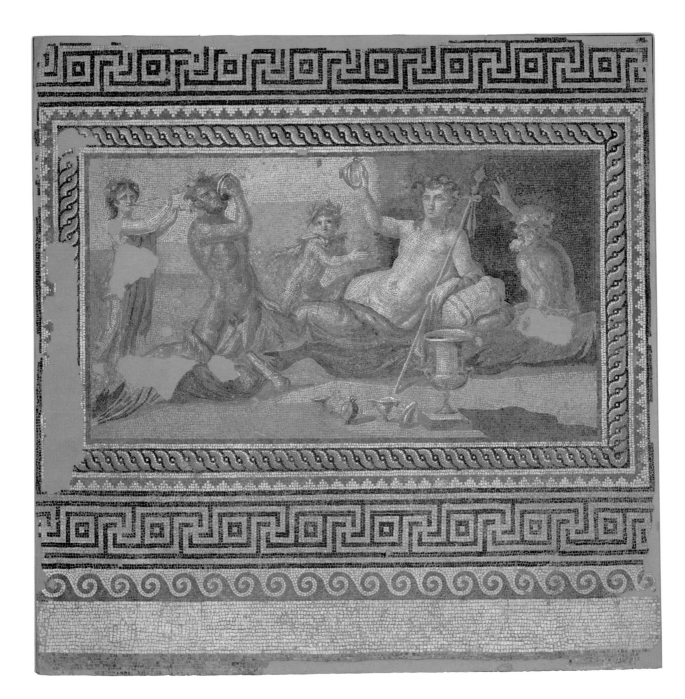

fig. 3. Detail, Silenos.

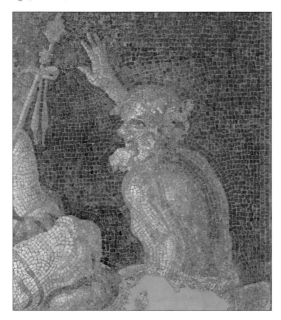

by shadows cast in dark grays and blacks on the wall behind the figures, especially Dionysos and Silenos. The drinking theme is appropriately emphasized by the variety of vessels, including a gilded *krater* for mixing wine and water on a base, a *rhyton*, a flask, a *kantharos* and a *phiale*, all depicted in gray tones to

suggest they were made of silver, laid out on the floor below Dionysos.

Curiously, this contest between a god and a mortal hero, rarely depicted in ancient art, receives two lavish interpretations in Antioch. The other was found in a third-century house (House of the Drinking Contest) in the port city of Seleucia Pieria and is today on display in the Princeton University Art Museum.[1] Set at the center of a triclinium, this mosaic Drinking Contest fits into an illusionistic space —an elaborate architectural niche. The viewer is invited to look deep inside the space, passing through a colonnade supporting a coffered barrel vault and through a curtained doorway into the interior room where the contest takes place. There Herakles and Dionysos drink to the rhythms of a maenad playing cymbals. Both Antioch panels are distinguished by their elaborate use of glass tesserae for colorful highlights—blues and greens are especially dominant in the Worcester panel, while reds and oranges stand out in the Princeton panel. Despite their clear dependence on a shared model, the two mosaics, separated by several generations, reveal

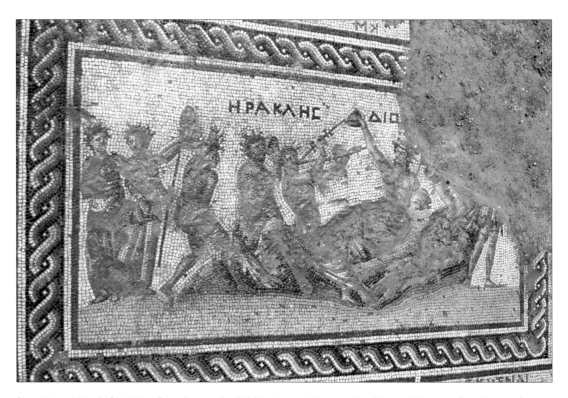

fig. 4. Central Panel of *triclinium* floor showing the Drinking Contest Between Herakles and Dionysos, from House of Dionysos, Sepphoris.

stylistic and technical innovations that bring us closer to an appreciation of the creativity of mosaic workshops.

A third contest was recently excavated in the Galilee with archaeological evidence suggesting a date around 200 c.e. This scene is the centerpiece of an elaborate composition covering the floor of the *triclinium* of the House of Dionysos at Sepphoris[2] (fig. 4). While this example is executed in a simpler figure style and with little spatial illusionism, its style and technique are closest to contemporary Antioch mosaics. In the Sepphoris version, the figures of Herakles and Dionysos are identified by Greek inscriptions and are accompanied by six members of the Dionysiac retinue.[3] The theme was also represented in the Latin west, best known in a panel of a monumental pavement from Vienne in the Rhône dated to the late second century c.e. Here a drunken Herakles is held up by several satyrs and maenads in the foreground while a controlled Dionysos watches from a rocky elevation above. The circular arrangement of the Vienne mosaic is similar to the depiction of the contest on a rare gold *patera* from Rennes now in the Cabinet des Médailles in Paris, dated by the coins set along its rim to the Severan period.[4]

Because we know no specific myth to which these mosaics can be related, they raise questions about the development of visual compositions independent from textual traditions. The only textual reference to Herakles and Dionysos reclining together at a banquet occurs in the *Dionysiaca* of Nonnos from the mid-fifth century c.e., but no specific contest is described.[5] The absence of the contest from the 48 books by Nonnos describing Dionysos and the celebration of his cult in Asia Minor and the Near East is puzzling. Also surprising is the fact that, while several of the Dionysiac scenes depicted on the Sepphoris pavement can be traced to vignettes and floats in the Grand Procession of Ptolemy Philadelphos, the central panel of the Drinking Contest does not occur even in this Alexandrian festival program dedicated to Dionysos and wine drinking—in fact, Herakles appears nowhere in the procession.[6] In terms of the relevance of the contest to the dining context, the choice of the mosaicists seems logical and the intended message of moderation, discussed in the main essay of this volume, resonant of a Hellenic sensibility. Yet the process of transmission, whether from texts or images, by which the contest captured the imaginations of the artists at Antioch and those under their influence in Galilee remains unclear.

PUBLISHED: *Antioch I 1934, 42–45; Morey 1938, 27–28, pl. 2; Morey 1938, 28; Levi 1947, 21–24, 156–159; pl. I a; Baratte 1978, 87–92; Campbell 1988, 20–21, pl. 72; Dunbabin 1999, 161, fig. 164; Çimok 2000, 26–27; Kondoleon 2000, 170–172, no. 55 with illus.*

1. Levi 1947, 156–159.

2. Talgam and Weiss 2004, pp. 48–51, 125–126, color pl. IB.

3. Although not noted in the recent monograph on the mosaic, there seems to be a figure lying down below Dionysos; if so, it is definitely an oddity that should be explained. See Talgam and Weiss 2004, 50, where it is not mentioned in the description.

4. Levi 1947, fig. 5, 23.

5. *Dionysiaca* XL, 411–578, and see Bowersock 1993, 46–49.

6. The Hellenistic text describing this elaborate third-century b.c.e. procession through Alexandria was preserved by the second-century c.e. author Athenaeus in Book V of his *Deipnosophistai*; see Rice 1983, 103–105.

2.

Mosaic of
Dionysos and Ariadne

Christine Kondoleon

From the House of the Sundial

Site: **Daphne (DH 35-U, House 1, 1935)**

Date: **Mid- to late 3rd century**

Material: **Stone and glass tesserae embedded in lime mortar**

Dimensions: **97.5 × 288.7 cm**

Worcester Art Museum, Antioch Excavation, 1936.25

According to the excavation diaries for April 1935, three rooms with mosaics were found in Daphne (DH 35-U)(fig. 1).[1] Room 1 contained the Worcester panel with the busts of Dionysos and Ariadne, as well as two other figural panels, each with a man standing beside a sundial whence the excavators' name for the complex, the House of the Sundial. These three figural panels were flanked by four geometric panels and together they formed the bar of the T-shaped mosaic design typical of Roman *triclinia*. A large figural panel was probably set at the center of the room, but only a small portion of its white background survives. A photograph taken when the mosaic was still *in situ* clearly shows that busts of Dionysos and Ariadne faced outwards towards people entering the room (fig. 2).[2] The two rectangular panels with the sundials faced inwards towards the dining couches. Below each panel is a medallion filled with a colorful (red, ochre, black and white against a yellow background) eight-pointed star (see figs. 8, 9).

The arrangement of the rooms in close proximity to one another, as well as the themes of their mosaic floors, suggests a

fig. 1. **Plan of original mosaic locations**

This is the fragmentary floor plan of part of a Roman house in Daphne near Antioch. Shaded portions indicate areas revealed by the excavation; solid and dotted lines are reconstructed areas.

Room 1
a Dionysos and Ariadne, Worcester Art Museum; **b** and **c**, Sundial readers, Hatay Archaeological Museum, Antakya

Room 2
Krater and peacocks, Hatay Archaeological Museum, Antakya

Room 3
a Lower portion of central panel with legs of Dionysos, panther, and satyr, Hatay Archaeological Museum, Antakya; **b** Fragment with vine scroll border and Greek key pattern, Princeton University Art Museum; **c** Geometric Pattern, Princeton University Art Museum

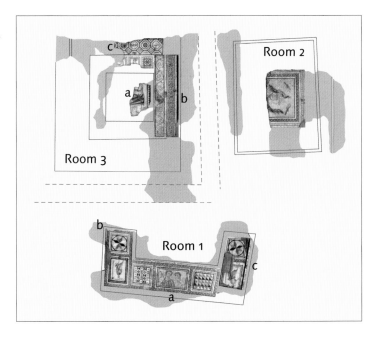

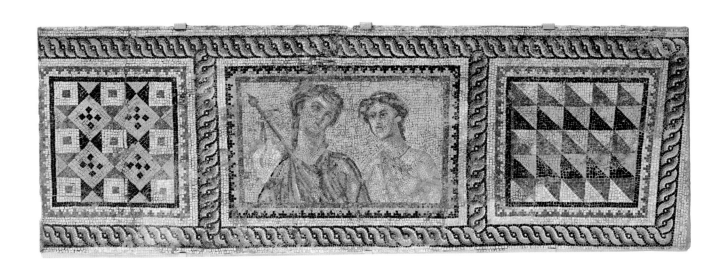

suite of reception rooms. While only fragments of their mosaic floors were found, enough remains to reconstruct their basic compositions. Room 3 had a large central panel facing toward room 2. Enough of the lower portion remains to confirm that it contained Dionysos with his panther by his feet and on the other side, a satyr (fig. 3).³ It was bordered by

vines on one end and busts, probably Seasons, on another.⁴ Dionysiac figures and vines connote a convivial atmosphere.

Room 2 faced west toward room 3 and contained a charming panel of birds against a bright yellow background (fig. 4). A red-tailed peacock perches on the edge of a large silver *krater* from which water spills over; there are also smaller birds with twigs and another peacock. Various colorful birds scattered across a plain ground occur in a number of Antioch mosaics. A panel nearly identical to the House of the Sundial, with the same yellow ground, decorated the center of a dining room in Daphne.⁵ Another similar composition that included *erotes* as bird catchers was part of a large pavement in the apsed dining room of the House of the Buffet Supper.⁶ There the peacock faces forward above the overflowing *krater* and serves as a pendant to the adjacent illusionistic dinner-table setting encircling Ganymede. Clearly, the birds and *krater* are part of a luxurious dining experience worthy of the

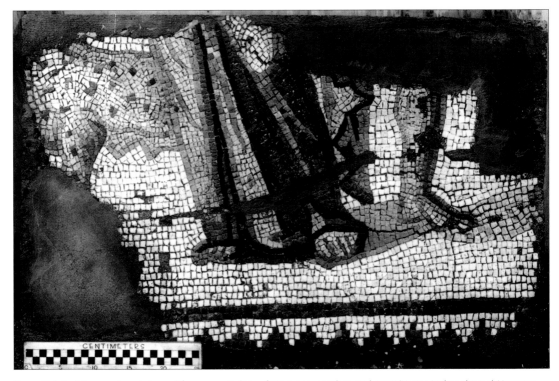

fig. 3. Detail of damaged central panel from room 3: legs of Dionysos, panther, and satyr (Hatay Archaeological Museum, Antakya).

gods. Various birds, especially the peacock, and the water-filled vessels evoke gardens and settings for outdoor dining parties and may be read as a *topos* of pleasure.[7]

Dionysos with the satyr and panther, the birds and *krater*, and the sundial readers flanking the busts of Dionysos and Ariadne produce a series of visual experiences that are a pleasant backdrop to various smaller and larger dining parties in what must have been a domestic reception area.[8] The grouping of rooms as a reception suite occurs in several houses at Antioch, for example, in the House of Menander and in the House of the Boat of the Psyches.[9] Room 1 is set at an angle to rooms 2 and 3, which are aligned. The off-axis arrangement might have accommodated a fountain or water feature within a courtyard shared by this group of rooms, as in other Antioch houses. Room 2 is small for a dining room, but it could have served for more intimate gatherings. Room 3 is the largest of the group, with a wide outer border of octagons and squares that might have designated the couch areas.[10]

Dionysos and Ariadne Mosaic

The Worcester Art Museum houses the front section of the entrance into room 1, which includes three panels: Dionysos and Ariadne, depicted from the waist up, flanked by two geometric panels (figs. 5–7). The geometric panel on Ariadne's side is filled with a chessboard pattern of alternating red, white, black and yellow triangles.[11] On Dionysos' side is a squarish panel with a grid of eight-pointed stars formed by red and black triangles set on vertices, a yellow square on point set within each star.[12] Dionysos, his long brown hair crowned with a wreath of green glass leaves, tilts his head toward Ariadne; his tunic is shaded with grays, white, dark brown, and dark red. The god of wine is easily identified by the thyrsos he holds, topped by a pine cone and tied with pinkish red ribbons. To his side is a young female wearing a tunic of white shaded in gray. She is adorned by a green glass necklace with yellow pendant and a golden arm bracelet; her dark brown and red hair is tied back and again crowned with a wreath of green glass leaves. A similar representation of Dionysos and his consort

Ariadne occurs in a roughly contemporary house in Ephesos, where the couple is featured in a medallion at the center of a barrel vault covered with glass mosaic.[13]

The Worcester mosaic was the central part of what originally formed the bar of the T-shaped mosaic design typical of later Roman *triclinia*. The letter T in this design is given a slight variation: it has a ligature so that the bar is not a straight horizontal line. This bar was composed as a U-shaped band that originally, although much of the mosaic is lost,

must have joined up with another U-shaped band of plain mosaic over which three dining couches were placed. As the centerpiece, the Worcester panel greeted the guests as they entered room 1. Forming the uprights of the U were rectangular panels showing male figures beside sundials. The better preserved of the two panels shows a bearded man facing the couple beside a column surmounted by a sundial. He brings his closed fists to his breast in a lively exclamation as if reading the Greek inscription above him, ΕΝΑΤΗΠΑΡΗΛΑΣΕΝ, "the ninth hour is

fig. 6. Geometric panel with chessboard pattern of triangles (Worcester Art Museum).

fig. 7. Geometric panel with eight-pointed stars (Worcester Art Museum).

past" (fig. 8). On the other panel (damaged at the top) a beardless male figure stands with his arms outstretched as if in surprise beside a column presumably surmounted by a sundial, now lost (fig. 9). This man faces away from the central couple. Both figures stand with their legs apart and their drapery indicates they are in motion.

Meaning

The ninth hour, the third hour before sunset, was when business was concluded and the evening began. It was the custom to go to the baths just before proceeding to dinner.[14] The hours were told by watching the lines of the sundial, as we learn from the second-century author Pollux in his *Onomasticon* (6.44): "From the shadows they knew the time to go to dinner…and when this was ten feet long, it was time to hurry up."[15] The idea that the hour of dinner was fixed and strictly adhered to by hosts and guests is reinforced by an epigram in the Greek Anthology: a man orders his servant to "go and buy us an egg and garlands and sandals and scent, and I wish them to be here at 4 o'clock sharp."[16] The men in these mosaic panels are shown by their stance and drapery to be rushing. Their gestures seem theatrical, as if they are declaiming or miming, and the inclusion of "lines," as it were, reinforces this impression. There is a textual tradition, probably derived from Greek comedy, of parasites eagerly awaiting dinner. We hear the voice of the hungry parasite named Trechedeipnus or "dinner chaser" in one such text dated around the same time as this mosaic: "The pointer does not mark the sixth hour yet and I am in danger of withering away, so goaded am I by hunger…If we throw down the whole column which supports this hateful sundial, or bend the pointer this way…."[17] This provides an entertaining read on these two panels and one that suggests the way in which such images were received in third-century Antioch. The figures might even represent a scene of hungry parasites from one of the many Greek comedies now lost to us. In any case, the importance of the proper hour for dining is found in text and image—the mosaic clearly tells the guests it is time for dinner.

The Greek inscription accompanying the bearded sundial reader directly addresses the guests taking their places on the dining couches in room 1 of the House of the Sundial. While relatively rare, examples of mosaics and frescoes that include phrases to be read aloud, "talking" walls and floors, were certainly in the Roman decorative repertoire. In the House of the Moralist (House III, 4, 2) at Pompeii, dated to around 50 C.E., three Latin distichs are painted on the walls of the *triclinium*.[18] These were probably read aloud and, given their content, served as a source of dinner humor. They admonish guests not to flirt with other men's wives and to refrain from insults and quarrels, otherwise go home. Another verse, tells the guest to "Let water

fig. 8. Mosaic with bearded sundial reader, inscription and eight-pointed star (Hatay Archaeological Museum, Antakya).

wash your feet, and let a slave-boy dry them." The instructive tone of these Latin distichs finds its Greek parallel in the announcement of the time for dinner in Antioch.

Time is a recurring banquet theme, usually paired, however, with death. The common sympotic message "live while you may" is communicated through texts and images. Epigrams such as "Death is a debt due by all men and no mortal knows if he shall be alive tomorrow...make thee merry since you possess wine that is oblivion of death" were re-

fig. 9. Mosaic with sundial reader and eight-pointed star (Hatay Archaeological Museum, Antakya).

cited during banquets.[19] Skulls and skeletons appear on dining-room mosaics, as well as on precious metal and ceramic drinking vessels. Texts reveal that miniature skeletons, some of which survive, were passed around among diners, inspiring discussions of the fleeting pleasures of life.[20] Dunbabin suggests that, in a similar vein, the Antioch sundial panels served to remind the living of their mortality and to encourage them to partake fully of the evening before them.[21] Sundials appear in several mosaics with seated philosophers and can be understood to represent learning and encourage discourse.[22]

While there is no doubt that members of third-century Antioch society would have appreciated the philosophical and mortal implications of time passing, they must have had a more immediate response to the calling of the dinner hour. The presence of the divine couple underlines the invitation to dinner, as do the mosaics of the nearby rooms with their convivial themes of birds and fountain, Dionysos and satyr.

PUBLISHED: *Antioch II, 202, no. 93, pl. 75; Levi 1947, 219–222, pl. 49; Çimok 2000, 191–193.*

Arts of Antioch

1. The information in the diaries from the Princeton University Archive does not agree with Levi who writes that four rooms were found in March 1938, (see Levi 1947, 219), but there is no evidence of a fourth room in any other reports and the diaries are quite clear about the date of discovery, April 3, 1935.

2. Levi 1947, 220, n. 1, fig. 82.

3. Although only the lower part of the panel remains, the composition seems quite close to two panels with Dionysiac scenes from the House of Drunken Dionysos and the House of the Bacchic Thiasos, both from Antioch (20-O) and dated to the first half of the second century C.E.

4. Part of room 3 is in the Princeton University Art Museum and part is in the Hatay Archaeological Museum in Antakya; see fig. 1 for details.

5. For the Mosaic of the Bird and Kantharos, today in the Louvre, see Levi 1947, pl. 15a, and Baratte 1978, 126–128, no. 51, figs. 135–136, who calls the composition a "semis" of birds.

6. For the Buffet Supper mosaic, dated to the early third century, see the color reproduction in Çimok 2000, 111, and Levi 1947, pl. 23a, b.

7. On the peacock as an icon of greeting in Roman domestic decoration, see Kondoleon 1995, 109–117.

8. Since only three rooms were partially excavated, the function of the building remains a question, but it is likely that these rooms were part of a house.

9. For the floor plans with mosaics inserted for these two houses, see Dobbins 2000, 57–61, 50, and fig. 5, respectively.

10. Remains of three sides of this geometric border can be seen in an excavation photograph reproduced in Levi 1947, pl. 49d.

11. For the pattern, see Décor 1985, 312, pl. 197d, where it is described as "a chessboard pattern of right-angled isosceles triangles in four counterchanged colors creating the effect of bands of identically parti-colored squares."

12. The closest parallel for this pattern is Décor 1985, 215, pl. 142g, described as "a grid pattern of tangent eight pointed stars, the colors counterchanged, the stars and interspaces bearing inscribed squares...."

13. From the tablinum off the peristyle of Terrace House II in Ephesos, see Jobst 1977, 65–74, color pls. 112–114.

14. Translation from Levi 1947, 220–221; see also therein several other ancient authors on the division of the day, sundials and dining.

15. Pliny in his letter to Calvisius Rufus (Book III.i) admiringly describes the daily routines of Spurinna, who went to the baths at about three o'clock in winter and in summer about two, exercised, and then waited a bit for dinner.

16. No. 35 by Philodemus; Loeb translation, Paton 1948, 86–87.

17. From Book 3, Letter 2 of Alciphron, Benner and Fobes 1949, 148–151. Alciphron may possibly be an author from third-century Syria. I am grateful to Jason König for this reference.

18. Clarke 2003, 233–239, esp. 238, where Clarke calls the distichs "wisecracks" shared among guests who probably knew each other well.

19. *Greek Anthology*, Book XI, Convivial Epigrams, Palladas, no. 62, Loeb translation, Paton 1948, iv, 101.

20. E.g., a small bronze skeleton at the Getty Museum (acc. No. 78.AB.307) with movable parts; see Causey 1980, 171–172, esp. n. 2 for citations to extant statuettes made of silver, wood, and bronze.

21. Dunbabin 2003, 132–140, esp. 137–138; she reviews a range of Roman art featuring skeletons used in a dining context.

22. The Pompeii mosaic known as the Torre Annunziata mosaic is displayed in the Archaeological Museum in Naples (inv. 124545).

3.

Mosaic of Hermes Carrying the Infant Dionysos

Rebecca Molholt

From Bath D

Site: **Antioch**

Date: **350–400 C.E.**

Materials: **Stone tesserae embedded in lime mortar**

Dimensions: **293.6 × 198.6 cm**

Worcester Art Museum, Antioch Excavation, 1936.32

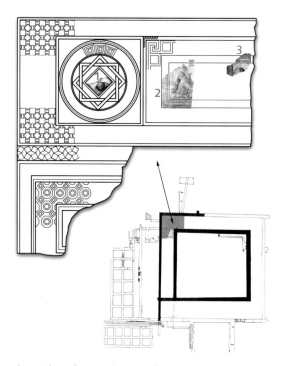

fig. 1. **Plan of original mosaic locations**

1. Gethosyne: Hatay Archaeological Museum, Antakya

2. Hermes and Dionysos: Worcester Art Museum

3. Nymph: Hatay Archaeological Museum, Antakya
Geometric panels: not raised.

The city of Antioch boasted baths of all sizes; according to Libanios, from "each of the public baths pours forth a stream as large as a river."[1] In April 1933, one of these great public baths was discovered on the site of the ancient island in the Orontes River, and labeled Bath D by its excavators. A coin of Septimius Severus (r. 193–211) was found embedded in one of the foundation walls of the bath's great portico. The coin showed considerable wear from circulation, and a third-century date for the construction of the baths is generally accepted.[2]

"At Bath D, mosaics never seem to cease," reported the excavation diary of 25 April 1933, but many of these mosaics were heavily damaged. The site of Bath D was in the very lowest part of the terrain, meaning that the Roman level was sometimes just a few centimeters below the modern surface of the ground. Even the long-buried mosaics, among the flattest of all archaeological remains, had been scarred repeatedly by the plows of local farmers.[3]

Most of the pavements, including those of the octagonal caldarium, were of geometric design. These were photographed for study and then left in the ground. Figural mosaics were found in one corner of a large portico that surrounded an open court some 90 meters square (fig. 1). The pavements were raised in three pieces: a female personification of Gethosyne (Pleasure), an image of Hermes and the infant Dionysos, and a fragment depicting the head of a nymph with part of a tree next to a column. The pavements were dated to 350–400 by Doro Levi.[4]

Some fine masonry and even a small patch of marble flooring were also uncovered, enough to suggest that Bath D must have been a spectacular place. "The district in front of the palace shares the grandeur within," says Libanios in his Oration in praise of the city.[5] Some of the opus sectile and the mosaics had been repaired, evidence that Bath D had been in use for some time in antiquity.[6]

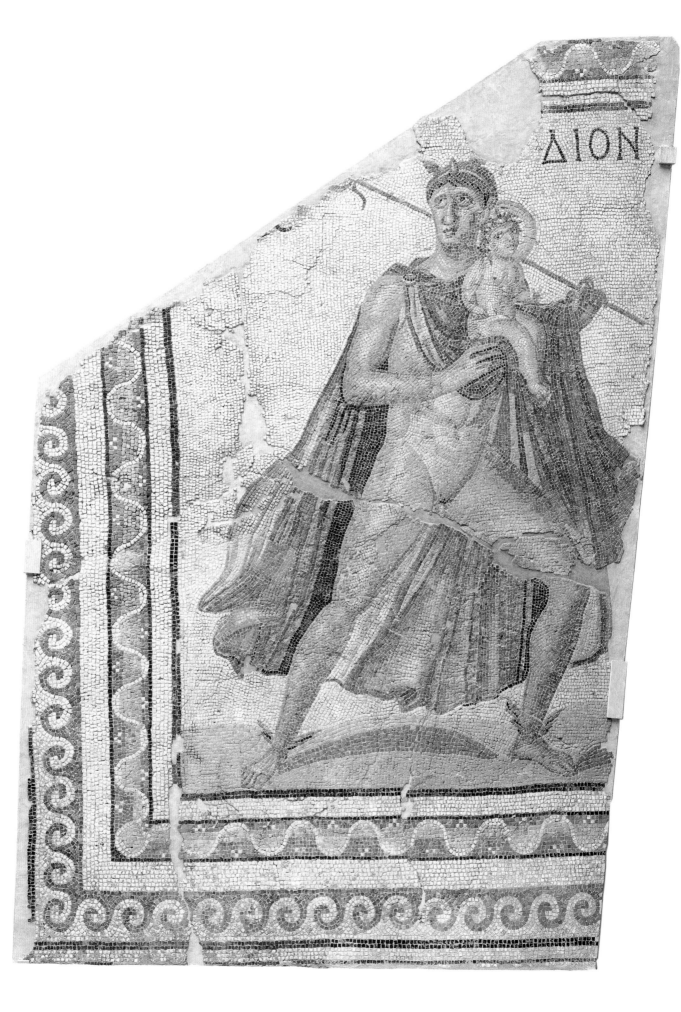

ΔΙΟΝ

Hermes and Dionysos

The Worcester mosaic shows part of the story of Hermes and Dionysos.[7] Hermes looks with wide eyes back over his shoulder as he moves forward with some haste. Behind his nude body, his great red cloak spreads out as evidence of the speed and urgency of his mission. Hermes has green and black wings at his ankles, and golden wings and a golden, jeweled fillet at his head. The infant Dionysos, cushioned in the arms of Hermes, looks up and out at the viewer. He appears calm and comfortable, cradled in the cloth of Hermes' cloak and enjoying the ride. A white and gray nimbus surrounds his head; he wears both a diadem and a garland of leaves and leans his head on Hermes' cheek. The figures are about one and a half times life size, as befits their divine status.

The very early childhood of the god Dionysos was not easy. His mother, Semele, was killed even before he was born. Hermes took the unborn fetus and sewed it into the thigh of Zeus, king of the gods and Dionysos' father. Immediately at birth, the infant Dionysos was sent by his father to be raised by the nymphs of Nysa. Hermes,

messenger god, was the courier entrusted with this mission, and this is the scene depicted by the Worcester mosaic. Hermes' anxious look back over his shoulder suggests he is just now being sent forth by Zeus, whose commands still echo in the air.

This is, in fact, a particularly appropriate myth for a bath building. We might recall the words of Nonnos, the fifth-century Egyptian author who wrote a long poem in luxuriously stylized Greek about the god Dionysos, including a description that fits this scene: "Thus Hermes carried upon his arm the little brother who had passed through one birth without a bath...."[8] In the turmoil and disaster surrounding Dionysos' birth, with a jealous Hera raging dangerously in the background, it was more important to whisk the infant away into safe hiding than take the time to wash him up. But the infant

fig. 2. One of the nymphs of Nysa, her head wreathed in leaves, awaiting the arrival of the infant Dionysos. 350–400 C.E. (Hatay Archaeological Museum, Antakya).

Arts of Antioch

fig. 3. Preparations for the first bath of the infant Dionysos, attended by Hermes, a nurse, the Nymphs of Nysa and various figures, including personifications of Nectar and Ambrosia. From the *triclinium* of the House of Aion, Nea Paphos, Cyprus. Mid-fourth century C.E.

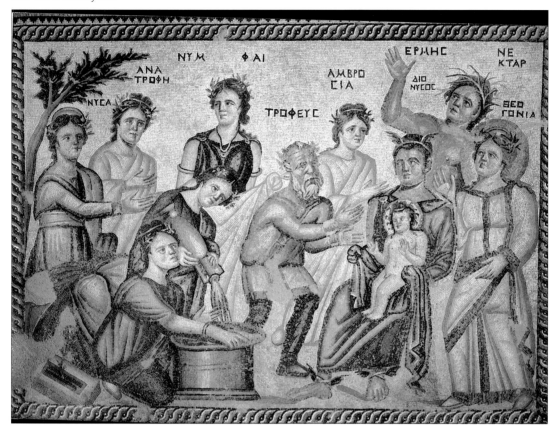

was taken to the nymphs, water deities who could be charged with this task of the bath.

In fact, the second fragment from this corridor at Bath D shows the head of a nymph, thickly garlanded with leaves (fig. 2) and set next to a branch of a tree and a part of a flat-topped column. Nymphs are female water deities, making their homes in bodies of water. They were the guardians of springs, lakes, and rivers and thus, by extension, even of man-made baths.[9] Libanios called nearby Daphne the "palaces of some nymphs" and credited them with the "gift that the waters are the purest and clearest."[10]

The nymphs of Nysa were the ones to give Dionysos his first bath, as is clearly illustrated by an impressive Cypriot mosaic also from the mid-fourth century (fig. 3).[11] Here, one nymph pours water from an ewer into a large bronze or golden basin, while another nymph tests the temperature of the water with her hand. The seated Hermes holds forth the naked Dionysos to the arms of his old, bearded nurse.

Nysa was a frequent place name in the ancient world. One town of Nysa was in nearby Caria; according to Byzantine legend, this site was a Hellenistic foundation by Antiochus I, who named the town after his wife.[12] In Antioch, the story of the childhood of Dionysos thus takes on the added aura of local history, being associated with a location akin to that of the city's own namesake.

Of course, Dionysos would grow up to be the wine god, and the mixing of wine with water was a sign of refinement in the Greco-Roman world.[13] This refinement may also have stood as testament to the tempering force of the young god's education. The Greek bath-gymnasium complex was itself the site of a great deal of education for young citizens. Dionysos' own education and upbringing by the nymphs in such a setting may stand as a model for his human counterparts, and Hermes himself was a great patron both of literature and of the palaestra.[14]

Thus the story of Hermes and Dionysos reminded beholders that they were in the home of the nymphs, water spirits capable of caring for gods. The mosaics of Bath D play with the idea that even

the gods might bring their children here to be washed and educated. The pavement evidences the civilizing and tempering forces of water and of education, both of which were found in quantity in bath buildings in the Greek world.

Gethosyne

The third fragmentary mosaic from this corner of the Antioch bath complex presents a large figure of a female personification (fig. 4). Though her face is now broken away along with the second half of her name, enough of her label survives to recognize her as none other than Gethosyne, the personification of Joy, Delight, and Pleasure. She wears a yellow robe with a purple collar or scarf over a red under-tunic. Her head is turned slightly to the right, showing her emerald-green earrings. Gethosyne appears shifted into the corner of her square, because she was diagonally oriented at the corner of the portico, accessible to pedestrians coming down the hallway from either direction (see fig. 1).

Romans would have expected to find pleasure and delight at the baths. "This is the bath of joy; it washes away care, it lightens labor," proclaimed an inscription recorded in the Greek Anthology.[15] Even Augustine called baths a place to enjoy life in the "most exquisite and pleasurable of buildings."[16] At Bath D, the presence of such pleasure was quite literally ensured in a very direct way by the permanent presence of the personification of Gethosyne. Her image greeted those who strolled around the great court; the personification both illustrated and prompted the experience of delight for visitors to Bath D.

In the fourth century, Gregory of Nyssa included baths on his list of "things which are valued in our life…everything that pleasure has invented… [things] by which life is made pleasant for luxury lovers."[17] Doubtless, part of that pleasure must have been the abundance of waters of all temperatures at the baths, and the beauties of the marble-clad walls, the high ceilings and the spaces flooded with light that we can now only imagine. Pleasure came too from the lavish program of mosaic decoration adorning this massive portico at Bath D. Though

fig. 4. Personification of Gethosyne: "Joy," "Delight" or "Pleasure." 350-400 C.E. (Hatay Archaeological Museum, Antakya).

we have only one corner of the space, personifications probably anchored the other corners as well, female figures like Soteria (Renewal or Salvation), Ktisis (Foundation), Euphrosyne (Happiness), Apolausis (Enjoyment).[18] Such long halls, apparently characteristic of baths in Asia Minor, were designed for walking and talking with friends and colleagues, teachers and students.[19]

Another of the pleasures of Bath D might simply have been the recognition of the personification Gethosyne as such, given the Roman predilection for thinking up exotic classifications for different aspects of the good life.[20] Alone in her roundel, however, Gethosyne is attached to no one single narrative. All kinds of physical and intellectual pleasures are possible; none are mutually exclusive. Gethosyne can even be taken as a manifestation of the joy that presides over the rescue of the infant Dionysos, the story told in the adjacent mosaic.

PUBLISHED: *Morey 1938, 35, pls. 13–14; Schenck 1937, 388–396; Hanfmann 1939, 229–239; Antioch II 1938, 181, no. 36; Levi 1947, 285–89; Campbell 1988, 16–17, pls. 60–66, fig. 12; Çimok 2000, 228–229.*

1. Libanios *Or.* XI, 231, 244–5, transl. Downey 1959, 677, 678–679. For a recent discussion of the baths at Antioch, see Yegül 2000, 146–151.

2. Levi 1947, 285.

3. See Excavation Diaries, Princeton University Archives, April 1933.

4. Levi 1947, 626. Balty 1995, 203, discusses parallels for the geometric motifs of the border, especially the curving ribbon, which she also dates to the second half of the fourth century. She notes (85, 108 with citations) that the geometric schemas and decorative compositions of Bath D were used as well in churches in Syria, synagogues in Apamea, Bath C in Antioch, and private homes in Apamea and Mariamin. The geometric pavements of Bath D are discussed and illustrated with line drawings in Levi 1947, I, 427–429, figs. 161–164. Photographs can be found in Levi 1947, pls. 116–117.

5. Libanios *Or.* XI, 232, transl. Downey 1959, 677.

6. Antioch II 1938, 181.

7. A useful study of the Worcester pavement was published by Schenck 1937, 388–396.

8. Nonnos, *Dionysiaca*, IX.25–26, see Nonnos 1962.

9. Statius referred to the baths of one of his patrons as the mansion of the Nymphs, claiming that, "in no other grotto did [they] ever dwell in wealthier style." *Silvae* 1.5.25–30, Statius 2003.

10. *Or.* XI, 240, transl. Downey 1959, 678.

11. This pavement comes from the triclinium of the House of Aion, Nea Paphos. See Daszewski 1985, and Deckers 1985, 145–72.

12. Bean 1971, 211. See also von Dienst, 1913, and Becatti, 1970–71.

13. See: Dunbabin 1993, 116–141.

14. Liebeschuetz 1972, 12 and 148, discusses Libanios' devotion to Hermes and Apollo as patron gods of literature. He also examines the liturgies connected with the baths of Antioch. The connection between Hermes and the palaestra remains something of an unknown at Antioch: as Yegül 2000, 146 notes, none of the excavated baths seem to have had an exercise courtyard, and none are mentioned in the ancient sources regarding bathing in Antioch. He suggests that the hot climate may have precluded physical exercise in open courtyards. It is, however, at least possible that this portico surrounded an open exercise courtyard at Bath D.

15. *Greek Anthology* IX.815. Many sources on the pleasures of Roman baths are discussed in Dunbabin 1989.

16. Augustine, *Against the Academicians*, 1.1.2. , see Augustine 1995.

17. Gregory of Nyssa, *Homily VII on the Beatitudes*, VII.152. The complete list is: "wealth, health, wife, children, house, parents, servants, friends, land and sea with the rich contents of each, gardens, hunts, baths, wrestling-rings, gymnasia, luxury clubs and youth clubs, and every thing that pleasure has invented, to which should be added theatrical entertainments and musical performances, and whatever else there is by which life is made pleasant for luxury lovers," see Drobner and Viciano 2000.

18. All of these personifications can be found at least once in the mosaics of Antioch. Around 400, the Baths of Apolausis were built on the slopes near the city; a mosaic personification of Soteria adorned the frigidarium. Like Gethosyne, Soteria was set in double row of triangles, and her roundel was held within an eight-pointed star. As illustrated in Çimok 2000, 234, one of the outer borders surrounding the personification of Soteria is a close parallel to the winding ribbon pattern decorated with white tesserae in an L that immediately surrounds the panel of Hermes and Dionysos. The other Syrian parallels conform to a later 4th-century date for the Bath D mosaics, Balty 1995, 203.

19. Yegül 1992, 414–415.

20. Dunbabin 1989, 19–20.

4.

Mosaic of a Women's Funerary Banquet

Rebecca Molholt

From Tomb Chamber of a necropolis

Site: **Antioch (sector 24-L)**

Date: **mid- to late 4th century C.E.**

Material: **Stone and glass tesserae embedded in lime mortar**

Dimensions: **178.8 × 270.2 cm**

Worcester Art Museum, Antioch Excavation, 1936.26

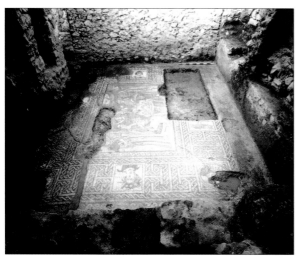

fig. 1. The tomb chamber at the time of its discovery, April 1935 (Antioch Expedition Archives).

"As soon as the gates are left behind, one is struck by the variety of gardens on the left-hand side, of places of entertainment, the abundance of fountains, villas hidden among the trees, with rooms overlooking the treetops — a spot fit for Aphrodite and her archer son."

— Libanios[1]

So it was to travel out from the gates of Antioch in the fourth century C.E.: gardens, fountains and country houses visible among the greenery. Perhaps it is not surprising that in this encomium of Antioch, Libanios neglected to mention the many tombs and necropoleis that must have lined this and every other road leading out from the city. Such an arrangement was typical in Greek and Roman towns: the cities of the living were surrounded by the cities of the dead. It was here, outside the Daphne Gates of Antioch, that archaeological explorations focused in April 1935. One of Antioch's ancient cemeteries had been located on the lowest slopes of Mount Silpios (sector 24-L). The excavations quickly turned up several floor mosaics and tomb chambers, and soon archaeologist Jean Lassus was invited to a nearby home, whose occupant had realized that a Roman mosaic lay partly beneath his residence. This was the mosaic of the women's funerary banquet (fig. 1).[2]

On 17 April 1935, Lassus' excavation diary describes the room of the mosaic as "surrounded by tombs," but he noted that modern overlay precluded any further exploration of the site.[3] The original chamber measured approximately thirteen by nine feet. "Floors as wide as [this one] may belong to the burial chamber itself, or to some annex of it," noted Doro Levi.[4] Photographs of the site from 1935 reveal shelves and niches cut into the walls of the chamber, perhaps to accommodate burials (see fig. 1). At some later point, a large hole, carefully positioned to avoid damaging the central scene, had been cut through one corner of the floor. Space was typically at a premium in any

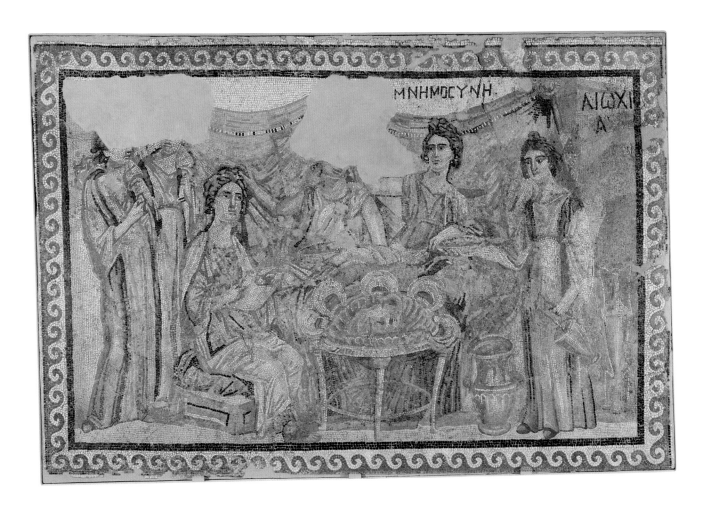

cemetery, but especially outside of densely populated cities like Antioch. This cut may have been the result of a later inhumation.

The paucity of finds in the area did not encourage archaeologists to linger in this part of the cemetery, and the excavations were abandoned after only two weeks (April 12–30, 1935). The limits of the cemetery were never established. Several geometric pavements, as well as a mosaic of a gaming board, had been excavated but the banquet scene was the only figured pavement to be uncovered.[5] No external dating evidence was found, and Doro Levi assigned a later fourth century date on a stylistic basis. A slightly earlier date of the mid-fourth century is suggested by the close parallel of the geometric border with that of the pavements from the Constantinian Villa in Daphne.[6]

The Funerary Banquet

The central scene of the pavement depicts six women gathered around a table. The figures fill the space almost from end to end. In the foreground, a woman sits on a low coffered stool in a place of honor, holding an open scroll. Behind her to the left, two women enter, perhaps bearing refreshments or decorations for the banquet. Slung over their shoulders are shapes that might represent either wineskins or cloth-covered bundles of flowers. They turn to each other as if caught in conversation, lending a relaxed, informal air to the scene. On a green and red striped couch recline two more women, their cloaks slipping casually from their shoulders. At the far right stands a girl holding an ewer and a bowl (fig. 2): fresh water for the diners to wash their hands.[7] The banquet is about to begin.

fig. 2. Detail including girl holding ewer and bowl, with dining table.

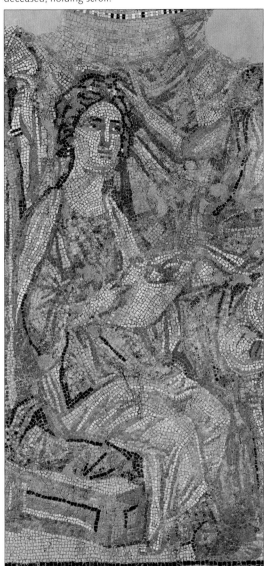

A limited amount of material wealth is on display. Across the background circular bosses hold up an expensive wall hanging patterned with silver and gold stripes.[8] All the women are richly dressed in multicolored belted tunicae and jeweled (pearl?) earrings. The costume of *stola* and *palla* suggests these women have the status of free-born matrons.[9] Expensive tableware is prominently displayed in the foreground: a tall pointed wine amphora is set into a metal stand at far right, and in front of the water-bearer stands a *krater*, used for mixing wine with water. The yellow color of all these items suggests polished bronze. An elegant scalloped table, already laden with a whole roasted fowl, stands in front of the dining couch. The multi-lobed, sigma-shaped table was popular in the eastern Mediterranean; in fact, one like it was excavated from a villa in Daphne.[10]

In all likelihood, this pavement is an evocation of actual dinners that may have been held in this very room, on the surface of this mosaic. This intimate gathering may reflect the size of dinners held in this space. It is also possible that the mosaic scene is merely a shorthand indication for a much larger group. Sitting down to dinner is one of the joys of this life, and such scenes also evoked the promised bounty of the next life. Furthermore, scenes of banquets recalled (and promised) those times of the year when the living visited the tomb to have dinner alongside deceased friends and family. From the cemeteries of Antioch we have many small stone stelae also decorated with banquet scenes.[11]

Banquets at the tomb were a regular feature of Roman funerary rituals.[12] Excavations across the Roman empire have revealed physical evidence for the funerary banquet in the form of sepulchral *triclinia* and even kitchens in tombs at Pompeii, on the via Latina, at Caere, Palmyra and Dura Europos among many others. Sometimes the banquet chamber is alongside the tomb, and sometimes it is located on the second floor above.[13]

Funerary art works to bridge the gap between this world and the next and to honor the deceased. In the complex visual language of Roman funerary monuments, the seated woman at front may repre-

sent the deceased herself, shown here as the guest of honor or host at her own funerary banquet (fig. 3). The woman reclining on the couch at center reaches over to caress the head of the deceased, or perhaps to place a wreath of honor on her head. This simple gesture makes tangible the link between the living and the dead, and illustrates the desire for contact that motivates any visit to a tomb.

The deceased is shown holding an open scroll, a clear sign of her learned status.[14] Poetry readings or speeches were a welcome part of many Roman banquets, and doubtless a part of funerary banquets as well. This woman, however, has looked up from her scroll. Though shown as if in physical contact with the living, she is completely self-contained and seems unaware of her companions. If anything, her distant gaze serves to connect

her space with ours. She has looked up from her own reading, and now her line of sight leads to the upper right corner of the scene, as if towards the words that we can read. The short inscription at the upper right gives a title for the scene. MNHMOCYNH AIωXIA is probably best translated as "Memory Banquet."[15] Mnemosyne may also be a woman's name, perhaps the deceased or the owner of the tomb. As noted by Dunbabin, the words "Memory" and "Banquet" can also be taken as names for the figures who recline and stand below the words. The servant standing at right would thus be an allegorical figure "Banquet," who attends the feast of the deceased. The first of the reclining women would then personify "Memory." Though shown in contemporary dress, these figures can still be taken as attendant allegories.[16]

Documentary evidence for such women's groups is scarce, and this mosaic is outstanding as a visual record.[17] It seems likely that this scene presents us with a rare glimpse of a women's funerary association, probably one connected by lines of kinship or of commerce.

Burial associations were common in the Roman world. Only the truly wealthy could rely on their families to provide for them at death. Instead, groups like this one, a kind of burial insurance organization, were formed to provide fictive kin and a proper burial for those who might otherwise have neither. Such groups also reinforced extant kinship ties and could open up business connections as well. Members of the Roman middle classes joined burial associations to help defray the considerable costs of burial rituals, the care of the body and the upkeep of the tomb. As a collective, the groups purchased spaces where they could meet and subscribed funds on a monthly basis. The monies paid for regular festivities and ensured that individuals would not be forgotten in death.[18]

Banquets at the tomb were the centerpieces of Roman burial societies. The memory of the deceased was celebrated and the living became the guests of the dead in their new dwelling place.[19] Responsibility for the refreshments circulated among the members each month. According to the 136 C.E. constitution of a burial club in Lanuvium in Italy,

if a member of the (all-male) burial society failed to bring a good wine when it was his turn, his membership could be revoked:

"It was also decided that if any member of this club has not paid his fair share for six months in a row, and then meets death, arrangements will not be made for his funeral, even if he has made a will.... Chairmen for the dinners, four at a time, selected in turn according to the membership list, ought to provide one amphora each of good wine, and bread worth two asses, proportionate to the number of club members, and four sardines, and a room for the dinner, and hot water, and a waiter..."
(CIL 14.2112, ILS 7212)[20]

The text describes a meager banquet, but then burial societies were not necessary for the truly wealthy. The fare depicted on our Antioch mosaic consists only of a roasted fowl, placed atop the table, though there appears to be no shortage of wine. The women at left may be holding wineskins that fulfilled the conditions of membership to provide wine with dinner.

The social world of Roman women was frequently characterized by the absence of men, who were much more often out in the city and indeed often away at war.[21] The strikingly different roles for men and women after the death of a friend, relative, or fellow burial society member are listed in a second-century inscription from Feltria:

"To the gods of the dead. Lucius Veturis Nepos, who, in order that they might carry out his funeral rites, gave the Ciarenses 1600 sesterces, and the women 400 sesterces, so that the Ciarenses might celebrate his birthday with incense, sausages and wine, the Heraclenses the parentalia, and the women the roses. He did this while he was still alive." (CIL V, 2072)

Mary Lefkowitz and Maureen Fant have suggested that this inscription refers to a kind of ladies' auxiliary group for honoring the dead,[22] and it does appear that the women are not to partake in the

fig. 4. Reconstruction of the entire floor.

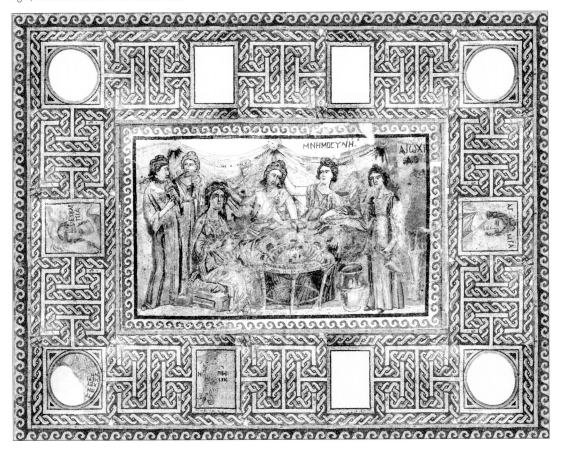

sanctioned birthday or parentalia banquets. Only one-fifth of the monies Nepos provided for his funeral rites and celebrations went to the women, a group with the distinct task of decorating the tomb with roses, perhaps during the spring celebration of the Rosalia.[23] Note that the Ciarenses, a group distinct from "the women," are the ones who will celebrate with sausages and wine. It is possible, then, to imagine women's groups meeting separately for their banquets, despite the relative scarcity of the literary and artistic evidence for women's associations.[24]

An excellent parallel for our pavement can be found in the late-fourth century mosaic of the Musicians, a pavement from an upper-class home in Mariamin.[25] Here we see a group of six women poised to perform on an array of musical instruments, looking out to the viewer as if awaiting a signal to begin the performance. These beautifully dressed women seem not to be professional entertainers, but rather an upper-class family group. As Janine Balty has described, our pavement and the mosaic of the Musicians share an "aristocratic ele-

gance of the figures, the delicate rendering of the garments, the lightly affected grace of their postures." She also notes that the details of hair and dress, so closely matched by our mosaic, were brought into fashion by Helen, mother of Constantine, and lasted through the fourth century.[26]

A scattered assortment of textual sources also attests to women's activities. An all-female association of the initiates of the Great Mother, Cybele, existed at Serdia in Thracia, as attested by a single inscription.[27] Gatherings of female relatives in honor of Mater Matuta are also recorded.[28] Emily Ann Hemelrijk suggests that women may well have had literary coteries in which their work was circulated, but she notes that there is no hard evidence.[29] It may be telling that female testators usually bequeathed their worldly belongings (*mundus*) to their daughters or to female friends.[30] The Worcester Funerary Banquet mosaic may evidence just such a line of matrilineal kinship, but the group almost certainly had commercial ties as well, as suggested by the set of personifications inhabiting the border around the central scene.

The Border: Seasons and Turning Points of the Year (Tropai)

The central scene was set within an ornate geometric and figural border (fig. 4). A wave crest of red on white lines the central figured panel and also surrounds the entire mosaic. Within these wave crests, a meander of guilloche forming spaced pairs of opposed horizontal Ts surrounds the central scene and also frames the rectangles inhabited by figural imagery.[31] In all probability, no fewer than ten female personifications were embedded in this rich geometric surround, though only four survive. Each figure is labeled in Greek and all face inward to the central banquet scene. The four corners, the turning points of the room, were marked by personifications of the four seasons, turning points of the year. This was a common strategy, but these corner figures, in bust format and carefully labeled, were accompanied by another set of full-length, standing figures, each repeating the attendant season. Thus, a personification labeled ΤΡΟΠΗ ΧΕΙΜΕΡΙΝΗ (the "Winter Season") anchored one corner, while a second personification of ΧΕΙΜωΝ ("Winter") stood nearby (fig. 5). The Tropai are representatives of the solstices and equinoxes, important designations in the festival and agricultural calendars. Thus,

an endless circuit of time, specifically solar time, framed the funerary banquet.

The Romans found the connotations of the Seasons to be especially appropriate for display in two places: the dining room and the tomb. In many dining rooms of Antioch, the Seasons signified the abundance of nature that made the feast possible.[32] A line from *De aeternitate* makes clear why seasonal imagery was so popular in a funerary context:

"For just as the annual Seasons circle round and round, each making room for its successor as the years ceaselessly revolve, so too, the elements of the world in mutual interchange seem to die yet are made immortal; as they continually pass along the same road up and down."[33]

Thus, the women's banquet is wrapped in a border of time: seasonal, calendrical and eternal. In the *Antiochikos*, Libanios repeatedly mentions the Seasons: "Over so fair a land as ours the Seasons dance harmoniously…one season, having given us pleasure, passes by, and the next approaches bringing equal pleasure."[34] The patrons of this mosaic were well aware of the connotations of agricultural wealth, as the two major border personifications make clear.

fig. 5. Two female personifications from the border: standing figure of Winter and medallion with bust (destroyed) and inscription "Winter Season" (Mead Art Museum, Amherst College).

Border: Agora and Eukarpia

The commercial ties of the group are advertised by the unusual personifications at the left and right of the central scene. Here, two bust-length images of women (figs. 6 and 7) appear to look over the banquet. Carefully labeled, they represent Agora ("Marketplace," or "Trade") and Eukarpia ("Fertility"). These two aspects of agricultural fertility—the bounty of a good harvest, and the implied profits gained from selling this harvest at the market—anchor each side of the banquet scene.

Agora has been interpreted by Levi as a translation of the Latin Annona, the seasonal yield of the earth.[35] "Marketplace" or "Trade" is probably a more apt translation,[36] and one more in keeping with her cosmopolitan appearance. Agora could be mistaken for a well-dressed Roman matron, her

yellow cloak pulled securely around her shoulders and her hair in an elegant chignon. In fact, Agora could easily step from her spot in the border into the central banquet scene without appearing at all out of place. The mosaic designer's decision to represent this personification in the guise of the contemporary women of the central scene strengthens the visual connection between the banqueters and the idea or the site of the marketplace.

Eukarpia—"Fertility," or "the good crop" —has a much more rustic appearance. With bare arms and a crown of fruits and grain-stalks woven in her hair, she would be recognizable as Fertility even without her inscription. The personification of Eukarpia was clearly excerpted from the greater identity of Demeter, goddess of the earth.

Libanios would have us believe that fourth-century Antioch had achieved a profitable link between agriculture and the marketplace. "The first

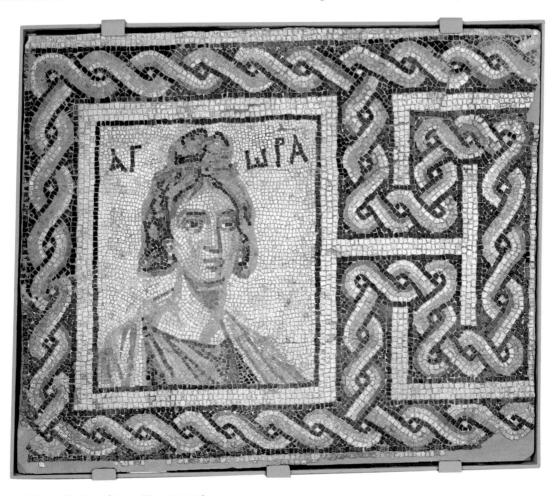

fig. 6. Personification of Agora (80 × 104.1 cm).

fig. 7. Personification of Eukarpia (80.4 × 98.6 cm).

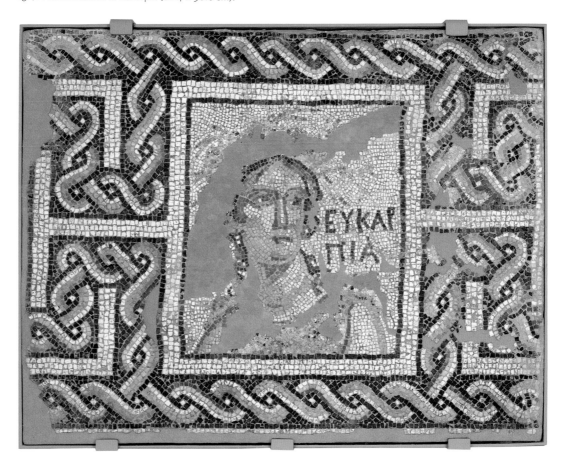

and foremost cause of praise for a city is the fertility of the land," he writes, using the phrase *ges arete* (literally "virtue of the land") to describe the farms around Antioch (*Or.* 11.13). He extols the pleasures of conversation in the marketplace (*Or.* 11.266), a part of town that was crowded all day long.[37] Libanios claims that the land around Antioch was so fertile and strong, and the supply of fresh water so plentiful, that the city comfortably accommodated huge numbers of soldiers preparing for campaigns against the Persians. These hoards were "nourished to satiety" in the city of Antioch (*Or.* IX, 178).

As might be expected, Libanios was exaggerating. Certainly, the city did owe a great part of its wealth to the blessings of the seasons and the agricultural fertility of the land.[38] But the threat of famine was ever-present. In the mid-fourth century, at the very moment that Libanios was writing (and perhaps also while our necropolis pavement was being laid in place), a series of famines struck the city: in 333, 354, and 360 C.E. In 360, Julian the Apostate was forced to import wheat to his new imperial capital.[39]

During the famine, some people were obviously still making money through the business of agriculture. The very specific and unusual personifications in the border strongly suggest that instead of (or in addition to) kinship ties, the women in this association were linked by a commercial connection, specifically with the vital business of supplying food-stuffs to the city of Antioch. Burial rites were usually just one function of such associations,[40] and Agora and Eukarpia particularize the nature of the women's association represented here. Perhaps they were involved in the transport of goods to market, or they owned shops in the city.[41] Certainly a pavement such as this was a costly addition to a tomb chamber—the financial backing for this image may well have come from their commercial connections.

The Worcester Funerary Banquet mosaic is a compelling combination of reality and aspiration, loss and renewal. With a business linked to the food supply, the blessings of the Greek earth goddess Demeter would be crucial for these women. Demeter's implied presence underpins many aspects

of the gathering shown on our mosaic. Eukarpia and the Season personifications are all abstracted from the overarching identity of this goddess of agriculture and fertility. Demeter is also the guardian of the dead, and a mother whose daughter was stolen from her.[42] Year after year, when mother and daughter are reunited, the earth renews itself in a fruitful agricultural cycle. This process of regeneration evokes the wealth of the market place, the links of family, and the eternal bounty of the afterlife, themes knit so closely together by this mosaic.

fig. 8. Detail of table with five crescent-shaped objects.

What Is on the Banquet Table?

Christine Kondoleon

The five crescent-shaped objects along the edge of the table raise a number of interesting questions about late antique dining (fig. 8). They are rather large and dominate the scallop-shaped top of the three-legged table on which they are precariously set, almost seeming as if they might fall off. They compete in scale with the cooked fowl at the center. Since they are represented in colors (white, yellow, and ochre) similar to the gilded wine vessels, they may well be not food but some type of utensil.

Their closest parallels can be found on a wall of the recently discovered Tomb of the Banquet in Constanza, Romania, dated to the mid-fourth century.[43] Here six similar objects are set along the edge of a circular table, around which recline five male diners. They are most likely not bread rolls, as suggested by some scholars. Significantly, these too are painted in yellow as if made of metal. Their shape is clearer in the Romanian painting—a horizontal bar attached by two knobs at either end of the crescent. In both dining scenes, they are laid with this bar away from the diners; in Constanza a male diner reaches for one by this bar, suggesting that it might function as a handle. The context of the two scenes is closely related as well. In the Romanian tomb, an all-male cast gathers outdoors on a curved masonry couch to honor the deceased in a commemorative meal. These objects may well be associated with dining at the tomb and may even be utensils for communal dining away from home.

Two identical objects are depicted with liturgical vessels on the altar table for the Communion of the Apostles shown in relief in the center of a silver paten from the Early Byzantine period.[44] Here the separation of the horizontal bar and the protruding attachments or knobs is quite clear. The objects are identified as "two wine skins," but the fact that one rests on its side and the other stands upright challenges that view.[45] The manner in which they rest flat on the tables of the fourth-century tomb banquets would seem to rule out their use as drinking vessels. Might they be an as yet unidentified type of tableware, a portable utensil for shared meals outdoors or at the tombs? Perhaps, like the spoons and ladles that became fashionable in domestic silver sets in the fourth century (e.g. the Kaiseraugst Treasure), these crescent-shaped metal objects are a new type of tableware for changing late-antique dining customs. While there can be no certainty until such an object is found in excavation, it seems clear that we are not dealing with a late Roman croissant.

PUBLISHED: *Antioch II 1938, 193, no. 76, pl. 55; Levi 1947, 295–304, pl. 66; Campbell 1988, 77–78, pls. 217–21; Çimok 2000, 230–231; Molholt in Kondoleon 2000, 121–22, no. 9; Dunbabin 2003, 184–185, pl. 14.*

1. Transl. Norman 2000, 54–55. Libanios' Oration 11, the *Antiochikos: In Praise of Antioch*, was delivered at the Olympic festival of 356 C.E.

2. The pavement of this room is now split into four pieces. The central scene, along with Agora and Eukarpia, two personifications from the wide border, are at the Worcester Art Museum. The figures of Winter and the Winter Solstice, another surviving segment of the border, are housed at the Mead Art Museum in Amherst. Not all of the border was raised, and after the pavement's removal to Massachusetts, tesserae pillaged from the border were used to restore losses to the central scene.

3. Antioch Excavation Diary, Princeton University Archives. See especially 11–29 April 1935 for discussion of the excavation of the cemetery in Sector 24-L.

4. Levi 1947, 291–304 describes the site as not far from the ring of walls near the lowest slopes of the mountain. The tombs were covered with vaults of rubble and concrete; sarcophagi were built of rubble and brick, and covered with brocks laid flat or vaulted. "Aside from the general funerary character of the area, we are in no position to establish the exact character of the single buildings where remains of mosaic were found" (p. 291). Marcello Spanu laments the relative lack of archaeological excavations of cemeteries in Asia Minor, and notes that "the extremely fragmentary information available does not seem at the moment even to allow final conclusions and not even a guess at the number of those who could afford monumental, or in any case, lasting tombs, although it would be a minority (the percentage we cannot say)... The rituals related to the dead person, either during the burial or afterwards, have yet to be studied." (Spanu 2001).

5. Other mosaics were found in this area: Dig D revealed two relatively large rooms preceded by a long corridor, all paved with geometric mosaics. Also found was the mosaic of a gaming board, today in the Princeton University Art Museum. See Kondoleon and Padgett in Kondoleon 2000, 160.

6. See the general chronology in Levi 1947, I, 626. Levi himself notes the parallel between the two examples of the geometric motif, Levi 1947, I, 431.

7. As suggested by Dunbabin 1993, 120. Indeed, the remains of blue glass tesserae fill the top of this bowl.

8. The hanging curtain (*parapatesma*) recalls similar devices used to frame deceased couples on Roman sarcophagi and may allude to apotheosis. See Koortbojian, 1995, 52 n. 10.

9. Sebesta 1994, 49. It is important to note, however, that the iconography of the stola was easily and regularly usurped by women of lower rank for use of their funerary monuments. See Berg, 2002, 47. The women are dressed in a similar way to those in scenes 78.2 and 78.3 of the catacombs of SS. Peter and Marcellinus in Rome. See Dunbabin 2003, 185.

10. From Daphne-Harbie 27-P, Antioch II 1938, 178, no. 226, pl. 21.

11. Several examples are published in Kondoleon 2000, 140–1.

12. For banqueting themes in funerary art, see Dunbabin 2003, 103–140 and 175–202.

13. Levi 1947, 298 and 300.

14. Janet Huskinson notes that "overwhelmingly the funerary imagery for women in the early empire idealized domestic virtues and physical beauty... but by the middle of the third century C.E. the image of a woman with a scroll became a regular occurrence." See Huskinson, 1999, 190–213. See also Amedick, 1991. For upper class women, basic literacy was a requirement. For most women, however, the acquisition of literacy was haphazard, dependent upon the "traditions, interests and standing of their families... highly educated women were far fewer than men." See Hemelrijk 1999, p. 71–72, and 182. See also Marrou 1938.

15. For αἰωχία as a corrupt form of εὐωχία, or "the banquet," see Levi 1947, I, 297 with citations.

16. Dunbabin 2003, 184–185 with parallels.

17. Very few scenes of women's banquets survive. One of the few parallels for our mosaic is a small ivory pyxis from Egypt, probably part of the Cathedral treasury at Trier in the sixth century. A group of five women are shown dining, a roasted fowl on the table. Three of the women hold bowls, as is also the case on our mosaic. The women recline on curved banquettes and are served by two other women. A Nilotic scene decorates the other side of the pyxis, suggesting that the banquet was held in honor of the goddess Isis to celebrate the fertility of the lands around the Nile. See Carra 2000.

18. Spanu notes the presence of "more and more frequent burials for families or groups" in the Roman period in Asia Minor. See Spanu 2001, 174.

19. For a discussion of the complex relationships between the houses of the living and of the dead, see Waelkens 1980.

20. CIL 14.2112, ILS 7212; transl. Shelton 1998, 96–98. See also Toynbee 1971, 54–5.

21. Treggiari 1996, 120.

22. CIL V, 2072, cited in Lefkowitz and Fant 1982, 245, no. 236. As another example, we have the wealthy women named Agrippanilla, who lived in Tuscany in the second century C.E., and endowed her own funerary society dedicated to the god Dionysos. The society boasted 400 members, their sex unspecified, all under her leadership. This society would certainly have been larger than the norm, which Robin Lane Fox believes to have been closer to forty. (See Fox 1986, 84–86 and also Prieur 1986.) Though primarily focused on the second century, useful contextual information is provided by Da Costa, 1997.

23. On the *Ludi Florales* in April and May, see Wiseman 1999, 195–203.

24. Lefkowitz and Fant 1982 collect three first and second century examples of women's associations, nos. 233–5, page 244.

25. Dunbabin, 1999, 171.

26. See Balty 1977, 94–98.

27. Cited by Philip Harland in his unpublished dissertation *Claiming a Place in Polis and Empire: The Significance of Imperial Cults and Connections among Associations, Synagogues, and Christian Groups in Roman Asia c. 27 B.C.E.–138 C.E.* University of Toronto, 1999, p. 32. CIL VI 2239 (Rome) mentions a woman named Veturia Semne who was honored on account of a magistracy in the Collegium of Bona Dea, but it is not clear whether this collegium was all-female or not. I am grateful to Jinyu Liu of Columbia University for providing these citations.

28. Kraemer 1992, 66–67 on the *matralia* with its "temporary constitution of a women's community."

29. Hemelrijk 1999, 148 and also 181, where she notes that "mingling with male friends outside the family circle was regarded as inappropriate for any respectable upper-class woman." For Roman women's lives generally, see Clark 1993.

30. Berg 2002, 51.

31. The description of the geometric border motif appears in Décor 2002, I, 85, pl. 41b. The same guilloche meander of opposed horizontal T's appears in the mosaics of Rooms 1 and 2 of the Constantinian villa at Daphne, as noted by Levi 1947, I, 431. This parallel suggests a date for our mosaic closer to the middle of the fourth century, rather than Levi's own late-fourth century date.

32. At Antioch, busts of the four tropai appear at the House of the Calendar and the House of Ge and the Seasons. See Levi 1947, I, pp. 36ff. and 346–347. For a discussion of time in Roman houses, see Kondoleon 1999, 321–341.

33. As quoted in Hanfmann 1951, 194.

34. Libanios, *Or.*, 11.29–34. Transl. Norman 2000.

35. Levi 1947, I, 295. In the Late Antique period, this word has little to do with the Hellenic political institutions of Greece, as Levi himself notes.

36. As suggested by Jean-Charles Balty, LIMC I,1: 305–6. He also mentions "Trade" as a good translation, as does Sophocles 1957.

37. "For what could be more abundant or satisfying than the profusion of goods on sale? These are so widely distributed over the whole city that no one part of the city can be called the market area, and purchasers need not go to one special place; it is suited to every man's convenience, for he has but to stretch out his hand, either before his front door or anywhere in town, and he can get whatever he wants." *Or.* 11.251. See also *Or.* 11.171. Transl. Norman 2001, 200.

38. The wealth of many Late Antique cities depended upon agricultural production. See Garnsey and Saller 1987, esp. 46–51, and Garnsey, Hopkins, and Whittaker 1983.

39. Libanios' Oration 11, the *Antiochikos: In Praise of Antioch,* is dated to 356. On the increasing population of fourth century Antioch, and the famines, see Petit 1955, 107–122 and also Liebeschuetz 1972, 92–100, 127–8. Despite the repeated famines of the fourth century, the city had long been renowned (and reviled) for its luxuries and its addiction to lavish banquets. The author Herodian (who may have lived in Antioch ca. 180–250), wrote that "Syrians are by nature lovers of feasts, and especially those of them that live in Antioch, a great and rich city, [they] feast almost throughout the city, partly in the city itself, partly in the suburbs." And partly in the cemeteries, he might have added. In his biography of the Emperor Julian, Ammianus Marcellinus, a historian born in Antioch (lived ca. 325–395), described the populace: "gluttony and deep abysses of banquets grew apace, and the place of triumphs won in battle was taken by those gained at table" (As quoted in Haddad 1949, 153).

40. According to Fox 1986, 84–5, "In the Greek East, clubs for the sole purpose of burial were not traditional; funerary rites were only one purpose among many."

41. Van Bremen 1996, 268–271 discusses the evidence for female landownership, but notes that this level of property was restricted to the very upper classes. Also noted is an inscription of Flavia Menogenis, who owned a private granary in Lydia.

42. See also Wood 2000, 77–100. Ceres was also the goddess to whom imperial women were most often assimilated, a link made especially often on coinage. See Spaeth 1996, 119–123 and 184. For the possibility of religious feasts for women only in the cult of Demeter, see Bookidis 1990, 86–94.

43. See Dunbabin 2003, 168, 241, n. 79, pl. 13, who follows Barbet in identifying the objects as bread rolls.

44. The Riha paten at Dumbarton Oaks is dated to 577 by control stamps, see Mango 1986, 165–170, fig. 35.6, esp. 170, where she notes that similar objects are found on the Antioch Funerary Banquet mosaic.

45. Ibid., 170.

5.

Mosaic of Ktisis (Foundation)

Christine Kondoleon

From the House of Ge and the Seasons: upper level

Site: **Daphne DH24-P, Room 4, M78)**

Date: **late 5th century C.E.**

Material: **Stone tesserae embedded in lime mortar**

Dimensions: **285.3 × 276.9 cm**

Worcester Art Museum, Antioch Excavation, 1936.35

fig. 1. **Plan of original mosaic locations**

1 Earth and the Seasons: Princeton University Art Museum

2 Star: Hatay Archaeological Museum, Antakya; Geometric panels: (still *in situ*)

3 Female Bust: Hatay Archaeological Museum, Antakya

4 Ktisis: Worcester Art Museum

Like so many of the houses found during the 1930s expedition to Antioch, this house in Daphne was only partially excavated. The layout of the geometric and figured mosaics is shown reinserted into the plan (fig. 1). The house was named by the excavators "House of Earth and the Seasons" because of the themes in the large dining room (room 1 on the plan) and was dated by Doro Levi, largely on stylistic grounds, to the last decades of the fifth century.[1] The size, theme, and location of room 1 in this house suggest that it was the main reception and dining room.

In order to contextualize the Worcester Ktisis mosaic, the decoration of the entire house requires our attention. At the center of room 1 is a female bust labeled GE, "Earth;" she is surrounded by four female busts labeled as the winter and summer solstices and the spring and fall equinoxes that today are on display in the Princeton University Art Museum. Immediately adjacent to this reception room was a corridor decorated with geometric mosaics (area 2). The part of this long hall that was excavated demonstrates a basic principle of Antiochene domestic design, namely the sequential arrangement of a main reception room, portico or corridor and a fountain.[2] While a water feature was not uncovered in the House of Ge and the Seasons, surely one existed. This type of arrangement is well illustrated by the plan of the House of the Drinking Contest in Seleucia Pieria of the early third century (see pg. 59 above).[3] In this earlier house, the bedding surfaces at the entrance to the dining room indicated that there was a large door framed by columns that opened onto the portico decorated with mosaics. While the remains of the House of Ge and the Seasons has no such door or column remains, one would assume a similar arrangement had existed. Two smaller rooms, possibly bedrooms, were found on the north side of the Seleucia house; the two smaller rooms toward the southeast end of the House of Ge and the Seasons, rooms 3 and 4 on our plan, echo the Seleucia arrangement. Room 3 contained another female bust at its center framed by birds and plants, today in the Hatay Archaeological Museum in Antakya. Room 4 also had a female bust at its center with the identifying Greek label Ktisis.

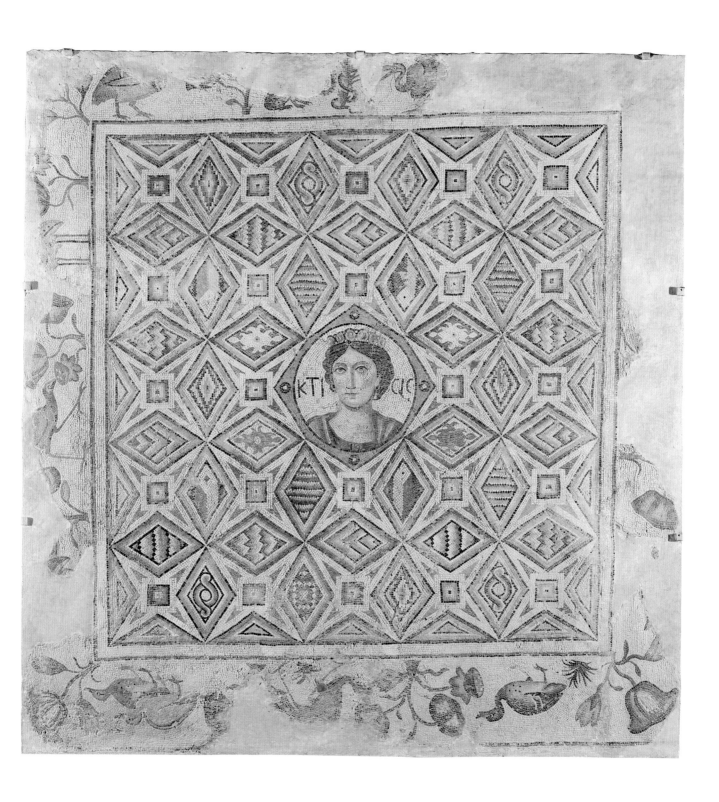

fig. 2. Detail of central bust.

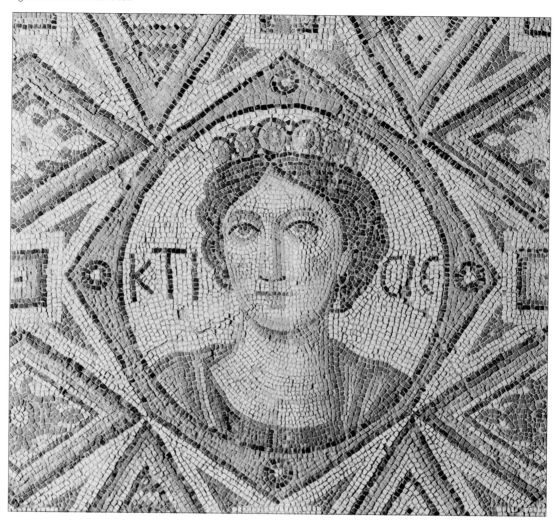

Ktisis Mosaic

The focus of the pavement is a female bust framed by an irregular octagon, outlined in black with an ochre filling and four white circles, that seems to simulate a jeweled frame with inlaid pearls (figs. 2, 3). This central medallion is surrounded by a dense polychrome design, "orthogonal pattern of tangent four-pointed stars, forming lozenges alternately recumbent and upright and creating the effect of intersecting octagons; here the stars bear a square inscribed at 45° to the axes"[4] (fig. 4). The lozenges are filled with a variety of patterns in graded shades (yellow/ocher, red/pink and gray/black); in addition there are four lozenges with looped circles (outlined in black with red/pink/white fill), four with perspective solids (red/pink/white against black ground), and four with what Levi calls "silver-plate motifs" (two in red on white, two in white on red).[5] The impulse to vary the coloring and filling motifs

essentially undermines the unity of the geometric design, so that the pavement reads as a series of colorful lozenges.

The central geometric design is framed by various birds and aquatic creatures (fig. 5). Although damaged on two sides, there is a sequence of three bushes of large lotus buds and lilies in between a series of aquatic fowl (ducks, geese, cranes). On the side above Ktisis one can make out a snake winding around a stalk with a toad or frog looking on. While they function as an ornamental border, these Nilotic motifs set Ktisis in a particular frame of reference that will be taken up below.

fig. 3. Detail of jeweled crown of Ktisis.

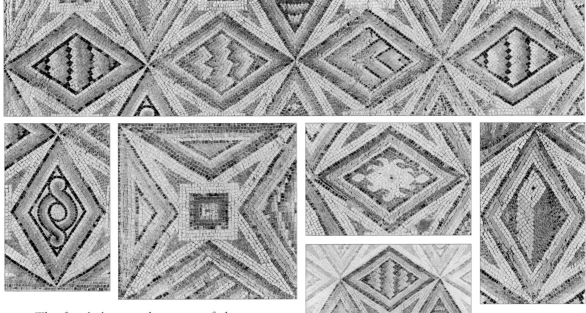

The female bust at the center of the pavement is dressed in a dark gray tunic and red mantle and has a diadem or crown with red and green stones (amethysts and emeralds?), each stone separated by a vertical row of pearls. She wears thick gold hoop earrings with triangular pendants. Her hairstyle, dress and jewelry identify her as an elite woman. The fact that the Code of Justinian (XI, 12) restricts the wearing of pearls, amethysts and emeralds to members of the imperial court suggests that imperial portraits inspired such representations.[6]

The Greek inscription KTICIC is divided by her face in two parts; we are meant to read her title across her face and to understand her as a visual representative of that word. The Greek noun is feminine and can be translated as "Foundation." It might refer to the construction of the building itself, analogous to the use of cornerstones today. Similar busts labeled Ktisis show a woman holding

fig. 4. From top, left to right: rainbow-patterned lozenges; looped circle lozenge; four-pointed star; silver-plate lozenge; perspective object lozenge; four lozenges and star describing octagon.

a Roman measuring device, specifically linking the bust to the notion of building. More than a century earlier, a female bust holding a Roman measure is identified as Ktisis in the border of a reception-room pavement in the Constantinian Villa near Daphne.[7] There she is accompanied by three other bejeweled females identified as Dynamis (power), Euandria (manliness) and Ananeosis (renewal). A mosaic from the period of Theodosius II (402–450) adorns an apsed hall in the Eustolios complex at Kourion, Cyprus; here Ktisis has long loose locks of hair and turns in profile to gaze up at her attribute, the measuring device (fig. 6).[8] The visitor to the fifth-century house in Daphne must have understood this bust literally as a personification of "Foundation." This notion is reinforced by the occurrence of the title "ktistes" on Asia Minor inscriptions. For example, various members of the Vedii Antonini family were honored with the title "founders" on their statues in the Ephesian buildings they funded.[9]

Personifications, human forms used to represent abstract ideas, were an established tradition in

fig. 5. Detail of Nilotic border, duck.

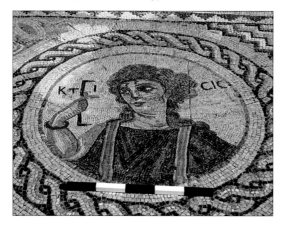

ancient Greek and Roman rhetoric and imagery.[10] If their frequency in the mosaic repertoire at Antioch (where they are for the most part female), is any indication, their popularity grew immensely during the late Roman and early Byzantine periods.[11] In the houses and public buildings, largely baths, at Antioch, personifications might signify states of being, such as "Enjoyment" or "Luxury," aspects of nature, such as rivers or the earth itself, or aspects of time, such as the seasons or months.[12] Most scholars accept, perhaps too readily, that the feminine gender of the abstract nouns accounts for the female sex of these representations. Tradition, it would seem, demands that these abstract qualities be represented in female form.[13]

One of the most popular personifications was Tyche, the fortune of a city. The earliest documented Tyche for a city was the monumental bronze seated statue made around 300 B.C.E. for Seleucid Antioch. The Antioch Tyche was a seated woman with her foot upon the swimming Orontes River; she wore a turreted crown and held sheaves of grain. She became the model for Tyche/Fortuna produced in many media and sizes throughout the ancient world.[14] For an excellent example in the WAM collection see catalogue 10. Undoubtedly, the fame of their Tyche enhanced the interest of the Antiochenes in Roman female personifications. Certainly, the association of the famed statue with the good fortune of the city established a tradition of blessings and protection from such female images. The appearance of Tyche on Antioch's coinage and on

the reverses of many other city coinages confirms these associations, as does the use on imperial coinage of empresses and female personifications of Roman virtues such as Concordia.

Female imagery, in the form of bronze busts of Athena and of late Roman and early Byzantine empresses, was also used for the lead-filled bronze weights employed in daily commerce from the fourth to the seventh centuries. In this context, the female busts functioned as guarantors of fair trade, that is, abiding by official standards. In keeping with this association, statues of empresses were positioned at locations in Constantinople where state supplies of food were distributed.[15] Although empresses may have already been linked to Roman virtues in the imperial period, these links became more intense during the Theodosian dynasty (379–455). In his funerary encomium for Aelia Flacilla (d. 387), Gregory of Nyssa refers to the departed empress as the "ornament of the Empire," a "harmonious mixture of all the virtues." Among these virtues he names "decoration" (of altars), "wealth" (of the needy), and "love of mankind" (philanthropia).[16] Although Flacilla's virtues are given an ecclesiastical slant, it should be noted that Gregory, as one of the Cappadocian Fathers, was educated in Antioch; the female busts adorned as imperial personages and representing "Decoration" and "Wealth" on the fourth- and fifth- century pavements of Antioch must be seen as part of the same cultural landscape. In terms of chronology, then, the increased popularity of these female personifications may be tied to the rising potency of the empresses as bearers of basileia (imperial dominion).[17] The association between the empress and personifications such as that of "Earth" or "Ktisis" is revealed in the dedicatory inscriptions for the statues of Aelia Flaccilla from Ephesos and Aphrodisia.[18] A rare gold bracelet in the Worcester Art Museum collection (2001.87) (fig. 7), one of a pair, indicates that these ideals as personified by female representations became fashionable for precious objects, as well as for monumental decoration.[19] The bust of a richly dressed woman bedecked in earrings and necklace is identified in Greek as XAPIC, "grace" or "charm." Her hairstyle and dress fit that

fig. 7. Bust of Charis, gold bracelet. WAM 2001.87.

of the fifth- and sixth-century empresses. A vine scroll is incised on the hoop of this bracelet — here too, as in the Worcester Ktisis mosaic, nature reinforces the message of the label.

Furthermore, literary sources report that several portraits of Flacilla at Antioch were attacked during the tax riots of 387. We begin to reconstruct from texts and images an interesting web of imperial and secular imagery, one reinforcing the perception of the other, so that the Worcester Ktisis might well be understood as a contemporary, i.e. late Roman or early Byzantine, version of imperial virtue that offered protection and security.[20]

Such images were more than apotropaic devices or good-luck symbols. A revealing example is the pavement fragment recently acquired by The Metropolitan Museum of Art that shows a bust holding a Roman measure identified by the Greek label as Ktisis (1999.99).[21] Unusually for a Ktisis image, this bust was apparently flanked by two running male figures that hold cornucopia filled with fruit. Only one side is extant, bearing the word "ΚΑΛΟΙ"; it was probably complemented on the other side by a similar figure with the word "ΚΑΙΡΟΙ" or "Good Times," the Greek equivalent

of the Latin FELICITAS TEMPORUM. Similar male figures accompany the inscription "ΚΑΛΟΙ ΚΑΙΡΟΙ" in a mosaic from a later fifth-century or early sixth-century Christian basilica in Delphi, where they are offering seasonal fruits.[22] Typically, the running figures with seasonal offerings allude to the earth's abundance and accompany Earth herself. It would seem that in the Metropolitan mosaic Ktisis is a stand-in for GE or Earth. And the earth's abundance is certainly alluded to in the border of the Worcester Ktisis.

The message of the Earth — its creation and abundance — is clear once the Worcester Ktisis is put into its original context, both in the room and within the house where it was found. Looking first within the room itself, the border of various Nilotic motifs (ducks, lotus buds and flowers, and water lilies) colorfully depicted (pale yellow, pink, and gray-green) contextualize the word Ktisis in a very particular way. The individual motifs and their style are closely replicated in another Antioch mosaic found on the property of Rassim Bey Adali at Daphne and dated to the last quarter of the fifth century.[23] The figured panels, part of a larger floor, feature ducks and lotus buds and fish that clearly allude to the life along the Nile. The palette and bold expressive style of the Antiochene Nilotic motifs find their closest parallels in the transept floors of the church of the Multiplication of Loaves and Fishes at Tabgha on the Sea of Galilee dated to the second half of the fifth century.[24] The presentation of the Nilotic motifs within an early Byzantine church reflect a trend to introduce the observed world of nature and the topography of the built world of men. The appearance of these Nilotic motifs in Antiochene houses makes it clear that the artists appropriated domestic art for the ecclesiastical

fig. 8. Details of Ktisis border: water fowl, a snake wrapped around a stalk, a frog or toad.

fig. 9. Details of the Ktisis border: lotus blossoms and flowers, stork and herons.

realm. The faithful probably viewed these images through the prism of their earlier domestic contexts. The label accompanying the Worcester Ktisis provides a vehicle for interpretation, namely that of "creation," an alternate meaning for Ktisis and probably the reason why this very personification appears in several churches.

If we step outside the room and examine the mosaics in the three other rooms with figural mosaics, there are seven female busts that represent aspects of nature (Earth) and its cycles (Seasons), and "Creation," as well as an unnamed female bust with a halo and surrounded by peacocks and other birds. Taken together, the mosaics of the House of Ge and the Seasons suggest that, just as the Earth renews itself through the changing of the Seasons as seen in the dining-room mosaic, so too man builds (Ktisis) and renews his cities and houses.

A Christian counterpart to this ensemble is found in the Justinianic basilica of Qasr-el-Lebia (c. 530) in Cyrenaica, where many of the same motifs appear—peacocks, Nilotic birds, fish, rural scenes, animals, and most importantly, female personifications including Ktisis, Kosmesis, and Ananeosis, are set into a grid of panels in the nave. Taken as a whole, the pavement is a visual gloss on a fifth-century commentary on Genesis written by Bishop Theodoret of Cyrus, a town near Antioch: "man imitates God who made him by building dwellings, walls, town, harbors, boats…countless other things." The clear visual simile between God as creator and those who built and decorated the churches was dependent on an artistic vocabulary developed in the secular realm to represent the patron of a house as founder and benefactor. The recent discovery and publication of a large Nile mosaic at Sepphoris from a civic building of the early fifth century offers vivid testimony to the association of Nilotic motifs with abundance and prosperity in the secular realm.[25]

PUBLISHED: *Antioch II, 194, pl. 58 fig. 81; Morey 1937, 39, pl. 18; Levi 1947, 346–347, pl. 82, b; Çimok 2000, 281; Kondoleon 2000, 65, 67 with fig. 3.*

1. Levi 1947, in the "Technique and Style" section of his monumental study of the Antioch mosaics, makes many comparisons between the geometric patterns and ornamental treatments in this house and the dated churches of Gerasa in Jordan, especially the Church of the Prophets dated to 464–5 C.E.; see 468, 475–476. Balty argues that Levi assigns a date between 450 and 475 to the House of Ge and the Seasons, upper level, without any archaeological evidence. She believes a later date is possible, see Balty 2001, 311, n. 37.

2. Following Dobbins 2000, 53.

3. Dobbins 2000, fig. 1, 53.

4. Décor 1985, 288, pl. 184f. The Worcester Ktisis mosaic is used as the example for this variant of the star pattern in this handbook of mosaic designs.

5. Although for Levi 1947, 468, this curvilinear design recalls the outlines of Roman imperial silver plates, I would suggest an alternate and perhaps more closely related source, namely inlaid marble designs.

6. Campbell 1994, 57, note 13.

7. These busts are discussed extensively by Levi 1947, 253–255, esp. 255, pl. 61 a,b,c. For a recent discussion of Ktisis and how she relates to other images of "general and personal ambition" found in the mosaics of Antioch, see Kiilerich 1998, 28–30. Kiilerich proposes that Ktisis, which means either Possession or Foundation, taken together with the other busts on this floor, communicates a sense of prosperity and good luck .

8. Michaelides 1992, 86–87, no. 47 with illus.

9. Dillon 1996, 274, no. 52.

10. For their appearance in Greek literature and art, see Stafford 2000, esp. 1–44, and Shapiro 1993.

11. About 80 personifications—50 of them are female and 31 present a young woman in bust format—occur in Levi's catalogue of the Antioch mosaics.

12. See also Downey 1938, 349–363.

13. See Stafford 2000, 27–35, who points out the contrast between the lower status of women in classical society and their ready appropriation for positive values; adult males are used very rarely as personifications, and then they usually represent negative values.

14. See Kondoleon 2000, 116–119 with relevant bibliography.

15. For a recent discussion, see Gittings 2002, esp. 69–70; also Vikan and Nesbitt 1980, 32.

16. See Holum 1982, 23–26.

17. The role of the female members of the Theodosian dynasty in imperial dominion is extensively explored by Holum 1982, 22–47; however, he does not make the connection to the secular personifications found in art.

18. Holum 1982, 40–41, n. 104.

19. See Kalavrezou 2003, 251, cat. no. 143.

20. Here I agree with Campbell's argument that personifications functioned as apotropaia in places like Antioch and Carthage: Campbell 1994, esp. 58.

21. See Evans 2001, 16–17.

22. Several examples of this inscription are found in fifth- and sixth-century pavements in Greece; see Spiro 1978, esp. Delphi, no. 83, 240–245, another from Old Corinth, no. 42, 97–98, pls. 95–97, and the lost apse mosaic of a Christian building in Tegea, no. 69–70, 182–183.

23. Levi 1947, 349.

24. See Levi 1947, 467, no. 260.

25. Weiss and Talgam 2002, esp. 69–72.

6.

Mosaic of Rams' Heads

Anna Gonosová

From the House of the Rams' Heads

Site: **Daphne (DH 16-N)**

Date: **late 5th or early 6th century C.E.**

Material: **Stone tesserae embedded in lime mortar**

Dimensions: **76.4 x 209.1 cm**

Worcester Art Museum, Antioch Excavation, 1936.33

This is one of the four border fragments of a floor discovered in Daphne in 1933 and raised in 1934 (figs. 1–4).[1] The accidental discovery in 1939 of two additional mosaics in the area permits the assumption that they came from the same residence, now referred to as the House of the Rams' Heads.[2] Although two coins of Valentinian I (364-375) and Valens (364–378) and late fourth- or early fifth-century pottery shards found beneath one of the mosaics set the *terminus post quem*, the overwhelming resemblance between their design elements and other late fifth- and very early sixth-century Antiochene floors supports the same date for the House of the Rams' Heads floors.[3]

The border is composed of an outer frieze of rams' heads, more accurately their foreparts or protomes, an inner frieze of an inhabited acanthus scroll, and two bands of a wave design. Only the fragment in the Baltimore Museum of Art is complete (fig. 1); the Worcester Art Museum panel includes the rams' protomes frieze, the middle band of wave design, and a small section of the acanthus scroll (fig. 2).[4]

Outlined in black, the outer frieze has a white ground of loosely laid scale pattern carrying the pairs of facing rams' protomes, each set on a pair of open eagle's wings with streaming ribbons alternating with red and pink rosebuds on long green stems. The rams' protomes have powerful frontally represented chests and necks with plain red ribbons; the heads are in profile but with both two ears and horns showing. The animals are drawn in brown, with the bodies and heads modeled in browns, yellows and beiges. The horns vary from gray to dark brown; some are striated but all curve in wide, emphatic arches. The eagle wings are quite simple and joined along the spine; they have gray forearms, wing feathers striated in gray and brown and streaming ribbons also in gray. The protomes and wings units also contain simple floral buds projecting above the spines and between the rams' heads.

The inner frieze is the widest part of the border. It is framed by narrow bands in red brown, ochre and light yellow. The main field has a dark, almost black ground covered with a dense acanthus scroll in many shades of green, olive and white

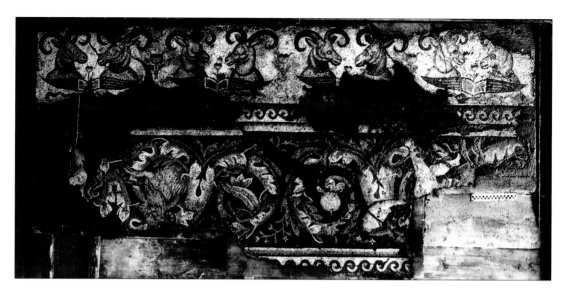

fig. 1. Daphne. The Mosaic of the Rams' Heads. The Baltimore Museum of Art fragment.

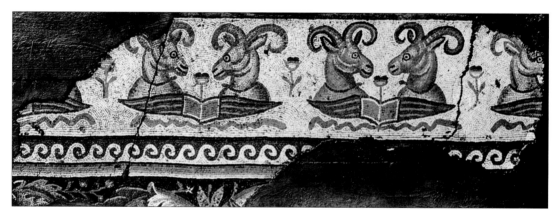

fig. 2. Daphne. The Mosaic of the Rams' Heads. The Worcester Art Museum fragment.

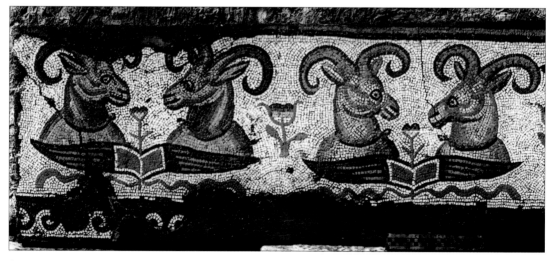

fig. 3. Daphne. The Mosaic of the Rams' Heads. Antakya, The Hatay Archaeological Museum fragment.

enriched with red and white flowers and floral buds. The fully preserved scroll in the Baltimore Museum of Art fragment displays several filler motifs including a hunting eros and an animal protome. The two figural friezes are separated by a wave design in red and white,[5] also used as the innermost band around the main field of the floor (which did not survive).

The inhabited acanthus scroll frieze and the wave band are rooted in the traditional Greco-Roman repertory and were employed frequently on Antiochene floors.[6] But this is not the case with the rams' frieze, which contains motifs found in the art of fourth- and fifth-century Sasanian Iran that are paralleled in only one other floor at Antioch, the Phoenix mosaic also from Daphne (fig. 5).[7]

In Sasanian art, the ram and eagle wings are sacred symbols associated with Zoroastrian divinities, specifically the warrior god Verethraghna and the goddess Anahita.[8] Together with the fluttering ribbon motif—called *pativ*—they were also the most important expressions of the king's *xvarnah*, the royal glory and fortune.[9] Extant Sasanian art is mainly connected with royalty and the Zoroastrian priesthood. Its symbolic elements, however, related

to principal Zoroastrian divinities and their auspicious powers, were used widely as pious, propitious, and protective signs, as evidenced by their frequent appearance not only on coins and royal silver plates, but also in textiles and architectural decoration.[10]

Significantly, however, although the individual components of the Antiochene rams' protomes are distinctly Sasanian, the way in which they are combined and depicted in Antioch are not. In Sasanian art the protome motifs appear either singly or in pairs rising from a shared base but almost always facing outward, stressing their more abstract and ornamental aspect; the animal motifs are represented as much as possible in strict profiles (except for the horns, frequently portrayed frontally.)[11] In the Antiochene version, the profiles of the heads are modified by an addition of the second ear and altogether ignored in the nearly frontal chests and necks; also, the plasticity of the heads implies movement, endowing them with an innate naturalism associated with Hellenistic and Roman artistic traditions.

There is no evidence to suggest why Sasanian art might have appealed to local Antiochenes other

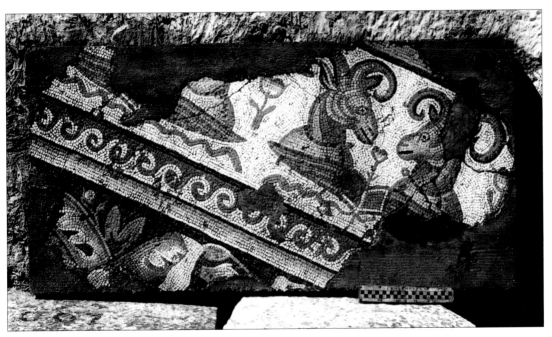

fig. 4. Daphne. The Mosaic of the Rams' Heads. The Princeton University Art Museum fragment.

fig. 5. Daphne. The Mosaic of the Phoenix. Paris, Musée du Louvre.

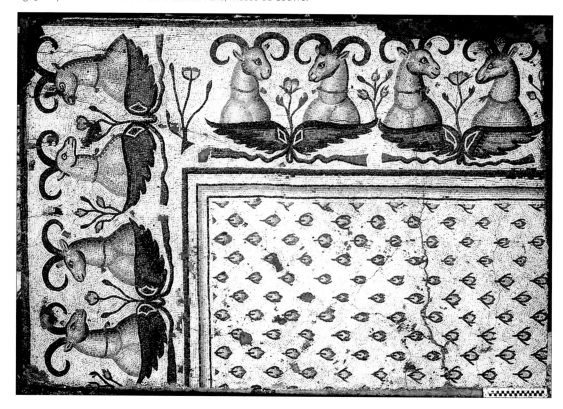

than its exotic novelty and general visual appeal. Whether used in Antioch[12] or elsewhere in the Late Roman empire,[13] the religious and royal associations and sacred significance of Sasanian motifs were lost and only their visual appeal and their decorative potential were transmitted.[14] While the path of transmission is not altogether clear, encounters with portable arts, like coins and metalwork but above all textiles, is most likely. For example, the two rams' protomes mosaic borders could have been inspired by a textile similar to a Sasanian silk found in a sixth-century grave in Antinöe in Egypt (fig. 6).[15] Roman decorative art had a long tradition of accepting new motifs and Sasanian art offered new decorative possibilities whose popularity proved long lasting.[16] The Antiochene mosaics were in the forefront of this development.

fig. 6. Silk fragment from Antinöe. Lyons, Musée Historique des Tissus.

PUBLISHED: *Morey 1937, 21, no. 11; Antioch II 1938, 188, no. 60, pl. 45; Levi 1947, 350, 478–79; Teitz 1971, 17, fig. 7; Çimok 2000, 286; Kondoleon 2000, 133–34, cat. no. 20.*

1. The three other fragments are in the Baltimore Museum of Art, the Hatay Archaeological Museum in Antakya, and the Princeton University Art Museum. See Antioch II 1938, pls. 45–6; also Kondoleon 2000, 134, fig. 1.

2. Levi 1947, 350, pl. 133c and pl. 133d. Both floors had geometric patterns. Floor 1 had an outer frame of tangent posted squares with central florets (Décor 2002, vol. 1, 44–45, pl. 15e) and a field of intersecting circles with inscribed squares and circles (Décor 2002, vol. 1, 372–373, pl. 238d). Floor 2 had a double border of an interlace of circles and lozenges (Décor 2002, vol. 1, 132–133, pl. 82c) and an undulating ribbon (Décor 2002, vol. 1, 115, pl. 65f) around a field with a diagonal grid of rosebuds/tassels with central crossed florets (Décor 2002, vol. 1, 190–191, pl. 125d).

3. See especially the diagonal grid of rosebuds around the Mosaic of Ananeosis, ca. 450-475 (Levi 1947, 320–321, pl. 131d; Campbell 1988, IV A 10, 27–28, pl. 81; Antakya, the Hatay Archaeological Museum); the rams' heads border of the Phoenix Mosaic, late fifth century (Lassus 1938, 89, 103–104; Levi 1947, 351–352, pl. 104 a–b; Baratte 1978, no. 44, 92–99; Çimok 2000, 289); the interlace field of the Ge Mosaic from the House of Aion, Upper Level, about 500 (Levi 1947, 355–356, pl. 136; Campbell 1988, IV A 24, 58–59, pl. 172).

4. As the field photograph indicates, only two center protome units and the left side of the inner border are ancient. Antioch II 1938, pl. 45, no. 60, Section 4.

5. Décor 2002, vol. 1, 156, pl. 101b.

6. An especially elegant early second-century acanthus scroll frames the Aphrodite and Adonis Mosaic from the Atrium House (see herein, pg. 25, fig. 14); a more robust version is used in the large mosaic of the Seasons in the Constantinian Villa, ca. 325 (Levi 1947, 226–228, pls. 56–57; also Baratte 1978, no. 45, 106–117, figs. 96, 125 and frontispiece; Çimok 2000, 203); an inhabited acanthus scroll around the Worcester Hunt Mosaic exemplifies the early sixth-century phase of the motif (Levi 1947, 363–365, pls. 144b–c; see herein, 233, fig. 8–9).

7. Paris, Musée du Louvre, Ma 3445, MND 1947a–f, MND 1948. Lassus 1938; Levi 1947, 313–315, pl. 70; Baratte 1978, no. 44, 92–98, figs. 86–93; Çimok 2000, 203). For the Sasanian aspect of the border, see Lassus 1938, esp. 117–121; also Levi 1947, 478–479.

8. Boyce 1975, 62–63; Yarshater 1983, 324–326; Harper 1978, 106.

9. The kings and deities are always shown wearing multiple plated ribbons, the fluttering of which surrounded them with a visible physical aura. Yarshater 1983, 324–326, 345–346.

10. For an overview of Sasanian art see Ghirshman 1962, 119–254; Harper 1978; Brussels 1993.

11. As, for example, on a stucco relief from the fifth-century palace at Kish in Iraq (Kröger 1982, 140, 190–193, pl. 81,3-4; Kondoleon 2000, 134-135, no. 21) and a seventh-century Sasanian silver plate in the Arthur M. Sackler Gallery in Washington, D.C. (Gunter and Jett 1992, 131-135, no. 18; also Kondoleon 2000, 136, no. 24).

12. E.g., the Mosaic of the Beribboned Lion, fifth century (the Hatay Archaeological Museum, Antakya; Levi 1947, 313–314, pl. 70b–c; Çimok 2000, 241); the Phoenix Mosaic (see above n. 7), and two mosaics with beribboned parrots from the early sixth century (Paris, Musée du Louvre: Kondoleon 2000, 136–137, no. 25; Levi 1947, 358, pl. 137d; Baratte 1978, 123–124, no. 49, fig. 131; the border of the Dumbarton Oaks Hunt: Levi 1947, 358–359, pl. 85d; Çimok 2000, 292).

13. A Sasanian silk was copied in the fifth century on the south vault mosaic in the church of St. George in Thessalonike (Gonosová 1987, 236–7, figs. 7 and 8; Torp 1963, 16–17, 21; Spieser 1984, 133–134, 141–142), while Sasanian art, especially stucco, influenced much of the architectural sculpture in the Church of St. Polyeuktos in Istanbul, dated to 524–52. See Harrison 1986, 111–112, 121–135, figs. B–C and pls.; also Strube 1984, 61–68.

14. Considering the late fifth-century date of the Phoenix Mosaic, it is highly unlikely that the House of the Phoenix was built for the cult of Anahita-Artemis as proposed by Lozinski 1995.

15. Lyons, Musée historique des Tissus, inv. 897.III.41 (26.812/24); Martiniani-Reber 1986, 51–52, cat. 17. For an overview of Sasanian textiles see Brussels 1993, 113–122, and Martiniani-Reber 1997; and still useful Kitzinger 1946.

16. Mango 1977, 316–321; Grabar 1971, 679–707.

7.

Four Panels from the Geometric Mosaics of the House of Aion

Rebecca Molholt

From the House of Aion: upper level

Site: **Antioch (15-M)**

Date: **early 6th century C.E.**

Material: **Stone tesserae embedded in lime mortar**

Dimensions: **269 × 211.1 cm**
268 × 146 cm
274.2 × 142.3 cm
273.7 × 174.8 cm

Worcester Art Museum, Antioch Excavation, 1939.90, D-G

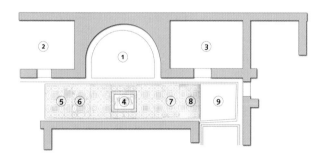

fig. 1. **Plan of original mosaic locations. Adapted from Stillwell 1961, plan IV.**

Room 1. Exedra mosaic of florets: (not raised)

Room 2. *Opus sectile* floor: (not raised)

Room 3. No pavement found here

Corridor area 4. GE and the Karpoi: Allen Memorial Art Museum, Oberlin College. Panels of the geometric pattern to the left and right of Ge are also at Oberlin.

Corridor areas 5, 6, 7, 8. Geometric panels: Worcester Art Museum

Corridor 9. Geometric panels: (not raised)

During the last campaign of the Antioch excavations in 1939, the archaeologists pursued their fervent desire to obtain more precise information about the overall street plan of the city.[1] In the search for the main east-west street, they sunk trenches six meters deep beneath an olive grove near the Justinian wall on the western edge of the ancient city. But instead of a street, the archaeologists uncovered a long hallway and a suite of rooms (see fig. 1) paved with mosaics.

Excavations below Room 3 revealed several more mosaics, all of which were photographed, catalogued, and left *in situ*.[2] One of the mosaics from this lower, earlier level included the figure of Aion, personification of eternal time. The excavators gave his name to both the earlier and the later levels, referring to the entire structure as the "House of Aion."

The pavements from the upper level, the focus of this entry, date to the early sixth century. Sealed beneath the mosaics were many coins, some from the fourth century and many

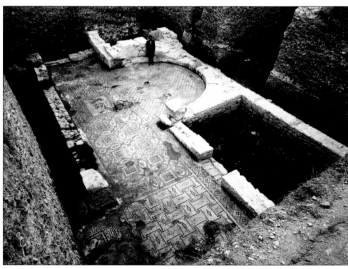

fig. 2: View of the site at Antioch, sector 15-M, with a man standing in the apsed exedra to show scale. Note that the area of Room 3 has been entirely dug away to make possible exploration at a lower, previous level of construction. One mosaic from the lower, earlier level included the figure of Aion, and the excavators gave his name to the entire structure, calling both levels the "House of Aion" (Antioch Expedition Archives).

1 2 3 4 5 6 7

Composite view of the corridor mosaic, showing the seven panels
into which it was split at the site. The central panels 3–5 are at
Oberlin; the four exterior panels 1, 2, 6, and 7 are at Worcester.

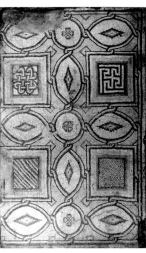

1. 1939.90 D, 269 × 218 cm. 2. 1939.90 E, 269 × 147 cm. 6. 1939.90 F, 274 × 142 cm. 7. 1939.90 G, 274 × 170 cm.

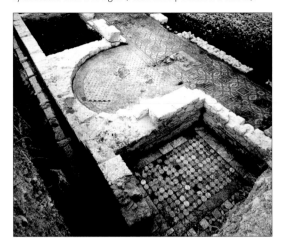

fig. 3. Exedra mosaic of rosebuds and corridor mosaic of Ge and the Karpoi at the House of Aion, upper level. Note the *opus sectile* at lower right (Antioch Expedition Archives).

others that appeared to belong to the late fifth and perhaps even the beginning of the sixth century. Pottery sherds sealed underneath the corridor mosaics confirmed a late date of after 500 C.E.[3] The early sixth century was a prosperous time for Antioch; Glanville Downey attributed the affluence to a major expansion in olive oil production at the end of the fifth century.[4] The prosperity of the early sixth century was short-lived: a major fire swept the city in 525, followed by a devastating earthquake in 526, another in 528, and then the sack of Antioch by the Persians in 540.

Efforts to expand the excavation trenches in 1939 were hampered by the depth of the dig, the unpredictable water table, and the lack of time, given the onset of World War II later that year. Today, plans and site photographs, coupled with recently excavated comparanda from nearby Apamea, suggest that the suite of rooms from the sixth-century level of the House of Aion may have been the guest quarters of an elite residence.

Architecture and Mosaics

The architecture of the House of Aion, upper level, remained intact up to perhaps a meter high in some places (fig. 2), preserving critical features such as methods of wall construction and the placement of doorways. All the walls discovered were deemed contemporary by the archaeologists, though there was evidence for later reuse as some doorways had been filled in. A wide, semicircular exedra (fig. 3) and two flanking rooms opened onto a broad hall-

way 12.4 m long and 3.3 m wide.[5] Room 2 was paved with a magnificent *opus sectile* floor,[6] while by all accounts no pavement of Room 3 was ever found. The exedra mosaic (room 1) exhibits one of the most popular motifs of the sixth-century mosaic repertoire: small pink rosebuds arranged in an allover scale pattern.[7] Several other rooms can be seen at the northern end of the hallway, where a second wing of the corridor begins, paved by a mosaic of a key pattern with a diamond shape in each element. The excavators speculated that these corridors formed part of a peristyle around a planted garden court and Doro Levi characterized this corridor as colonnaded.[8]

While most of the pavements from the House of Aion were left *in situ*, the corridor mosaic was raised in seven sections. Four panels from this long hallway are in the Worcester Art Museum today. The overall design of these mosaics is a polychrome grid of bands produced by tangentially interlooped circles and recumbent ellipses (the circles at the intersections), all in asymmetrically

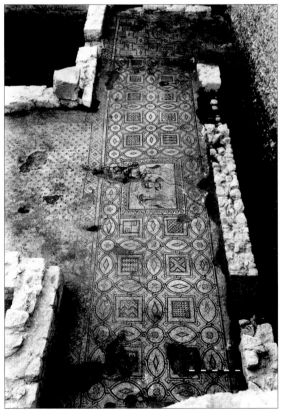

fig. 4. House of Aion, upper level (Antioch Expedition Archives).

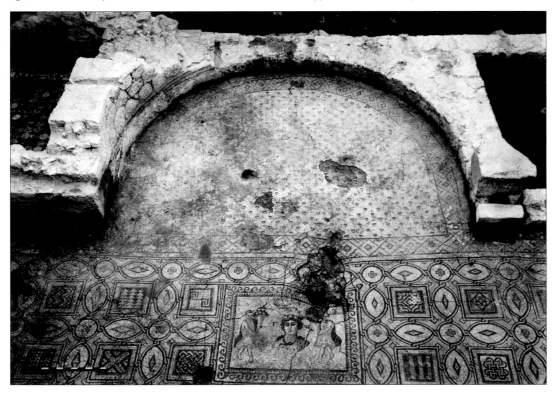

shaded bands.[9] Four-petaled florets and diamonds decorate the circles and ellipses. The palette is not broad: the bands are made of rows of black, red, pink and white; the background is white and tan and the filling motifs only rarely add to the colors already mentioned.

Along the floor of the colonnaded corridor, bands of circles and ellipses surrounded a series of squares (fig. 4). Almost every one of these squares presents a different geometric motif: zigzag rainbows in serrated simple filets, knots, diagonal rainbow patterns of tangent poised squares, checker patterns of single tesserae, and tangent cuboids alternating in angle and direction. The composition of the corridor mosaic can be compared with many examples from houses as well as churches in fifth- and sixth-century Syria, Cilicia, Palestine, Phoenicia, and Cyprus.[10] The ends of this long corridor panel seem to have coincided with the doorways to rooms 2 and 3 flanking the apse. In each case, a new mosaic design began in the hallway and a doorway opened above the juncture of patterns on the floor.

At the center of the corridor, marking the entrance to the apsed exedra, an image depicting the earth goddess Ge and her two attendant Karpoi punctuates the geometric design (fig. 5).[11] The Karpoi are small boys, the children of Earth, who per-

sonify the produce of the land. Each one carries a cornucopia overflowing with fruit and they step forward together as if presenting gifts to the viewer, or the guests about to enter the room.

Function

The architecture and mosaics of the upper level of Antioch's House of Aion find many parallels at the Maison du Cerf in nearby Apamea, dated by Janine Balty to the fifth and early sixth centuries (see plan, fig. 6).[12] This house is, however, a much more imposing structure, and one that is more completely excavated. Corridor G is a particularly wide gallery of circulation whose geometric décor of interlaced diamonds, circles and squares is a more elaborate version of the mosaic design of the narrower corridor of the House of Aion.[13] At the Maison du Cerf, the corridor likewise gives onto a suite of three rooms (AA, AB, AC on the plan) that are configured similarly to Rooms 1–3 at the House of Aion in Antioch: an apsed exedra at the center and rectangular flanking rooms at either side.[14]

A mosaic inscription in corridor G, just at the threshold of the apsed chamber AA, presents verses 123–124 from Book I of the *Odyssey*: "Hail, stranger; in our house thou shalt find entertainment, and

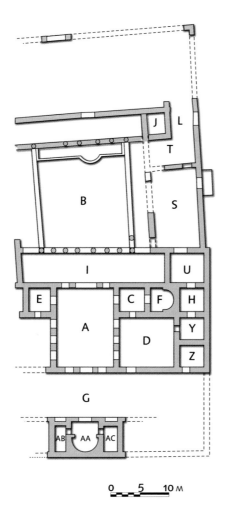

fig. 6. Plan of the Maison du Cerf, Apamea. Sixth century C.E. (after Balty 1997, figure 19). The guest quarters are rooms AA-AB-AC at the base of the plan.

0 5 10 M

prosperity of [the patron's] dominions."[17] Together with the proleptic wish for abundance that Ge embodies, she also represents the bounty of the earth that would make its way to the tables of guests and homeowner alike. Libanios makes a clear connection between the bounty of the earth and the hospitality that the Antiochenes were able to offer to people from out of town:

"So well suited to the multitude is the nature of the earth [around Antioch] . . . we have never been compelled to dishonor Zeus Xenios through any harshness concerning strangers, even though we have the example of Rome, which, whenever any scarcity of the necessities of life occurs, turns this to abundance by driving out the foreigners. The earth has never driven us to such a remedy as this. . . [Antioch keeps to] its old custom, I think, of solving troubles for strangers, not creating them."[18]

The bounty implied by the Ge mosaic at the House of Aion would announce the owner's intention to house his guests comfortably, with spacious quarters and abundant hospitality. Seen in this light, the few surviving rooms of the upper level of the House of Aion offer more than just a sample of the decoration and architecture of early sixth-century Antioch. They hint at the cultural and social life of the city, furnishing evidence of the elite lifestyle of late antiquity. Even though all we have is a hallway and a few rooms, these lavish quarters suggest the frequent presence of guests at this beautiful house in downtown Antioch.

PUBLISHED: *Antioch III 1941, 175–76, no. 109; Levi 1947, 355–56; Lodge and McKay 1981–82, 55–69; Campbell 1988, 58–59, no.24c, pls. 170–173.*

then, when thou hast tasted food, thou shalt tell of what thou hast need."[15] These words enabled Balty to identify the suite of three rooms as the guest quarters of the Maison du Cerf, perhaps a guest dining room and two bedrooms.[16] The parallels in architecture and décor suggest that the contemporary three-room suite at the House of Aion could also be guest quarters. Though the Antioch rooms lack the verbal specificity of the Apamea threshold inscription, the image of Ge and the Karpoi offers a similar message: the bounty of the earth and the generosity of the host are put forth visually by the mosaics of the exedra threshold.

The personification of Ge can itself be connected to the presence of guests in the house. Henry Maguire has suggested that personifications of the earth and her produce demonstrate the "extent and

1. Knowledge of the plan of the city itself could have led the team to discover Antioch's great public monuments, made famous by ancient literary sources. In fact, Richard Stillwell noted that the drive to ascertain the street plan of Antioch "governed the strategy of the successive campaigns," not just the last one in 1939. See Stillwell 1961, 47. The Antioch Excavation Diary, Summary of Excavation in 15-M, 1939 (Princeton University Archives) gives 5.88 m. as the level at which habitation dated to the sixth century was revealed. I am grateful to Shari Kenfield of Princeton University for her assistance with the Antioch archives.

2. See Levi 1947, 195–198 for a discussion of the mosaics and previous construction on the site, House of Aion, lower level.

3. The coins were found sealed underneath the corner panel with the mosaic of a key pattern, area 9 on the plan, figure 1. The earliest type of Late C pottery was found sealed beneath the mosaic of Ge. See Levi 1947, 355–6 and 626.

4. See Downey 1961, 501–3.

5. The doorway to Room 3 is clearly visible in the site photographs (see fig. 2). Only the jamb of the doorway from Room 2 onto the corridor was preserved; the doorway itself had been filled up at some later point. See: Antioch Excavation Diary, 15-M, Trenches 1 and 2 (Princeton University Archives). On the later reuse of the houses of Antioch, their subdivisions and reoccupations in late antiquity, see Ellis 2004.

6. Pauline Donceel-Voûte calls the early sixth century "one of the most brilliant eras in the history of opus sectile in the Near East." See Donceel-Voûte 1994, 93. According to the excavation files, the opus sectile in Room 2 was of gray, gray and white, white, porphyry and alabaster. The room was divided into two rectangular zones, one side paved with circles, the other with alternating squares and rosettes, in a layout not inappropriate for a bedchamber. This opus sectile pavement was not raised. I have found no mention of any pavement or floor surface in Room 3.

7. The floret semis of the apse mosaic are of a type called "an essential component of the peaceful, equanimous style with which the sixth century opens… [the pattern of] all-over scales with rosebuds [is] the most popular isotropic pattern throughout the century." See Donceel-Voûte 1995, 93–94.

8. Levi 1947, vol. I, 355.

9. Following Décor 1985, figure 149c. Donceel-Voûte notes that the use of such narrow bands to form interlooped patterns is common to the sixth century. See Donceel-Voûte 1995, 93.

10. See Balty 1995, 125–6, esp. note 142 for parallels, with citations.

11. There are many parallels for the personication of Ge in mosaics of houses and churches in Syria. See Balty 1995, 131, note 187 with citations. The Oberlin panel was published in Lodge and McKay 1981–82. A mosaic personication of Ge/Tyche also adorned the peristyle of the Maison du Cerf at Apamea. See Balty 1997.

12. Balty 1997, esp. 100–107.

13. Corridor G at the Maison du Cerf is over 7.5 m wide and at least 20 m in length. See Balty 1997, 103.

14. Note that in the Maison du Cerf, the two ancillary rooms are accessed from the central exedra. At Antioch, each of the three spaces is accessed independently from the corridor.

15. Transl. A.T. Murray, Loeb edition, 1976.

16. Balty 1997, 104.

17. Maguire 1987, 75.

18. Libanios Antiochikos, 174–175 (transl. Downey).

Mosaic of the Worcester Hunt

Christine Kondoleon

From the House of the Worcester Hunt (Daphne-Harbiye, Sector 27-P, 1935)

Site: **Antioch**

Date: **480–520 C.E.**

Material: **Stone tesserae embedded in lime mortar**

Dimensions: **625.5 × 866.8 cm with border (625.5 × 710.6 cm without border)**

Worcester Art Museum, Antioch Excavation, Hunt, 1936.30; Borders, 1936.31

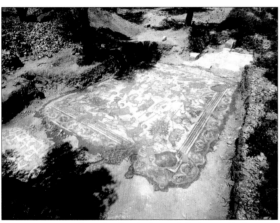

fig. 1. *In situ* photograph facing west of Worcester Hunt room (Antioch Expedition Archives).

Daphne, famed as a summer resort for the elite of Antioch, yielded many elaborate mosaics. Three adjacent rooms were found in May 1935 in the sector south of the theater, which was an area dense with mosaic finds (fig. 1).[1] Like most of the others, this complex was not fully excavated—the mosaics were lifted and a schematic plan was drawn (fig. 2). The assumption is that this was a residential quarter inhabited from the second century through the decline of the city in the sixth century.[2] Because the walls do not survive, it is impossible to determine how these rooms were connected or what doorways they shared.[3] Nevertheless, the thematic interrelation of their mosaic pavements suggests a suite of reception rooms like those found in earlier Antioch houses. The Worcester Hunt was designated as room 1 by the excavators and is certainly the grandest of the three rooms. The only indication of orientation is provided by the central hunter, who probably faced the entrance of the room. At one end of the large hunt was the much smaller room 2, decorated with a circular medallion containing a bust of Earth (identified by the Greek label ΓH) in a field of green leaves with large bold red fruits; she faces into the large room (fig. 3). In the adjacent room 3 was a mosaic of a wild beast hunt centered on a striding lion that faced toward the Worcester Hunt room (fig. 4).[4] The relationship of these themes to the large hunt is considered below.

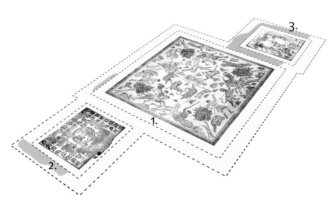

fig. 2. **Plan of original mosaic locations**

Room 1 Worcester Hunt, Worcester Art Museum

Room 2 Mosaic of ΓH (Earth), Hatay Archaeological Museum, Antakya

Room 3 Honolulu Hunt, Honolulu Academy of Art

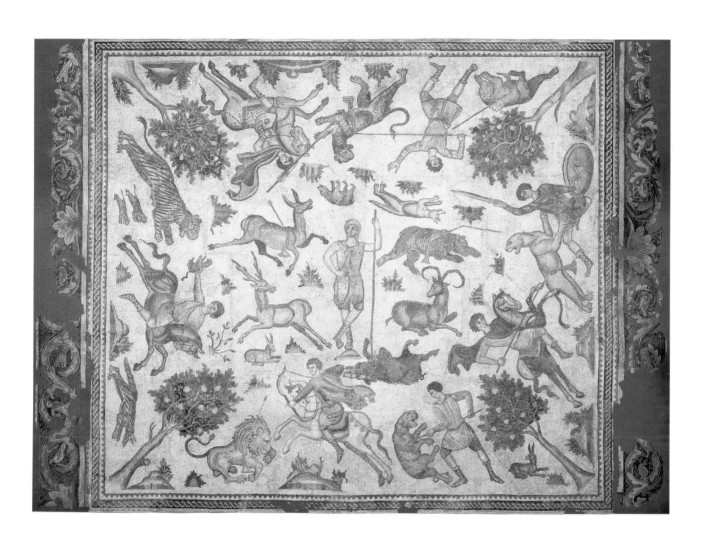

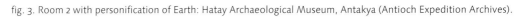

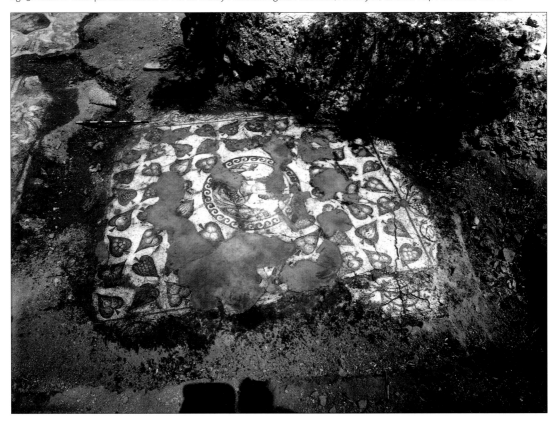

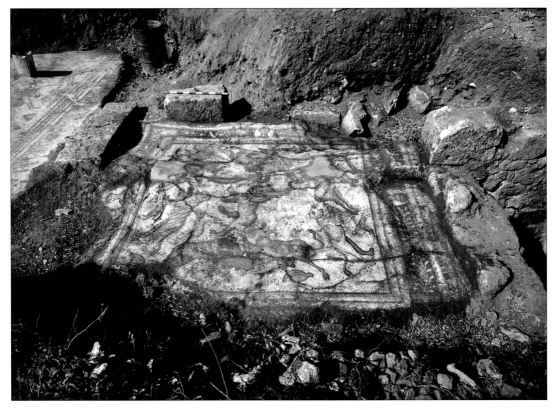

fig. 4. Room 3, Honolulu Hunt: Honolulu Academy of Art (Antioch Expedition Archives).

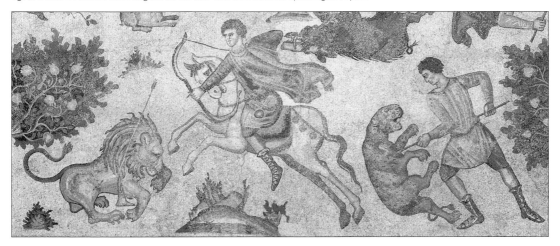

Worcester Hunt and Borders

The monumental hunt mosaic is comprised of eight bold, colorful hunters and beasts against a cream background laid in a scale pattern. The composition has two main zones, an outer series of seven discrete hunting scenes along the edges and an inner zone arranged in a circle around a central figure and divided into four sections by diagonal fruit trees. The landscape is treated in an abbreviated fashion with only the four fruit trees, a few small tufts of gray-green foliage, and shaded hillocks. Along each of three sides a mounted huntsman and another on foot attack a lion, lioness, leopards and a bear (fig. 5). The most dramatic episode unfolds along the east side: a tigress with her two cubs pursues a mounted hunter who, attempting to trap the tigress, holds another of her cubs in his hand (fig. 6). A hyena runs in front of the horseman toward the pomegranate tree. The hunters wear mantles of varying colors over their long-sleeved short tunics and knee-length breeches with laced boots and socks.

At the center of the room, a single hunter stands cross-legged with one hand on his waist and the other leaning on a spear whose end is driven into a supine boar (fig. 7). He wears a panther skin (a gray skin with black and white spots) over his head and body, dark gray-green breeches, and laced boots. In a circle around him are beasts; some are wounded (a doe and a bear), others flee from him (a stag and a hyena), and still others just graze, unaware of his presence (a hare, a bear cub). Several green-gray bushes are scattered around the central field.

A frame of two-strand guilloche between two rows of gray and white crowstep separates the hunt scene from a richly depicted foliate border set against a dark (black and charcoal gray) ground. Roughly at the midpoint of each side of the hunt panel are lush acanthus leaves that send offshoots in even convolutions. A variety of hunting boys, animals, and

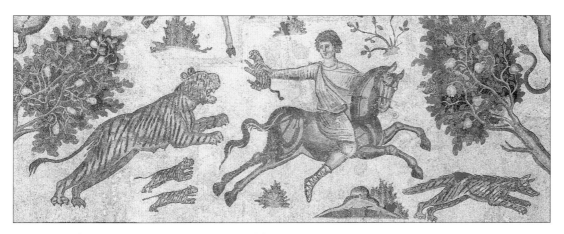

fig. 6. Detail of hunter on horseback luring a tigress with her own cub.

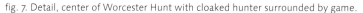

birds jump in and out of these unfurling vines. They face into the central panel. The young boy hunters are nude except for mantles tied around their necks; although wingless, they can be identified as *erotes*. The hunters are spearmen confronting spotted felines, and, thus serving as diminutive, even lighthearted foils to the adult hunters at the center. The ducks and other waterfowl and birds among the wild beasts enhance this playful quality (figs. 8, 9).

Much of the outer edge of the border was damaged and the north and east sides were especially fragmentary. While approximately one third of the excavated border was shipped with the central hunt panel to Worcester, many of the border tesserae were used to fill losses in the central panel.[5] The remaining border fragments were then put into storage and not examined again until 1995 when the Worcester Art Museum undertook the campaign to treat them and unite them with the hunt panel.[6]

Dating

The mosaics of the three rooms from this house were found almost at ground level, and excavations of the earlier structures below them yielded no significant archaeological data. Scholars have had to depend on stylistic criteria to date the mosaics. A chronological range is suggested by a closely related series of hunt mosaics produced in Antioch from the mid-fifth century until the devastating earthquake of 526. The first of this series is the Megalopsychia hunt from the Yakto complex in Daphne, dated by internal evidence to around 450–460.[7] Levi suggested that the other Antioch hunts, namely the House of Ktisis, the Dumbarton Oaks and the Worcester Hunts, were produced in the first quarter of the sixth century. Subsequent mosaic studies all opt for a closer dating of these hunts. Most recently, Janine Balty reviewed the Levi chronology for the Antioch mosaics and proposed that the hunt series should date 480–520.[8] Confirmation of a widespread regional taste for hunt

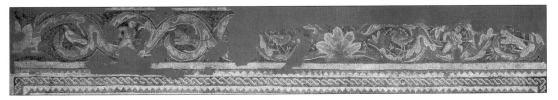

carpets comes from grand houses in Apamea Syria. The hunt mosaic from the Triclinos building, now in Brussels, covered a huge apsed hall located off the peristyle, probably for large receptions.[9]

Stylistically, the Worcester Hunt reflects innovations that appear in Antioch in the fifth century. It belongs to the group of "carpet" mosaics on which figurative elements are placed against a uniform background, here an imbricated cream-colored pattern, in order to provide a flexible system for decorating architectural spaces of various shapes and sizes.[10]

When the Worcester Hunt was first published, scholars pointed out what were then considered to be Persian aspects, namely the mounted huntsman attacking a lion with a bow and the style of dress with leggings.[11] However, archers appear in hunting scenes from other parts of the Mediterranean and the hunting outfit conforms to the rural dress represented on many of these mosaics.[12] There is no reason to suppose that this is a Persian-inflected hunt. However, the border of the closely related Dumbarton Oaks Hunt is comprised of rows of beribboned parrots. This is most certainly a Sasanian Persian motive that probably entered the Roman and early Byzantine ornamental repertory sometime in the fifth century or later.[13] Persian influence is reflected in several decorative motives in Antioch, but their dating is not precise enough to narrow the dates of the Antioch hunt mosaics.[14]

Meaning

The various segments of this grand hunt encourage viewing from many angles, both literally and metaphorically. The general tendency in Roman art of the period to move away from mythic narratives accounts in part for the way in which the Worcester Hunt displays related scenes in segments without any linear sequence. Liberated from the illusionistic restrictions of single-perspective scenes, late Roman mosaicists could mix elements in novel ways and create new compositions. In their attention to the detail of compositional units at the expense of the whole, and in their patterns of repeating elements, these hunt mosaics can be compared with the stylistic characteristics of late antique poetry.[15] The hunt mosaics produced in Antioch from the mid-fifth to the early sixth century provide an excellent case study for tracking stylistic and iconographic shifts in late antique art.

In the earliest of these mosaics, the Megalopsychia Hunt from the Yakto complex at Daphne, the hunters have Greek names (Hippolytos, Adonis, Meleager, etc.). The personification of Megalopsychia at the center distributing coins and the topographical border with civic scenes of Antioch and Daphne have been used to interpret this mosaic as commemorative of a staged hunt in the Antioch amphitheater.[16] But unlike the many North African mosaics that are exceptional for their documentary realism of staged wild-beast hunts (*venationes*), the Syrian hunts, with the possible exception of

fig. 9. Inhabited scroll border with hunters and birds (Worcester Art Museum, 1936.31).

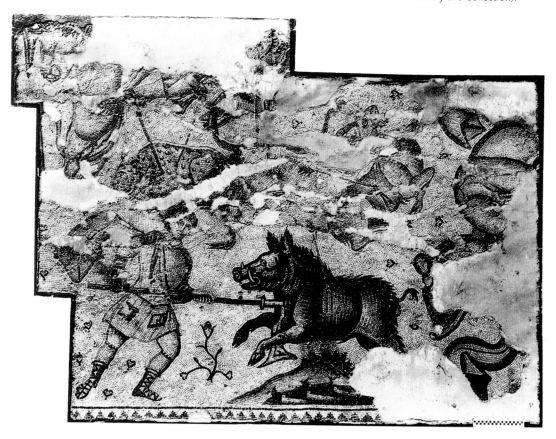

Megalopsychia, do not seem to be reporting actual events. The inclusion of various birds and grazing animals suggests another context and intent.

A strong hint comes from the central figures in the four Antioch hunts. The Dumbarton Oaks Hunt is so similar to the Worcester Hunt that it surely was done by the same hands (fig. 10).[17] Although much damaged, the Dumbarton Oaks Hunt contained a central figure—a female huntress who has shot her arrow and stands over a wounded leopard and who in her stance and dress follows the conventions for representing Artemis.[18]

Another Artemis stands over a slaughtered lion at the center of a hunting scene found in a peristyle of a house in Sarrîn in the province of Osrhoène, beyond the Euphrates.[19] Here the goddess is flanked by a wounded stag and an alert deer, as well as two hunters spearing a leopard and a wild boar. The next panel along the peristyle shows Meleager and Atlanta, clothed and resting in the woods. While there are strong echoes of the Antioch workshop, for example in the hunting vignettes and in the Nilotic motives of the border,

the technique and style of these mosaics are decidedly more provincial.[20] The Sarrîn mosaic, however, demonstrates that in the Syrian region hunting scenes were often connected to mythological figures like Artemis and Meleager.

In the Dumbarton Oaks and Sarrîn hunts, Artemis is a super-hunter by virtue of being at the center of the melee, surrounded by slaughtered beasts. The unidentified hunter of the Worcester Hunt stands calmly in the same way amidst slaughtered beasts and other prey. Might it merely be that the artist replaced Artemis with this male hunter? Like the brave Meleager in being depicted on foot and killing a boar, and unlike the idealized nude heroes of mythology, he wears a panther-skin cloak and hood. His dress sets him apart and makes it difficult to identify him. It is worth noting that in Sarrîn, Meleager who is typically shown nude, is dressed in late Roman hunting gear, including a pointed cap. The popularity of heroic hunters on Roman sarcophagi of an earlier age surely reflects the widespread reception of them as meaningful to the deceased and their families. In death as in life,

Roman patrons found heroic models, such as Meleager and Hippolytos, compelling. Perhaps the mosaic hunters are their late Roman descendants in the domestic realm, although the absence of specific dress and attributes makes their identification less certain.

Several scholars have noted that the Worcester hunter is an allegorical figure, a personification of valor and manly courage (fig. 11).[21] He embodies the good fortune of the successful hunter and provides a central focus for the hunting scenes scattered around him. Balty suggests that the impressively monumental and three-dimensional wild-beast hunters of the hunt pavement at Apamea communicate the *virtus* of the Roman Emperor and probably indicate that the apsed dining hall was part of an official residence.[22] In yet another Antioch hunt, a medallion of Ktisis, best understood here as a personification of "possessions," is set in the center of wild beasts hunting their prey, and numerous birds divided into four sections by fruit trees.[23] The similarity of the Syrian hunters and the animals and birds suggests that artists used the same supporting cast of repeating elements around different central figures. Ernst Kitzinger proposed that "the presence of a central figure or group always means a distinction of two levels, the human and the divine, strife and victory, effort and achievement."[24] This neatly sums up the balance achieved between the inner and outer circles of hunting episodes in the Worcester Hunt.

The tendency toward allegorization of myth and toward more concentrated images that reveal their meaning through associations seems to be operative in these hunt compositions.[25] The absence of any linear arrangement liberates the viewer and designer and opens up the potential for multiple layers of meaning. On a purely descriptive level, the Worcester Hunt presents a visual catalogue of hunting techniques, either practiced or known from popular texts such as the *Cynegetica*. This Greek manual of hunting, attributed to Oppian but thought to be authored by a third-century poet from Apamea, includes the beasts (boars, hyenas, tigers, bears, lions) represented in the Antioch hunts.[26] The Worcester Hunt might also represent the type

of scene described in Philostratos's (*Imagines* 1.28) detailed account of paintings in a Neapolitan collection. The painter, Philostratos writes, depicted the story of five hunters by repeating figures in different episodes separated by landmarks such as trees and a temple of Artemis. From his description it appears that a handsome youth was at the center of the scene: "The boy is still in the pool, in the attitude in which he threw his javelin. The others gaze at him in astonishment, as though he were a picture."[27] The Worcester hunter has speared his prey and seems also to invite the admiration of witnesses.

By mixing the real with the fantastical, the Antioch mosaic eludes a direct correspondence with specific events or texts.[28] Furthermore, the device of the central figure in the Antioch hunts casts the whole composition into an allegorical framework. The personification of Ktisis amidst hunting beasts provides the most direct message from those who commissioned the Antioch hunt mosaics. Dressed in expensive late-Roman fashion, the female bust of Ktisis represents "Possessions." The hunting scenes project an idealized image of the owner as member of a leisure class engaged in activities that imply ownership of estates, wild-beast parks (*theriotropheia*), hounds, horses, and hunting equipment. The popularity of hunting themes in the mosaic pavements,

textiles and silverware of late Roman art attests to a remarkably homogeneous taste and message, usually conveyed in the context of dining.[29] At Antioch the message is delivered through a single centralized image. The wild beasts can best be understood as generalized emblems of wealth: they are the "possessions" of the patrons of these mosaics.

In the House of the Worcester Hunt, the concept of possessions is reinforced through the related mosaic themes of the two smaller rooms. In room 2 the bust of Earth is surrounded by a carpet of large leaves superimposed with fruits, in room 3, wild beasts roam as if in a game park. The bounty of the harvest, the fruits of the fields, is celebrated in a rich tapestry design dominated by reds and greens. Together they reference the agricultural riches and the wooded game enclosures on estates and frame the grand hunt. The diverse beasts and various hunting techniques set out along the outer edges of the Worcester Hunt are part of this message of the owner to his guests; all three rooms display "Wealth" in related ways.[30]

Finally, a brief look at the remarkable silver vessels produced in the fourth and fifth centuries with scenes of hunting and its related myths makes clear that the theme was a *topos* of later Roman art and part of the ideology of the elite. The large display plates from the Kaiseraugst or Sevso Treasures (some are 70 cm in diameter and weigh close to 10 kg) are the precious equals of the monumental hunt floors. Several plates explore hunting themes through the myths of Meleager and Hippolytos.[31] Did the collectors of this silver associate themselves with the courage of these mythical hunters, or do they simply reflect a taste for hunting themes? In either case, a great deal of expense was involved in owning and displaying these metalworks, not to mention the servants needed to carry them in and out of reception rooms. The outdoor picnic featured in the very center of a fourth-century incised silver plate from the Sevso Treasure makes us aware that the passion for the hunt was rooted in reality. Above and below the picnic scene are registers depicting the capture of the game, its preparation for the feast, and tethered horses. Those dining in the room with the Worcester Hunt underfoot saw below them the same world that the Sevso plate celebrated, but at Antioch real guests were dining on real food. The world of the game parks was brought inside and made a natural setting for the picnics associated with hunting outings.

No doubt the late Roman audience in Antioch appreciated the Worcester Hunt on many levels. The ingenuity of its design allowed the composition to be all-over, both literally and figuratively. The hunting vignettes permitted multiple views but the imposition of an inner circle lent a structure. While allegory and myth were embedded in the central hunter, most obviously, the hunt taken together with the adjacent rooms celebrates the luxurious lifestyle of the owners and their guests.

PUBLISHED: *Antioch II, 200–202, no. 90, pl. 73; Morey 1938, 40–42, pl. 20; Levi 1947, 363–365, pl. 90a; Lavin 1963, 187–190, fig. 2; Çimok 2000, 296–297; Kondoleon 2000, 65–66, fig. 2, 159.*

1. Sectors 23/29-K/P, Levi 1947, II, pls 2 and 3.

2. The plan of Daphne as a summer resort is discussed in Downey 1963, 44.

3. For the challenges faced by the excavator and the lack of coherent floor plans, see Dobbins 2000, 51–52.

4. The Honolulu Academy of Art, inv. 4672; its border of fruit garlands with female busts is now at the Princeton University Art Museum.

5. Italian mosaic artists installing the Worcester Hunt in 1936/37 used the border tesserae to fill the losses in the central panel.

6. For more details about this process and the recent treatment and installation, see Artal-Isbrand's discussion of the Conservation of the Worcester Hunt in this volume.

7. In this case the evidence is provided by the inscriptions in the topographical border; the name attached to a bath building is Ardabur, a high-ranking official in Antioch in the 450s who lived there until the 460s; see Lassus, 1934, 132.

8. Balty 2001, 314–315; see also Lavin 1963, 190, note 20, who saw no stylistic discrepancies that justify Levi's time lag; Lavin recommended dates from 450–500 for the hunt series. Balty 1969, 32, disagreed with Lavin and felt that the Worcester Hunt was stylistically later than 500 and could be favorably compared with the treatment of themes on the Great Palace Floor in Constantinople. Recent archaeological data supports a date of 527–565 for the Great Place floor (Jobst 1997, 61). Dunbabin 1999, 180–184, esp. 180, describes the Worcester Hunt as "stylistically somewhat later" than the Megalopsychia Hunt.

9. Balty 1969.

10. For a comprehensive overview of this stylistic evolution toward all over mosaic designs, see Lavin 1963, esp. 189–195; see also Dunbabin 1978, 222–233.

11. For example, Morey 1938, 41.

12. For a similar hunting costumes and the use of an archer, see an early fifth-century hunt mosaic featuring the Offering of the Crane to Diana from Carthage (Dunbabin 1978, 57–58, pls. 35–36).

13. On beribboned parrots in Antioch, see Kondoleon 2000, 136–137, cat. 25.

14. For a discussion of Persian motifs in Antioch mosaics, see herein Gonosová on Rams' Head mosaic from Worcester, cat. 6.

15. Roberts 1989, 81–85.

16. This is the interpretation of several scholars, including Dunbabin 1978, 228, n. 145, citing those who offer this explanation, namely that the Megalopsychia Hunt commemorates an act of civic munificence. On the archaeological and textual evidence for venationes in Antioch, see Kondoleon 2000, 159–160, cat. 43.

17. The Dumbarton Oaks Hunt differs in that it uses the device of scattered roses to reinforce the effect of an allover design. It came from a building on Mount Stauris; see Levi 1947, 358–359, pls. 85d and 86a, and Campbell 1988, 70, no. IV A 31.

18. She resembles the statue of Artemis in a hunting scene in the reception mosaic of the Constantinian Villa in Antioch, Levi 1947, pl. 56a.

19. The mosaic is in the Aleppo Museum. See Balty 1990, 3–5, 74–75, pl. 2, 1. As there is no archaeological evidence for dating, the mosaic is dated on the basis of its style to the late fifth or early sixth century.

20. I disagree with Balty's suggestion that an itinerant workshop from Antioch might have produced these mosaics. The Sarrîn mosaics are executed in a very flat and linear style that is not paralleled in any of the extant mosaics of Antioch. See Balty 1990, 84–85.

21. See especially the discussion in Kitzinger 1951, 108–118, esp. 114, n. 138.

22. The hunt mosaic was found in the Triclinos building, see Balty 1969, 35.

23. Much of the pavement was damaged and only a small fragment was lifted. From the House of Ktisis found west of the circus of Antioch, see Levi 1947, 357–358, fig. 147.

24. Kitzinger 1951, 117.

25. This process is insightfully explained in terms of developments in mythological sarcophagi in Brilliant 1984, esp. 163–165.

26. Anderson 1985, 135.

27. Translation taken from Anderson 1985, 136.

28. In contrast, the North African hunts, whether they depict staged hunts in the amphitheater or the hunts on country estates, are quite realistic in their details. One example provides an interesting comparison because it too is organized around a central theme, here a shrine to Artemis and Apollo. It is a late fourth-century mosaic from the Khéreddine district of Carthage in which rural hunters ride off from a walled estate in the top register, and in the other registers hunters and archers on horseback spear felines. A group of hunters makes a pious offering of a slaughtered crane to invoke divine assistance for the hunt from the two deities represented as statues in the shrine; see Dunbabin 1978, 57–58, pls. 35–37.

29. On the depiction of these themes in various media, for outdoor dining and hunters' picnics, see Dunbabin 2003, 141–150; for mosaics in dining rooms throughout the Empire, see Ellis 1991, 124–127. Both authors discuss the shifting role of hunt scenes and their increased importance to the self-image of wealthy Romans.

30. An earlier mosaic from Antioch directly depicts wealth in the depiction of the personification *Chresis* or "acquired wealth;" see Levi 1947, 278, pl. 14a.

31. For a recent discussion of these silver plates and their iconography, see Leader-Newby 2004, 130–141.

9.

Mosaic with Peacocks

Anna Gonosová

From the House of the Bird Rinceau: upper level

Site: **Daphne (DH 28-O/P)**

Date: **ca. 526–540 C.E.**

Material: **Stone tesserae embedded in lime mortar**

Dimensions: **116.8 x 381 cm**

Worcester Art Museum, Antioch Excavation, 1936.23

The Peacock Mosaic in the Worcester Art Museum is part of the border of a large floor (Room 1) uncovered in Daphne at the end of the 1934 campaign; the subsequent discovery of a second floor (Room 2) and some wall lines confirmed the existence of a house,[1] while a similar but not identical set of rooms at a lower level revealed the presence of an earlier structure.[2] A coin of Emperor Justin (518–527) embedded below the geometric floor of Room 2 places the upper-level mosaics to the period between the 526 and 528 earthquakes and the Persian sack of Antioch in 540.[3] The archaeologists named the site for its mosaic floor, "House of the Bird Rinceau."

Room 1 of the upper level was large, more than 700 square feet (about 32 × 23 ft./9.50 × 6.50 m),[4] and completely covered with a mosaic floor (fig. 1). Although the mosaic had substantial root damage and the excavators preserved only the border,[5] its overall appearance can be easily reconstructed (fig. 2).[6] It consisted of an irregular white surround accented with widely spaced lozenge motifs and a white field with a scale pattern and rosebuds framed by a wide border composed of multiple bands: a simple wave motif on the outside, an inhabited vine scroll in the middle, and a folded ribbon design on the inside.

The colorful border (between 44 and 46 in. wide) includes a narrow wave band in purple-brown and yellow, an old and ubiquitous decorative motif,[7] and a much wider vine scroll band

fig. 1. Daphne. The Mosaic of the Bird Rinceau; 1934 excavation photograph. Worcester panel is outlined in red (Antioch Expedition Archives).

fig. 2. Daphne. The Mosaic of the Bird Rinceau. Computer reconstruction.
1. Worcester Art Museum
2, 3. Baltimore Museum of Art
4. St. Louis Art Museum
5. Princeton Art Museum
6. Paris, Musée du Louvre

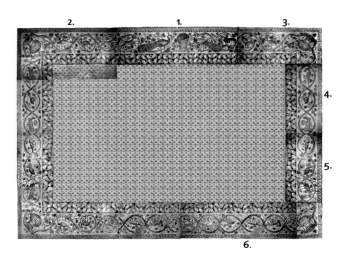

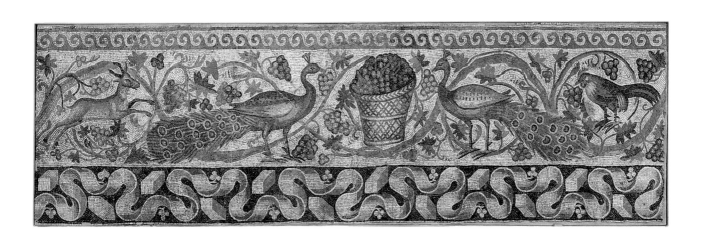

fig. 3. Daphne. Mosaic of the Bird Rinceau. The Baltimore Museum of Art panel.

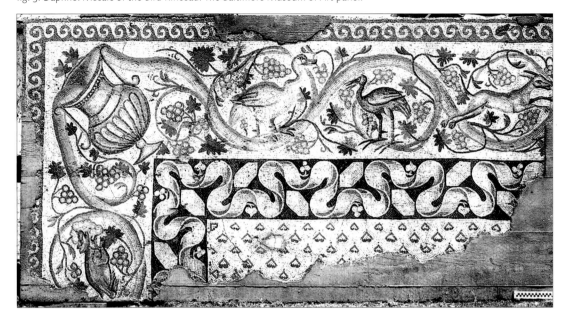

on a white ground. The vine stems, laden with grapes and leaves, issue from four corner metal vases, two stems from each growing into the adjacent sides of the mosaic. Two short and one long side have the stems overlapping, intertwining and forming ovoid fields as they grow in opposite directions and ending in curved loops with leaves and grape bunches. The other long side has a modified design: the loops formed by single vine stems end by curling around a slightly off-center composition of two peacocks facing a basket.[8] The ovoid frames of the scroll are filled with a variety of birds and animals; in the Worcester panel, a horned quadruped, probably a deer, fills the loop to the left of the peacocks, while to the right a colorful rooster pecks on grapes.

Except for the corner vases, the peacocks and the basket are the largest motifs in the vine scroll band. The peacocks, separated by a light brown woven basket overflowing with grapes, are nearly identical as they pose in profile, pecking on the grapes of the vines curling around them. They are boldly represented with vivid green crested heads, necks and bodies that contrast with the gold, yellow and purple of their neatly folded wings and tails. The tails are set in purple and brown tesserae, individual feathers indicated by spines ending in orange, brown, and olive-green eyes.

The vine scroll band is laid in a very effective manner. The nearly white ground of regular tesserae provides an opaque solid background for the vine rinceau, which seems to rise above it. The changing

width and other irregularities of the stems give the vine a naturalistic appearance that is enhanced by the varied green of the foliage and differing hues and modeling of the grape bunches. The interlaced stems create three-dimensional frames around the bird and animal fillers. The spatial effect is even stronger in the Worcester peacock panel: here the basket seems to occupy the middle ground emphasized by the encircling vine stems, while the peacocks are placed distinctly in the foreground. Like the scroll, the peacocks and other fillers are rendered naturalistically with great richness of color and attention to volume and modeling.

The vine scroll appeared as a decorative motif in the Late Hellenistic period and became very popular in Roman imperial art in general, both as a border and a surface design.[9] The Roman versions are profusely inhabited, first with birds, later with animals and genre motifs as well, a trend that continued throughout the early Byzantine period.[10] In the excavated Antiochene mosaics the inhabited vine scroll is more common among the later floors. Only five such scrolls have been found at Antioch: as a luxurious border of the Judgment of Paris panel in the second-century Atrium House;[11] in an elegant scroll in the fourth-century Constantinian Villa;[12] and in three simple, more stylized later versions (the borders in the late fifth-century Church in Seleucia near Antioch,[13] in the early sixth-century House of Ktisis[14] and in the House of the Worcester Hunt).[15]

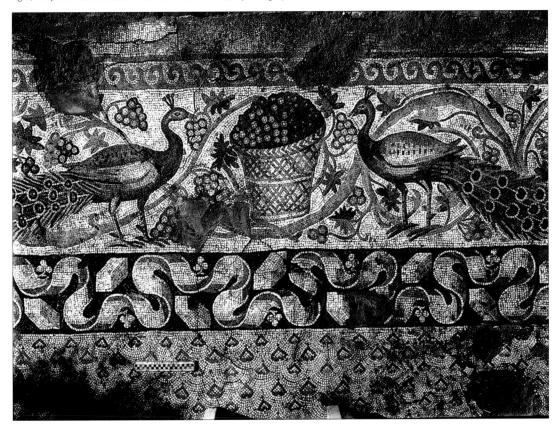

The dark ground of the wide inner folded-ribbon band creates a spatial void appropriate for the convoluted and foreshortened turns of the ribbon outlined in white.[16] The curling pattern of the ribbon is controlled by the foreshortened light-brown and yellow solids projecting forward in the interstices. In addition, the inner loops contain light-colored trefoils and ivy leaves. The color of the ribbon changes from red to brown to yellow and blue-gray; in the Worcester panel gold-yellow, brown-red, and gray-blue were used. The colors change gradually as if affected by light, stressing the three-dimensionality of the motif. Furthermore, the colors of the upper side of the ribbon are more saturated, varying from darker to light and off-white, while the reverse has more muted olive-greens and beiges. The lighter areas radiate sheen and highlights, the darker enhance the coloristic richness and three-dimensionality. The folded ribbon motif is a late Roman and early Byzantine variant of the undulating and twisted ribbon that appears in Roman Syria by the middle of the fifth century[17] and is found frequently in sixth- and seventh-century floors in Palestine and Transjordan.[18] The folded ribbon in the House of the Bird Rinceau, the only known example from Antioch, is exceptionally fine

in its spatial and coloristic complexity and represents one of the last Byzantine versions of the motif.[19]

In contrast to the elaborateness of the border, the scale and rosebud pattern of the main field is simple.[20] As preserved in the Baltimore Museum of Art panel (fig. 3), the scales were small, necessitating a dense rosebud covering and giving the floor a carpet-like appearance. The rosebud patterns began appearing on early fifth-century floors and were quite popular all through the sixth century, especially in the Eastern Mediterranean, including Antioch.[21]

In its complete state, the floor of Room 1 offered an interesting contrast between a firmly grounded main field, its solidity reaffirmed by the scale and rosebud pattern, and a spatially ambiguous frame. This visual interplay of designs could have drawn viewers' attention to the anomaly of the confronting peacocks and the basket, which introduced a focal point in the otherwise even flow of the border design. The distinctness with which the peacock composition is both integrated into the vine scroll border yet succeeds as a discrete visual entity opens the possibility that more was intended here than a decorative diversion (fig. 4).

In the Hellenistic and Roman east, the vine scroll was used either in the context of the Dionysiac myth[22] or as a decorative motif that might or might not have carried a general propitious meaning of abundance.[23] With the advent of Christianity and guided by scriptural passages and exegetical writings, the vine theme acquired a Christian meaning that eventually found its way first into funerary and later into Christian art in general, including floor mosaics.[24] As a symbolically potent but in principle neutral motif, the inhabited vine scroll, both as a field design and as a border, attained considerable popularity in the fifth and sixth centuries in both religious and domestic contexts. The repertory of fillers expanded beyond the customary — but random—birds, animals, flowers and hunting *erotes* to include contemporizing genre scenes and more coherent selections of living creatures.[25] If these scrolls once had more specific meanings, the lack of corroborative evidence makes them unknown today.[26] The three early sixth-century examples, including the House of the Bird Rinceau from Antioch, serve as evidence for the rising popularity of this decorative and thematic motif in the Eastern Mediterranean in general.[27]

Representations of peacocks carried many meanings in Greco-Roman and early Christian art.[28] In classical myth, peacocks were sacred birds of Hera/Juno[29] and a counterpart to the eagle of Zeus/Jupiter. Ever since they appeared in the Mediterranean centuries earlier, however, peacocks were raised for the beauty of their plumage as living garden ornaments, a custom indirectly confirmed by their constant presence in the aviaries portrayed in Antioch mosaics.[30] They became symbols of immortality in the Roman west, figuring frequently in Roman funerary art because of the resemblance of their open tails to the starry heavens, the abode of the dead, and because the autumnal shedding and spring regrowth of their tail feathers evoked rebirth and renewal.[31] This meaning also carried over into the Christian funerary art.[32] In the Hellenistic and Roman east, it is their beauty that was much commented upon in classical literature and other writings still read in the fifth and sixth centuries, and praised by Byzantine writers as the beauty of

the Creation.[33] Dionysios of Philadelphia's description of the peacock, surviving in a fifth-century C.E. version, exemplifies these sentiments:

"The peacock admires its own beauty. When someone calls it beautiful, it immediately raises and displays the brilliant colors of its feathers mingled with gold, like a field of flowers, spreading them into a circle with its eyes in an array and shining from its tail like stars. When someone looks at it and compliments it on its beauty, it straightaway takes pride also in its voice. If someone makes fun of it, it conceals its tail as if hated to be scorned. This was the one [Argos] who guarded Io when Hera was angry with her. Hermes killed him, and after his death the earth brought forth a bird that had the marks of his former eyes."[34]

The Antiochene floors of the fifth and sixth centuries abound in personifications representing moral and propitious concepts and themes.[35] The Worcester peacocks and the grape-laden basket, shown within yet apart from the vine scroll, could have also been intended to communicate such a salutatory message of beauty and abundance. The specific composition of confronting peacocks— and other creatures as well—was a common way of providing visual accents and guides in decorative programs, as many examples in all types of Roman and early Byzantine art demonstrate.[36] This elaboration of the border could had also been dictated by an upper wall design no longer extant; it may have related to the function of the room, no longer known, or it may be another instance of the Antiochene fondness for these birds, two of more than twenty peacock representations found either in aviary compositions or as pattern fillers in second-through sixth-century floors.[37]

PUBLISHED: *Antioch II 1938, 186–87; Levi 1947, 366, pl. 181 d; Çimok 2000, 306–307; Kondoleon 2000, 208–210, cat. no. 96.*

1. Levi 1947, 257, fig. 96, pl. 92b. Room 2 had a mosaic with a grid of smaller and larger squares framed by a border of overlapping circles (Décor 2002, vol. 1, 224–225, pl. 147a and 372–373, pl. 238b).

2. Levi 1947, 257–258, figs. 96–97, pl. 108a. Both rooms had geometric floors, a variant of a grid of bands with squares over the intersections and squares inside the cross compartments. A central panel of two T-meander components decorated one (Décor 2002, vol. 1, 222–223, pl. 146a-b and 76–77, pl. 34b variant), and a field of polychrome overlapping circles the other (Décor 2002, vol. 1, 374–375, pl. 239c).

3. Coin C 3771. Levi 1947, 257.

4. The dimensions of Room 1 are estimated from the size of the border, measurements from Levi (Levi 1947, pl. 91) and an excavation photograph, since in the excavation reports the measurements for the mosaic vary: 9 × 7.50 m in the field diary for September 22, 1934; 9 × 6.50 m in the Worcester Museum of Art Annual Report for 1934, 39; 9 × 14 m in Antioch II 1938, 186, no. 55. The latter may refer to the overall dimensions of the House of the Bird Rinceau.

5. The border was divided into six segments given to the following museums: Baltimore Museum of Art (two panels), Worcester Art Museum, St. Louis Museum of Art, Princeton University Art Museum, and the Musée du Louvre.

6. Levi 1947, pl. 91; Çimok 2000, 305; Kondoleon 2000, 209, fig. 1.

7. Décor 2002, vol. 1, 156, pl. 101b.

8. The right half of the border is shorter and the design motifs more compact, including a slightly shorter peacock.

9. Levi 1947, 508–516; Toynbee and Ward-Perkins 1950; Kondoleon 1994, 236–248.

10. Dauphin 1987.

11. Levi 1947, 16–21, pl. 1b; Baratte 1978, 87–92, fig. 84; Kondoleon 2000, 172, cat. no. 58.

12. Room 4. Levi 1947, 226, fig. 87, pls. 61d, 143 b-d.

13. Antioch III 1941, 42–44, 218–219, no. 180, pl. 92; Levi 1947, 359–360, pls. 87–89; Donceel-Voûte 1988, 290–299.

14. Room 1. Levi 1947, 357–358, fig. 147; Campbell 1988, 5–6, no. IV A 1, pl. 2.

15. Room 2 with the Ge and leaf semis design. This vine scroll appears particularly close to the one in the House of the Bird Rinceau. Levi 1947, 363, 365, fig. 150, pl. 90c.

16. Levi's folded ribbon description of this motif is more accurate (Levi 1947, 457, fig. 174,15) than the 'crinkled' ribbon term used in Décor 2002, vol. 1, 116, pl. 66a-b.

17. Levi 1947, 457, fig. 174, 11–15. A simpler, crinkled version of the motif was used in the nave decoration in the Church of the Holy Martyrs at Tayabat al-Imam near Hama, dated by an inscription to 447. Zaqzuq and Piccirillo 1999, 450, pl. 3.

18. E.g., in St. John's in Gerasa/Jerash, from 531 (Levi 1947, 457; Piccirillo 1993, 288–289, figs. 506 and 541); around the Calendar mosaic from a tomb in el-Hammam, Beth Shean/Beisan, ca. mid-sixth century (Ovadiah and Ovadiah 1987, 30–31, no. 27, pl. 25.2); in the crypt of St. Elianus in Madaba, 595–596 (Piccirillo 1993, 120, fig. 124) and in the Theotokos Chapel in the Moses Memorial at Siyagha, 603–609 (Piccirillo 1993, 151, figs. 198–199).

19. A very similar version of the motif was used around the central panel of the bath hall in the Umayyad castle at Khirbat al-Mafjar in Transjordan, ca. 724–743: Creswell and Allan 1989, fig. 112.

20. Décor 2002, vol. 1, 340–341, pl. 219c.

21. Levi 1947, 436–446; Gonosová 1987; Dunbabin 1999, 178–179. An outstanding example of this type of floor design is the nearly contemporary Phoenix mosaic, also from Daphne; see cat. 6, fig. 4, 226, n. 7.

22. E.g., in two third-century mosaics, the Lykurgos panel in Room 3 of the House of the Boat of Psyches from Daphne (Levi 1947, 178–179, pls. 37a, 38a; Kondoleon 2000, 72, fig. 5), and the Ambrosia panel from Tarsus in Cilicia (Budde 1972, 122–123, fig. 22, pls. 118, 146–148); also around the Dionysos and Ariadne roundel on a vault mosaic in a house in Ephesos, ca. 400 (Jobst 1977, 65–67, pls. 110, 112–121; Dunbabin 1999, 249, fig. 266).

23. To the Antiochene mosaics already listed above (notes 11 and 12) can be added a fine inhabited vine scroll border of the Dionysos and Ariadne mosaic from Shahba-Philippopolis, also in Syria, ca. 325–350. Balty 1977, 50–57, nos. 20–23; Balty 1995, 144–145, pl. 11.1.

24. Leonardi 1947; Maguire 1987, 9–10.

25. Dauphin 1987.

26. Dauphin 1978.

27. Notes 14 and 15.

28. Levi 1947, 130; Toynbee 1973, 250–253; Maguire 1987, 39–40; Kondoleon 1994, 109–117; still useful: Lother 1929.

29. As in Ovid, *Metamorphoses I*, 622–723; also in the early sixth century *Dionysiaca XII*, 70–71 of Nonnos of Panopolis in Egypt.

30. Toynbee 1973, 250. This theme occurs at least six times among the excavated Antiochene floors. The Mosaic of the Birds and the Kantharos from the lower level of the Yakto Complex in Daphne, second century (Levi 1947, 90–91, pl. 15a; Baratte 1978, 126–128, no. 51; Çimok 2000, 96), and the Mosaic with Birds from Feleet Village, ca. 500 (Levi 1947, 348, 180d; Campbell 1988, 32–33, IV A 13, pl. 93) illustrate the point. The pair of peacocks in the latter look similar to those in the House of the Bird Rinceau border.

31. Toynbee 1973, 252. Lother 1929.

32. Lother 1929; Maguire 1987, 39.

33. Maguire 1987, 39, with references to the writings of Gregory of Nazianzus (d. ca. 390) and George of Pisidia (d. ca. 631–634)

34. Papathomopoulos 1976, 11–12. I thank Jonathan Harrington for the translation of the peacock passage and for the reference to Papathomopoulos's edition. The first-century C.E. treatise on the characteristics of birds, the *Ornithiaka* by Dionysios of Philadelphia, survives only in a shortened version written for an imperial patron in the fifth century (Kádár 1978, 77–81). This version of the treatise was also included in a luxury manuscript made for a Byzantine princess Juliana Anikia around 512–513 in Constantinople, known as the *Vienna Dioskurides*, which also contains a full-page image of a strutting peacock (Mazal 1998, 3–16, fol. 1v).

35. The Mosaic of Ktisis, cat. 5.

36. Donceel-Voûte 1988, 478–479.

37. From the frequency of the peacock representations, the peacock was one of the favorite decorative (?) or iconographic (?) motifs among the Antiochene mosaicists and patrons. It was used five times as a filler motif in the third-century House of the Boat of Psyches, also from Daphne, alone (Rooms 1–3, 8–9; Antioch II 1938, 184–186, nos. 46–48, 53–54, pls. 34–36, 50; Kondoleon 2000, 72, fig. 5).

10.

Tyche of Antioch

Florent Heintz

Formerly Possenbacher Collection, Germany

Date: **2nd century C.E.**

Material: **Bronze, gold**

Dimensions: **H. 17.1 cm, Diam. 10.5 cm**

Worcester Art Museum, Purchased with funds from the Stoddard Acquisition Fund, 1999.7

The goddess personifying and guarding the fortune of Antioch sits on a flat rocky outcrop with her legs crossed, her head tilted, and nesting her left hand on the projecting edge of the rock. Her missing right hand originally held a sheaf of wheat. She wears *chiton* and *himation*, high-soled sandals (*kothurnoi*), and a tall and flaring mural crown with four projecting towers. The figure sits on what appears to be its original circular base with convex moldings (X-ray fluorescence (XRF) spectra of areas analyzed on the base and the figure correspond closely).[1] Patches of copper corrosion on the base suggest that Tyche was originally resting her right foot on the shoulder of a separately cast and now lost youthful nude male figure, the river-god Orontes, shown half submerged and swimming toward the left of the goddess with his left arm raised.[2] The quality of execution is high, as evidenced in the gold-inlaid irises of the eyes and the extent of post-casting coldwork, including skillful chasing of the drapery to enhance the modeling, and fine detailing through incisions, such as the crenellations and arched double-door gate engraved on the crown's front tower.

The group formed by the present figurine and her missing companion is a small-scale replica approximating the famous early Hellenistic statuary group carved by Eutychides of Sikyon shortly after Antioch's foundation ca. 300 B.C.E. (Pausanias 6.2.7). The Tyche by Eutychides had its own temple structure "where public ritual in honor of the city's Tyche would take place."[3] Eutychides' work, therefore, functioned not merely as a personification but also and more importantly as the cult-statue of a goddess which, in addition to presiding over its destiny, protected and nurtured the city of Antioch. The mural crown alluded to the actual city walls of Antioch, and it also symbolized the deity's supernatural powers of protection. The sheaf of wheat can be read as referring to the *polis'* surrounding countryside or *chora*, which fed the city with its rich alluvial soil; for a Greek it was also the attribute of Demeter, the goddess responsible for the rebirth of nature every year. Similarly, the male figure swimming by Tyche's feet was more than a geographically correct embodiment of the river Orontes

(which, from the ancient city's perspective, flows left toward the sea) or an allusion to the city's reliance on river commerce; it also represented a mighty and benevolent god, one worshipped in his own right alongside Tyche.

The present statuette belongs to a series of closely related bronze statuettes, most of which were found outside Antioch and several beyond the borders of the ancient Roman province of Syria.[4] Just like the original statue on which it is based, it acquires its full meaning only when seen as a religious artifact. As a cult object it is likely to have graced the *lararium* or household shrine of a private home in the Roman period. How the cult of the Tyche of Antioch could have spread beyond the walls of her own city is no mystery: as the goddess directing the destinies of one of the eastern Empire's two largest and most prosperous cities (the other being Alexandria), she was just as powerful a deity as the Tyche of Alexander the Great, who also received a cult in the Hellenistic and Roman periods because Alexander himself was seen as having been extraordinarily favored by good fortune.[5]

In spite of its site-specific attributes, such as the rocky outcrop representing the Silpios mountain towering above the city, the Antiochene version of Tyche served as a model for the city goddesses of hundreds of other cities across the Hellenistic and Roman world, thus becoming "the archetypal representation of a city's protector."[6] Syncretism, an essential feature of pagan cults in the imperial period, made Tyche the perfect catalyst for all kinds of divine identifications and combinations.

Eutychides' Tyche, seen in profile and facing right, appears for the first time on Antioch's coinage on the silver issues of King Tigranes II of Armenia, who ruled over Syria between 83 and 69 B.C.E. In the late first century B.C.E. Augustus uses the same type for his own silver coins (see pgs. 285, 286).[7] In the late Hellenistic and early imperial period, Tyche is commonly abbreviated on the city's copper coins by showing only her crowned head facing right. In the centuries that follow, Eutychides' complete group appears more and more frequently on the city's copper coins in several variants, some of them significant. In the third century C.E., for instance,

the statue is normally shown facing the viewer from under a *baldacchino* or temple-like structure made of a conical roof supported by Corinthian columns. Presumably this late type represents a structure built much earlier to house the deity and her cult, maybe even as early as the time of the city's foundation.[8] Alexander Severus (222–235 C.E.), on the other hand, chooses to show Tyche flanked on one side by Fortuna holding a cornucopia, and on the other side by a man, probably Seleukos Nikator, wearing a cuirass and crowning her with a laurel wreath, a composition also found on several gems.[9] It is unclear whether these ancillary features are new additions commemorated by the coin issue or whether they already existed but had never been shown before.

PUBLISHED: *Manchester 1994; Kondoleon 2000, 120, no. 8.*

1. For specifics of the instrumentation see the introduction to Small Finds preceding cat. 27. XRF analyses were carried out directly on the object with the X-ray beam directed at small areas that were cleaned of corrosion to expose the underlying metal. The figure and base are presently independent. No evidence of mechanical attachment was visible on the Tyche or the base, suggesting that any original join was achieved with solder.

2. For a complete example of this group and an isolated figure of Orontes see Kondoleon 2000, nos. 6 and 7.

3. S. Takacs, in Kondoleon 2000, 198.

4. See Dohrn 1960, pls. 14–19, and Balty 1981, 843.

5. On the "magical quality" of images of Tyche and Alexander see Pollit 1986, 3.

6. Broucke 1994, 40.

7. See Metcalf in Kondoleon 2000, 107–108.

8. Thus, according to Malalas (*Chron.* P. 201, 5–8), Seleukos had a statue of the Tyche of Antigonia set up in Antioch under a similar *tetrakionion*, or four-columned baldacchino.

9. Balty 1981, 845–846, nos. 33–63, and 847–849, nos. 105–125.

11.

Statue of Hygieia

Cornelius Vermeule

From Bath F

Site: **Antioch (13-R)**

Date: **2nd century C.E.**

Material: **Marble with gilding**

Dimensions: **187.0 × 73.0 × 46.7 cm**

Worcester Art Museum, Antioch
Excavation, 1936.36

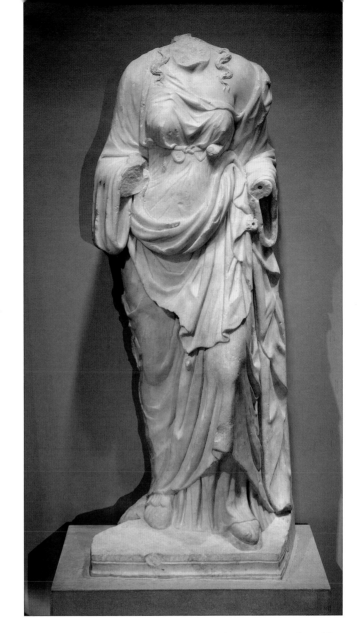

The god of medicine Asklepios (Aesculapius in Latin) and his majestic daughter Hygieia (Salus) were found in a large bath complex at Antioch. Only the plinth, feet, and the bottom of the serpent-entwined staff, on a small *omphalos*, of Asklepios survive (cat. 12), while Hygieia lacks head, arms, most of the snake rising up her right side onto her right arm, and the dish (*phiale, patera*), out of which the sacred serpent was feeding, in her extended left hand.

Both statues were carved at the height of peace and prosperity in the Roman empire around 150 C.E. The differing plinths have led scholars to observe that the statues are not a pair. They were probably carved in different workshops along the coast of Asia Minor, imported in a finished or partly carved state, and perhaps even brought to Bath F, from elsewhere in the metropolis of Antioch at a later date. Towards the middle of the sixth century C.E., a Christian basilica was built through the center of Bath F. Asklepios, so clearly pagan, may have been abandoned and cut up, in the old bath area, while saintly Hygieia–Salus was reinstalled in or beside the basilica. Such transformations were frequent in the eastern Mediterranean at the outset of the Byzantine Christian era.

fig. 2. *In situ* photograph of Hygieia in Bath F (Antioch Expedition Archives).

Hygieia in her *chiton* and rich *himation*, with its triangular overfold across her lower body, is a luxurious tour de force of carving, heightened by the gilding of the goddess' hair (fig. 3) and possibly other details of the statue such as footwear and jewelry. We are very fortunate that parts of the gilding as well as the red-colored preparatory ground layer are extant, since it is extremely unusual for these to survive on ancient marble.[1] Adhesives and binders originally used to attach these decorative elements to the stone surface typically deteriorate in a wet burial environment, leading to the detachment of gilding in the ground or right after excavation when the archaeological find is washed. Few examples of gilded stone statuary have survived. The red coloration of the ground may have lent a warm, rich color to the gold, analogous to the function of red bole on later wood sculpture and panel painting. Traces of red color are occasionally visible in the hair, jewelry and footwear of classical marble sculpture, suggesting that these parts were originally gilded.[2] On the feet of Asklepios (cat. 12) this red coloration is visible next to the sandals, possibly an indication that they too were gilded.

The ultimate sources of this statue type are draped figures of divine nature in the kingdom of Pergamon in the second century B.C.E. This Hygieia is related to less striking figures from Roman sites elsewhere in the Greek imperial world and in North Africa, but the figure is no copy. She is as truly original as the pedimental figures of the Parthenon in the fifth century B.C.E. or the statues of the Mausoleum at Halikarnassos around 350 B.C.E. Pergamon's source for this Hygieia is confirmed by her appearance beside an Asklepios like the Antioch statue on a big, commemorative bronze coin of the former city struck under the Emperor Marcus Aurelius (175 C.E.). Hygieia is far and away the most impressive freestanding statue found during the excavations at Antioch.

What is perhaps most impressive is the handling of drapery, the *himation* or cloak in front, especially when seen from the left side. Here the zig-zag folds are large and broad and imaginative in the way they fall down toward the heavy, molded plinth. On the side opposite, the statue's own right side, the *himation* is pulled much more tightly and more horizontally from across the back to the contours of Hygieia's body. It is interesting to notice

Arts of Antioch

the very different quality of carving around the abdomen of the statue: it is shallow, stylized and looks unfinished. The likely reason for this is that this entire area was neither visible nor accessible to the sculptor's hand behind Hygieia's outstretched arm holding the *patera*. A similar unfinished appearance of the carved surface is apparent on the back side of the statue, again an angle that was not to be seen due to the statue's intended placement in a niche. The molding of the plinth stops halfway back on the left side, and clearly did so, before damage, on the right side as well. This was customary for a statue carved to be placed in an architectural setting, but it would not discourage viewers from admiring this masterpiece from angles other than strict frontality. The coiling of the sacred snake against the complex movement of draperies turns this statue into a masterpiece of motion most worthy of the traditions of the Hellenistic sculptural school of Pergamon around 150 B.C.E.

Up against her niche in Bath F (hence her columnar, pillar-like back), Hygieia was an impressive symbol of the health citizens of Antioch sought when they took the waters. Coins from all over the Roman imperial world tell us how popular were Hygieia and Asklepios, in cities large (like Antioch) and small, in health and hospital complexes everywhere.

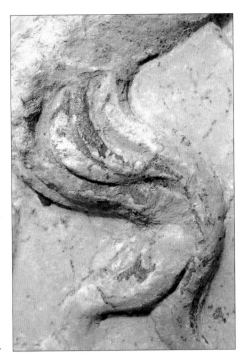
fig. 3. Detail of gilding on hair of Hygieia.

PUBLISHED: *Antioch III 1941, 116–117, no. 241, pl. 1; Vermeule 2000, 90–92.*

1. Artal-Isbrand et al., 2002.
2. Reutersward 1960; Strong and Brown 1976, 204.

12.

Feet of Asklepios

Roman copy (2nd century C.E.) of a Hellenistic type

Provenance: **Antioch 13-R, Bath F**

Material: **marble**

Dimensions: **Foot with *omphalos*, 40.64 × 47.63 × 48.26 cm; foot with snake, 28.56 × 44.45 × 32.39 cm.**

Condition: **Fragmentary: only the feet from above the ankles down, part of the *omphalos*, and the base of a staff with a snake's tail are extant. There is a large dowel hole in the upper part of the *omphalos*, perhaps an ancient repair. There is much surface wear, particularly on the toes of the left foot.**

Worcester Art Museum, Antioch Excavation, 1939.80.1–.2

These sandaled feet belonged to a statue of Asklepios, the Greek and later Roman god of healing. They are clearly identified by his attributes: the curving snake's tail near the proper right foot and the *omphalos* near the left one. The footwear is a type of strapped sandal known as *krepides*.[1] In this example the toes are exposed and the laces are covered with a leather tongue (*lingula*) ending in three points. The weight-bearing left foot is pointed forward, while the disengaged right foot is turned slightly out. The complete statue would have shown the god wearing a loosely draped *himation* that revealed his chest, his left arm bent with hand at hip and the staff with the serpent winding up it under his right arm. The weight on the left foot and the bent right knee seem to indicate he was stepping forward or resting his weight on the staff.

Although very little of this statue remains, we can compare it to a well-established corpus of other Asklepios statues, most of which are Roman copies based on one or more Greek originals. Roman statues of Asklepios in the Vatican and Naples[2] wear similar shoes, but the most striking comparison is with a figure of Asklepios from the Altar to Artemis at Magnesia-on-the-Maeander. This Hellenistic statue, now at the Pergamon Museum in Berlin, shows the presence of the *krepides* shoe type in Asia Minor during the late Greek/early Roman period.[3]

The Worcester Museum's Asklepios feet were discovered next to a more complete statue of the god's daughter, Hygieia (cat. 11), also known as a healing deity. Both statues were found in a sixth-century bath complex, though this was not their original setting.[4] However, ancient writers concur that both Hygieia and Asklepios were associated with water as part of the healing aspect of their natures, and so an original location in a bath would not be surprising.[5] ALW

PUBLISHED: *Antioch III 1941, 117, no. 242, pl. 11; Vermeule 2000, 92, fig. 1.*

1. Morrow 1985, 116–120.

2. Vatican, Braccio Nuovo 2288; Naples, Mus. Naz. 6360.

3. Humann 1904, 176, no. 1, pl. VI, right. The altar and frieze have been dated to between 221 and 203 B.C.E. Özgan 1982, 209.

4. Differences in their plinths indicate they were not originally meant as a pair. Antioch III 1941, 8, 117.

5. Norman 1986, 429.

13.

Statue of a Young Boy

2nd century C.E.

Provenance: **House of Menander, Daphne**

Material: **marble**

Dimensions: **67.0 × 30.5 × 18.0 cm**

Condition: **Fragmentary: the left arm is missing from just below the shoulder, the left leg is entirely gone, and the right leg is missing from below the knee. There is an area of loss of about 4 cm. in diameter on the right forearm and another smaller one near the navel. This damage has burial incrustations, indicating that the breaks are ancient. In numerous areas on the proper left side of the body there are more recent losses and fractures, perhaps caused during excavation.**

Worcester Art Museum, Antioch Excavation, 1940.9

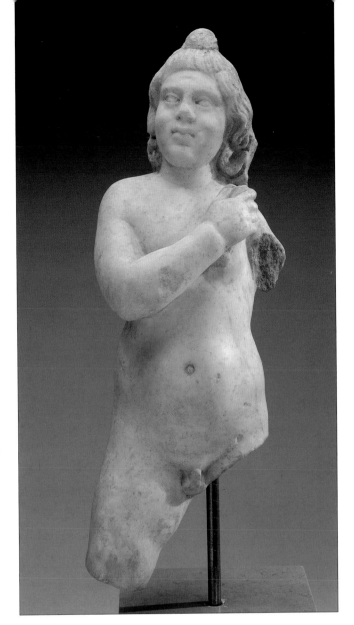

The under-lifesize figure represents a boy, still young enough to have chubby limbs and a pot belly. He stands in a hip-shot pose, his weight on the left leg (not extant) and the right leg advanced with knee bent. His right arm crosses his chest as he grasps something slung over his left shoulder. His left arm, much of which is missing, was placed slightly away from the body, since there are no attachment points on the boy's side. From a comparison with similar statues, he was probably resting his hand on an object at his side that formed the support.

The boy's topknot hairstyle led to his identification as Harpokrates in the initial excavation report.[1] However, he is not making the gesture most often associated with the child god, that is, holding his right hand to his lips.[2] Also, he lacks the other attributes of Harpokrates, such as the long side lock of hair, Egyptian kilt, or lotus flowers.[3]

In his pose he most resembles a series of Roman statuettes based on a late Hellenistic original, "Boy with Jumping Weights."[4] In one of the best preserved examples of this series, now in the Cleveland Museum of Art, a young boy stands with

his right leg advanced, right arm reaching across to his left shoulder. In his right hand he holds a leather strap connecting two weights slung over his shoulder. The left hand is lowered and holds a tall, cylindrical bag that rests on the ground and forms the statue's support.

While the figures in this group have a number of features in common with the Worcester statue, there are important differences. First, the head of the Worcester figure is nothing like those in the "Boy with Jumping Weights" series. Their hair is cropped short in front and arranged in a braid at the back. In addition, their heads are not tilted up as the Worcester boy's head is, but look introspectively down or straight ahead. Despite the Worcester boy's similar gesture with his right arm, there is no evidence that he held jumping weights; the fragment in his hand looks more like a handle.

As Herrmann notes, this series was copied rather freely because of its "intimate, decorative quality."[5] Meant to adorn a garden or courtyard, the Worcester statue's charm outweighed its adherence to the type. It is a conflation of two popular subjects, the "Boy with Jumping Weights" and Harpokrates. The statue, along with a number of other fragmentary sculptures, was excavated from a pool in the House of Menander at Daphne. These sculptures had probably been in niches in the three nymphaea of the house.[6]

ALW

PUBLISHED: *Antioch III 1941, 120, cat. 290, pl. 3; Mango 1986, 272, cat. 99, fig. 99-I; Kondoleon 2000, 176, cat. 62.*

1. Antioch III 1941, 120, cat. 288, pl. 4.

2. Kondoleon 2000, 176.

3. See Anastasiades 1993 for more attributes of the god.

4. See Herrmann 1993, 308–314 for the identification of this type.

5. Ibid., 308.

6. Kondoleon 2000, 176. See also 50, 57–59 for her discussion of the House.

14.

Statue of Dionysos

2nd century C.E.

Provenance: **House of Menander, Daphne**

Material: **marble**

Dimensions: **49.0 × 22.5 × 12.0 cm**

Condition: **The statue is missing its head, hands, and feet. Considerable burial accretions present on the front. Traces remain of a white ground layer and red pigment.**

Worcester Art Museum, Antioch Excavation, 1940.10

The male figure stands with right leg engaged and right hip thrown out, bending his left leg and resting his left elbow on a grapevine-covered tree stump. He holds a cluster of grapes in his left hand and he probably held a *kantharos* in his right, now missing (the strut is partially preserved on his leg). A mantle is loosely draped across his legs, leaving his genitals exposed, and then crosses his back to lie over his left shoulder. Traces of his long hair are on his right shoulder. His body is depicted as youthful, with soft, smooth curves and little muscle definition.

The grapevines and languorous pose indicate that this is Dionysos, the god of wine. Derived from a Hellenistic original attributed to Praxiteles, this type was reproduced throughout the Roman world for decoration in residential settings.[1] Sculpture such as this was meant to be a pleasing complement to a home, along with mosaics and wall paintings, and usually demonstrates neither great artistic originality nor regional individuality.[2] Dionysos would have been an appropriate subject for a courtyard to be viewed by guests eating and drinking in the dining area.

In addition to his association with grapes and wine, the erotic element to this figure would also have been appreciated by the dinner guests. Dionysos is represented as a prepubescent boy, a socially acceptable object of homosexual love in both the Greek and Roman cultures.[3] The long hair, casually inviting pose and loose drapery all add to the sexual innuendo of this figure; the slipping mantle draws attention to his genitals in the same way that the drapery of the Aphrodite of Melos underscores her nudity.[4] This statuette, set in a courtyard, would have been a sculptural reflection of the young male slaves (always the most handsome boys) who served the food and wine at banquets.[5]

This figure was discovered in a late pool in the House of Menander at Daphne, along with a number of other sculptural fragments (including the young boy, cat. 13), all probably buried there after an earthquake. ALW

PUBLISHED: *Antioch III 1941, 120, cat. 290, pl. 3; Kondoleon 2000, 176, cat. 63; Artal-Isbrand et al. 2002; Artal-Isbrand, Becker and Wypyski 2002, 199–200.*

1. Gasparri 1986, 436, no. 126a (from Rome), no. 126c (from Corinth); 437, no. 129 (from Thasos).

2. Vermeule 2000, 95.

3. While the Greeks were more open to homosexuality, it was tolerated, and definitely practiced, among the upper classes of Roman society. Bartman 2002, 266–267.

4. Ibid., 262–263.

5. Ibid., 267.

15.

Plate

4th century C.E.

Provenance: **Daphne, House of Menander, room 3**

Material: **silver**

Dimensions: **Diam. 33.1 cm, H 3.0 cm**

Weight: **860 gr.**

Condition: **When excavated, the plate was partly covered with calcareous deposits, cracked in many areas, and missing about 20% of the undecorated middle section between the rim and central medallion. The rim and central medallion are better preserved. There are many surface scratches, perhaps from cleaning.**

Worcester Art Museum, Antioch Excavation, 1940.17

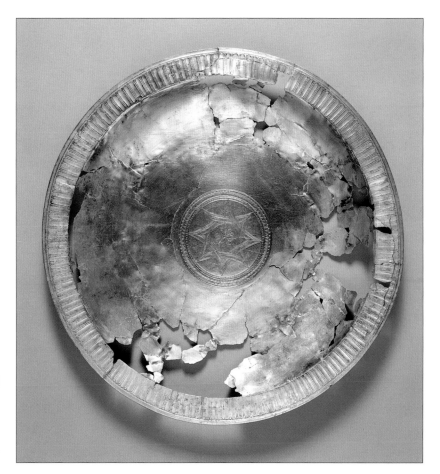

fig. 1. Detail of graffito "MAKAR..." on the underside of the plate.

The plate has a shallow concave bowl and a flat rim. X-ray radiography confirms that the basic shape of the plate was formed by hammering. Carving followed by polishing appears to have been used to create the radial fluting, with linear details engraved and some punchwork also evident. The presence of centering marks on both sides of the plate suggests some form of rotary process was used to articulate the concentric decoration and refine the shape. The foot ring appears to be a separate element soldered in place. Concentric marks on the foot are evidence of a turning process employed to refine its shape.

Concentric grooves border the flute-and-dart decoration on the rim, two on the outside and one on the inside. The fluting is very evenly spaced and the grooves between the flutes and darts are carefully articulated. This type of decoration finds a parallel in a bowl from the mid-fourth-century Kaiseraugst silver hoard.[1]

The central medallion is surrounded by three concentric grooves separated by concentric circles of punched decoration: a band of dots on the outside, then a band of leaves, and then a band of short lines. Within this is an eight-pointed star made up of two interlocked squares with concave sides, outlined with engraved grooves. Finally, at the center is a twelve-petal rosette, each petal of which is also delineated by a groove. At the middle of the rosette is the centering hole for working the plate on a lathe.

fig. 2. Detail of the quatrefoil design.

fig. 3. Detail of another graffito, possibly a bird.

The eight-pointed star motif can be traced back at least to the Assyrian period.[2] Early Roman examples include two first-century-C.E. mosaics from Pompeii, both of which have interlocking squares forming a star that itself surrounds either a rosette or another star.[3] This pattern became very popular in the third and fourth centuries, where it appears in Roman mosaics from Timgad[4] and Djemila[5] in northern Africa, Piazza Armerina[6] in Sicily, and even at Antioch itself.[7] In addition to mosaics, it appears on jewelry[8] and textiles as well.

On the underside of the bowl, within the foot ring, are some graffiti markings. A fragment of a name, "MAKAR…" (fig. 1) is scratched on the surface, as well as a quatrefoil floral design (fig. 2), and another mark which may represent a bird (fig 3). The inscription is probably the male personal name Makarios[9] and would have read "MAKARIOU," meaning "(plate of) Makarios." There is little doubt that this was the owner of the plate; in general, manufacturer's marks were punched or stamped into the metal, while owners more simply scratched their names on the bottom.[10]

The plate was discovered in a small hoard of silver objects, containing a bowl, a ewer, and a statuette of Aphrodite,[11] that was buried in a dining room corner when the house collapsed in an earthquake in either 485 or 526 C.E.[12] and was not retrieved by the owner. The plate's broad, flat shape and its decoration suggest an earlier date, but it was not unusual for cherished silver pieces to be passed down from generation to generation. ALW

PUBLISHED: *Ross 1953, 40; Dresser 1954, 15–16; Strong 1966, 174; Cahn and Kaufmann-Heinimann 1984, 192, 321, pl. 102; Mango 1986, 268–269, no. 95, fig. 95-1; Kondoleon 2000, 191, cat. 75.*

1. Cahn and Kaufmann-Heinimann 1984, 133–136, pls. 37–41.

2. Ibid., 191.

3. Rosette: Pompeii 1997, 629, fig. 24. Mosaic floor from a cubiculum in the House of Ganymede. Star: Pompeii 1990, 510, fig. 42. Mosaic floor from the *tablinum* in the House of Paquius Proculus or of Cuspius Pansa.

4. Germain 1969, no. 168, pl. LVI.

5. Blanchard-Lemée 1975, 202, pl. 48f.

6. Décor 1985, pl. 178c.

7. Levi 1947, 156, pl. 101b, mosaic from the House of the Drinking Contest; 105, pl. 97d, mosaic from the Atrium House.

8. A gold necklace pendant with a coin of Honorius in Berlin (Antikensammlung der Staatliche Museen inv. no. 30505) has an *opus interrasile* frame incorporating the star design.

9. See Mango 1986, 269, for discussion of the identity of this person.

10. Cahn and Kaufmann-Heinimann 1984, 387.

11. The bowl is in the Baltimore Museum of Art (acc. no. 1940.33), and the ewer at Dumbarton Oaks (acc. no. 40.24); the Aphrodite remains in Turkey (Hatay Archaeological Museum, Antakya).

12. Antioch III, 25 ff., 155, no. 49. The date is uncertain because the stratigraphy was unclear.

16.

Grave Relief of Caesianus

1st or 2nd century C.E.

Provenance: Antioch, Northeast Cemetery, Tomb 3 (Antioch 7/8-Y)

Material: marble

Dimensions: 37.5 × 28.6 × 2.9 cm

Condition: The relief is in good condition. A diagonal band of brown-orange accretion on the top third of the relief and a circular accretion along the proper right edge, with corresponding orange-to-brown discoloration, extends onto the back of the relief and covers over half the area. There are two groupings of shallow white-colored abrasions along the bottom edge near the corners on the front. The upper and lower right corners are missing.

Worcester Art Museum, Antioch Excavation, 1936.41

The rectangular relief is crowned by a pediment with acroteria and a central rosette. Within the framework of pilasters a male figure stands frontally, looking out at the viewer. His left hand holds what appears to be a bottle, and his right hand rests over his stomach. He wears a simple tunic that ends at his knees, and perhaps sandals. Below the figure is the inscription ΚΑΕϹΙΑΝΑΙΑΛΥΠΕ/ΧΑΙΡΕ (Caesianus, free of care, hail and farewell).

The architectural shape of the relief is meant to call to mind a *naiskos*, a free-standing funerary monument resembling a small temple. Representing this grand building in a small relief was a common solution for people who could not afford an elaborate memorial for their loved ones. The dress of the figure is rather unusual: often the deceased is swathed in a cloak that covered the arms and legs almost completely, but here the figure's arms are uncovered to the elbow and the legs are exposed from the knees down. Perhaps this costume indicates his race or social status; he may be a foreigner who had adopted a Latin name or a freed slave. The bottle that Caesianus holds is also unusual. The deceased person was frequently shown holding a *patera*, scroll, or occasionally a *situla* (handled bucket), an

item related to the worship of Isis.[1] Another more coarsely worked stele from Antioch also shows a frontal figure holding a bottle in his left hand.[2] The bottle might contain wine for the deceased or perhaps scented oil, a common gift for the dead.

The thinness of the stone, typical of finds at Antioch, indicates that most of the grave reliefs functioned as *loculus* lids placed over burial niches, rather than free-standing monuments;[3] this relief also served as a *loculus* lid. Tomb 3, the findspot for the relief, was partially cut into the rock and partially constructed.[4] It consisted of a corridor off which a tomb with three burial niches was located. The grave relief of Caesianus was at the other end of the corridor, near the entrance. In addition to the relief itself, coins and pottery, grave gifts for the deceased, were recovered.[5] ALW

PUBLISHED: *Antioch II 1938, 156, cat. 57; IGLSyr III.1, 438, no. 758; Kondoleon 2000, 140, cat. 28.*

1. Comstock and Vermeule 1976, 172, no. 276. Second-century c.e. grave stele of Sosibia.
2. Antioch III 1941, 123, no. 351, pl. 15.
3. Weir 2001, 275.
4. Jean Lassus field notes (Princeton Archives).
5. Ibid.

17.

Grave Relief of Claudius

1st or 2nd century C.E.

Provenance: Antioch, Southeast Cemetery or Necropolis of Mnemosyne, Corridor 6 (Antioch 24-L)

Material: green marble

Dimensions: 34.3 × 36.2 × 3.0 cm

Condition: The relief is in good condition. There are groupings of shallow abrasions along the bottom and top edges near the corners, probably from old mounts. There is a small loss in the top proper left corner and a brown area of discoloration to the left of the figure's head. The surface is worn.

Worcester Art Museum, Antioch Excavation, 1936.42

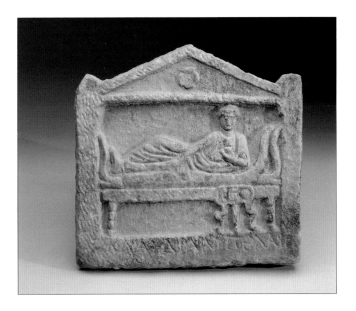

This rectangular relief is crowned by a pediment with acroteria and a central rosette. Simple pilasters frame the figure of the deceased, a male who reclines on a padded kline with a high head- and footboard. The figure's head and torso are turned to face the viewer, with his legs extended and right knee slightly bent, as typical in this type of pose. He wears a tunic with a mantle draped over it and props himself on his left elbow, holding a drinking cup in his left hand. In front of the kline is a three-legged table on which are placed cakes and/or fruit. Below the figure is the inscription ΚΛΑΥΔΙΑΛΥΠΕΧΑΙΡΕ (Claudius, free of care, hail and farewell).

The funerary banquet was an extremely popular theme for grave reliefs; the idea of the dead enjoying themselves in the afterlife clearly appealed to their grieving loved ones. Often these reliefs are quite detailed in representing furniture and clothing and portray a number of people (spouse, children, servants) in addition to the deceased. This relief is unusual in showing a lone figure against a very simple background. However, there are parallels for this type, several from Antioch, although not from excavated contexts.[1] Also, other reliefs from the area in and around Istanbul show a single banqueter holding a drinking cup.[2]

The relief was found in the corridor of a tomb, along with another fragmentary stele.[3] The tomb, although fairly well preserved, must have been disturbed; Arabic lamps and fragments of Muslim glass were found in it, suggesting reuse of the space.[4] Like the funerary stele of Caesianus (cat. 16), this thin stone slab served as a loculus lid for the burial. ALW

PUBLISHED: *Antioch II 1938, 153, cat. 41; IGLSyr III.1, 476–477, no. 857; Kondoleon 2000, 140, cat. 29.*

1. Antioch II 1938, 163, no. 106. Antioch III 1941, 102, no. 207 and 123, no. 347.
2. Firatli 1964, 71, no. 72. Stele of Damatrios, from Çatalca, a suburb of Istanbul. Pfühl and Möbius 1977, 370, cat. 1491, 372, cat. 1509.
3. Antioch II 1938, 153, no. 42, Stele of Etete.
4. Jean Lassus field notes (Princeton Archives).

18.

Sarcophagus Fragments

2nd century C.E.

Provenance: Seleucia Pieria, 17-E

Material: marble

Dimensions: sphinx fragment, 65.0 × 70.0 × 21.0 cm; leg fragment, 22.0 × 34.5 × 20.0 cm

Condition: Fragmentary. The two pieces do not join but appear to come from the same sarcophagus. The surface of the sphinx fragment is in good condition except for losses along the upper edge, the face and chest of the sphinx, and some of the drapery edges of the human figure. There are also several deep gouges in the background to the right of the sphinx's head, possibly made during excavation. Both the broken edges and the finished surface of the smaller leg fragment are more weathered than the other piece.

Worcester Art Museum, Antioch Excavation, 1939.79, 1940.11

The larger fragment is roughly triangular in shape, the upper edge finished with a horizontal molding and the other two sides rough and broken. To the left are the head and foreparts of a sphinx in right profile raising her right paw towards a fragmentary garland. On the right is a female figure, with only part of the right leg and arm extant. She wears a *chiton*, the skirt of which is parted over her leg to expose her thigh. The fabric billows out to the side, where it is caught in her hand; curving up around her wrist and over her forearm, it ends in an edge that flutters as if blown by a strong wind. The smaller fragment belongs to the bottom section of the relief, for it shows the lower leg of a woman, broken off just below the knee. The leg is bare, but drapery flutters behind it in the same billowing folds as in the other fragment. To the left of this drapery is a curve of ribbon (*taenia*) from the garland. The figure's foot (the toes of which are lost) rests on a globe-shaped element.

The thickness of these reliefs suggests that they are from a sarcophagus and not a wall plaque; the decoration also supports this identification. The vegetation near the sphinx's paw, which includes an oak leaf and a bunch of grapes, appears to be the top of a draped swag of fruits and leaves. Hence the fragments come from a type of funerary monument known as a garland sarcophagus.

Vegetation arranged in swags or garlands became a popular sculptural motif in the Augustan period, as seen in the reliefs from the interior walls of the Ara Pacis. On that monument the garlands refer to the peace and prosperity brought about by Augustan rule; the fruits and flowers of the

four seasons, ripe and blooming simultaneously, allude to the cycle of the seasons and to regeneration. This latter aspect was why the garland was adopted in second-century sarcophagi, and the use of *erotes* and Victories further reinforced the notion of life after death.[1]

One of the most famous garland sarcophagi with Victories is in the Louvre.[2] Dated to about 130 C.E. and discovered in 1738 near Rome, it is attributed to a local workshop that was greatly influenced by the Greek artists of Asia Minor. Although the stance and clothing of the Louvre Victories are different (they stand with one leg turned to the side, as though walking, and their legs are completely covered), the composition must closely reflect that of Worcester's sarcophagus. The long sides would have had three Victories (one at each end and a central figure) who supported the garlands. In the Louvre example, the *taeniae* tying up the garlands flutter down on each side of the Victory; as noted above, a ribbon is visible on the smaller Worcester fragment. Another sarcophagus, also from Rome, has Victories more closely resembling the Worcester figures.[3] They stand frontally, with one leg exposed from the thigh down. The leg position as well as the fluttering overfold of fabric above the thigh are quite similar to the Worcester Victory. Finally, the use of a sphinx as a motif in the curve of the garland finds a parallel in a sarcophagus from Athens.[4] On that sarcophagus, the garlands are held by *erotes*. Flanking the central eros are two griffins, facing towards the center and raising a paw towards the garland; this is the exact gesture that the Worcester sphinx makes. Since these animals were positioned facing in, we can assume that the sphinx of the Worcester sarcophagus faces the central Victory.

Although all of these comparisons are from outside Syria, the Worcester sarcophagus was not necessarily an import. There was a thriving sculpture industry in Syria in which the stone for funerary monuments was roughly blocked out and shipped to Antioch to be finished.[5] Local craftsmen drew on the repertoire of images popular in the Roman Empire.

The Worcester fragments were found in the town of Seleucia Pieria, on the coast to the west of Antioch. The Tunnel of Vespasian and Titus, created to divert flood waters, runs through a mountain at the northern end of the town and bisects a necropolis there. During excavations in the tunnel these fragments and several others[6] were discovered in a rock-cut tomb, already plundered by grave robbers. ALW

1. Ramage and Ramage 2001, 256.

2. Baratte and Metzger 1985, 49–55, cat. 15.

3. Herdejürgen 1996, 154–155, cat. 138.

4. Koch 1993, 106–107, fig. 62.

5. Vikan 1995, 12.

6. Some of these sarcophagus fragments (Antioch III 1941, 123, no. 338) are now in Princeton. Padgett 2001, 270–271, cat. 107. Herdejürgen 1996, 154–155, cat. 138.

PUBLISHED: *Antioch III 1941, 123, cats. 336, 337, pl. 13.*

Architectural Elements

19.
Corinthian Capital
5th century C.E.

Provenance: Purchased at Daphne in 1936, inv. no. P3778 A35

Material: Limestone or coarse marble

Dimensions: 28.5 × 41.5 × 39.5 cm

Museum purchase, 1936.37

Condition: Good. The surface shows some evidence of over-cleaning, done on site at the excavation. There are still many accretions in the crevices of the carving, and some pick marks and chips in the surface. The bottom of the capital has a hole 3.2 cm in diameter that is filled with a sandy substance and a square iron plug.

The capital is a local adaptation of the Corinthian type. It is simplified by having only one row of acanthus plants that extend to the abacus, with the top leaf curling down as though pushed out by the abacus. This treatment may replace the volute on the more traditional type of Corinthian capital. The acanthus plants are each separated into five lobes, and each lobe has three leaves. The leaves are sculpted in a linear, almost abstract style, and their central crease gives them a scoop-like appearance. The interstices of the lobes, known as the "eye," are rectangular.[1] A different vegetal design is centered on each of the four sides of the abacus. Shown here is a nine-petaled flower.

ALW

Published: Antioch III, 158–159, no. 86, pl. 35; Morey 1937, 27, no. 38.

1. A similar capital with a single register of acanthus plants and bearing the rectangular eye was published in Kautzsch 1936, 12–13, pl. 2.16. It is from Salona, Croatia and dated to ca. 300 C.E.

20.
Corinthian Capital
Late 4th or early 5th century C.E.

Provenance: Excavated at Daphne in 1936, section 24-P

Material: Marble

Dimensions: 48.6 × 60.5 × 60.3 cm

Worcester Art Museum, Antioch Excavation, 1936.38

Condition: Good. The surface is abraded and some of the protruding vegetal elements are broken off.

The capital has three rows of acanthus leaves that support the volutes and the abacus. The leaves are deeply drilled and channeled and the upper register is worked in bold swirling patterns, with no apparent attachment to calyxes, as seen on the more traditional Corinthian capitals. The volutes appear to be flattened by the abacus, which is divided by a horizontal groove into two bands. At the center of each side, the abacus has a floral element. The width of the abacus is such that it gives the capital a strongly pronounced outward curve toward the top, and also gives the profile a rather squat appearance.

Stillwell noted that the mosaics from the villa in which this capital was found would suggest a late fourth- or early fifth-century date.

ALW

Published: Antioch III, 154, no. 43, pl. 31; Morey 1937, 27, no. 37.

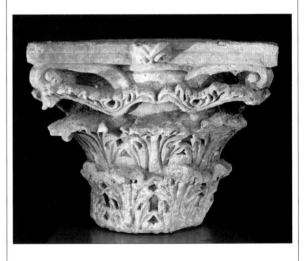

21.
Ionic Capital
1st century C.E.

Provenance: Excavated at Daphne in 1936, section 26-K

Material: Marble

Dimensions: 44.5 × 77.5 × 66.0 cm

Worcester Art Museum, Antioch Excavation, 1936.40

Condition: The capital is missing two volutes and the extant volutes are chipped. One bolster retains only its central section (*balteus*), while the other is missing fragments of the acanthus-leaf decoration. The decoration of the abacus is almost completely lost. Much of the egg-and-dart decoration is damaged.

On the main sides, the capital's two large volutes frame five deeply carved eggs, separated by darts with lateral elements following the curve of the egg. The egg-and-dart register rests on a bead-and-reel pattern. The angle palmettes have three leaves emerging from a calyx; the leaves terminate with hooked ends. The volutes and the treatment of the angle palmettes find parallels at Aphrodisias, dated to the early second century C.E.[1] The bolsters are decorated with foliage; acanthus leaves spring from each side of the central element, the *balteus*. The *balteus* has a scale pattern and is bordered with a roped design.

ALW

Published: Antioch III, 160, no. 102, pl. 37.

1. Bingöl 1980, 168, cat. 42, pl. 2.

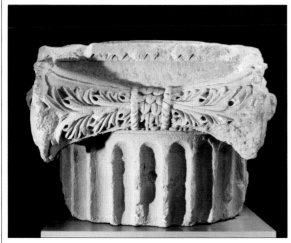

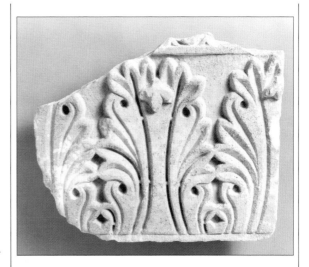

22.
Pilaster Capital
Late 4th or early 5th century C.E.

Provenance: Excavated at Daphne in 1936, section 26-K/L

Material: Marble

Dimensions: 33 × 42.1 × 6 cm

Worcester Art Museum, Antioch Excavation, 1936.39

Condition: The pilaster is missing large fragments from the left side, upper and lower corners. There is a large chip in the middle of the right edge. The abacus is almost entirely gone. The surface is heavily encrusted.

The pilaster capital has a row of acanthus leaves that extends the entire height of the capital, terminating just below the raised border of the abacus. There is a central leaf flanked by two half leaves; on each, the topmost lobe is turned downward over the central spine of the leaf. As in cats. 19 and 20, the leaves have a strong central crease. In addition, some of these leaves also curl around in a distinctive "eye" pattern.[1]

ALW

Published: Antioch III, 154, no. 45, pl. 34.

1. See Group 6 in Dentzer-Feydy 1990, 651–662 for other acanthus plants with the circular eye pattern.

Sculpture Fragments

23.
Arm
First half of the 1st century C.E.

Provenance: Excavated at Antioch, sector 16-P

Material: Marble

Dimensions: 10.7 × 8.8 × 3.3 cm

Worcester Art Museum, Antioch Excavation, 1940.12

Condition: Fragmentary. The arm is broken just above the wrist. The iron pin at the shoulder join has caused some staining of the stone.

This fragment is the proper left arm of an under-lifesize figure. The marble is smoothed flat at the shoulder join for attachment to the torso. Along with cat. 24, it was discovered in sector 16-P at Antioch, in what was a sculptor's workshop.[1]

ALW

Unpublished

1. See Padgett 2001, 250–251, cats. 92, 93 for other material from this sector. It is suggested that the sculpture fragments, found near a lime kiln, were destined to be destroyed.

24.
Toe
First half of the 1st century C.E.

Provenance: Excavated at Antioch, sector 16-P

Material: Marble

Dimensions: 6.9 × 5.0 × 4.5 cm

Worcester Art Museum, Antioch Excavation, 1940.13

Condition: Fragmentary. The toe is broken off just before the join to the foot. There is a dowel hole in the broken side for an ancient (?) repair.

The fragment is a big toe, perhaps from the proper right foot of an over-lifesize statue.

ALW

Unpublished

26.
Animal Hoof
Roman period

Provenance: Purchased at Jekmejeh, inv. no. Pc424-s607

Material: Steatite

Dimensions: H 9.2 × Diam. 4.3 cm

Museum purchase, 1940.16

Condition: Fragmentary. The leg is missing just above the fetlock. The surface is worn and abraded.

The fragment is a cloven hoof and lower leg of a goat. A hole is pierced through the fetlock, perhaps for attachment to a support backing. At the back of the hoof is a square strut.

The use of dark stone in sculpture was not uncommon at Antioch, particularly for groups in which different stone colors would have made some figures stand out more clearly.[1] The goat was an animal often associated with Dionysos, and so might have been part of a grouping with the god. This would have been an appropriate theme for the decoration of a villa.

ALW

Published: Antioch III, 119, no. 282, pl. 11.

1. Padgett 2001, 252–253, cat. 94.

25.
Fragment of a Hand and Snake
2nd–3rd century C.E.

Provenance: Purchased at Daphne in 1939, inv. no. Pc71-S558

Material: Black stone

Dimensions: 7.0 × 7.5 × 6.2 cm

Museum purchase, 1940.15

Condition: Fragmentary. The hand is preserved to the wrist; the snake is broken above the hand, and also to the right of it. There are many scratches and accretions on the surface.

A proper left hand in the clenched position, tendons prominent, is placed before the fragmentary body of a snake. The scales of the snake are roughly indicated in relief. The scale pattern is not carried through on the right side or upper surface of the snake, suggesting that the human forearm hid these portions from view.

The tautness of the hand suggests that this was not a statue of Asklepios or Hygieia, who were often shown calmly holding snakes in reference to their roles as healers. Rather, this fragment might have come from a sculptural group similar to the Laocoön group in Rome, showing a human attacked by a snake.

ALW

Published: Antioch III, 122, no. 323, pl. 12; Padgett 2001, 255.

Small Finds

Anne Leinster Windham

Large mosaics and sculpture might be the showpieces of an excavation, but the bulk of excavated material is classified as "small finds." These are bits of pottery, jewelry, metal tools and the like, items in daily use in the ancient world and often considered so minor that they were left, broken and discarded, to be discovered centuries later. Their value has changed: now they can help the archaeologist identify the function and date of a site.

The Worcester Art Museum acquired a number of important large-scale objects due to its involvement with the Antioch excavations of 1932–1939. In addition to these, a number of smaller pieces were also acquired. Many of these small finds are fragmentary and damaged, and most have been in storage since their acquisition. While often inappropriate for museum display, the context they provide for the "major" finds is invaluable. They are presented here in order to give a more complete picture of the material discovered at Antioch.

The objects in the following list run the gamut of materials and dates. Some of them, particularly the gold items, come from unexcavated contexts. Those found *in situ* can be extremely helpful in enhancing our understanding of the ancient city of Antioch.

Qualitative analysis of metal objects (cat. nos. 28–37, as well as cat. 10 (Tyche figure and base) and 15 (silver plate)) were carried out at the Worcester Art Museum by Philip Klausmeyer. The analysis sought to identify the various elements present within each object as well as to gain semi-quantitative information through the use of energy dispersive X-ray fluorescence spectrometry (ED-XRF). The instrument used was an ArtTAX portable μXRF spectrometer, manufactured by Röntec of Berlin, Germany.

Analyses were carried out directly on the surface of the objects. Since surface composition can differ significantly from the underlying alloy, small areas intended for analysis were cleaned of corrosion and surface accretions down to the underlying metal or at least (in the case of some copper alloy objects) to the cuprite level. The operating conditions of the analyses allowed a definitive identification of bronze, brass, or copper only in certain cases; elsewhere the general term "copper alloy" is used.

27.
Mold for a Vessel
no date

Provenance: Purchased at Antioch, inv. no. Pc456-5617

Material: Dark stone

Dimensions: 7.2 × 6.0 × 2.9 cm

Museum purchase, 1940.14

Condition: Good. There is general surface wear.

The object is half of a mold for a narrow-necked glass (?) jug. The two diagonally placed holes would have locked the mold into place with projections on the missing half. Glass may have been blown into the mold or the mold might have produced a solid glass form that then would have been drilled out to make a useful vessel.

Unpublished

Metalwork

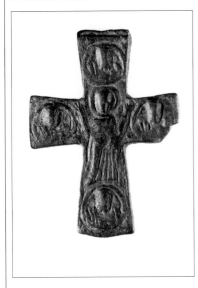

28.
Reliquary
6th to 7th century C.E.

Provenance: Excavated (?) at Antioch in 1936, no inv. no.

Material: Copper alloy

Dimensions: 7.5 × 5.4 cm

Worcester Art Museum, Antioch Excavation, 1939.75

Condition: Fragmentary. The reliquary is missing the back half. The decoration is very worn and abraded.

The object is the front half of a two-part cast bronze reliquary pendant. The figure of the Virgin Mary, arms raised in the *orans* position, is placed at the center of the cross. An encircled bust of a bearded male is in each of the four arms, perhaps representing the four evangelists.

A similar reliquary cross with the Virgin and four busts, dated to the Byzantine period, was discovered at Corinth.[1] These reliquaries were sold as souvenirs to pilgrims in the Holy Land.

Unpublished

1. Davidson 1952, 257–258, cat. 2065, pl. 110.

29.
Spatula
Late Roman–early Byzantine period

Provenance: Excavated at Antioch, section 15-M

Material: Copper alloy (handle has a significantly higher amount of zinc than blade)

Dimensions: 19.2 × 1.5 × 0.6 cm

Worcester Art Museum, Antioch Excavation, 1940.332

Condition: Good. The handle was not worked after casting and is in better condition than the blade end, which was hammered. The metal of the blade is chipped along one edge and has a small hole near the central crease.

The spatula has a long handle, decorated with relief rings near the blade end and at the middle. It terminates in a small ovoid bulb. The spatula blade is leaf-shaped with a vertical crease down the middle. This tool could have functioned as either a cosmetic or a surgical implement.

This type of spatula can be dated to approximately the sixth through eighth centuries, based on similar finds at other sites.[1] This one however was found in an area of plundered fill and so is impossible to date more accurately.

Unpublished

1. For comparison see Hattatt 1989, 479, cat. 191 (Pompeii), Perdrizet 1908, 108, cat. 546, fig. 372 (Delphi), Colt 1962, 53–54, pl. XXIII.7 (Nessana), and Waldbaum 1983, 107, cat. 640, pl. 41 (Sardis).

30.
Knob
no date

Provenance: Excavated at Antioch, inv. no. 37-119

Material: Brass with gilding

Dimensions: H 1.4, Diam. 1.1 cm

Worcester Art Museum, Antioch Excavation, 1940.340

Condition: Poor. The object is fragmentary and is covered with burial soil and is heavily corroded, but a gilded surface is clearly apparent. XRF detected mercury, indicating amalgam gilding.

It was probably the knob for the lid of a small vessel, such as a pyxis.

Unpublished

31.
Ring with Four Beads
Late Roman–Byzantine

Provenance: Antioch, surface find, no inv. no.

Material: Copper alloy with glass beads

Dimensions: Diam. 2.2 cm

Worcester Art Museum, Antioch Excavation, 1940.335

Condition: Fair. The metal is corroded. The glass beads have deteriorated and are fractured.

The ring is made of three copper wires braided together. Four ivory-colored melon-shaped glass beads are threaded onto the wires.

This is an unusual type of ring. A similar example found at Corinth[1] is dated to the late Roman or Byzantine period.

Unpublished

1. Davidson 1952, 244, cat. 1943, pl. 106.

32.
Horse-Head Buckle
7th century C.E.

Provenance: Excavated at Antioch, inv. no. C856-U802

Material: Copper, brass (eyes), tin plating

Dimensions: 2.8 × 2.4 × 0.9 cm (horse's head), 2.9 × 2.3 × 0.9 cm (ring)

Worcester Art Museum, Antioch Excavation, 1940.327.1–.2

Condition: Good. Only traces of plating and eye inlay are extant.

The cast tin-plated copper buckle consists of a horse's head, hooked at the neck, and an ogival ring.[1] One side of the ring is a narrow band where the hook of the horse would have attached, the head forming the tongue of the buckle. The details of the head (eyes, mouth, and bridle) were created by incising the wax model. The eyes were inlaid with brass.

Published: Russell 1982, 152, n. 40.

1. Compare this type of ogival plate to Waldbaum 1983, 121, no. 710 (from Sardis) and Davidson 1952, 270, cat. 2177, pl. 113 (from Corinth).

33.
Buckle Plate
First half of the 7th century C.E.

Provenance: Excavated at Antioch, inv. no. C305-U743

Material: Copper with gilding

Dimensions: 3.1 × 3.8 × 1.3 cm

Worcester Art Museum, Antioch Excavation, 1940.330

Condition: Fair. The surface is worn and much of the original gilding is lost.

The cast shield-shaped plate has two projecting pierced lugs at the corners for hinge attachment to the buckle (not extant). The incised design of ivy leaves is surrounded by a broken linear incised border. The plate is framed with a bead border. The designs were incised in the wax model before casting. On the back are three more pierced lugs. The plate was originally gilded, and some of the gilding remains.

This buckle plate is one of a well-established corpus represented throughout the eastern Roman world in the seventh century C.E. Other examples come from Anemurium, Constantinople, and Sardis.[1]

Published: Russell 1982, 152, n. 42.

1. Russell 1982, 139, no. 12, 142–43, fig. 7.24.D. Csallány 1954, 320, 345–46, pl. IV.1, 1a (type 6). Waldbaum 1983, 120, cat. 700, pl. 44.

34.
Crossbow Brooch
Mid 3rd– early 4th century C.E.

Provenance: Excavated at Antioch, inv. no. 298

Material: Brass with gilding

Dimensions: 6.4 × 5.1 × 2.6 cm

Worcester Art Museum, Antioch Excavation, 1940.338

Condition: Fragmentary. The brooch is missing its pin. The surface is corroded, and much of the gilding is lost.

The cast brooch has a straight foot, decorated in relief with lateral grooved ribs that are framed by two notched double-ax shapes. The curved bow would have terminated with a knob (not extant), similar to the knobs that terminate the bow's arms. There is some gilding remaining, particularly on the bow. XRF detected mercury, indicating amalgam gilding.

On the basis of the proportions of the foot, bow, and arms, as well as the decoration, the brooch can be dated fairly accurately. The crossbow brooch is associated with Roman soldiery, and is often found in border areas of the Roman Empire.[1] Other similar examples have been found in Britain and Greece.[2]

Unpublished

1. Rostovtzeff 1949, 51.
2. Hattatt 1985, 132, cat. 503 (Britain), Davidson 1952, 270, cat. 2171 (Corinth).

Metalwork with Enamel

35.
Tab for a Buckle
6th–7th century C.E.

Provenance: Excavated (?) at Antioch, no inv. no.

Material: Copper alloy, red enamel or inlay (?)

Dimensions: 2.0 × 6.0 × 1.1 cm

Worcester Art Museum, Antioch Excavation, 1940.331

Condition: Good. There are some accretions in the crevices of the design. At least three of the red inlays are missing.

The copper alloy tab is a long plaque that is rounded at one end. At the rounded end is a knob, while at the squared end two pierced lugs project from each corner. There are also two pierced lugs on the reverse side, set near the squared end. On the main side the decoration is divided into three distinct zones. A band of engraved diamonds with central dots, bordered by triangles, is placed near the squared end. The center of the tab has a rectangular area decorated with fantastic intertwined birds with large round eyes. At the rounded end is a circular pattern bordered with punched squares that also have central dots. Within the circle are two concentric squares, surrounded by enamel inlays.

The tab was made of two pieces. The front segment, perforated to hold the enamel or inlay, was attached to the main body of the tab with four copper alloy pins.

Dumbarton Oaks has a similar tab, also excavated at Antioch.[1] Another tab, found in Damascus, still has its plate and tongue of the buckle.[2]

Unpublished

1. Ross 1965, 41, cat. 41, pl. XXXIII.
2. Schlunk 1939, 49, cat. 136, pl. 44.

36.
Mandorla Brooch
2nd–3rd century C.E.

Provenance: excavated at Antioch, sector S-19-J, from under a mosaic in the south corridor of a building.

Material: Copper alloy with red[1] and white (?) enamel

Dimensions: 2.7 × 3.8 × 1.0 cm

Worcester Art Museum, Antioch Excavation, 1940.337

Condition: Fair. The brooch is missing its pin. The surface is heavily incrusted and much of the enamel is missing. Two of the protruding lobes are broken off.

The cast brooch is of an unusual mandorla shape, surrounded by eight protruding decorative lobes. The lobes are punched with a concentric circle pattern, and the mandorla is bordered by two concentric rows of punched lines. The center section is inlaid with white enamel, within which is a cell of red enamel with a central metal circle, punched in the same manner as the lobes.

The mandorla shape has few comparisons, as most enameled disc brooches are circular or diamond-shaped. Several types of circular brooches have similar lobes,[2] and two lobed mandorla-shaped brooches are cited in Hattatt's catalogue,[3] although they both have fewer lobes.

Unpublished

1. Results of the EDS analysis of the red enamel follow cat. 37.
2. Hattatt 1987, 176–178, cat. 1055.
3. Hattatt, 1985, 163–165, cat. 590–591.

37.
Oval Brooch
2nd–3rd century C.E.

Provenance: Excavated at Antioch, inv. no. 350.6

Material: Bronze with gilding and white enamel[1]

Dimensions: 2.4 × 3.4 × 1.8 cm

Worcester Art Museum, Antioch Excavation, 1940.339

Condition: Fair. The brooch lacks its pin. Much of the enamel is missing, and the surface of the metal is heavily corroded.

The cast brooch is oval, with a central knob of metal. Set around the knob is a pattern, originally gilded and inlaid with enamel, consisting of four arms terminating in *pelta* shapes. In between each arm are other *peltae*, this time in reversed position. The recessed areas for the enamel were carved into the wax model before casting.

 Peltae were small, lightweight shields associated with Amazon warriors. The design, frequently seen in pierced fibulae[2] is unusual in this enamelled form.

1. For EDS analysis see below.
2. Rostovtzeff 1949, 65–67, pls. XVI–XVII.

Oxide	1940.337 Red Enamel cat. 36	1940.339 White Enamel cat. 37
NaO	12.2	14.6
MgO	2.0	0.5
AlO	2.5	2.0
SiO	53.0	63.3
PO	0.7	0.2
SO	0.2	0.6
Cl	0.8	0.7
KO	1.6	0.5
CaO	7.6	7.7
TiO	0.2	0.05
MnO	0.4	0.3
FeO	2.3	0.4
CoO	n.d.	n.d.
CuO	2.3	0.03
ZnO	0.07	n.d.
SnO	0.5	0.03
SbO	0.5	9.1
BaO	0.04	0.01
PbO	13.0	n.d.

n.d. = not detected

Gold Jewelry

38.
Pendant with Medallion
Roman period

Provenance: Antioch, surface find, inv. no. C66-J28a

Material: Gold

Dimensions: 1.5 × 1.3 × 0.4 cm

Worcester Art Museum, Antioch Excavation, 1940.320

Condition: Good. The tip of the nose is dented in and there is a loss and a crack there. There are dirt and accretions on the reverse, in the deeper areas of repoussée.

The pendant is round, with a frontal head worked in low-relief repoussée. The head is surrounded by a border of raised dots. The suspension loop is made of a thin, ridged band of gold.

 The gender of the face in uncertain, but the free-flowing hair and frontal three-quarter view suggest the sun god Helios, familiar to the ancient viewer from the coinage of Rhodes.

Published: Kondoleon 2000, 78, 85.

39.
Pendant, Cross Within a Circle
3rd–4th century C.E.

Provenance: Antioch, surface find, inv. no. C66-528G

Material: Gold

Dimensions: Diam. 1.4 × 0.3 cm

Worcester Art Museum, Antioch Excavation, 1940.321

Condition: Good. There are some surface accretions, particularly at attachment points.

The pendant is a flat circle cut from gold sheet. Within this is a Greek cross, made of two cut ribbons of gold sheet. The arms of the cross terminate with a gold bead, and there is a bead at the center. This is a simpler version of a cross pendant in the collection of the Museum of Fine Arts, Boston.[1]

 Before Constantine's acceptance of Christianity in 313 C.E., Christians would often secretly wear the emblems of their religion. This cross within a circle is typical of that period, being a symbol also used in secular contexts.

Published: Kondoleon 2000, 78, 85.

1. Vermeule 1976, 123, cat. 136.

40.
Nine Beads
Hellenistic–Roman period

Provenance: Antioch, surface find, inv. no. C68–J30 a–I

Material: Gold

Dimensions: each bead 0.5 cm

Worcester Art Museum, Antioch Excavation, 1940.322

Condition: Good. Four of the beads have surface discoloration. Some beads are dented.

The melon-shaped beads are worked in repoussé, and the central perforation is ringed at each end with a gold wire. They were part of a necklace.

Published: Kondoleon 2000, 78, 85.

41.
Club-Shaped Beads
Hellenistic period

Provenance: Antioch, surface find, inv. no. C67 J29 a–d

Material: Gold

Dimensions: 1.6 × 0.4 cm (1940.323), 1.9 × 0.5 cm (1940.324)

Worcester Art Museum, Antioch Excavation, 1940.323, 1940.324

Condition: Fragmentary. Each bead is broken off at the narrow end.

The two club-shaped beads are hollow, and decorated with triangular and diamond patterns of granulation and gold wire. The wider end of each is rounded, with a central hole for stringing the bead to the necklace.

These beads would have been terminal elements to a necklace.[1]

Published: Kondoleon 2000, 78, 85.

1. Compare similar examples from Sardis (Densmore Curtis 1925, 25, cat. 47, pl. IV, 5a, 5b), Damascus (Higgins 1980, xxvi, 166, fig. 49a), and Kyme in Aeolis (Marshall 1911, 227, cats. 2036–37 and 2038–39).

42.
Pendant
Hellenistic–Roman period

Provenance: Antioch, surface find, inv. no. C67 J29 a–d

Material: Gold

Dimensions: 1.5 × 0.2 Diam. (cone) × 0.4 Diam. (loop) cm

Worcester Art Museum, Antioch Excavation, 1940.325

Condition: Good. There are some accretions inside and around the loop.

The pendant is made from sheet gold rolled into a long, thin cone. At the wider end of the cone is an attachment loop made of a ridged band of gold.

Published: Kondoleon 2000, 78, 85.

43.
Pendant
Hellenistic–Roman period

Provenance: Antioch, surface find, inv. no. C67 J29 a–d

Material: Gold

Dimensions: 1.5 × 1.3 cm

Worcester Art Museum, Antioch Excavation, 1940.326

Condition: Good. There is some discoloration of the surface.

The stirrup-shaped pendant has a ridged band of gold for a loop across its long side. The ends of the prongs and the center where the loop and stirrup join are decorated with gold beads.

The prongs of the stirrup might have held a sealstone or gem in place, or another gold ornament might have hung from the central bead.[1]

Published: Kondoleon 2000, 78, 85.

1. For comparison with the latter type, see Marshall 1911, 348, cat. 2931, pl. LXVIII, where the stirrup element supports another gold decoration worked in repoussé.

44.
Intaglio Gem
1st century C.E.

Provenance: Antioch, inv. no. C599-S675

Material: Agate (?)

Dimensions: 1.5 × 1.1 × 0.3 cm

Worcester Art Museum, Antioch Excavation, 1940.328

Condition: Good. There are some small surface chips.

The oval-shaped gem has an intaglio portrait of a female, facing right. Her hair is drawn back in a bun and she wears a *modius*. The style of carving is linear and somewhat rough.

The portrait is perhaps of the goddess Fortuna. Depictions usually show her full-figure, holding a cornucopia. A bust is rare, but the *modius* she wears on her head is an identifying attribute.

Unpublished

Bone

45.
Pin with Face
Roman period

Provenance: Excavated at Antioch, inv. no. C77-U699

Material: Bone

Dimensions: 2.2 × 7.8 × 0.9 cm

Worcester Art Museum, Antioch Excavation, 1940.329

Condition: Good. The pin is complete except for a large chip from the upper right edge of the face and a small chip from the nose. The pin was broken at the neck and repaired.

The pin's terminal decoration is a trapezoidal head with an abstract face consisting of large oval eyes, eyebrows, and a nose. Below the face are four incised horizontal lines. The pin itself is short (approximately the same length as the head) and roughly chiseled to a point.

Unpublished

46.
Pin
Roman period

Provenance: Excavated at Antioch, inv. no. C418-B254

Material: Bone

Dimensions: large, 9.3 × 0.7 cm; small, 8.1 × 0.4 cm

Worcester Art Museum, Antioch Excavation, 1940.333

Condition: Good. The pin is undamaged.

The pin is of simple shape, with a conical head that tapers to a sharp point.

Unpublished

47.
Pin
Roman period

Provenance: Excavated at Antioch, inv. no. 350.6

Material: Bone

Dimensions: 10.5 cm

Worcester Art Museum, Antioch Excavation, 1940.334

Condition: Good. The pin is unbroken but has some surface abrasions and losses.

The pin has a knobbed head, its shaft is narrow at the neck, then bulges toward the center before tapering to a point.

Unpublished

48.
Boss
Roman period

Provenance: Excavated at Antioch, inv. no. C544-B260

Material: Bone

Dimensions: 2.7 Diam. × 1.0 cm

Worcester Art Museum, Antioch Excavation, 1940.336

Condition: Good. There are some cracks in the surface and some small losses along the edge.

The object is a convex disc with an incised ridge around the edge. Five incised circles with central dots are arranged near the circumference of the disc; at the center is another dot within two concentric incised circles.

Other bone counters with the same number of dots were discovered at Anemurium and Corinth.[1] These were perhaps game pieces.

unpublished

1. Russell 1982, 137, fig. 4.26 (Anemurium), Davidson 1952, 220, cat. 1700, pl. 99 (Corinth).

Coins

Anne Leinster Windham

THE COINS IN THIS CHECKLIST are from the Hellenistic, Roman, Byzantine and Crusader periods. They are not all minted at Antioch; some are from other cities in Syria, or even further afield. However, they reflect Antioch's influence in the political and economic life of the ancient world.

Antioch was founded in 300 B.C.E. by one of Alexander the Great's generals, Seleucus I. The mint began that year and outlasted even Rome's mint by striking coins up until the destruction of Antioch by the Arabs in 641 C.E. The earliest coins were minted by the authority of King Seleucus and his successors, known as the Seleucids. The Greek section of the checklist begins with a coin of Alexander and continues chronologically through the Seleucids, followed by some non-Seleucid rulers. The section ends with autonomous coinage, municipal issues that bear the name of the minting city but not the ruling king.

Although Pompey the Great captured Antioch for Rome in 64 B.C.E., there was no substantial change in the coinage until Augustus' tetradrachms of 6 B.C.E., which depicted Augustus on the obverse and the famous Tyche of Antioch on the reverse.[1] Throughout the Roman period, the mint produced coins set to both the Greek and Roman monetary standards; hence, this checklist has both tetradrachms and antoniniani of some emperors.

In the later Roman period Antioch became at least as politically important as the new capital of the empire, Constantinople. Antioch's location near the eastern border made it the first line of defense against the Persians. The city's large production of gold coins in the fourth century attests to its wealth and to the need to keep the Roman soldiers armed and ready.[2]

The reign of Anastasius I (491–518 C.E.) conventionally marks the beginning of the Byzantine period. Anastasius restructured the unwieldy coin denominations (in which 14,400 bronze nummi equaled one gold solidus) and introduced a new coin, the bronze follis, worth forty nummi.[3] After the devastating earthquake of 528 C.E., Antioch was renamed Theopolis ("City of God"), and the mint marks on the coins reflect that change. Byzantine coinage ends with Antioch's destruction in 641 C.E.,

which is followed by a long hiatus in minting. However, the two twelfth-century coins of Bohemond III of Antioch show that the city was again active during the Crusader period.

This catalogue refers to and relies upon Dorothy Waagé's fine publication of the Antioch coins. Following her lead, I use these explanations in the checklist.

Materials:	AV	gold
	AR	silver
	AE	bronze or copper

Condition of inscription:

[] occurring in the coin descriptions show that the enclosed letters are off the flan.

() occurring in the coin descriptions show that the enclosed letters are illegible.

References in the bibliography of each entry:

an unqualified reference means that the coin is just like the reference.

"cf." means that the coin differs in some minor respect from the reference (different monogram, symbol, etc.).

"type of" means that the coin is like the reference only in general type, and differs in some important detail(s).

The term "bust" is limited to the clothed bust. "Head" is applied to the head alone and to the head and nude shoulders.

The author would like to acknowledge Denis Deriev, who researched and wrote entries for six of the late Roman coins (1999.372–1999.375, 1999.377 –1999.378). He also provided valuable historic insight on the coins of the early Christian period.

Photographs of the coins appear at a scale of 1:1.

1. It is interesting to note that the early use of this most Antiochene figure was by two foreigners, Augustus and Tigranes of Armenia.
2. Metcalf 2000, 110.
3. Ibid.

Alexander III The Great
(336–323 B.C.E.)

AR tetradrachm, ca. 315–294 B.C.E., mint of Amphipolis

25 mm, 16.96 gr., rev. at five o'clock

Obverse. Head of Herakles, beardless and wearing lion's skin headdress, to right. Border of dots.

Reverse. Zeus enthroned, to left. He holds an eagle in his extended right hand and a scepter in his left. ΑΛΕΞΑΝΔΡΟΥ to right. To left, Λ over T with race torch below. Below throne, E. Border of dots.

Price 1991, 133, no. 440A.
Cf. Grose 1979, 55, no. 3430.

WAM 1999.320

Antiochus II Theos
(261–246 B.C.E.)

AR tetradrachm, ca. 256–255 B.C.E., mint of Seleucia-on-the-Tigris

30 mm, 15.43 gr., rev. at nine o'clock

Obverse. Diademed head of Antiochus I to right.

Reverse. Apollo seated to left on *omphalos*. He holds an arrow in his right hand and a bow in his left. ΒΑΣΙΛΕΩΣ to right, ΑΝΤΙΟΧΟΥ to left. In outer left field Ⱥ, in outer right field 𝅓.

Babelon 1890, 18, no. 122.
Gardner 1878, 9, no. 9.
Houghton and Lorber 2002, no. 587.2.
Newell 1978, no. 186.
This coin published in Kondoleon 2000, 104–105.

WAM 1999.321

Seleucus II Kallinikos
(246–226 B.C.E.)

AR tetradrachm, ca. 246–244 B.C.E., mint of Apamea?

29 mm, 16.61 gr., rev. at one o'clock

Obverse. Diademed head of Antiochus I to right. Border of dots.

Reverse. Apollo seated to left on *omphalos*. He holds an arrow in his right hand and a bow in his left. [ΣΩ]ΤΗΡΟΣ to right, [ΑΝ]ΤΙΟΧΟΥ to left.

Note: This coin was minted during the power struggle between Laodice and Berenice, the first and second wives, respectively, of Antiochus II. Each wanted her son to rule; Apamea avoided taking sides in this battle by minting coinage showing the grandfather of both young men, Antiochus I.

Houghton 1983, 29, no. 421.
Houghton and Lorber 2002, 227, no. 641.
Newell 1977, 163, no. 1144, pl. XXXIV, 11.
Cf. Le Rider 1999, 74–75, pl. 8.

WAM 1999.446

Seleucus II Kallinikos
(246–226 B.C.E.)

AR tetradrachm, ca. 244 B.C.E., mint of Antioch

28 mm, 16.71 gr., rev. at one o'clock

Obverse. Diademed head of Seleucus II to right, border of dots.

Reverse. Apollo standing to left, resting an elbow on tripod. ΒΑΣΙΛΕΩΣ to right, ΣΕΛΕΥΚΟΥ to left. In outer left field, Ⱦ. In outer right field, 𝈿.

Houghton and Lorber 2002, 254, no. 690a.
Le Rider 1999, 66, no. 94.
Newell 1977, 128, no. 1021, pl. XXV, 2.

WAM 1999.322

Antiochus III The Great
(223–187 B.C.E.)

AR tetradrachm, ca. 200–187 B.C.E., mint of Antioch

30 mm, 16.86 gr., rev. at one o'clock

Obverse. Diademed head of Antiochus III to right, fillet border.

Reverse. Apollo seated to left on *omphalos*. He holds an arrow in his right hand and a bow in his left. ΒΑΣΙΛΕΩ[Σ] to right, ΑΝΤΙΟΧ[ΟΥ] to left. In left field, outside inscription, line \ which might be part of a monogram.

Cf. Houghton 1983, 5, no. 79.

WAM 1999.323

Antiochus IV Epiphanes
(175–164 B.C.E.)

AE coin, ca. 168 B.C.E., mint of Antioch

35 mm, 39.22 gr., rev. at one o'clock

Obverse. Laureate head of Zeus-Serapis to right.

Reverse. Eagle standing to right, on thunderbolt. (ΒΑΣ)ΙΛΕ(ΩΣ) ΑΝΤΙΟΧΟΥ to right, ΘΕΟΥ (Ε)ΠΙΦΑΝΟΥ to left.

Note: This was part of a commemorative issue struck for Antiochus' victorious Egyptian campaigns, and hence was an unusual weight and denomination.

Gardner 1878, 38, no. 42, pl. XII, 11.
Houghton 1983, 8, no. 118, pl. 7.
Newell 1917, 25, no. 59.

WAM 1999.325

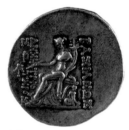

Antiochus IV Epiphanes
(175–164 B.C.E.)

AR tetradrachm, 167–165/4 B.C.E., mint of Ake-Ptolemais

33 mm, 15.74 gr., rev. at one o'clock

Obverse. Diademed head of Antiochus IV to right. To left of head, ₿. Fillet border.

Reverse. Zeus *nikephoros* enthroned, to left. In outer left field, palm branch. ΒΑΣΙΛΕΩΣ ΑΝΤΙΟΧΟΥ to right, ΘΕΟΥ ΕΠΙΦΑΝΟΥΣ ΝΙΚΗΦΟΡΟΥ to left. In exergue, Ⲙ.

Cf. Babelon 1890, 70, no. 543.
Cf. Houghton 1983, 78, no. 780, pl. 46.
Cf. Newell 1917, 29, no. 73.

WAM 1999.324

Demetrius I Soter
(162–150 B.C.E.)

AR tetradrachm, ca. 156–155 B.C.E., mint of Antioch

32 mm, 16.51 gr., rev. at one o'clock

Obverse. Diademed head of Demetrius I to right, laurel wreath border.

Reverse. Tyche seated to left on *cippus* adorned with a winged monster whose body ends in scrolls or a fish tail (perhaps representing Scylla). Tyche holds a scepter in her outstretched right hand and a cornucopia in her left. ΒΑΣΙΛΕΩΣ to right, ΔΗΜΗΤΡΙΟΥ ΣΩΤΗΡΟΣ to left. In left field, outside inscription, Ⲛ.

Note: The previous rulers from Antiochus III to Antiochus V used a fillet or dot border on the obverse of their coins. Demetrius' use of the laurel wreath may refer to his military successes and to the patronage of the god Apollo.

Gardner 1878, 46, no. 23.
Newell 1917, 39, no. 100, pl. VI.

WAM 1999.326

Demetrius I Soter
(162–150 B.C.E.)

AR drachma, ca. 152–151 B.C.E., mint of Antioch

18 mm, 3.92 gr., rev. at one o'clock

Obverse. Diademed head of Demetrius I to right, fillet border.

Reverse. Cornucopia. ΒΑΣΙΛΕΩΣ to right, ΔΗΜΗΤΡΙΟΥ ΣΩΤΗΡΟΣ to left. To right of cornucopia, ⟨monogram⟩. In exergue, ΑΕΡ.

Cf. Waagé 1952, 13, no. 130.
Type of Newell 1917, 41, no. 119, for identical monograms on a tetradrachm.

WAM 1999.327

Demetrius I Soter
(162–150 B.C.E.)

AE drachma with serrated edge, undated, mint of Antioch

17 mm, 4.22 gr., rev. at one o'clock

Obverse. Horse's protome to left, border of dots. Strike is partially off flan.

Reverse. Elephant protome to right. ΒΑΣΙΛΕΩΣ above, ΔΗΜΗΤΡΙ[ΟΥ] below.

Note: Cornelius Vermeule has suggested that the horse was Alexander the Great's steed, Bucephalus.

Mørkholm 1959, pl. 7, no. 242.
Waagé 1952, 13, no. 133. (42 examples of this type were found in the excavation at Antioch.)

WAM 1999.329

Demetrius I Soter
(162–150 B.C.E.)

AE didrachm with serrated edge, undated, mint of Antioch

20 mm, 6.78 gr., rev. at twelve o'clock

Obverse. Bust of Artemis to right, with quiver behind shoulder. Strike is partially off flan.

Reverse. Bow and *gorytus.* ΒΑΣΙΛΕΩ(Σ) to right, ΔΗΜΗΤΡΙΟΥ to left.

Lindgren 1985, 98, no. 1853.
Mørkholm 1959, pl. 7, no. 241.
Waagé 1952, 13, no. 132.

WAM 1999.328

Alexander I Balas
(150–145 B.C.E.)

AR tetradrachm, ca. 149–148 B.C.E., mint of Antioch

31 mm, 16.34 gr., rev. at one o'clock

Obverse. Diademed head of Alexander I to right, fillet border.

Reverse. Zeus *nikephoros* enthroned, to left. ΒΑΣΙΛΕΩΣ ΑΛΕΞΑΝΔΡΟΥ to right, ΘΕΟΠΑΤΟΡΟΣ ΕΥΕΡΓΕΤΟΥ to left. To the left of Zeus, ⟨monogram⟩. In left field, outside inscription, ⟨monogram⟩. In exergue, ΔΞΡ.

Babelon 1890, 111, no. 876.

WAM 1999.330

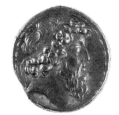
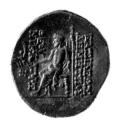

Antiochus VII Sidetes
(138–129 B.C.E.)

AR tetradrachm, ca. 134–132 B.C.E., mint of Damascus

30 mm, 16.75 gr., rev. at one o'clock

Obverse. Diademed head of Antiochus VII to right, fillet border.

Reverse. Athena *nikephoros* standing to left. ΒΑΣΙΛΕΩΣ ΑΝΤΙΟΧΟΥ to right, ΕΥΕΡΓΕΤΟΥ to left, all inside laurel border. To left of Athena, outside inscription, ⚲.

Cf. Gardner 1878, 71, no. 19.

WAM 1999.331

Demetrios II Nikator
(second reign, 130–125 B.C.E.)

AR tetradrachm, ca. 125 B.C.E., mint of Antioch

29 mm, 16.23 gr., rev. at twelve o'clock

Obverse. Diademed and bearded head of Demetrios II to right, fillet border.

Reverse. Zeus *nikephoros* enthroned, to left. To right, ΒΑΣΙΛΕΩΣ ΔΗΜΗΤΡΙΟΥ, to left, ΘΕΟΥ ΝΙΚΑΤΟΡΟΣ. To left, outside inscription, Ξ, under throne, Ο.

Gardner 1878, 77, no. 17.
Houghton 1983, 17, no. 289.
Newell 1917, 82, no. 320.

WAM 1999.447

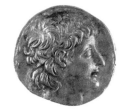
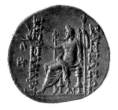

Antiochus VII Sidetes
(138–129 B.C.E.)

AR didrachm, 129 B.C.E., mint of Sidon

22 mm, 6.95 gr., rev. at twelve o'clock

Obverse. Diademed bust of Antiochus VII to right, wearing *chlamys*. Border of dots.

Reverse. Eagle standing to left, palm over right shoulder. Between eagle's legs, ⚲. ΒΑΣΙΛΕΩΣ to right, ΑΝΤΙΟΧΟΥ to left. To left, A over P E, and ⚲ over inverted club. To right, ΑΣ̄ over ΓΠΡ. Border of dots.

Cf. Babelon 1890, 141, no. 1091.
Cf. Gardner 1878, 70, no. 12.

WAM 1999.332

Alexander II Zebina
(128–123 B.C.E.)

AR tetradrachm, undated, mint of Antioch

28 mm, 16.39 gr., rev. at twelve o'clock

Obverse. Head of Alexander II to right, fillet border.

Reverse. Zeus *nikephoros* enthroned, to left. To right, ΒΑΣΙΛΕΩΣ, to left, ΑΛΕΞΑΝΔΡΟΥ. In outer left field, ⚲. Under throne, ΑΙ.

Newell 1917, 86, no. 341.
Cf. Gardner 1878, 81, no. 4.

WAM 1999.334

Alexander II Zebina
(128–123 B.C.E.)

AE didrachm, undated, mint of Antioch

21 mm, 7.5 gr., rev. at twelve o'clock

Obverse. Head of Alexander II to right, wearing lion's skin headdress. Border of dots.

Reverse. Nike walking to left, holding wreath in extended right hand, palm in left. ΒΑΣΙΛ(ΕΩΣ) to right, ΑΛΕΞΑ(ΝΔΡΟΥ) to left. To left, near leg, H.

Babelon 1890, 169, no. 1315.
Cf. Gardner 1878, 83, nos. 26 and 27.
See Newell 1917, 89 for discussion of dating.

WAM 1999.333

Cleopatra Thea and Antiochus VIII Grypus
(125–121 B.C.E.)

AR tetradrachm, 121 B.C.E., mint of Antioch

29 mm, 16.34 gr., rev. at twelve o'clock

Obverse. Diademed busts of Cleopatra Thea, wearing veil and *stephane*, and Antiochus VIII, both to right. Border of dots.

Reverse. Zeus *nikephoros* enthroned, to left. To right, [Β]ΑΣΙΛΙΣΣΗ[Σ] ΚΛΕΟΠΑΤΡΑΣ, to left, ΚΑΙ ΒΑΣΙΛΕΩΣ [Α]ΝΤΙΟΧΟΥ. In outer left field, IE. Under throne, AI.

Note: Cleopatra, after helping her son Antiochus to power, was killed by him in 121 B.C.E.

Newell 1917, 91, no. 361, pl. XI.
Cf. Gardner 1878, 86, no. 5.
Cf. Houghton 1983, 20, no. 316.
This coin published in Kondoleon 2000, 107.

WAM 1999.400

Antiochus VIII Grypus
(121–96 B.C.E.)

AR tetradrachm, ca. 117–115 B.C.E., mint of Ake–Ptolemais

30 cm, 16.28 gr., rev. at twelve o'clock

Obverse. Diademed head of Antiochus VIII to right, fillet border.

Reverse. Zeus Orianos, nude, stands to left. He holds a star in his raised right hand, a scepter in his left; a crescent is over his head. ΒΑΣΙΛΕΩΣ ΑΝΤΙΟΧΟΥ to right, ΕΠΙΦΑΝΟΥΣ to left, and the monogram M all within a laurel border.

Babelon 1890, 183, no. 1409, pl. XXV, 2.
Houghton 1983, 80, no. 812, pl. 48.
Newell 1939, 25, no. 28.

WAM 1999.337

Antiochus VIII Grypus
(121–96 B.C.E.)

AR tetradrachm, undated, mint of Tarsus

32 mm, 16.21 gr., rev. at twelve o'clock

Obverse. Diademed head of Antiochus VIII to right, fillet border.

Reverse. Conical shrine mounted on a garlanded base, with an eagle surmounting it. Within the shrine, the statue of the Near Eastern god Sandan stands on a horned lion. [Β]ΑΣΙΛΕΩΣ ΑΝΤΙΟΧΟΥ to right, ΕΠΙΦΑΝΟΥΣ to left. In outer left field, ⅄ and �H.

Note: The reverse image refers to a famous monument in Tarsus, the Altar of Sandan. This coin was probably minted at Tarsus during the time when Antiochus Philopator, Grypus' rival, had control of Antioch.

Gardner 1878, 89, no. 22, pl. XXIV, 3.
Cf. Babelon 1890, 185, no. 1424.
Cf. Comstock and Vermeule 1964, 64, no. 290.
Cf. Oman 1917, 190.

WAM 1999.335

Antiochus VIII Grypus
(121–96 B.C.E.)

AE coin, 121 B.C.E., mint of Antioch

17 mm, 5.93 gr., rev. at twelve o'clock

Obverse. Radiate head of Antiochus VIII to right. Border of dots.

Reverse. Eagle standing to left, scepter over right shoulder. ΒΑΣΙΛΕΩΣ ΑΝΤΙΟΧΟΥ to right, [Ε]ΠΙΦΑΝΟΥΣ to left. Below eagle, B9P.

Gardner 1878, 90, no. 25.
Lindgren 1985, 99, no. 1864.

WAM 1999.336

Seleucus VI Nikator
(96–95 B.C.E.)

AR tetradrachm, undated, mint of Antioch

29 mm, 15.15 gr., rev. at one o'clock

Obverse. Diademed head of Seleucus VI to right, fillet border.

Reverse. Zeus *nikephoros* enthroned, to left. To right, [B]ΑΣΙΛΕΩΣ ΣΕΛΕΥΚΟΥ, to left, ΕΠΙΦΑΝΟΥΣ ΝΙΚΑΤΟΡΟΣ. Below throne, N, all within laurel border.

Gardner 1878, 95, no. 1, pl. XXVIII, 11.
Cf. Houghton 1983, 23, no. 364.
Cf. Newell 1917, 111, no. 423.
This coin published in Kondoleon 2000, 104–105, 107.

WAM 1999.338

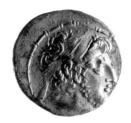
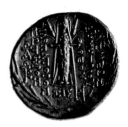

Demetrios III Philopater
(95–88 B.C.E.)

AR tetradrachm, 95 B.C.E., mint of Damascus

30 mm, 15.47 gr., rev. at twelve o'clock

Obverse. Diademed head of Demetrios III to right, fillet border. Strike is partially off flan.

Reverse. Veiled polymastic statue of Demeter, ears of barley rising from her shoulders, her hands extended. To right, ΒΑΣΙΛΕΩΣ ΔΗΜΗΤΡΙΟΥ ΘΕΟΥ, to left, ΦΙΛΟΠΑΤΟΡΟΣ ΣΩΤΗΡΟΣ. In left field, ℥ above ℟. In exergue, ⅡΣ, ℍ, all within laurel border.

Gardner 1878, 101, no. 1.
Newell 1939, 78, no. 115.

WAM 1999.448

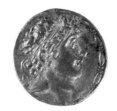
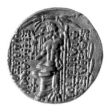

Philip Philadelphus
(95–83 B.C.E.)

AR tetradrachm, undated, mint of Antioch

27 mm, 15.43 gr., rev. at twelve o'clock

Obverse. Diademed head of Philip to right, fillet border.

Reverse. Zeus *nikephoros* enthroned, to left. To right, ΒΑΣΙΛΕΩ[Σ] ΦΙΛΙΠΠΟΥ, to left, ΕΠΙΦΑΝΟΥ[Σ] ΦΙΛΑΔΕΛ[ΦΟΥ]. To left of Zeus' legs, φ, under throne, △. All within laurel wreath.

Gardner 1878, 100, no. 11.
Cf. Newell 1917, 122, no. 454.

WAM 1999.339

Non-Seleucid Rulers

Egypt

Ptolemy I
(323–285 B.C.E.)

AR tetradrachm, ca. 310–305 B.C.E., mint of Alexandria

29 mm, 13.18 gr., rev. at twelve o'clock

Obverse. Bust of Alexander the Great with *aegis* and elephant-skin headdress, to right. Border of dots.

Reverse. Athena walking to right, holding spear and shield. To left, ΑΛΕΞΑΝΔΡΟΥ. In left field, star, in right field, the monogram ⊞, Corinthian helmet, and eagle below.

Kromann 1977, no. 28.
Poole 1883, Ptolemaeus I Soter, fourth coinage, no. 35.
Svoronos 1904–1908, vol. II, 30, no. 174, pl. VI, 11.

WAM 1999.449

Ptolemy II Philadelphus
(283–246 B.C.E.)

AR tetradrachm, undated, mint of Sidon

25 mm, 14.18 gr., rev. at twelve o'clock

Obverse. Diademed bust of Ptolemy II to right, wearing *aegis*.

Reverse. Eagle standing to left, on thunderbolt. To right, ΒΑΣΙΛΕΩΣ, to left, ΣΙ. The additional inscription ΠΤΟΛΕΜΑΙΟΥ has been noted on other coins, but here is completely off the flan.

Note: Ptolemy II had close ties to the Seleucid realm. His daughter, Berenice, was the second wife of Antiochos II. After her murder at the hands of Antiochos' first wife, Berenice's brother Ptolemy III conquered much of Syria, even occupying Antioch for several years (246–244 B.C.E.).

Kromann 1977, nos. 506, 507.
Poole 1883, 27, no. 32, pl. IV, no. 7.
Svoronos 1904–1908, vol. II, 105, no. 713, pl. XXI, 2.

WAM 1999.403

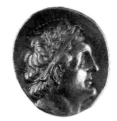

Ptolemy III Euergetes
(246–221 B.C.E.)

AR tetradrachm, ca. 245 B.C.E., mint of Ake-Ptolemais?

30 mm, 14.06 gr., rev. at twelve o'clock

Obverse. Diademed head of Ptolemy I to right. Border of dots.

Reverse. Eagle standing to left, on thunderbolt. To right, ΣΩΤ(ΗΡΟ)Σ, to left, ΠΤΟΛΕΜΑΙΟΥ. Monograms to right, Β above Α; to left, ⊓ above ⊏.

Cf. Kromann 1977, no. 471.
Cf. Poole 1883, 33, no. 116.
Svoronos 1904–1908, vol. II, 163, no. 1035, pl. XXXII, 13.

WAM 1999.404

Thrace

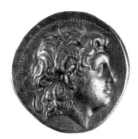

Lysimachus
(323–281 B.C.E.)

AR tetradrachm, ca. 297–281 B.C.E., mint of Sestos

32 mm, 16.79 gr., rev. at twelve o'clock

Obverse. Diademed head of the deified Alexander the Great to right, with the horn of Ammon in his hair. Border of dots.

Reverse. Athena *nikephoros* seated to left. She rests her left arm on her shield, behind. To right, ΒΑΣΙΛΕΩΣ, to left, ΛΥΣΙΜΑΧΟΥ. In inner left field, ⊕. In exergue, a crescent.

Muller 1966, no. 399.
Thompson 1968, 171, no. 49.

WAM 1999.398

Lysimachus
(323–281 B.C.E.)

AR tetradrachm, ca. 297–281 B.C.E., mint of Sestos

32 mm, 16.79 gr., rev. at one o'clock

Obverse. Diademed head of the deified Alexander the Great to right, with the horn of Ammon in his hair. Border of dots.

Reverse. Athena *nikephoros* seated to left. She rests her left arm on her shield, behind. To right, ΒΑΣΙΛΕΩΣ, to left, ΛΥΣΙΜΑΧΟΥ. In inner left field, a flower.

Thompson 1968, 170, no. 29, pl. 16.

WAM 1999.443

Pergamon

Attalos I
(241–197 B.C.E.)

AR tetradrachm, undated, mint of Pergamon

28 mm, 16.67 gr., rev. at twelve o'clock

Obverse. Laureate head of King Philetairus, founder of the Attalid dynasty, to right. Border of dots.

Reverse. Helmeted Athena seated to left on a stool. With her outstretched right hand she crowns the king's name, [Φ]ΙΛΕΤΑΙΡΟΥ. There is a spear at her side, shield behind. In the right field, a bow, in the left, A. In outer left field, a bunch of grapes.

Kleiner 1957 b, no. 1358.
Wroth 1892, 116, no. 38, pl. XXIV, 3.

WAM 1999.444

Bithynia

Nicomedes II of Bithynia
(149–120 B.C.E.)

AR tetradrachm, undated, unknown mint

39 mm, 15.91 gr., rev. at twelve o'clock

Obverse. Diademed head of Nicomedes II, to right.

Reverse. Zeus standing to left, wearing a *himation* and holding a scepter in his left hand. With his right hand he reaches out to crown the inscribed name of the king. To right, ΒΑΣΙΛΕΩΣ, to left, ΕΠΙΦΑΝΟΥΣ ΝΙΚΟΜΗΔΟΥ. Inner left field, between Zeus and inscription, an eagle above thunderbolt. Below that, the monograms ⊠ and ℕℙ.

Note: Under the leadership of Zipoëtes, Bithynia broke from the Seleucid empire during the reign of Antiochus I.

Cf. Kleiner 1957 a, no. 262.
Cf. Waddington 1976, 228.
Cf. Wroth 1889, 213, no. 1.

WAM 1999.399

Autonomous Coinage

Antioch-On-The-Orontes
(first century B.C.E.)

AE coin, 89 B.C.E., mint of Antioch

22 mm, 7.84 gr., rev. at one o'clock

Obverse. Diademed head of Zeus, to right. Border of dots.

Reverse. Zeus *nikephoros* enthroned, to left. To right, ΑΝΤΙΟΧΕΩ[Ν] ΤΗΣ, to left, [Μ]ΗΤΡΟΠΟΛΕ[ΩΣ]. To left of Zeus' legs, Η, to right, Ι. In exergue, ΓΚΣ.

Note: In the early first century B.C.E. bronze coins were minted in the name of the ruling Seleucid king. After 92 B.C.E. they were issued in the name of the city, even though Demetrius III still reigned. This type of municipal coinage continued until Augustus' rule in 7–6 B.C.E.

Cf. Lindgren 1985, 103, no. 1937.
Cf. Wroth 1889, 153, no. 14.

WAM 1999.340

Tigranes I of Armenia
(83–69 B.C.E.)

AR tetradrachm, undated, mint of Antioch

28 mm, 15.68 gr., rev. at twelve o'clock

Obverse. Draped bust of Tigranes I to right. He wears the high Armenian crown with side-flaps, decorated with a starburst between opposed eagles. Fillet border.

Reverse. Turret-crowned Tyche of Antioch seated to right on a rock. She holds a palm branch, and the river god Orontes swims below her feet. To right, ΒΑΣΙΛΕΩΣ, to left, [Τ]ΙΓΡΑΝΟ[Υ]. On rock, ⚏. Laurel border.

Note: Due to the political instability of the first century, the Syrian people offered their kingdom to Tigranes of Armenia.

Gardner 1878, 103, no. 6.
Cf. Babelon 1890, 213, no. 12, pl. XXIX, fig. 9.
Cf. Macdonald 1902, 194. He dates this coin type to early in Tigranes' reign.
This coin published in Kondoleon 2000, 104–105, 107.

WAM 1999.401

Arados
(first century B.C.E.)

AR tetradrachm, 87–86 B.C.E., mint of Arados

27 mm, 14.02 gr., rev. at twelve o'clock

Obverse. Bust of Tyche to right, wearing a turreted crown and veil. Border of dots.

Reverse. Nike walking to left, holding the *aphlastron* in her right hand and a palm branch in her left. To right, ΑΡΑΔΙΩΝ, to left, ΓΟΡ ✝ ΜΣ, all within laurel wreath.

Cf. Brett 1955, 286, no. 2199, pl. 103.
Cf. Hill 1910, 29, no. 230.

WAM 1999.382

Laodiceia
(first century B.C.E.)

AR tetradrachm, ca. 48–47 B.C.E., mint of Laodiceia

29 mm, 15 gr., rev. at twelve o'clock

Obverse. Bust of Tyche to right, wearing a turreted crown and veil. Behind her head, graffito ΜΑΡΙΩΝ (modern?). Fillet border.

Reverse. Zeus *nikephoros* enthroned, to left. To right, ΛΑΟΔΙΚΕΩΝ ΤΩΝ ΠΡΟΣ, to left, ΘΑΛΑΣΣΗ. To left, between Zeus and inscription, the letters Α Ι Η arranged vertically. Below throne, ⋈. In exergue, ΚΔ.

Mørkholm 1983, 105, no. 21b, pl. 18, no. 38.

WAM 1999.402

Side
(ca. 187–36 B.C.E.)

AR tetradrachm, undated, mint of Side

30 mm, 15.9 gr., rev. at twelve o'clock

Obverse. Head of Athena to right, in plumed Corinthian helmet.

Reverse. Nike walking to left, *taenia* in extended right hand. On either side of her, the inscription ΚΛΕΥΧ. In left field, a pomegranate.

Hill G. 1964, 148, no. 42.
Mørkholm 1965, no. 4797.

WAM 1999.445

Roman Coins

Augustus
(27 B.C.E.–14 C.E.)

AR tetradrachm, ca. 5/4 B.C.E., mint of Antioch

25 mm, 13.82 gr., rev. at twelve o'clock

Obverse. Laureate head of Augustus to right, ΚΑΙΣΑΡ(ΟΣ) (ΣΕ)ΒΑΣΤΟΥ around. Fillet border.

Reverse. Tyche of Antioch seated to right, with the personification of the River Orontes swimming below. Tyche wears the turret crown and holds a palm branch. ΕΤΟΥΣ ΖΚ ΝΙΚΗΣ around. To right, ⳩ IB, with ⳩ below.

Burnett, Amandry and Ripollès 1992, cat. 4152, pl. 158.
Wroth 1964, 166, cat. 132.
Wruck 1931, 178, cat. 3.
This coin published in Kondoleon 2000, 108.

WAM 1999.341

Nero
(54–68 C.E.)

AR tetradrachm, ca. 61/62 C.E., mint of Antioch

26 mm, 14.78 gr., rev. at twelve o'clock

Obverse. Laureate bust of Nero to right, wearing *aegis*. ΝΕΡΩΝΟΣ ΚΑΙΣΑΡ[ΟΣ] [ΣΕΒΑΣΤΟΥ] around. Border of dots.

Reverse. Eagle standing to left, on thunderbolt. To left, palm branch; to right, H over IP. Border of dots.

Burnett, Amandry and Ripollès 1992, cat. 4182, pl. 159.
Wroth 1964, 174, cat. 192.
Wruck 1931, 182, cat. 39.
This coin published in Kondoleon 2000, 104–105, 108.

WAM 1999.342

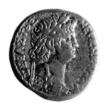
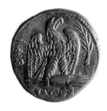

Nero
(54–68 C.E.)

AR tetradrachm, ca. 63/64 C.E., mint of Antioch

26 mm, 13.67 gr., rev. at twelve o'clock

Obverse. Laureate bust of Nero to right, wearing *aegis.*
ΝΕΡΩΝ ΚΑΙΣΑΡ ΣΕΒΑΣΤΟΣ around. Border of dots.

Reverse. Eagle standing to right, on thunderbolt. Palm branch
to right. To left, ΒΙΡ Ι. In exergue, ΕΤΟΥΣ upside down.
Border of dots.

Burnett, Amandry and Ripollès 1992, cat. 4189, pl. 160.
Wroth 1964, 175, cat. 198, pl. XXI, 9.
Wruck 1931, 182, cat. 47, pl. 3.

WAM 1999.343

Galba
(68–69 C.E.)

AR tetradrachm, 68 C.E., mint of Antioch

26 mm, 14.22 gr., rev. at twelve o'clock

Obverse. Laureate head of Galba right, star under chin.
ΓΑΛΒΑΣ ΑΥ[ΤΟΚΡΑΤΩΡ ΣΕΒΑΣΤΟΣ] around.

Reverse. Eagle standing to left on thunderbolt, palm to left.
ΕΤΟΥΣ [ΝΕΟΥ ΙΕΡΟ]Υ Α around.

Burnett, Amandry and Ripollès 1992, cat. 4194.
Wruck 1931, 184, cat. 55.

WAM 1999.344

Nero
(54–68 C.E.)

AE coin, undated, mint of Antioch

26 mm, 13.67 gr., rev. at twelve o'clock

Obverse. Laureate head of Nero to right, *lituus* below chin.
IMP NERO CLAV CÆSAR around. Border of dots.

Reverse. SC within laurel wreath. Border of dots.

Burnett, Amandry and Ripollès 1992, cat. 4308, pl. 163.
Waagé 1952, 34, nos. 348, 349. Nine of these coins were found at
Antioch.
Wroth 1964, 173, nos. 181–183, pl. XXI, 6.
Wruck 1931, 182, cat. 53.

WAM 1999.450

Vespasian
(69–79 C.E.)

AR tetradrachm, 69 C.E., mint of Antioch

30 mm, 13.87 gr., rev. at twelve o'clock

Obverse. Laureate head of Vespasian to right. ΑΥΤΟΚΡΑ
ΟΥΕΣΠΑΣΙΑΝΟΣ ΚΑΙΣΑΡ ΣΕΒΑΣΤΟΣ around. Bor-
der of dots.

Reverse. Eagle standing to left on club. To left, palm branch.
ΕΤΟΥΣ ΝΕΟΥ ΙΕΡΟΥ Β around. Border of dots.

McAlee 1995–1996, 135, cat. 76.
Wroth 1964, 178, cat. 227.
Wruck 1931, 186, cat. 76.
This coin published in Kondoleon 2000, 109.

WAM 1999.345

Titus
(79–81 C.E.)

AE dupondius, ca. 72–73 C.E., mint of Antioch

30 mm, 17.18 gr., rev. at twelve o'clock

Obverse. Laureate head of Titus to right. (T C)ÆSAR IMP (P)ONT around. Border of dots.

Reverse. S C within wreath. Border of dots.

Waagé 1952, 36, cat. 368.
Wroth 1964, 179, cat. 236.
Wruck 1931, 188, cat. 102.

WAM 1999.346

Domitian
(81–96 C.E.)

AR tetradrachm, ca. 90–91 C.E., mint of Antioch

25 mm, 14.17 gr., rev. at twelve o'clock

Obverse. Laureate head of Domitian to right. ΑΥΤ ΚΑΙΣΑΡ ΔΟΜΙΤΙΑ ΝΟΣ (Σ)ΕΒ ΓΕΡΜ around.

Reverse. Eagle standing on thunderbolt, with head to right. Palm branch to left. ΕΤΟΥΣ ΝΕΟΥ ΙΕΡ(ΟΥ) ΕΝΔΕΚΑΤΟΥ around. Border of dots.

Wroth 1964, 182, cat. 258.
Wruck 1931, 188, cat. 110, pl. 5.

WAM 1999.347

Trajan
(98–117 C.E.)

AR tetradrachm, ca. 110–111 C.E., mint of Antioch

27 mm, 14.44 gr., rev. at six o'clock

Obverse. Laureate head of Trajan to right. Below, eagle, in the field to left, club. ΑΥΤΟΚΡ ΚΑΙΣ ΝΕΡ ΤΡΑΙΑΝΟΣ ΣΕΒ ΓΕΡΜ ΔΑΚ around. Border of dots.

Reverse. Bust of Herakles to right. ΔΗΜΑΡΧ ΕΞ ΙΔ(?) ΥΠΑΤ Ε around. Border of dots.

Cf. Mørkholm 1959, 193, pl. 5.
Wruck 1931, 194, cat. 159.

WAM 1999.381

Trajan
(98–117 C.E.)

AR tetradrachm, ca. 110–111 C.E., mint of Antioch

25 mm, 13.99 gr., rev. at six o'clock

Obverse. Laureate head of Trajan to right. ΑΥΤΟΚΡ ΚΑΙΣ ΝΕΡ ΤΡΑΙΑΝΟΣ ΣΕΒ ΓΕΡΜ ΔΑΚ around.

Reverse. Eagle standing to left on club. ΔΗΜΑΡΧ ΕΞ ΙΕ ΥΠΑΤ Ε around.

Mørkholm 1959, 195, pl. 5.
Wruck 1931, 194, cat. 158.

WAM 1999.348

Hadrian
(117–138 C.E.)

AE coin, no date, mint of Antioch

26 mm, 19.93 gr., rev. at twelve o'clock

Obverse. Laureate bust of Hadrian to right, wearing *paludamentum* and cuirass. AYT KAI . . (remainder of inscription illegible). Control stamp under chin. Border of dots.

Reverse. SC within laurel wreath, ΓΔ below.

Wroth 1964, 186, cat. 299.
Cf. Waagé 1952, 41, cat. 433.

WAM 1999.349

Septimius Severus
(193–211 C.E.)

AR denarius, ca. 197–198 C.E., mint of Rome

17 mm, 2.64 gr., rev. at six o'clock

Obverse. Laureate head of Septimius Severus to right. L SEPT SEV PERT AVG IMP X around.

Reverse. Pax seated to left holding branch and scepter. PACI (ÆT)ERNÆ around.

Hill P. 1964, 21, cat. 346.

WAM 2000.63

Septimius Severus
(193–211 C.E.)

AR denarius, 195 C.E., mint of Rome

18 mm, 2.32 gr., rev. at six o'clock

Obverse. Laureate head of Septimius Severus to right. L SEPT SEV PER(T AUG IMP VI) around.

Reverse. Victory running to left holding wreath and trophy. ARAB ADIAB COS II PP around.

Note: This coin commemorated the Battle of Issus and Severus' Arabian victory.

Hill P. 1964, 18, cat. 187.

WAM 2000.62

Caracalla
(211–217 C.E.)

AR tetradrachm, ca. 215–217 C.E., mint of Seleucia Pieria

26 mm, 16.19 gr., rev. at twelve o'clock

Obverse. Laureate bust of Caracalla to right. AYT.K.M.A. ANTΩNEINOC around. Border of dots.

Reverse. Eagle standing to right on thunderbolt. ΔHMAPX EΞ YΠATO Δ around. Border of dots.

Bellinger 1940, 36, cat. 76, pl. VI, 18.

WAM 1999.350

Macrinus
(217–218 C.E.)

AR tetradrachm, ca. 217 – 218 C.E., mint of
Laodicea-Ad-Mare

28 mm, 13.99 gr., rev. at six o'clock

Obverse. Laureate head of Macrinus to right. AYT K M OΠ
CE MAKPEINOC (CEB) around.

Reverse. Eagle standing to left, between legs, a star.
ΔHMAPX EΞ YΠATOC Π Π around.

Bellinger 1940, 35, cat. 73, pl. VI, 12.

WAM 1999.351

Elagabalus
(218–222 C.E.)

AR tetradrachm, ca. 219–220 C.E., mint of Antioch

27 mm, 13.45 gr., rev. at twelve o'clock

Obverse. Laureate head of Elagabalus to right. AYT KMA
ANTΩNEINO(C CEB) around. Border of dots.

Reverse. Eagle standing, head to left. ΔHMAP(X) EΞ
(YΠA)TOC TO B around. Δ and E to left and right of
eagle, star between legs.

Wroth 1964, 202, cat. 418.

WAM 1999.352

Severus Alexander
(222–235 C.E.)

AE coin, undated, mint of Antioch

32 mm, 17.29 gr., rev. at five o'clock

Obverse. Laureate head of Severus Alexander to right. Inscrip-
tion, which is illegible, should read (AYT KAI MACEO
AΛEΞANΔPOC CE).

Reverse. Tyche seated to left, holding ears of corn. The river
Orontes swims below her; above, a ram running and looking
right. Δ and E on either side, below that S and C on either
side. ANTIOΞ around.

Waagé 1952, 60, 635.
Wroth 1964, 207, cat. 470.

WAM 1999.451

Gordian III
(238–244 C.E.)

AR antoninianus, ca. 238–239 C.E., mint of Rome

24 mm, 5.13 gr., rev. at six o'clock

Obverse. Radiate bust of Gordian, draped and cuirassed, to
right. IMP CÆS M ANT GORDIANVS AVG around.
Border of dots.

Reverse. Fides standing frontally with head to left, holding a
standard and scepter. FIDES MILITVM around. Border of
dots.

Mattingly, Sydenham and Sutherland 1949, 15, cat. 1, pl. 1, 1.

WAM 2000.64

Gordian III
(238–244 C.E.)

AR antoninianus, ca. 241–243 C.E., mint of Rome

23 mm, 3.42 gr., rev. at twelve o'clock

Obverse. Radiate bust of Gordian, draped and cuirassed, to right. IMP GORDIANVS PIVS FEL AVG around. Border of dots.

Reverse. Sol standing frontally with head to left, holding globe. ÆTERNITATI AVG around. Border of dots.

Mattingly, Sydenham and Sutherland 1949, 24, cat. 83, pl. 2, 5.

WAM 2000.65

Philip I, the Arab
(244–249 C.E.)

AR tetradrachm, ca. 244 C.E., mint of Antioch

25 mm, 10.85 gr., rev. at six o'clock

Obverse. Laureate bust of Philip, draped and cuirassed, to right. ΑΥΤΟΚ Κ Μ ΙΟΥΛ ΦΙΛΙΠΠΟΣ ΣΕΒ around. Border of dots.

Reverse. Eagle standing, head to left. ΔΗΜΑΡΧ ΕΞ ΟΥCΙΑC around. SC on either side of eagle's legs. MON VRB in exergue. Border of dots.

Note: Vermeule suggests that S[ENATUS] C[ONSULTO] MON[ETA] URB[IS] might have been added to explain the coinage to Roman soldiers from the Western Empire.

Pick 1887, 316 for discussion of MON URB inscription.
Wroth 1964, 212–213, cat. 507, 508, pl. XXV, 3.

WAM 1999.354

Gordian III
(238–244 C.E.)

AR tetradrachm, ca. 241–244 C.E., mint of Antioch

26 mm, 11.43 gr., rev. at twelve o'clock

Obverse. Laureate bust of Gordian III, draped and cuirassed, to right. ΑΥΤΟΚ Κ Μ ΑΝΤ ΓΟΡΔΙΑΝΟΣ ΣΕΒ around. Border of dots.

Reverse. Eagle standing, head to left. ΔΗΜΑΡΧ (ΕΞ ΥΠΑ)ΤΟ Β around. Between legs of eagle, ram running to left, head turned back, with crescent above. Border of dots.

Wroth 1964, 211, cat. 501.

WAM 1999.353

Philip I, the Arab
(244–249 C.E.)

AR tetradrachm, ca. 247–248 C.E., mint of Antioch

26 mm, 12.71 gr., rev. at one o'clock

Obverse. Laureate bust of Philip, wearing cuirass, to left. ΑΥΤΟΚ Κ Μ ΙΟΥΛ Ι ΦΙΛΙΠΠΟΣ ΣΕΒ around. Border of dots.

Reverse. Eagle standing, head to left. ΔΗΜΑΡΧ ΕΞ ΥΠΑΤΟ Δ around. ΑΝΤΙΟΧΙΑ/SC in exergue. Border of dots.

Wroth 1964, 214, cat. 517.

WAM 1999.355

Philip I, the Arab
(244–249 C.E.)

AR antoninianus, 248 C.E., mint of Rome

22 mm, 3.32 gr., rev. at twelve o'clock

Obverse. Radiate bust of Philip, draped and cuirassed, to right. IMP PHILIPPVS AVG around. Border of dots.

Reverse. Hexastyle temple with image of Roma, seated facing, within. SÆCVLVM NOVVM around. Border of dots.

Note: Philip's coins with the reverse inscription SÆCVLVM NOVVM ("new age") were struck to celebrate the millennium of Rome.

Mattingly, Sydenham and Sutherland 1949, 71, cat. 25a and 25b, pl. 6, 7.

WAM 1999.356

Philip I, the Arab
(244–249 C.E.)

AR antoninianus, ca. 247–249 C.E., mint of Rome

24 mm, 3.56 gr., rev. at six o'clock

Obverse. Radiate bust of Philip, draped and cuirassed, to right. IMP PHILIPPVS AVG around. Border of dots.

Reverse. Elephant walking to left, with a rider holding a goad and wand. ÆTERNITAS AVGG around.

Note: The elephant and the other exotic animals portrayed here and on 1999.359 and 1999.360 represented some of the animals shown in performances for the millennium celebration of Rome.

Mattingly, Sydenham, and Sutherland 1949, 75, cat. 58, pl. 6, 5.

WAM 1999.358

Philip I, the Arab
(244–249 C.E.)

AR antoninianus, 248 C.E., mint of Rome

23 mm, 3.92 gr., rev. at seven o'clock

Obverse. Radiate bust of Philip, draped and cuirassed, to right. IMP PHILIPPVS AVG around. Border of dots.

Reverse. Circular *cippus* or altar with COS III. SÆCVLARES AVGG around. Border of dots.

Mattingly, Sydenham, and Sutherland 1949, 71, cat. 24c, pl. 6, 6.

WAM 1999.357

Philip I, the Arab
(244–249 C.E.)

AR antoninianus, 248 C.E., mint of Rome

23 mm, 3.36 gr., rev. at one o'clock

Obverse. Radiate bust of Philip, draped and cuirassed, to right. IMP PHILIPPVS AVG around. Border of dots.

Reverse. Antelope walking to left, SÆCVLARES AVGG around. VI (or UI) in exergue.

Mattingly, Sydenham, and Sutherland 1949, 70, cat. 21, pl. 6, 12.

WAM 1999.359

Otacilia Severa, Wife of Philip I
(244–249 C.E.)

AR antoninianus, 248 C.E., mint of Rome

23 mm, 5.11 gr., rev. at seven o'clock

Obverse. Diademed and draped bust of Otacilia, on crescent, to right. OTACIL SEVERA AVG around. Border of dots.

Reverse. Hippo walking to right, SÆCVLARES AVGG IIII around.

Mattingly, Sydenham, and Sutherland 1949, 82, cat. 116b, pl. 7, 16.

WAM 1999.360

Otacilia Severa, Wife of Philip I
(244–249 C.E.)

AR antoninianus, ca. 246–248 C.E., mint of Rome

24 mm, 3.6 gr., rev. at twelve o'clock

Obverse. Diademed and draped bust of Otacilia, on crescent, to right. M OTACIL SEVERA AVG around. Border of dots.

Reverse. Concordia seated to left, holding a *patera* and double cornucopiae. CONCORDIA AVGG around.

Mattingly, Sydenham, and Sutherland 1949, 83, cat. 125.

WAM 1999.361

Trajan Decius
(249–251 C.E.)

AR tetradrachm, ca. 249–251 C.E., mint of Antioch

28 mm, 10.09 gr., rev. at seven o'clock

Obverse. Laureate bust of Trajan Decius, draped and cuirassed, to right. ΑΥΤΟΚ Κ ΓΑΙ ΜΕ ΚΥΙΝ ΔΕΚΚΙΟC ϹΕΒ around. Border of dots.

Reverse. Eagle standing frontally on palm, head to left. ΔΗΜΑΡΧ ΕΙ (ΕΞ?) ΟΥϹΙΑϹ around, S C below. Border of dots.

Wroth 1964, 222, cat. 595.

WAM 1999.362

Trajan Decius
(249–251 C.E.)

AR antoninianus, ca. 249–251 C.E., mint of Rome

24 mm, 4.3 gr., rev. at one o'clock

Obverse. Radiate bust of Trajan Decius, draped and cuirassed, to right. IMP TRAIANVS DECIVS AVG around. Border of dots.

Reverse. Helmeted Virtue seated to left on cuirass, holding a branch and a scepter. VIRTVS AVG around. Border of dots.

Mattingly, Sydenham, and Sutherland 1949, 121, cat. 8, pl. 10, 9.

WAM 1999.363

Trajan Decius
(249–251 C.E.)

AR antoninianus, ca. 250–251 C.E., mint of Milan

26 mm, 3.17 gr., rev. at two o'clock

Obverse. Radiate head of Hadrian to right. DIVO HADRIANO around. Border of dots.

Reverse. Eagle flying to right, head turned back. CONSECRATIO around. Border of dots.

Note: This coin is one of the series issued by Trajan Decius to celebrate the millennium of Rome. Various deified emperors are depicted in this issue; the reverse eagle symbolizes the soul of the emperor rising to join Jupiter in heaven.

Mattingly, Sydenham, and Sutherland 1949, 131, cat. 87, pl. 12, 10.

WAM 1999.364

Volusianus
(251–253 C.E.)

AR antoninianus, ca. 251–253 C.E., mint of Antioch

21 mm, 3.51 gr., rev. at twelve o'clock

Obverse. Radiate bust of Volusianus, draped and cuirassed, to right. IMP C C VIB VOLVSIANVS AVG around. Border of dots.

Reverse. Felicitas standing, looking to left and holding caduceus and cornucopia. FELICITAS PVBL around. Border of dots.

Mattingly, Sydenham, and Sutherland 1949, 183, cat. 217, pl. 14, 17.

WAM 1999.366

Trebonianus Gallus
(251–253 C.E.)

AR tetradrachm, ca. 251–253 C.E., mint of Antioch

26 mm, 11.67 gr., rev. at twelve o'clock

Obverse. Laureate bust of Trebonianus Gallus, draped and cuirassed, to right. ΑΥΤΟΚ Κ Γ ΟΥΙΒ ΤΡΕΒ ΓΑΛΛΟC CEB around. Beneath the bust, three pellets. Border of dots.

Reverse. Eagle, standing facing, head to right. Between legs, Γ. ΔΗΜΑΡΧ ΕΞ ΟΥCΙΑC around, in exergue, S C. Border of dots.

Wroth 1964, 227, cat. 632, pl. XXVI, 3.

WAM 1999.365

Valerian I
(253–260 C.E.)

AR antoninianus, ca. 253–254 C.E., mint of Antioch

24 mm, 3.54 gr., rev. at five o'clock

Obverse. Radiate bust of Valerian, draped and cuirassed, to right. IMP C P LIC VALERIANVS AVG around. Border of dots.

Reverse. Valerian and Gallienus standing facing, wearing military clothing. One holds a spear and globe, the other a Victory and spear. VIRTVS AVG around. Border of dots.

Mattingly, Sydenham, and Webb 1927, 60, cat. 293.

WAM 1999.367

Gallienus
(253–268 C.E.)

AR antoninianus, ca. 260–268 C.E., mint of Asia

23 mm, 4.28 gr., rev. at twelve o'clock

Obverse. Radiate bust of Gallienus, draped and cuirassed, to right. GALLIENVS AVG around. Border of dots.

Reverse. Roma seated to left on cuirass and shield, holding Victory. Star below. ROMÆ ÆTERNÆ around. Border of dots.

Mattingly, Sydenham, and Webb 1927, 188, cat. 655.

WAM 1999.368

Salonina, Wife of Gallienus
(253–268 C.E.)

AR antoninianus, ca. 260–268 C.E., mint of Asia

22 mm, 3.76 gr., rev. at one o'clock

Obverse. Diademed and draped bust of Salonina, on crescent, to right. SALONINA AVG around. Border of dots.

Reverse. Roma seated on right handing Victory to standing emperor on left. ROMÆ ÆTERNÆ around. Border of dots.

Mattingly, Sydenham, and Webb 1927, 115, cat. 67, pl. IV, 61.

WAM 1999.369

Constantius I Caesar
(293–305 C.E.)

AE follis, ca. 297 C.E., mint of Antioch

27 mm, 14.27 gr., rev. at six o'clock

Obverse. Laureate bust of Constantius to right. FL VAL CONSTANTIVS NOB CÆS around.

Reverse. Genius stands with head to left, wearing *modius* and holding a *patera* and cornucopia. A in right field, ANT in exergue. GENIO POPVLI ROMANI around.

Sutherland 1967, 619, cat. 49a.

WAM 1999.370

Galerius Maximianus Caesar
(292–305 C.E.)

AR argenteus, ca. 298 C.E., mint of Antioch

20 mm, 3.18 gr., rev. at twelve o'clock

Obverse. Laureate bust of Galerius to right. MAXIMIANVS CÆSAR around. Border of dots.

Reverse. Three-turreted camp gate. VIRTVS MILITVM around, *ANTH* in exergue. Border of dots.

Sutherland 1967, 618, cat. 43b.
This coin published in Kondoleon 2000, 110.

WAM 1999.371

Maximinus II
(305–313 C.E.)

AE nummus, ca. 309–310 C.E., mint of Antioch

28 mm, 7.05 gr., rev. at twelve o'clock

Obverse. Laureate bust of Maximinus, wearing helmet and cuirass, to left, with spear over right shoulder and shield on left shoulder. MAXIMINVS NOB C(ÆS) around.

Reverse. Virtus standing, facing, head to left, in military dress, right hand leaning on round decorated shield, left on vertical spear. VIRTVS EXERCITVS around. ANT in exergue. S in field to right, altar in field to left.

Sutherland 1967, 634, no. 125.

WAM 1999.372

Constantine I, the Great
(306–337 C.E.)

AE coin, 324 C.E., mint of Heraclea

20 mm, 3.11 gr., rev. at twelve o'clock

Obverse. Laureate bust of Constantine to right. CONSTANTINVS AVG around. Border of dots.

Reverse. Wreath within which is the inscription VOT XX. (DN CONSTANTINI MAX AVG) around (inscription illegible).

Bruun 1966, 549, cat. 56.
Cf. Waagé 1952, 119, cat. 1410.

WAM 2000.67

Constantine I, the Great
(306–337 C.E.)

AE follis, ca. 311–313 C.E., mint of Thessalonike

25 mm, 3.49 gr., rev. at twelve o'clock

Obverse. Laureate bust of Constantine, draped and cuirassed, to right. IMP C CONSTANTINVS PF AVG around. Border of dots.

Reverse. Jupiter standing frontally, head to left, with *chlamys* over shoulder. He holds a Victory on a globe and a scepter; an eagle stands before him. IOVI CONSERVATORI AVGG NN around. Border of dots.

Sutherland 1967, 518, cat. 54, pl. 11.
Waagé 1952, 119, cat. 1424.

WAM 2000.66

Constantine I, the Great
(306–337 C.E.)

AE coin, 335 C.E., mint of Antioch

18 mm, 2.53 gr., rev. at five o'clock

Obverse. Diademed bust of Constantine to right. CONSTANTINVS MAX AVG around. Border of dots.

Reverse. Two soldiers standing, facing each other. Each holds a spear and rests a hand on a shield. Between them are two standards. GLORIA EXERCITVS around. In exergue, SMANA. Border of dots.

Bruun 1966, 549, cat. 56.
Waagé 1952, 118, cat. 1404.

WAM 2002.33

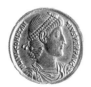

Constantius II
(337–361 C.E.)

AV solidus, ca. 347–355 C.E., mint of Antioch

21 mm, 4.41 gr., rev. at five o'clock

Obverse. Pearl-diademed bust of Constantius, draped and cuirassed, to right. FL IVL CONSTANTIVS PERP AVG around.

Reverse. Roma and Constantinopolis enthroned. Both draped figures support a shield inscribed VOT XX MVLT XXX. Roma holds a spear; Constantinopolis holds a scepter and rests her foot on a prow. GLORIA REIPVBLICÆ around. ΣMAN Γ in exergue.

Cf. Kent 1981, 518, cat. 81.

WAM 1999.373

Constantius II
(337–361 C.E.)

AE centenionalis, ca. 350–355 C.E., mint of Thessalonike

23 mm, 4.41 gr., rev. at six o'clock

Obverse. Diademed bust of Constantius, draped and cuirassed, to right. D N CONSTANTIVS P F A(VG) around.

Reverse. Emperor in military dress advancing left, holding Victory on globe and *labarum*, spurning a seated barbarian with his right foot. FEL TEMP RE(PARATIO) around. *T(SA)* in exergue. Γ in field to left, star in field to right.

Kent 1981, 418, cat. 172.

WAM 1999.374

Constantius II
(337–361 C.E.)

AE centenionalis, ca. 348–351 C.E., mint of Nicomedia

22 mm, 3.96 gr., rev. at six o'clock

Obverse. Diademed bust of Constantius, draped and cuirassed, to left, holding globe in right hand and with shield on left shoulder. D N CONSTANTIVS P F AVG around.

Reverse. Emperor in military dress standing left, holding *labarum* in right hand and resting left hand on shield. In front of emperor are two kneeling captives. FEL TEMP REPARATIO around. ΣMN(A) in exergue. Γ in field to left, star in field to right.

Kent 1981, 476, cat. 71.

WAM 1999.375

Julian the Apostate
(361–363 C.E.)

AE coin, ca. 361–363 C.E., mint of Cyzicus

29 mm, 9.35 gr., rev. at one o'clock

Obverse. Pearl-diademed bust of Julian, draped and cuirassed, to right. DN FL CL IVLIANVS PF AVG around. Border of dots.

Reverse. Bull walking to right, two stars above. SECVRITAS REI PVB around. In exergue, CVZB.

Kent 1981, 500, cat. 127.

WAM 2000.68

Jorian
(363–364 C.E.)

AE coin, ca. 363–364 C.E., mint of Antioch

29 mm, 8.7 gr., rev. at six o'clock

Obverse. Rosette-diademed bust of Jorian, draped and cuirassed, to right. DN IOVIANVS PF AVG around. Border of dots.

Reverse. Emperor standing frontally, head to right. In right hand, *labarum*, in left, Victory on globe. (VICT)ORIA ROMANORVM. In exergue, ANTA. Border of dots.

Kent 1981, 533, cat. 228.
Waagé 1952, 133, cat. 1719.

WAM 2000.69

Arcadius
(393–408 C.E.)

AE coin, ca. 395–401 C.E., mint of Antioch

22 mm, 3.45 gr., rev. at five o'clock

Obverse. Diademed bust of Arcadius, draped and cuirassed, to right. (DN) ARCADIVS PF AVG around.

Reverse. Emperor standing frontally, head right, holding standard and globe. (GLORIA) ROMANORVM around. ANT △ in exergue.

Goodacre 1928, 25, cat. 33.
Kent 1994, 247, no. 70.
Waagé 1952, 142, cat. 1917.

WAM 1999.377

Valentinianus I
(364–375 C.E.)

AV solidus, ca. 364–367 C.E., mint of Antioch

21 mm, 4.17 gr., rev. at five o'clock

Obverse. Pearl-diademed bust of Valentinianus, draped and cuirassed, to right. DN VALENTINIANVS PF AVG around.

Reverse. Emperor standing frontally holding *labarum* and Victory on globe. Cross in field to left. RESTITVTOR REI PVBLICÆ around. In exergue, ANT A.

Mattingly, Sutherland, Carson and Pearce 1968, 270–272, cat. 2.

WAM 1999.376

Honorius
(393–423 C.E.)

AE coin, 395 C.E., mint of Antioch

21 mm, 4.40 gr., rev. at five o'clock

Obverse. Diademed bust of Honorius, draped and cuirassed, to right. DN HONORIVS PF AVG around.

Reverse. Emperor standing frontally, head right, holding standard and globe. GLORIA ROMANORVM around. ANT B in exergue.

Kent 1994, 246, no. 55.
Cf. Waagé 1952, 140, cat. 1883.

WAM 1999.378

Honorius
(393–423 C.E.)

AE coin, undated, mint of Antioch

20 mm, 5.13 gr., rev. at five o'clock

Obverse. Diademed bust of Honorius, draped and cuirassed, to right. (DN HONORIVS PF AVG) around (inscription is illegible).

Reverse. Emperor standing frontally, head right, holding standard and globe. (GLORIA) ROMANORVM around. ANT Γ in exergue.

Kent 1994, 246, no. 55.
Waagé 1952, 140, cat. 1883.

WAM 2002.34

Theodosius II
(408–450 C.E.)

AV solidus, ca. 420–422 C.E., mint of Constantinople

22 mm, 4.43 gr., rev. at twelve o'clock

Obverse. Helmeted and diademed bust of Theodosius II facing, head slightly to right. He wears a cuirass and cloak, and carries a shield and spear. DN THEODOSIVS PF AVG around. Border of dots.

Reverse. Victory standing frontally, looking to left. She holds a tall cross in one hand. VOT XX MVLT XXX I around. In exergue, CONOB. Border of dots.

Goodacre 1928, 31, cat. 12.
Kent 1994, 256, cat. 219.

WAM 1999.405

Theodosius II
(408–450 C.E.)

AV solidus, ca. 408–420 C.E., mint of Constantinople

21 mm, 4.43 gr., rev. at six o'clock

Obverse. Helmeted and diademed bust of Theodosius II facing, head slightly to right. He wears a cuirass and cloak, and carries a shield and spear. DN THEODOSIVS PF AVG around. Border of dots.

Reverse. Constantinopolis seated facing, wearing a helmet and *chiton*, holding a scepter which rests on a prow, and a Victory on a globe. Star in left field. CONCORDIA AVGG around. In exergue, CONOB. Border of dots.

Cf. Goodacre 1928, 31, cat. 4.
Kent 1994, 253, cat. 202.

WAM 1999.406

Sasanian Coins

Chosroes II
(591–628 C.E.)

AR coin, date unknown, mint possibly Damascus

32 mm, 4.03 gr., rev. at three o'clock

Obverse. Bust of Chosroes to right, bearded and wearing elaborate winged headdress and jewelry. Inscriptions in Pehlevi.

Reverse. A Sasanian fire altar with an attendant priest on each side. Above altar in field to left, a star; in field to right, a crescent. Inscriptions in Pehlevi.

Note: The Sasanian kingdom was influential on the art of Roman Antioch, but also posed a substantial threat to the city. Chosroes' father had captured Antioch in 573 c.e., although it was regained shortly after that.

Walker 1941, 5 ff.

WAM 2000.70

Chosroes II
(591–628 C.E.)

AR coin, date unknown, mint possibly Damascus

31 mm, 4.11 gr., rev. at four o'clock

Obverse. Bust of Chosroes to right, bearded and wearing elaborate winged headdress and jewelry. Inscriptions in Pehlevi.

Reverse. A Sasanian fire altar with an attendant priest on each side. Above altar in field to left, a star; in field to right, a crescent. Inscriptions in Pehlevi.

Walker 1941, 5 ff.

WAM 2000.71

Autonomous Coins

Antioch-On-The-Orontes
(first century C.E.)

AE coin, ca. 13/14 C.E., mint of Antioch

20 mm, 6.0 gr., rev. at one o'clock

Obverse. Laureate head of Zeus to right.

Reverse. Ram, running to right and looking back. Above, star. The inscription is illegible.

Cf. Burnett, Amandry and Ripollès 1992, 626, cat. 4269, pl. 162. Waagé 1952, 30, cat. 312. Thirteen of these coins were found at Antioch. Molnar 1999, see pages 50–51 for a discussion of the date of this coin and WAM 2000.79.

WAM 2000.78

Antioch-On-The-Orontes
(first century C.E.)

AE coin, ca. 13/14 C.E., mint of Antioch

20 mm, 7.29 gr., rev. at twelve o'clock

Obverse. Laureate head of Zeus to right. Border of dots.

Reverse. Ram, running to right and looking back. Above, star. ΕΠΙ ΣΙΛΑΝΟΥ ΑΝΤΙΟΧΕΩΝ. In field below ram, ΔΜ.

See bibliography for WAM 2000.78.

WAM 2000.79

Byzantine Coins

Justinus I
(518–527 C.E.)

AV solidus, ca. 519–527 C.E., mint of Constantinople

22 mm, 4.43 gr., rev. at six o'clock

Obverse. Helmeted, cuirassed bust of Justinus, facing in three-quarter view. He holds a spear and shield. DN IVSTINVS PP AVG around.

Reverse. Victory standing, facing. She holds a long cross and a globe surmounted by a cross. Star in right field. VICTORIA AVCCCΓ around. In exergue, CONOB.

Bellinger 1966, 36, cat. 2c.
Goodacre 1928, 65, cat. 1.

WAM 1999.407

Justinianus I
(527–565 C.E.)

AV solidus, ca. 527–538 C.E., mint of Constantinople

22 mm, 4.43 gr., rev. at six o'clock

Obverse. Helmeted, cuirassed bust of Justinianus, facing in three-quarter view. He holds a spear and shield. DN IVSTINIANVS PP AVG around.

Reverse. Victory standing, facing. She holds a long cross and a globe surmounted by a cross. Star in right field. VICTORIA AVGGG A around. In exergue, CONOB.

Bellinger 1966, 67, cat. 3a.
Goodacre 1928, 70, cat. 6.

WAM 1999.409

Justinianus I
(527–565 C.E.)

AV solidus, ca. 527–538 C.E., mint of Constantinople

23 mm, 4.41 gr., rev. at six o'clock

Obverse. Helmeted, cuirassed bust of Justinianus, facing in three-quarter view. He holds a spear and shield. DN IVSTINIANVS PP AVG around.

Reverse. Victory standing, facing. She holds a long cross and a globe surmounted by a cross. Star in right field. VICTORIA AVCCC B around. In exergue, CONOB.

Bellinger 1966, 67, cat. 3b.
Goodacre 1928, 70, cat. 6.

WAM 1999.408

Justinianus I
(527–565 C.E.)

AV solidus, ca. 545–565 C.E., mint of Constantinople

22 mm, 4.34 gr., rev. at six o'clock

Obverse. Helmeted, cuirassed bust of Justinianus, facing. He holds a globe surmounted by a cross and a shield. DN IVSTINIANVS PP AVG around. Border of dots.

Reverse. Victory standing, facing. She holds a long staff with a chi-rho at the top and a globe surmounted by a cross. Star in right field. VICTORIA AVGG A around. In exergue, CONOB.

Bellinger 1966, 70, cat. 9a.1–a.2.
Goodacre 1928, 71, cat. 9.

WAM 1999.410

Justinianus I
(527–565 C.E.)

AE follis, ca. 544–545 C.E., mint of Nicomedia

33 mm, 19.84 gr., rev. at six o'clock

Obverse. Helmeted, cuirassed bust of Justinianus, facing. He holds a cross on orb in his right hand, cross in right field. DN IVSTINIANVS PP AVG around.

Reverse. Large M with the chi-rho above and B below. To left, ANNO vertically, to right, X U II I vertically. In exergue, NIKO. Border of dots.

Bellinger 1966, 115, cat. 124b.1–b.3, pl. XXVII.

WAM 1999.379

Justinianus I
(527–565 C.E.)

AE follis, ca. 546–547 C.E., mint of Antioch

37 mm, 13.84 gr., rev. at five o'clock

Obverse. Helmeted, cuirassed bust of Justinianus, facing. He holds a cross on orb in his right hand, cross in right field. (DN IVSTINIANVS PP AVG) around (inscription is illegible).

Reverse. Large M with the chi-rho. To left, ANNO vertically, to right, X X vertically. In exergue, ԿԿԿͶ. Border of dots.

Bellinger 1966, 143, cat. 217, pl. XXXVII.
Goodacre 1928, 72, cat. 26.

WAM 1999.380

Justinus II
(565–578 C.E.)

AV solidus, 566 C.E., mint of Constantinople

21 mm, 4.34 gr., rev. at six o'clock

Obverse. Helmeted, cuirassed bust of Justinus II, facing. He holds a globe surmounted by Victory, who crowns him with a wreath. DN IVSTINVS PP AVG around.

Reverse. Constantinople seated, wearing helmet, tunic and mantle. She holds a spear and a globe surmounted by a cross. VICTORIA AVGGG I around. In exergue, CONOB. Border of dots.

Bellinger 1966, 198, cat. 3.
Goodacre 1928, 76, cat. 1.

WAM 1999.411

Phocas
(602–610 C.E.)

AV solidus, ca. 603–607 C.E., mint of Constantinople

23 mm, 4.46 gr., rev. at seven o'clock

Obverse. Bust of Phocas facing, wearing crown, cuirass and *paludamentum.* He holds a globe surmounted by a cross. ON FOCAS PERP AVG around.

Reverse. Victory standing, facing. She holds a long staff with a chi-rho at the top and a globe surmounted by a cross. VI(CTORI)A AVCC Γ around. In exergue, CONOB. Border of dots.

Grierson 1968, 154, cat. 5c.
Goodacre 1928, 90, cat. 1.

WAM 1999.413

Maurice Tiberius
(582–602 C.E.)

AV solidus, ca. 583–601 C.E., mint of Constantinople

22 mm, 4.33 gr., rev. at six o'clock

Obverse. Helmeted, cuirassed bust of Maurice Tiberius, facing. He holds a globe surmounted by a cross. DN TIBER MAVRIC PP AV around.

Reverse. Victory standing, facing. She holds a long staff with a chi-rho at the top and a globe surmounted by a cross. VICTORIA AVCC Θ around. In exergue, CONOB.

Bellinger 1966, 297, cat. 5i.
Goodacre 1928, 85, cat. 1.

WAM 1999.412

Phocas
(602–610 C.E.)

AV solidus, ca. 603–607 C.E., mint of Constantinople

23 mm, 4.4 gr., rev. at seven o'clock

Obverse. Bust of Phocas facing, wearing crown, cuirass and *paludamentum.* He holds a globe surmounted by a cross. ON FOCAS PERP AVG around.

Reverse. Victory standing, facing. She holds a long staff with a chi-rho at the top and a globe surmounted by a cross. N in right field. VICTORIA AVCC △ around. In exergue, CONOB.

Grierson 1968, 155, cat. 6b.
Goodacre 1928, 90, cat. 1.

WAM 1999.414

Heraclius
(610–641 C.E.)

AV solidus, ca. 636–637 C.E., mint of Constantinople

20 mm, 4.44 gr., rev. at six o'clock

Obverse. Three figures walking to left. In the center, Heraclius with a mustache and beard; on right, Heraclius Constantine unbearded; on left, Heraclonas unbearded. They all wear the *chlamys* and crowns surmounted by a trefoil design, and each carries a globe surmounted by a crucifix.

Reverse. Cross potent on base and three steps. In the field to the left, ħ. In field to right, I. VICTORIA A4S4ſ around, CONOB in exergue.

Grierson 1968, 259, cat. 36c.
Goodacre 1928, 98, cat. 28.

WAM 1999.415

Bohemond III
(1163–1201 C.E.)

AR dinar, undated, mint of Antioch

18 mm, .95 gr., rev. at five o'clock

Obverse. Helmeted bust facing, wearing chain armor. +BOAMVNDVS around (much of inscription is illegible). Border of dots.

Reverse. Cross with a crescent in upper right field. +ANTIOCHIE around (much of inscription is illegible).

Metcalf 1983, 32 ff., pls. 10–13.
Cf. Waagé 1952, 169, cat. 2292.

WAM 2002.30

Bohemond III
(1149–1201 C.E.)

AR dinar, undated, mint of Antioch

17 mm, .86 gr., rev. at six o'clock

Obverse. Helmeted bust facing, with cross on helmet. +BOAMVNDVS around (much of inscription is illegible). Border of dots.

Reverse. Cross with a crescent in upper right field. +ANTIOCHIE around (much of inscription is illegible).

Metcalf 1983, 32 ff., pls. 10–13.
Cf. Waagé 1952, 169, cat. 2292.

WAM 2002.31

Glossary

Alkalis: Reactive elements in the first column of the periodic table and their oxides, herein specifically soda (Na_2O) and potassia (K_2O). Alkalis from mineral salt deposits such as natron as well as from different types of plant ash were used as fluxes in glass making in antiquity.

Alloy: A mixture of two or more metals or a metal and a non-metal.

Amalgam: An alloy of mercury with any other metal. Amalgam or fire gilding generally involves the application of a paste of gold and mercury to a copper alloy or silver surface followed by heating to evaporate the mercury and promote adherence of the gold to the underlying metal.

Aphlastron: Curved prow of a ship, often used in trophy monuments.

Batch: As used in this text, the term batch denotes a specific mixture of raw or previously fired materials heated at a particular time to form a glass.

Brass: An alloy of copper and zinc.

Bronze: An alloy of copper and tin.

Calcite: A form of calcium carbonate ($CaCO_3$) that constitutes the major mineral in most limestones and marbles.

Chasing: The technique of displacing metal from the front to create relief or linear decoration.

Chiton: Basic garment worn usually knee-length by women.

Chlamys: Short cloak or mantle, a military cloak.

Cippus: Inscribed stone pillar set up as a boundary marker or commemorative monument.

Cuirass: Armor that covered the torso, breastplate.

Cuprite: Cuprous oxide (Cu_2O): generally purple-red to orange-red in color, it is found as a naturally occurring mineral and a corrosion product. In glasses containing copper, cuprite forms under reducing conditions and both colors and opacifies the glass.

Dolomite: A mineral composed of both magnesium and calcium carbonate [$CaMg(CO_3)_2$]. Dolomite is found independently and sometimes with calcite in limestones or marbles.

Emblema: A mosaic panel, usually the centerpiece of a composition, made separately and inserted as a unit.

Enamel: Melted glass fused to the surface of metal.

Energy dispersive X-ray spectrometry (EDS): An analytical method used to determine the chemical composition of a material. Characteristic X-rays are produced by each element when bombarded by an incident electron beam, as in the scanning electron microscope (SEM). The EDS detector measures the energies of the X-rays produced to identify the elements present, as well as counting the number of X-rays produced to quantify the amounts of the different elements present.

Engraving: A technique of surface decoration that involves cutting into metal with a sharp tool usually made of steel. Metal is removed by this process.

Erotes: Plural of Eros, Greek god of love: cupid, cherub.

Flux: A material added to another material or to a mixture of materials to lower its melting point.

Gorytus: Bow case, quiver.

Himation: Mantle worn over a peplos or chiton.

Labarum: Sacred military standard of the early Christian Roman emperors.

Litharge: Lead monoxide (PbO), generally produced from the oxidation of molten metallic lead as a byproduct of the cupellation process used to extract silver from lead-bearing ores.

Lituus: Curved staff or wand of an augur.

Modius: Roman unit of dry measurement, equivalent to a peck. The bucket in which the measurement was made is also called a modius, as is a similarly shaped headdress.

Natron: Naturally occurring mineral deposits of sodium compounds used as a source for soda (Na_2O) in glass making. The term relates to the Wadi Natrun in Egypt, a major source of these deposits.

Nikephoros: Carrying the figure of Victory.

Nucleus: Upper layer of mortar in the bedding for a mosaic pavement.

Omphalos: Sacred oval or hemispherical stone, associated with the god Apollo.

Opacifier: Particles dispersed in a glass matrix that impede the transmission of light. An opacifier may be separately added to molten glass or may precipitate (crystallize) from the glass melt during cooling.

Orans: Hands raised in a gesture of prayer.

Oxidation firing: Firing taking place in an oxygen-rich atmosphere. Excess oxygen is available to react with elements in the material being fired.

Paludamentum: Long military cloak, fastened at the shoulder with a brooch.

Patera: Shallow bowl, often used in the pouring of libations.

Pewter: An alloy of lead and tin.

Raising: A process of compressing metal to make a hollow form or vessel by hammering a flat sheet against a stake or other unyielding support.

Reduction firing: Firing that takes place in an oxygen-depleted atmosphere.

Repoussé: Raised relief decoration made by hammering from the back of a metal sheet.

Stable isotope analysis: An analytical method used for characterizing carbonate rocks based on calculating the ratios of stable carbon and oxygen isotopes. Comparison of ratios can sometimes help group samples by quarry site or even by blocks within a quarry.

Stephane: Crown-like headdress.

Taenia: Fillet or ribbon.

Tesserae: Pieces of stone, glass or other material, generally roughly cubic in shape, that are combined to form mosaics.

Triclinium: A Roman dining room; the term derives from the U-shaped arrangement of three couches (kline) in the dining area.

Type: As defined in this text, a general term used to group glasses that share one or more basic processing features.

Wavelength dispersive energy spectrometry (WDS): An analytical method used to determine the chemical composition of a material. Characteristic X-rays are produced by each element when bombarded by an incident electron beam, as in the scanning electron microscope (SEM). The WDS detector measures the wavelengths of the X-rays produced to identify the elements present, as well as counting the number of X-rays produced at each wavelength to quantify the amounts of the different elements present. The WDS detector has greater resolution than EDS, but is much more time consuming.

Workshop: As used in this text, the term mosaic workshop includes any group of workers or other entity engaged in the ongoing production of mosaics. The term glass workshop is defined in the same manner except that it concerns the production of glass and/or glass products. The term is also sometimes used to define the production site, which may be a fixed or temporary workspace.

X-ray diffraction (XRD): An analytical method for identifying crystalline materials based on the characteristic X-ray diffraction pattern produced when an X-ray beam is passed through a crystalline sample.

X-ray fluorescence (XRF): An analytical method used to determine the chemical composition of a material. As in EDS analysis, the detector measures the energies of characteristic X-rays to identify the elements present, as well as counting the number of X-rays produced to quantify the amounts of the different elements present. Unlike EDS in the SEM, however, a beam of X-rays rather than electrons is used to excite the characteristic X-rays from the material being analyzed. XRF is often used as a surface analysis technique and care must be taken in interpreting the results, since the composition of the surface can often differ from that of the interior.

Bibliography

The abbreviations used for periodicals and reference works are those recommended by the *American Journal of Archaeology* 95 (1991):

ACNAC Ancient Coins in North American Collections

ActaArchHung Acta archaeologica Academiae scientiarum Hungaricae

AIEMA Association internationale pour l'étude de la mosaïque antique

AJA American Journal of Archaeology. The Journal of the Archaeological Institute of America

AJN American Journal of Numismatics

ASR Die antiken sarkophagreliefs

CASVA Center for Advanced Study in the Visual Arts. National Gallery of Art, Washington, D.C.

DOP Dumbarton Oaks Papers

IGLSyr Inscriptions grecques et latines de la Syrie

IstMitt Istanbuler Mitteilungen

JGS Journal of Greek Studies

JRA Journal of Roman Archaeology

JRA Suppl Journal of Roman Archaeology. Supplementary Series

LIMC Lexicon iconographicum mythologiae classicae (Zurich and Munich 1974–)

NC Numismatic Chronicle

NNM American Numismatic Society. Numismatic Notes and Monographs

NS American Numismatic Society. Numismatic Studies

OJA Oxford Journal of Archaeology

PBSR Papers of the British School at Rome

ProcPhilSoc Proceedings of the American Philosophical Society

Qedem Qedem. Monographs of the Institute of Archaeology, Hebrew University of Jerusalem

RDAC Report of the Department of Antiquities, Cyprus

SNG Sylloge nummorum graecorum

YaleBull Yale University Art Gallery Bulletin

ZfN Zeitschrift für Numismatik

Abadie-Reynal and Darmon 2003
Abadie-Reynal, Catherine and Jean-Pierre Darmon. "La Maison et la mosaïque des Synaristôsai." In *Zeugma: Interim Reports*, by R. Early et al., JRA Suppl. 51, 79–99. Portsmouth, R.I., 2003.

AIEMA 2001
Association Internationale pour l'Étude de la Mosaïque Antique (AIEMA) Abstracts, IX Colloquium. Rome, 2001.

AIEMA 2005
Association Internationale pour l'Étude de la Mosaïque Antique (AIEMA), IX Colloquium. Rome, 2005.

Allison 1995
Allison, Penelope. "'Painter Workshops' or 'Decorators' Teams'?" in *Mededelingen van het Nederlands Instituut te Rome.* 54 (1995): 98–109.

Amedick 1991
Amedick, Rita. *Die Sarkophage mit Darstellungen aus dem Menschenleben: Vita Privata.* ASR 1.4. Berlin, 1991.

An Jiayao 2004
An Jiayao, "The Art of Glass Along the Silk Road." In *China: Dawn of a Golden Age, 200–750 AD*, James C. Y. Watt, 56–65. New York 2004.

Anastasiades 1993
Anastasiades, Aristodemos. "An Harpokrates Head in the Paphos District Museum." *RDAC* 1993: 275–278.

Anderson 1985
Anderson, J.K. *Hunting in the Ancient World.* Berkeley, Los Angeles, and London, 1985.

Antioch I 1934
Elderkin, George W., ed. *Antioch-on-the-Orontes I: The Excavations of 1932.* Princeton, 1934.

Antioch II 1938
Stillwell, Richard, ed. *Antioch-on-the-Orontes II: The Excavations of 1933–1936.* Princeton, 1938.

Antioch III 1941
Stillwell, Richard, ed. *Antioch-on-the-Orontes III: The Excavations of 1937–1939.* Princeton, 1941.

Artal-Isbrand 2002
Artal-Isbrand, Paula. "The Conservation of Antioch Mosaics at the Worcester Art Museum." In *Objects Specialty Group Postprints of the 29th Conference of the American Institute for Conservation, Dallas, May 30–June 5, 2001*, 136–149. Washington, D.C., 2002.

Artal-Isbrand, Becker, and Wypyski 2002
Artal-Isbrand, Paula, Lawrence Becker, and Mark T.
Wypyski. "Remains of Gilding and Ground Layers on
a Roman Marble Statue of Hygieia." In *Interdisciplinary
Studies in Ancient Stone: ASMOSIA 5*, eds. John J.
Herrmann Jr., Norman Herz, and Richard Newman,
196–200. London, 2002.

Artal-Isbrand and Nunberg 2003
Artal-Isbrand, Paula, and Sarah Nunberg. "New
Solutions for Loss Compensation on Mosaics at the
Worcester Art Museum." In *International Committee for
the Conservation of Mosaics, Arles/Saint Romain-en-Galles,
November 22–28, 1999*, 313–321. Arles, 2003.

Artal-Isbrand and Vignalo 2005
Artal-Isbrand, Paula, and Alisa Vignalo. "The
Worcester Hunt Mosaic: A 65-Year Treatment
History", *International Committee for the Conservation of
Mosaics, Thessaloniki (Greece), October 29–November 3,
2002*. 2005.

Athenaeus 1927
Athenaeus. *The Deipnosophists*. Vol. V, Charles Burton
Gulick, trans. Loeb Classical Library. London and
Cambridge, Mass., 1927–41.

Augustine 1995
Augustine. *Against the Academicians. The Teacher*. P. King,
trans. Indianapolis, 1995.

Babelon 1890
Babelon, Ernst. *Catalogue des monnaies grecques de la
Bibliothèque Nationale. Les Rois de Syrie, d'Arménie et de
Commagène*. Paris, 1890.

Balty 1969
Balty, Janine. *La grande mosaïque de chasse du triclinos*.
Brussels, 1969.

Balty Janine 1977
Balty, Janine. *Mosaïques antiques de Syrie*. Brussels, 1977.

Balty 1990
Balty, Janine. *La mosaïque de Sarrîn (Osrhoène)*. Paris, 1990.

Balty 1995
Balty, Janine. *Mosaïques antiques du Proche-Orient:
Chronologie, iconographie, interprétation*. Annales Littéraires
de l'Université de Besançon, 551. Paris, 1995.

Balty 1997
Balty, Janine. "Mosaïque et architecture domestique
dans l'Apamée des Vᵉ et VIᵉ siècles." In *Patron and
Pavements in Late Antiquity*, eds. Signe Isager and Birte
Poulsen, 84–110. Odense, 1997.

Balty 2001
Balty, Janine. "Doro Levi, *Antioch Mosaic Pavements*:
Cinquante Ans Après," *Byzantion* 71 (2001): 303–324.

Balty Jean Charles 1981
Balty, Jean-Charles. "Antiocheia." In *LIMC* I.I ,
840–851. Munich, 1981.

Baratte 1978
Baratte, François. *Catalogue des mosaïques romaines et
paléochrétiennes du Musée du Louvre*. Paris, 1978.

Baratte and Metzger 1985
Baratte, François, and Catherine Metzger. *Catalogues des
sarcophages en pierre d'époques romaine et paléochrétienne*. Paris,
1985.

Bartman 2002
Bartman, Elizabeth. "Eros's Flame: Images of Sexy
Boys in Roman Ideal Sculpture." In *The Ancient Art of
Emulation. Studies in Artistic Originality and Tradition from the
Present to Classical Antiquity*, ed. Elaine K. Gazda,
249–271. Ann Arbor, 2002.

Basgelen and Ergeç 2000
Basgelen, Nezih and Rifat Ergeç. *A Last Look at History:
Belkis/Zeugma, Halfeti, Rumkale*. Istanbul, 2000.

Bean 1971
Bean, George E. *Turkey Beyond the Meander: An
Archaeological Guide* (London, 1971).

Becatti 1970–71
Becatti, G. *Ninfe e divinità marine. Ricerche mitologiche,
iconografiche e stilistiche*. Studi Miscellanei 17. Rome,
1970–71.

Becker, Schorsch, Williams, and Wypyski 1994
Becker, Lawrence, Deborah Schorsch, Jane L.
Williams, and Mark T. Wypyski. "Technical and
Material Studies, Appendix 2: Enamel Enkolpion." In
*Art of Late Rome, and Byzantium in the Virginia Museum of
Fine Arts*, Anna Gonosová and Christine Kondoleon,
410–415. Richmond, Va., 1994.

Bellinger 1940
Bellinger, Alfred R. *The Syrian Tetradrachms of Caracalla
and Macrinus. NS no. 3*. New York, 1940.

Bellinger 1966
Bellinger, Alfred R. *Catalogue of the Byzantine Coins in the
Dumbarton Oaks Collection and in the Whittemore Collection*.
Vol. I. *Anastasius I to Maurice, 491–602*. Washington,
D.C., 1966.

Benner and Fobes 1949
The Letters of Alciphron, Aelian, and Philostratus, tr. A. R.
Benner and F. H. Fobes. Loeb Classical Library.
London and Cambridge, Mass., 1949.

Berg 2002
Berg, Ria. "Wearing Wealth: Mundus Muleibris and
Ornatus as Status Markers for Women in Imperial
Rome." In *Women, Wealth and Power in the Roman Empire*,
Acta Instituti Romani Finlandiae 25. Rome, 2002.

Bergmann and Kondoleon 1999
Bergmann, Bettina and Christine Kondoleon, eds. *The Art of Ancient Spectacle*. Studies in the History of Art 56. CASVA Symposium Papers 34. Washington, D.C., and New Haven, Conn., 1999.

Bingöl 1980
Bingöl, Orhan. *Das ionische Normalkapitell in hellenistischer und römischer Zeit in Kleinasien*. IstMitt. Bei Heft 20, Tübingen, 1980.

Blanchard-Lemée 1975
Blanchard-Lemée, Michèle. *Maisons à mosaïques du quartier central de Djemila, Cuicul*. Paris, 1975.

Blatt 1982
Blatt, Harvey. *Sedimentary Petrology*. San Francisco, 1982.

Bookidis 1990
Bookidis, N. "Ritual Dining in the Sanctuary of Demeter and Kore at Corinth. Some Questions," in *Sympotica. A Symposium on the Symposion*, ed. O. Murray, 86–94. Oxford, 1990.

Bowersock 1990
Bowersock, G. W. *Hellenism in Late Antiquity*. Ann Arbor, 1990.

Boyce 1975
Boyce, Mary. *A History of Zoroastrianism. I. The Early Period*. Handbuch der Orientalistik. Erste Abteilung. Der Nahe und der Mittlere Osten. 8. Band, 1. Abschnitt, Lieferung 2, Heft 2A. Leiden, 1975.

Brandi 1996
Brandi, Cesare. "Theory of Restoration, I, II." In *Historical and Philosophical Issues in the Conservation of Cultural Heritage*, eds. N. S. Price, K. Talley, A. Melucco Vaccaro, 230–235, 339–342. Los Angeles, 1996.

Brett 1955
Brett, Agnes Baldwin. *Catalogue of Greek Coins*. Boston, 1955.

Brill 1976
Brill, Robert H. "Scientific Studies of the Panel Materials." In *Kenchreai, Eastern Port of Corinth, II. The Panels of Opus Sectile in Glass*, eds. L. Ibrahim, R. Scranton and R. H. Brill, 225–255. Leiden, 1976.

Brill 1988
Brill, Robert H. "Scientific Investigations of the Jalame Glass and Related Finds." In *Excavations at Jalame: Site of a Glass Factory in Late Roman Palestine*, ed. G. D. Weinberg, 257–294. Columbia, 1988.

Brill 1999
Brill, Robert H. *Chemical Analyses of Early Glasses*. Vol. 2. The Tables. Corning, N.Y., 1999.

Brill 2001
Brill, Robert H. "Some Thoughts on the Chemistry and Technology of Islamic Glass." In *Glass of the Sultans*, eds. S. Carboni and D. Whitehouse, 25–45. New York, 2001.

Brill and Cahill 1988
Brill, Robert H. and Nicholas D. Cahill. "A Red Opaque from Sardis and Some Thoughts on Red Opaques in General." *JGS* 30 (1988): 16–27.

Brill and Whitehouse 1988
Brill, Robert H. and David Whitehouse. "The Thomas Panel." *JGS* 30 (1988): 34–50.

Brilliant 1984
Brilliant, Richard. *Visual Narratives. Storytelling in Etruscan and Roman Art*. Ithaca, 1984.

Broucke 1994
Broucke, Pieter. "Tyche and the Fortune of Cities in the Greek and Roman World." In *An Obsession with Fortune: Tyche in Greek and Roman Art*, ed. Susan B. Matheson, 40. YaleBull 1994. New Haven, Conn., 1994.

Brussels 1993
Splendeur des Sassanides: l'empire Perse entre Rome et la Chine (224–642): 12 février au 25 avril 1993. Exh. cat. Brussels, 1993.

Bruun 1966
Bruun, Patrick M. *The Roman Imperial Coinage. VII, Constantine and Licinus, A.D. 313–337*. London, 1966.

Budde 1972
Budde, Ludwig. *Antike Mosaiken in Kilikien*. II, *Die heidnischen Mosaiken*. Recklinghausen, 1972.

Burnett, Amandry, and Ripollès 1992
Burnett, Andrew, Michel Amandry, and Pere Pau Ripollès. *Roman Provincial Coinage I: From the Death of Caesar to the Death of Vitellius*. London, 1992.

Cable and Smedley 1987
Cable, M. and J. W. Smedley. "The Replication of an Opaque Red Glass from Nimrud." In *Early Vitreous Materials*, eds. M. Bimson and I. C. Freestone, 151–164, British Museum Occasional Paper 56. London, 1987.

Cahn and Kaufmann-Heinimann 1984
Cahn, Herbert A., and Annemarie Kaufmann-Heinimann, eds. *Der spätrömische Silberschatz von Kaiseraugst*. Derendingen, 1984.

Campbell 1934
Campbell, William A. *Antioch Field Diary, 1934 Season*, 1934.

Campbell 1935
Campbell, William A. *Antioch Field Diary, 1935 Season*, 1935.

Campbell 1988
Campbell, Sheila. *The Mosaics of Antioch. Subsidia Mediaevalia 15. Corpus of Mosaic Pavements in Turkey.* Toronto, 1988.

Campbell 1994
Campbell, Sheila. "Enhanced Images: The Power of Gems in Abstract Personifications." *IV^e colloque internationale pour l'étude de la mosaïque greco-romaine. Trèves, 8–14 août 1984*, eds. J.-P. Darmon and A. Rebourg, 55–59. *Bulletin de l'AIEMA*. Supplement. 1994.

Caputo 1959
Caputo, Giacomo. *Il teatro di sabratha e l'architettura teatrale africana.* Rome, 1959.

Carra 2000
Carra, Rosa Maria Bonacasa. "Pisside con scene nilotiche." In *Aurea Roma. Dalla Città Pagana alla Città Cristiano,* eds. Serena Ensoli and Eugenio La Rocca, 472–474, *cat. no. 83.* Rome, 2000.

Causey 1980
Causey, Faya. "A Larva Convivalis in the Getty Museum." *The J. Paul Getty Museum Journal* 8 (1980): 171–172.

Çimok 1995
Çimok, Fatih, ed. *Antioch Mosaics.* Istanbul, 1995.

Çimok 2000
Çimok, Fatih, ed. *Corpus of Antioch Mosaics.* Istanbul, 2000.

Clark 1993
Clark, Gillian. *Women in Late Antiquity: Pagan and Christian Life-styles.* Oxford, 1993.

Clarke 1991
Clarke, John R. *The Houses of Roman Italy 100 B.C.–A.D 250: Ritual, Space, and Decoration.* Berkeley, Los Angeles, and London, 1991.

Clarke 1994
Clarke, John R. "Mosaic Workshops at Pompeii and Ostia Antica." In *Fifth International Colloquium on Ancient Mosaics, Bath, England, September 5–12, 1987,* eds. Peter Johnson, Roger Ling, and David J. Smith, 89–102. JRA Suppl. 9. Part 1. Ann Arbor, 1994.

Clarke 2003
Clarke, John R. *Art in the Lives of Ordinary Romans.* Berkeley, Los Angeles and London, 2003.

Colt 1962
Colt, H. Dunscombe. *Excavations at Nessana (Auja Hafir, Palestine).* Vol. 1. London, 1962.

Comstock and Vermeule 1964
Comstock, Mary B., and Cornelius C. Vermeule. *Greek Coins 1950–1963.* Boston, 1964.

Comstock and Vermeule 1976
Comstock, Mary B., and Cornelius C. Vermeule. *Sculpture in Stone: The Greek, Roman, and Etruscan Collections of the Museum of Fine Arts, Boston.* Boston, 1976.

Cott 1940
Cott, Perry. Unpublished talk presented at the *American Association of Museums,* Detroit, 1940.

Creswell and Allan 1989
Creswell, K. A. C. *A Short Account of Early Islamic Architecture.* Revised and supplemented by James W. Allan. Aldershot, 1989.

Csallány 1954
Csallány, D. "Les Monuments de l'industrie byzantine des métaux I." *ActaArchHung* 2, fasc. 3–4, (1954): 311–340, with résumé in French, 340–348.

Da Costa, 1997
Da Costa, Virginia. "Funerary Portraiture and Symbolism: the Depiction of Women in Roman Asia Minor." Ph.D. thesis, University of California, Santa Barbara, 1997.

Daszewski 1985
Daszewski, W. A. *Dionysos der Erlöser: Griechische Mythen im spätantiken Cypern.* Mainz am Rhein, 1985.

Dauphin 1978
Dauphin, Claudine. "Symbolic or Decorative? The Inhabited Scroll as a Means of Studying Some Early Byzantine Mentalities." *Byzantion* 48 (1978): 10–34.

Dauphin 1987
Dauphin, Claudine. "The Development of the 'Inhabited Scroll' in Architectural Sculpture and Mosaic Art from Late Imperial Times to the Early Seventh Century A.D." *Levant* 19 (1987): 183–213.

Davidson 1952
Davidson, Gladys R. *Corinth,* 12. *The Minor Objects.* Princeton, 1952.

Deckers 1985
Deckers, J. G. "Dionysos der Erlöser? Bemerkungen zur Deutung des Bodenmosaiken im Haus des Aion in Nea-Paphos auf Cypern durch W.A. Daszewski." *Römische Quartalschrift für christliche Altertumskunde und Kirchengeschichte* 80 (1985): 145–72.

Décor 1985
Balmelle, Catherine, et al. *Le décor géométrique de la mosaïque romaine: repertoire graphique et descriptif des compositions lineaires et isotropes.* Paris, 1985.

Décor 2002

Balmelle, Catherine, et al. *Le décor géométrique de la mosaïque romaine I. Répertoire graphique et descriptif des compositions linéaires et isotropes.* 2nd edition, revised and corrected. Paris, 2002.

Demir 1996

Demir, Ataman. *Antakya Through the Ages.* Istanbul, 1996.

Densmore Curtis 1925

Densmore Curtis, C. *Sardis*, vol. 13. Part I: *Jewelry and Gold Work, 1910–1914.* Rome, 1925.

Dentzer-Feydy 1990

Dentzer-Feydy, J. "Les chapiteaux corinthiens normaux de Syrie méridionale." *Syria* 67 (1990): 633–663.

Dillon 1996

Dillon, Sheila. "The Portraits of a Civic Benefactor of 2nd-c. Ephesos." *JRA* 9 (1996): 261–274.

Dobbins 2000

Dobbins, John. "The Houses at Antioch." In *Antioch: The Lost Ancient City*, ed. Christine Kondoleon, 50–61. Princeton and Worcester, Mass., 2000.

Dohrn 1960

Dohrn, Tobias. *Die Tyche von Antiochia.* Berlin, 1960.

Donceel-Voûte 1988

Donceel-Voûte, Pauline. *Les pavements des églises byzantines de Syrie et du Liban.* Vol. 1, *Décor, archéologie et liturgie.* Publications d'histoire de l'art et d'archéologie de l'Université catholique de Louvain, 69. Louvain-la-Neuve, 1988.

Donceel-Voûte 1994

Donceel-Voûte, Pauline. "Syro-Phoenician Mosaics of the Sixth Century." In *Fifth International Colloquium on Ancient Mosaics, Bath, England, September 5–12, 1987*, eds. Peter Johnson, Roger Ling, and David J. Smith, 88–100. *JRA*, Suppl. 9. Part 2. Ann Arbor, 1994.

Donderer 1989

Donderer, Michael. *Die Mosaizisten der Antike und ihre wirtschaftliche und soziale Stellung* (Erlanger Forschungen Band 48). Erlangen, 1989.

Downey 1938

Downey, G. "Personifications of Abstract Ideas in the Antioch Mosaics," *ProcPhilSoc* 69, (1938): 349–363.

Downey 1959

Downey, Glanville. "Libanius' Oration in Praise of Antioch (Oration XI)." *ProcPhilSoc* 103, no. 6 (1959): 652–86.

Downey 1961

Downey, Glanville. *A History of Antioch in Syria: From Seleucus to the Arab Conquest.* Princeton, 1961.

Downey 1963

Downey, Glanville. *Ancient Antioch.* Princeton, 1963.

Dresser 1954

Dresser, Louise. "A Silver Plate from Antioch." *News Bulletin and Calendar* (Worcester Art Museum) 19, no. 4 (1954): 15–16.

Drobner and Viciano 2000

Drobner, Hubertus R. and Albert Viciano. *Gregory of Nyssa: Homilies on the Beatitudes. An English Version with Commentary and Supporting Studies.* Leiden, 2000.

Dunbabin 1978

Dunbabin, Katherine M. D. *The Mosaics of Roman North Africa.* Oxford, 1978.

Dunbabin 1989

Dunbabin, Katherine M. D. "*Baiarum Grata Voluptas:* Pleasures and Dangers of the Baths," *PBSR* 57 (1989): 6–46, plates II-XV.

Dunbabin 1993

Dunbabin, Katherine M. D. "Wine and Water at the Roman Convivium." *JRA* 6 (1993): 116–141.

Dunbabin 1999

Dunbabin, Katherine M. D. *Mosaics of the Greek and Roman World.* Cambridge, 1999.

Dunbabin 2003

Dunbabin, Katherine M. D. *The Roman Banquet. Images of Conviviality.* Cambridge, 2003.

Elderkin 1932

Elderkin, G. W. *Director's Report, Antioch Excavations, 1932 Season*, 1932.

Ellis 1991

Ellis, Simon. "Power, Architecture, and Décor: How the Late Roman Aristocrat Appeared to His Guests," In *Roman Art in the Private Sphere*, ed. Elaine K. Gazda, 117–134. Ann Arbor, 1991.

Ellis 2004

Ellis, Simon. "The Seedier Side of Antioch." In *Culture and Society in Later Roman Antioch: Papers from a Colloquium. London, 15 December 2001*, ed. Isabella Sandwell and Janet Huskinson, 126–133. Oxford, 2004.

Entwistle 2003

Entwistle, Chris, ed. *Through a Glass Brightly: Studies in Byzantine and Medieval Art and Archaeology Presented to David Buckton.* Oxford, 2003.

Evans 2001

Evans, Helen C. "The Arts of Byzantium." *The Metropolitan Museum of Art Bulletin* 18, no. 4 (Spring 2001).

Firatli 1964

Firatli, Nezih. *Les Stèles funéraires de byzance gréco-romaine.* BAH Istanbul, no. 15. Paris, 1964.

Fisher 1932a

Fisher, Clarence S. *Antioch Field Diary, 1932 Season,* 1932.

Fisher 1932b

Fisher, Clarence S. *Antioch Field Notes, 1932 Season,* 1932.

Fisher 1933a

Fisher, Clarence S. *Antioch Field Diary, 1933 Season,* 1933.

Fisher 1933b

Fisher, Clarence S. *Antioch Field Notes, 1933 Season,* 1933.

Fox 1986

Fox, Robin Lane. *Pagans and Christians.* San Francisco, 1986.

Foy 2000

Foy, D., Vichy M. and Picon M. "L'ingots de verre en Méditerrané occidentale." *Annales du 14e Congrès de l'Association internationale pour l'histoire du verre* (2000): 51–57.

Freestone 1987

Freestone, Ian C. "Composition and Microstructure of Early Opaque Red Glass." In *Early Vitreous Materials,* eds. M. Bimson and I. C. Freestone, 173–191. British Museum Occasional Paper 56. London, 1987.

Freestone 1990

Freestone, Ian C. "Laboratory Studies of the Portland Vase." *JGS* 32 (1990): 103–107.

Freestone 1991

Freestone, Ian C. "Looking Into Glass." In *Science and the Past,* ed. Sheridan Bowman, 37–56. London, 1991.

Freestone 2003

Freestone, Ian C. "Primary Glass Sources in the Mid First Millenium AD." *Annales du 15e Congrès de l'Association internationale pour l'histoire du verre* (2003): 111–115.

Freestone, Bimson, and Buckton 1990

Freestone, Ian, Mavis Bimson, and David Buckton. "Compositional Categories of Byzantine Glass Tesserae." *Annales du 11e Congrès de l'Association internationale pour l'histoire du verre* (1990): 271–279.

Freestone, Gorin-Rosen, and Hughes 2000

Freestone, Ian C., Yael Gorin-Rosen, and Michael J. Hughes. "Composition of primary glass from Israel." In *La Route du verre: ateliers primaires et secondaires de verriers du second millenaire av. J.-C. au Moyen-Age,* ed. M. D. Nenna, 65–84. Travaux de la Maison de l'Orient Méditerranéen no. 33. Lyon, 2000.

Freestone, Ponting, and Hughes 2002

Freestone, Ian C., M. Ponting, and Michael J. Hughes. "Origins of Byzantine Glass from Maroni Petrera, Cyprus." *Archaeometry* 44 (2002): 257–272.

Freestone, Stapleton, and Rigby 2003

Freestone, Ian C., Colleen Stapleton, and Valery Rigby. "The Production of Red Glass and Enamel in the Late Iron Age, Roman and Byzantine Periods." In *Through a Glass Brightly: Studies in Byzantine and Medieval Art and Archaeology Presented to David Buckton,* ed. C. Entwistle, 142–154. Oxford, 2003.

Gardner 1878

Gardner, Percy. *The Seleucid Kings of Syria.* London, 1878.

Garnsey, Hopkins, Whittaker 1983

Garnsey, Peter, Keith Hopkins, and C. R. Whittaker, *Trade in the Ancient Economy.* Berkeley, Los Angeles and London, 1983.

Garnsey and Saller 1987

Garnsey, Peter and Richard Saller, *The Roman Empire: Economy, Society, and Culture.* Berkeley, Los Angeles and London, 1987.

Gasparri 1986

Gasparri, Carlo. "Dionysos." In *LIMC* III.I, 414–514. Munich, 1986.

Germain 1969

Germain, Suzanne. *Les mosaïques de Timgad: étude descriptive et analytique.* Paris 1969.

Ghirshman 1962

Ghirshman, Roman. *Persian Art. Parthian and Sassanian Dynasties 249 B.C.–A.D. 651.* New York, 1962.

Gittings 2003

Gittings, E. "Elite Women. Dignity, Power, and Piety." In *Byzantine Women and Their World,* ed. Ioli Kalavrezou, 67–75. Cambridge, Mass. and New Haven, Conn., 2003.

Gonosová 1987

Gonosová, Anna. "The Formation and Sources of Early Byzantine Floral Semis and Floral Diaper Patterns Reexamined." *DOP* 41 (1987): 227–237.

Goodacre 1928

Goodacre, Hugh. *A Handbook of the Coinage of the Byzantine Empire.* Pt. 1: *Arcadius to Leontius.* London, 1928.

Gorin-Rosen 2000

Gorin-Rosen, Yael. "The Ancient Glass Industry in Israel: Summary of the Finds and New Discoveries." In *La Route du verre: ateliers primaires et secondaires de verriers du second millenaire av. J.-C. au Moyen-Age,* ed. M. D. Nenna, 49–63. Travaux de la Maison de l'Orient Méditerranéen no. 33. Lyon, 2000.

Grabar 1971
Grabar, André. "Le Rayonnement de l'art sassanide dans le monde chrétien." *Convegno internazionale sul tema: La Persia del Medioevo, Roma 1970*, 679–707. Accademia nazionale dei Lincei, Problemi attuali de scienza e di cultura, no. 160. Rome, 1971.

Gratuze, Soulier, Blet and Vallauri
Gratuze, B., I. Soulier, M. Blet and L. Vallauri. "De l'origine du cobalt: du verre à la céramique." *Revue d'Archéometrie* 20 (1996): 77–94.

Grierson 1968
Grierson, Philip. *Catalogue of the Byzantine Coins in the Dumbarton Oaks Collection and in the Whittemore Collection.* II, *Phocas to Theodosius III, 602–717*, Pt. I: *Phocas and Heraclius (602–641).* Washington, D.C., 1968.

Griswold and Uricheck 1998
Griswold, John, and Sari Uricheck. "Loss Compensation Methods for Stone." *Studies in Conservation* 37 (1998): 89–110.

Grose 1979
Grose, S.W. *Catalogue of the McClean Collection of Greek Coins, Fitzwilliam Museum.* Vol. 2. Chicago, 1979.

Gunter and Jett 1992
Gunter, Ann C., and Paul Jett. *Ancient Iranian Metalwork in the Arthur M. Sackler Gallery and the Freer Gallery of Art.* Washington, D.C., 1992.

Haddad 1949
Haddad, George. *Aspects of Social Life in Antioch in the Hellenistic–Roman Period* New York, 1949.

Hafez, Raif 1977
"The Treatment of Mosaic Pavements in Syria Since 1939." In *Mosaics No. 1: Deterioration and Conservation,* 92–93, Rome, 1977.

Hanfmann 1939
Hanfmann, George M. A. "Notes on the Mosaics from Antioch," *AJA* 43 (1939): 229-246.

Hanfmann 1951
Hanfmann, G. M. A. *The Seasons Sarcophagus in the Dumbarton Oaks.* Dumbarton Oaks Studies 2, Cambridge, Mass. 1951.

Harding 1989
Harding, Catherine. "The Production of Medieval Mosaics: The Orvieto Evidence." *DOP* 43 (1989): 73–102.

Harper 1978
Harper, Prudence Oliver. *The Royal Hunter. Art of the Sasanian Empire.* New York, 1978.

Harrison 1986
Harrison, R. Martin. *Excavations at Saraçhane in Istanbul.* Vol. 1. *The Excavations, Structures, Architectural Decoration, Small Finds, Coins, Bones, and Molluscs.* Princeton, 1986.

Hattatt 1985
Hattatt, Richard. *Iron Age and Roman Brooches.* Oxford, 1985.

Hattatt 1987
Hattatt, Richard. *Brooches of Antiquity.* Oxford, 1987.

Hattatt 1989
Hattatt, Richard. *Ancient Brooches and Other Artefacts.* Oxford, 1989.

Hemelrijk 1999
Hemelrijk, Emily Ann. *Matrona Docta: Educated Women in the Roman Elite from Cornelia to Julia Domna.* London and New York, 1999.

Henderson J. 1985
Henderson, Julian. "The Raw Materials of Glass Manufacturing in Antiquity." *OJA* 4 (1985): 267–291.

Henderson J. 1991a
Henderson, Julian. "Chemical Characterization of Roman Glass Vessels, Enamels and Tesserae." *Materials Issues in Art and Archaeology II. Materials Research Society Symposium Proceedings* 185 (1991): 601–607.

Henderson J. 1991b
Henderson, Julian. "Technological Characteristics of Roman Enamels." *Jewelry Studies* 5 (1991): 64–76.

Henderson P. 2000
Henderson, Priscilla. "Mosaic." In *Making Classical Art: Process and Practice,* ed. Roger Ling, 78–90. Charleston, S.C., 2000.

Herdejürgen 1996
Herdejürgen, Helga. *Stadtrömische und italische Girlanden sarkophage.* In *Die Sarkophage des ersten und zweiten Jahrhunderts.* ARS 6.2. Berlin, 1996.

Herrmann 1993
Herrmann, Ariel. "The Boy with the Jumping Weights." *The Bulletin of the Cleveland Museum of Art* 80, no. 7 (1993): 299–323.

Herrmann and Kondoleon 2003
Herrmann, John and Christine Kondoleon, "The Poetry of Water in Roman Imperial Art," *Apollo*, May 2003, 14–19.

Herz and Garrison 1998
Herz, Norman and Ervan G. Garrison. *Geological Methods for Archaeology.* Oxford, 1998.

Higgins 1980
Higgins, Reynold. *Greek and Roman Jewellery*. London, 1980.

Hill 1910
Hill, George Francis. *Catalogue of the Greek Coins of Phoenicia*. London, 1910.

Hill G. 1964
Hill, George Francis. *Catalogue of the Greek Coins of Lycia, Pamphylia and Pisidia*. London, 1897. Bologna, 1964, reprint.

Hill P. 1964
Hill, Philip V. *The Coinage of Septimius Severus and His Family of the Mint of Rome A.D. 193–217*. London, 1964.

Holum 1982
Holum, Kenneth G. *Theodosian Empresses*. Berkeley, 1982.

Houghton 1983
Houghton, Arthur. *Coins of the Seleucid Empire from the Collection of Arthur Houghton*. ACNAC no. 4. New York, 1983.

Houghton and Lorber 2002
Houghton, Arthur, and Catharine Lorber. *Seleucid Coins. A Comprehensive Catalogue*. Part 1: *Seleucus I through Antiochus III*. New York, 2002.

Humann 1904
Humann, Carl. *Magnesia am Maeander. Bericht über die Ergebnisse der Ausgrabungen der Jahre 1891–1893*. Berlin, 1904.

Huskinson 1999
Huskinson, Janet. "Women and Learning: Gender and Identity in Scenes of Intellectual Life on Late Roman Sarcophagi." In *Constructing Identities in Late Antiquity*, 190–213, ed. Richard Miles. London, 1999.

Huskinson 2002–2003
Huskinson, Janet. "Theater, Performance, and Theatricality in Some Mosaic Pavements From Antioch," *Bulletin of the Institute of Classical Studies* 46 (2002–2003) 131–165.

Jobst 1977
Jobst, Werner. *Römischen Mosaiken aus Ephesos. I: Die Hanghäuser des Embolos. Forschungen in Ephesos*. Band 8/2. Vienna, 1977.

Jobst 1997
Jobst, Werner. *Istanbul. The Great Palace Mosaic*. Vienna, 1997.

Kádár 1978
Kádár, Zoltán. *Survivals of Greek Zoological Illuminations in Byzantine Manuscripts*. Budapest, 1978.

Kalavrezou 2003
Kalavrezou, Ioli, ed. *Byzantine Women and Their World*. Cambridge, Mass. and New Haven, Conn., 2003.

Kautzsch 1936
Kautzsch, Rudolf. *Kapitellstudien. Beiträge zu einer Geschichte des spätantiken Kapitells im Osten vom vierten bis ins siebente Jahrhundert*. Berlin, 1936.

Kennedy 1998
Kennedy, David. "The Twin Towns of Zeugma on the Euphrates. Rescue Work and Historical Studies." In *JRA* Suppl. 27, 36–60. Portsmouth, R.I., 1998.

Kent 1981
Kent, J. P. C. *The Roman Imperial Coinage. VIII, The Family of Constantine, A.D. 337–364*. London, 1981.

Kent 1994
Kent, J. P. C. et al. *The Roman Imperial Coinage. X, 395–491*. London, 1994.

Kiilerich 1998
Kiilerich, Bente. "The Abundance of Nature—The Wealth of Man: Reflections on an Early Byzantine Seasons Mosaic from Syria." In *Kairos: Studies in Art History and Literature in Honor of Professor Gunilla Akerstrom-Hougen*, ed. Elizabeth Piltz and Paul Astrom, 22–31. Jonsered, 1998.

Kitzinger 1946
Kitzinger, Ernst. "The Horse and Lion Tapestry at Dumbarton Oaks: A Study in Coptic and Sassanian Textile Design." *DOP*, 3 (1946): 2–72.

Kitzinger 1951
Kitzinger, Ernst. "Studies on Late Antique and Early Byzantine Floor Mosaics: The Mosaics at Nikopolis," *DOP* 6 (1951): 81–122.

Kleiner 1957a
Kleiner, Gerhard. *SNG. Deutschland: Sammlung v. Aulock. Pontus, Paphlagonien, Bithynien*. 1. Heft. Berlin, 1957.

Kleiner 1957b
Kleiner, Gerhard. *SNG. Deutschland: Sammlung v. Aulock. Mysien*. 4. Heft. Berlin, 1957.

Kleiner and Matheson 2000
Kleiner, Diana E. E. and Susan B. Matheson, eds. *I Claudia II: Women in Roman Art and Society*. Austin, 2000.

Koch 1993
Koch, Guntram. *Sarkophage der römischen Kaiserzeit*. Darmstadt, 1993.

Kondoleon 1991
Kondoleon, Christine. "Signs of Privilege and Pleasure: Roman Domestic Mosaics." In *Roman Art in the Private Sphere*, ed. Elaine K. Gazda, 105–115. Ann Arbor, 1991.

Kondoleon 1995
Kondoleon, Christine. *Domestic and Divine: Roman Mosaics in the House of Dionysos.* Ithaca, N.Y., 1995.

Kondoleon 1999
Kondoleon, Christine. "Timing Spectacles: Roman Domestic Art and Performance." In *The Art of Ancient Spectacle*, eds. Bettina Bergmann and Christine Knodoleon, 321–341. Studies on the History of Art 56. *CASVA* Symposium Papers 34. Washington D.C. and New Haven, Conn., 1999.

Kondoleon 2000
Kondoleon, Christine. *Antioch: The Lost Ancient City.* Princeton and Worcester, Mass., 2000.

Kondoleon 2001
Kondoleon, Christine. Review of Signe Isager and Birte Poulsen, eds. *Patron and Pavements in Late Antiquity.* Odense, 1997. *JRA* 14 (2001): 648–650.

Koob 1986
Koob, Stephen P. "The Use of Paraloid B-72 as an Adhesive: Its Application for Archaeological Ceramics and Other Materials." *Studies in Conservation* 31 (1986): 7–14.

Koob 1991
Koob, Stephen P. "The Use of Acryloid B-72 in the Treatment of Archaeological Ceramics: Minimal Intervention." *Materials Research Society Symposium Proceedings* 185 (1991): 591–596.

Koortbojian 1995
Koortbojian, Michael. *Myth, Meaning, and Memory on Roman Sarcophagi.* Berkeley, Los Angeles and London, 1995.

Kraemer 1992
Ross Sheperd Kraemer, *Her Share of the Blessings: Women's Religions Among Pagans, Jews and Christians in the Greco-Roman World.* Oxford and New York, 1992.

Kriseleit 2000
Kriseleit, Irmgard. *Antiken Mosaiken: Altes Museum, Pergamonmuseum.* Berlin, 2000.

Kröger 1982
Kröger, Jens. *Sasanidischer Stuckdekor.* Baghdader Forschungen, 5. Mainz am Rhein, 1982.

Kromann 1977
Kromann, Anne and Otto Mørkholm. *SNG. Egypt: The Ptolemies.* Copenhagen, 1977.

Lassus 1934
Lassus, Jean, "La Mosaïque de Yakto." *Antioch I* 1934, 114–156.

Lassus 1938
Lassus, Jean. "La mosaïque du Phénix." *Monuments et mémoires de la fondation Piot* 36 (1938): 81–122.

Lavagne 2001
Lavagne, Henri, ed., *Mosaico romano del Mediterráneo: exposición presentada en el Museo arqueológico nacional Madrid, del 28 de mayo al 30 de julio de 2001.* Madrid, 2001.

Lavin 1963
Lavin, Irving. "The Hunting Mosaics of Antioch and their Sources," *DOP* 17 (1963): 180–285.

Leader-Newby 2004
Leader-Newby, Ruth. *Silver and Society in Late Antiquity. Functions and Meaning of Silver Plate in the Fourth to Seventh Centuries.* Aldershot, 2004.

Lefkowitz and Fant, 1982
Lefkowitz, Mary and Maureen B. Fant, *Women's Life in Greece and Rome.* Baltimore, 1982.

Leonardi 1947
Leonardi, Corrado. *Ampelos. Il simbolo della vita nell'arte pagana e paleocristiana.* Bibliotheca ephemerides liturgicae 2. Rome, 1947.

Le Rider 1999
Le Rider, Georges. *Antioche de Syrie sous les Séleucides: corpus des monnaies d'or et d'argent.* Vol. I, *De Séleucos I à Antiochos V c. 300–161.* Paris, 1999.

Levi 1947
Levi, Doro. *Antioch Mosaic Pavements.* 2 vols. Princeton, 1947.

Liebeschuetz 1972
Liebeschuetz, J.H.W.G. *Antioch. City and Imperial Administration in the Later Roman Empire.* Oxford, 1972.

Lilyquist, Brill, Wypyski,and Koestler 1993
Lilyquist, Christine, Robert H. Brill, Mark T. Wypyski, and Robert Koestler. "Part 2. Glass." In *Studies in Early Egyptian Glass*, eds. C. Lilyquist and R. H. Brill, 23–58. New York, 1993.

Lindgren 1985
Lindgren, Henry Clay and Frank L. Kovacs. *Ancient Bronze Coins of Asia Minor and the Levant from the Lindgren Collection.* San Mateo, 1985.

Ling 1994
Ling, Roger. "Against the Reverse Technique." *Fifth International Colloquium on Ancient Mosaics, Bath, England, September 5–12, 1987*, eds. Peter Johnson, Roger Ling, and David J. Smith, 77–88. *JRA* Suppl. 9. Part 1. Ann Arbor, 1994.

Ling 1998
Ling, Roger. *Ancient Mosaics.* Princeton, 1998.

Ling 2000
Ling, Roger, ed., *Making Classical Art: Process and Practice.* Charleston, S.C., 2000.

Lodge and McKay 1981–82
Lodge, Robert and Gina McKay. "The Antioch Mosaics at Oberlin: Their History and Preservation," *Bulletin of the Allen Memorial Art Museum, Oberlin College* 39:2 (1981–82): 55–69.

Lother 1929
Lother, Helmut. *Der Pfau in der altchristlichen Kunst: eine Studie über das Verhältnis von Ornament und Symbol.* Leipzig, 1929.

Lozinski 1995
Lozinski, B. Philip. "The Phoenix Mosaic from Antioch: A New Interpretation." In *Fifth International Colloquium on Ancient Mosaics, Bath, England, September 5–12, 1987,* eds. Peter Johnson, Roger Ling, and David J. Smith, 135–142. *JRA* Suppl. 9. Part 2. Ann Arbor, 1995.

Macdonald 1902
Macdonald, George. "The Coinage of Tigranes I." *NC* ser. 4, 2 (1902): 193–201.

MacDonald and Pinto 1995
MacDonald, William L. and John A. Pinto. *Hadrian's Villa and Its Legacy.* New Haven, 1995.

Maguire 1987
Maguire, Henry. *Earth and Ocean: The Terrestrial World in Early Byzantine Art.* University Park and London, 1987.

Manchester 1994
Manchester, Karen. "A Bronze Statuette Representing the Tyche of Antioch: Roman Copy or Roman Original," *Re/Collections* (The Merrin Gallery, New York), no. 1, 1994.

Mango 1977
Mango, Cyril. "Storia dell'arte." *La civiltà bizantina dal IV al IX secolo. Aspetti e problemi,* 285–350. Studi di Bari I, 1976. Bari, 1977.

Mango 1986
Mango, Marlia Mundell. *Silver from Early Byzantium: The Kaper Koraon and Related Treasures.* Baltimore, 1986.

Markoulaki 1990
Markoulaki, Stavroula. "Psiphidota Oikias Dionysou sto Mouseio Chanion," *Pepragmena tou 6th Diethnous Kretologikou Synedriou,* Vol. A1. Chania, 1990, 449–463 with illus.

Marrou 1938
Marrou, H. I. ΜΟΥCΙΚΟC ΑΝΗΡ. *Étude sur les scenes de la vie intellectuelle figurant sur les monuments funéraires romains.* Grenoble, 1938.

Marshall 1911
Marshall, F. H. *Catalogue of the Jewellery, Greek, Etruscan, and Roman, in the Departments of Antiquities, British Museum.* London, 1911.

Martiniani-Reber 1986
Martiniani-Reber, Marielle. *Lyon, Musée historique des tissus. Soieries sassanides, coptes et byzantines V^e – XI^e siècles.* Inventaire des collections publiques françaises, 30. Paris, 1986.

Martiniani-Reber 1997
Martiniani-Reber, Marielle. *Musée du Louvre. Textiles et mode sassanides. Les tissus orientaux conservés au département des antiquités égyptiennes.* Inventaire des collections publiques françaises, 39. Paris, 1997.

Mass, Stone, and Wypyski 1998
Mass, Jennifer L., Richard E. Stone, and Mark T. Wypyski. "The Mineralogical and Metallurgical Origins of Roman Opaque Colored Glasses." In *Prehistory and History of Glassmaking Technology. Ceramics and Civilization.* Volume 8, ed. P. McCray, 121–144. Westerville, Ohio, 1998.

Mass, Wypyski, and Stone 2002
Mass, Jennifer L., Mark T. Wypyski, and Richard E. Stone. "Malkata and Lishtglassmaking Technologies: Towards a Specific Link Between Second Millenium BC Metallurgists and Glassmakers." *Archaeometry,* 44:1 (2002): 67–82.

Mattingly, Sydenham, and Sutherland 1949
Mattingly, Harold, Edward A. Sydenham and C. H. V. Sutherland. *The Roman Imperial Coinage. IV.3, Gordian III to Uranius Antoninus.* London, 1949.

Mazal 1998
Mazal, Otto. *Der Wiener Dioskurides.* Vol. 1. Kommentar. Glanzlichter der Buchkunst 8/1. Graz, 1998.

McAlee 1995–1996
McAlee, Richard G. "Vespasian's Syrian Provincial Coinage." *AJN* 7–8 (1995–1996): 113–143.

Metcalf 1983
Metcalf, D. M. *Coinage of the Crusades and the Latin East in the Ashmolean Museum.* Oxford, 1983.

Metcalf 2000
Metcalf, William E. "The Mint of Antioch." In *Antioch: The Lost Ancient City,* ed. Christine Kondoleon, 105–111. Princeton and Worcester, Mass., 2000.

Métraux 1985
Métraux, Guy P. R. "Mosaics of the Villa San Rocco Francolise: Aspects of Style and Technique." *Bulletin de l'AIEMA* 10 (1985): 139–143.

Molnar 1999
Molnar, Michael. *The Star of Bethlehem. The Legacy of the Magi.* New Brunswick, N.J., 1999.

Moorey 1994
Moorey, P. R. S. *Ancient Mesopotamian Materials and Industries.* Oxford, 1994.

Morey 1937
Morey, Charles Rufus. *Art of the Dark Ages.* Exh. cat. Worcester, Mass., 1937.

Morey 1938
Morey, Charles Rufus. *The Mosaics of Antioch.* New York, 1938.

Mørkholm 1959
Mørkholm, Otto. *SNG. Copenhagen: Syria, Seleucid Kings.* Copenhagen, 1959.

Mørkholm 1965
Mørkholm, Otto. *SNG. Deutschland: Sammlung v. Aulock. Pamphylien.* Vol. 11. Berlin, 1965.

Mørkholm 1983
Mørkholm, Otto. "The Autonomous Tetradrachms of Laodicea ad Mare." *ANSNNM* 28 (1983): 89–107.

Morrow 1985
Morrow, Katherine Dohan. *Greek Footwear and the Dating of Sculpture.* Madison, Wisc., 1985.

Muller 1966
Muller, L. *Lysimachus, King of Thrace. Mints and Mint-Marks.* 1856. New York, 1966, reprint.

Neal 1976
Neal, David S. "Floor Mosaics." In *Roman Crafts,* eds. Donald Strong and David Brown, 241–252. London, 1976.

Nenna, Picon, and Vichy 2000
Nenna, M. D., M. Picon, and M. Vichy. "Ateliers primaires et secondaires en Egypt à l'époque gréco-romaine." In *La Route du verre: ateliers primaires et secondaires de verriers du second millenaire av. J.-C. au Moyen-Age,* ed. M. D. Nenna, 97–112. Travaux de la Maison de l'Orient Méditerranéen no. 33. Lyon, 2000.

Newell 1917
Newell, Edward T. "The Seleucid Mint of Antioch." *AJN* 51 (1917): 1–151.

Newell 1919
Newell, Edward T. "The Pre-Imperial Coinage of Roman Antioch." *NC* ser. 4, 19 (1919): 69–113.

Newell 1939
Newell, Edward T. "Late Seleucid Mints in Ake-Ptolemais and Damascus." *NNM* 84 (1939): 1–107.

Newell 1977
Newell, Edward T. *The Coinage of the Western Seleucid Mints from Seleucis I to Antiochus III. NS,* no. 4. New York, 1977. Augmented reprint of 1941 edition.

Newell 1978
Newell, Edward T. *The Coinage of the Eastern Seleucid Mints from Seleucus I to Antiochus III. NS* no. 1. New York, 1978. Augmented reprint of 1938 edition.

Nonnos 1962
Nonnos. *Dionysiaca.* Vol. 1. W. H. D. Rouse, trans. Loeb Classical Library. London and Cambridge, Mass., 1962.

Norman 1986
Norman, Naomi J. "Asklepios and Hygieia and the Cult Statue at Tegea." *AJA* 90 (1986): 425–430.

Norman 2000
Norman, A. F. *Antioch as a Centre of Hellenic Culture as Observed by Libanius.* Liverpool, 2000.

Oman 1917
Oman, C. "The Chronology of the Coinage of Antiochus VIII of Syria." *NC* ser. 4, 17 (1917): 190–206.

Önal 2002
Önal, Mehmet. *Mosaics of Zeugma.* Istanbul, 2002.

Oppenheim, Brill, Barag, and Von Saldern 1988
Oppenheim, Leo A., Robert H. Brill, Dan Barag, and Axel Von Saldern. *Glass and Glassmaking in Ancient Mesopotamia. An Edition of the Cuneiform Texts Which Contain Instructions for Glassmakers with a Catalogue of Surviving Objects.* Corning, N.Y., 1970, reprint 1988.

Ovadiah 1987
Ovadiah, Ruth and Asher. *Hellenistic, Roman and Early Byzantine Mosaic Pavements in Israel.* Rome, 1987.

Ovid
Ovid. Vol. III. *Metamorphoses.* F. J. Miller, trans. Loeb Classical Library. London and Cambridge, Mass., 1977.

Özgan 1982
Özgan, Ramazan. "Zur Datierung des Artemis Altars im Magnesia am Maeander." *IstMitt* 32 (1982): 196–206.

Padgett 2001
Padgett, J. Michael. *Roman Sculpture in the Art Museum, Princeton University.* Princeton, 2001.

Papathomopoulos 1976
Papathomopoulos, Manoles. *Anônymou paraphrasis eis ta Dionysiou Ixeutika.* Panepistemion Iôanninôn philosophike schole. Seira "Peleia" 3. Ioannina, 1976.

Paton 1948
Paton, W. R. *The Greek Anthology.* Loeb Classical Library, Cambridge and London, 1948.

Pearce 1951
Pearce, J. W. E. *The Roman Imperial Coinage. IX. Valentinian I—Theodosius I.* London, 1951.

Perdrizet 1908
Perdrizet, P. *Fouilles de Delphes. Vol. 5, Monuments figures: Fasc. 1: Petits bronzes, terre-cuites, antiquités diverses.* Paris, 1908.

Petit 1955
Petit, P. *Libanius et la vie municipale à Antioche au IVe siècle après J.-C.* Paris, 1955.

Pfuhl and Möbius
Pfuhl, Ernst and Hans Möbius. *Die ostgriechischen Grabreliefs.* Mainz am Rhein, 1977.

Philippot 1977
Philippot, Paul. "The Problem of Lacunae in Mosaics." *Mosaics No. 1: Deterioration and Conservation*, 83–88. Rome, 1977.

Piccirillo 1993
Piccirillo, Michele. *The Mosaics of Jordan.* American Center of Oriental Research Publication 1. Amman, 1993.

Pick 1887
Pick, B. "Zur Titulatur der Flavier." *ZfN* 14 (1887): 294–374.

Pollitt 1986
Pollitt, Jerome J. *Art in the Hellenistic Age*, Cambridge, 1986.

Pompei 1990
Pompei. Pitture e mosaici. Vol. I, Regio I, parte I, ed. Giovanni Pugliese Carratelli. Rome, 1990.

Pompei 1997
Pompei. Pitture e mosaici. Vol. VII, Regio VII, parte II, ed. Giovanni Pugliese Carratelli. Rome, 1997.

Poole 1883
Poole, Reginald Stuart. *The Ptolemies, Kings of Egypt.* London, 1883.

Price 1991
Price, Martin Jessop. *The Coinage in the Name of Alexander the Great and Philip Arrhidaeus. A British Museum Catalogue.* Zurich and London, 1991.

Prieur 1986
Prieur, Jean. *La mort dans l'antiquité romain.* Rennes, 1986.

Ramage and Ramage 2001
Ramage, Nancy H., and Andrew Ramage. *Roman Art. Romulus to Constantine.* Upper Saddle River, N.J., 2001.

Reuterswärd 1960
Reuterswärd, Patrick. *Studien zur Polychromie der Plastik: Griechenland und Rom*, Scandinavian University Books, Stockholm, 1960.

Rice 1983
Rice, E. E. *The Grand Procession of Ptolemy Philadelphus.* Oxford, 1983.

Roberts 1989
Roberts, Michael. *The Jeweled Style. Poetry and Poetics in Late Antiquity.* Ithaca, N.Y., 1989.

Roncuzzi and Fiori 1989
Roncuzzi, I. and C. Fiori. "Applicazione dell'analisi chimica allo studio del vetro musivo Bizantino del V–VI secolo." *Mosaico e Restauro Musivo* 5 (1989): 9–57.

Rooksby 1962
Rooksby, H. P. "Opacifiers in Opal Glasses." *General Electric Corporation Journal* 29 (1962): 20–26.

Ross 1953
Ross, Marvin C. "A Silver Treasure Found at Daphne-Harbié." *Archaeology* 6 (1953): 39–41.

Ross 1965
Ross, Marvin C. *Catalogue of the Byzantine and Early Medieval Antiquities in the Dumbarton Oaks Collection.* Vol. 2, *Jewelry, Enamels, and Art of the Migration Period.* Washington, D.C., 1965.

Rostovtzeff 1949
Rostovtzeff, Michael I., ed. *The Excavations at Dura-Europos. Final Report IV.* New Haven, 1949.

Russell 1982
Russell, James. "Byzantine *Instrumenta Domestica* from Anemurium: The Significance of Context." In *City, Town, and Countryside in the Early Byzantine Era*, ed. Robert L. Hohlfelder, 133–163. New York, 1982.

Russell 2000
Russell, James. "Household Furnishings." In *Antioch: The Lost Ancient City*, ed. Christine Kondoleon, 79–89. Princeton and Worcester, Mass., 2000.

Sayre and Smith 1961
Sayre, E. V. and R. W. Smith. "Compositional Categories of Ancient Glass." *Science* 133 (1961): 1824–1826.

Schenck 1937
Schenck, Edgar C. "The Hermes Mosaic from Antioch." *AJA* 41 (1937): 388–396.

Schlunk 1939
Schlunk, Helmut. *Kunst der Spätantike in Mittelmeerraum: Spätantike und byzantinische Kleinkunst aus Berliner Besitz.* Berlin, 1939.

Sebesta 1994
Judith Lynn Sebesta, "Symbolism in the Costume of the Roman Matron." In *The World of Roman Costume*, eds. Judith Lynn Sebesta and Larissa Bonfante, 46–53. Madison, 1994.

Shapiro 1993
Shapiro, Alan. *Personifications in Greek Art*. Zurich, 1993.

Shelton 1998
Shelton, Jo-Ann. *As the Romans Did: A Sourcebook in Roman Social History*. Oxford and New York, 1998.

Shugar 2000
Shugar, A. N. "Byzantine Opaque Red Glass Tesserae from Beit Shean, Israel." *Archaeometry* 42 (2000): 375–384.

Smith 1963
Smith, R. W. "Archaeological Evaluation of Ancient Glass." *Advances in Glass Technology II: Sixth International Congress on Glass*. Washington D.C., 1963.

Sophocles 1957
Sophocles, E. A. *Greek Lexicon of the Roman and Byzantine Periods (from BC 146 to AD 1100)*. Boston, 1870, Cambridge, 1957 reprint.

Spanu 2001
Spanu, Marcello. "Burial in Asia Minor During the Imperial period, with a Particular Reference to Cilicia and Cappadocia." In *Burial, Society and Context in the Roman World*, eds. John Pearce, Martin Millett and Manuela Struck, 169–177. Oxford, 2001.

Spaeth 1996
Spaeth, Barbette Stanley. *The Roman Goddess Ceres*. Austin, 1996.

Spieser 1984
Spieser, J.-M. *Thessalonique et ses monuments du IVe au VIe siècle. Contribution à l'étude d'une ville paléochrétienne*. Bibliothèque des écoles françaises d'Athènes et de Rome 254. Paris, 1984.

Spiro 1978
Spiro, Marie. *Critical Corpus of the Mosaic Pavements on the Greek Mainland, Fourth/Sixth Centuries*. New York, 1978.

Stafford 2000
Stafford, Emma. *Worshipping Virtues. Personification and the Divine in Ancient Greece*. London, 2000.

Statius 2003
Silvae 1.5.25–30. Transl. D. R. Shackleton Bailey. Loeb Classical Library. London and Cambridge, Mass., 2003.

Stillwell 1961
Stillwell, Richard. "Houses of Antioch," *DOP* 15 (1961): 47–57.

Strong 1966
Strong, Donald E. *Greek and Roman Gold and Silver Plate*. London, 1966.

Strong and Brown 1976
Strong, Donald and David Brown, eds. *Roman Crafts*. London, 1976.

Strube 1984
Strube, Christine. *Polyeuktoskirche und Hagia Sophia. Umbildung und Auflösung antiker Formen, Entstehen des Kämpferkapitells*. Bayerische Akademie der Wissenschaften. Philosophisch-historische Klasse. Abhandlungen. N.F., Heft 92. Munich, 1984.

Sutherland 1967
Sutherland, C. H. V. *The Roman Imperial Coinage. VI, From Diocletian's Reform (A.D. 294) to the Death of Maximus (A.D. 313)*. London, 1967.

Svoronos 1904–1908
Svoronos, Jean. *Ta nomismata tou Kratous ton Ptolemaion*. Athens, 1904–1908.

Sweetman 2003
Sweetman, Rebecca. "The Roman Mosaics of the Knossos Valley." *The Annual of the British School at Athens*, 98 (2003) 517–547.

Talgam and Weiss 2004
Talgam, Rina and Zeev Weiss. "The Mosaics of the House of Dionysos at Sepphoris." *Qedem, Monographs of the Institute of Archaeology, The Hebrew University of Jerusalem*. Jerusalem, 2004.

Tammisto 1997
Tammisto, Antero. *Birds in Mosaics: A Study of the Representation of Birds in Hellenistic and Romano-Campanian Tessellated Mosaics to the Early Augustan Age*. Acta Instituti Romani Finlandiae, 18. Rome, 1997.

Teitz 1971
Teitz, Richard Stuart. "The Antioch Mosaics." *Apollo* 94 (December 1971): 438–44.

Thompson 1968
Thompson, Margaret. "The Mints of Lysimachus." In *Essays in Greek Coinage Presented to Stanley Robinson*, eds. C. M. Kraay and G. K. Jenkins, 163–182. Oxford, 1968.

Torp 1963
Torp, Hjalmar. *Mosaikkene i St. Georg-Rotunden i Thessaloniki*. Oslo, 1963.

Toynbee 1971
Toynbee, J. M. C. *Death and Burial in the Roman World*. Baltimore and London, 1971.

Toynbee 1973
Toynbee, Jocelyn M. C. *Animals in Roman Life and Art*. London, 1973.

Toynbee and Ward-Perkins 1950
Toynbee, Jocelyn M. C. and John B. Ward-Perkins, "Peopled Scrolls: A Hellenistic Motif in Imperial Art." *PBSR* 18 (1950): 1–43.

Treggiari 1996
Treggiari, Susan. "Women in Roman Society." In *I Claudia: Women in Ancient Rome,* eds. Diana E. E. Kleiner and Susan Matheson, 116–125. Austin, 1996.

Turner and Rooksby 1959
Turner, W. E. S. and H. P. Rooksby. "A Study of the Opalizing Agents in Ancient Opal Glasses Throughout 3400 Years." *Glasstechnische Berichte* 32K VIII (1959): 17–29.

Van Bremen
Van Bremen, Riet. *The Limits of Participation: Women and Civic Life in the Greek East in the Hellenistic and Roman Periods.* Amsterdam, 1996.

Verità, Basso, Wypyski and Koestler 1994
Verità, M., R. Basso, Mark T. Wypyski and R. J. Koestler. "X-ray Microanalysis of Ancient Glassy Materials: A Comparative Study of Wavelength Dispersive and Energy Dispersive Techniques." *Archaeometry* 36 (1994): 241–251.

Vermeule 1976
Vermeule, Cornelius C. *Romans and Barbarians.* Boston, 1976.

Vermeule 2000
Vermeule, Cornelius C. "The Sculptures of Roman Syria." In *Antioch: The Lost Ancient City,* ed. Christine Kondoleon, 90–102. Princeton and Worcester, Mass., 2000.

Vikan 1995
Vikan, Gary. *Catalogue of Sculpture in the Dumbarton Oaks Collection from the Ptolemaic Period to the Renaissance.* Washington, D.C., 1995.

Vikan and Nesbitt 1980
Vikan, Gary and Nesbitt, John. *Security in Byzantium. Locking, Sealing, and Weighing.* Washington, D.C. 1980.

Vitruvius
The Ten Books on Architecture. M. H. Morgan, trans. New York, 1960.

von Dienst 1913
von Dienst, W. *Nysa ad Meandrum.* Berlin, 1913.

Waagé 1952
Waagé, Dorothy B. *Antioch-on-the-Orontes IV. Part Two: Greek, Roman, Byzantine and Crusaders' Coins.* Princeton, 1952.

Waddington 1976
Waddington, William Henry, completed by Ernest Babelon and Théodore Reinach. *Recueil général des monnaies grecques d'Asie Mineure. I., Pont et Paphlagonie.* Paris, 1908. New York, 1976, reprint.

Waelkens 1980
Waelkens, M. "Das Totenhaus in Kleinasien." *Antike Welt* 11, no. 4 (1980): 3–12.

Waldbaum 1983
Waldbaum, Jane C. *Metalwork from Sardis: The Finds Through 1974.* Cambridge, Mass., 1983.

Walker 1941
Walker, John. *A Catalogue of the Arab-Sassanian Coins.* London, 1941.

Webb 1927
Webb, Percy H. *The Roman Imperial Coinage. V.I, Valerian I to Florian.* London, 1927.

Wedepohl and Baumann 2000
Wedepohl, K. H., and A. Baumann. "The Use of Marine Molluskan Shells for Roman Glass and Local Raw Glass Production in the Eifel Area (Western Germany)." *Naturwissenschaften* 87 (2000): 129–132.

Weinberg 1988
Weinberg, Gladys Davison, ed. *Excavations at Jalame: Site of a Glass Factory in Late Roman Palestine.* Columbia, Mo., 1988.

Weir 2001
Weir, Robert G. A. "Antiochene Grave Stelai in Princeton." In *Roman Sculpture in the Art Museum, Princeton University,* ed. J. Michael Padgett, 274–310. Princeton 2001.

Weiss and Talgam 2002
Weiss, Zeev and Rina Talgam. "The Nile Festival Building and Its Mosaics: Mythological Representations in Early Byzantine Sepphoris." In *The Roman and Byzantine Near East,* 3, ed. J. H. Humphrey, 55–90. *JRA* Suppl. 49. Portsmouth, R.I., 2002.

Wiseman 1999
Wiseman, T. P. "The Games of Flora." In *The Art of Ancient Spectacle,* eds. Bettina Bergmann and Christine Kondoleon, 195–203. *Studies in the History of Art 56. CASVA Symposium Papers 34.* Washington, D. C. and New Haven, 1999.

Wood 2000
Wood, Susan. "Mortals, Empresses, and Earth Goddesses: Demeter and Persephone in Public and Private Apotheosis." In *I Claudia II: Women in Roman Art and Society,* eds. Diana E. E. Kleiner and Susan B. Matheson, 77–100. Austin, 2000.

Wroth 1889
Wroth, Warwick. *Catalogue of Greek Coins. Pontus, Paphlagonia, Bithynia, and the Kingdom of Bosporus.* London, 1889.

Wroth 1892
Wroth, Warwick. *Catalogue of the Greek Coins of Mysia.* London, 1892.

Wroth 1964
Wroth, Warwick. *Greek Coins of Galatia, Cappadocia, and Syria.* London, 1899. Bologna, 1964, reprint.

Wruck 1931
Wruck, Waldemar. *Die syrische Provinzialprägung von Augustus bis Traian.* Stuttgart, 1931.

Wypyski forthcoming
Wypyski, Mark T. "Technical Analysis of Glass Mosaic Tesserae from Amorium." *DOP* 59, forthcoming.

Wypyski unpublished
Wypyski, Mark T. Unpublished analyses of a group of ancient Roman glass fragments from The Metropolitan Museum of Art, part of the bequest of Edward C. Moore, 1891.

Wypyski and Mass unpublished
Wypyski, Mark T. and J. L. Mass. Unpublished analyses of red tesserae from the fountain mosaic in the Casa della Fontana Piccola, Pompeii.

Yarshater 1983
Yarshater, Ehsan, ed. *The Cambridge History of Iran.* Vol. 3. *The Seleucid, Parthian, and Sasanian Periods.* Cambridge, 1983.

Yegül 1992
Yegül, Fikret. *Baths and Bathing in Classical Antiquity.* Cambridge, Mass., 1992.

Yegül 2000
Yegül, Fikret. "Baths and Bathing in Roman Antioch." In *Antioch: The Lost Ancient City,* ed. Christine Kondoleon, 146–151. Princeton and Worcester, Mass., 2000.

Zaqzuq and Piccirillo 1999
Zaqzuq, A. and M. Piccirillo. "The Mosaic Floor of the Church of the Martyrs at Tayibat al-Imam-Hamah, in Central Syria." *Liber Annuus* 49 (1999): 443–464.

Index

—A—

abundance,
 Nilotic motifs associations of; 214
 personification of, in Ktisis mosaics; 213
 representation in Peacock mosaic; 242

acanthus leaves,
 See Also inhabited foliate borders;
 in borders; 23
 on capitals,
 Corinthian; 262
 (note 1); 262
 pilaster , (figure); 263
 in inhabited foliate borders,
 Atrium House triclinium; 24
 Rams' Heads mosaic; 216, 219
 Worcester Hunt mosaic; 231
 scroll descriptions, (note 6); 221
 in Sepphoris, Galilee Dionysiac mosaic, Atrium House triclinium foliate borders compared with; 24

Adonis,
 See Also Aphrodite and Adonis mosaic;
 Aphrodite and Adonis mosaic, (figure); 47
 in Aphrodite and Adonis mosaic (Atrium House triclinium), visual description, (figures); 25

Aelia Flacilla,
 example of female virtue; 212

Aesculapius,
 See Asklepios;

Agle, C. K.,
 Atrium House triclinium floor plan, (figure); 30

Agora mosaic,
 See Also Eukarpia mosaic; Funerary Banquet mosaic;
 (figure); 61, 203
 glass tesserae analysis; 60
 (table); 150
 restoration treatments,
 1998, (figure); 100
 conservation and; 99–100
 stable isotopes chart, (figure); 69
 visual and iconographic description; 203

agriculture,
 See Also plants; prosperity;
 theme in border of Funerary Banquet mosaic; 203

Agros and Opora mosaic,
 glass tesserae analysis, (table); 154

Aion,
 See Also Antioch, House of Aion; Nea Paphos, Cyprus, House of Aion;
 personification of eternal time; 222

Ake-Ptolemais,
 mint of,
 Antiochus IV Epiphanes coins; 278
 Antiochus VIII Grypus coin; 281
 Ptolemy III Euergetes coins; 283

Alciphron,
 (note 17); 189

Alexander I Balas,
 coins during reign of; 279
 image on Alexander I Balas coins; 279

Alexander II Zebina,
 coins during reign of; 280, 281
 image on Alexander II Zebina coins; 280, 281

Alexander III The Great,
 coins during reign of; 277

Alexander Severus,
 See Severus Alexander;

Alexander the Great,
 image on,
 Lysimachus coins; 283, 284
 Ptolemy I coins; 283

Alexandria,
 mint of, Ptolemy I coins; 283

allegory,
 See Also iconography;
 in Funerary Banquet mosaic interpretation; 200
 in Worcester Hunt mosaic; 235

Allen Memorial Art Museum (Oberlin College),
 Antioch mosaic; 14
 Geometric mosaics; 222

alloy,
 See Also minerals;

altar(s),
 image on Philip I, the Arab coins; 292
 Sasanian fire altar, image on Chosroes II coins; 300

aluminum,
 See glass tesserae, analysis; glass tesserae, Atrium House triclinium, material study;

amber,
 translucent, glass tesserae analysis, (table); 168

American University of Beirut; 5

amethyst(s),
 color, glass tesserae, differences between figural mosaic and border of Judgment of Paris mosaic; 58
 in crown of Ktisis mosaic figure; 211
 translucent color, glass tesserae analysis, (table); 156

Amherst College Mead Art Museum,
 Antioch mosaic ; 14,
 (note 33); 112
 Funerary Banquet mosaic border fragment; 95

Amissos, Turkey,
 signed mosaic location; 38

Ampelos,
 See Also Dionysos;
 in Drinking Contest Between Dionysos and Herakles mosaic; 178

Amphipolis,
 mint of, Alexander III The Great coins; 277

Anahita,
 iconography, in Rams' Heads mosaic; 219

analysis,
 Atrium House triclinium, overview; 18
 composition, of differences between Dancing Satyr and Drinking Contest mosaics; 42
 glass tesserae,
 Atrium House triclinium, (table); 138–145
 by color, (table); 156–169
 grouped by batch and by recipe, House of the Drinking Contest, (table); 174
 grouped by batch, Atrium House triclinium, (table); 170–173
 House of Narcissus, (table); 154
 House of the Boat of Psyches, (table); 154
 House of the Drinking Contest, (table); 146–149
 House of the Sundial, (table); 154
 Tomb of the Funerary Banquet, (table); 150–153
 glassmaking technology, at Antioch; 115–135
 metal objects; 266
 style, artist identification use of; 39
 themes, of differences between Dancing Satyr and Drinking Contest mosaics; 42

Ananeosis,
 in Ktisis mosaic from the Constantinian Villa near Daphne; 211
 rosebuds around, (note 3); 221

animal hoof,
 sculpture fragment, catalogue description; 265

animals,
 See Also antelope; bear; birds; boar; bull; deer; elephant; fish; frog; hare; hippo; horse; hyena; leopards; lion/lioness; lizards; mice; motifs; panther; ram; serpent; snails; snakes; sphinx; tiger/tigress; toad;
 in House of the Bird Rinceau mosaic border; 240
 in inhabited foliate border, of Earth mosaic, visual description; 236

Antakya, Turkey,
 See Also Antiochas ancient city on same location;

Antioch College,
mosaic fragment; 12

"Antioch: The Lost Ancient City" exhibition,
mosaic conservation and restoration in preparation for, three case studies; 81–113
Worcester Art Museum Antioch mosaics exhibition, fall 2000; 17

Antioch Visiting Committee,
role in selling the Antioch project to Worcester trustees; 5

Antioch-on-the-Orontes,
municipal coins; 285, 300

Antiochus,
as mosaic artist name on Dionysos Discovering Ariadne mosaic (Chania, Crete), (note 62); 74

Antiochus I,
image on,
Antiochus II Theos coin; 277
Seleucus II Kallinikos coin; 277

Antiochus II Theos,
coins during reign of; 277

Antiochus III The Great,
coins during reign of; 278
image on Antiochus III The Great coin; 278

Antiochus IV Epiphanes,
coins during reign of; 278
image on Antiochus IV Epiphanes coin; 278

Antiochus Philopater; 281

Antiochus VII Sidetes,
coins during reign of; 280
image on, Antiochus VII Sidetes coins; 280
image on Antiochus VII Sidetes coins; 280

Antiochus VIII Grypus,
coins during reign of; 281, 282
image on,
Antiochus VIII Grypus coins; 281, 282
Cleopatra Thea and Antiochus VIII Grypus coin; 281

Apamea, Syria,
Cynegetica manual of hunting, Worcester Hunt mosaic illustration of; 235
excavations, dating use for Antioch House of Aion; 224
Maison du Cerf,
Antioch House of Aion compared with; 225
plan, (figure); 226
mint of, Seleucus II Kallinikos coins; 277
Triclinos building,
hunt mosaics; 233
hunt mosaics, symbolism; 235

apatite,
in stone tesserae samples; 64

Aphrodisias, Turkey,
statue of Aelia Flacilla at; 212

Aphrodite,
as symbolic of pleasure, (note 25); 73
in Aphrodite and Adonis mosaic; 29
detail from Aphrodite and Adonis mosaic, (figure); 46
in Judgment of Paris mosaic; 23, 28
silver statuette; 256

Aphrodite and Adonis mosaic,
See Also Atrium House triclinium;
Adonis detail, (figure); 47
Aphrodite detail, (figure); 46
border,
details, (figures); 48
foliate border description; 23
glass tesserae analysis; 57
Drinking Contest Between Dionysos and Herakles mosaic vs., tesserae arrangement techniques; 45
glass tesserae analysis,
figural vs. border; 57
red glass; 131
(table); 144
Judgment of Paris mosaic vs.,
borders; 47
(figure); 44
palette; 44
realism and figure representation; 45
visual differences reflected in glass material differences; 57
conservation treatments,
(figures); 88, 91, 92
problems and processes; 86–93
stable isotopes chart, (figure); 69
stone tesserae sample analysis, (table); 63
visual description, (figures); 25

Apolausis,
personification of enjoyment; 194

Apollo,
image on,
Antiochus II Theos coin; 277
Antiochus III The Great coin; 278
Seleucus II Kallinikos coin; 277

appetite,
See Also iconography; moderation;
iconographic representation of, in House of the Sundial mosaics; 187

apsed exedra,
See exedra;

aquatic creatures,
in border of Ktisis mosaic; 210

Arados,
mint of, Arados coins; 285
municipal coins; 285

Arcadius,
coins during reign of; 298
image on Arcadius coins; 298

Archaeological Institute of America,
Paul B. Morgan as trustee of; 12

Archaeological Museum (Naples, Italy),
Torre Annunziata mosaic, (note 22); 189

archaeology,
Antioch advantages for; 4
Atrium House triclinium; 17–48
archaeological record analysis; 31–37

architecture,
See Also exedra;
Antioch House of Aion, value of; 224

Ariadne,
in Dionysos and Ariadne mosaic; 182

Ara Pacis (Rome),
foliate carvings on; 23

arm,
sculpture fragment, catalogue description; 264

art/artistic,
See Also style; visual;
analysis, of Atrium House triclinium; 17–48
differences, in Atrium House triclinium; 71
evaluation, of Antioch finds by M. Charbonneau; 9
impact,
of glass tesserae deterioration; 52
of surface damage to Funerary Banquet mosaic; 97
mosaic, reconstructing the process; 31
skill, of Atrium House triclinium border execution; 32
sophistication, differences between Dancing Satyr and Drinking Contest mosaics; 43
techniques, shadow and highlights, (figure); 41
thread of process resulting in Roman mosaics; 72

Artemis,
in Dumbarton Oaks Hunt mosaic; 234
image on Demetrius I Soter coins; 279
in Sarrîn Hunt mosaic; 234

Arthur M. Sackler Gallery (Washington, DC),
Sasanian motifs, (note 11); 221

artists,
See Also art/artistic;
difficulties in identifying individuals; 38
evidence for different,
Aphrodite and Adonis, and Judgment of Paris mosaics; 44
Dancing Satyr and Drinking Contest mosaics; 42

Asia,
mint of,
Gallienus coins; 295

color(s), cont.
 amethyst(s);
 black;
 blue;
 brown;
 clear;
 green;
 maroon;
 red;
 turquoise;
 white;
 yellow;
 glass, in Judgment of Paris and in Aphrodite and Adonis mosaic; 44
 glass tesserae analysis organization by, (table); 156–169
 glass tesserae analysis parameter; 50
 stone, in Judgment of Paris and in Aphrodite and Adonis mosaic; 44
 stone tesserae samples, analysis of; 64

comedy,
 Greek, dinner entertainment described in; 187

commerce,
 See Also culture; economy; women;
 female,
 images relationship to; 212
 involvement in, Funerary Banquet mosaic indications of; 204
 theme in border of Funerary Banquet mosaic; 203
 thread of process resulting in Roman mosaics; 72

Committee for the Excavation of Antioch and Its Vicinity; 6
 Antioch meeting in 1936; 8
 (figure); 8

composition,
 analysis, of differences between Dancing Satyr and Drinking Contest mosaics; 42
 border, differences between Judgment of Paris and in Aphrodite and Adonis mosaics; 47
 criteria, in studying mosaic workshop relationships; 51
 differences, among the Tomb of the Funerary Banquet mosaics; 60
 glass tesserae; 117–120
 analysis of; 49
 tesserae, Drinking Contest mosaic vs. Aphrodite and Adonis mosaic; 45
 Type 1 red glass tesserae; 52
 Type 2 red glass tesserae; 53
 Type 3 red glass tesserae; 53
 Worcester Hunt mosaic; 231

Concordia,
 image on Otacillia Severa, wife of Philip I coins; 293

condition,
 Agora mosaic, 1998; 99
 Atrium House triclinium, 1998; 87
 border fragments from Worcester Hunt mosaic; 109
 Eukarpia mosaic, 1998; 99

Funerary Banquet mosaic, 1998; 96
glass tesserae, variations in; 52
Worcester Hunt mosaic; 102
 2000; 107

conservation,
 materials, selection criteria; 85
 mosaic,
 1930s experts, (note 36); 112
 three case studies; 81–113
 restoration and,
 of Atrium House triclinium; 86–93
 of Funerary Banquet mosaic; 94–101
 of Worcester Hunt mosaic; 102–113
 treating mosaics, 1994–2004, (figure); 81

Constantine I, the Great,
 coins during reign of; 296
 image on Constantine I, the Great coins; 296

Constantinian Villa,
 example of Antiochene inhabited foliate borders; 240
 Ktisis mosaic, iconography; 211

Constantinople,
 image on,
 Justinus II coins; 303
 Theodosius II coins; 299
 mint of,
 Heraclius coins; 304
 Justinianus I coins; 301
 Justinus I coins; 301
 Justinus II coins; 303
 Maurice Tiberius coins; 303
 Phocas coins; 303
 Theodosius II coins; 299

Constantinopolis,
 image on Constantius II coins; 297

Constantius I Caesar,
 coins during reign of; 295
 image on Constantius I Caesar coins; 295

Constantius II,
 coins during reign of; 297
 image on Constantius II coins; 297

Constanza, Romania,
 Tomb of the Banquet mosaic, crescent-shaped objects; 205

constituents,
 glass tesserae, as type determinant; 52

content,
 criteria, in studying mosaic workshop relationships; 51

contest(s),
 See Also Drinking Contest Between Dionysos and Herakles mosaic; Judgment of Paris mosaic; Musical Contest Between Apollo and Marsyas mosaic;
 Atrium House triclinium theme; 29

between mortals and immortals, as Atrium House triclinium theme; 71

context,
 loss,
 See Also field, damage;
 in Antioch mosaic excavation; 31
 small finds value for determining; 266

copper,
 See glass tesserae, analysis; glass tesserae, Atrium House triclinium, material study;

Corinthian capitals; 262
 (figures); 262

cornucopia,
 image on Demetrius I Soter coins; 279

corridor,
 in Antioch House of Aion, visual description; 224

Cott, Perry B.,
 comments on 1930s restoration attempts; 95

cracking,
 See Also damage;
 border fragments from Worcester Hunt mosaic; 109
 in Aphrodite and Adonis mosaic; 89
 in Funerary Banquet mosaic; 96
 mosaic damage,
 causes of; 88

cranes,
 in border of Ktisis mosaic; 210

creation,
 See Also Christianity; iconography;
 alternate interpretation for Ktisis; 214
 of mosaic, techniques, (note 44 and 59); 73
 peacock as symbol of; 242
 personification of, in Ktisis mosaics; 213

crescent-shaped objects,
 in Funerary Banquet mosaic, identification and meaning issues; 205

Crete,
 Chania, mosaic artist signature found in; 38
 Villa of Dionysos at Knossos, Dionysian busts in; 24

cricket,
 in foliate border around Atrium House triclinium mosaics, Dionysian significance of; 24

cross,
 See Also Christianity;
 image on Bohemond III coins; 304
 image on Heraclius coins; 304
 within a circle pendant, (figure) and catalogue description; 270

crossbill,
in Judgment of Paris mosaic, possibility of; 76

crossbow brooch
catalogue description; 269

crystal forms,
glass tesserae batch determination use; 51

culture, See burial associations; commerce; dining; economy;

cuprite,
See glass tesserae, analysis; glass tesserae, Atrium House triclinium, material study;

Cynegetica manual of hunting,
Worcester Hunt mosaic illustration of; 235

Cyprus,
Bishop Theodoret commentary on Genesis, mosaics of Qast-el-Lebia basilica in Cyrenaica as visual gloss on; 214
Eustolios complex at Kourion, Ktisis mosaic iconography; 211
fifth and sixth century, Geometric mosaics composition compared with examples in; 225
Musical Contest Between Apollo and Marsyas mosaic, (figure); 29
Preparation for the First Bath of Dionysos mosaic, (figure); 193

Cyzicus,
mint of, Julian the Apostate coins; 297

—D—

damage,
See Also cracking; losses (mosaic);
earthquake, Funerary Banquet mosaic; 97
field,
Aphrodite and Adonis mosaic border losses; 48
Aphrodite and Adonis mosaic, (figure); 25
to Atrium House triclinium; 87
context loss through; 31
Eukarpia mosaic, (figure); 99
Funerary Banquet mosaic, (figure); 97
negative impact on Atrium House triclinium studies; 18
Worcester Hunt mosaic; 103
glass tesserae; 89
Judgment of Paris mosaic, (figure); 88
iron corrosion as cause of; 88
weathering as cause, in Princeton University mosaics; 89
Worcester Hunt mosaic; 102

Damascus, Syria,
mint of,
Antiochus VII Sidetes coins; 280
Chosroes II coins; 300

Demetrios III Philopater coins; 282

Dancing Maenad mosaic,
See Also Atrium House triclinium;
conservation and restoration issues and processes; 86—93
Drinking Contest Between Dionysos and Herakles and Dancing Satyr mosaics with, (figure); 42
(figure); 22
glass tesserae analysis, (table); 140
glass tesserae analysis, (table); 140
guilloche border, (figure); 56
restoration; 90—93
stone tesserae sample analysis, (table); 63
visual and mythological description; 22

Dancing Satyr mosaic,
See Also Atrium House triclinium;
conservation and restoration issues and processes; 86—93
detail, (figure); 43
Drinking Contest Between Dionysos and Herakles and Dancing Maenad mosaics with, (figure); 42
(figure); 22
glass tesserae analysis,, (table); 140
restoration; 90—93
(figure); 88
stone tesserae sample analysis, (table); 63
visual and mythological description; 22

Daphne, Turkey,
See Also Antioch;
Antioch summer resort; 228
Constantinian Villa, Ktisis mosaic iconography; 211
Dumbarton Oaks Hunt mosaic, Worcester Hunt mosaic dating clues from; 232
House of the Rams' Heads;
See Also Rams' Heads mosaic;
description of floors, (note 2); 221
origin of mosaic artist who signed his work, (note 62); 74
Libanios quotation about; 196
origin of mosaic artist who signed his work; 38
site of,
Peacocks mosaic; 238
Phoenix mosaic; 220
Worcester Hunt mosaic; 8, 228

Dar Buc Ammera (Zliten, Libya),
inhabited acanthus volutes in Villa at, Atrium House triclinium foliate borders compared with; 24

Darmon, Jean-Pierre,
Zosimos of Samosata vs. Zosimos analysis; 39

dating,
Antioch House of Aion mosaics; 224

Antioch mosaics, value of Sasanian sack of Zeugma for; 38
Atrium House,
construction; 20
triclinium foliate borders; 24
coins, (note 3); 227
Funerary Banquet mosaic, issues; 198
House of the Bird Rinceau; 238
House of the Worcester Hunt; 228
Worcester Hunt mosaic; 232

de Beaumont, Edmond,
observations on Worcester Hunt mosaic condition; 106

death,
See Also burial associations; funerary; grave; iconography; sarcophagus; themes; time;
banquet theme; 188
rituals surrounding, Funerary Banquet mosaic reflection of; 199

deer,
in House of the Bird Rinceau mosaic border; 240
in Worcester Hunt mosaic; 231

defects,
manufacturing, as contributor to glass tesserae deterioration; 52

deification of emperors,
on Rome millennium commemoration coins; 294

delight,
Gethosyne as personification of; 194

Demeter,
image on Demetrios III Philopater coins; 282
implied presence in Funerary Banquet mosaic; 204

Demetrios II Nikator,
coins during reign of; 280
image on Demetrios II Nikator coin; 280

Demetrios III Philopater,
coins during reign of; 282
image on Demetrios III Philopater coins; 282

Demetrius I Soter,
coins during reign of; 278, 279
image on Demetrius I Soter coin; 278
image on Demetrius I Soter coins; 279

depth,
illusion techniques, in Atrium House triclinium; 43

design accuracy,
Atrium House triclinium border execution, as evidence of artistic skill; 32
goal of Antioch mosaic conservation and restoration campaign; 85

desire,
possible Atrium House triclinium theme; 29

green, cont.
 differences between figural mosaic and border of Judgment of Paris mosaic; 57
 fabrication; 55
 glass tesserae analysis; 123–124 (table); 162
 light green (translucent), glass tesserae analysis, (table); 160
 pale green, glass tesserae analysis, (table); 160
 translucent, glass tesserae analysis, (table); 160
 yellow-green, glass tesserae analysis, (table); 162

green woodpecker,
 (note 1); 79

greenfinch,
 in Judgment of Paris mosaic, possibility of; 76

Gregory of Nyssa,
 approval of baths; 194
 (note 17); 195
 praise of Aelia Flacilla; 212

guidelines,
 mosaic pavement execution use; 32

guilloche border,
 See Also border(s); inhabited foliate borders;
 Constantinian villa, (note 30); 206
 Dancing Maenad, (figure); 56
 glass batch correspondence in; 56
 Worcester Hunt mosaic; 231

—H—

Hadrian,
 coins during reign of; 289
 image on,
 Hadrian coins; 289
 Trajan Decius coins; 294
 Villa (Tivoli, Italy), Residence Basilica mosaic(figure); 26

Hagia Sophia, Constantinople excavation,
 painting as part of Worcester 1937 exhibition; 11

hand,
 sculpture fragment, catalogue description; 265

Haner, Paul,
 Worcester Hunt mosaic protection concerns; 106

hare,
 in Worcester Hunt mosaic; 231

Harpokrates,
 Statue of a Young Boy differences from; 251

Hatay Archaeological Museum (Antakya, Turkey),
 Atrium House triclinium geometric pavement stored in; 17, 86

Earth mosaic, from House of the Worcester Hunt; 228
Female bust mosaic, from House of Ge and the Seasons; 208
Gethosyne mosaic, from House of the Sundial; 190
Nymph mosaic, from House of the Sundial; 190
Rams' Heads mosaic fragment, (figure); 218
silver jewelry, (note 8); 256
Star mosaic, from House of Ge and the Seasons; 208

healing,
 See medicine;

hedone virtue,
 in Sophocles lost play, (note 25); 73

Hellenistic,
 culture,
 Antioch as center of; 4
 Antioch mosaics, components of; 26
 foliate border around Atrium House triclinium mosaics; 24
 painting, influence on Atrium House triclinium; 71

helmeted bust,
 image on Bohemond III coins; 304

Hephaistos mosaic (Pergamon),
 Aphrodite and Adonis foliate borders compared with, (figure); 26
 named for the artist who signed it, (note 22); 73

Hera,
 detail from Judgment of Paris, (figure); 45
 in Judgment of Paris mosaic; 23, 28
 peacock as sacred bird of; 242
 role in the story of Hermes and Dionysos; 192

Heraclea,
 mint of, Constantine I, the Great coins; 296

Heraclius,
 coins during reign of; 304
 image on Heraclius coins; 304

Heraclius Constantine,
 image on Heraclius coins; 304

Heraclonas,
 image on Heraclius coins; 304

Herakles,
 in Drinking Contest Between Dionysos and Herakles mosaic; 178
 image on Alexander III The Great coin; 277
 image on Trajan coins; 288

Hermes,
 Dionysos and, myth description; 192
 in Judgment of Paris mosaic; 23
 patron of literature and the palaestra; 193

Hermes Carrying the Infant Dionysos mosaic,
 Bath D,
 catalogue description; 190–195
 current location; 190
 (figure); 191
 stable isotopes chart, (figure); 69

heroes/heroines,
 See Atalanta; Herakles; Hippolytos; Meleager; Paris;

hexastyle temple,
 image on Philip I, the Arab coins; 292

Higgins, Aldus,
 potential donor; 6

High Commissionary of the State of Syria,
 November 1930 accord signed by; 4

highlights,
 glass tesserae use for, in Antiochian Drinking Contest Between Dionysos and Herakles mosaics; 180

hippo,
 image on Otacillia Severa, wife of Philip I coins; 293

Hippolytos,
 heroic model for Romans; 235
 in silver vessel hunting scenes; 236

homosexual love,
 Dionysos statue representation of; 254
 Greek and Roman attitudes, (note 3); 254

Honolulu Academy of Art,
 Honolulu Hunt mosaic, from House of the Worcester Hunt; 228

Honolulu Hunt mosaic,
 in situ photograph, (figure); 230
 visual description; 228

Honorius,
 coins during reign of; 298, 299
 image on Honorius coins; 298, 299

horn of Ammon,
 image on Lysimachus coins; 283, 284

horses,
 horse-head buckle, (figure) and catalogue description; 268
 image on Demetrius I Soter coins; 279
 in Worcester Hunt mosaic, (figures); 104, 231
 significance of; 235

hospitality,
 See Also abundance; banquet(s); dining; iconography; reception area; themes; triclinia;
 Dionysos statue association with; 253
 function of the House of the Worcester Hunt, House of the Worcester Hunt rooms; 228
 Libanios quotation connecting earth's bounty with; 226

Judgment of Paris, cont.
 condition, (figure); 89
 in House of Dionysos at Kos, falcon
 in; 76
 reverse side after lifting, (figure); 34
 stone tesserae sample analysis, (ta-
 ble); 63
 unique qualities of; 57
 visual and mythological description;
 23

Judgment of Paris theme,
 in Sabratha relief, (note 27); 73

Julian the Apostate,
 Antiochian theatre importance, (note
 28); 73
 coins during reign of; 297
 image on Julian the Apostate coins;
 297

Juno,
 peacock as sacred bird of; 242

Jupiter,
 eagle as sacred bird of; 242
 image on Constantine I, the Great
 coins; 296

Justin I,
 coin found under House of the Bird
 Rinceau; 238

Justinianus I,
 coins during reign of; 301, 302
 image on Justinianus I coins; 301, 302

Justinus I,
 coins during reign of; 301
 image on Justinus I coins; 301

Justinus II,
 coins during reign of; 303
 image on Justinus II coins; 303

—K—

Kaiseraugst Treasure,
 crescent-shaped objects in Funerary
 Banquet mosaic compared with ob-
 jects in; 205
 hunting scenes on, hunting scenes
 on; 236

Karpoi,
 personification of earth's produce;
 225

Kenchreai, Greece,
 opus sectile floor, glass composition
 comparisons with Antioch; 134

King Philetairus,
 image on Attalos I coins; 284

Kish, Iraq,
 Sasanian motifs, (note 11); 221

Kitzinger, Ernst; 235

Klausmeyer, Philip,
 metal object analysis by; 266

knob
 catalogue description; 267

Knossos, Crete,
 Villa of Dionysos, Dionysian busts
 in; 24

Kos, Greece,
 House of Dionysos, Judgment of
 Paris mosaic; 76

krater,
 iconic significance of; 185

Ktisis mosaic; 208–215
 border, details, (figure); 214
 Constantinian Villa near Daphne,
 iconography of; 211
 current location, (figure); 208
 detail,
 of central bust, (figure); 210
 of jeweled crown, (figure); 210
 Eustolios complex at Kourion, Cy-
 prus,
 (figure); 212
 iconography of; 211
 (full-page figure); 209
 in Metropolitan Museum of Art, de-
 scription and iconography; 213

Ktisis personification,
 of foundation; 194
 in hunt mosaics, significance of; 235
 of protection; 213

ktistes,
 title on Asia Minor inscriptions; 211

—L—

lamps,
 Atrium House construction dating
 significance and issues; 20

landscape,
 Judgment of Paris mosaic, Residence
 Basilica of Hadrian's Villa com-
 pared with; 26
 in Worcester Hunt mosaic; 231

Lanner falcon,
 in Judgment of Paris mosaic, possibil-
 ity of; 76

Laodicea ad Mare,
 mint of, Macrinus coins; 290

Laodiceia,
 mint of, Laodiceia coins; 285
 municipal coins; 285

lapis,
 glass as substitute for, (note 71); 74

Lassus, Jean,
 (figure); 11, 82
 Funerary Banquet mosaic field notes;
 94
 Tomb of the Funerary Banquet dis-
 covery; 196

layers,
 bedding, variations in; 33
 mosaic pavement,
 cross section of, (figure); 33
 foundations, detailed field notes
 on; 33
 variations in; 33

lead,
 See glass tesserae, analysis; glass tes-
 serae, Atrium House triclinium, ma-
 terial study;

leaf warbler,
 in Judgment of Paris mosaic, possibil-
 ity of; 77

leopards,
 in Worcester Hunt mosaic; 231

Levi, Doro; 18, 20, 208, 224, 232
 emblemata reports; 37
 identification of Antioch House peri-
 ods of construction; 20

Libanios,
 Antioch stone quarries; 62
 assertion that the Judgment of Paris
 took place in Antioch; 28
 (note 1); 195, 206
 (note 14); 195
 (note 18); 227
 (note 33); 206
 (note 5); 195
 quotations; 202
 about Daphne; 196
 bounty of the earth and hospital-
 ity; 226

light(ing),
 highlights, glass use for, (figure); 41
 inconsistencies, in differences be-
 tween Dancing Satyr and Drinking
 Contest mosaics; 43
 shadow illusion techniques and, in
 Atrium House triclinium; 43

lilies,
 in border of Ktisis mosaic; 210

limestone(s),
 quarry sites; 62
 in stone tesserae samples, analysis of;
 64
 types of; 62

lion/lioness,
 in Worcester Hunt mosaic; 231

literature,
 Hermes as patron of; 193

litharge,
 characteristics and source; 122
 glassmaking component; 55

little green bee-eater,
 in Judgment of Paris mosaic, possibil-
 ity of; 76

liturgical vessels,
 crescent-shaped objects shown in con-
 junction with; 205

lizards,
 Atrium House triclinium mosaics,
 Dionysian significance of; 24
 Judgment of Paris mosaic; 47

losses (mosaic),
 See Also damage; restoration;
 handling,
 Aphrodite and Adonis mosaic;
 91–92

losses, cont.
Drinking Contest Between Dionysos and Herakles mosaic; 90
Worcester Hunt mosaic; 108
issues and problems; 85

lotus buds,
in border of Ktisis mosaic; 210
Nilotic motifs; 213

Louvre museum,
conflicts with Francis Henry Taylor; 7
House of the Bird Rinceau mosaic border fragment, (figure); 238
mosaics, See,
Atrium House triclinium;
Judgment of Paris mosaic;
museum treatment of newly excavated mosaics; 88
Phoenix mosaic, (figure); 220
representatives, at Antioch meeting in 1936; 8
Victories on sarcophagus in; 261

lozenges,
in Ktisis mosaic, (figures); 211

Lucite,
Worcester Hunt mosaic treatment with; 105

Ludi Florales,
(note 23); 206

Lyon, France,
Musee Historique des Tissus, silk fragment, (figure); 220

Lysimachus,
coins during reign of; 283, 284

—M—

M letter,
image on Justinianus I coins; 302

Macrinus,
coins during reign of; 290
image on Macrinus coins; 290

maenad,
See Also Dancing Maenad mosaic;
in Drinking Contest Between Dionysos and Herakles mosaic; 178
in foliate border around Atrium House triclinium mosaics, Dionysian significance of; 24

magnanimity,
See Megalopsychia;

magnesium,
See glass tesserae, analysis; glass tesserae, Atrium House triclinium, material study;

Maillart, Mlle,
(figure); 8

Maison du Cerf (Apamea),
Antioch House of Aion compared with; 225
plan,
(figure); 226

notes 13 and 14); 227

mandorla brooch
catalogue description; 269

manganese,
See glass tesserae, analysis; glass tesserae, Atrium House triclinium, material study;

Marcus Aurelius,
Hygieia on commemorative bronze coin of; 248

Mariamin, Syria,
Musicians mosaic; 201

Marine Mosaic, Museum of Fine Art, Boston,
See Also Erotes;
analysis,
glass palette; 60
glass tesserae, (table); 148
details, (figures); 59
in situ photograph, (figure); 59

maroon,
stone tesserae,
analysis; 66
photomicrographs, (figures); 66

masks,
in foliate border around Atrium House triclinium mosaics, Dionysian significance of; 24

material(s),
glass, Atrium House triclinium study; 49–61
sources,
glass tesserae, as type determinant; 52
issues and questions about; 40
stone, Atrium House triclinium study; 62–72

matralia,
(note 27); 206

Maurice Tiberius,
coins during reign of; 303
image on Maurice Tiberius coins; 303

Mausoleum at Halikarnassos,
Hygieia statue compared with; 248

Maximinus II,
coins during reign of; 296
image on Maximinus II coins; 296

Mead Art Museum,
Amherst College, Antioch mosaic; 14, (note 33); 112
Funerary Banquet mosaic border fragment; 95

meander,
Atrium House triclinium border theme,
(figure); 22
integrating function of; 32
border, varying measures of, (note 31); 73
guilloche border, Constantinian villa, (note 30); 206

in Hephaistos mosaic of Pergamon, Atrium House triclinium foliate borders compared with; 26

measurements,
See Also dimensions; size;
Atrium House triclinium, details and types of; 31

medallion pendant
catalogue description; 270

medicine,
Asklepios as god of; 247
Hygieia as goddess of; 247

Megalopsychia,
personification in Megalopsychia Hunt mosaic; 233

Megalopsychia Hunt mosaic,
Yakto complex in Daphne, Worcester Hunt mosaic dating clues from; 232, 233

Meleager,
in Sarrîn Hunt mosaic; 234
in silver vessel hunting scenes; 236

Menander,
"Synaristosas," as mosaic subject; 39

Menetier's warbler,
in Judgment of Paris mosaic, possibility of; 78

metalwork with enamel
catalogue description; 269–270

methodology,
glassmaking technology analysis; 115–135
mosaic fabrication analysis, issues and strategies; 18

Métraux, Guy P. R.,
emblemata reports, Villa San Rocco (Francolise, Italy); 37

Metropolitan Museum of Art,
analytical equipment, glass analysis use; 115
Francis Henry Taylor becomes Director of; 14
Ktisis mosaic, description and iconography; 213

mice,
in Villa at Dar Buc Ammera (Zliten, Libya), Atrium House triclinium foliate borders compared with; 24

microscopy,
See binocular microscopy; Fourier transform infrared microspectroscopy (FTIR); polarizing light microscopy; qualitative X-ray microanalysis; scanning electron microscopy (SEM);

Milan,
mint of, Trajan Decius coins; 294

minerals/metals,
 See alkalis; alloy; aluminum; amalgam; antimony; apatite; basalt; brass; bronze; calcite; calcium; cassiterite; copper; cuprite; dolomite; iron; lead; limestone(s); litharge; magnesium; manganese; natron; obsidian; pewter; phosphorus; potassium; silica; silver vessels; soda-lime; stone;

mints for coins, See,
 Ake-Ptolemais, mint of;
 Alexandria, mint of;
 Amphipolis, mint of;
 Antioch, mint of;
 Apamea, mint of;
 Arados, mint of;
 Asia, mint of;
 Constantinople, mint of;
 Cyzicus, mint of;
 Damascus, mint of;
 Heraclea, mint of;
 Laodicea ad Mare, mint of;
 Laodiceia, mint of;
 Milan, mint of;
 Nicomedia, mint of;
 Pergamon, mint of;
 Rome, mint of;
 Seleucia Pieria, mint of;
 Seleucia-on-the-Tigris, mint of;
 Sestos, mint of;
 Side, mint of;
 Sidon, mint of;
 Tarsus, mint of;
 Thessalonike, mint of;

Mnemosyne,
 inscription, in Funerary Banquet mosaic; 200

moderation,
 iconic significance of water for, in Greco-Roman world; 193
 importance of, as Atrium House triclinium theme; 71
 principal theme for, Drinking Contest Between Dionysos and Herakles mosaic; 181
 support for by Athenaios; 28
 support for, in Drinking Contest Between Dionysos and Herakles mosaic; 27

mold
 for a vessel, catalogue description; 266

money,
 See economy;

moral implications,
 See Also iconography; moderation;
 Drinking Contest Between Dionysos and Herakles mosaic; 27
 Judgment of Paris mosaic; 28
 Peacocks mosaic; 242

Morey, Charles Rufus,
 biographical sketch; 3
 comment on mosaic field treatment; 83

death in 1955; 14
(figure); 3, 8, 82
medieval art studies with Taylor, (note 1); 15
mentor of Francis Henry Taylor; 3
motivations for Antioch expedition; 4
role in Antioch excavations, overview; 3

Morgan, Paul B,
 archaeological background; 12
 impact on Francis Henry Taylor's interest in archeology; 12

mortality,
 See Also iconography; themes;
 banquet theme; 188

mortar,
 See bedding, mortar;

mosaic(s),
 art, reconstructing the process; 31
 artists,
 difficulties in identifying individuals; 38
 evidence for different, in Aphrodite and Adonis, and Judgment of Paris mosaics; 44
 evidence for different, in Dancing Satyr and Drinking Contest mosaics; 42
 conservation and restoration campaign; 81–113
 1930s experts, (note 36); 112
 goals; 85
 creation techniques, (note 44 and 59); 73
 current locations, See,
 Amherst College;
 Antioch College;
 Baltimore Museum of Art;
 Hatay Archaeological Museum (Antakya, Turkey);
 Louvre museum;
 Metropolitan Museum of Art;
 Oberlin College;
 Princeton University;
 Wellesley College;
 Worcester Art Museum;
 Djemila, star motif on; 256
 examples, See,
 Agora mosaic;
 Ananeosis mosaic;
 Aphrodite and Adonis mosaic;
 Atrium House triclinium;
 Beribboned Lion mosaic;
 Bird and Kantharos mosaic;
 Buffet Supper mosaic;
 Dancing Maenad mosaic;
 Dancing Satyr mosaic;
 Dionysos and Ariadne mosaic;
 Dionysos Discovering Ariadne mosaic (Chania, Crete);
 Drinking Contest Between Dionysos and Herakles mosaic;
 Earth and the Seasons mosaic;
 Earth mosaic;

 Eukarpia mosaic;
 Female bust mosaic;
 gaming board mosaic;
 Marine Mosaic;
 Four Seasons mosaic;
 Funerary Banquet mosaic;
 Ge and the Karpoi mosaic;
 Geometric mosaics;
 Gethosyne mosaic;
 Hephaistos mosaic (Pergamon);
 Hermes Carrying the Infant Dionysos mosaic;
 Honolulu Hunt mosaic;
 Judgment of Paris mosaic;
 Ktisis mosaic;
 Musical Contest Between Apollo and Marsyas mosaic;
 Musicians mosaic;
 Nymph mosaic;
 Peacocks mosaic;
 Phoenix mosaic;
 Preparation for the First Bath of Dionysos mosaic;
 Rams' Heads mosaic;
 Season (Spring or Summer) mosaic;
 Star mosaic;
 Thetis handing weapons to Achilles mosaic;
 Tomb of the Funerary Banquet mosaic;
 Torre Annunziata mosaic;
 Worcester Hunt mosaic;
 excavation and field treatment; 82–84
 (figures); 84
 fabrication,
 as a key object of museum study; 17
 techniques of; 32–37
 field lifting and backing system; 82–83
 painting, glass and stone tesserae palette; 41
 pavements,
 layers of, detailed field notes on; 33
 stages in laying, material analysis aid in understanding; 57
 stages involved in execution of; 32
 tools for manipulating, (note 43); 73
 Piazza Armerina, star motif on; 256
 Pompeii, star motif on; 256
 restoration and conservation; 81–113
 surface, Atrium House triclinium mosaics restoration treatment; 90
 Timgad, star motif on; 256
 workshops,
 Antioch, influence on Sepphoris, Galilee mosaics; 24
 relationship to glass tesserae workers, issues and questions; 49
 size and organization questions; 40

mosaic(s), cont.
structure, issues and questions about; 39
Villa of Dionysos (Knossos, Crete), age of, (note 17); 73

motifs,
See Also iconography; themes;
examples, See,
animals;
birds;
insects;
Nilotic motifs;
plants;
pativ, in Sasanian iconography; 219
power, in Ktisis mosaic from the Constantinian Villa near Daphne; 211
ribbon, in House of the Bird Rinceau mosaic border; 241

multiple points of view,
in Worcester Hunt mosaic; 233, 236

Multiplication of Loaves and Fishes church,
at Tabgha on the Sea of Galilee, Nilotic motifs in; 213

Munsell system,
See Also color(s);
reasons for not using in glass tesserae analysis; 51

Musee Historique des Tissus (Lyon, France),
silk fragment, (figure); 220

Musees Nationaux de France,
See Louvre museum (Paris, France); National Museums of France;

Museo Ostiense (Ostia, Italy),
grave stele image of tesserae preparation, (note 68); 74

museums,
See Allen Memorial Art Museum (Oberlin College); Baltimore Museum of Art; Hatay Archaeological Museum (Antakya, Turkey); J. Paul Getty Museum; Louvre museum; Metropolitan Museum of Art; Museum of Fine Art, Boston; National Museums of France; Princeton University, Art Museum; Samsun Archaeological Museum; St. Louis Art Museum; Virginia Museum of Fine Arts; Worcester Museum of Art;

Musical Contest Between Apollo and Marsyas mosaic,
(figure); 29

Musicians mosaic,
Mariamin, Syria; 201

mustached warbler,
in Judgment of Paris mosaic; 76
possibility of; 77

Mycenaean culture,
proposed alternative to further involvement in Antioch; 12

mythological description,
allegorization of, in hunt mosaics; 235
Atrium House triclinium mosaics; 22–23, 27–30
Hermes and Dionysos; 192

—N—

Naples, Italy,
Archaeological Museum, Torre Annunziata mosaic, (note 22); 189

narrative style,
move away from, in Worcester Hunt mosaic; 233

National Museums of France,
See Also Louvre museum;
initial monetary pledge; 4
motivations for Antioch expedition; 4

natron,
See Also glass tesserae, analysis; glass tesserae, Atrium House triclinium, material study;
composition and source of; 117

naturalism,
in foliate border around Atrium House triclinium mosaics; 24
in Rams' Heads mosaic interpretation of Sasanian motifs; 219

Nea Paphos, Cyprus,
House of Aion,
Musical Contest Between Apollo and Marsyas mosaic, (figure); 29 (note 11); 195
Preparation for the First Bath of Dionysos mosaic, (figure); 193

necropolis,
See Also death;
feature of ancient roadsides around cities; 196

Necropolis of Mnemosyne,
site description, (note 4); 206
Tomb of the Funerary Banquet location; 60
Nero,
coins during reign of; 286, 287
image on Nero coins; 286

Nicomedes II of Bithynia,
coins during reign of; 284
image on Nicomedes II of Bithynia coins; 284

Nicomedia,
mint of,
Constantius II coins; 297
Justinianus I coins; 302

Nike,
image on Alexander II Zebina coins; 281
image on Arados coins; 285
image on Side coins; 286

Nilotic motifs,
See Also animals; birds; iconography; insects; plants; themes;

abundance associations of; 214
in Antioch mosaic on property of Rassim Bey Adali; 213
in border of Worcester Ktisis mosaic; 210, 213
(figure); 211
in church of Multiplication of Loaves and Fishes at Tabgha on the Sea of Galilee; 213
in Qast-el-Lebia basilica in Cyrenaica; 214
on ivory pyxis from Egypt, (note 17); 206

nine beads
catalogue description; 271

Noble, W. H.,
(figure); 8

non-linearity,
in hunt mosaics, significance and function of; 235
Worcester Hunt mosaic; 233

Nonnos,
(note 8); 195

Ny-Carlsberg Glyptothek,
potential sponsor of excavation; 4

Nymph mosaic,
Bath D, current location; 190

Nysa,
nymphs of, relationship to Hermes and Dionysos; 192, 193

—O—

Oberlin College,
Antioch mosaic; 14
conservation students treatment of Worcester Hunt mosaic,
evaluation of; 107
(figure); 106
Geometric mosaics; 222
(note 11); 227

obsidian,
glass tesserae analysis; 126
sources of, (note 110); 74
stone tesserae sample, analysis of; 67

Odyssey,
quotation from, in Maison du Cerf; 225

oecus,
See triclinia;

opacity,
glass tesserae opacifiers; 120–126
to translucency range of glass tesserae, in Atrium House triclinium; 50

Oppian,
Cynegetica manual of hunting, Worcester Hunt mosaic illustration of; 235

optical examination,
glass tesserae analysis technique; 49

opus sectile floor,
See Also mosaic(s);

opus sectile floor, cont.
 in Antioch House of Aion, (figure); 224
 description, (note 6); 227
 Kenchreai, Greece, glass composition comparisons with Antioch; 134

orange glass tesserae,
 analysis; 127–133
 (table); 166
 batch vs. firing conditions; 51
 reducing atmosphere requirement; 54

order,
 mosaic fabrication, beveled edge evidence for; 36

orientation,
 Atrium House triclinium figural mosaics; 22

Orontes river,
 See Also iconography; Tyche;
 Antioch Tyche statue representation of,
 impact of; 212
 visual description; 244
 image on,
 Augustus coins; 286
 Severus Alexander coins; 290
 mosaic signature reference to; 38

Osrhoene province, Syria,
 Sarrîn Hunt mosaic, Artemis in; 234

Ostia, Italy,
 grave stele image of tesserae preparation, (figure); 40

Otacillia Severa, wife of Philip I,
 coins during reign of Philip I, the Arab; 293
 image on Otacillia Severa, wife of Philip I coins; 293

oval brooch
 catalogue description; 270

oxidation,
 reduction vs., as factor producing either green or red glass; 53

—P—

painting(s),
 See Also art/artistic;
 Hellenistic, influence on Atrium House triclinium; 71
 mosaic, glass and stone tesserae palette; 41
 stone, Atrium House triclinium mosaics as; 22, 26
 techniques, in Antioch and Hadrian's Villa mosaics; 27

palaestra,
 Hermes as patron of; 193

Palestine,
 fifth and sixth century, Geometric mosaics composition compared with examples in; 225

palette,
 See Also color(s);

criteria, in studying mosaic workshop relationships; 51
differences, as evidence of different artists; 44
glass,
 House of the Drinking Contest mosaics; 60
 scope of, Atrium House triclinium; 50
 tesserae; 41
 Tomb of the Funerary Banquet mosaics; 60
stone tesserae; 41

Palladas,
 (note 19); 189

panther,
 in Dionysos mosaic fragment from House of the Sundial room 3, (figure); 184
 skin, in Worcester Hunt mosaic; 231, 234

parapatesma,
 significance of, (note 8); 206

parasites,
 See Also iconography;
 iconic representation of, in House of the Sundial mosaics; 187

Paris,
 See Judgment of Paris mosaic;

Paris, France,
 Louvre museum,
 Atrium House triclinium fragment; 7
 Phoenix mosaic, (figure); 220

parrot(s),
 in border, of Aphrodite and Adonis mosaic; 48
 in Dumbarton Oaks Hunt mosaic; 233
 ribbon motif on, (note 12); 221

partridge,
 in foliate border around Atrium House triclinium mosaics, Dionysian significance of; 24

pativ motif,
 in Sasanian iconography; 219

pavements,
 See mosaic(s), pavements;

pax,
 image on Septimius Severus coins; 289

peacocks,
 in foliate border around Atrium House triclinium mosaics, Dionysian significance of; 24
 in fragment from House of the Sundial room 2, (figure); 185
 in House of Ge and the Seasons mosaic; 214
 in House of the Bird Rinceau mosaic, visual and iconographic description; 241–242
 in House of the Buffet Supper mosaic; 184

in Judgment of Paris mosaic; 76, 79
in Peacocks mosaic; 240

Peacocks mosaic; 238–243
 (figure); 239
 in situ photograph, (figure); 241
 stable isotopes chart, (figure); 69

peafowl,
 (note 6); 79

pearls,
 simulation of, in Ktisis mosaic; 210

pendant(s),
 catalogue descriptions; 270–271

Pergamon, Turkey,
 Hephaistos mosaic, Aphrodite and Adonis foliate borders compared with, (figure); 26
 Hygieia statue based on models from; 248
 inhabited foliate scrolls in, Atrium House triclinium foliate borders compared with; 24
 mint of, Attalos I coins; 284

Persephone,
 Demeter's daughter, implied presence in Funerary Banquet mosaic; 205

Persia,
 See Also Sasanian kingdom (Iran);
 Worcester Hunt mosaic influence; 233

personifications,
 See Also iconography; motifs; themes;
 abstract nouns, mosaic use; 211
 examples, See,
 Aion;
 Apolausis;
 Charis;
 Euandria;
 Euphrosyne;
 Ge;
 Gethosyne;
 Karpoi;
 Ktisis;
 Soteria;
 tropai personification;
 Tyche;
 kinds of; 212
 nature and its cycles, in mosaics of House of Ge and the Seasons; 214

pewter,
 glassmaking component, issues with; 55

Philip I, the Arab,
 coins during reign of; 291, 292
 image on Philip I, the Arab coins; 291, 292

Philip Philadelphus,
 coins during reign of; 282
 image on Philip Philadelphus coins; 282

Philodemus,
 (note 16); 189

Philostratos,
"Imagines," Worcester Hunt mosaic representation of; 235

Phocas,
coins during reign of; 303
image on Phocas coins; 303

Phoenicia (Lebanon and Syria coastal plain),
fifth and sixth century, Geometric mosaics composition compared with examples in; 225

Phoenix mosaic,
design purpose, (note 14); 221
(figure); 220
rams' heads border, (note 3); 221
Sasanian iconography in; 218

phosphorus,
See glass tesserae, analysis; glass tesserae, Atrium House triclinium, material study;

photographs,
mosaic art process reconstruction use; 31
of Levi, inaccuracy of, (note 32); 73

physical fitness,
personification, See, Euandria;

Piazza Armerina, Sicily,
star motif on mosaics from; 256

pilaster capital,
(figure); 263

pilaster capital catalogue description; 263

pin(s),
with face, (figure) and catalogue description; 272

plans,
mosaic art process reconstruction use; 31

plant(s),
See Also acanthus leaves; flowers; foliate; fruit(s); fruit trees; grapes; landscape; lilies; lotus buds; motifs; rosebuds; roses; vines;
as vegetable decoration, Levi's study of, (note 14); 73
ash, See,
glass tesserae analysis;
glass tesserae Atrium House triclinium, material study;
in female mosaic from room 3 of the House of Ge and the Seasons; 208
silver, hunting scenes on; 236

plate (silver),
details, (figures); 256
(figure); 255
catalogue description; 255–256

pleasure,
Gethosyne as personification of; 194

Pliny,
daily routine description, (note 15); 189

Plutarch,
"Convivial Questions," support for moderation as a virtue; 28

polarizing light microscopy,
stone tesserae sample analysis use; 64

political unrest,
in Antioch in 1938, impact on excavation; 12

Pollux,
Onomasticon, sundial significance described in; 187

Pompeii, Italy,
Casa del Fauno, (note 1); 79
Casa della Fontana Piccola, red tesserae analysis, (note 21); 136
excavated couch sizes, impact on Antioch House triclinium size determination; 21
House of Ganymede, (note 3); 256
House of the Moralist, distichs on the walls of; 187
House of Paquius Proculus, (note 3); 256
inhabited foliate scrolls in, Atrium House triclinium foliate borders compared with; 24
mosaic tesserae compared with Antioch mosaic tesserae; 134
painting execution order evidence; 36
star motif on mosaics from; 256
Torre Annunziata mosaic, (note 22); 189

possessions,
Ktisis personification, in hunt mosaics; 235

potassium,
See glass tesserae, analysis; glass tesserae, Atrium House triclinium, material study;

power motif,
in Ktisis mosaic from the Constantinian Villa near Daphne; 211

prefabrication,
See Also fabrication; preparation;
Judgment of Paris elements, possibilities; 58
speculations about; 35
practices of, in Hellenistic and early Roman periods; 36
unliklihood of, in Bosra beveled edge mosaics; 36

preparation,
See Also fabrication; prefabrication;
detailed, Atrium House triclinium features that suggest; 32
mosaics, for installation; 11
tesserae, Ostia grave stele image, (figure); 40

Preparation for the First Bath of Dionysos mosaic,
(figure); 193

preservation,
See Also conservation; restoration;

goal of Antioch mosaic conservation and restoration campaign; 85

Princeton Expedition House,
site of 1936 meeting; 8

Princeton University,
Antioch Archives,
mosaic conservation and restoration research use; 81
role in mosaic restoration; 111
as sources for mosaic fabrication analysis; 18
Art Museum,
Aphrodite and Adonis mosaic, (figure); 25
Aphrodite and Adonis mosaic on exterior wall of, (figure); 88
Atrium House triclinium component owner; 17
Drinking Contest Between Herakles and Dionysos mosaic, House of Dionysos (Sepphoris, Galilee); 180
Earth and the Seasons mosaic; 208
gaming board mosaic, (note 5); 206
House of the Bird Rinceau mosaic border fragment, (figure); 238
initial interest in excavation; 4
Francis Henry Taylor's graduate school; 3
initial monetary pledge; 4
museum treatment of newly excavated mosaics; 88
National Museums of France interest in; 4
representatives, at Antioch meeting in 1936; 8

process,
See Also fabrication; prefabrication;
mosaic art production, difficulties in ascertaining; 31

produce,
earth, personification of, in Ge and the Karpoi mosaic; 225

proportions of constituents,
glass tesserae, as type determinant; 52

prosperity,
See abundance;

protection,
Ktisis as personification of; 213
Tyche as representation of; 246
Worcester Hunt mosaic,
attempts over the years; 105
concerns about; 106

protomes,
ram, in Rams' Heads mosaic; 216

Psyche,
in Judgment of Paris mosaic; 23

Ptolemy I,
coins during reign of; 283
image on Ptolemy III Euergetes coins; 283

Ptolemy II Philadelphus,
coins during reign of; 283
image on Ptolemy II Philadelphus coins; 283

Ptolemy III Euergetes,
coins during reign of; 283

pyxis,
banquet of women, scene description, (note 17); 206

—Q—

Qast-el-Lebia basilica in Cyrenaica,
Nilotic motifs in; 214

quail,
in Judgment of Paris mosaic; 76, 78

qualitative X-ray microanalysis,
stone tesserae sample analysis use; 64

quantitative analysis,
of glassmaking technology, at Antioch; 115–135

quarry(s),
near Antioch; 62
sources and relationships,
analysis based on samples; 67
stable isotope mass spectrometry use in determining; 68

quartz,
in stone tesserae samples; 64

—R—

raking light,
Worcester Hunt mosaic appearance under, (figure); 107

ram,
image on Antioch-on-the-Orontes coins; 300
protomes,
in Phoenix mosaic; 219
in silk fragment, (figure); 220

Rams' Heads mosaic; 216–221
(figures); 217, 218, 219
visual description; 216

raptors,
in Judgment of Paris mosaic, possibility of; 76

Rassim Bey Adali,
Antioch mosaic on property of; 213

realism,
differences between Judgment of Paris and in Aphrodite and Adonis mosaics; 45

rebirth,
peacock as symbol of; 242

reception area,
See Also hospitality;
House of Menander, visual description; 185
House of the Boat of the Psyches, visual description; 185

House of the Worcester Hunt, visual description; 228
Triclinos building from Apamea, Syria, hunt mosaics from; 233

red,
dark red, glass tesserae analysis, (table); 166
glass tesserae,
analysis; 127–133
analysis, (table); 166
differences between figural mosaic and border of Aphrodite and Adonis mosaic; 57
(note 21); 136
type and composition variations; 53
on Hygieia statue; 248
red glass, Type 1,
characteristics of; 52
red glass, Type 2,
characteristics of; 53
explanation of lead levels, (note 88); 74
red glass, Type 3,
characteristics of; 53
stone tesserae, analysis; 66

red-breasted flycatcher,
in Judgment of Paris mosaic, possibility of; 78

red-orange,
differences between figural mosaic and border of Judgment of Paris mosaic; 58
glass tesserae analysis, (table); 166
glass tesserae, batch vs. firing conditions; 51

redstart,
in Judgment of Paris mosaic, possibility of; 78, 79

reduction,
condition, required for red glass production; 52
oxidation vs., as factor producing either red or green glass; 53
process, in creating orange glass; 54

reed-warbler,
in Judgment of Paris mosaic, possibility of; 77

religions,
See Christianity; mythological description; Zoroastrianism;

reliquary,
See Also death;

reliquary catalogue description; 267

Renaissance Court,
preparation for original Antioch installation; 10

renewal,
motif, in Ktisis mosaic from the Constantinian Villa near Daphne; 211
Soteria as personification of; 194

Residence Basilica of Hadrian's Villa (Tivoli, Italy), mosaic,
(figure); 26
location of, (note 23); 73

restoration,
See Also conservation; excavation; field; installation;
1930s attempts,
(figure); 95
on Funerary Banquet mosaic; 94
on Funerary Banquet mosaic, deleterious effects of; 95
on Funerary Banquet mosaic, undoing the effects of; 98
Worcester Hunt mosaic; 104
Agora mosaic, 1998; 100
conservation and,
of Atrium House triclinium; 86–93
of Funerary Banquet mosaic; 94–101
of Worcester Hunt mosaic; 102–113
Eukarpia mosaic, 1998; 100
Funerary Banquet mosaic; 97
mosaic, three case studies; 81–113
on kings and deities, (note 9); 221
(note 4); 195

ribbon motif,
examples of, (note 12); 221
in House of the Bird Rinceau mosaic border, visual description; 241
on kings and deities (note 9); 221
(note 4); 195

ring with four beads
catalogue description; 268

rock thrush,
in Judgment of Paris mosaic, possibility of; 78, 79

roller,
in Judgment of Paris mosaic; 76
possibility of; 77

Roma,
image on Constantius II coins; 297
image on Gallienus coins; 295
image on Philip I, the Arab coins; 292
image on Salonina, wife of Gallienus coins; 295

Roman Villa,
original name for Atrium House; 18
plan, relative to Atrium House triclinium, (figure); 21

Rome,
millennium commemoration,
Philip I, the Arab coin; 292
Trajan Decius coin; 294
mint of,
Gordian III coins; 290, 291
Otacillia Severa, wife of Philip I coins; 293
Philip I, the Arab coins; 292
Septimius Severus coins; 289
Trajan Decius coins; 293

Rome, cont.
 (note 4); 195
 sarcophagus of Casino Rospigliosi,
 description, (note 20); 73

room arrangement,
 See Also architecture; exedra;
 in Antiochene houses; 208

rooster,
 in House of the Bird Rinceau mosaic
 border; 240

rose-ringed parakeet,
 in Judgment of Paris mosaic, possibil-
 ity of; 76

rosebuds,
 Ananeosis mosaic, (note 3); 221
 in exedra mosaic of Antioch House
 of Aion,
 (figure); 224
 visual description; 224
 in House of the Bird Rinceau mo-
 saic; 238
 visual description; 241
 in Rams' Heads mosaic border; 216

Rosen, David,
 preparation of mosaics for installa-
 tion; 11

roses,
 in Villa at Dar Buc Ammera (Zliten,
 Libya), Atrium House triclinium fo-
 liate borders compared with; 24

rust,
 mosaic damage caused by; 88

rutile,
 in stone tesserae samples; 64

—S—

S C letters,
 image on Hadrian coins; 289
 image on Titus coins; 288

Sabratha,
 judgment of Paris in reliefs at, (note
 27); 73

Saker falcon,
 in Judgment of Paris mosaic; 76

Salamis, Cyprus,
 proposed alternative to further in-
 volvement in Antioch; 12

Salonia, Croatia,
 capital with acanthus leaves, (note 1);
 262

Salonina, wife of Gallienus,
 coins during reign of Gallienus; 295
 image on Salonina, wife of Gallienus
 coins; 295

Salus,
 See Hygieia;

salvation,
 Soteria as personification of; 194

Samosata, Turkey,
 origin of mosaic artist who signed
 his work; 38

sampling,
 techniques, for glass tesserae analysis
 studies; 49

Samsat, Turkey,
 See Samosata, Turkey;

Samsun Archaeological Museum,
 signed mosaic location; 38

Sandan,
 image on Antiochus VIII Grypus
 coins; 281

sarcophagus,
 Casino Rospigliosi (Rome, Italy), de-
 scription, (note 20); 73
 catalogue description; 260—261

Sarrîn Hunt mosaic,
 Artemis in; 234

Sasanian kingdom (Iran),
 fire altar, image on Chosroes II coins;
 300
 iconography, modification into deco-
 rative motifs; 220;
 (note 7); 221
 motifs in Dumbarton Oaks Hunt
 mosaic; 233
 silk, (note 13); 221
 source, of Rams' Heads mosaic ico-
 nography; 219
 Zeugma sack, mosaic dating value; 38

satyr(s),
 See Also Ampelos; Dancing Satyr
 mosaic; gods/goddesses;
 in Dionysos mosaic fragment from
 House of the Sundial room 3,
 (figure); 184

scanning electron microscopy (SEM),
 glass tesserae analysis use; 49, 116
 stone tesserae sample analysis use; 64

sculpture,
 See Also statues;
 fragments, catalogue description;
 264—265

Season (Spring or Summer) mosaic,
 glass tesserae analysis, (table); 154

seasons,
 in Dionysos mosaic fragment from
 House of the Sundial room 3; 184
 in Funerary Banquet mosaic border;
 202
 personifications, in mosaics of
 House of Ge and the Seasons; 214

security,
 Ktisis as personification of; 213

sedge warbler,
 in Judgment of Paris mosaic, possibil-
 ity of; 77

Seleucia church,
 example of Antiochene inhabited foli-
 ate borders; 240

Seleucia Pieria, Turkey,
 House of the Drinking Contest,
 room arrangement; 208
 mint of, Caracalla coins; 289

sarcophagus fragments found in; 261

Seleucia-on-the-Tigris,
 mint of, Antiochus II Theos coins;
 277

Seleucid Antioch,
 Tyche statue made for; 212

Seleucus II Kallinikos,
 coins during reign of; 277
 image on Seleucus II Kallinikos coin;
 277

Seleucus VII Nikator,
 coins during reign of; 282
 image on Seleucus VII Nikator
 coins; 282
 in on Severus Alexander coin; 246

SEM (scanning electron microscopy),
 See scanning electron microscopy
 (SEM);

Sepphoris, Galilee,
 acanthus scroll, Atrium House
 triclinium foliate borders compared
 with; 24
 House of Dionysos,
 Drinking Contest Between
 Dionysos and Herakles mosaic;
 181
 Drinking Contest Between
 Herakles and Dionysos mosaic;
 181
 Drinking Contest Between
 Herakles and Dionysos mosaic,
 (figure); 180
 mosaic preparation evidence at; 33
 House of the Dionysos, preliminary
 drawings of figural scenes; 32
 Nile mosaic at; 214

Septimius Severus,
 coins during reign of; 289
 image on Septimius Severus coins;
 289

Serapis,
 on lamps, Atrium House dating use
 of; 20

serpent,
 See snake(s);

Sestos,
 mint of, Lysimachus coins; 283, 284

Severus Alexander,
 coins during reign of; 290
 image on Severus Alexander coins;
 290
 Tyche on coins of; 246

Sevso Treasure,
 hunting scenes on; 236

sexuality,
 Dionysos statue display of; 253
 Greek and Roman attitudes, (note 3);
 254

shadows,
 differences between Dancing Satyr
 and Drinking Contest mosaics; 43
 light illusion techniques and, in

women, cont.

 in Funerary Banquet mosaic; 199

 in Musicians mosaic; 201

 (note 14); 206

woodpeckers,

 in Judgment of Paris mosaic, possibility of; 76

Worcester Art Museum,

 See Also Antioch; Taylor, Francis Henry;

 acquisitions during first five years of excavation; 9

 initial monetary pledge,

 as actually committed; 6

 as proposed by Charles Rufus Morey; 4

 mosaics, See,

 Atrium House triclinium;

 Geometric mosaics;

 Peacocks mosaic;

 Rams' Heads mosaic;

 Worcester Hunt mosaic; 220

 museum treatment of newly excavated mosaics; 88

 trustees, selling the Antioch project to; 5

Worcester Hunt mosaic; 228–238

 1930s restorations, (figures); 104

 arrival at the Worcester Art Museum, (figures); 102

 border,

 conservation and installation; 109

 details, (figures); 233

 current installation with borders, (figure); 110

 dating; 232

 description and background; 8

 detail, (figure); 231, 232

 Dumbarton Oaks Hunt mosaic compared with; 234

 example of Antiochene inhabited foliate borders; 240

 excavation and field treatment; 103

 (figure); 83

 (figure); 229

 fragment, in Antioch, (figure); 8

 iconography; 233

 in situ photograph, (figure); 102, 220

 installation, (figures); 103

 restoration; 102–113

 attempts evaluation, (figures); 107

 treatment, (figures); 108

 stable isotopes chart, (figure); 69

 stone tesserae sample analysis, (table); 63

 treatment,

 conservation; 102–113

 conservation , 2000–2004; 107

 from 1937–2000; 105

 visual description; 231

 Worcester Museum of Art acquisition; 8

Worcester Museum of Art,

 See Worcester Art Museum;

workshop(s),

 emblemata assembly in, during Hellenistic and early Roman periods; 36

 glass, differentiating by glass type; 52

 identification, as a goal of museum study; 17

 mosaic,

 Antioch, influence on mosaics in Sepphoris, Galilee; 24

 relationship to glass tesserae workers, issues and questions; 49

 size and organization questions; 40

 relationships,

 glass tesserae batch use in studying; 51

 glass tesserae type use in studying; 52

 structure, issues and questions about; 39

World War II,

 termination cause for Antioch excavations; 224

wreath,

 image on Constantine I, the Great coins; 296

—X—

X-ray microanalysis,

 See Wavelength Dispersive energy Spectrometry (WDS);

—Y—

Yakto complex in Daphne,

 site of, Dumbarton Oaks Hunt mosaic; 232

Yale University,

 Jerash excavations, tesserae use for Worcester Hunt mosaic 1930s restoration work; 104

 potential sponsor of excavation; 4

yellow,

 glass tesserae,

 analysis; 122–124

 analysis, (table); 164

 differences between figural mosaic and border of Judgment of Paris mosaic; 58

 pale yellow, glass tesserae analysis, (table); 164

Young Boy statue

 catalogue description; 251–252

—Z—

Zeugma, Turkey,

 mosaic rescue operations; 38

Zeus,

 eagle as sacred bird of; 242

 image on,

 Alexander I Balas coins; 279

 Alexander II Zebina coins; 280

 Alexander III The Great coin; 277

 Antioch-on-the-Orontes coins; 285, 300

 Antiochus IV Epiphanes coin; 278

 Cleopatra Thea and Antiochus VIII Grypus coin; 281

 Demetrios II Nikator coin; 280

 Laodiceia coins; 285

 Nicomedes II of Bithynia coins; 284

 Philip Philadelphus coins; 282

 Seleucus VII Nikator coins; 282

 in Judgment of Paris mosaic; 23

Zeus Orianos,

 image on Antiochus VIII Grypus coins; 281

Zeus Xenios,

 in Libanios' quotation; 226

Zeus-Serapis,

 image on Antiochus IV Epiphanes coin; 278

Zoroastrian religion,

 iconography, in Rams' Heads mosaic; 219

Zosimos,

 Zosimos of Samosata vs., artist identification issues; 39

Zosimos of Samosata,

 mosaic artist signature; 38

 Zosimos vs., artist identification issues; 39

Sources for the Illustrations

Steve Briggs, pg. II, pg. XVI

Victoria I and Mary Todd, adapted by Jon Albertson, pgs. XIV–XV

From Antioch to Worcester, The Pursuit of an Ancient City

Yousuf Karsh, © 1957, fig. 13

Antioch Expedition Archives, Research Photographs, Department of Art and Archaeology, Princeton University, figs. 6–9, 12

Unknown (?), figs. 1–5, 10–11

The Atrium House Triclinium

Jon Albertson, figs. 8, 22, 23, 27, 71

Paula Artal-Isbrand, figs. 12 (details), 33, 35–36, 44–46

Lawrence Becker, figs. 52, 55

Steve Briggs, figs. 4–5, 9–12, 14, 18–19, 26, 31–32, 37–43, 47, 49, 58–60, pgs. 76–79

Chet Brummel, figs. 10, 18

Wes Chilton, adapted by Jon Albertson, fig. 2

With the kind permission of the Director of the Department of Antiquities, Cyprus, fig. 20

Victoria I, adapted by Jon Albertson, figs. 2, 53

Department of Antiquities Israel, fig. 13

Philip Klausmeyer, figs. 3, 34

Courtesy of the Muzeo Nazionale Romano, Palazzo Massimo, fig. 28

Richard Newman, figs. 62–70

Corine Norman, figs. 3 (reconstruction), 34 (reconstruction)

Courtesy of the Bildarchiv Preussischer Kulturbesitz/ Art Resource, NY., fig. 16

Antioch Expedition Archives, Research Photographs, Department of Art and Archaeology, Princeton University, figs. 1, 6–7, 15, 21, 24–25, 29, 50–51, 54, 61

Mei-An Tsu, figs. 56–57

Courtesy of Scavi di Ostia e Museo Ostiense, fig. 30

Courtesy of Vatican Museums, fig. 17

Mark Wypyski, fig. 48

The Mosaic Conservation Campaign: Three Case Studies

Jon Albertson, figs. 27, 67

Paula Artal-Isbrand, figs. 10–24, 32, 40, 42, 51, 53–55, 60–64

Steve Briggs, figs. 1–2, 25, 31, 33, 43, 68

Victoria I, fig. 27

Sarah Nunberg, figs. 30, 34–37

Antioch Expedition Archives, Research Photographs, Department of Art and Archaeology, Princeton University, figs. 3–9, 26, 28, 39, 41, 44, 52

The Worcester Art Museum, Worcester, Massachusetts, figs. 29, 38, 44–50, 56–59, 65–66

Glassmaking Technology at Antioch, Evidence from the Atrium House Triclinium and Later Mosaics

Jon Albertson, figs. 3–5, 7, 10, 12

Steve Briggs, fig. 1

Mark Wypyski, figs. 2, 6, 8, 9, 11, 13–16

Appendix: Glass Composition Analyses

Baltimore Museum of Art, Antioch Subscription Fund, pg. 154 (Europa BMA 1937.129 and Agros and Opora BMA 1937.127)

Lawrence Becker, pg. 148 (Four Seasons)

Steve Briggs, pgs. 138, 140, 142, 144, 150, 152, 154 (Dionysos and Ariadne)

The Metropolitan Museum of Art, pg. 154 (Season)

Antioch Expedition Archives, Research Photographs, Department of Art and Archaeology, Princeton University, pg. 146

Mei-An Tsu, pg. 148 (Marine Mosaic)

Catalogue

Jon Albertson, cat. 4, fig. 4; cat. 7, figs. 1, 6

Paula Artal-Isbrand, cat. 11, fig. 3; cat. 15, figs. 1 (bottom), 2–3

Steve Briggs, pg. 176–177; cat. 1, figs. 1–3; cat. 3, pg. 191; cat. 4, pg. 197, figs. 2–4, 6–9; cat. 5, pg. 209, figs. 2–5,7–9; cat. 6, pg. 217; cat. 8, figs. 5–9, 11, pg. 229; cat. 10, pg. 244; cat. 11, pg. 247; cat. 12, pg. 250; cat. 13, pg. 251; cat. 14, pg. 253; cat. 15, pg. 255 (top); cat. 16–48 (all)

Chet Brummel, pg. 176; cat. 1, figs. 1–3

With the kind permission of the Director of the Department of Antiquities, Cyprus, cat. 3, fig. 3

Anna Gonosová, cat. 6, fig. 6

Victoria I, adapted by Jon Albertson, cat. 2, fig. 1; cat. 3, figs. 1, pg. 191; cat. 4, fig. 5; cat. 5, fig. 1; cat. 8, fig. 2; cat. 9, fig. 2

Christine Kondoleon, cat. 5, fig. 6

Courtesy of Eric and Carol Meyers, cat. 1, fig. 4

Antioch Expedition Archives, Research Photographs, Department of Art and Archaeology, Princeton University, cat. 2, figs. 2–9; cat. 4, fig. 1, 5; cat. 6, figs. 1–5; cat. 7, figs. 2–5, pg. 222; cat. 8, figs. 1, 3, 4; cat. 9, figs. 1, 3, 4, pg. 239; cat. 11, fig. 2

Coins

Steve Briggs, pgs. 274–304 (all)

The Worcester Art Museum's
participation in the excavation at
Antioch was funded by
the bequests of the
Reverend Austin S. Garver
and Sarah C. Garver.
The Museum is forever indebted to
them for the opportunity to support the
excavation and acquire works from it.